Dividing Paris

Dividing Paris

Urban Renewal and Social Inequality, 1852–1870

ESTHER DA COSTA MEYER

PRINCETON UNIVERSITY PRESS PRINCETON AND OXFORD

Requests for permission to reproduce material from this work should be sent to permissions@press.princeton.edu
Published by Princeton University Press,
41 William Street, Princeton, New Jersey 08540
In the United Kingdom: Princeton University Press,
6 Oxford Street, Woodstock, Oxfordshire OX20 1TR

press.princeton.edu

Front cover: (top) Eugène Moreau, the new Boulevard de la Reine Hortense above the canal Saint-Martin, embellished with gardens and fountains (detail). Musée Carnavalet. © Paris Musées / Musée Carnavalet; (bottom) Félix Thorigny, demolitions on the Left Bank, during the cutting of the Rue des Écoles (detail). *L'Illustration*, June 26, 1858. Bibliothèque nationale de France, Paris. © Bibliothèque nationale de France.

ISBN 978-0-691-162-80-5
ISBN (ebook) 978-0-691-22353-7
Library of Congress Control Number: 2021945054

British Library Cataloging-in-Publication Data is available

This publication is made possible in part from the Barr Ferree Foundation Fund for Publications, Department of Art and Archaeology, Princeton University

Design and composition by Julie Allred, BW&A Books, Inc.
This book has been composed in Dante, Didot, and Montserrat

Printed on acid-free paper. ∞
Printed in Italy
10 9 8 7 6 5 4 3 2 1

In Memory of Vincent Scully

Contents

Acknowledgments

Every author incurs debts that cannot be repaid: to mentors, colleagues, students, friends, and family. This book owes its greatest debt to Vincent Scully, who once described the urban fabric as one of our most precious and fragile legacies, a conviction that hovers over this study of nineteenth-century Paris. His passion and integrity, as a teacher and scholar, guided me through graduate studies and have served as continuing inspiration in my own career as a scholar and a teacher. He lives on in the loving memory of friends, students, and scholars. I also wish to express my deep gratitude to his widow, Catherine Lynn (Tappy), for her friendship and support.

All scholars stand on the shoulders of our predecessors, and I am keenly aware that any book is always but a contribution to an ongoing conversation. I hope that I have discharged some measure of this debt through acknowledgments both in my text and in annotations. I am most particularly indebted to feedback from friends and fellow architectural historians throughout the gestation of the manuscript. I am grateful above all to Professors Mary McLeod (Columbia University) and Jean-Louis Cohen (Institute of Fine Arts), whose critical reading and insights resulted in numerous crucial corrections and improvements. Kenneth Silver, Jonathan Weinberg, and John Goodman also played a fundamental role in providing advice and encouragement.

A number of colleagues were kind enough to read selected chapters, including my very dear friend Jim Clark, former director of the University of California Press. Alan Mann, professor of anthropology at Princeton, offered much-appreciated corrections and suggestions in my discussion of Parisian prehistory; Joseph Disponzio, director of the landscape design program at Columbia University, contributed insights to the chapter on gardens; and Peter Barberie, curator of photographs at the Philadelphia Museum of Art, was instrumental in advising me on technical aspects of nineteenth-century photographic images. I also wish to thank Professor Catherine Bruant from the École Nationale Supérieure d'Architecture de Versailles for allowing me to read an electronic version of her excellent book on the Cité Napoléon unavailable at the time.

At Princeton University, I was fortunate to profit from the wise council of Giles Constable, Arno Mayer, Carl Schorske, Eva and Lionel Gossmann, Walter Lippincott, Walter

Hinderer, Mary Harper, and Carol and François Rigolot. Over the years, students in several seminars enriched my ideas with their comments and questions. I thank them collectively for being such attentive and critical interlocutors. The generosity of both the Spears Fund and the Barr Ferree Fund of the Department of Art and Archaeology merits my grateful thanks. I profited enormously from the enviable organizational skills and resourcefulness of Susan Lehre, for many years the department's manager, and her successor, Maureen Killeen. Julia Gearhart, director of visual resources, spared no effort in providing access to photographs. Stacey Bonette was of invaluable assistance in securing photographs. Jessica Dagci, Rebecca Friedman, and David Platt from Marquand Library worked tirelessly to help locate important sources. Warm thanks to John Blazejewski for his photographs executed in trying circumstances in the midst of the pandemic. Korin Kazmierski, from Firestone Library's Interlibrary Loan, cheerfully made mountains of digitized articles available to me. At Yale, Helen Chillman accompanied this work from its inception and advised me on images. I will never repay my debt to Julie Angarone for her digital support.

In Paris, Paul and Mimi Horne provided hospitality in their beautiful apartment in the early stages of this project. The late Pierre Casselle and Madame Christine Huvé from the Bibliothèque de l'Hôtel de Ville did everything they could to aid me in locating manuscripts and plans. The department of reproductions of the Bibliothèque Nationale de France patiently guided me in navigating their rich database of photographs. Francine Allard and David Henry, also in Paris, were extremely generous in allowing me to publish their photographs. Scott Bukatman graciously allowed me to use one of his witty aphorisms as an epigraph.

The unwavering support and encouragement of the editors at Princeton University Press have helped sustain this project, beginning with Hanne Tidnam, who shepherded this manuscript in its earliest stages. Kenneth Guay answered every question, calmed every fear, and found solutions to last-minute problems. Kathleen Kageff did a terrific job copyediting the manuscript, catching errors and inconsistencies with morale-saving lightness of touch. Michelle Komie's patience and understanding, and ability to coax this book into fruition, deserve my gratitude. Karen Carter's editorial help was indispensable.

Behind many—perhaps most—books stand an inner circle of friends whose warm interest and encouragement are woven into the experiences that accompany the joys and agonies of research and writing. Among the dearest I wish to thank Mallica Kumbera Landrus, Matthew Landrus, Nadhra Naeem Khan, Anne Howells, June and Shed Behar, Thurmond Smithgall, Jonathan Weinberg, Nicholas Boshnack, and Amalia Contursi. I owe special thanks to the late Charlotte Hyde, that consummate Parisian-in-exile, whose discerning insights inevitably cast new perspectives on every question. Avrum Blumin heard early versions the chapters, alerted me to new publications, and offered continuous support. With her long experience in publishing, Rosalie Wolarsky was a fountain of strength.

Finally, my deepest gratitude is owed to my long-suffering spouse, Christopher, my dearest and toughest critic, for his encouragement, humor, and sound editorial advice.

Abbreviations

AHPML	*Annales d'hygiène publique et de médecine légale*
BHdV	Bibliothèque de l'Hôtel de Ville
BHVP	Bibliothèque historique de la Ville de Paris
CM	*La Construction moderne*
GAB	*Gazette des architectes et du bâtiment*
JSAH	*Journal of the Society of Architectural Historians*
NAC	*Nouvelles annales de la construction*
RGA	*Revue générale de l'architecture et des travaux publics*
TS	*Les travaux souterrains de Paris*, Eugène Belgrand

Dividing Paris

Introduction

"There are many Parises in Paris," wrote the architect César Daly in 1862.[1] An important authority on urban issues, Daly was referring to city's archaeological remains, but his observation can be applied more broadly. A layering of buildings of different ages, erected by different peoples, nineteenth-century Paris was never a clear, graspable entity, not even to its own inhabitants. Its population was a bracing mélange of locally born citizens and a large influx of provincials and foreigners whose divergent incomes, cultural backgrounds, and views of the city changed constantly over the years as they adjusted to an ever-shifting urban kaleidoscope. Their relationship to Paris was not the same in 1848 or 1868, nor before or after the Commune.

In Paris as elsewhere, the Industrial Revolution shattered the form of the classic Western city, placing great stress on the urban environment. Mass production, reliant on consumption, required a network of broad streets and boulevards that allowed crowds and merchandise to circulate. At the same time, rapid demographic growth called for improved water supply, sewerage, systems of transportation, and public greenery. In their search for new models of urban space, cities around the globe opted for a variety of solutions, depending on the economic and social price they were prepared to pay. In the case of Paris, there have been excellent studies documenting the radical reconfiguration of the city during the second half of the nineteenth century under Napoleon III and his strong-willed prefect of the Seine, Georges-Eugène Haussmann.[2] Together with a team of first-rate engineers and thousands of workers, they overhauled the capital, endowing it with all the amenities of a modern metropolis.

For the financial elites, urban renewal became a matter of urgency. Industrialization enriched and empowered the nation's powerful bankers and mercantile classes. Representatives of an aggressive industrial capitalism eager to promote its products, they helped fund the agenda pursued by the municipality and spared no effort to make their institutions visible throughout Paris, with their own grand displays of architectural self-representation. Banks, department stores, theaters, and railway stations, designed with an eye to monumentality and aimed at facilitating circulation and consumption, were the perfect complement to Haussmann's networks of broad streets and public squares. Paris had to be remade into a showcase for the regime that also served the dictates of new hegemonic groups.

At the same time, a rising middle class, flush with money from industry and commerce, clamored for elegant housing in attractive neighborhoods in keeping with their

new social station. It became increasingly clear that urban space would have to be manu-
factured like other industrialized goods, and this called for bold and unprecedented mea-
sures. Speculation—one of the chief motors of urban change and the great machinery
of revenue—ruled. There was a great deal of money to be made. Parcels were bought;
equipped with sidewalks, water mains, sewers, gaslight; and sold again at great profit.
If Second Empire Paris differed from other cities in the throes of modernization, it was
largely in the scale of its ambitious project of urban renovation, the systematic way with
which it was carried out by Haussmann and his large circle of experts, and, not least, the
burden that this transformation placed on the laboring classes.

Such momentous urban changes relied on a massive influx of workers whose arrival
overwhelmed the existing housing stock just when the modernization of Paris, as envis-
aged by the moneyed classes, called for upgrading vast parts of the city. This brought
about a conflict between the goals of the municipality and its supporters, and the needs of
those who actually built and maintained the new infrastructure. In a city racked by revolu-
tions since 1789, the ruling elites saw the old labyrinthine warrens in the center, inhabited
mainly by the poor, as a threat to political stability. In their eyes, urban governance was
rooted in a clear, intelligible fabric, shorn of slums and dilapidated tenements. Thousands
lost their homes when Haussmann razed huge swaths of the center to make way for build-
ings of higher quality. Redevelopment, to call the process by its present name, brought
about a widening gap between the affluent sectors and the urban poor, the social group
most adversely affected by the radical makeover of Paris. And it entailed a spatial division
of labor that consigned workers to interstitial spaces throughout the city or banished them
to the amorphous sprawl of the periphery, which lacked the services so lavishly doled out
to richer parts of Paris.

Since the mid-nineteenth century, architects, urbanists, and scholars have followed the
rebuilding of the French capital passionately, siding either with the Second Empire or with
its republican critics, some praising, some excoriating the prefect, others conceding the
value of his undertakings while emphasizing his innumerable debts to previous adminis-
trators. Critiques of the empire's spatial politics have been directed chiefly at widespread
demolitions in the historic center, the consequent eviction of workers, and the ensuing
polarization of the urban fabric. Attacked by opponents of the regime in his own day,
Haussmann went on to receive a stream of exuberant accolades in the first half of the
twentieth century. From Daniel Burnham to Robert Moses, city planners and adminis-
trators held him in the highest esteem as the epitome of visionary boldness.[3] Looking at
Paris through the reductive lens of high modernism, Le Corbusier and Sigfried Giedion
wrote enthusiastically of Haussmann's sweeping plans for slum clearance that made large
stretches of land available for circulation.[4] Adopting a top-down approach, they had little
to say about how the new capital's new urban spaces were used and perceived by a diverse
and deeply divided population. Preferring to study the city in vitro, Haussmann's admir-
ers painted the picture of a disembodied world of streets and squares, monuments and
buildings as complete entities, basing themselves exclusively on plans, photographs, and
documentary sources.

By reading Paris exclusively from the point of view of its administrators, architects,
and politicians, in keeping with the scholarly traditions of their time, these latter-day enthu-
siasts contented themselves with "seeing like a state," according to James Scott's brilliant

formulation, producing works premised on essentialist conceptions of architecture and urban space that left untouched the interested nature of representations.[5] Such positive appraisals overlooked both the enormous contribution of the working class, which laid the infrastructure, opened roads, and erected hundreds of buildings, and the deliberate neglect with which it was treated. In subsequent years, as a more tolerant age sought other models, the pendulum swung in the opposite direction, and the prefect's stock declined. "Haussmann's Paris is a city built by an idiot, full of sound and fury, signifying nothing," exclaimed Guy Debord scornfully in 1967.[6]

It was largely in the 1970s that scholarship began to reassess Haussmann's role as author of the largest project of urban renewal in Western Europe.[7] Anthony Sutcliffe wrote a tightly argued analysis of city planning under Haussmann, followed by David Pinkney and Pierre Lavedan, who gave much of the credit for the renovation of the capital to Napoleon III.[8] Since then, others have stressed the continuity between the Second Empire's urban practices and those of previous regimes. David Van Zanten and Nicholas Papayanis, among others, have shifted the focus from Haussmann to the July Monarchy, rightly credited with some of the innovative initiatives put into practice by the Second Empire.[9] François Loyer carefully studied the architecture of the period, broadening the scope of the debate to include typology, ordinances, and equipment. Pierre Pinon conducted research in several Parisian archives, demystifying many assumptions concerning the prefect.[10] David Jordan, meanwhile, produced an exemplary and much-needed monograph on Haussmann, drawing principled conclusions from a prodigious amount of research.[11]

In 1997, the discovery of the Siméon papers by Pierre Casselle led to a far-reaching reevaluation of the part played by Haussmann, the emperor, and several advisers in overhauling Paris. Nominated by Napoleon III as chair of a committee tasked with producing general outlines that would help renovate the capital, Count Henri Siméon and his colleagues produced exhaustive documentation outlining a multifaceted agenda for the renewal of the city.[12] Their impressive dossier shows unequivocally that the essential features of the Second Empire's reconfiguration of Paris, long associated with Haussmann, had already been advanced by the Siméon committee, even though their original conception went through many iterations in its implementation.

Casselle's articles led several specialists to attribute all progressive changes to the July Monarchy or Napoleon III, exonerating the emperor from all blame in the destruction of the historical center and the callous treatment of the working class.[13] Emphasizing Haussmann's coercive urban politics, they passed over in silence his achievements as well as the complicity of the emperor, his ministers, and the ruling classes who sustained and bankrolled the regime. Haussmann is the easiest of targets: "heavy of eye and tread, stiff, coarse, demanding, humourless, and vain," in the words of John Russell.[14] Of the prefect's dismissive attitude toward the poor there can be no doubt. After stepping down as prefect he declared that the overthrow of the empire in 1871 drove home the "impressionable and turbulent nature of Paris's popular masses" that had to be contained by every possible means.[15] Yet one cannot disregard the responsibility of the emperor in the final product. Haussmann's unliberal city could not have been built without the assent and assistance of his more liberal master, who ratified all the latter's decisions with imperial decrees. And the emperor's plan could hardly have been executed without Haussmann, who did so with considerable skill, determination, and utter ruthlessness.

Surprisingly, after Casselle's pathbreaking research, three biographies appeared in print, only one of which, by Nicolas Chaudun, took the new discoveries into consideration. Those of Michel Carmona and Georges Valance mentioned it but did not dwell on the conclusions drawn from Casselle's discoveries, contenting themselves with conservative accounts that left deeper issues unexplored.[16] The same year, Haussmann's memoirs were republished with a long introduction by Françoise Choay, whose apologia of the prefect glosses over his shameful cruelty toward the laboring poor and heedless destruction of countless landmarks of historical and art-historical importance. Such glowing narratives of Haussmann's work reveal the tenacity of traditional historiographic models at the expense of historic context and critical thinking.

A purely voluntarist approach can hardly explain the enormous pressures brought to bear on city planning, an ongoing process contingent on national and transnational trends, political and economic concerns, and municipal practices and discourses that were not always in agreement. Nor can it account for the heterogeneity of actors and the complex concatenation of causes that produce the urban. In an attempt to address these lacunae, historians such as Jeanne Gaillard dwelt at length on economic and political factors, without demonizing the prefect as some scholars continue to do.[17] Art historian T. J. Clark and urban sociologist David Harvey had already underscored the ideological dimensions of the Second Empire's urban plans with penetrating insight, stressing the centrality of capitalism in the reconfiguration of Paris.[18] *Urbanism*, a word that did not yet exist in Haussmann's day, is the expression of vested interests, finely calibrated to preserve and consolidate the status quo. Nevertheless, urbanism is also shaped by a slow, gradualist undertow made up of conflicting and overlapping agendas, mostly planned, but often the result of contingency.[19] In their zeal to modernize the city, the forms of renewal favored by the Second Empire brought with them the expulsion and ghettoization of the urban poor, which followed on the heels of what we now call gentrification. Haussmann's draconian measures expressed not only his own authoritarian goals, but also the strategy of an entire class that stood to benefit the most from this kind of imperially mandated form of urban renovation. The capital's new geopolitical configuration as a historic core encircled by distant working-class faubourgs, and the partitioning of the city into areas that were increasingly (though never entirely) class specific, expressed clearly and unapologetically the prevailing attitude of the privileged toward the disenfranchised. A surrounding belt of villages inhabited by workers horrified the upper and middle classes, who, both desiring and fearing insulation, no longer wanted to coexist with the poor in the city's residential areas. Urban space was part of the Second Empire's apparatus of power.

The importance of the most theoretically sophisticated of these scholarly works can hardly be overestimated: together, they have mapped out the sequence of crucial events; analyzed works and writings by architects, engineers, and administrators; established chronologies; unearthed crucial precedents; and examined the political foundations that gave shape to Second Empire Paris. Taken as a whole, these publications allow a far more nuanced view of Haussmann, Napoleon III, and their sociopolitical context. But these two approaches, broadly speaking, of apprehending Paris—the biographical and the socioeconomic—are no longer sufficient.

UNHEARD VOICES

It is time to trouble the focus on major monuments that has so far dogged architectural histories of nineteenth-century Paris. Insofar as extant documentation allows, we must seek out the divergent ways in which the empire's networked infrastructure was received by a heterogeneous population to grasp what urban philosopher Henri Lefebvre called *l'espace vécu*—not the abstract space of planners and architects but the affect-charged space experienced by a plurality of subjects.[20] To fully understand how different social groups accepted, rejected, transgressed, and interpreted the new Paris involves taking into account both the production and the perception of urban space—this last, a highly volatile construct, inflected by class, age, gender, occupation, and province or country of origin, as well as language or patois. Whatever the motivations of the imperial and municipal governments, the infrastructure they put in place could not in and of itself "determine social practices."[21] Transportation systems, water supply and sewage disposal, public parks, gas lighting, and modern institutions of commerce and culture had many and often contradictory social implications. Workers who built new boulevards, laid sewers and water mains, erected buildings, and installed urban technologies subjected such forms of urban modernity to their own interpretations. Women, who crisscrossed the city for either work or leisure, were also profoundly affected by urban change. Rather than taking networks for granted, it is crucial to understand how they were socialized. Far from seeing citizens as autonomous and transcendental beings, wrote Michel Foucault, we must try to achieve "an analysis which can account for the constitution of the subject within a historical framework."[22]

Yet the staggering majority of books and articles written during the nineteenth century, authored by middle- or upper-class men, gives a distorted picture of how the city was perceived by other social groups. Whereas primary sources written by workers are still being discovered, we are far from a comprehensive view of the urban lives of those who constituted the larger part of the population. Even when they did leave a record, these do not necessarily mention the city's new streets and networks. Nor could they speak for their entire constituencies: like other social groups, they did not have unmediated access to truth. As Jacques Rancière has pointed out, workers who left memoirs, often years after the fact, usually adopted the language of the bourgeoisie to make their points understood, thereby opening up a gulf between themselves and their peers.[23] We cannot escape the elusiveness of the *peuple*, "known through the viewpoint of the elites," in Miriam Simon's incisive words.[24] At present, recovering their voices remains an aspiration, perhaps an impossible one. Where archives are silent, scholars have no alternative to representing—with principled caution—those whom they know only through representations.[25]

The working classes of Paris have received a great deal of attention, primarily from labor historians, social scientists, and literary scholars. French museums have also devoted important exhibitions to the topic.[26] Architectural historians, by contrast, have continued to analyze the city in terms of buildings of aesthetic worth, but only the center, politically coded as "Paris," has been worthy of attention. Mistaking a part for the whole, they write as if the belt of working-class villages surrounding Paris, incorporated into the city in 1860, did not exist. In consequence, we know very little about the architecture that defined the lives of the laboring poor, which varied greatly in terms of quality, location, and typology. What did urban renewal mean to the hundreds of thousands of workers who resided in

the anomic outskirts, and swept in and out of the historic center every day, on their way to and from work? What measures did they adopt to cope with their needs such as housing and infrastructure? Urban environments are co-constitutive of citizens and of social cleavages by means of space, distance, and services (or lack thereof), as well as the aesthetic quality of buildings, streets, and neighborhoods. Those who were so brutally displaced were active participants in the transformation of the capital; their expertise laying and maintaining pipes and sewers, building roads and bridges, clearly revealed their ability to master difficult technologies on a daily basis. Loss of their homes, followed by forced relocation to the fringes, sparked feelings of anger and revanchism that would explode with greater force during the Commune.

Working-class women constitute another major gap in our knowledge, which can only partly be attributed to the paucity of sources. For several decades, feminist art historians have shed light on the inequality with which women were treated in their day, and on their continued marginalization in scholarship. Architectural history has been slower to react. By leaving issues of gender unexplored, it has unconsciously universalized the experience of men, reproducing the asymmetries of power that shaped the lives of men and women in the city. Without accounts by the protagonists themselves we cannot understand how Haussmannization affected women of different social classes, nor the impact it had on the conquest and constitution of public space by all women. From impressionist painters to writers, photographers, and early film directors, countless images of Parisian women have come down to us, in boulevards and brothels, gardens, and cabarets. Not being authored by women, these representations do not reflect their subjectivities any more than they address issues of difference. Those who did write about the city came mostly from a well-heeled minority, wealthy bluestockings such as George Sand, Delphine Gay, Frances Trollope, or Countess Marie d'Agoult, who could not understand the problems and preoccupations of their working-class counterparts. Redevelopment signified one thing for ladies who frequented banks and department stores, rode through parks in fashionable landaus, and visited museums and exhibitions. Poor women, equally visible in the public realm, were far less likely to leave a record of their struggles. Echoes of their voices can be found in the writings of others, refracted unwittingly by those who did not share their experience.

CAPITAL OF THE METROPOLE

All cities see themselves through the prism of myth, but if research on Paris is to yield fresh insights, it must make greater efforts to resist the pervasive myth of Paris, an enduring staple of the humanities, which naturalizes exclusionary views of the capital. This is not to assume a fixed, incontrovertible reality behind the myth but to acknowledge that Paris does not and did not exist outside the social relations that bound its residents to an urban space in the throes of radical reconfiguration.[27] That something dramatically new happened to the city during the Second Empire is beyond dispute: the sheer scale of new construction, modern boulevards, and infrastructure aroused the admiration of contemporaries. That said, shopworn clichés such as "Capital of the Nineteenth Century" or "Capital of Modernity" are unacceptable to a growing number of scholars for whom these two overlapping—indeed, inseparable—terms are characteristic of unquestioned and unconfessed Eurocentric assumptions.[28]

Paris was not the capital of modernity—that long-drawn, transnational, diverse, and open-ended process that was never autochthonous.[29] What Michael Geyer and Charles Bright said of the end of the twentieth century was equally true of the second half of the nineteenth: what we are faced with is "not a universalizing and single modernity but an integrated world of multiple and multiplying modernities."[30] To claim Paris as capital of modernity is to erase the contributions of other nations and cities that, often under the yoke of colonialism, contributed richly to the beauty of the French capital. "Europe's arrogation of the notion of modernity to itself," wrote historian Dipesh Chakrabarty, "is an integral part of European imperialism. Colonized nations were equal partners in this modernizing ideology."[31] Architectural historians have to chart a difficult course, investigating the numerous urban innovations that made this extraordinary city a much-imitated model worldwide, while avoiding unexamined explanations premised on exceptionalism. Furthermore, we must challenge the tendency to see urban modernity in a purely affirmative light—a story of resplendent boulevards, water and sewerage systems, and beautiful parks and gardens. It is time to consider the many ways in which this definition-defying entanglement of practices, technologies, and political ideas embodied enduring strategies that enabled the privatization of public space, the creation of profit-driven partnerships between municipalities and the private sector, and the legal and economic mechanisms that allowed the poor to be dispossessed of their homes and territory.[32] These, too, are part and parcel of modernity.[33]

Nor was Paris the "Capital of the Nineteenth Century," a long-held article of faith that has only recently begun to be questioned.[34] For scholars from the Global South or those involved with postcolonial theory, the world was too large and too diverse even then to have had a single capital of the nineteenth century or of modernity—except as a persistent ideology suggestive of Europe's sense of centrality and superiority. Both these tags pass over in silence the fact that Paris was the capital of an imperial and imperialist France whose domains overseas stretched from territories or footholds in China, Cochinchina, India, New Caledonia, North Africa, the Middle East, and the Caribbean. Napoleon III tried aggressively, and at times disastrously, to expand the regime's geo-imperial reach. After taking part in the Second Opium War in China (1856–60), France gained the right to trade in lucrative treaty ports and began to secure control of southern Vietnam in 1858; created a protectorate in Cambodia in 1863; launched an abortive campaign against Korea in 1866; and sent a military mission to Japan (1867–68) to train the troops of Tokugawa Yoshinobu, the last shogun, in Western-style warfare before they were overthrown by the imperial forces. In Mexico, French intervention ended in disaster, when Napoleon III tried to establish the Hapsburg prince Ferdinand Maximilian as emperor in 1867. Despite these failures, the emperor's expansionist drive succeeded in doubling the empire's territories.

Colonialism was not a static backcloth but helped mold French culture and politics in a variety of ways. Empire building exerted a strong influence on discourse, print culture, and the visual arts in the metropole. With its steady stream of imported products and technologies, colonial modernity was responsible for many aspects of the newly refurbished capital, many visible to this day, in buildings, statues, art collections, and street names.[35] Spoils from these campaigns found their way into the city. Museums were filled with works of art plundered from conquered peoples. In 1863, Empress Eugénie created a "Musée Chinois" at Fontainebleau with objects seized by French troops during the sack of

Yuanmingyuan, the Summer Palace in Beijing, during the Second Opium War, and with gifts from the ambassadors of Siam.[36] Before hostilities were even over, French auction houses began selling art looted from China.[37]

The triumphalist iconography deployed in public space during important holidays promoted France's colonial exploits with nocturnal illumination evoking Chinese, Egyptian, and Mexican buildings linked to specific overseas conquests or expeditions. International expositions, particularly that of 1867, foregrounded products and artifacts from the colonies. Landscape architecture likewise flaunted the empire's territorial possessions, disseminating exotic shrubs, flowers, and trees across the city's new parks and gardens. The systems of knowledge involved in different disciplines and practices was not solely French: science, culture, and technology traveled in both directions along trade routes taken by soldiers, officials, commercial entrepreneurs, or missionaries.[38] Although the exchange was rooted in the military, social, and cultural violence inherent in imperialism, colonies and metropole were deeply interconnected, disavowing reductive binaries.

Nineteenth-century Paris cannot thus be understood in terms of Paris or even France alone but was a porous part of this larger constituency. Nation and empire, of course, had distinctly different contours and powers, and tensions between them played themselves out in the capital, particularly when the army was unleashed against those the regime saw as its enemies. It was the laboring classes who felt the brutal impact of colonial warfare. French generals trained in warfare in North Africa (the *généraux africains*) were repeatedly brought to Paris to quell insurrection, which they did with unrestrained ferocity.[39] Workers, their main targets, and political opponents were shot, imprisoned, or deported to the overseas territories. To understand this broader colonial context requires that architectural history break out of the closed circuit of Western theory within which the discipline has entrapped itself.

Finally, we must learn from our own age how to ask new questions of nineteenth-century Paris, a time of extraordinary political, social, and urban upheaval, although this, too, carries its own dangers. From the perspective of the longue durée, the greatly admired city is not irrevocably cut off from our day. Its mistreatment of the laboring classes and the distant banlieues where they were warehoused, throws into relief our own forms of spatial segregation today. Likewise, the slums that now house the majority of the world's urban population shed light on the everyday living conditions of vast agglomerations of people who lack decent housing, running water, or sanitation. Far from accepting their lot passively, today's shantytown residents are always learning how to cope, adapting their know-how and meager resources to produce a fragile and ephemeral infrastructure, fighting to improve their surroundings, both like—and unlike—their nineteenth-century counterparts. Although their motivations for resettling may differ, the innumerable legal and illegal immigrants who undertake the most menial jobs in our societies prompt us to probe Second Empire Paris, where thousands of workers from the provinces or from other countries such as Hessia, Switzerland, and Russia were engaged in jobs that gave them little self-esteem or decent financial compensation.

Globalization itself, with its flows and networks, its layered interactions between powerful international forces and entrenched local communities, can suggest new approaches to a topic—nineteenth-century Paris—that is both highly popular and tenaciously elusive. It can do so, however, only if it does not magically displace colonialism, which was

transnational in a very different way. Furthermore, none of these trends follows automatically from the days of the Second Empire to ours, according to a seamless trajectory from cause to effect. "The question," wrote Rancière, "is always to subvert the order of time prescribed by domination, to interrupt its continuities and transform the pauses it imposes into regained freedom."[40] It is important to dwell on ruptures as well as continuities, avoiding the pitfalls of teleology and remembering the historical specificities that undergird urban development around the globe. Contemporary problems can offer insights and suggest heuristic tools that help illuminate aspects of this period that would otherwise be hard to access, provided we remain mindful of the enormous difference that separates us from the past, and acknowledge that our own views are no less disinterested.

Cities are not transparent signifiers but transient entities in constant flux, generating ambiguities and contradictions. Their diverse inhabitant-interpreters—workers and aristocrats, native born and foreigners, in the case of nineteenth-century Paris—never coalesced around identical points of view but offer a flood of changing opinions, insights, and misreadings contingent on their affiliations. Urban space has no intrinsic meaning but is always burdened with an excess of signification. Data itself falls into a slippery, non-objective category: none of the documents with which we study cities is value-free. Photographs, architectural drawings, etchings, paintings, novels, and newspapers do not adhere to facts in a tightly sealed covenant. The unquestioned authority given to urban plans presupposes an epistemological realism that naively accords such documents the validity of "truth." Whether we are dealing with maps or photographs, we are inevitably looking at Paris through representations and seeing it through several subjectivities at once.[41]

How, then, can one do justice to the terrifying complexity of the urban transformation of Second Empire Paris—a city that, like all others, does not exist outside representations and thus exceeds any single author or methodology? This book hopes to give an idea of the multiplicity of Parises mentioned by Daly, though not according to the terms that he envisaged. Its overview of the overwhelming modernization of Paris during two decades of imperial rule follows the complicated process of Haussmannization, that is, urbanism, rather than architecture. Broadening architectural history's scope beyond the more traditional, narrowly defined focus on monuments, it seeks to include the counter-histories of diverse groups of actors and the spaces where they lived and toiled, insofar as available sources permit. Our discipline must not limit itself to the visual, that is, to architecture and urbanism that have been severed from social relations. To understand this sprawling, viscous metropolis requires problematizing and pluralizing authorship, and interpellating the varied forms of subject formation within the new urban framework informed by modern networks. Cities can be neither reduced to their material traces, nor sublimated into superstructures that "evict place and materiality."[42] Any book on such a protean referent must remain provisional. We need a new nineteenth-century Paris for our own day, even if it, too, will go the way of all others, when the evolving present uncovers in the past a different narrative. The past needs changing almost as much as the present.

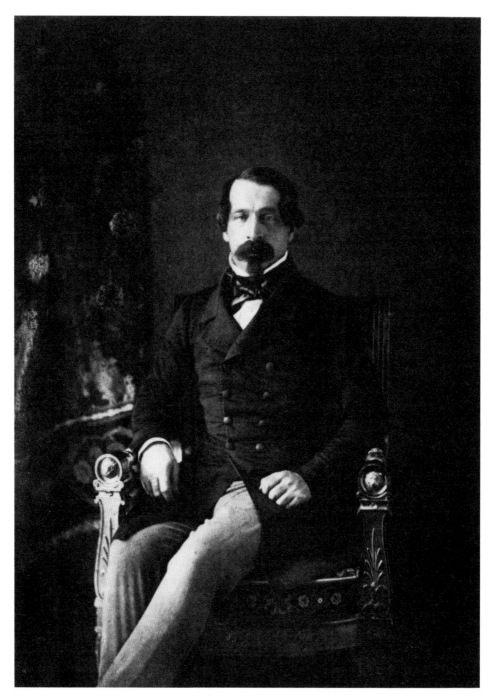

FIG. 1.1. Gustave Le Gray, *Portrait of Louis-Napoléon Bonaparte, Prince-President*, 1852. Metropolitan Museum of Art, New York.

The President, the Emperor, and the Prefect

In the space of power, power does not appear as such; it hides under the
organization of space.
　　—Henri Lefebvre, *The Production of Space*

Charles-Louis Napoleon Bonaparte was a man torn by deep contradictions. Born in
1808 to Napoleon's brother Louis Bonaparte and Hortense de Beauharnais (Jose-
phine's daughter), he wanted to reestablish the Bonaparte dynasty and ensure political
continuity through unelected power. Transforming Paris into a splendid modern capital
was part of this goal. At the same time, he was deeply preoccupied with the plight of the
poor—insofar as they did not threaten his political ambitions. His publications had met
with some success, particularly his tract *Extinction du paupérisme*, written in 1844 when
he was imprisoned in the fortress of Ham in northern France.[1] Influenced by French
and British social reformers, Louis Napoleon dreamed of working for the public good,
albeit within an authoritarian framework. These two antithetical goals shaped his career
in office. Elected president in December 1848, with almost 75 percent of the votes, he
embarked on an ambitious plan to transform Paris into a modern metropolis (fig. 1.1).
Improving circulation, providing low-income housing, and alleviating poverty ranked high
on his list of priorities. "Let us make every effort to embellish this great city, and improve
the lot of its inhabitants," he announced in a stirring speech laced with Republican ideals.
"Let us open new streets, sanitize populous districts that lack air and sunlight, and may
the beneficial radiance of the sun penetrate our walls and the flame of truth our hearts."[2]

Having left the capital at the age of seven, after the fall of his uncle Napoleon Bona-
parte, he had spent most of his life in exile. Before his election to the presidency, Paris was
a city he knew largely from books, and he undoubtedly read more about its urban prob-
lems than any French ruler before him. There was a lot to read. In the preceding years,
numerous architects, engineers, and political thinkers had published various agendas for
change that had a pronounced influence on a succession of municipal planners.[3]

Since the French Revolution, the city had had a virtually uninterrupted series of
great administrators who maintained the same general directives despite changing polit-
ical regimes.[4] Nicolas Frochot (1761–1828), prefect of the Seine under Napoleon I from
1800 to 1812, was succeeded by Gilbert-Joseph-Gaspard Chabrol de Volvic (1773–1843), who
served in that capacity from 1812 to 1830 under Napoleon I and later, the Restoration.
Claude-Philibert Barthelot, Comte de Rambuteau (1781–1869), held the office from 1833
to 1848, under Louis-Philippe. Jean-Jacques Berger had served the Second Republic and

Napoleon III between 1848 and 1853. All had tried, with varying degrees of success, to address circulation problems by cutting new streets and clearing areas in the congested city center. Nevertheless, their best projects, scattered across the urban territory, were carried out piecemeal, without an overarching plan for the entire city: "I have often been reproached," wrote Rambuteau, "as has Monsieur de Chabrol, for not having prepared or followed a great plan d'ensemble."[5] Many were clamoring for a different approach, and in 1839, the municipal council officially asked Rambuteau to draw up a comprehensive plan for the embellishment of the capital.[6] Fearful of undertaking costly projects that would draw large numbers of workers to Paris, he refused.[7] The Second Republic could no longer afford this cautious strategy. After the revolutions of 1830, 1834 and 1848, a plan d'ensemble had become mandatory.

Heir to decidedly postrevolutionary politics, Louis Napoleon may have studied the Republican Plan des Artistes of 1795 that had left its mark on the urban projects of the First Empire, the July Monarchy and, less improbably, the short-lived Second Republic.[8] Conceived by a group of artists, architects, and engineers working in concert with the Convention, it represented one of the very first attempts to envisage a profound transformation of the city. Their mandate was to propose urban solutions—new streets and squares—that would valorize large properties confiscated by the state and yield public revenue when sold. Endowing Paris with public spaces and perspectives was one of their priorities, but they were also concerned with slum clearance, hygiene, and circulation. The committee, wrote the authors in 1795, "has thus considered Paris as a whole from different points of view, and was particularly struck by the incoherence and irregularity of all its communications and their insufficiency for commerce and circulation; by the lack of squares and public markets, by quays obstructed by a tangle of narrow and sinuous streets where air flows with difficulty, and finally, by the foci of infection and unhealthiness that one finds there; for years, a suffering humanity has called for their destruction."[9]

Some streets of the Artists' Plan were arguably designed as embellishments rather than solutions to existing problems, according to the classic traditions of the past.[10] But the plan was extraordinarily prescient, establishing clear, feasible goals, and envisaging new projects for east and west, Left Bank and Right Bank. Like previous regimes, the Second Empire saw the wisdom of its views and implemented part of its proposals. The plan did not survive the destructions of the Siege and the Commune and was poorly reconstructed in 1889 (fig. 1.2). Since that time, however, family memoirs and personal papers of the main protagonists have been steadily coming to light, allowing us to reconstruct the document with some degree of accuracy.[11]

Louis Napoleon found a different and more modern strand of ideas in the work of the followers of Claude Henri de Rouvroy, Comte de Saint-Simon (1760–1825), who believed in the betterment of society through industrial development, and the greater mobility of capital and merchandise. Many high-ranking members of Louis Napoleon's entourage were Saint-Simonians, including the economist and engineer Michel Chevalier and the brothers Émile and Isaac Péreire, whose Société Générale du Crédit Mobilier helped provide the financial backing for the city's urban renewal. Chevalier, one of the emperor's most important economic advisers, had written in 1838 that everything was in place to unify the nation by bringing highways, waterways, and railroads into a single system: "We lack only

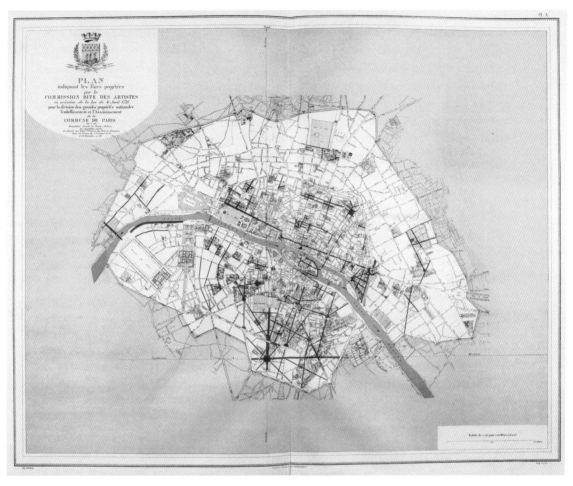

FIG. 1.2. The Plan des Artistes, reconstructed by Alphand in 1889. Alphand, *Les travaux de Paris, 1789–1889.*
Bibliothèque historique de la Ville de Paris.

a plan d'ensemble."[12] Utopian socialists such as Charles Fourier (1772–1837), deeply con-
cerned with social issues, also influenced Louis Napoleon and the administrators involved
in urban planning.

Fourierist and Saint-Simonian ideas resonated strongly in the Grandes Écoles, the
great breeding-ground of French architects and engineers.[13] Since the 1840s, polytech-
niciens such as Considerant and Perreymond had published extensively on urban issues.
Imbued with utopian ideals characteristic of the 1840s, and equipped with a solid technical
education, they based their analysis on a detailed knowledge of the economy and topog-
raphy of Paris. At a time when city planning did not yet exist as a discipline, they brought
new standards of professionalism to urban studies, and a less empirical approach.[14] For
years they had clamored for a global strategy for Paris. "We believe," wrote Consider-
ant and Perreymond, "that the department of the Seine should be considered as [. . .] a
systematic ensemble, and that the projects that are currently executed piecemeal by the

communes, the department itself and the very State, should be combined, centralized, and brought into line, each in its own way and location, with a general plan encompassing the unity of the department in its entirety."[15]

An early opponent of Louis Napoleon, Considerant went into exile in 1848 but remained in touch with friends and supporters who followed his attempts to create a utopian community in Texas. Perreymond, whose true identity has only recently been discovered, was the pseudonym of Edmond Perrey, a polytechnicien who frequented the circles of Fourier and Saint-Simon.[16] Between 1842 and 1843, he published a series of articles in César Daly's *Revue générale de l'architecture* and, in collaboration with Considerant, in the Fourierist newspaper *La Démocratie pacifique*. Although Perreymond did not offer specific proposals in terms of new streets and squares, his articles on Paris constitute some of the most lucid analyses of the city written at the time.[17]

Perreymond was chiefly preoccupied with the deterioration of the urban core. The ensuing flight of capital to the west and north of the city entailed a drastic loss of revenues for the center. Uncontrolled growth in the communes around Paris also contributed to the economic stagnation of the historic kernel: "Politically and morally speaking, the Government [...] loses its strength of action since it no longer finds, in the center of the capital, a point of resistance on which to exert its powerful leverage. Paris becomes an ungraspable and floating entity, which was here yesterday, is there today, and will be God knows where tomorrow."[18] In his view, there were only two options: either to reclaim the center or to rebuild it elsewhere, following the westward drift of finance capital. Perreymond strongly believed that the centrifugal forces that threatened the old historic core had to be resisted.

Saint-Simonian interest in improving urban infrastructure had a profound impact on the July Monarchy, whose approach to planning had been predicated on networks then being developed for the entire country.[19] But piecemeal solutions could not solve the pressing problems that beset the city. A global approach was long overdue, and Considerant and Perreymond called for "the adoption *of a general plan of broad circulation* that would link the different neighborhoods of each bank with those of the center, thus connecting the capital's two divided halves."[20] They also foresaw the need to annex the periphery: it was only a question of time till a ruler cracked the old carapace and allowed the city to ooze into the surroundings, incorporating them within its administration. The longer they waited, the more expensive the land in the outlying suburbs would be, and the greater the damage to be undone.[21]

For Perreymond, the old Île de la Cité was to be razed to make way for an administrative center (the Nouvelle Lutèce); a commercial one (the Bazar National) would spill over into the Île Saint-Louis. Both islands would be attached to the Left Bank: if the left arm of the Seine were filled, a sizeable portion of prime real estate would be available for new construction. Anticipating traits that would reappear under the Second Empire, Perreymond thought that Paris should be transformed into a spectacle fit for consumption, "a place more and more desirable, more and more attractive;—a panorama that one would contemplate for its pleasures;—a great source of light open to the entire world;—a stock exchange, a commercial center where, thanks to the railroad and the telegraph, information arriving by night and by day from all corners of the globe, would permit one to follow the course of the market."[22] Grounded on a detailed knowledge of Paris and faith in a perfectible society typical of Saint-Simon and Fourier, Perreymond's ideas contributed powerfully to lift the

level of debate concerning the future of the city, but his surgical response to the problem of circulation would have led to the destruction of the historic center.

Yet Perreymond never lost sight of the anthropological dimension—what he called, perhaps influenced by Adam Smith, the "social wealth of the nation."[23] Like all followers of Fourier, he believed ardently in a more equitable society, and Perreymond's pages bristle with indignation at the blatant urban inequalities that consigned the poor to miserable areas unfit for human habitation. Dark and humid neighborhoods had to be sanitized according to standards of modern hygiene, and houses designed in proportion to the width of streets.[24] Equally passionate in its defense of the underprivileged was Perreymond's book of 1849, *Paris monarchique et Paris républicain*, which Louis Napoleon may have read.[25]

Perreymond espoused the opinions typical of the entrepreneurial Saint-Simonians and Fourierists, the liberal wing of the French bourgeoisie, who saw in urban renewal a deterrent to popular insurrection. Slum clearance would dissolve the city's impoverished enclaves that constituted, in his view, a permanent threat to social order: "The breakup of the dangerous, depraved or miserable population of the quartiers of the Cité, Les Halles, Arcis, Saint-Victor, etc., will produce great improvements in the morality and well-being of the Parisian population."[26] Perreymond, concludes the historian Frédéric Moret, "suggests solutions often similar to Haussmannization (the destruction and reconstruction of the center, an administrative space in the Île de la Cité, east-west and north-south axes structuring the city, the primacy of commerce over production...) but the fundamental principles are very different, as are the methods he proposes."[27]

From Saint-Simon and his followers, Louis Napoleon derived both progressive and regressive urban ideals. Circulation, exchange, and enhanced productivity were seen in terms of the needs of the industry-dependent middle classes rather than those of the industrious proletariat. "The concept of working-class cities, the enclosure of *ouvriers* in huge barracks, the myth of the rectilinear street, surrender of the city to circulation, apologia of green spaces, and demolitions in the name of hygiene and order, all this Napoleon III found in the writings of Saint-Simon, Considerant, and Cabet," observed Michel Ragon.[28]

Hippolyte Meynadier, another important writer on urban issues, also influenced Louis Napoleon and his circle of experts. In *Paris sous le point de vue pittoresque et monumental*, published in 1843, the author offers a remarkable analysis of the state of the city. Empirical rather than analytical, his suggestions were practical and based on specific locations. Since Paris lacked a network of broad thoroughfares linking different parts of the city to the center, he advocated the creation of a north-south axis, which he called the "grande rue du centre."[29] Situated between the Boulevards Saint-Denis and Saint-Martin, it would go all the way to the Châtelet. This, as Victor Fournel realized two decades later, was the model for the Boulevard de Strasbourg and its prolongation, the Boulevard de Sébastopol, initially known as the Boulevard du Centre, a clear reference to Meynadier. By proposing that the artery continue across the river, Meynadier laid the template for the Boulevard Saint-Michel. Yet in marked contrast to the brutal way in which this street was later executed, Meynadier wanted to ensure that the opening of the new boulevard displaced neither the inhabitants of the area nor their means of livelihood: "One would not violently dislodge any of the industries rooted in these old quartiers that are opposed to any thought of emigration."[30] Furthermore, this new street "would violate no architectural landmark,"

an observation taken to heart by Louis Napoleon, but disregarded by Napoleon III and his prefect.[31]

Meynadier believed firmly in the benefits of slum clearance, though on a more moderate scale than Perreymond. His interest in the urban fabric was inseparable from its social dimension. Old houses should not be destroyed, else the poor would no longer be able to find refuge in the city. "May Paris, in the midst of all its grandeur, continue to preserve these obscure retreats for the undeserved misfortunes which wealth does not always understand, and sometimes crushes, because it is more convenient to forget their cause."[32] Like Perreymond and Considerant, Meynadier called for a comprehensive city plan years before Louis Napoleon embarked on a similar project: "But where is the general plan d'ensemble, formulated by the municipal authority and the government, to correlate all these works of art and of public utility in the city of Paris?"[33] We do not know how much Louis Napoleon knew of all these texts; his advisers certainly did and were often acquainted with their authors.

As someone who planned to seize absolute power to achieve his political aims, the *prince-président* was deeply preoccupied with the strategic aspect of urban planning, and the need to defend Paris from any attempt at insurgency. In this respect, the articles written by Frederic Engels on the Paris revolution of 1848 may well have influenced Louis Napoleon, a different man in 1848 than he was in 1853, when the realities of empire began to harden his political arteries. The publications had received a great deal of attention in England, where

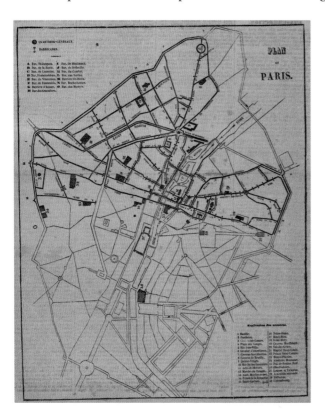

Engels and Louis Napoleon had resided. The future emperor—who spent his youth in Switzerland, studied in Germany, and spoke French with a slight German accent—would have had no problem understanding Engels's original dispatches to the *Neue Rheinische Zeitung*, which read like a blueprint for any politician hoping to master the unruly potential of Paris's urban masses. Engels noted that the faubourg du Temple and the faubourg Saint-Antoine were already inhabited almost exclusively by ouvriers who were protected by the Canal Saint-Martin.[34] These, he wrote, "immediately began to separate their territory, the Paris of the workers, from the Paris of the bourgeoisie." Their barricades defined a line leading south from the porte Saint-Denis through the Cité (fig. 1.3).[35] This clear-cut separation would be strengthened in Louis Napoleon's reconfiguration of Paris.

FIG. 1.3. Plan of the barricades erected in Paris in June 1848 in the eastern part of the city. Bibliothèque nationale de France, Paris.

AFTER THE COUP

> But magnanimous as always, the people thought they had destroyed their
> enemy when they had overthrown the enemy of their enemies.
> —Karl Marx, "The June Revolution"

On December 2, 1851, Louis Napoleon's forces arrested members of the opposition, dis-
solved the National Assembly, and abolished the Constitution. Over twenty-six thousand
people were detained, and several hundred opponents killed. Thousands more were
deported to Algeria.

A year later, on December 2, 1852—forty-seven years after Napoleon I was crowned
emperor—Louis Napoleon abolished the Second Republic and proclaimed the empire, his
overriding goal all along. Napoleon I cast a long shadow over his nephew's reign. Haunted
by the mystique of his uncle's fame, Napoleon III no doubt read the *Mémorial de Sainte-
Hélène* carefully: eager to associate himself to Bonaparte's enduring popularity, while
stressing his own different personality and pursuits, he completed a few projects planned
or begun by his uncle.[36] The influence, programmatic rather than stylistic, had to do with
the need to build monumental architectural prospects without neglecting services. Brush-
ing aside the cumbersome machinery of parliamentary rule, Napoleon III decided that
henceforth all "public" works within the capital would be decided by imperial decree.[37]
Like his uncle before him, he eliminated the position of mayor of Paris instituted by the
First and Second Republics and split municipal authority between a prefect of police and
a prefect of the Seine.

Inevitably, the transition from constitutional prince-président to emperor entailed
major differences in the approach to city planning (fig. 1.4). The freshly minted emperor
rejected many of the president-elect's ideals. Henceforth, the possibility of counterupris-
ings would haunt both Napoleon III and the municipality. An early memorandum by
Count Henri Siméon, one of his advisers on urban matters, bluntly states the emperor
wanted "to clean up the old quartiers where the population is crammed and circulation
impossible, to facilitate access to the vicinity of railroads, cut great roads in all directions
in order to abridge distances and, in case of insurrection, ensure an immediate repression
of attacks on public order."[38]

As the emperor became inured to power, his ambitions grew, but so did the need to
accept compromises in order to carry out his gigantic enterprise. His allegiance to Saint-
Simon's progressive agenda now had to coexist with the requirements of political stability
and the cult of monumentality central to his goal of rejuvenating the capital. No master
plan could account beforehand for the scale and complexity of the Second Empire's make-
over of the city. Hundreds of decisions, particularly regarding infrastructure, had to be
taken daily by innumerable specialists: some were planned from the outset; others were ad
hoc improvisations in response to unforeseen problems or new urban technologies. The
empire's actual accomplishments and the financial means used to achieve them, no less
than the scorched-earth policy unleashed on large areas of the city, also required the com-
plicity of government ministers.[39] Urbanism, Maurice Halbwachs would write in 1920, is
always the result of shared aspirations: "The layout of the streets, and the transformations
of the infrastructure of Paris cannot be explained by the concerted intentions of one or

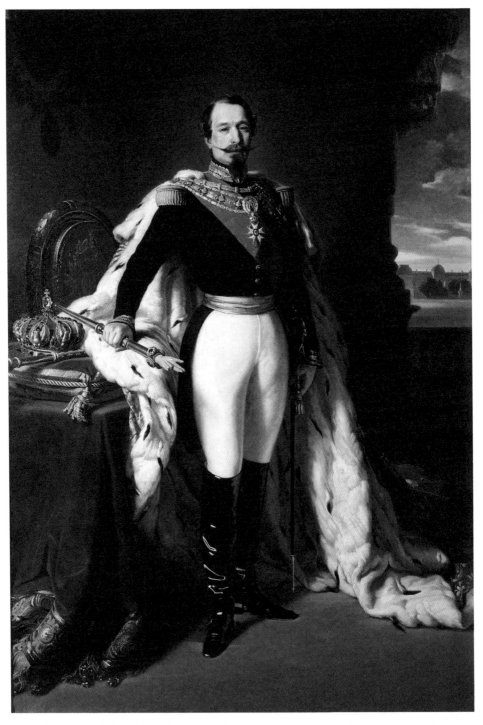

FIG. 1.4. Franz Xaver Winterhalter, *Emperor Napoleon III*, 1855. Oil on canvas, 94.4 × 61 in. (240 × 155 cm). Museo Napoleonico, Rome.

more persons, nor by individual wishes, but by the tendencies or collective needs followed by builders, architects, prefects, municipal councilors, heads of state, who did not have a very clear picture of these social forces and sometimes had the illusion that they were inspired by their own conceptions."[40]

Once he became emperor, Napoleon III accelerated his plans for the capital and signed decrees ordering, among other things, the creation of the Boulevard de Strasbourg and of Rue des Écoles, the completion of the Louvre, clearance of the area surrounding Les Halles, and the continuation of Rue de Rivoli.[41] This last—the *voie impériale* suggested by the Plan des Artistes and envisaged by Bonaparte—was generously proportioned and revolutionary in its novel use of street frontage imposed on proprietors. Another concern of the new emperor was the chokehold of narrow streets that hindered circulation in the center. Civic improvements formed a crucial part of his agenda, as a politically driven safety valve that provided employment to the city's restive workers and helped consolidate his power.

The first phase of public works revolved around two intersecting axes known as *la grande croisée de Paris*, an old dream dating back to the days of the Valois king, Charles V. Once part of the indelible Roman plan underlying the city's urban layout, the old cross-roads had survived, formed by two roads running north-south, Rue Saint-Martin and Rue Saint-Jacques (the old Via Superior of the Romans) on the Left Bank, and an east-west axis (Rue Sainte-Honoré) on the Right Bank.[42] To reestablish a similar cardinal intersection, Napoleon III prolonged the Rue de Rivoli, begun by Bonaparte, continued by the Second Republic, and taken over by Jean-Jacques Berger (Louis Napoleon's first prefect of the Seine). Perpendicular to this axis, the emperor opened the Boulevard de Strasbourg, since the two ancient north-south roads that intersect the Rue de Rivoli—Rue Saint-Denis and the Rue Saint-Martin—were too narrow to sustain heavy traffic.[43] Napoleon III's attempt to improve communications on the Left Bank met with less success. Rue des Écoles, parallel to the river, was cut through the slopes of the Montagne Sainte-Geneviève.

Napoleon III also wanted to pry the city's six railheads loose from the weave of crooked streets that blocked access to the center. His Saint-Simonian interest in circulation and exchange, and deep concern for security, determined the priority given to railway stations: they, rather than the old customs booths, were now the true gates to the city.[44] Hence the importance of the new Boulevards de Strasbourg and de Sébastopol, which led directly to the Gare de l'Est (fig. 1.5), and the Boulevard de Magenta, which connected the Gare du Nord to the Gare de l'Est, all linked to nearby garrisons. Yet except for the latter, none of these stations have adequate approach streets. Across the river, municipal engineers had begun work on the Rue de Rennes, a north-south thoroughfare that led from the Gare Montparnasse to the center. Costly adjustments had to be made to render it serviceable: poorly planned, it remains problematic to this day. Given the scope of his ambitions, Napoleon III needed a strong-willed administrator, capable of seeing his projects through to fruition. Despite Berger's loyalty to Napolcon III, he hesitated to burden the city with the fiscal debt needed to fund the vast projects that the emperor had in mind.[45] Berger's reluctance in carrying out costly reforms spelled the end of his career. On June 23, 1853, Haussmann was named prefect of the Seine. He was forty-four years old.

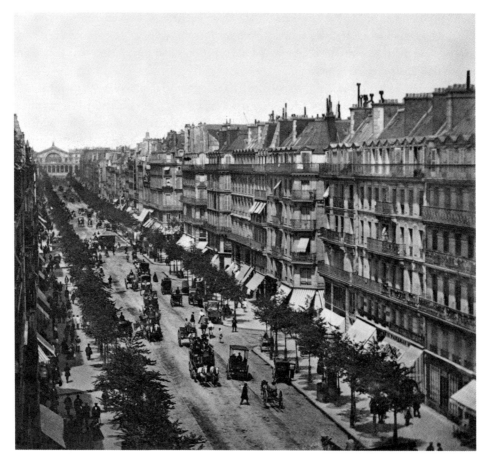

FIG. 1.5. Boulevard de Sébastopol with the Gare de l'Est at the end, 1852. Roger-Viollet.

HAUSSMANN

It was Napoleon III, not Louis Napoleon, who created Haussmann. Born in Paris to a Protestant family of German descent, Georges-Eugène Haussmann (1809–91) was well educated. He had studied music at the conservatory (cello) and was a friend of major composers. At the university, he had read law at the École de Droit, before embarking on a career in the administration (fig. 1.6). After languishing in the provinces for twenty-one years as subprefect or prefect of various small towns, he finally caught the eye of the future emperor, who appointed him to areas where the Bonapartist party needed help: the Var, the Yonne, and the Gironde. Haussmann thus spent the last years of the Second Republic, 1850 and 1851, as a political administrator, trying to rally support for the cause of the prince-président, whose imperial ambitions were well known.[46] Haussmann's maternal grandfather had served under Napoleon I, granting him a political pedigree that could hardly have escaped the eyes of his master. Haussmann was rewarded for his services by being named prefect of the Gironde, at the time, a major promotion. Equipped with a gift for political accommodation, Haussmann first swore allegiance to Louis-Philippe and then to the Second Republic, which exiled his monarch. But Haussmann's true leanings

lay with the empire. He once described himself as an *Impérialiste de naissance et de conviction* and did, in fact, remain loyal to the empire even when it was impolitic to do so.[47] As he boldly declared to the Senate in April 1869, "the parliamentary regime fatally raises unsurmountable obstacles to all that is grand and beautiful."[48] If he joined the new empire with a convert's enthusiasm, the move fit well with his own authoritarian personality. His priorities, mostly set by the emperor, were clear: to endow Paris with new networks of interconnected streets and boulevards; improve water supply and sewerage; create parks and gardens; embellish the western half of the city where the elites lived and worked; secure the capital against the possibility of future uprisings by redesigning part of its urban fabric; and finally, placate the large number of workers by providing jobs.

Like Napoleon III, Haussmann subscribed to selective ideals of industrial progress and productivity prevalent among the Grandes Écoles and Saint-Simonian salons. American urbanism may have been a source of inspiration for spacious, leafy thoroughfares and vast public squares.[49] Since the Enlightenment, French Republicans had shown great interest in the success of the American cause. Both the last king of France, Louis-Philippe, and its last emperor, Napoleon III, had spent time in the United States when they were young. Haussmann's maternal grandfather, Georges Frédéric Dentzel, had fought there for independence. Saint-Simon, whose complex heritage helped shape the Second Empire's policies, had been to America, as had his follower Michel Chevalier. Louis Napoleon had a keen interest in the United States and assured Victor Hugo that he had no imperial ambitions: "I will not copy Napoleon; [. . .] I shall imitate Washington.[50] Years later, his American dentist, Dr. Thomas Evans, observed that the emperor "especially liked to talk about the marvelous inventions and the practical improvements which were brought to Europe from the United States."[51]

It was Washington, DC, that most Gallic of American cities, that drew the admiration of contemporaries though few of its great monuments were complete. The Republican Henri Lecouturier had already linked political tranquility to the "broad avenues planted with superb trees" of the American capital. "This city of light," he wrote enthusiastically, "will not please those who seek shadows: [it offers] no hiding place for rogues, no den for criminals. Such as it is organized, Washington could never serve as a refuge for evil passions."[52] Given Louis Napoleon's early Republican leanings, he may well have read Lecouturier. Haussmann, too, was interested, for equally political reasons: he wanted to invoke for Paris the statute of exception that he saw as being characteristic of Washington. As he noted in his memoirs, "in most Nations of the first order, the Capital is subjected to a regime of exception," which varied according to its constitution. "In the United States itself, this is the case of the District of Columbia."[53] Beneath Washington's ample boulevards, he sought L'Enfant's Versailles, which to his eyes embodied executive privilege and freedom from legislative power.

Haussmann no doubt saw the well-known plan by Edme Verniquet (1785–91), kept at the Prefecture of the Seine.[54] "A Plan of Paris," he wrote in his memoirs, "was drawn up by order of the Government in 1790, on the scale of the Verniquet plan, under the name of *Plan des Artistes*, although its true authors are not known; it contains the layout of a great number of cuttings studied by them, and partly realized since then, aimed at regularizing circulation in all districts of the City, facilitating construction and clearing major monuments."[55] The fact that the revolutionary artists had been asked to design new streets in

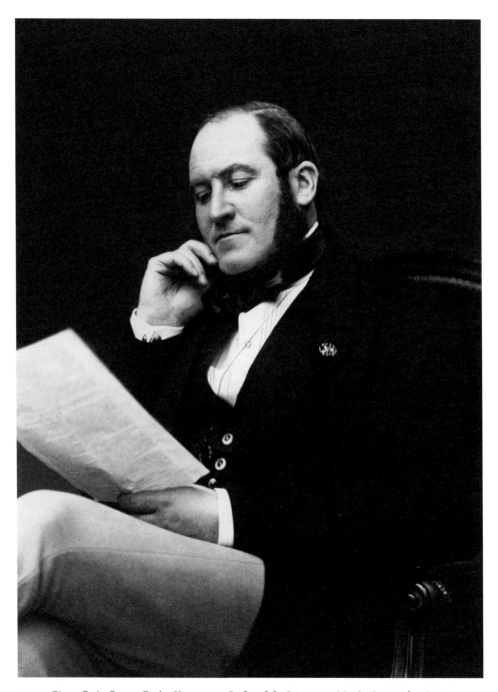

FIG. 1.6. Pierre Petit, *Georges-Eugène Haussmann, Prefect of the Seine*, 1864. Musée Carnavalet, Paris.

order to maximize the real estate value of properties confiscated after the Revolution, was not lost on a ruler seeking to reactivate the economy, nor on an ambitious prefect in need of funds to finance large urban projects.[56]

Formerly, the idea of cutting arteries through the old urban fabric was used sparingly: new streets were usually built in empty areas.[57] It was just this deference to the existing city that led some critics to compare the work of the revolutionary artists to that of Haussmann, whom they considered the executor of the urban testament of the sansculottes. The Plan des Artistes, wrote Georges Pillement in 1941, "contains the best and the worst; the artists were primarily architects and engineers who followed the same cult of the straight line and of perspective as baron Haussmann would later on. They are ready to sacrifice everything that lies in their path in exchange for a beautiful perspective [. . .]. Napoleon I or Napoleon III would carry out whatever the artists did not have the time to demolish."[58]

Over the centuries, the city Haussmann was about to transform had already been divided into three distinct areas: the Cité, seat of political and ecclesiastical authority; the university, on the Left Bank, with its numerous colleges; and, on the Right Bank, the Ville itself, with its monumental buildings, theaters, upscale retail, restaurants, and elegant residences. As Paris grew, the Right Bank came to predominate. Trade routes connected it to the rich industrial centers of northern France and Flanders. It became the financial and business center of the city, and French rulers relocated their palaces accordingly.

To a certain extent, the Second Empire reinterpreted this old polycentric model that followed capitalist forms of urbanization. Each trade tended to concentrate in those areas that best answered its needs in terms of production, transportation, and marketing, leading to increasing differentiation and specialization of different parts of Paris. Publishing houses preferred the Left Bank, near educational institutions in the Quartier Latin; the faubourg Saint-Antoine had long been the headquarters to furniture makers and cabinetmakers. Bankers and finance capital favored the area around the Bourse and Rue Lafitte. Newspapers strengthened their hold over the center, while the Sentier was being taken over by the garment trade.

With the exception of Place Dauphine, built on the Île de la Cité by Henri IV, the capital's most beautiful urban ensembles were all situated on the Right Bank: Place Royale (now Place des Vosges), Place Louis-le-Grand (Place Vendôme), Place des Victoires, Place de la Concorde, the Champs-Élysées. Smaller and less populated than the Right Bank, the Left Bank did not benefit from the same amount of infrastructure, despite the number of bridges built or rebuilt under Napoleon III and the elimination of tolls that had contributed to isolate it. Few buildings of any importance were built there by the state. Home to the university, the écoles, and a number of churches and convents, it was poorly connected to the networks of canals and well-traveled roads leading north. With fewer industries, and lacking an active class of entrepreneurs, it produced less revenue, often attracting tanners and ragpickers who trafficked in insalubrious trades. A dwindling and largely ornamental aristocracy, with little political or economic clout, cloistered itself in the exclusive faubourg Saint-Germain, still largely legitimist.[59]

A PLAN D'ENSEMBLE FOR PARIS

For years, Haussmann was given sole credit for reshaping Paris and conditioning its future development, although this is not true of recent scholarship.[60] He himself never denied his debt to Napoleon III. As he wrote to César Daly in 1864, "I owe to my very faithfulness the animosity with which my acts have been attacked, and as a result, have been accorded a larger part than I deserved in the conception of the plans for the new Paris."[61] In his three-volume memoirs, begun in 1888, however, Haussmann claimed that most of the city's urban changes were due to his initiatives.[62] Written twenty years after the fall of the empire, when many of the leading protagonists had died and could no longer dispute the facts, the memoirs record a wealth of information, including the name of numerous collaborators. They are also irritatingly conceited, marred by inconsistencies and insupportable vanity. Many of Haussmann's most important projects were only then being completed by the Third Republic, and in an attempt to lay claim to his contribution, he ascribed to himself a role out of proportion to reality. An indefatigable self-promoter, Haussmann also wanted to provide an authoritative version, an imperial view of the past in which the transformation of Paris was attributed largely to himself, the emperor, and their close collaborators. Ironically, the Commune did Haussmann a great service: the burning of the extensive holdings of the Hôtel de Ville, including the newly formed municipal library, and the archives of Avenue Victoria, as well as the two royal residences, the Tuileries and Saint-Cloud, destroyed many documents that might have undermined many of his claims. The absence of crucial material concerning other crucial protagonists gave his memoirs an unchallenged authority over those published by well-informed contemporaries such as Jean-Gilbert Victor Fialin, duc de Persigny, minister of the interior— accounts that were more biographical in content, and lacked detailed factual information regarding the urban transformation of the capital.

At the heart of the matter lies the master plan for Paris. Haussmann stated quite clearly that when he took office as prefect of the Seine, "the emperor was eager to show me a plan of Paris, on which one could see, drawn by Him in blue, red, yellow, and green, the different roads that He proposed to carry out, according to their degree of urgency."[63] Several sources confirmed this. Charles Merruau, secretary general of the Prefecture of the Seine under Berger and later Haussmann, was categoric: "I would like to describe here a precious plan of Paris on which he [Louis Napoleon] had successively traced, rectified, coordinated the axes that determined the overall picture. Before the Empire, this plan existed exclusively in the form of a sketch; it was definitively adopted only after [the hearing of] the highly regarded views of Mr. Haussmann [...]. But the main directives and overall conception had already been determined in the Prince's mind since the day of his Presidency, and on many essential points, long before."[64] Persigny, Haussmann's immediate superior, remarked in his own memoirs that the mastermind behind the city's main transformations was the emperor himself: "Always passionately concerned with improvements, with great causes, he had studied for some time, and in situ, the different projects to be carried out within Paris. It is he, in effect, who actually mapped out the great roads that one admires today, and established the order of their implementation."[65]

Although the original plan annotated by Napoleon III was lost during the fire that consumed the Hôtel de Ville during the Commune, it can be partly reconstructed thanks

FIG. 1.7. Map of Paris marked in color by Louis Napoleon after he was deposed, and published by Charles Merruau in 1875. Bibliothèque historique de la Ville de Paris.

to three different versions. After the fall of the empire, Merruau began to chronicle the history of the Hôtel de Ville during the Second Republic, which he published in 1875. He was well acquainted with Napoleon III's plan, which hung in Haussmann's office for years. "Unfortunately," says Merruau, "this plan no longer exists in Paris, at least in my opinion. The Emperor had signed it and given it, for general guidance, to Mr. Haussmann in the beginning of his reign; toward the end, that is, when the works were almost completed, he authorized its reproduction by autographic procedure, but only in three or four examples."[66] As the original had been destroyed in 1871, Merruau asked Napoleon III, then exiled to Britain, to mark on a recent plan of Paris the new streets and boulevards of his personal initiative.[67] The deposed emperor complied and sent the plan back to Merruau colored in his own hand, through the intermediary of his former minister of state Eugène Rouher (fig. 1.7). Another copy had been gifted to Wilhelm I, king of Prussia, who visited Paris during the universal exposition of 1867. This copy was found at the Schloss-Bibliothek in Berlin by Haussmann's biographer André Morizet, who published photographs of it in 1932, before it too disappeared during the bombardments of World War II (fig. 1.8).[68]

In 1997 a third variant came to light, when the papers of Count Henri Siméon (1803–74) were acquired from his heirs by the Bibliothèque de l'Hôtel de Ville.[69] Shortly after Haussmann assumed office, Napoleon III asked Siméon to chair an advisory committee to help craft a comprehensive urban plan for Paris. Members included the Duke of Valmy, assigned to study the Left Bank, and Louis Pécourt (member of the municipal council), responsible for streets linking railway stations.[70] The existence of this group was hardly

FIG. 1.8. Plan of Paris given to the king of Prussia by Haussmann. André Morizet, *Du Vieux Paris, au Paris moderne: Haussmann et ses prédécesseurs*, 1932. Private collection.

unknown. Haussmann himself mentions it in his memoirs but downplays its significance, saying of a meeting that he attended: "Count Siméon and the Duke of Valmy read two reports, well written but full of banal remarks devoid of any practical consideration, on projected cuttings which I no longer remember."[71] This is an outrageous untruth. About twelve hundred pages of extant documentation contain detailed memoranda on streets, squares, bridges, markets, bread, cemeteries, theaters, churches and synagogues, mortality rates, fountains, reservoirs, railway prices for workers, working-class housing, and greenery. Full of notes by specialists, the dossiers attest to the thoroughness with which the committee executed its task during the first six months after Haussmann became prefect of the Seine.[72] Haussmann, in other words, inherited much more than a simple map given him by the emperor.

Eager to free himself from its oversight, Haussmann persuaded Napoleon III to dismiss the group. Despite this cavalier treatment of the Siméon committee, a study of their report clearly shows that before Haussmann embarked on his plan for Paris, its main outlines had already been formulated by Napoleon III and his experts.[73] On August 2, 1853, Persigny wrote Siméon enumerating several points of concern to the emperor, urging the committee to treat both sides of the river equitably, though the final report acknowledged that one side was economically more important than the other.[74] The eastern and poorer half of the city was to receive as much attention as the western and wealthier half, favored by Haussmann. And from the very start, the emperor instructed his consultants to

focus on the greater Paris, thus including within their purview villages that would not be annexed until 1860.[75] In contrast to the large swaths cut in the urban fabric by Haussmann, Napoleon III cautioned the committee against the tyranny of the straight line, which would threaten works of historic or aesthetic relevance; architects should "make use of as many angles as necessary so as not to destroy either monuments or beautiful buildings," while preserving the same generous width required by new streets.[76]

Siméon, a wealthy landowner with strong administrative experience (having been a prefect himself), drew heavily on the expertise of several specialists on urban issues, including Meynadier, the brothers Louis and Félix Lazare, Jacques-Séraphin Lanquetin, Théodore Jacoubet, and the architect Hector Horeau.[77] Louis Lazare, who authored several books on Paris, was editor of *La Revue municipale*, an indispensable source of information on urban issues, suppressed by Haussmann in 1862 for its criticism of his urban practices. Siméon was also aware of an influential analysis of the city's shift toward the west by Lanquetin, a former municipal councilor who had also called for a general plan for the capital.[78] Equally decisive for the committee was the important atlas of Paris published in 1839 by Jacoubet, one of the most respected experts on the city's topography.[79] Interestingly, several new thoroughfares originated in the private sector, such as the Boulevard de Strasbourg, built by the bankers Jules Ardoin and his son.[80] Louis Napoleon received property owners and shopkeepers who sent him detailed proposals for new streets such as the Rue des Écoles, Boulevard de Strasbourg, and Boulevard de Sébastopol, occasionally visiting the areas in person.[81]

The documents are also shot through with references to the need for strategic streets and barracks, coming from the emperor, Siméon and his fellow committee members, their experts, and even proprietors. As the final report stated, "In a fortified city, whose tranquility is the best guarantee of the country's prosperity and whose convulsions are the ruin of France, garrisons will always be a question of utmost importance."[82] When Siméon tendered his final report on December 27, 1853, the emperor finally had a remarkable blueprint of the main changes to be implemented in the capital. The accompanying plan is much closer to his original ideas than those published by Merruau or Morizet and shows a clear attempt to treat east and west equally (fig. 1.9).

Yet the prefect was more than the executive tool of Napoleon III, whose original intentions must have been continuously changed and challenged during seventeen years in power. Furthermore, the plan found by Morizet in Berlin does not coincide with the deposed emperor's recollections as published by Merruau, and both depart markedly from the extant plan of the Siméon report. The Second Empire's reconfiguration of the city bears the unequivocal stamp not only of Napoleon's intentions, but also of Haussmann's personal vision and that of his collaborators. Charles-Alfred Janzé, a former deputy, remarked acidly that "if one is generally in agreement with Mr. Haussmann in that the responsibility of the conception of the project should be attributed to the Emperor, one is equally reluctant to admit that the sovereign must be held responsible for the details of the execution, the means and measures adopted, the subterfuges and financial detours used."[83]

Over the years, Haussmann produced a somewhat coherent urban project out of disparate shards, beginning with the progressive proposals of the Siméon report (fig. 1.10). These had to be adapted to financial and topographic constraints, and to the regime's often conflicting concerns in terms of political security and social aspirations. Haussmann made numerous contributions, as did his experts. Water supply and sewage disposal, for

FIG. 1.9. Achin map of Paris, 1853–54, published by J. Andriveau-Goujon, and found in the papers of the committee of Count Siméon. Existing streets are shown in green, the streets projected by Louis Napoleon in blue, and the garrisons in red. Bibliothèque de l'Hôtel de Ville, Paris.

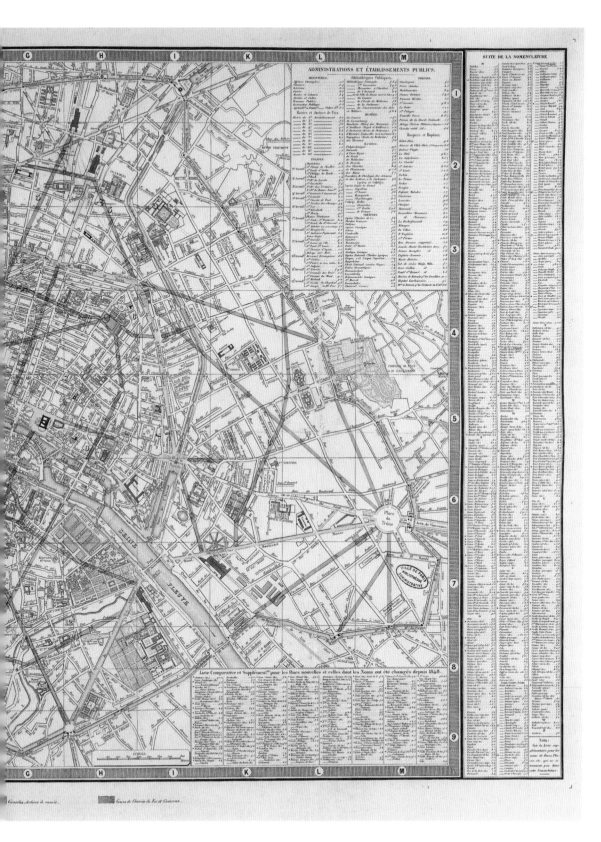

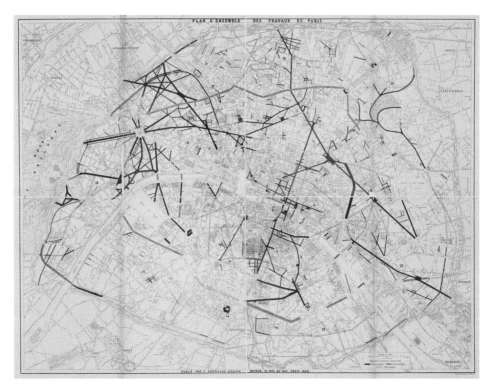

FIG. 1.10. Diagram of all streets executed and projected by the Travaux de Paris from 1851 to 1868, marked on a plan by Andriveau-Goujon, 1868. Bibliothèque nationale de France, Paris.

example, were not in the Siméon papers. Nor could they be found in the work of well-known specialists such as the Lazare brothers or Meynadier. By the same token, both the lack of interest in the greater Paris except as a zone to colonize and exploit, and the unsympathetic treatment of the working class, bear the unequivocal stamp of Haussmann and of imperial rule. As for the unnecessary destruction of the Cité and the rigidity of unswerving boulevards that swept everything in their path, the evidence is more ambiguous. The same traits characterized the urban policies of the July Monarchy and the Second Republic. While the Siméon committee advocated restraint in dealing with the urban fabric, their final plan entailed slum clearance in several parts of Paris.

One must avoid a Manichaean dichotomy that sees the emperor as the fount of all good, and Haussmann as an evil figure incapable of doing anything farsighted. The very scale of operations prevents us from attributing blame or credit to one or two men alone. Haussmannization (the word "haussmannized" was coined during the prefect's term in office) was a collaborative effort.[84] Napoleon III must bear responsibility for the manner in which Haussmann carried out his plans for urban renewal. If their politics varied— Haussmann was far more conservative than the emperor—Napoleon III could and did block his prefect's projects whenever these were not to his liking. When Haussmann wanted to preserve Ange-Jacques Gabriel's original design for the Place de la Concorde, the emperor overruled him. And Napoleon III flatly refused to grant permission for the construction of the Pont Sully, which, unlike the city's other bridges, was not perpendicular

to the river.[85] Haussmann could not have carried out such radical transformations without imperial backing.[86] The emperor empowered Haussmann as no other prefect before or after: vested him with unprecedented power, showered him with favors, shielded him from opposition more than was politically advisable, allowed him to attend senatorial meetings, and gave him the use of the elegant villa at Longchamp as a summer residence. Twice the prefect declined the post of minister of the interior, and once that of minister of agriculture, commerce, and public works. Without the emperor's support, Haussmann declared truthfully, "I would not have been able to fight successfully against the difficulties inherent in each operation, against the ill will born either of sincere convictions or of unconfessed but implacable jealousies in the Grands Corps of the State, the Government and the very entourage of His Majesty; nor against the overt attacks of parties hostile to the imperial Regime."[87] As different as they were, emperor and prefect functioned beautifully in tandem. Haussmann willingly played the role of the blunt alter ego to the soft-spoken Napoleon III, who relished the part of a benign public persona.

In order to manufacture the kind of urban space required by the needs of the moneyed classes that sustained the empire, Napoleon III and Haussmann had to invent the legal instruments and economic incentives necessary to implement the new infrastructure without having recourse to the public exchequer. This included setting up a pliant municipal council whose members, carefully selected by Haussmann, were appointed by Napoleon III. Haussmann's training in law helped him navigate complex issues, but he lacked any interest in the poor, who made up most of the population, and whom he always viewed with distaste and mistrust. An efficient bureaucrat, remote and impersonal but with a great capacity for getting things done, Haussmann directed the gargantuan operations from his office at the Hôtel de Ville. Networks—of streets, sewers, water conduits—reassured him, laid out in neat patterns, susceptible to representation by numbers. Émile Zola, a caustic critic of the regime, scoffed at Haussmann's obsession with graphs and grids to the exclusion of human beings: "In his dreams, he must see Paris as a gigantic checkerboard of geometric symmetry."[88] A somewhat similar charge was often leveled at the emperor: "He had a sort of abstract adoration for the people," wrote Alexis de Tocqueville.[89] Haussmann's cold municipal rectitude and the emperor's distant imperial philanthropy blinded them both to the human drama of the dispossessed: the thousands displaced by their grandiose plans for the capital.

When Haussmann took office, he inherited several projects in varying states of completion. Topography was a major issue that had foiled his predecessor. When Berger attempted to prolong the Rue de Rivoli without taking into account the different levels of the terrain through which the street was to pass, he found, to his horror, that the entire quartier of Arcis would have to be lowered, along with its major landmark, the medieval Tour Saint-Jacques. To avoid such costly surprises and take relief into account, Haussmann commissioned the first topographic plan of Paris.[90] After founding the Service du plan de Paris, he placed it under the direction of architect Eugène Deschamps, whose surveyors built elevated platforms rising from street corners, to triangulate the layout of the city. The resultant map, now lost, was of enormous significance, not just for Haussmann but for the entire administration.

Haussmann was not the first to grasp the importance of a comprehensive plan, but he was the first prefect to conceptualize Paris as a whole, albeit conceived as abstract space.[91]

A gigantic plan, on a scale of 1 to 5,000, was mounted on wheels in his office. With the great loom of the city before him, he could weave his complex tapestry of intersecting networks. This panoptic vantage point, however, encouraged a schematic drawing-board mentality, a tendency to solve problems on paper, relying on formalism and geometric niceties while ignoring the social dimension.[92] Haussmann and his master, claimed a former municipal councilor, Ferdinand de Lasteyrie, "presume to pose their compass, ruler and T-square on the razed, denuded, and level soil of the good city of Paris, as if on the white sheet of paper where they trace their drawings."[93] The huge map in Haussmann's office helped sustain the illusion that the city could be understood as a whole, offering a detached bird's-eye view impossible in reality and in stark contrast to the pedestrians' more revelatory, worm's-eye perspective. Transforming the city into an "optical artifact," the alienating stance arrogated to the prefect the illusion of power.[94] Legibility, wrote James Scott, is "a central problem in statecraft."[95] In Second Empire Paris, it was an ongoing concern; both the state and the municipality worked indefatigably to make certain changes visible—boulevards, parks, squares—while making sure that other interventions were cloaked in invisibility, particularly those concerning political strategy.

Haussmann's Paris was produced by its map. Printed at various scales and versions as the city changed, its orientation favored the richest part of the city, the Right Bank, to the north, always shown on top. This way of rendering Paris, which continues to this day, was institutionalized long before Haussmann and was hardly due to a conscious decision to mystify the public. Representations rather than reproductions, maps do not reflect space but construct it. In Paris as elsewhere, their rhetoric changed continuously, according to the city's economic evolution.[96] Maps follow and naturalize power, erasing boundaries and legitimizing exclusions. They project the fantasy of a perfect homology with their referent, suggesting an elusive sense of closure. Contemporaries saw the plan of Paris as the regime wanted them to see it—as abstract, homogenized space, contained within a rational mesh of streets and avenues. These holistic, totalizing views always show the city as complete, a form of depiction that is itself ideological, stressing progress and unbroken continuity, its social fractures domesticated by the benign grisaille of fine lines. Contrary to daily experience, in the comforting world of paper, no gaping building yards or social cleavages upset the smooth flow of streets.

THE THREE NETWORKS

Equipped with a reliable map of Paris and a solid grasp of its topography, Haussmann could pursue the gist of the Siméon report: a web of wide streets and boulevards, enabling swift communication between different parts of the capital, well served by train stations and garrisons. Given the enormity of the undertaking, all new streets were divided into three distinct networks or *réseaux*, depending on the location, the nature of the streets, and the kind of financing they were to receive.[97] The first, begun by Louis Napoleon after his election, and underwritten by the state, was aimed at improving circulation and upgrading all streets deemed of national importance—those connected to roads leading to other parts of France. This type of network received top priority and was completed in 1858. The crux of this network was the extension of Rue de Rivoli, and perpendicular to it, the Boulevard de Sébastopol, which linked the Boulevard de Strasbourg to the river. Under its

provisions, key areas like the Hôtel de Ville and the Châtelet were cleared. Although Meynadier and the Siméon committee had stressed the need to tie the two sides of the river together by means of a north-south axis extending across the Seine, Haussmann attributes the idea to himself: "I had no difficulty persuading His Majesty to accept the project of continuing this second major thoroughfare through the Cité and on to the left Bank of the Seine."[98] This great crossroads would later be echoed on the Left Bank, by the intersection of the Boulevard Saint-Michel with the Boulevard Saint-Germain.

While the first network was finished in record time, the second was spread out over a much longer period to avoid, in the eyes of some, "too great a concentration of workers in the capital."[99] Financed jointly by the state and the city (the notorious treaty of 180 millions), the network was meant to facilitate communications between different parts of Paris, providing access from the center to outlying areas.[100] In principle, it involved only those streets that proved vital to the city rather than the state, among others, the Avenue Napoléon (now Avenue de l'Opéra); the Rue de Rome, connecting the Gare Saint-Lazare to the center and to the outskirts; and Boulevard Malesherbes, begun under the July Monarchy, which led from the Madeleine to the fashionable area around Parc Monceau. Thoroughfares serving transportation and commerce were likewise part of this network, which often favored wealthy neighborhoods. Circulation in the eastern and poorer part of Paris also improved, but there, streets servicing military establishments were accorded greater importance. One has only to compare the elegance of Place de l'Étoile, Place de la Concorde, and Place Vendôme in the west to the squares in the east, such as Place de la Bastille and Place du Trône, to see the difference in treatment between the two halves of the city.[101]

The first two networks, based on Napoleon III's preliminary plans for Paris, had been funded with help from the state; the third was financed entirely by the city and encompassed a broader stretch of urban territory. With the annexation of the periphery in 1860, all new streets in the outlying districts automatically fell within this third group. So did crucial arteries such as Boulevard Saint-Germain, Boulevard Ornano, and Avenue Daumesnil, which helped connect the outskirts to the center. Broadly speaking, the first network concerned the center of Paris and the area within the inner boulevards; the second was situated largely between the inner boulevards and the tax walls; the third included streets in all parts of the city.[102] It is only in theory, however, that the three groups can be separated into discrete entities. Rue de Rivoli, for example, belonged to the first network between the Place du Louvre and the Hôtel de Ville, but from there to the Bastille it fell within the second.[103]

Money for the *grands travaux* came primarily from municipal bonds and from the octroi, a tariff levied on all goods entering the city. As the emperor wanted to defray costs without raising taxes, the prefect found the necessary sums by means of a stratagem advocated by the canny Persigny (though Haussmann claimed to have come up with it himself): deficit financing.[104] A law of 1841, granting French cities the right to expropriate land required for works of public utility, greatly facilitated the prefect's task. Other laws followed, providing the legal and financial armature required to give greater power to municipalities desirous of tearing down insalubrious housing to replace it with new buildings for the middle and upper classes. Haussmann was adept at wielding capitalist finance tools to the advantage of the municipal government and managed to implement the huge project of urban renewal without raising taxes.[105] Aware that the services he would provide—water, gas, sewage, greenery, transportation—would assure significant financial

returns, he floated huge loans, deferring fiscal accountability to future generations.[106] Wily and visionary when it came to planning for his beloved city (and its elites), Haussmann shrewdly bought up more land than he actually needed, thanks to an expropriation law of 1852. Once the new infrastructure was in place, the resale value of the properties adjoining the new boulevards exceeded the original expropriation costs, netting a handsome profit for the municipality. Rambuteau had already cut new streets where they would create "beautiful squares to build on and where façades would obtain a high price." Rue Rambuteau, he added, "cost nine million whereas the buildings lining it must be worth fifty."[107]

The primacy of expenditure over income drew the wrath of the opposition; the municipality also had to stave off property owners who wanted for themselves the plus value that Haussmann allocated to the municipal coffers. In 1858, they ultimately prevailed: the Conseil d'État gave them the right to reclaim whatever property was not used up by the municipality, which now lost a huge amount of revenue resulting from its urban improvements.[108] Haussmann was furious; city hall would do all the work while the private sector reaped the rewards. In addition, juries awarded munificent sums to the aggrieved property owners, thus prompting Haussmann to borrow money the city would otherwise have received from surplus.

Speculation, fueled by expropriations, syphoned off large sums of money from the state and the city. Hundreds of buildings had to be pulled down to make room for new streets and squares, their real estate value adjudicated by special juries. Although Haussmann was honest, the same could not be said for all members of government. Indiscretions among its entourage led to a frenzy of buying and selling before the news of the areas slated for redevelopment became public. Nepotism and preferments ruled under Napoleon III. Property values became inflated and expropriations a prime means of profiteering.[109] As the public works dragged on, the municipal administration found itself battling fraud while trying to rein in costs.[110]

It was a story contemporaries loved to tell and magnify. "A new industry sprang up which, under the pretext of taking the interests of the expropriated in hand, did not balk at any kind of fraud," wrote Maxime Du Camp. "It provided numerous clients that crowded the shop on the day when the jury came to pay the regulatory visit; it concocted exaggerated, extended, and predated leases, on sheets of old stationery it had managed to lay its hands on [. . .]. It was a sort of black gang that robbed the City coffers."[111] In his novel *La Curée*, published in 1871, Zola left a devastating, if overdrawn, picture of the gold rush atmosphere triggered by real estate speculation under Haussmann. Saccard, one of Zola's most corrupt characters, comments on the prefect's second network: "Look over there, toward Les Halles," he exclaims. "Yes, the 'Great Crossing' of Paris, as they're calling it. They're clearing out the area around the Louvre and the Hôtel de Ville. But that's mere child's play! Just enough to whet the public's appetite. . . . When the first network of new streets is finished, the big dance will begin. The second network will cut through the city in all directions to link the suburbs to the first network. The buildings that need to be cleared away will collapse in clouds of plaster."[112] Haussmann was indignant at the complaisance of the juries, who awarded generous indemnities to property owners at the expense of the municipality. Class-based attitudes as well as corruption motivated the obeisance of the judiciary institutions, which appeared to defend public interest but in fact favored their own ranks with unjustifiable appraisals.[113]

STRATEGIC BOULEVARDS

Haussmann's critics have always reproached him for designing his arterial thoroughfares with the army in mind. With their broad surfaces and clear connection to the city's train stations and garrisons, they attracted the anger of the opposition, which accused the prefect of erecting a permanent network of riot control so troops could sweep down the untrammeled corridors of space.[114] "If you examine the boulevard Sébastopol, the boulevard Saint-Germain, the boulevard of the Prince-Eugène, as well as the continuation of the Rue de Rivoli, you will be surprised to see to what extent they help free the buildings capable of serving as centers and fortresses of insurrection, in order to cut up and isolate popular neighborhoods, and create everywhere impregnable [points of] entry and egress for the armed forces," wrote Victor Fournel, angrily.[115] Zola's Saccard invokes the dramatic image of "a city crisscrossed by fine strategic highways that will put fortresses right in the heart of the old neighborhoods."[116]

Conservatives, too, believed that boulevards were designed to facilitate troop deployment. Louis Veuillot, an ultramontane Catholic and adamant opponent of the regime, voiced similar arguments: "On one hand, they wanted to favor the circulation of ideas, on the other to ensure the circulation of regiments."[117] In London, stated the *Building News* in 1861, "society and the Government have no grounds to fear the hostility of any one class. Consequently there is no cause to imitate Paris by constructing military roads through our capital. We have no 'citadels of revolution' to be sapped by trenches disguised as streets."[118] Closer to our day, Walter Benjamin lent his powerful voice to this current: "The true goal of Haussmann's projects was to secure the city against civil war. He wanted to make the erection of barricades in the streets of Paris impossible for all time. [...] Widening the streets will make the erection of barricades impossible, and new streets will connect the barracks in straight lines with the workers' districts."[119] "Cannon-shot boulevards," an expression often attributed to Sigfried Giedion but in fact coined by Elbert Peets, was too good to be wasted and gained common currency.[120]

Both emperor and prefect built streets dictated by political expediency.[121] Haussmann denied the political motivations clearly stated in the Siméon papers: "Assuredly, by planning the Boulevard de Strasbourg, the Emperor [...] gave no thought to the strategic use of this extension, any more than that of so many great thoroughfares such as the Rue de Rivoli, for example, whose rectilinear path did not lend itself to the usual tactic of local insurrections. But if he did not seek this result above all, as the Opposition reproached him, one cannot deny that this was the happy consequence of all the cuttings conceived by His Majesty to improve and sanitize the old city."[122] It almost seems, wrote Rougerie (long before the publication of the Siméon papers), "as if Haussmann wanted to ratify and improve the boundary mentioned by Engels" with a continuous north-south axis that cuts across the river: the Boulevards de Strasbourg, Sébastopol, and Saint-Michel (fig. 1.11).[123] But in 1857, Haussmann acknowledged the need for streets carefully plotted to prevent insurrection: "It is a question of establishing routes that will assure broad, direct and multiple connections among the main points of the capital and the military establishments assigned to protect them."[124] In a letter to Persigny, he mentions with brutal cynicism the "broad strategic arteries which lead from the center to the perimeter of Paris, which will little by little drive workers to the exterior and scatter them there, allowing us, if need be,

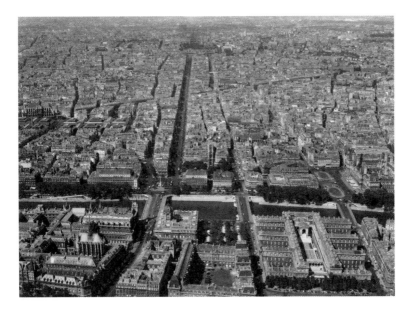

FIG. 1.11.
*Boulevards de
Sébastopol and
de Strasbourg.*
Roger Henrard,
1960–61. Musée
Carnavalet,
Paris.

to follow and contain them."[125] And in a speech delivered to the Senate in 1861, Haussmann called attention to an urban node of utmost importance "for circulation and also for public safety [. . .] protected by the Lourcine barracks. The street to the east of the montagne [Sainte-Geneviève], was overseen by the Mouffetard barracks; the street to the west, by the barracks planned for the crossroads of rue Soufflot [. . .]. To the north, there were the barracks slated for construction in the Cité, as well as the Napoleon barracks and the barracks of City Hall."[126] These garrisons were hard to miss. Field Marshall Helmuth von Moltke, who accompanied the future king Wilhelm to Paris in 1856, wrote that "this city hall and the adjoining barracks are a pretty *strong hold* in the center of the city."[127]

Military security had been a prime consideration of the emperor, the moneyed classes, proprietors, and politicians, before being embraced by Haussmann. During the quarter of the century preceding the Second Empire, Paris had seen barricades go up nine times, a fact no sovereign could afford to ignore.[128] Rambuteau's concessions to military strategy, widening and uniting streets, were a response to the insurrection of July 1830.[129] Louis Napoleon, who owed his presidency to the revolution of 1848 and his empire to a referendum following the coup d'état of 1851, never forgot the revolutionary potential of the Parisian masses. He was an officer, and military strategy was his forte, or so he thought until Sedan proved otherwise. The Siméon papers, laced with references to strategy and garrisons, include a caveat paraphrasing the emperor's words: "When cutting broad strategic thoroughfares, it is important not to neglect the crucial issue of a good location for troops."[130] Significantly, barracks and railway stations appear highlighted in red in Siméon's plan, to underscore their importance and connection to one other (see fig. 1.9).[131] Merruau confirms the emperor's intentions: "It was necessary, by means of avenues and important thoroughfares, to cut breaches in the midst of districts that had until then been closed like citadels of insurrection, such as the environs of the l'Hôtel de Ville, the faubourg Saint-Antoine, the two sides of the montagne Sainte-Geneviève. One had to decide, on

plan, where to place powerful barracks, interconnected by ordinary streets, and capable of serving, at a given moment, as strategic roads to insure that order would always have the upper hand."[132] The goal, wrote the politician Augustin Cochin, was to render popular space more *gouvernable*.[133] This interest in garrisons and special roads of access was neither a left- nor a right-wing issue, but a concern of the upper and middle classes in general.

The isolation of working-class enclaves in the eastern part of Paris formed a crucial part of the emperor's agenda. Given the active role of the faubourg Saint-Antoine during the French Revolution and then again in 1832 and 1848, it was subjected to ruthless political containment. The Boulevard du Prince-Eugène (today's Boulevard Voltaire), Boulevard Mazas (now Diderot), and Boulevard Richard-Lenoir define an irregular triangle that grips the faubourg Saint-Antoine in its vise. Boulevard Voltaire, the capital's longest artery, was already in the Siméon committee plan, as well as those published by Merruau and Morizet, which reflect the emperor's intentions. Together with two diagonal streets, Boulevard du Nord (now Magenta) and Rue de Turbigo, which led to Les Halles, they were linked to the barracks in Place du Chateau d'Eau (Place de la République) and Place du Trône (Place de la Nation).[134] The Boulevards Strasbourg and Sébastopol, divide two turbulent faubourgs, Saint-Martin and Saint-Denis, while the prolongation of the Rue de Rivoli separates Les Halles, a popular neighborhood, from the Tuileries and the Hôtel de Ville.[135]

Yet the empire's urban interventions cannot be reduced to riot control alone: many were also characteristic of modern forms of city planning. Paris had to be answerable to the needs and aspirations of the prosperous entrepreneurial bourgeoisie, while placating the laboring poor with public works. Industrial capitalism required a new urban form that differed radically from the old classical city: broad streets to enhance circulation, improved living conditions for part of the population to stimulate economic activity, enhanced security to protect property, and new representations of space. Many of the prefect's endless streets, such as Rue Lafayette or the Boulevard Haussmann, bore no relation to urban warfare: the new Paris served consumption as much as it did political strategy. The intractable nature of the old urban network alienated the industrial bourgeoisie and the affluent classes, while the clear, reticulated texture of Haussmann's urban plan attracted pedestrians and hence business. As T. J. Clark has forcefully pointed out, "Haussmann's Paris was not a neutral form in which capitalism incidentally happened: it was a form of capital itself, and one of the most effective."[136]

The need to endow the city with new streets, water supply, sewerage, parks, and gardens presupposed a close collaboration among different branches of specialists, synchronization of theory and practice, and reliance on national as well as international approaches. Under Haussmann, Paris became a gigantic laboratory for experimentation. Large numbers of engineers entered the municipal services, eagerly following what other nations were doing.[137] Instrumental in previous municipalities, building roads and bridges, providing water and sewers, they now played a pivotal role in the creation and maintenance of modern urban space. Unlike Napoleon III, Haussmann preferred engineers to architects and had first-rate polytechniciens working for him, often plucked from the provinces and oblivious to the municipality's byzantine factions. His fierce independence, truculence, and bull-dog-like stamina—one of the reasons for his choice as prefect—enabled him to ignore the internecine squabbles surrounding the emperor and the "political eunuchs" at court.[138]

IMPERIALIZING PARIS

Once the capital was secured—in the empire's view—against the possibility of urban insurgency, Haussmann could devote himself to a trend that had begun to take shape long before the Second Empire: the gradual exodus of the affluent classes and the institutions addressing their needs to the west.[139] Napoleon I wanted to embellish the western half of the city with major public buildings such as the École Militaire, and the unexecuted Palais du Roi de Rome on the heights of Chaillot.[140] Rambuteau also built most of his new streets to the west.[141] The city's old historic core had reached saturation point, worsened by the cholera epidemics of 1832, 1848, and 1849. Waves of popular revolt and rising social antagonisms also encouraged the flight of the middle and upper classes fearful of political unrest, particularly since the epicenters of the revolutions of 1789, 1830, 1832, and 1848 had all been situated between the center and the eastern part of the city.[142]

Previous administrations worried about the erosion of the historic center and displacement of commerce to the west: a shrinking tax base within the inner city deprived the center of much-needed revenues and social stability. In 1839, Rambuteau named a committee to analyze the *déplacement* of Paris, a major preoccupation of the municipality.[143] Perreymond and other contemporaries undertook the task on their own initiative, publishing articles remarkable for their analytical depth.[144] But Rambuteau's prudent interventions were marked by the fiscal conservativism that characterized the July Monarchy.[145] The drive toward the west continued, stamping the political landscape of the city with increasingly clear-cut social divisions. Given the decrepit state of the historic center, wealthier classes preferred new residential areas and forms of spatial affirmation. Napoleon III was aware of this westward drift. Friends and enemies often compared his new Paris to London's West End, which he greatly admired.[146] Although his initial plans made little distinction between east and west, his ideas changed after the coup d'état. If he showed greater sympathy for the poor than his prefect, he also enjoyed being a princely Maecenas, following the urban transformation with keen interest, picking his battles with the opposition carefully—when he could choose at all—and leaving the rest up to his headstrong prefect, whose ambitious plans he fully endorsed and ratified by imperial decrees.

From his office in the Hôtel de Ville Haussmann followed the flow of wealth to the west, where he created another center devoted to consumption and representation, aggressively promoting the western part of Paris at the expense of the city's eastern half. He could not have done so without the support of the emperor, the industrial and managerial classes, and the *haute banque* that constituted the political and financial backbone of the Second Empire. If the stability of empire depended on a pacified city without pockets of unrest simmering in a maze of insalubrious streets, the economy demanded more space for circulation and consumption. New infrastructure and generous subsidies were calculated to attract investments so that private enterprise would lend its support to the venture. Haussmann lavished urban enhancements on the emperor's projects, particularly streets of importance to the economic elites, punctuated with references to the regime. Trees, benches, lampposts, and kiosks accompanied the broad leafy boulevards and sidewalks doled out to affluent districts. At the same time, the prefect tried to contain the working-class strongholds of eastern Paris to protect his areas of exclusivity, although they too saw varying degrees of improvement.

FIG. 1.12. Charles Garnier, the Opéra de Paris, 1863–75.

Paris, or at least the part cosseted by public amenities, had to be transformed into a *ville-spectacle*. Social hierarchies were expressed spatially. Industries that disfigured the urban scenery and produced noise and pollution were banished to the outskirts, as urban reformers had called for since the eighteenth century. A nineteenth-century *vedutista*, Haussmann sought ceremonial perspectives in areas newly built or rebuilt for the privileged. The Paris that he wanted to bequeath to posterity was meant to appeal to its citizens in terms of spectatorship as well as functionality. Broad new streets and public areas, and the almost curatorial staging of urban tableaux, addressed pedestrians as consumers of urban space. Rows of new apartment houses were instrumentalized as backdrops for monuments representing the pageantry of church and state according to the best principles of Gallic city planning: "the foreground building representative of authority in the Absolutist tradition—broad and roomy, scenographic, using the conventions of axes and Greco-Roman forms once constituent of the king's style—and background construction— self-effacing in form but tightly packed in space and function."[147]

Eventually, emperor and prefect decided that the linchpin of the capital's fashionable district should be the new Opéra, thus consolidating the drive of the leisured classes toward the west (fig. 1.12). It was to rise on the Boulevard des Capucines, more or less where Siméon had suggested. Five hundred architects signed a petition against moving the opera from its original location in Rue Le Peletier, where the emperor had narrowly survived an assassination attempt in 1858. By the time the competition for the design was announced, plans for the new quartier had already been laid out, and surrounding buildings such as the luxurious Jockey Club were virtually finished. The Grand Hôtel and its Café de la Paix, which flanked it on the left, were also under way.[148] This led journalist Gustave Nast to raise the specter of corruption: how could the banker Émile Péreire, "a sort of Siamese twin of the prefect of the Seine," have bought large tracts of land in this exact location long before the news of the opera and the avenue leading up to it had been made public?[149] And architect Hector Horeau denounced the "mock competitions one saw for the new Opéra, for example, where the examination and adjudication [of the projects] were made behind closed doors."[150]

Built by Charles Garnier in the florid, declamatory style dear to the Second Empire, the Opéra (1863–75) is an opulent *Gesamtkunstwerk*, cushioned in splendor and adorned with sculpture, painting, mosaics, and richly veined marbles. Haussmann eventually planned it as the terminating vista of the new (unfinished) Avenue Napoléon (now Avenue de l'Opéra).[151] Interestingly, Haussmann disliked Garnier's opera, "the giant theatre in the pygmy square."[152] By the time the opera was inaugurated in 1875, under the Third Republic, it had succeeded as a catalyst for new development, drawing yet other prestigious buildings to neighboring lots. The streets and buildings that defined this luxurious hub were like a giant allegory of the power of the bankers, captains of industry, and entrepreneurs for whom and by whom it was ultimately built, a plutocracy that would survive the change of regime virtually intact. Paris's most famous couturiers and parfumiers—Worth and Paquin—established themselves nearby, in Rue de la Paix. Banks, previously located a few blocks away in the Chaussée d'Antin, also chose to open new headquarters in the Boulevard des Italiens, or in the district's most recent thoroughfare, named, appropriately enough, Boulevard Haussmann.[153]

Equally significant was the proximity of the Gare Saint-Lazare (1840–43), the main line serving suburban commuters (fig. 1.13).[154] Not by chance would two of the city's most famous department stores, the Printemps and the Galeries Lafayette, be built in the new bourgeois node of leisure and consumption, close to the train station, banking establishments, and elegant districts to the west, from which they drew a prosperous clientele. Banks built under the Third Republic, such as Bouwens van der Boijen's Crédit Lyonnais (1876–78), and Achille Hermant's Société Générale (1908–12) typify the extravagant architecture of consumption that characterized this part of the city: historicist and contextual on the outside, spectacularly modern in the interior. The industrious sectors of society not only commissioned important buildings but also sponsored urban initiatives that served their interests, adding a different voice to the imperial agenda as they sought social legitimization through architectural patronage. With their domes, dramatic masses, and salient corners, theaters, banks, hotels, and department stores stood out boldly, proudly asserting the importance of their cultural capital.

The new Paris attracted citizens from all over the globe. "From the Madeleine to the Chaussée d'Antin one finds the cosmopolitan, international Paris," complained an observer with chauvinist indignation. "Parisians are mixed with foreigners. The shops themselves have the elegant and banal appearance of shops in other capitals; here and there, signs are in English and Russian; the cafés, American or Neapolitan; not a single one, in this latitude, can boast of being Parisian."[155] The colonies were equally present. Small communities hailing from the Caribbean territories or former territories—Guadeloupe, Martinique, and Haiti—also established themselves in the city, at times temporarily.[156] Many had come to plead the cause of abolition. While the Second Republic had voted to end slavery, the Second Empire suppressed slaves' political rights.[157]

Consumption—*consommation*—was beginning to play a decisive role in city planning that had had no precedent in the past. "To make a city flourish," remarked Meynadier under the July Monarchy, "one must have *consommateurs*."[158] Paris does not need so many manufactures and factories in its midst, wrote Auguste Chevalier in 1850: "The destination of our capital is to be a city of luxury and pleasure: the goal toward which it should strive is to attract more and more foreigners, and thus, commerce and *consommation*."[159] Cities,

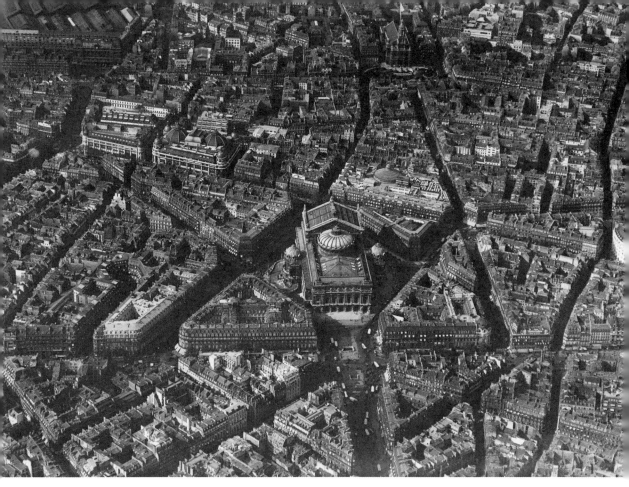

FIG. 1.13. Aerial view of the Paris opera. Behind it, the large buildings of the department stores. On the upper left-hand corner, the Gare Saint-Lazare. Roger-Viollet.

too had become a form of merchandise. Not all approved, of course. In his book *Paris incompatible avec la république*, written a few years before Haussmann took office, Lecouturier castigated the new role of the modern city: "Cities, denied all natural production, have become accelerated machines of *consommation*, a *consommation* [that is] all the more frightening because, deprived of air, light, and sun which are half of life, man must supply by art that which he lacks in nature."[160]

While spending fortunes on the wealthiest part of Paris, Haussmann threatened class-based institutions catering to the poor in areas reclaimed for purposes of security or wealthier social groups. To build Boulevard du Prince-Eugène and Place du Château d'Eau (today, Place de la République), he destroyed six of the seven theaters in the old Boulevard du Temple, an enclave of entertainment that addressed a diverse audience, particularly the working class (fig. 1.14).[161] A slight deviation would have spared them, but Haussmann's geometric imagination rarely allowed him to relax the implacable rules he had set for urbanism unless it was in his interest to do so.[162] The theaters of the Boulevard du Temple—known as the Boulevard du Crime because of its melodramatic performances—boasted an innovative and independent stage, often successful at circumventing imperial censorship. Haussmann, complained several contemporaries, erased part of the old boulevard because

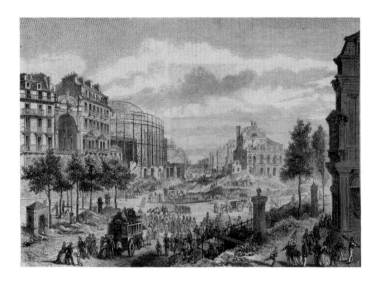

FIG. 1.14. Félix Thorigny, demolition of the theaters on Boulevard du Temple, ca. 1857. *Paris dans sa splendeur*, 1861. Bibliothèque nationale de France, Paris.

it was a stronghold of popular culture. Here, too, wrote a contemporary, municipal funds were used to destroy "the most spacious, jolliest, and liveliest boulevard in all Paris."[163] Well aware of the population's attachment to its theaters, Haussmann claimed brazenly that his administration would already have finished overhauling the square that was to take their place "had we not feared to spoil the pleasure of the laboring classes by destroying their favorite theaters before erecting new ones."[164]

In fact, Haussmann built theaters only for the wealthy. While razing the modest theaters accessible to the populace, he rebuilt the Théâtre Lyrique (now Théâtre de la Ville) and the Cirque Impérial (Théâtre du Châtelet), aimed at middle- and upper-class audiences. Designed by Gabriel Davioud, chief architect for the municipality, the two rather ungainly structures face each other across the Place du Châtelet, which acquired greater prominence as the meeting point of the *grande croisée*, the new north-south and east-west streets that quartered the capital (fig. 1.15).[165] Haussmann introduced compulsory measures to limit the number of seats, theoretically because of safety but in fact to discourage the poor from frequenting establishments destined to the bourgeoisie and so foreclose any possibility of public disorder.[166] The municipality funded two more theaters in wealthier areas. The Théâtre de la Gaîté, built by Alphonse Cusin (1862–64), was relocated on the Square des Arts-et-Métiers (now called Émile-Chautemps). In 1869, the Théâtre du Vaudeville, designed by Auguste Magne, was inaugurated on the elegant Boulevard des Capucines (fig. 1.16).[167] Admittedly, Haussmann asked Davioud to design a huge concert hall with ten thousand seats in the new Place du Château d'Eau. The Orphéon was to be for the eastern and poorer part of the city what the Opéra was to the richest, but the project never came to fruition.[168]

Urban renewal heightened the political and economic difference between the two sides of the river, just as it sharpened the existing divide between east and west, center and periphery. The map of the city's social geography was redrawn. Poor families had difficulty finding affordable housing after their tenements were destroyed to make way for upscale apartment buildings. Although large numbers of masons were required in the historic center's construction yards, part of the working class was gradually forced to move because

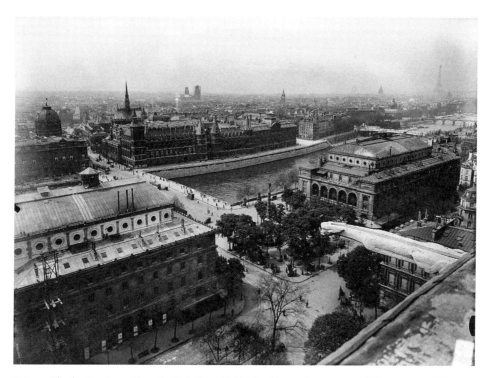

FIG. 1.15. Charles Lansiaux, Place du Châtelet with Davioud's two theaters, 1917. Département d'histoire de l'architecture et d'archéologie de la Ville de Paris.

of rising costs of real estate and the relocation of industries and many small firms to the east or extramuros.[169] The wealthy bourgeoisie moved west, wrote Louis Lazare, where it could savor "for years to come, the honey of the Parisian hive without being troubled by the buzzing of the bees."[170] The gradual polarization of urban space during the Second Empire was shaped by the political fears of the government and the propertied classes, who had not forgotten the successive insurrections of the underprivileged, and who would have preferred a city divided into income-stratified areas as a safeguard against urban strife. There was no question of zoning. Speculation itself foiled all attempts at social homogeneity in any part of the city. Thanks to demolitions, huge lots were now available all over Paris, prompting the construction of new buildings that continually challenged and transgressed class boundaries with their least desirable spaces. Comparing the population of the faubourg Saint-Germain, the Chaussée d'Antin, and the Marais in prerevolutionary Paris to that of his own day, writer Paul de Kock notes: "The first had the pretension of being inhabited by the nobility, the second by finance, the third by the bourgeoisie. Now, all these distinctions have ceased to exist."[171] Strictly speaking, only working-class settlements in certain parts of the periphery could be considered more or less class specific. And if the prefect managed to deindustrialize the center and shunt industries to the outskirts, workers and artisanal trades continued to find refuge within the city throughout the nineteenth century. Nevertheless, though there was never a perfect match between areas and social groups, by 1870 Paris's *arrondissements* were much more sharply identified by class than was the case in 1848.[172]

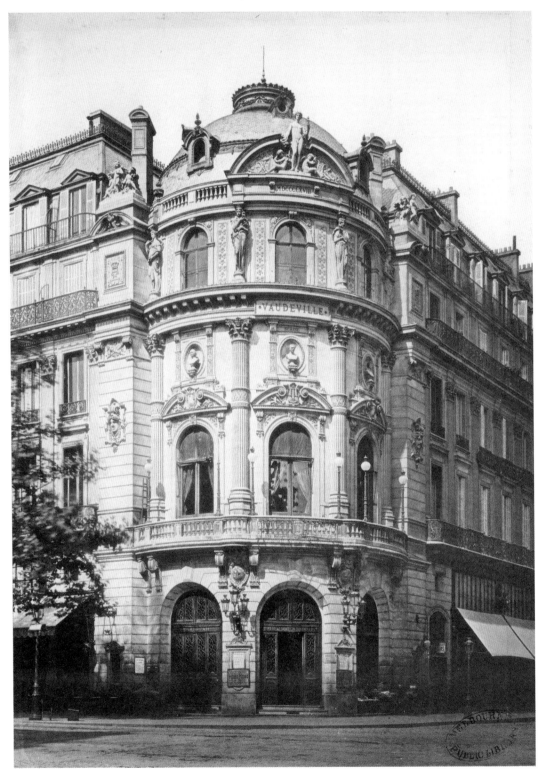

FIG. 1.16. Charles Marville, Théâtre du Vaudeville, ca. 1877. State Library of Victoria, Melbourne.

HUBRIS

Haussmann's financial brinkmanship could not last. His third network took off just as Napoleon III's grip on power slackened, leaving him unable to defend his increasingly vulnerable prefect. When the emperor's ill-conceived attempt to impose a Hapsburg emperor on Republican Mexico ended in disaster with Maximilian's capture and execution in 1867, Napoleon III's reputation as statesman was tarnished. The derogation of imperial power undermined Haussmann, who overreached with the "chronic illegality" of his finances, as Jules Ferry put it, though accusations of personal dishonesty were unwarranted.[173] Different winds were blowing, clamoring for parliamentary reform. Even the success of the world exhibition held in Paris in 1867 could not hide the crepuscular glow of a fading empire.

After almost seventeen years at the helm of the municipal government, the *grand préfet* was asked to step down for what his opponents considered his profligate spending and cost overruns, but also because he was seen as a proxy for Napoleon III. Haussmann refused to resign: relieved from his duties on January 2, 1870, he was replaced by Henri Chevreau. "France still has her Napoleon, but Paris has lost her Emperor," read the editorial of *The Times* of London a few days later.[174] Haussmann's beloved empire survived him by only eight months. On September 4, 1870, the Republic was proclaimed in Paris, after the emperor's inglorious capture at Sedan. Louis Napoleon would end his life as it had begun: in exile.

Requiem

"We won't have demolished everything unless we demolish the ruins as well!"
—Alfred Jarry, *Ubu roi Ubu Enchaîné*

Paris, too, had to be "demolished into a great metropolis."[1] Cities live by destruction, molting continuously to make room for new construction and growing at the expense of the historic fabric. Smaller and less populated, historic towns often have the opposite problem. Promoted to the rank of historic monuments, often after years of neglect, they sometimes end up as lifeless museums, overrestored, almost embalmed, withdrawn from the destructive yet strangely creative hand of time. Like other urban environments in the throes of advanced industrialization, Paris witnessed a violent transition from the old classical polis to the modern metropolis with its significantly larger scale, increasing subdivision of urban space in terms of trade and commerce, and aggressive redistribution of social classes across the urban territory. To make space available for the elites who were avidly shaping and being shaped by the forces of capitalist modernity, entire districts were effaced, along with their architectural landmarks and topographic features. Thousands of residents lost their homes, the "collateral damage" of the great epic of redevelopment.

Even though the emperor had initially advised his councilors to respect monuments of historic interest, his ambitious plans for the capital were premised on a considerable amount of slum clearance.[2] Jean-Jacques Berger, Haussmann's immediate predecessor, had been tasked with upgrading the center by enlarging its impossibly cramped streets to ventilate the area but fell from office before he had time to complete it. Haussmann went further and eviscerated the old center following the main priorities of the regime: the stability of the government and the needs of the haute bourgeoisie. Napoleon III must be considered guilty by association: the imperial Bonaparte met his imperious prefect almost every day and ratified all acts of destruction. Their brutal indifference to the historic fabric and the careless way in which buildings were mutilated and fragments dragged across the city, bring to mind Mussolini's treatment of the area surrounding the Vatican in the 1930s. Urban devastation at this scale was possible only under autarchy, at least until World War II devised more radical means of doing away with the past.[3]

In razing tortuous streets and dilapidated pockets of urban decay, Napoleon III and his prefects were following a well-established trend. Fighting epidemics and contagious diseases had been a major preoccupation of virtually all the city's nineteenth-century administrators, who also favored slum clearance as a salve for sociopolitical problems. For decades medical topographies had pathologized Paris, presenting it as sick, and in

need of improved sanitation, air, and sunlight. In 1830, Louis-René Villermé, a specialist in epidemiology considered in relation to social causes, published a report that correlated the high death rate in different Parisian neighborhoods to factors such as proximity to the river, presence of gardens, exposure to prevailing winds.[4] In 1842, another physician, Henri Bayard, wrote a lengthy study of the populous fourth district, between the Louvre and Les Halles, and concluded that "cutting broad and airy streets, enlarging markets, and relating them to the needs of the population of Paris, are the best way to sanitize these old districts that have preserved all their primitive conditions."[5] Hygiene had been a major concern among Saint-Simonians. Paris, wrote Victor Considerant, was "a huge atelier of putrefaction, where misery, plague and illness work in concert, and neither air nor sunlight penetrate. Paris is an evil place where plants wither and waste, and four out of seven small children die each year."[6] Haussmann, who saw himself as the great pathologist of modern Paris, extirpating slums as a doctor excised tumors or an ecclesiastical authority eradicated heresy, described the old city in terms of illness: the plan of Paris, he wrote, "showed me the infirmities of its network of public arteries."[7]

The cholera pandemic of 1832, which killed over twenty thousand people, mostly in the historic core, had already goaded the July Monarchy into action. Its campaign to sanitize the city led to a proliferation of studies on the slums of the historic center. "It is particularly urgent," stated the official report on the disease, "to clear the center of Paris by cutting streets all directions, by [adding] public squares sufficiently spacious to be planted with trees [...] and finally by bringing sunlight and life to these dark districts where half the population vegetates so sadly, where dirt is so repugnant, the air so infected, the streets so narrow, and death so active that it strikes here more than elsewhere."[8] Haussmann's urban planning was guided not only by epidemiological concerns but also by political motivations. As the highest mortality rates occurred precisely in districts that had witnessed the most virulent insurrections, as early as 1832—when cholera coincided with the uprising—the government and the propertied classes construed the epidemic as a Jacobin illness, conflating cholera and revolution (fig. 2.1).[9]

Cholera reappeared in 1848, 1849, and in 1854, the year after Haussmann took office.[10] As the etiology of the disease would not be discovered by Robert Koch until 1883, many hygienists believed that it spread more easily in tightly woven streets lacking adequate water supply, sewage disposal, and sunlight.[11] Fear of contagion, heightened by cholera's political connotations, was displaced from the impoverished inhabitants to their derelict tenements. An implacable determinism elided disease and dilapidated housing. Even Louis Lazare, an ardent opponent of Haussmann, called for an end to "this network of narrow and mud-caked

FIG. 2.1. T. Blanchard, *Le choléra morbus: Ah Chère Révolution de Juillet*, 1832. Colored etching. Bibliothèque nationale de France, Paris.

streets, permanently complicit with epidemics that scythe first and foremost our labor-
ing classes."[12] The municipality's attempt to rid Paris of the dark, humid canyons that, it
believed, trapped noxious exhalations and helped perpetuate cholera among their disen-
franchised residents, had a long genealogy. Yet urbanism did not produce cholera, however
much overcrowded and unsanitary neighborhoods may have contributed to its propaga-
tion, and the disease continued to plague Parisians long after the end of the Second Empire.

QUOD NON FECERUNT BARBARI . . .

There is a mother-city; think on it, nations of Europe. *Parricide* can be spelled
Pariscide.
—Victor Hugo, *Choses Vues*, volume 2

Haussmann began by prying loose the seats of imperial and municipal power from the clut-
ter of encroaching buildings that he considered a threat to the forces of law and order. Both
the short-lived Second Republic and the July Monarchy had begun to disengage the Place
du Carrousel, where a decaying neighborhood had grown in disorderly fashion between the
Louvre and the Tuileries. The new prefect completed the task before turning his attention
to the old Hôtel de Ville, an enduring symbol of popular liberties, encircled by streets inhab-
ited by large numbers of construction workers.[13] Haussmann, who had his home as well as
his office in the building, interpreted the entire area as a political liability and blasted it from
its squalid surroundings. As it had been the site of uprisings in 1830 and 1848, Napoleon III
had it linked to two nearby garrisons by means of underground passages.[14]

Another area drastically affected by redevelopment were the central markets of Paris,
Les Halles. Napoleon I chose to rebuild them on their original location, but it was his
nephew who carried out the task. To make room for this ambitious project, Haussmann
tore up numerous streets in this old and densely populated part of the city, where one of
the most remarkable structures of Second Empire architecture was erected: Victor Bal-
tard's iron-and-glass market pavilions, demolished in 1971 to make way for a new shopping
and entertainment center, Le Forum des Halles.[15]

One would have expected an empire with dubious claims to the throne to have
protected aristocratic properties. But in the interests of circulation it wiped out several
remarkable palaces, including the seventeenth-century Hôtel de la Force, the elegant Hôtel
d'Angivilliers, the Hôtel Forcalquier, and Ledoux's Hôtel de Montmorency. Even in the
western part of the city, princely residences, barely a few years old, were swept away. Faced
with the outrage of those who lost their opulent homes, the emperor and the municipality
defended their actions, which they attributed to egalitarian principles. As they wrote in
their official mouthpiece, *Le Moniteur universel*: "One can well understand that these per-
sons, unfamiliar with the harsh conditions that the requirements of life impose on others,
should experience with regard to expropriations, an unpleasant surprise when faced with
the democratic rule of equality for all before the law."[16]

The Left Bank was particularly vulnerable. Legal, ecclesiastical, and literary his-
tory were rooted in its many medieval convents, colleges, and streets, such as the Rue
du Fouarre mentioned by Dante in *Paradiso* X (fig. 2.2). Indifferent to their rich history,
Haussmann tore down important landmarks: the old Collège de Cluny, the fourteenth-
century Collège du Cardinal-Lemoine, and the Collège Bayeux; the high-arched halls of

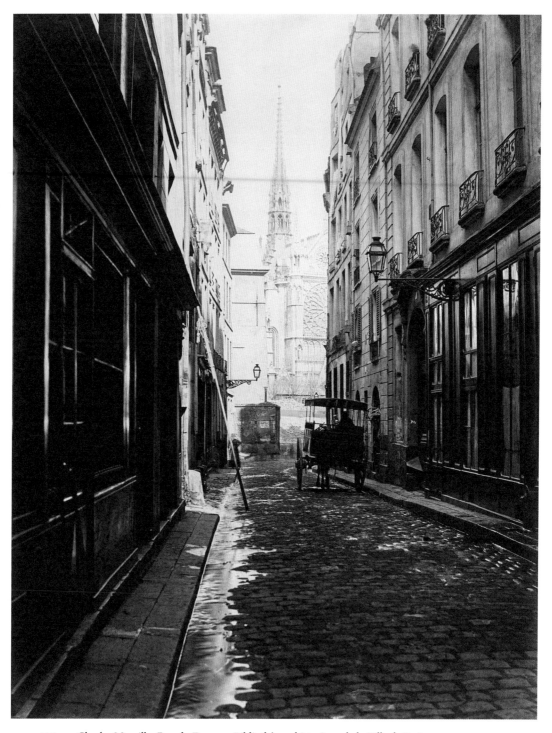

FIG. 2.2. Charles Marville, Rue du Fouarre. Bibliothèque historique de la Ville de Paris.

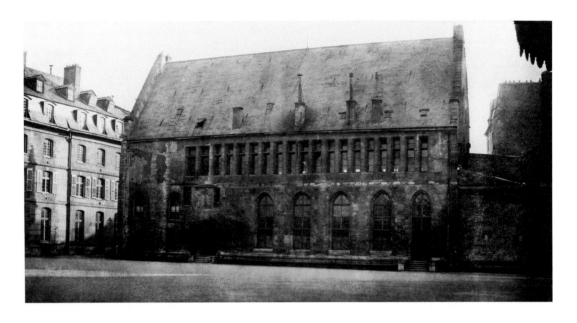

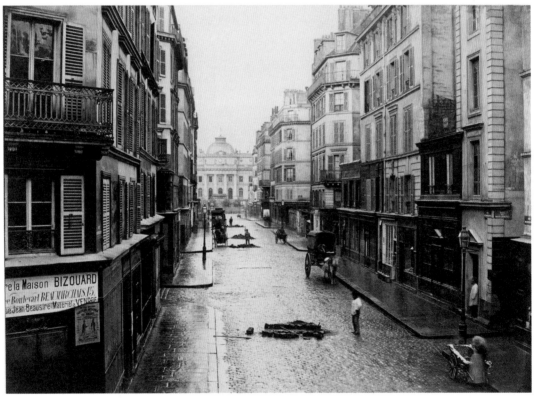

FIG. 2.3. Charles Marville, façade of the library of the College de Navarre, 1860. Bibliothèque historique de la Ville de Paris.

FIG. 2.4. Charles Marville, Rue de Constantine, ca. 1865. Bibliothèque historique de la Ville de Paris.

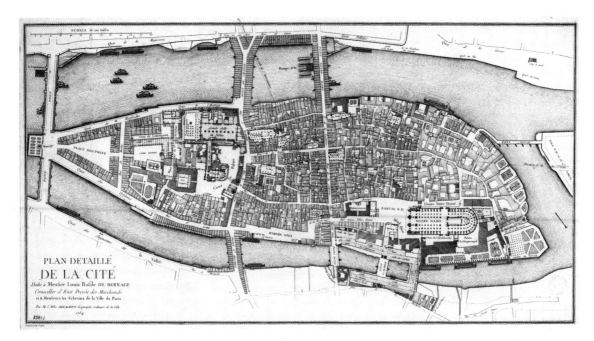

FIG. 2.5. Abbé Jean Delagrive, detailed plan of the Île de la Cité, 1754. Engraving. Bibliothèque nationale de France, Paris.

the Collège de Narbonne, along with the sixth-century church of Saint-Benoît. A slight inflection would have saved the tower of Saint-Jean de Latran, destroyed to make room for Rue des Écoles.[17] The library of the Collège de Navarre disappeared under the Third Republic as Haussmann's collaborators completed the task he had begun (fig. 2.3).

The brunt of the prefect's demolition campaign focused on the oldest part of the capital and the richest in historic monuments, the Île de la Cité, a palimpsest thickly strewn with Gallo-Roman, Roman, Merovingian, and French ruins. Home to a population of poverty-stricken residents, Paris's ancient center stood condemned in the name of progress and hygiene. Since the French Revolution, successive administrations had practiced slum clearance on an increasing scale. If the First Empire's urban interventions earlier in the century were largely restricted to the area around Notre-Dame, the Restoration inflicted severe damage on the historic fabric of the island, destroying a considerable number of secular and religious buildings.[18] The July Monarchy was even worse. Rambuteau wiped out two ancient churches to build Rue d'Arcole and Rue de Constantine, this last enlarged by Haussmann (fig. 2.4). These demolitions brought important ruins to light but left them at the mercy of a hastily improvised salvage archaeology. The Romanesque basilica of Saint-Étienne, enlarged in Merovingian times, was discovered when Rambuteau built a sewer in front of Notre-Dame. "There are several Parises built one above the other," wrote César Daly, one of the city's most respected authorities in architectural matters. "It is rare to dig a sewer or change the orientation of a street within the limits of old Paris without finding vestiges of underground Parises, ten, twenty feet below the current ground level. We cleave to all these old Parises that we possess. They constitute our wealth and glory, our parchments and titles of nobility."[19]

FIG. 2.6. Charles Marville, the old Hôtel-Dieu, 1875–77 (destroyed in 1878). Bibliothèque historique de la Ville de Paris.

A century earlier, a plan of the Île de la Cité by the Abbé Jean Delagrive gives an idea of the richness of the urban landscape ravaged since the mid-eighteenth century (fig. 2.5).[20] In the Cité alone, sixteen churches were destroyed between 1789 and 1889.[21] To link the two sides of the river, Haussmann drove the Boulevard de Sébastopol straight through the island, razing everything in its path. Churches and chapels were niched among the moldering tenements, along with a few remaining convents.[22] The ruined splendor of these monuments was lost on Haussmann and his predecessors, who saw them as fungible entities to be harvested when necessary, and the dense knotted fabric where they were embedded as a threat to public order. Few relics survived unscathed. In his effort to sanitize the island and transform it into the juridical center of the capital, the prefect tore down the remaining religious buildings, except for Notre-Dame, the Sainte-Chapelle, and Saint-Aignan. Notre-Dame, pruned of unwanted additions, was isolated like a historic stump. Two nearby historic landmarks were slated for destruction, the Hospice des Enfants-Trouvés designed by Germain Boffrand between 1746 and 1748, and the mass of the Hôtel-Dieu, the city's oldest surviving hospital, rebuilt several times (fig. 2.6).

Rambuteau's rectilinear thoroughfares had also demolished everything that stood in their way: churches, cloisters, turrets, trefoil windows (fig. 2.7). Had the prolongation of Rue Racine (1835–36) been less rigidly rectilinear, wrote the Count of Montalembert, one could have saved "the precious church of Saint Côme which, though sullied by modern usage, was nonetheless unique in dating and style within Paris."[23] Many architectural casualties dated from the Middle Ages, and even before Haussmann it had become something

FIG. 2.7. Attributed to Charles Marville, turret, Place de l'Hotel-de-Ville, reproduction of a photograph by Henri Le Secq by 1852. Musée Carnavalet, Paris.

of a cliché to mourn the "assassination" of the Gothic.[24] Although the neo-Gothic was occasionally used under the Second Empire, it remained closely associated to the July Monarchy and met with mounting opposition from proponents of the Beaux-Arts. Haussmann also destroyed Classical and Baroque buildings, but they lacked powerful advocates like the Romantics to defend them. César Daly declared (with racialist innuendoes): "One tolerates Gothic varieties that sit well with their ancestor, the Romanesque; but the pickax can never be heavy enough to smash the styles of the 17th and the 18th centuries, should any member of this degenerate progeny be rash enough to contract marriage with the ogival family."[25]

An equally drastic fate awaited the island's most important secular building, the old palace of the kings of France, an agglomeration of structures from different periods (fig. 2.8). Haussmann edited the Palais de la Cité (now the Palace of Justice) with a leaden hand. The grim Tour Bonbec was raised to bring it in line with new construction; the medieval Galerie Saint-Louis was torn down and a neo-Gothic façade by Joseph-Louis Duc interpolated between the massive towers of the Conciergerie. What remains of the original exterior is a pastiche, filled with the Second Empire's prosthetic additions. For Haussmann, who wanted to place the entire cradle of ancient Paris under the baleful eye of the law, even this was insufficient. "I felt, however, that there was a lacuna in this crucial and useful concentration of judicial bodies of different levels and of the Prefecture of the Police, their legal helpmeet, in the center of Paris, in the ancient 'Cité,' and that

FIG. 2.8. Édouard Denis Baldus, the Conciergerie in the 1860s, before it was transformed by Haussmann. Bibliothèque nationale de France, Paris.

it was necessary, to complete it, to add [...] the Tribunal of Commerce."[26] Driven by his forensic proclivities, he transferred the commercial court from the Right Bank, where it was housed in the stock exchange, to a freshly razed plot in front of the new Palais de Justice. His final touch to this lugubrious scenography consisted in moving the morgue to the eastern tip to the island, where it remained for almost half a century.[27]

Had Haussmann had his way, every house on the island would have been destroyed to create voids around the major monuments.[28] As it is, most were torn down, and ten thousand inhabitants banished to other parts of Paris.[29] Across the river, on the Right Bank, between thirty and forty thousand people had already been deprived of their homes by Berger, proving that this high-handed form of urban renewal met with the emperor's approval.[30] Despite Haussmann's single-minded zeal, substantial parts of the island were still standing at his dismissal from office. Boffrand's foundlings' hospital was not leveled until 1877, to free the view of the new Hôtel-Dieu, while the lovely Place Dauphine, which had undergone several changes in the previous century, lost its eastern wing in 1874.[31] Here, as in so many other areas, the Third Republic finished what the Second Empire set out to do. Many thought it had not gone far enough: "Unfortunately," wrote Du Camp in 1875, "in the very center of Paris, in the commercial area, there still exist streets so narrow, so filthy, so dark that they resemble open sewers. Sunlight has never managed to penetrate; high walls, bulging, cracked, seem to falter beneath the weight of five stories; they rise, hunchbacked, greenish, mildewed, leprous, exhaling an unbearable stench of humid salt- peter, with rags at each window, tottering above their enfeebled foundations."[32] The island is now dominated not only by the cathedral, but by the hulking masses of Haussmann's ungainly buildings.

Haussmann's imperial vandalism constitutes one of the great missed opportunities of urban history.[33] Slum clearance abolished both continuity in time and contiguity in space. Drained of all vitality, the empty square of Notre-Dame, framed by the insipid Hôtel-Dieu, and the dreary city barracks (now the Prefecture of Police) serve as a mute witness against the blind self-assurance of the prefect and the craven acquiescence of his superiors. His overscaled and unimaginative interventions and the prosaic reorganization of architectural landmarks transformed the heart of the capital into the barren space we see today. Its social and architectural topography destroyed, its citizens dispersed, the Île de la Cité has become a hollow signifier, home to fleeting historic referents.

Flanked by tall tenements that tapered downward so that little light reached ground level, the island's winding alleys formed a dark warren that romantic writers loved to paint with lurid colors (fig. 2.9). Eugène Sue evoked the decaying bas-fonds of the Île de la Cité in a famous passage of his sensationalist serialized novel *Les Mystères de Paris* (1842–43): "The soot-colored houses were pierced by few windows with worm-eaten casements and scarcely any glass panes. Dark, filthy alleys led to stairways darker still and even filthier, so steep that one could hardly climb them with the help of a thick rope fastened to the humid walls by iron brackets."[34] Although the dismal state of overcrowded areas like the Cité or nearby Arcis was undeniable, it was class as much as hygiene that triggered these representations and generated broad support for the destruction of entire blocks in the heart of the city.

Many writers gave support directly or indirectly to what was clearly seen as Haussmann's civilizing mission, a task of interior colonization, driven by the racialized fantasy of a mythical Paris where the poor threatened the lives and spaces of the rich. A useful metaphor lay at hand. Fired by James Fenimore Cooper's *The Last of the Mohicans*, translated into French in 1826, they saw the inner city as a jungle inhabited by "Indians," people of a different ethnic group.[35] Cooper, who lived in Paris during the Restoration, had a lasting impact on his French confrères. "We shall attempt to conjure up for the reader scenes from the life of other barbarians, just as foreign to civilization as the savage hordes so well depicted by Cooper," wrote Sue in the opening page of *Les Mystères de Paris*.[36] The first volume of Dumas's popular novel *Les Mohicans de Paris* was published in 1854.[37] A few years later, Baudelaire's friend Alfred Delvau wrote of the *"Peaux Rouges* of modern Paris, who are like the dregs of the great capital bubbling with progress... They know not where they come from, any more than a litter of vipers who know neither father nor mother."[38] Under the Third Republic, Pierre-Léonce Imbert published his book on the trappers of Paris (*Les Trappeurs de Paris*), a collection of essays on unusual forms of labor: workers who raised leeches for rent, or tore wings from swallows to procure feathers for milliners. As late as 1888, Gustave Aimard brought out *Les Peaux-Rouges de Paris*.[39] Discrimination against the inhabitants of rundown tenements clustered in filthy streets produced the tenebrous darkness, so utterly devoid of nuance, that characterized the style of these novels.

To raze the areas where the Parisian "Mohicans" lived was to remove from sight the unwanted part of the population and destroy the inexorable yoke that made them consubstantial with their dilapidated dwellings. Years earlier, Balzac himself had evoked the analogy to native Americans with the demeaning term characteristic of the time. "Paris is like a forest peopled by twenty different tribes of red Indians,—Iroquois, Hurons, and the like,—who all live by hunting the prosperous classes. You are bent on bagging millions.

FIG. 2.9. Charles Marville, Rue Gervais-Laurent, 1868. Bibliothèque historique de la Ville de Paris.

FIG. 2.10. Henri Émile Cimarosa Godefroy, Notre-Dame with the new Hôtel-Dieu to the left. Date unknown but after 1877, when the hospital was completed. Musée Carnavalet, Paris.

Your trapping will require snares, decoys, and bird-lime."[40] Fear of the *classes dangereuses* weighed heavily on the imaginary of the middle and upper classes and left its imprint on art and literature, no less than on urbanism, as it gradually shifted from the close-knit urban fabric of the past to the vast uninflected spaces of Second Empire Paris.

THE POLITICS OF *DÉGAGEMENT*

Belief in the isolation of historic landmarks, shared by Haussmann and his contemporaries, altered forever the way surviving monuments would be seen by posterity. Gone was the straggle of streets that withheld the view of Notre-Dame until the last moment, heightening the element of surprise.[41] Untethered from its original moorings, and now dwarfed by the encompassing voids, the old church that once towered above its urban setting lies marooned like a large reef in a vast square, its uneven, weather-beaten façade flattened and bleached by overrestoration in 1844, tragically aggravated by the terrible fire of 2019 (fig. 2.10). Disarticulated fragments like the Sainte-Chapelle fared even worse, immured within the precincts of the Conciergerie and the Palais de Justice. "You have hidden the Sainte-Chapelle, this beautiful reliquary gleaming like an aureole, this paragon, this canon of Gothic architecture, this Parthenon of the Middle Ages, in the bottom of a pit," exclaimed an indignant observer in 1856.[42]

Slum clearance in this oldest part of Paris wiped out the delicate interplay of the vernacular and the monumental that made the approach to medieval cathedrals so memorable. Such destructive practices were predicated, in part, on the widespread conception of the vernacular as an urban blight that threatened to stifle and ultimately ruin architectural monuments. Haussmann's spoliation of the Cité's urban fabric brings to mind the

beautiful words of Fritz Stahl describing the role played by minor buildings in the urban tissue: "Each monumental edifice...appears with an escort, like a prince with his train of followers, and by this retinue it is separated from the respectfully withdrawing masses. It becomes the ruling nucleus of a neighborhood that appears to have gathered around it."[43] The Romantics alone had grasped the importance of recessive architecture, seeing in their derelict but affect-laden appearance an appropriately dark setting for their stories, while "closing their eyes to urban misery."[44] Paris's decaying housing stock varied widely in quality and style, from nondescript structures to a few medieval townhouses (fig. 2.11). With their steep gables and crooked profiles, the city's picturesque half-timbered tenements rubbed their urban patois against grave and stately landmarks, like comic characters in a Shakespearean tragedy.

Those rare structures that the prefect agreed to spare were treated like museum pieces, deprived of the context that gave them meaning and clarified their architectural purpose.[45] Formerly cherished for religious reasons alone, they were now singled out for aesthetic appreciation and, thanks to slum clearance and restoration, acquired a new audience. An ultramontane like the Count of Montalembert had already noted this change: "Where we worship and pray," he told the agnostic Victor Hugo bitterly, "you go only to dream and admire."[46] A few years after Haussmann's death, an American observer noted ruefully that old Notre-Dame had been "surrounded with houses which seemed to lean upon the mother-church for comfort and support, before the restorer had worked his will upon the crumbling, dark, pathetic fragments of carving, whilst the noblest façade ever raised by northern Gothic builders still looked like a great medieval church, and not like an *objet d'art* to be gazed at in a museum."[47] By the early twentieth century this shift was a fait accompli. The invention of the historic monument, that ambivalent creation of modernity, had changed the spectator's relation to architectural landmarks, and Proust could write with confidence that old cathedrals "exerted far less impact on a devout believer of the seventeenth century than they did on an atheist of the twentieth."[48] Like the Sainte-Chapelle, the tiny island's other great religious building, Notre-Dame had become an exquisite husk, a container of unstable meaning.

The transformation of historic structures into freestanding icons had political implications. Architectural landmarks played a central role in the construction of the modern state. With Haussmannization, notes David Jordan, the church was pressed into the service of the nation, and Notre-Dame changed its significance from a religious building to an essential part of the "increasingly popular cult of French historical reminiscence."[49] With its storied past, Notre-Dame helped confer legitimacy on a regime that sought to distance itself from the coup d'état that had brought it to power. Symbols with broad popular appeal were needed to forge a new national identity. Having lost part of its use value as well as its insertion in everyday life, the old church was reduced to a largely representational status as a monument of national importance.

Haussmann, like the emperor, had a limited artistic armory. Yet his assault on the historic fabric had the backing of major figures and experts, in his day and before. Isolating architectural monuments from their surroundings had been a valued architectural tenet since the Renaissance. Leonardo argued that buildings should be detached on all sides so that their forms might be clearly revealed.[50] During the Enlightenment, Voltaire had called attention to the sorry state of the Louvre, "hidden by buildings by Goths and

FIG. 2.11. David Henry, Medieval half-timbered house on Rue François Miron, rebuilt in the seventeenth century.

Vandals," adding that it was necessary "to widen narrow, foul-smelling streets, disentangle landmarks that cannot be seen, and build others that can."[51] Before Haussmann took office, the Second Republic had voted in favor of freeing several important landmarks such as the Tuileries. "Works of art are not meant to be buried among amorphous hovels," wrote Henri Lecouturier in 1848; "they demand to be seen from all sides, admired from every angle; their true place is the midst of flat terrain, planted with superb trees."[52] The very Commission des Monuments Historiques cast a favorable eye on disengaging important buildings, which had the advantage of minimizing fire hazards.[53] Freeing public buildings from their surroundings to restore their monumentality had also been advocated by the Siméon committee.[54] Despite the gradual advances made in the theory and practice of historic preservation, the separation of the historic monuments from their passive surroundings continued to be practiced well into the twentieth century and was strongly advocated in Le Corbusier's *Charte d'Athènes* (1941).[55] If many practitioners paid allegiance to the aesthetics of *dégagement* in the nineteenth century, their ideological motivations differed. When Napoleon I claimed boastfully (echoing Voltaire) that to embellish Paris one had to "destroy more than build," his statement had to do with the sorry state of the old city.[56] After the 1848 revolution, disengaging public buildings had as much to do with security as with urbanism: not by chance did Haussmann place the city barracks in the very heart of the Cité, in front of Notre-Dame.

Only in more recent decades did preservationists come to realize that historic landmarks derive part of their meaning and aesthetic qualities from the manner in which they are inserted into the urban fabric.[57] And yet even during the Second Empire, a few voices spoke up on behalf of the architectural context. "One must not create a void around our cathedrals, so as to drown the magnificent dimensions given them by their authors," wrote Montalembert angrily. "They were not meant for the desert like the pyramids of Egypt, but to soar above the tightly knit buildings and narrow streets of our old cities."[58] Stéphane Gachet, another contemporary, recognized the value of the domestic architecture adjoining Notre-Dame, though he proposed to replace it with new buildings: "Private houses are no less important than public buildings [...]. They contribute powerfully to variety, movement, life. By making use of them as a foil to the works of art that all admire, we show respect for the originality and independence of each one, convinced that the picturesque aspect of their attitudes and physiognomy are crucial for the overall effect of similitude and illusion."[59] Haussmann himself was occasionally aware of the dangers inherent in detaching a building from its conjunctive tissue: "If a monument needs to be surrounded by just enough space to permit the spectator to take in the full view, it cannot have too much space either, as one can see in the École Militaire which seems to crawl on the ground, ever since the Emperor made me remove the planted hills that framed it on the Champ-de-Mars."[60]

PERIPATETIC LANDMARKS

While countless buildings were torn down, others were dismembered to conform to the rectilinear layout of new streets and squares. When the ancient church of Saint-Éloi was destroyed in the Cité, its eighteenth-century façade was transported to the Right Bank: Haussmann ordered Baltard to append it to the south side of Notre-Dame-des-Blancs-Manteaux, a medieval church rebuilt in the seventeenth century.[61] Baltard also sheared

FIG. 2.12. Saint-Leu-Saint-Gilles on the Boulevard de Sébastopol, after its protruding chapels were sheared, ca. 1900.

three chapels from the apse of the thirteenth-century church of Saint-Leu-Saint-Gilles on Rue Saint-Denis, because they protruded into the new Boulevard de Sébastopol (fig. 2.12). Saint-Laurent, built in the fifteenth century, had the opposite problem: to align it with the Boulevard de Strasbourg, Haussmann had an extra bay added to the nave and replaced the seventeenth-century classical façade with a neo-Gothic one, adding a steeple as compensation. And when the old church of Saint-Benoît-le-Bétourné—the badly oriented one because its apse faced west rather than east—was razed on the Left Bank in 1854, its western portal was transported to the Hôtel de Cluny.[62] Like his predecessors, Haussmann treated spolia as commodities that could be recycled.

Fountains were particularly prone to relocation. The fontaine de Médicis and the fontaine de Léda in the Luxembourg gardens, the fontaine des Innocents, and the fontaine du Palmier on the Right Bank were all moved and rebuilt with modifications.[63] Inevitably, their new settings impinged on their significance. The errant fontaine du Palmier in the Châtelet, originally commissioned by Napoleon Bonaparte, had been designed by François-Joseph Bralle (1806–8) with another context and scale in mind. No longer on axis with the recently finished Boulevard de Sébastopol, and one meter below the new roadbed, it was moved. On April 21, 1858, crowds gathered to watch as the twenty-four-ton fountain was carried across the square on rails, then hoisted above a plinth under the supervision of the engineer Jean-Charles-Adolphe Alphand and the municipal architect Gabriel Davioud—all in eighteen minutes (fig. 2.13).[64] Circulation, one of the main preoccupations of the age, had affected historic landmarks themselves, once thought to be safely site specific.

Itinerant monuments were nothing new. After the French Revolution, the famous fontaine des Innocents was rebuilt in a different location in Les Halles. The July Monarchy also dispersed and recycled parts of buildings. In 1837, when the old church of

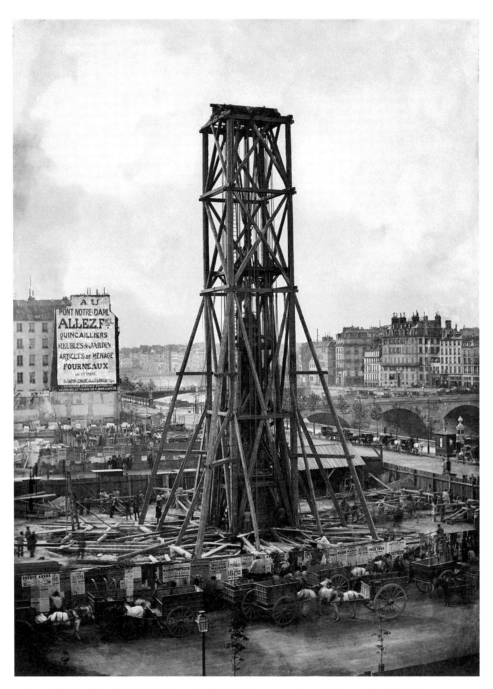

FIG. 2.13. Charles Marville, the fontaine du Palmier being moved on April 21, 1858. Bibliothèque historique de la Ville de Paris.

Saint-Pierre-aux-Boeufs was pulled down in the Cité, the architect Jean-Baptiste Lassus (who later restored Notre-Dame with the help of Viollet-le-Duc) grafted one of its portals onto Saint-Séverin, a beautiful Gothic church on the Left Bank.[65] Even worse was the Orléans dynasty's colonial policy in Algeria, which did not limit itself to moving monuments locally but attempted to carry them off altogether. "I ask that the triumphal Arch of Djemila, the most complete of the Roman monuments that we visited in Africa, be dismantled stone by stone and transported to Paris, as a consecration and trophy of our conquest of Algeria," wrote the Duke d'Orléans to his father, Louis-Philippe.[66] In the event, the arch remained in place; it was the dynasty that moved when it was overthrown and forced into exile in 1848.

HAUSSMANNIZATION BEFORE HAUSSMANN

Ever since the days of Louis-Philippe, the citizen-king, Parisians had wept over the destruction of the historic center. Victor Hugo's fiery pamphlet *Guerre aux démolisseurs* (*War on the Vandals*) circulated widely and pointed its biting sarcasm at those he held responsible for the scandalous treatment of the city's architectural heritage. "Vandalism practices architecture," he thundered.

> Every day, it razes part of the little that remains of this admirable old Paris [. . .].
> Vandalism whitewashed Notre Dame, retouched the towers of the Palais-de-
> Justice, vandalism razed Saint-Magloire, destroyed the cloisters of the Jacobins,
> amputated two of the three spires of Saint-Germain-des-Prés [. . .]. Vandalism
> has the support of the bourgeoisie. It is well fed, richly provided for, bloated with
> pride, almost knowledgeable, extremely classic, good in logic, strong in theory,
> joyous, powerful, affable when necessary, well spoken, and pleased with itself. It
> has something of the Maecenas. It protects young talent. A professor, it awards
> architectural *grands prix* [. . .]. It belongs to the Institute, frequents the court.[67]

Hugo's philippics against the educated vandals of the July Monarchy may seem more applicable to those of the Second Empire, but he had ample reason for his fears. The flurry of transformations that marked the reign of Louis-Philippe prompted the appearance of several proposals calling for the erasure of vast parts of the city. Most of the twenty churches that surrounded the cathedral had already been torn down by the French Revolution, the First Empire, and the Restoration.[68] The July Monarchy followed suit. Writing in the early 1840s, Perreymond proposed the demolition of numerous streets in the historic core, in Île Saint-Louis, and almost the entire fabric of Île de la Cité. In this respect, he appears less as a precursor of Haussmann's form of urban renewal than of Le Corbusier's Plan Voisin.[69] No less radical, other Saint-Simonians advocated the destruction of all slums in the congested urban core, and the transformation of large parts of the Île de la Cité into a park.[70] In 1765, Pierre Patte had suggested razing the whole island, except for Notre-Dame and Boffrand's eighteenth-century Hospice des Enfants-Trouvés.[71] Meynadier, usually so sensitive when it came to historic buildings, proposed the demolition of Boffrand's Enfants-Trouvés to show Notre-Dame to best advantage: "To destroy a monument still teeming with life is tantamount to vandalism, to severing a link in the monumental chain;

it constitutes an attack on all principles of conservation. So be it . . . , just this once, let us be vandals: there is no rule without exception."[72]

Alarmed at the deterioration of the historic kernel and its explosive political potential, the short-lived Second Republic rekindled these sweeping projects, giving them even broader scope. The tangled mass of old streets had to make way for the smooth-functioning machinery of the modern metropolis. In *Paris incompatible avec la république*, Lecouturier advocated razing a huge part of the center; it would then "cease to be a maze of dark, festering alleyways, to transform itself, lit by sunlight, into a place of leisure, embellished with all the riches of agriculture and luxuriant vegetation."[73] Haussmann's iconoclasm and the vast scale of his interventions were thus heir to a long tradition of urban planning and municipal slum clearance: he listened to the Saint-Simonians all too well. His remorseless destruction of historic buildings and of natural features accelerated a process that was well under way before his tenure, both in practice and in print, and would continue after he left office.

Architects also plundered the past like a commodity. When the Commission des Monuments Historiques complained to Joseph-Louis Duc that the remarkable arcade and two façades of Saint-Jean-de-Jérusalem, a Renaissance gem, were to be sacrificed to the headquarters of the police, the architect offered to use the remains "as a veneer on some of the new buildings."[74] Duc also demolished part of the lovely Place Dauphine to give greater visibility to a new wing of his Palais de Justice. After Haussmann's fall, the Third Republic destroyed innumerable historical buildings, and architectural fragments continued their wanderings as the city expanded. Half a century later, Le Corbusier, that latter-day Saint-Simonian, would propose a radical reconfiguration of the city save for a smattering of old landmarks: "The 'Voisin' plan shows, still standing among the masses of foliage of the new parks, certain historical monuments, arcades, doorways, carefully preserved because they are pages out of history or works of art."[75]

Many voices spoke up in favor of Haussmann's slash-and-burn interventionism. Exiles and opponents of the regime such as Hugo might well extol the beauties of the *vieux Paris*, but many intellectuals, shocked by the squalor of fetid streets and leprous tenements, favored the isolation of old monuments.[76] "Civilization," wrote Gautier, "needs air, sunlight, space for its frenetic activity and perpetual motion, and carves broad avenues out of the dark mass of alleys, crossroads, and culs-de-sac of the old city; it cuts down houses as the American pioneer chops trees."[77] César Daly, who in 1864 dedicated his three-volume work on domestic architecture to Haussmann, also gave unqualified support to the prefect's aesthetic policies:

> I have seen a few old reminiscences of our history disappear in this colossal
> reorganization of Paris; as artist and archaeologist, I felt misgivings all too easy
> to understand; but as a citizen, I acknowledged the rationale and consoled myself
> with the thought that memory and tradition yielded only to the legitimate and
> necessary advancement of life and progress. I applauded the destruction of
> unhealthy districts when I beheld elegant squares open to the public take the place
> of disgraceful crossroads, and sunlight percolate to levels that for centuries had
> seen nothing but shade and humidity; I rejoiced at the sight of broad boulevards
> crossing the city from one end to another, connecting among themselves the rail
> ways and imperial routes that link Paris to the provinces and to Europe.[78]

Liberals themselves applauded: "to sanitize is to moralize," wrote the bohemian Alexandre Privat d'Anglemont, well known for his sympathies toward the poor.[79] Even Louis Réau, who published the first comprehensive history of vandalism in Paris in 1959, extolled the prefect's achievement in glowing terms, perpetuating the mythic connection between housing and pandemics: "By razing innumerable hovels, digging sewers, broadening streets, providing green space, he has aired and sanitized the old mephitic Paris of the Middle Ages, hotbed of the plague and later, in Romantic times, of cholera."[80]

If Haussmann was the capital's *mastro ruinante*, he had a long and distinguished ancestry. Assuredly, one cannot judge the prefect with the beliefs of another age. For good and for ill, he left a modern city equipped with boulevards and streets that can more or less cope with the automobiles he could not have foreseen. But his inelastic approach needlessly condemned a sizeable portion of the city's architectural heritage that he destroyed to a greater extent than either his predecessors or his successors. Haussmann was all nouns; nuance was virtually unknown to him. In his iconoclastic zeal, he revealed himself as the unwitting and unlikely heir of the Jacobins.

Although Haussmann's spatial practices were clearly in keeping with the architectural culture of his day, demolitions seem to have given him enormous pleasure. As he said of the Place du Carrousel near the Louvre: "It gave me great satisfaction to raze all that during my beginnings in Paris."[81] In the Cité, which he knew since childhood, he wrote that he "had the joy" of leveling the maze of taverns, "those haunts of thieves and murderers."[82] And in the opening pages of his memoirs, he describes himself with characteristic aplomb as an "artiste démolisseur."[83] Old photographs of the time show entire blocks torn down by his orders in the Île de la Cité, Les Halles, and the Châtelet, as if they had been razed by fire.[84] This, of course, was exactly what Voltaire had recommended: "If half of Paris burned, we would rebuild it superbly and conveniently."[85] Voltaire ended his article on the embellishments of Paris with a plea to Providence: "Heaven grant that a man be found, devoted enough to undertake such projects, endowed with willpower to follow them through, sufficiently enlightened to formulate them, and with the requisite credentials to carry them to fruition."[86] Partisans and opponents of Haussmann alike saw the prefect as the man who fulfilled Voltaire's prophecy.[87]

HISTORIC PRESERVATION

Cities like Paris undergoing urban change under pressure from industrial capitalism lacked the critical arsenal that would have enabled principled forms of preservation. The concept of the historic center—as opposed to the single monument—was itself a modern creation, the fruit of new forms of urbanism.[88] The transformation of the city into a metropolis, bankrolled by the fruits of the Industrial Revolution, entailed a centripetal accumulation of capital, merchandise, and cultural and retail buildings, coupled with centrifugal forces that shunted to the outskirts those who could not afford new or upgraded housing or failed to find room in the old buildings still extant in the center. It was precisely the appearance of the periphery, that obverse of the center—often amorphous, sometimes dystopic—that gave value to the preindustrial past embodied in the old historic core.[89]

Historic preservation was still in its infancy. In France, as elsewhere, it went neatly hand in hand with destruction. Loss constitutes a powerful impetus to safeguard what

survives. Only after the iconoclastic fury of the Jacobins during the French Revolution did the idea of a national patrimony begin to emerge.[90] In 1830, François Guizot instituted the post of *inspecteur général des monuments historiques* with the aim of producing an inventory of the nation's most important architectural landmarks in danger of being destroyed by design or by neglect. Ludovic Vitet, the first inspector general, was followed in 1834 by Viollet-le-Duc's friend Prosper Mérimée, who, lacking funds, had to resign himself between choosing "the monuments that one must abandon, [and] those one must try to save."[91] Like the Commission des Monuments Historiques, founded in 1837, Mérimée's priority was to save major landmarks threatened by imminent ruin. Concern for the vernacular—for urbanism as opposed to architecture—came much later.

Disregard for historic landmarks often had the backing of major specialists. When an omnibus company discovered the remains of an old Gallo-Roman amphitheater on the Left Bank, Haussmann dismissed them as unimportant and had the area cleared despite vehement protests from the city's archaeologist, Théodore Vacquer. Haussmann was backed by the emperor, who visited the site in person, by Viollet-le-Duc, and by members of the Commission des Monuments Historiques. These particular ruins, they felt, were not grand enough to add luster the city or the empire. After the demise of the empire, an irate Victor Hugo returned to France and demanded that the archaeological site be preserved.[92] Today, only a pastiche survives, hastily cobbled together, after it was partly destroyed in 1870.[93]

For Haussmann, a faithful copy was sufficient to preserve the "essence" of an architectural monument. The Second Empire, he observed proudly, had reconstructed the gallery of Henri II in the Louvre by using extant carvings to create new molds that reproduced the old forms, a practice known today as anastylosis: "I admit that the stones that make up the new façade are no longer those of the days of Henri II; nonetheless, the architect's conception has been faithfully preserved and can be transmitted to future generations: in artistic matters, this is crucial. What is important is not the material aspect but the expression of the author's intention."[94] For the prefect and many of his peers, the issue of authenticity had to do exclusively with appearance rather than the thing-in-itself. Simulacra did the job just as well. Haussmann's bowdlerized buildings seem almost like a paraphrase of Viollet-le-Duc's notorious formula: "To restore a building is not to maintain, repair, or rebuild it; it is to give it a state of completeness that may never have existed at any given moment."[95]

Long before Alois Riegl's pathbreaking article on the cult of the historical monument came out in 1903, a celebration of *Alterswert* (age value) had already been articulated by John Ruskin, who ascribed aesthetic worth to the weather-stained patina bestowed by the passing ages.[96] In contrast to Haussmann or Viollet-le-Duc, who strove to return buildings to society, shorn of the aleatory accretions of time, Ruskin resigned himself to the mortality of artifacts; it was the gradual dispossession of the original form that he admired, slowly unraveled by the hand of time. "For, indeed, the greatest glory of a building is not in its stones, nor in its gold," he wrote in 1849. "Its glory is in its Age, and in that deep sense of voicefulness, of stern watching, of mysterious sympathy, nay, even of approval or condemnation, which we feel in walls that have long been washed by the passing waves of humanity."[97] Haussmann lacked this empathy with the world of things and once confessed to Achille Fould, minister of the imperial household (Bâtiments civils) and of the Beaux-Arts, that he did not subscribe to the cult of old stones for their own sake.[98] Not for

him or his peers the irregular profiles of disparate buildings packed in tight contiguity, the sediment of centuries past. A serviceable digest sufficed, pruned of politically unwanted souvenirs that could not be pressed into the service of imperial genealogies or the spectacle of power.

On occasion, the prefect actually intervened on behalf of landmarks threatened by urban renovation. When Fould asked him to raze the old church of Saint-Germain-l'Auxerrois in order to create a square in front of the east façade of the Louvre, Haussmann refused. Descending from an old Huguenot family, he persuaded Fould, a Jewish convert to Protestantism, that they would both be accused of trying to take revenge for the massacre of Saint Bartholomew of 1572 under Charles IX.[99] According to tradition, it was the bell of Saint-Germain-l'Auxerrois that gave the signal for the attack against the French Protestants. Haussmann also tried, unsuccessfully in this case, to prevent Jacques Ignace Hittorff from altering Ange-Jacques Gabriel's original design for the Place de la Concorde (though moving the obelisk!), but Napoleon III overruled him and had the square transformed to improve circulation.[100]

Haussmann's most important battle on behalf of preservation—and his most resounding defeat—came in 1883, when the Third Republic tore down the Tuileries after the palace burned during the Commune.[101] Although the vaults had caved in, Philibert De l'Orme's façades and parts of the interior survived, including Pierre Fontaine's beautiful stairway (fig. 2.14). Hubris had not made Haussmann less truculent: "The lower galleries, those of the ground floor, both on the side of the garden and on the side of the court, are priceless masterpieces of French Renaissance architecture. And this is precisely what you wish to destroy forever!"[102] But the former prefect no longer had any leverage: "You ruined the Luxembourg!" shot back deputy Georges Clemenceau.[103] Bourgeois democracy had learned the lessons of Haussmann's symbolic geography and erased from the map of Paris that uncomfortable emblem of the Second Empire.[104] Preservation, whether of landmarks or memories, rarely comes about naturally. Survival of the past is usually the endgame of a political or economic struggle.

Battles to save or condemn historical landmarks were always overshadowed by the complex question of the construction and representation of the historical past. Like the vandals of the July Monarchy pilloried by Hugo, those of the Second Empire loved to show off their historic credentials according to the empire's carefully curated past. Napoleon III was interested in preservation for reasons that were neither entirely artistic nor exclusively political. France's illustrious monuments could add prestige to his dynasty of such recent vintage. To protect historical remains, he created the National Museum of Antiquities in Saint-Germain-en-Laye, devoted to Celtic and Gallo-Roman finds; commissioned the catalogue of the Bibliothèque impériale (now the Bibliothèque nationale); encouraged archaeological digs and gave generous subsidies to historical publications.[105] His two-volume *Life of Julius Caesar* (1865–66), produced with considerable help from specialists and laced with political propaganda, nevertheless made some contributions to scholarship.[106] Haussmann likewise helped fund historical research lavishly and established several institutions dedicated to preserving the city's cultural heritage, such as the Commission municipale des travaux historiques (1862–63). In 1866, the first volume of the *Histoire générale de Paris* appeared over his signature as editor—Adolphe Berty's *Topographie historique du vieux Paris*—which recorded all buildings of historical importance, district by district.[107]

FIG. 2.14. Alphonse Liébert, the grand staircase of the Tuileries by Pierre Fontaine after the palace burned during the Commune in 1871. Bibliothèque historique de la Ville de Paris.

One of Haussmann's major interventions in cultural management was the creation of the museum of the city of Paris. In 1866, he purchased the Hôtel Carnavalet in the Marais to house the city's historical remains—which increased greatly after the beginning of the grands travaux. Stung by the relentless hostility shown by many critics to his destruction of heritage, he exclaimed with exasperation: "But, my good people, you who seem to have seen nothing at all, blinkered by your libraries, can you cite a single ancient monument worthy of interest, a building precious for its art, singular for its memories, that my administration has destroyed?" Have you forgotten, he adds, "the acquisition of the Hôtel Carnavalet which I ordered so as to preserve it and create from scratch a museum of the history of Paris?"[108] In fact, the idea of saving the Carnavalet was decided before Haussmann. In 1845, the Commission des Monuments Historiques informed Rambuteau, then prefect of the Seine, that the building had been classified as a landmark, enjoining him "to adopt measures to ensure its conservation by assigning it a new use."[109] At Haussmann's departure from office, restoration of the Carnavalet had not yet been completed, and part of the museum's collection, stored temporarily in the Hôtel de Ville, burned during the Commune. Like many of his contemporaries, though for different reasons, Haussmann wanted to document what was being wiped out, commissioning Charles Marville (pseudonym of Charles-François Bossu) to photograph streets slated for destruction (see fig. 2.9). This concern too preceded the prefect. In 1851, the conservator of the plan of Paris, Eugène Deschamps, asked Davioud to draw, house by house, all buildings condemned by the impending construction of Baltard's new market pavilions in Les Halles. Alluding to this earlier work, Haussmann asked Davioud to draw the 250 houses that were about to disappear in the prolongation of the Rue de Rivoli.[110] Like the museum, the archive too is rooted in destruction.

Haussmann's interest in building collections for the state came precisely from the inescapable fact that he destroyed so much of the capital's architectural heritage. A member of the prestigious Académie des Beaux-Arts, where he took the seat left vacant by Fould, Haussmann was eager to adorn himself with the nimbus of arts and letters. His writings reveal a certain knowledge of history or of those aspects that came pat to his purpose. Self-interest undoubtedly played a role as well: Haussmann's cultural initiatives were also used to launder his baneful practices that wiped out landmarks of art-historical significance. This obsession with making history visible, however, also reflected a broad shift in the ways it was understood and represented, and the broadening of the public beyond a narrow circle of specialists. Whether in the guise of books, museums, or newly isolated landmarks, history had to be readied and packaged for consumption by the masses.[111]

In some cases, Haussmann's destructions were motivated by politics, partly because he saw himself as the "éditeur responsable" of his master's oeuvre.[112] The ambiguous term can refer either to the publisher who makes visible the work of others, or to the editor who intervenes to improve the text. Haussmann was both. He emended Paris as if it were a manuscript, interpolating passages that best served the ends of the regime while erasing others that could not be harnessed to partisan ends. As the expurgated version of the Cité reveals, Haussmann's urban dramaturgy was aimed at highlighting Paris as a showcase for the Second Empire: buildings representing state, church, and law were given great prominence as focal points, a task facilitated by slum clearance. Symbols of the Republic,

FIG. 2.15. Honoré Daumier, *The Massacre at Rue Transnonain*, 1834.
Lithograph. Bibliothèque nationale de France, Paris.

including its motto, *liberté, égalité, fraternité*, were erased from pediments. To stage the
spectacle of power, Haussmann paid particular attention to monuments dear to the Napo-
leonic legend, such as the Madeleine and the Arc de Triomphe. These were inserted into
spatial itineraries according to a carefully scripted scenography that constituted a form of
narrative. Conversely, places pregnant with popular history were sometimes unceremoni-
ously expunged from the map as if they had never existed.

Such was the fate of Rue Transnonain near Les Halles, site of an infamous massacre
memorialized by Daumier that took place during the insurrection of 1834, which was sup-
pressed with ferocity by General Thomas Robert Bugeaud (fig. 2.15). Situated in one of
the oldest and most populous parts of the city, decimated by cholera, and associated with
social revolution, this landmark of the laboring classes was condemned on both urbanistic
and political grounds. "It was the evisceration of Old Paris," wrote Haussmann proudly
in his memoirs, "of the district of uprisings and barricades, by means of a wide central
artery, piercing from one end to the other, this almost intractable labyrinth."[113] Not even
a partial footprint remained, as in the case of the Bastille. Like other landmarks freighted
with unwanted mnemonic baggage, Rue Transnonain became part of the city's "repressed
topographies."[114]

A similar fate awaited the Canal Saint-Martin. A symbol of working-class resistance,
it slashed through the eastern part of the city, home largely to the laboring classes and
artisans. During the revolution of 1848, workers managed to hold up the troops of General
Louis-Eugène Cavaignac (fig. 2.16). Cavaignac had cut his teeth in Algeria, where he had
served under governor-general Bugeaud, before becoming governor of the colony himself.
Before Cavaignac managed to crush the uprising, his soldiers could not hoist their cannons
up the footbridges that spanned the canal. Seeing the waterway as a serious obstacle to
circulation and security, Haussmann asked the engineer Eugène Belgrand to lower its bed,
covering part of it with the Boulevard de la Reine Hortense (fig. 2.17). This new boulevard,
Haussmann wrote, "was meant to replace the means of defense that the canal offered
to the insurgents, with a new road of access in the habitual center of their uprisings."[115]

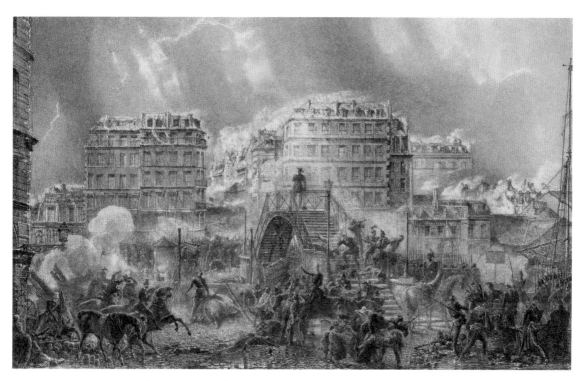

FIG. 2.16. François Bonhommé, General Louis-Eugène Cavaignac's troops held up by workers on the canal Saint-Martin, June 23, 1848. Lithograph. Bibliothèque nationale de France, Paris.

Napoleon III was enthusiastic: Haussmann had assured him that if necessary, one could now "take the entire Faubourg Saint-Antoine from the rear."[116] A levee to stem the tide of workers coming from the east, the canal disgorges discreetly in one of the old moats of the Bastille, the bassin de l'Arsenal. Embellished with Alphand's gardens and fountains, the boulevard that covers it became a place of promenade, a splendid screen memory that did the bourgeoisie proud (fig. 2.18).[117]

Urban issues, however, are rarely susceptible to monocausal explanations. Like other circulation routes, the canal affected the needs of local inhabitants, who complained that it blocked traffic for long periods of time when boats went through the locks. Even Lazare praised the canal in a book highly critical of the prefect, writing that it had been a "barrier to circulation during the day and a danger at night, owing to the length of its two ever-deserted banks. The Canal Saint-Martin is now vaulted; a magnificent boulevard, embellished with the name of a great industrialist, Richard-Lenoir, covers it felicitously."[118] Workers themselves were aware of the boulevard's ambivalent connotations: a symbol of class confrontation, it functioned as both barrier and link to the city's historic core, and as a locus of memory as well as countermemory. Haussmann received over thirty thousand depositions in favor of his intervention, coming largely from workers, and five hundred negative ones from businessmen indifferent, he claimed, to the advantages that his improvement offered the population.[119]

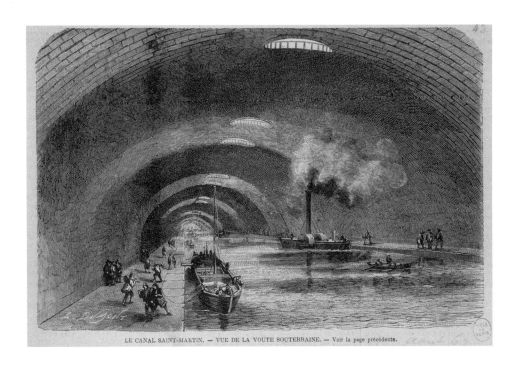

LE CANAL SAINT-MARTIN. — VUE DE LA VOUTE SOUTERRAINE. — Voir la page précédente.

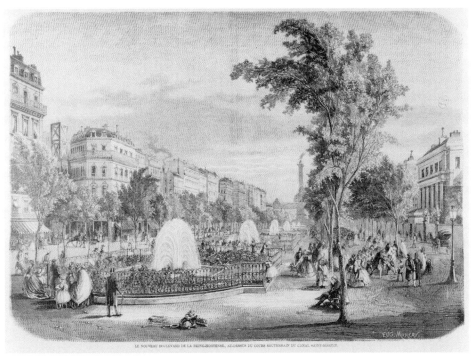

LE NOUVEAU BOULEVARD DE LA REINE-HORTENSE, AU-DESSUS DU COURS SOUTERRAIN DU CANAL SAINT-MARTIN.

FIG. 2.17. The canal Saint-Martin underground. *L'Illustration*, August 23, 1862. Bibliothèque nationale de France, Paris.

FIG. 2.18. Eugène Moreau, the new Boulevard de la Reine Hortense above the canal Saint-Martin, embellished with gardens and fountains. Woodcut. Musée Carnavalet.

THE CROOKED STRAIGHT AND THE ROUGH PLACES PLAIN

Both history and natural history played a major role in the present configuration of Paris. Its topography was partly the result of a long process of adapting nature to the population's evolving social and economic needs. Over the centuries, the city had grown slowly from a tiny archipelago situated on a strategic bend of the river. At the beginning of the Common Era, when commerce across Europe depended on fragile wooden bridges, the tiny islands made an ideal crossing point. During the Middle Ages, trade routes led from the Right Bank to the wealthy counties of what are now Belgium and Germany. Later still, the Seine connected Paris to important northern ports like Le Havre or Rouen further downstream, while the Marne linked it to rich farmlands to the east. On the Left Bank, a distant but powerful Rome could be reached by roads leading south. Geology, hydrology, and other natural constraints affected the expansion of the growing colony of the Parisii. When winter rains flooded the islands every winter, anxious citizens worked feverishly to raise the level of the ground. On the Right Bank, streams flowing down from the steep hills of Montmartre and Belleville were captured and channeled by the thirsty residents in the valley below. Ports along the river received wheat, wine, and merchandise from other parts of France.

Over the centuries, and thanks to a great deal of labor, the islands clustered around the Cité were knit into two, their prows smoothed and streamlined by the rushing waters: Île de la Cité and Île Saint-Louis. The former did not acquire its present form until the sixteenth century, when three eyots—the names varied over the years—were incorporated into the western tip of the Île du Palais: Île aux Juifs, Île aux Treilles, and Île Gourdaine, where the statue of Henri IV stands.[120] The tip of the island, the Square du Vert Galant, still preserves the low-lying level of the original islands, almost flush with the water. Île Saint-Louis received its current shape in the seventeenth century, when Louis XIV gave permission to build on the island. This required welding the Île aux Vaches to the east and Île Notre-Dame, property of the chapter of the cathedral. Further upstream, Île Louviers, once used to store wood, disappeared in 1843, when the narrow branch of the Seine separating it from the Right Bank was filled (fig. 2.19). The suture between the island and the Right Bank, now covered by the Avenue Morland, is visible on any city map. Downstream, the Île des Cygnes (or Île Maquerelle) itself made up of several eyots, was incorporated to the Left Bank in the eighteenth century.[121]

In the past, all man-made transformations of the city's topography had taken place gradually, with the aid of pick and shovel. Change was naturalized, its shocks absorbed over time. Steam upset the slow pace of transformations implemented by human hand. Large-scale construction sites now made use of railroads to facilitate earth removal. The magnitude of the Second Empire's urban interventions and even those of the July Monarchy, and the speed with which they were carried out, drove home inexorably the machine-made aspect of the city. Parisians no longer saw their capital as beholden to the benign and redemptive realm of nature, nor to the divine order of things. "Was it God who made Paris,—or was it man?" asked Considerant.[122] The question was not altogether rhetorical and betrays the anxieties provoked by the overwhelming changes to the city's configuration. Old Paris—handmade Paris, with its own forms of passive destruction—gave way to its industrialized counterpart, where hills were removed by the power of steam and rail. In 1867, when foreigners flocked to Paris for the World's Fair, Théodore de Banville

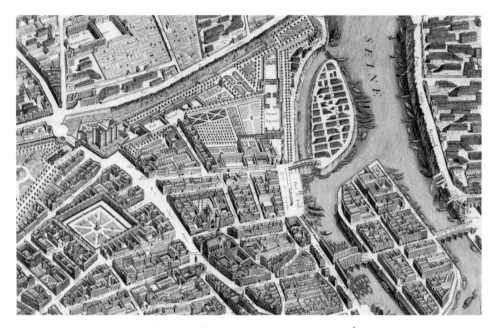

FIG. 2.19. Louis Bretez, detail of the plan of Paris commissioned by Michel-Étienne Turgot, engraved by Claude Lucas, 1739. To the right, the Île Saint-Louis; above it, the Île Louviers. Bibliothèque nationale de France, Paris.

reminisced about the good old days of the Quartier Latin, when "streets did not yet outrage mountains" but respected the lay of the land by making use of sinuous curves when necessary.[123] This docile acceptance of nature was precisely what midcentury economics opposed: expenditure of time and money in order to negotiate the winding path, occasional hill, or the clutter of crooked houses.[124]

With the help of modern technologies, knolls were eliminated, streets and bridges leveled, river beds lowered or covered. Boulevards had to be not only straight but level, and municipal engineers flattened the ground in the center of the city. The emperor's plans required this, and Berger had fallen from grace in part because he had not foreseen the need to lower a huge area on the Right Bank. Here too, the July Monarchy had preceded the Second Empire. Rambuteau dutifully eliminated the convexities of the terrain before embarking on new streets, sometimes removing up to two meters of earth to regrade his thoroughfares, along with the vestigial traces of underlying ramparts.[125] *Horizontalité*, a prerequisite of speed, was an important concern of the Saint-Simonians, for whom hills and natural relief obstructed circulation.[126] Haussmann cannot possibly have decided what to raze and what to spare entirely on his own. His infrastructure involved overlapping networks of streets, water supply, sewerage, and greenery, which were all being executed at the same time. Hundreds of decisions had to be made daily, and the prefect relied on the expertise of his corps of engineers to identify problems and suggest solutions.

On the Right Bank, the area most extensively affected by urban change, the prolongation of the Rue de Rivoli entailed flattening the entire district of Arcis because of its uneven grade. All intersecting streets and bridges had to be readjusted to conform to the width and pavement level of the new roadways. Bridges, periodically destroyed by fire

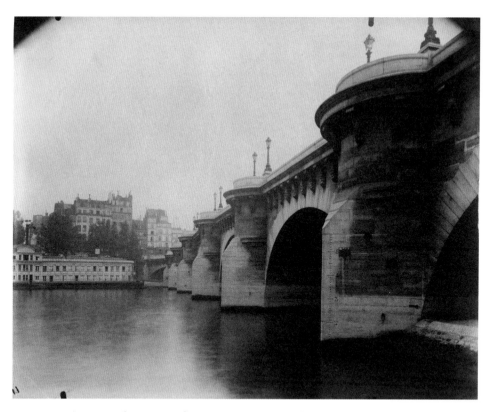

FIG. 2.20. Eugène Atget, the Pont Neuf, ca. 1900. Musée Carnavalet, Paris.

and water, had always been subject to rebuilding, though never so systematically. Rebuilt with fewer arches to enhance navigation, they also required stronger material to sustain increased traffic flow.[127] In 1854, the completion of the Boulevard de Sébastopol required the demolition of the oldest bridge of the capital, the Pont au Change, reconstructed on a slightly different axis. Pont Notre-Dame had to be brought in line with the old Rue Saint-Martin, whose carriageway had been lowered. Only Pont Neuf, the oldest surviving bridge in Paris, escaped this fate, though just before Haussmann took office it lost the little shops that Jacques-Germain Soufflot had designed to crown its piles (fig. 2.20).[128] "Have you by any chance seen the Pont Neuf as they are rebuilding it?" wrote Delacroix in his diary in 1852. "It will be truly worthy of its name, no longer having any connection with the old one, the one we have always seen and known so well that we used to say: *as familiar as the Pont Neuf.* It will be necessary to delete this proverb, along with so many illusions."[129]

Since Gallo-Roman times, low-lying areas, prone to flooding and constant erosion by water, had required extensive landfills. Signs of this kind of intervention are visible all over Paris. In the eighteenth century, Patte noted with alarm that in the past one climbed several steps to reach the square of Notre-Dame, which in his day was sunk below grade.[130] As the level of the Seine rose because of collapsed bridges and embankments, Haussmann's engineers had to raise the ground of the Cité by several meters to make it flush with the new streets on both sides of the river.[131] Ironically, one of the most visible changes to Parisian topography under Napoleon III had little to do with Haussmann. In 1866, the organizers

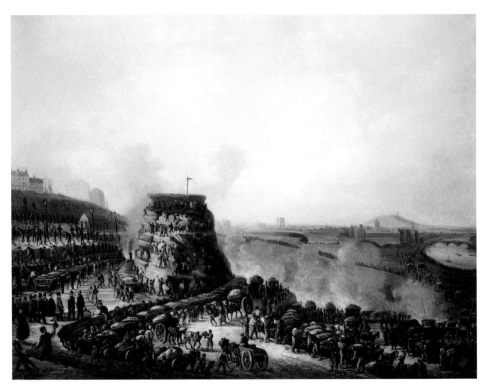

FIG. 2.21. Louis Moulin, *Visit of the Emperor and Empress to the Construction Site of Chaillot When the Hill Was Being Levelled*, February 24, 1867. Oil on canvas, 35 × 45 in. (89 × 116 cm). Musée Carnavalet, Paris.

of the universal exposition to be held in the Field of Mars realized that the uneven heights of the Trocadéro across the river offered an ungainly sight. The prefect was ordered to crop the butte of Chaillot by fifteen meters. This he did in a record time of three months, using land mines and a special railway to cart away the debris that was used to raise the low level of the Left Bank directly opposite (fig. 2.21). When the population turned out to see the explosion of over fifteen hundred mines, a caricaturist quipped: "The French capture the Trocadéro for the second time."[132] Haussmann's ubiquitous and cumbersome earthworks must have sorely tried the patience of its citizens. Older buildings sometimes found themselves dangling precariously above grade in the shifting topography of the new Paris (fig. 2.22). For years one side of Avenue Victor Hugo (then called Charles X), towered eight meters above the other.[133]

Haussmann's aggressive transformations of the city's topography met with less opposition than did the elimination of historic landmarks. Although an irate academician thundered against "the severed mountains and leveling of the entire city by this fanatic destroyer," popular response depended on what was being razed.[134] When the infamous hill known as La Petite Pologne was wiped out so Haussmann could build the Boulevard Malesherbes, only its impoverished residents seem to have protested, even though it had been vividly described by Balzac in *La Cousine Bette* and Eugène Sue in *Les Mystères de Paris*. Areas with historic associations were another matter. In the case of the Butte des Moulins, slated for destruction to make way for the Avenue de l'Opéra, the journalist Gustave Nast

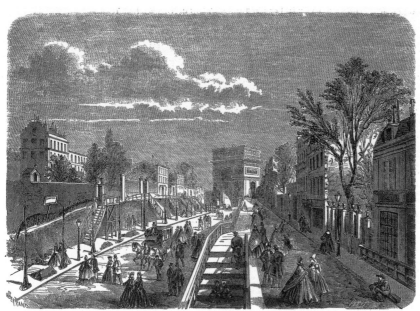

État actuel de la nouvelle avenue de Saint-Cloud reliant la barrière de l'Étoile au rond-point de Passy.

FIG. 2.22. The Avenue de Saint-Cloud, showing the temporary stairways built to connect the street, which had been lowered, to the houses on either side, 1864. *Le Monde illustré*, April 23, 1864. Bibliothèque nationale de France, Paris.

protested angrily that it was from that little knoll that Joan of Arc launched her unsuccessful assault against the English.[135] Nostalgic complaints of this sort overlooked the fact that the hillock, like some of the city's other mounds, was originally a rubbish dump situated outside city walls.[136]

Earthworks were sometimes faulted on aesthetic grounds. Topographic quirks helped give different neighborhoods their distinctive look and atmosphere. On the heights of Montmartre and Belleville, streets curled around natural obstacles creating picturesque perspectives. Architects often made use of different angles and inflections to offset their buildings.[137] Skillfully exploited, accidents of the terrain could add variety and contrast to the urban landscape. But modernity required facilitating circulation, and the Second Empire imbued Paris with new urban surfaces that responded to the nascent needs of an increasingly mobile society, even if they were short on the singularities that characterized the old city and its proven capacity for place making. "Paris will soon be a large phalanstery in which all asperities, all angles and all relief will have disappeared, homogenized and flattened to a single plane," wrote Victor Fournel reproachfully. "Instead of all these villages with their varied and pronounced physiognomies, there will be nothing but a new white city."[138] Capitalism had little use for discrete enclaves and hermetically sealed neighborhoods, preferring a uniform fabric in which the parts were connected to one another by networks of modern streets and boulevards.

And yet the unexecuted projects of the previous regimes would have surpassed in destructiveness the earthworks actually carried out by the Second Empire. Between 1840 and 1853, thirteen architects called for extensive topographic changes that would alter

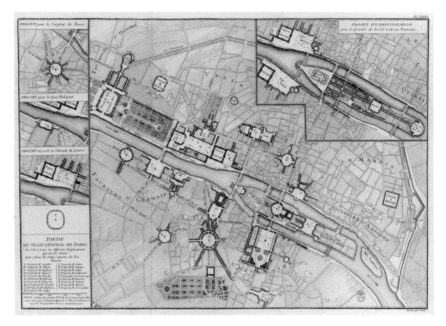

FIG. 2.23. Pierre Patte, plan of Paris showing Île de la Cité and Île Saint-Louis welded into one, 1765. Photo: Bibliothèque nationale de France, Paris.

Paris's beautiful waterfront significantly.[139] Patte's famous proposal of 1765, linking the Île de la Cité to the Île Saint-Louis, continued to resonate throughout the nineteenth century, a project not by accident sketched by Le Corbusier (fig. 2.23).[140] So did Patte's plan to close the small arm of the Seine between the Quai des Grands-Augustins and the Quai des Orfèvres, which was no longer navigable during part of the year.[141] Perreymond went further, suggesting that the left arm of the Seine be sacrificed altogether, so that the river could be contained within a single channel.[142] He also proposed that all the capital's stone bridges between Pont d'Austerlitz and the Pont des Arts, be destroyed and replaced by new ones with a free span. Although none of Perreymond's plans were carried out, his ideas, published in César Daly's influential *Revue générale de l'architecture*, of Saint-Simonian and Fourierist derivation, contributed to the climate of euphoria and faith in progress ushered in by industry and a booming economy.[143] Utopia, observed a modern-day commentator, "is a vandal."[144]

Except for the heights of Chaillot, scholars have neither analyzed the topographical features destroyed during the Second Empire nor acknowledged the importance of the voids erased by the regime. Time etched its marks deeply into the layout of the city. In the oldest districts, the configuration of lots often went back to patterns of land subdivision dating to the Middle Ages, tenacious testimonies of duration.[145] Traces of the past lingered in the curious meander of an alley or odd-shaped street. Winding arabesques of the urban tissue recorded ancient routes or footpaths; others, lost in the shroud of time, recalled flocks seeking the river or the seasonal migration of livestock. It was only in the twentieth century that historians and preservationists called attention to the aesthetic and historic aspects of the empty spaces shaped by streets and squares, which were equally worthy

of preservation. Camillo Sitte, Gustavo Giovannoni, and more recently, Françoise Choay, have emphasized the significance not only of monuments and their historic context, but also of urban voids. There are no nonsignifying spaces in the city, observed Choay.[146]

Toponyms suffered an equally irreversible blow. As streets disappeared, swallowed up by the great maw of redevelopment, so too did their names, memorializing historical events. Haussmann noted the designation of several vanished alleyways that he considered "appalling cloaca": Rue Jean-Pain-Mollet, des Mauvaises-Paroles, du Chevalier-du-Guet, de la Tuerie.[147] With their colorful nomenclature, so vividly evocative of everyday life, the events and actions they alluded to had long since passed into oblivion. For many, Haussmann's tabula rasa threatened to disrupt the temporal chain that linked inhabitants to the enduring fabric of associations. So eager were the municipal officials to do away with old streets, wrote Fournel acidly, that they believed it "necessary to unbaptize them (*débaptiser*), and so remove from Paris this last Gothic and rancid aroma that so offends their olfactory sense."[148] Some street names were indeed old: the Rue de la Juiverie, renamed Rue de la Cité in 1834, attests to a strong Jewish presence in the city, while Rue de la Tannerie (tanners), de la Vannerie (basketry), des Teinturiers (dyers), des Fourreurs (furriers) recall the trades once carried out within their precincts. Most, however, were of recent vintage and cannot be equated with collective memory.[149]

Demotic practices were superseded by more authoritarian tendencies as different regimes tried to politicize the urban fabric by constantly renaming important streets. During the French Revolution, place names were secularized: Saint-Denis became Denis tout court, while Quai d'Orléans and Quai de Béthune were renamed Quai de l'Egalité and Quai de la Liberté.[150] The First Empire put an end to these Jacobin procedures, replacing the names of politicians with those of the military.[151] Under the July Monarchy, political dates were first used to designate streets, a practice followed by the Second Empire, which also named streets and squares after colonial conquests.[152] Haussmann himself tried to memorialize the dynasty, assigning Bonapartist names to new boulevards such as Prince-Eugène (now Voltaire), Prince-Jérôme (Mac-Mahon), or Avenue de l'Impératrice (Foch). An officer like Napoleon III favored military victories, continuing a tradition begun by his uncle: "When succeeding generations shall traverse our great city," he said at the inauguration of the Boulevard de Sébastopol in 1858, "not only will they acquire a taste for the beautiful, from the spectacle of these works of art, but, in reading the names inscribed upon our bridges and our streets, they will recall to themselves the glory of our armies— from Rivoli to Sebastopol."[153]

To Republicans, this smacked of autocratic saber rattling. For Hector Horeau, one of the most gifted French architects of the day, though wholly marginalized by the municipal and imperial authorities, it was necessary "to replace as soon as possible the names of murderous struggles given to our squares, bridges and streets, by names of unity, peace, geography, art, science, and civilization."[154] The retrieval of old designations from the past could also reflect political disapproval. During the Commune, the population imposed new names on Second Empire streets and quays, and in 1870, a section of the International from the faubourg Saint-Denis chose to call itself the "Faubourg-du-Nord," a term that can be found only on an old map of Paris dating from 1793.[155] Walter Benjamin attributes this atavistic survival of urban designations to the power of names that often ride out political upheavals, "assured of their small municipal immortality."[156]

Disoriented by new boulevards that often disturbed traditional street patterns, scale, and orientation, many citizens now sought more impersonal means of navigation instead of finding their way about empirically, through trial and error. The proliferation of maps and guidebooks for locals and foreigners alike spoke to the bewildering, ever-shifting urban panorama, the gaping voids and building yards that changed and challenged the residents' urban experience. Maps domesticated the urban maze, rendering it intelligible and homogenous: a question of space rather than place. Fournel stressed the difficulties of making sense out of what he saw, and the constant comparative work it required: "As long as the Paris of Mr. Haussmann is not finished—and even the most optimistic among us dare not speculate when it will be—we are obliged to renew our provision of maps and *Guidebooks* every month, and unfurnish and refurnish our memory incessantly, compelled by these endless transformations to suffer even more relocations than the citizen most relentlessly driven by expropriations."[157] Paris had been there before. Writing in 1835, Raymond Bruker complained: "When you open a map fresh from the printing press, you already know more than its author. [. . .] it is history."[158]

REPRESENTING LOSS

We walk through the broad streets of the newly built town. But our steps and our glances are uncertain. Inside we tremble just as before in the ancient streets of our misery. Our heart knows nothing of the slum clearance which has been achieved. The unhealthy old Jewish town within us is far more real than the new hygienic town around us. With our eyes open we walk through a dream: ourselves only a ghost of a vanished age.
—Franz Kafka, *Conversations with Kafka*

Only the shelling of northern France during World War II can give an idea of the devastation of Second Empire Paris (fig. 2.24). Field Marshall Helmuth von Moltke noted in 1856 that demolitions had left behind ruined shells of buildings "and heaps of rubble, as after a bombardment."[159] As architectural casualties mounted, the sadness of things destroyed was doubled by fear of impending loss.

Forfeiture of one's home prompted a far more anguished response than the destruction of historic patrimony. What many mourned were not "monuments of unageing intellect" but buildings with no particular aesthetic or historic meaning that nevertheless served as anchoring points for memory and identity. Landmarks had to do with complex constructs like the self-imagination of peoples and nations—homes with something much more personal.[160] The burning affect that one finds in the personal reminiscences of those who had lost the houses or streets of their childhood was widespread. Fournel expressed his sadness at having lost forever the spatial moorings of his memories:

Yesterday, a vision of the past tugged at my heart. The gentle autumn sun shone softly; the macadam had the serenity of a cloudless sky, and the new Paris itself smiled with a tender and rather engaging air. I decided to revisit yet again a certain house I know. I wanted only to pace the sidewalk slowly, to lift my eyes to the level of the third floor, and contemplate the *place*. There are sunlit days like this, when

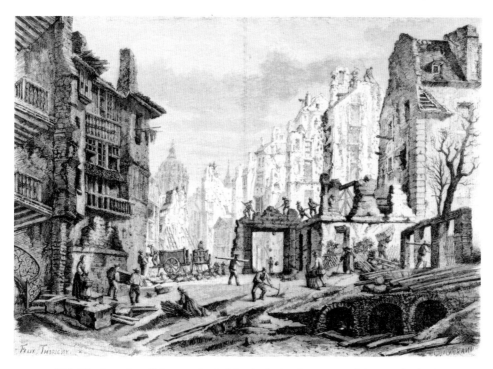

FIG. 2.24. Félix Thorigny, demolitions on the Left Bank, during the cutting of the Rue des Écoles. *L'Illustration*, June 26, 1858. Bibliothèque nationale de France, Paris.

happiness can be had cheaply. I had barely arrived when my heart felt a pang. There was nothing left; the very street had disappeared, and on the site of the demolished house, workers spread a layer of smoking asphalt whose stench filled the air within a hundred paces.[161]

For Fournel, the appearance of the new Paris no longer coincided with its remembered history: familiar referents were swept away, leaving him deracinated, torn from his youth by a radical discontinuity. Yet neither the Second Empire nor Haussmann can be held wholly responsible for the sense of estrangement described by contemporaries. Such desperate attachment to the past could also express a vehement rejection of change. Echoes of such feelings can be found in other countries, prompted by disenchantment with the present and nostalgia for the past, fueled by modernity.[162] Yet just as yearning for the vieux Paris cannot be equated with political resistance, so too love of the new did not necessarily signify approval of the regime. There were those, like Baudelaire, who remained uncomfortably though magnificently on edge, regretting old Paris but loyal to the beauty of the transient, the fleeting, and the contingent.

In their anger at the demolitions that destroyed their sense of place and irrevocably altered their frame of reference, many citizens gave vent to their sense of despondency. From the all-seeing vantage point of his hot-air balloon, the photographer Nadar recorded his feelings of helplessness and perplexity at the laceration of old Paris in the heyday of the Second Empire. As he gazed somberly down at the newly reconfigured city, he could

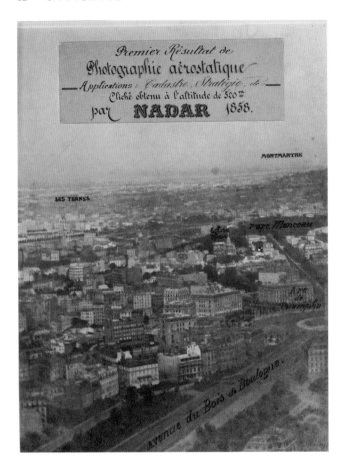

FIG. 2.25. Nadar (Gaspard Félix Tournachon), *Premier résulat de photographie aérostatique*, 1858. Bibliothèque nationale de France, Paris.

hardly recognize familiar landmarks, now tethered to a different context (fig. 2.25). Faced with the fungible, amnesic views of the capital, he experienced change as an exile: "I am powerless, old Parisian that I am, against this bitter, infinite sadness of seeking in vain for myself in this land that was once mine. I have a home no longer. There where my childhood and my youth unfolded, where each detail brought cherished memories to mind, [. . .] I feel like a traveler recently arrived in a foreign city. They have destroyed everything, even memory itself, in truth, as if they were not even French."[163] Like Fournel, Nadar was grieving for his youth as much as for Paris. The outpouring of grief that followed the destruction of innumerable streets and buildings was due partly to antiquarian concerns but also to the associative meaning vested in the old stones, the cobbled court, the third-floor window that often functioned as metonyms for the loved one. Nadar's despairing cry underscores the role of fantasy in the construction of memory and suggests that the object of desire was in part the city itself, the great seductress.[164]

This passionate yearning for the framework of one's youth could also reflect an older, more primordial form of psychological anxiety. A moving autobiographical passage in *Les Misérables* hints at the family romance that binds the citizen forever to the native city. Exiled from France for almost nineteen years, Hugo ached for the Paris of his childhood, which, he believed, he had committed to memory:

After we have gone, we realize that these streets are dear to us, that we miss these roofs, these windows and these doors [. . .]. All these places that we no longer see, may never see again, whose image we have kept, take on a painful charm [. . .] they are so to speak the very embodiment of France; and we love them and invoke them such as they are, such as they were, obstinately; we want nothing to change them, for we cleave to the countenance of our country as to the face of our mother.[165]

Hugo's poignant image of the mother-city appears in the words of a Parisian worker of an earlier generation who expresses his filiation to the city in moving terms:

Long deprived of my loved ones, having lost my mother quite young, I created a new family for myself out of the immense population that revolves daily around the heart of the city. I loved it as a second mother, still alive after the first had died. Alive in its harlequin houses and motley buildings, its sky and its noises, which I had seen and heard from the moment I was granted sight and hearing. Sitting on a curbstone like a baby in its cradle, I recognized a brother in every passing creature, a familiar toy in every monument, a friendly call in each of the countless sounds that assailed my ears.[166]

Although both men anchored their concept of the city in the image of the mother, Hugo's distant panoramic view differs from the worm's-eye vantage point of the worker. The psychological and the political were not quite independent variables. Anything but disinterested, memory is never a matter of purely individual recollection but a complex attempt to reconstruct the past, within the framework set by one's social parameters.[167] Remembering the old city took different forms, prompted by different motivations. An expression of nostalgia for some, a form of resistance for others, the searing evocation of the lost object could sometimes be doomed to failure: what was retrieved, streamlined by repression and condensation, was something else altogether.

Those who could not forget were condemned to remember. Large-scale destruction of urban areas and their distinctive topography gave rise to an upsurge of creative works, as literati, painters, and poets gave themselves over to the task of "cultural mourning."[168] Never was the urban past so alive as when its physical traces were being destroyed. While outspoken critics of Napoleon III voiced their anger at the new configuration of Paris openly, others expressed disapproval obliquely, often using setting to convey opposition. The picturesque nooks and crannies of the city portrayed by bohemians like Alfred Delvau, Gérard de Nerval, Privat d'Anglemont, Arsène Houssaye, and Champfleury (pseudonym of Jules Husson) were places of evasion, far from the boulevards and cafés of the metropolis.[169] It is significant that the most famous book penned during the Second Empire, written from Hugo's exile in the Channel Islands, takes place in the days of Louis-Philippe: "With its narrow and tortuous streets," Pierre Citron remarked perceptively, "the city of *Les Misérables*, protests against the city that Hugo does not wish to know, the city of Napoleon's palaces and of the earthworks cut by Haussmann."[170] Omission was a form of protest, a *damnatio memoriae*.

Haussmannization did not affect all neighborhoods equally. Snatches of the old city survived intact, dammed up behind the gleaming new boulevards. With their varied forms of livelihood and social texture, these enclaves achieved great importance as alternative

spaces, eagerly sought out by poets and writers for whom the prefect's new rectilinear streets no longer yielded the auratic consolations of old Paris.[171] "For Paris has this wonderful [characteristic] about it," wrote Privat d'Anglemont; "the mores of the population of one street no more resemble those of the next, than the mores of Lapland resemble those of South America. No sooner do you turn a corner, than the environment changes along with the population."[172]

Whether we are dealing with a requiem as in Nadar, or with a more muted form of dissent, these litanies identify the city as a locus of memory formation. Citizens could no longer take the vieux Paris for granted and were forced to conjure it up through anamnesis. They too had become preservationists after a fashion: widespread demolitions triggered the melancholic impulse to cling to what was already lost. Goaded into action by the destructions of Haussmann and the July Monarchy, intellectuals scrambled about to compile an archive of what was disappearing. In his book *Paris démoli*, first published the year Haussmann took office, Édouard Fournier outlines the task awaiting them: "Our mission is to inform the public preoccupied with these ruins and the passerby who sees them piling up, about the great historical value of what is disappearing; it is also to keep records, so that what turns to dust will not be forgotten."[173] It was urgent to keep forgetfulness at bay. "Each day," bemoaned Privat d'Anglemont, "the municipal or the private pickax whittles away a chunk of old Paris. We must make haste to sketch its biography, lest these ruins from another age disappear entirely from the memory of mankind, as they do from the face of the earth."[174] Balzac, of course, had said it all before, when faced with Rambuteau's forms of slum clearance: soon, old Paris will survive only in the works of attentive *flâneurs*, he noted, "those historians who have but a single reader, for they publish their works in a single volume."[175]

The visual arts also played a crucial role. Photography, wrote Baudelaire in his 1859 essay, "Le public moderne et la photographie," should "save from oblivion the tottering ruins, books, prints and manuscripts that time devours, precious things whose shape will disappear, and demand a place in the archives of our memory."[176] Walter Benjamin, his latter-day disciple, speculated that Haussmannization affected the imagination before it even took place. When something is about to be destroyed, he argued, it "becomes an image. Presumably this is what happened to the streets of Paris at that time. In any case, the work whose subterranean connection with the great remodelling of Paris is least to be doubted, was finished a few years before this remodelling was undertaken. It was Meryon's engraved views of Paris."[177] Charles Meryon's anticipatory memory, embodied in his extraordinary etchings, had parallels in other arts, above all in photography, as Baudelaire intuited.[178]

As buildings were torn down, half-destroyed houses became a common sight, their chimney flues and faded wallpaper brutally exposed to the passerby. Forced to exhibit their violated intimacy in public, these flayed bodies cried out for representation. Numerous photographs of such ruins, caught on camera just before they vanished for good, attest to the voyeuristic fascination they exercised on spectators (fig. 2.26). Only those whose homes were intact could view with aesthetic detachment the enigmatic, Piranesi-like stairs leading nowhere, darkened walls, and the empty sockets of the windows. Others reacted to these scenes with sadness. Demolition of familiar buildings triggered deeply personal associations and anxieties of separation. Fournel wrote enviously of the provincials who

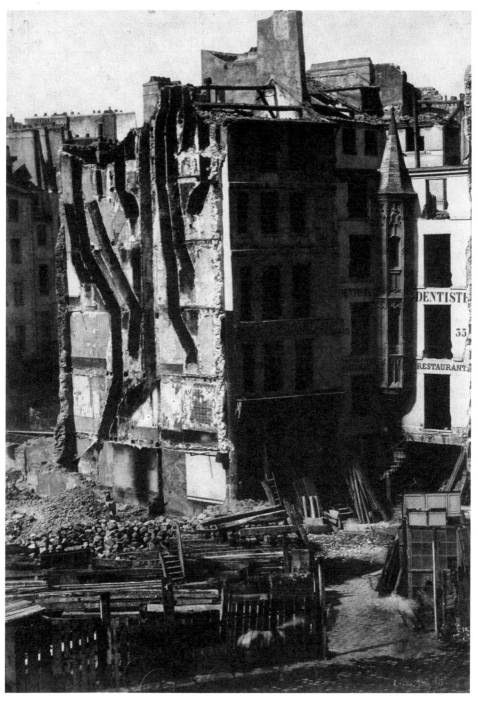

FIG. 2.26. Henri Le Secq, slum clearance at the Place de l'Hôtel-de-Ville, 1853. Bibliothèque historique de la Ville de Paris.

never had to move from one place to another because they owned the home where their families lived for generations: "They are born there and will die there. It overflows with traditions and memories."[179] The Parisian house, he continues sadly, "has no name. It has only numbers like those sheds of a penal colony where man himself becomes a cipher. We remember vaguely, if memory serves, that we lost our mother in number 134, that we got married in number 25, and that we had our first child in number 48, that is all. And we ask ourselves in which number we shall die."[180] Rambuteau, whose family homes remained intact, spoke warmly of this connection of streets to family history: "I loved walking though that little rue Sainte-Avoye," he reminisced, "where my father was born, and his father and mother died."[181] While wealthier citizens could remember where they were born, and where their parents and grandparents lived and died, workers had a very different reaction. Though equally devastated at having lost their lodgings, few knew their exact birthplace, as they were forced to move constantly, because of the fluctuations of the job market. "Home" was something they lost continually.

In the aftermath of redevelopment, many sought refuge in the passive, anesthetizing comforts of topophilia: the past relived uncritically, sweetened by a selective memory that edited out all that was unpleasant and unwelcome. This was particularly true of the moneyed elites, who unconsciously romanticized the degree to which different strata of society had interacted before urban renewal. Popularized under the July Monarchy, these sketches appeared just as the first interventions destroyed significant swaths of the city, and memories of old Paris were still locked into a painful dialectic with the new.[182] Social relations were extolled in vignettes showing cutaway sections of apartment buildings with different classes living peaceably under the same roof—the poor above, the rich below—according to a benign topology of vertical segregation that hardly corresponded to reality (fig. 2.27).[183] At times, there was a feeble attempt at social criticism, but even when the artist showed the sufferings of the poor in their crabbed quarters in the garrets, touches of humor reinforced the overall sense of social harmony. Class played a preponderant role in shaping such reminiscences. Relations between different social groups had never been as cordial as they were made out to be in retrospect; when they resided in the same apartment building, service stairs usually ensured segregation.[184] Denial of social division is constitutive of society and goes hand in hand with representations of that denial.

After Haussmann's reforms, the city was rarely analyzed vertically, in section. Given the increasing social homogenization taking place within each district or even within new apartment buildings in fashionable areas, many thought Paris could best be anatomized horizontally, on plan. This too was ideology, since workers and employees continued to live in the interstices of the city, while the western outskirts had affluent enclaves such as Auteuil and Passy. The replacement of vertical by horizontal forms of segregation became a favorite topos of the opposition, which tended to see the Paris of bygone days through the deforming lens of myth. Jules Ferry, one of Haussmann's bitterest antagonists, expressed this rose-tinted view of the past in emotional and exaggerated terms:

> It is a lost cause to regret old Paris, the Paris of history and thought, whose dying gasps we witness today; the artistic and philosophic Paris, where so many modest people, devoted to intellectual labor, could live on an income of 3,000 pounds;

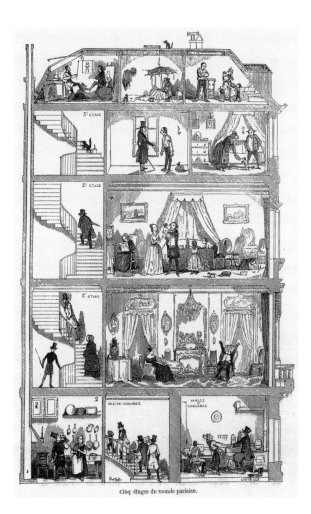

Cinq étages du monde parisien.

FIG. 2.27. Bertall (Charles Albert d'Arnoux), *Five Floors of Parisian Life*. Woodcut. Edmond Texier, *Tableau de Paris*, vol. 1 (1852). Bibliothèque nationale de France, Paris.

where communities, neighborhoods, districts, and traditions still existed; where expropriations did not constantly disrupt old relationships and the most cherished habits; where craftsmen, whom a pitiless system now chases from the center, lived side by side with financiers; where intellect was valued more highly than wealth; where the foreigner, crude and extravagant, did not yet influence theaters and customs. This old Paris, the Paris of Voltaire, Diderot and Desmoulins, the Paris of 1830 and 1848—we weep for it with all the tears of our eyes, in view of the magnificent and intolerable hostelry [*hôtellerie*], the costly disorder, triumphant vulgarity, and frightening materialism we bequeath to our heirs.[185]

A luxury not all could afford, nostalgia depended to a large extent on one's social status. The laboring classes also deplored the lost tenement buildings but gave a bleaker version of the past, rejecting the "imagined communities" of wealthier strata. "We do not regret those sordid old homes, poorly lit and unhealthy; no; but neither do we like these splendid buildings where the stairs are polished and the corridors are of stucco: where the bourgeois of the third floor no longer sees the ouvrier go by in his working clothes," wrote a group of proletarians in 1867.[186] Already during the July Monarchy, speculators were finding it difficult to attract tenants for "mixed" apartment houses, given the affluent

classes' aversion to living under the same roof as the laboring poor. "One worker sufficed to contaminate a building," declares the concierge in *Pot-Bouille*, Zola's pitiless portrait of class antagonism set during the Second Empire.[187] Though he continued to analyze the building in section, he showed it as a flashpoint of class antagonisms and entrenched hatreds. Paris had been changing steadily not only in its urban appearance but in social makeup, as immigrants and seasonal workers continued to flock to the city, disrupting the ever-precarious balance between place and identity. Peaceful cohabitation was a thing of the past, if it had ever existed.

Public and private buildings did not necessarily disappear from collective memory when they were destroyed. Like amputated limbs, they often resonated long after demolition. The headquarters of public welfare (Assistance Publique), once situated in the *parvis* (square) of Notre-Dame, was moved across the river when Haussmann reconfigured the area. Yet for many years the population continued to use the expression "aller au *parvis*" to designate the new headquarters.[188] A better-known instance is Place de Grève, formerly located in front of the Hôtel de Ville. Before the river was contained within high quays, its gravel-covered slope (*grève*) served as the city's most important port. By the nineteenth century, hundreds of workers would gather there every morning, in hope of being recruited for construction work. To this day, the French use the toponym *grève* for strikes, though workers no longer crowd the area in search of employment.[189] Like many old capitals, Second Empire Paris resembled a phantasmatic city, peopled by ghostly buildings that were still part of the emotional fabric of its inhabitants decades after destruction. The old city was remembered, and passionately so. But sooner or later, the burning personal recollections faded. Proust neatly summed up the suppressed motivation of forgetfulness: "Oblivion [. . .] is such a powerful instrument of adaptation to reality because it gradually destroys the living past within us that is in constant contradiction with it."[190]

REPRESENTING PARIS

> All that once was directly lived has become mere representation.
> —Guy Debord, *The Society of the Spectacle*

Representing loss and representing Paris in the grip of violent urban change yielded different kinds of cultural response. Experienced through daily interactions, these *seemed* to offer residents direct contact but were in fact always mediated by images, texts, and all forms of popular culture, as well as unconscious fears and desires—representations that produced the city even as they themselves were produced by its subjects.[191] With its polysemic complexities, the city's frenzied transformation constantly outstripped the narratives composed by its intellectuals. Nevertheless, when stamped with the imprimatur of literature, these carried immense weight. The written Paris of Balzac and Hugo, Sue and Dumas, Nerval and Baudelaire, now recoded as collective memory, lived on in the imaginary of its citizens. Louis-Philippe, Rambuteau, and Haussmann all destroyed medieval buildings, along with Renaissance, Baroque, and contemporary structures. But Romantic Paris was to a certain degree constructed retrospectively by its writers, illustrators, and their readers, homesick in part for a past that never was. The city's vanished history came to be known at least as much through fiction as through archaeological evidence.

The power of these literary works that took Paris for their setting can hardly be over-estimated. No book had been so fervently followed by all classes of society as Sue's *Les Mystères de Paris*, which painted the Île de la Cité in dark and indelible colors. Such was the novel's impact that Sue's characters were often taken for real-life personages. Haussmann himself tacitly acknowledged the importance of fiction by installing his city barracks in the Rue aux Fèves, the very site of Le Lapin-Blanc, the thieves' tavern in Sue's book.[192] But it was Hugo who left his compatriots the most memorable image of the doomed magnificence of old historic kernel in *Notre-Dame de Paris*, published under Louis-Philippe in 1831. Its celebrated chapter "Paris à vol d'oiseau" is an art-historical tour de force. The title came from Louis Sébastien Mercier's "À vue d'oiseau" in his *Tableau de Paris* (1781), where Mercier, too, looks down on the historic fabric from the towers of Notre-Dame.[193] Swooping down on the Île de la Cité like an eagle, Hugo describes it as a reliquary, brimful of irreplaceable works of art, as he imagined it to be in 1482:

> The City, then, first presented itself to the view, with its stern to the east and its prow to the west. Facing towards the prow there stretched an endless line of old roofs, above which rose, broad and domed, the lead-roofed transept of the Sainte-Chapelle, like an elephant with its tower, except that here the tower was the boldest, airiest, most elaborate and serrated spire that ever showed the sky through its fretted cone.
>
> Just in front of Notre-Dame three streets opened into the Cathedral close—a fine square of old houses. On the south side of this glowered the furrowed, beetling front of the Hôtel-Dieu, with its roof as if covered with boils and warts. Then, on every side, right, left, east, and west, all within the narrow circuit of the City, rose the steeples of its twenty-one churches, of all dates, shapes, and sizes, from the low, worm-eaten Roman belfry of Saint-Denis du Pas, *carcer Glaucini*, to the slender, tapering spires of Saint-Pierre aux Bœufs and Saint-Landry.[194]

In the early 1850s, these lines still sounded familiar to Parisians. Notre-Dame loomed over an inchoate tangle of steep roofs, turrets, and spires, beautifully captured by the lens of the Bisson brothers (fig. 2.28). So narrow were the streets of the Cité that they could scarcely be perceived from the cathedral, which seemed to rise from a solid mass of houses. In retrospect, the text must have resonated even more powerfully when the untidy cluster of gables and pinnacles had been destroyed, and the author, in exile, occupied the high moral ground of opposition. How different from Nadar's disenchanted view, gazing dejectedly at the indistinct urban sprawl from his balloon! Hugo's brush paints every detail with painstaking skill, placing the old city within the reassuring pale of a purposeful telos, a damning foil, in later years, to the Paris that the Second Empire was erecting.

Nevertheless, one must resist the beauty of Hugo's Gothic imagination, and avoid being trapped by nostalgia, romanticizing or hypostatizing pre-Haussmannian Paris. Already in 1848, there were rival perceptions of the same area. For a Saint-Simonian like Considerant, imbued with the ideology of progress, the picturesque massing and amorphous rooftops that had moved Hugo to eloquence mirrored societal ills: "Large cities, and Paris in particular, are sad spectacles to behold for whoever believes in order and harmony, who thinks of the social anarchy thrown into relief with brutal fidelity, by this amorphous jumble, this mêlée of buildings covered with angular, gaping, lacerated, divergent, jostling

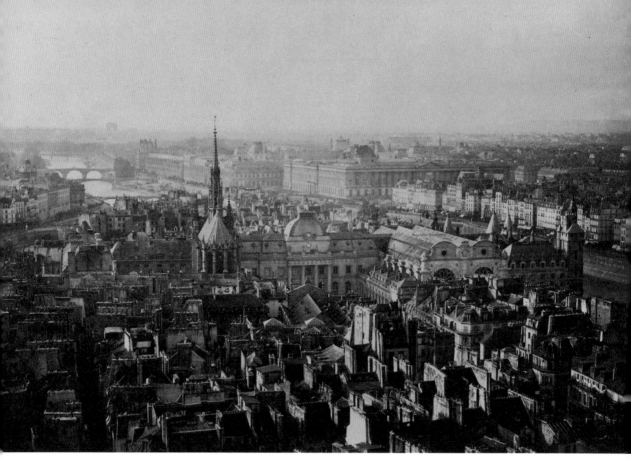

FIG. 2.28. Bisson Brothers, panorama of Paris taken from the towers of Notre-Dame, 1857. Bibliothèque nationale de France, Paris.

roofs, crested with metal fretwork, rusted weathervanes, and countless chimneys that delineate even more clearly the social incoherence and divisiveness that engendered this architectural chaos."[195]

Hugo's achievement was shaped by his powerfully visual imagination and his expertise both as a connoisseur of architecture and as a consummate draftsman. It also derived in no small measure from his chosen perspective. As Paris grew in girth and in height, the bird's-eye view became—at least theoretically—the only viewpoint that could encompass the ever-widening panorama as a whole. Hugo exploited this with virtuosity, as did Cooper and so many others. Haussmann himself argued that one of his projects, the Place de l'Étoile, was best appreciated from the air: "This fine layout, which I am very proud of having devised, and consider one of the most successful achievements of my administration, appears in its totality, as on a plan, from the top of the Arc de Triomphe."[196] One has only to contrast Haussmann's confident endorsement of the view from above with the words of an earlier Bonaparte to appreciate the degree to which attitudes had changed. Napoleon I had refused to underwrite architectural projects aimed at correcting the different axes of the Tuileries and the Louvre, which were not precisely parallel to one another, on the grounds that "birds alone are aware of the irregularity of great spaces."[197] This shift in vantage point had both cognitive and ideological implications. Tradition linked

the worm's-eye view to the acceptance of the divine, dwarfing the human to the glory of God.[198] By contrast, the view from above was fiercely secular and anthropocentric, apprehending the surroundings in a purely immanent way. Not by chance was this overarching perspective the devil's viewpoint, as he straddles the Seine in Grandville's well-known frontispiece for *Le diable à Paris*, first published in 1845–46 (fig. 2.29).

This way of conceptualizing the city appeared with increasing frequency in the second half of the century in literature, photography, and the graphic arts. Science and technology had something to do with this newfound predilection: taller buildings, the experience of flight in hot-air balloons (admittedly available to very few), and Nadar's aerial photographs popularized this type of rendering, which conurbation and smog had drastically curtailed by the 1850s.

From church towers, the world is still within reach of the human. With the hot-air balloon, as later with the Eiffel Tower, viewers become disengaged, lacking the empathy that distinguished Hugo's deep involvement in the world below the towers of Notre-Dame: scalelessness destroys familiarity. Abstract and

FIG. 2.29. Grandville (Jean Ignace Isidore Gérard), frontispiece, *Le Diable à Paris*, 1845 Bibliothèque nationale de France, Paris.

cerebral, this more distant bird's-eye view called for a hermeneutic gaze that posed the seen as a question to be deciphered, flattening the panorama perceptually. From high up, the eye does not perceive differences in altitude, explains Nadar: "The river runs flush with the mountaintop; one cannot distinguish between alfalfa fields and the tall crests of ancient oaks."[199] From this higher viewpoint, the earth had become enigmatic, as spectators compared what they saw with what they knew and remembered. If the vertical view of the city gave the prefect and the devil a sense of empowerment, contemporaries had a far more bewildering reaction.

Already then, environmental issues troubled onlookers. "Above," wrote Lecouturier in 1848, "a permanently nebulous sky, even in the most beautiful of days. Clouds of smoke, like a vast drifting curtain, hide [Paris] from view. A forest of chimneys, bristling with black or yellowish stacks, make the spectacle singularly monotonous."[200] A quarter of a century later, Du Camp stated categorically that Paris could no longer be seen from the heights: "It is from there," he says of the tip of the Île de la Cité, "near the statue of Henri IV, that one must see Paris; from the heights of Montmartre, Notre-Dame or Saint-Sulpice, the view is poor. A scrim of bluish smoke, constantly thrown up by two hundred thousand chimneys, floats above the roofs and shrouds the city in a hazy atmosphere, drowning details, deforming buildings, and producing a bewildering confusion."[201] Hugo's vivid scene acquired, in retrospect, the detailed clarity of a diorama.

Popular culture played a conspicuous role during urban renewal, transforming the capital into an object of visual consumption. A steady stream of images offered a lens through which the new Paris could be questioned, critiqued, or made into a soothing

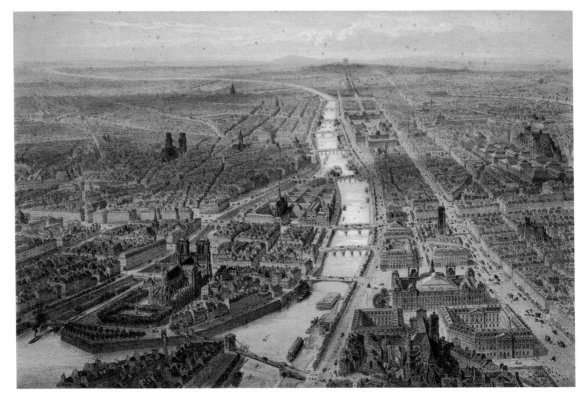

FIG. 2.30. Jules Arnout, bird's-eye view of Paris, 1860. *Paris dans sa splendeur*, 1860. Lithograph. Bibliothèque nationale de France, Paris.

anesthetic. Periodicals enjoying wide distribution such as *L'Illustration*, *Le Monde illustré*, and *Le Magasin pittoresque* reacted to redevelopment with different kinds of views. Some, accepted uncritically as reproductions, depicted the city from a great height, magically removing the confusion, the scaffolds, and yawning construction sites that rendered it illegible (fig. 2.30). With a little help from their imagination, illustrators improved on the scene that they could not see, both creating and concealing a fiction: great monuments alone were distinctly marked, in a setting that was all order and intelligibility. The goal of such popular illustrations, whether or not their authors were cognizant of the fact, was to persuade and enlist consent.[202] Their calm and stabilizing views functioned as an allegory of good government, performing the subliminal work of ideology.

In sharp contrast to these placid views, counterimages and vignettes in the very same publications showed specific areas of Paris as a jumble of ruins and rubble, sometimes accompanied by a distinguishing building to orient the viewer (see fig. 2.24). The portrayal of *Paris démoli* became a genre of its own, the equivalent of books and articles written to chronicle the destruction of the beloved city.[203] These reflected somewhat more faithfully the experience of the pedestrian, who witnessed a city adrift in a sea of perplexing shapes and forms that refused to coalesce into a holistic picture. Constantly embroiled in earthworks and building yards that converted the center into a maze of discontinuous and

disconcerting shards, Second Empire Paris challenged traditional forms of representation of the city.

These two different ways of seeing Paris coexisted in an uneasy dialectic, as if the iconography of devastation begged for a conciliatory, tranquilizing antidote. For a time, the view of Paris from a great distance, compressed into a single comprehensive frame, had to vie with other, equally popular renditions that showed chaotic destruction from the ground. "The spectacle," noted T. J. Clark, "is never an image mounted securely and finally in place; it is always an account of the world competing with others, and meeting the resistance of different, sometimes tenacious forms of social practice."[204] Failure to make the city intelligible was due to the fact that it was ultimately unrepresentable.[205] The very attempt to turn Paris into spectacle rendered it invisible, argued Clark: "It still seemed to propose that the city was one place, in some sense belonging to those who lived in it. But it belonged to them now simply *as an image*."[206]

Second Empire Paris could be visualized in its entirety only as fiction. The abiding success of Hugo's great romantic inventory of the Cité in *Notre-Dame de Paris*, set safely in the past, can be interpreted as a compensatory gesture, a reverse teleology, that restored the order found wanting in his day, when large-scale cuttings—tame, no doubt, by Haussmann's standards—were being carried out by the July Monarchy. The fact that Hugo chose to dwell on medieval Paris—Paris in the past tense, charged with nostalgic affect—has much to do with the novel's lasting popularity. The bird's-eye view served to reassure when applied retrospectively, or when it allowed itself to be guided by poetic license, avoiding the representational problems created by urban change. Such totalizing views erased the scenes of urban disarray presented by ubiquitous scaffolds and building yards. Both Nadar's distorted view of the past and the illustrators' edulcorated panoramas of the present were a reaction to the anxieties triggered by the Paris of their day and the destructions that imperiled their sense of self. Loss constitutes such a shattering experience that it generates its own formal language, imposing itself on the artist not just as subject matter but as an unstable means of expression.[207]

The view of Paris was reassuring only when seen from a temporal distance, as in Hugo's *Notre-Dame de Paris*, or a spatial one, as in popular illustrations with their impossible viewing points that no longer coincided with the immediacy of lived experience.[208] Both forms, in differing ways, involved time. "To perceive Paris from above," Roland Barthes suggested, "is infallibly to imagine a history; from the top of the Tower, the mind finds itself dreaming of the mutation of the landscape which it has before its eyes; through the astonishment of space, it plunges into the mystery of time, lets itself be affected by a kind of spontaneous anamnesis: it is duration itself which becomes panoramic."[209] To see the city from the air, like Nadar, was to evoke concomitantly the many pasts erased by successive regimes, and to offer up the present to an unfavorable comparison with earlier times. The abstractions forced on the spectator by foreshortening called forth urban genealogies that no longer meshed into a purposeful whole.

The spectacle of time had not always weighed so heavily on spectators. In the summer of 1826, Cooper stood at the top of Montmartre, with the great bowl of the city spread out beneath his feet. As he took in the vast panorama, he too acknowledged the diachronic disjunctions inherent in his view:

We were fortunate in our sky, which was well veiled in clouds, and occasionally darkened by mists. A bright sun may suit particular scenes, and peculiar moods of the mind, but every connoisseur in the beauties of nature will allow that, as a rule, clouds, and very frequently a partial obscurity, greatly aid a landscape. This is yet more true of a bird's-eye view of a grey old mass of walls, which give up their confused and dusky objects all the better for the absence of glare. I love to study a place teeming with historical recollections, under this light; leaving the sites of memorable scenes to issue, one by one, out of the grey mass of gloom, as time gives up its facts from the obscurity of ages.[210]

In Cooper's beautiful text, a benevolent and compliant nature collaborates with history in a world that providence has rendered meaningful, in contrast to the stubborn opacity of Paris under the glum, secular gaze of Nadar.

In the modern age, cities could come into being only by breaking up the form of the preindustrial city.[211] "A revolution in temporal and spatial relations," observed David Harvey, "often entails, therefore, not only the destruction of ways of life and social practices built around preceding time-space systems, but the 'creative destruction' of a wide range of physical assets embedded in the landscape."[212] Such overwhelming changes resonated loudly in every aspect of everyday life, affecting all citizens to some degree. Those who stood to gain from urban renewal welcomed the emperor's rejuvenation of the city. The desperate cry of others had to do with a constellation of causes, from loss of homes, relocation in the periphery, or deep-felt appreciation for the city's historic heritage. Confronted with the irreversible transformation of Paris and the demolition of thousands of buildings and architectural landmarks, many reacted with rage and sorrow—but in vain: Haussmann was already relegating wide swaths of heritage to memory.

Streets and Boulevards

This is the story of these modest streets that got lost amid the beau monde
and whose gauche manners, country airs, and ridiculous garb exposed
them to a thousand jokes and humiliations.
 —Xavier Feyrnet, "Courier de Paris"

For decades municipal authorities had tried to deal with the historic center's welter of
alleyways, which they considered dangerous warrens of dirt and disease, as well as
havens of political unrest. Fear of the volatile urban masses helped shape the scope and lay-
out of the new urban network, aimed at both enhancing circulation and consumption, and
preventing revolution. Narrow streets were seen as impassable canyons in which the army
maneuvered with difficulty and at great cost to its troops. Saint-Simonians, bankers, and
industrialists, bent on encouraging trade and communications, had put forth radical plans
of urban renewal. To increase productivity and reach wider markets, broad streets and
boulevards were required to facilitate the mobility of products and consumers. Obstacles
had to be removed and the urban network freed up to serve the goals of the industrious
and mercantile classes.

The same choke hold of fetid streets that so threatened the genteel bourgeoisie sig-
naled home to the urban poor, who had their own ideas on the subject. Streets were the
familiar territory where they spent much of their lives, conducted business, and found
entertainment. With the appearance of industrial capitalism, this old and sociable model
fell into disrepute among the elites. As the city's social strata became more sharply differ-
entiated, streets became sites of class confrontation, and arenas for rival political claims. If
Second Empire Paris inherited conflicting concepts of what constituted a street, its urban
initiatives reflect the multiple goals of the government and the propertied classes, from
political economy and hygienics to the hardened outlook of military strategy: urban space
could be wielded as an instrument of social control.

During the July Monarchy, Rambuteau had already introduced forms of modern
urbanism, broadening existing streets with the practice of frontage lines (*alignement*): one
side of the street would be pushed back, shearing whatever protruded beyond the limit
established by the municipality. When this was not possible, new streets would be cut
through the existing urban fabric at great expense. In such cases Rambuteau chose his
itinerary carefully, making use of preexisting voids like courtyards and passageways to
minimize expenditure and damage.[1] After widening roadbeds, he had them fitted with
sidewalks and lined with trees, setting a prototype that Haussmann would follow.[2] The

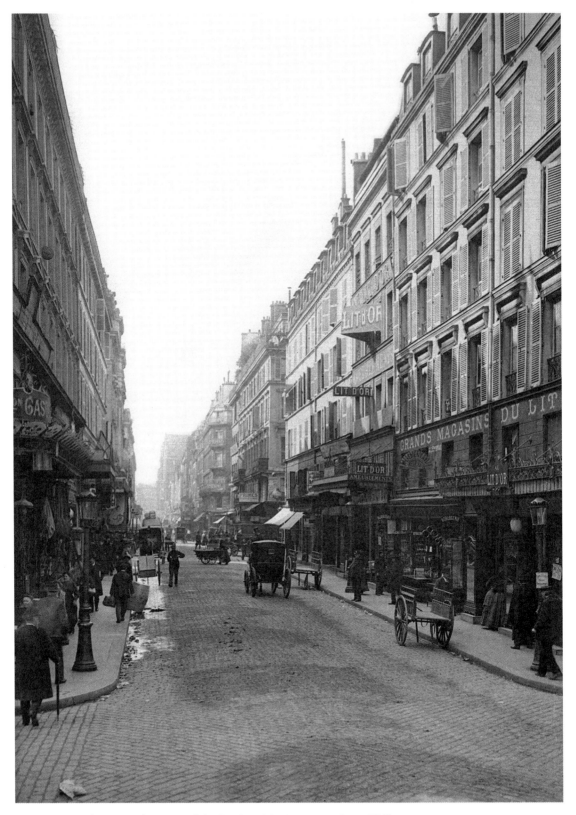

FIG. 3.1. Rue Rambuteau, at the corner of the Rue Saint-Martin, ca. 1900. Roger-Viollet.

moderation of Rambuteau's approach was dictated by the July Monarchy's unwillingness to engage in costly operations, and even more by its fear of upsetting the tense situation of the working classes, which had taken part in the uprisings of 1830 and 1832.[3] By midcentury, his homeopathic interventions could no longer keep pace with the changing needs of French domestic politics. His most important project, Rue Rambuteau, linking Les Halles to the eastern part of the city, came to be seen as excessively narrow: "that sumptuous thoroughfare which so astonished us during the last monarchy—today, an imperceptible alley," remarked Nadar with surprise, gazing down on it from his hot-air balloon (fig. 3.1).[4]

Napoleon III had more ambitious plans. Embellished with monumental boulevards, Paris would serve as a wealth-producing mechanism while calling attention to his achievements. Slum clearance would generate revenue, opening up opportunities for real estate, and enhancing productivity for urban services. When possible, rectilinear thoroughfares, lined with elegant buildings, banks, theaters, and department stores, were to replace the sinuous streets of the historic fabric. With its slow-paced civility, Rambuteau's old template was a thing of the past. The advent of the railroad also exerted a powerful impact on urbanism, shattering the form of the old historical city and exploding traditional notions of scale. Thousands of visitors and tons of merchandise poured into the city daily, clogging up the tightly circumscribed neighborhoods made for pedestrians. The Industrial Revolution required a new concept of urban space that gave primacy to the circulation of people, capital, goods, and information, providing a suitable incentive to consumption.

HAUSSMANN'S THOROUGHFARES

Where previous regimes had favored the street, Napoleon III and Haussmann preferred a grander and more autocratic model with a long history that evoked unambiguously the authority of the monarch. Louis XIV created the first boulevards when he had Vauban raze the old bastions of northern Paris in 1670: peace and prosperity had rendered them redundant. Planted with a double row of trees on either side, they were known originally as the *boulevarts intérieurs*, or *grands boulevarts* (fig. 3.2). Their connection to bulwarks (*Bohlwerk* in German or *bolwerk* in Dutch) is more than just etymology. Trees, too, had a defensive origin, protecting earthworks from cannonades with their roots.[5]

FIG. 3.2. Boulevard Saint-Antoine (now Beaumarchais), in the eighteenth century. Anonymous print. Musée Carnavalet, Paris.

Over the years, however, the boulevards' social and political connotations changed. Situated at the edge of the city, they became a place for promenade, pleasure, and spectacle. As Paris expanded, the Boulevard des Capucines and Boulevard des Italiens came to be seen as the true center of the city, shedding their military and rural overtones, and their connection to informal kinds of leisure and entertainment. An upscale reformulation of the hybrid genre of street and spectacle, lined with imposing buildings, replaced the old demotic practices. Under the Directoire, the Boulevard des Italiens, favored by royalists, was nicknamed "Le Petit Coblentz" after the city where many émigrés had found refuge. This reference to the ancien régime flourished again during the Restoration, when it was popularly known as the Boulevard de Gand (Ghent), an allusion to the Belgian town where Louis XVIII had spent his exile. Assured of prominent patrons, luxury shops on the *grands boulevards* flaunted their sumptuous wares so boldly that Balzac feared that such ostentatious wealth might encourage the disadvantaged to revolt: "The prefect of police should forbid the poor from passing there, lest they proceed immediately to agrarian reform."[6]

Although the president-elect was deeply committed to transforming the urban fabric in the interests of circulation and public health, he never lost sight of the political implications of spatial planning. In *Les Misérables*, written before the Commune, Victor Hugo described the "fatal insurrection of June 1848" as "the biggest street uprising history has seen."[7] The determination to avoid urban warfare at all costs weighed heavily on Louis Napoleon's initial plans and on Haussmann's revised versions. Haunted by their dread of revolution, the regime and the ruling classes distrusted the dense urban ganglia of the historic center and tried to redesign the city to forestall any threat to public order or to commercial interests. It was with this double aim in mind that Napoleon III set about renovating the capital's urban network. Broad streets were the linchpin of the Second Empire's strategy for manufacturing urban space. The Boulevard de Strasbourg, finished by Berger, was thirty meters wide, as opposed to the mere thirteen of Rue Rambuteau.[8] Haussmann's approach was to be more systematic than Rambuteau's, and far more destructive than Berger's.

Although Haussmann is always associated with boulevards, none of the capital's famous examples—Boulevard des Capucines, Boulevard des Italiens, Boulevard Montmartre, now known as the *grands boulevards*—were created by him, though all benefitted greatly from his plans for urban renewal.[9] Laid out roughly like an arc around the center of the Right Bank, they were relatively short, lined with miscellaneous buildings of different styles, each segment receiving a different name (fig. 3.3). By contrast, those due to Haussmann—Boulevard Sébastopol, Boulevard Haussmann, Saint-Germain, or Saint-Michel— were long and uneventful and lacked the liveliness and architectural variety characteristic of the older ones. Converging on monuments of church and state, they represented a throwback to the urbanism of the grand siècle (fig. 3.4): A majestic core, punctuated by grand representational buildings linked by broad and elegant thoroughfares, according to a ceremonial urban scenography that proclaimed loud and clear both the power of the sovereign and the status of the city as capital of France.[10]

Proud of its new arteries, the empire had them "unveiled like monuments" in splendid public pageants stage-managed by Haussmann and his experts with great éclat.[11] The inaugural ceremonies called attention to the providential hand of the sovereign who bestowed

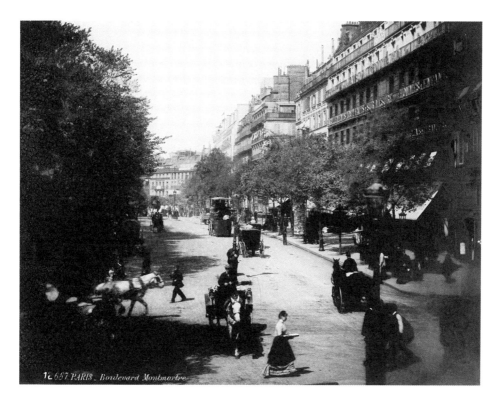

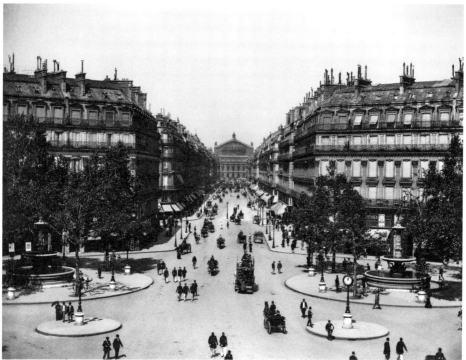

FIG. 3.3. Léopold Mercier, Boulevard Montmartre. Roger-Viollet.

FIG. 3.4. Avenue de l'Opéra at the turn of the century. Roger-Viollet.

FIG. 3.5. Pierre-Ambroise Richebourg, inauguration of the Boulevard de Sébastopol, April 5, 1858. Musée Carnavalet, Paris.

them so magnanimously on the population, driving home the boulevards' tenacious link to the ancien régime. In the most important ones, such as Boulevard de Sébastopol, Napoleon III cut the ribbons, drawing back huge curtains to reveal the long thoroughfare, punctuated with flagpoles designed by Baltard (fig. 3.5).[12]

Haussmann saw the metropolis as a vascular system of streets, irrigated by broad boulevards that enabled commercial exchange and, when necessary, facilitated control of the population. Yet he departed from tradition by ploughing his arteries forcefully across the urban fabric, a drastic measure first advocated by the revolutionary Plan des Artistes in 1797, and used sparingly by Rambuteau. Industrial capitalism required more than the naturalism of the old network, which followed the lay of the land, and Haussmann dutifully complied. With his unremitting hostility to deviations from the straight line, Haussmann rammed his roads through the existing fabric, destroying whatever lay in their path. Radial roads, introduced by that other strategic urbanist, the first Napoleon, played an important role as catalysts of new urban development and as political tools that permitted the regime to implement its ideology of containment. Diagonals, first proposed by Meynadier to shorten distances and save time, allowed Berger and Haussmann to dismember working-class enclaves, or circumvent areas considered politically incendiary. The turbulent faubourg Saint-Antoine is now wedged between the Boulevard du Prince-Eugène (renamed Boulevard Voltaire) and Boulevard Mazas (today, Diderot). Built between 1851 and 1852, both avenues already formed part of Siméon's plan. Rectilinear streets had a long history. Descartes

had already praised straight roads over the warped workings of chance in his *Discourse on Method*.[13] In his influential treatise of 1843, Meynadier, too, had emphasized the need for straight streets in order to save time.[14] Alexis de Tocqueville, on the other hand, complained in 1856 that under the ancien régime, the Corps of the Ponts et Chaussées (corps of engineers) was "as enamored of the geometric beauty of the straight line as it is today," preferring to "cut through a thousand inheritances" rather than upgrade existing roads.[15]

The prefect's urban aesthetics harked back to the Baroque prospects aimed at grand terminating vistas dear to French classicism. The resulting urban tableaux were meant to frame a dome or a façade at the end of a long enfilade. In Second Empire Paris, however, the time-honored precepts of French classical urbanism produced mixed results. In his memoirs, Haussmann boasted that he never authorized a single thoroughfare without taking the point of view into account, reproaching Berger for tracing the Boulevard de Strasbourg on a straight line when a simple adjustment would have brought into focus the beautiful dome of the Sorbonne across the river. To offset this lacuna, Haussmann commissioned the Tribunal du Commerce on the Île de la Cité, whose clumsy dome appears at the end of the new street.[16] While Haussmann's Boulevard Henri IV offers a tantalizing view of the Panthéon on one end, and of the July column on the other, not all his boulevards ended in urban epiphanies (fig. 3.6). In 1927, the American city planner Elbert Peets criticized Haussmann's unbending roads, which he compared unfavorably to the axial streets of the great Renaissance architects. "These," he wrote, "are not merely straight and convenient thoroughfares. They are definitely mastered, rhythmically articulated aesthetic compositions. When you come into the street you feel its organic entity, usually as part of a dominant building. But come to the Boulevard Strasbourg-Sébastopol from the Gare de l'Est. You see, generally, a long vista lost in blue haze. Descending, you make out a smallish dome on axis; still further, and you come into one corner of the Place du Châtelet and discover that your street has no actual connection with the domed building, which faces in another direction."[17] Cultured voices had little leverage with the tastemakers of the Second Empire. Despite his education, Haussmann had a touch of the vulgarian about him; the emperor and the court favored the brassy bombast exemplified by the new Louvre.

The final master plan entailed few streets that had not been foreseen by the Siméon committee, which counted on the collaboration of specialists such as Perreymond, Lanquetin, Meynadier, Jacoubet, and the Lazare brothers, as well as the private sector.[18] All practical decisions concerning new thoroughfares, including length, and width, were taken by Eugène Deschamps, who became head of the Plan de Paris in 1859. Graded and seeded, and much broader than any of their predecessors, the new streets were delivered to the public ready-made, complete with lighting, gaslight, water mains, sidewalks, and trees, built and serviced with first-rate technical expertise. Strict ordinances were promulgated to regulate the height of buildings in relation to the width of streets. These had first appeared in 1783 under Louis XVI and were taken up by the Plan des Artistes, and later by the July Monarchy.[19] Political considerations also played a role: "in case of sedition," warned the Siméon committee, "troops would lose part of their power," dominated by buildings towering above the streets.[20]

The law of expropriations passed under Louis-Philippe in 1841 allowed the municipality to seize private properties whenever public interest required it. Powers were

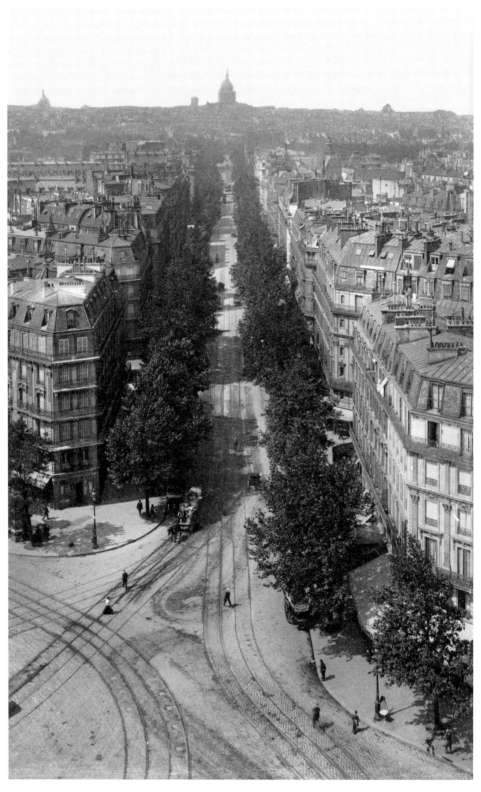

FIG. 3.6. The Boulevard Henri IV from the Place de la Bastille with the Panthéon in the background. Roger-Viollet.

considerably enlarged during the Second Republic with the Melun law of 1850, which gave municipalities the right to expropriate *logements insalubres* within the limits of the grands travaux.[21] These measures were given even broader scope by the decree of 1852, which enabled cities to expropriate properties along new streets for reasons of insalubrity and sell them at a profit when urban renewal was completed. Municipalities wanted a return on their capital.

Since the characteristic apartment buildings promoted by Haussmann were expensive pieces of real estate, tenants came from the wealthier echelons of society and developed a sense of entitlement toward the pampered spaces renovated for their use. In "The Eyes of the Poor," a celebrated passage in *Paris Spleen* (1869), Baudelaire exposes the anger inspired by the sight of the underprivileged in the new boulevards—an act of intolerance conveniently displaced to women. A ragged, prematurely aged father and his young children admire the magnificent café where the narrator sits with his mistress: "Not only was I touched by this family of eyes," writes Baudelaire's narrator, "but I was even a little ashamed of our glasses and decanters, too big for our thirst. I turned my eyes to look into yours, dear love, to read *my* thoughts in them; and as I plunged my eyes into your eyes, so beautiful and curiously soft [. . .] you said: 'Those people are insufferable with their great saucer eyes. Can't you tell the proprietor to send them away?'"[22]

GENDER

What determined compassion rather than contempt or indifference toward the poor was not gender but class. Yet gender had a major impact on the ways in which Haussmann's new Paris was experienced. In his book on the urban poor during the first half of the century, Louis Chevalier clearly established the asymmetry of the two halves of the city in terms of women. Based on available statistics, he showed how men outnumbered women in the poorest parts of the capital where work was seasonal, often executed by migrants from other parts of France.[23] During the second half of the century, the railroad changed the situation somewhat, though many workers still preferred to leave families behind and send their hard-earned remittance home. Yet if the number of female migrants to Paris increased, they earned significantly less than men for comparable work. As wages fluctuated according to neighborhood, single women often took jobs as domestic servants in the wealthy western half of the city.[24] There, the ratio of women to men increased at the expense of the eastern half where certain streets, rendered almost exclusively male by migration, became de facto "sexual ghettos."[25] Gender thus became a dividing factor socially and spatially, as women were more highly sought where they were most poorly represented.[26] Prostitution complicated this pattern by superimposing another shifting network of spatial relations that varied from day to night.

The broad new boulevards and their tributaries unquestionably affected all women's ability to navigate public space on their own (fig. 3.7). Writing at the height of the Second Empire, George Sand compared the opacity of old Paris with its snarled skein of narrow streets to the clarity of the new network: "Now that broad avenues, too linear for the artistic eye but unquestionably safe, allow us to saunter at length, hands in our pockets, without losing ourselves and being compelled at each step to consult the gendarme at the corner or the amiable street grocer, it is a blessing to stroll along a generous sidewalk."[27]

FIG. 3.7. Jean Béraud, *The Milliner on the Champs-Élysées*. Oil on canvas, 17.7 × 13.7 in. (45.1 × 34.9 cm). Undated but 1880s. Private collection.

For Sand, who valued her independence, security was a matter of priority, as was the ability to find her way about without asking directions. What others saw as a political problem (strategic boulevards), Sand perceived as an aesthetic one (avenues "too linear for the artistic eye"). For those who had time and leisure, Haussmann's new urban geometry spelled an unprecedented sense of freedom and ease. Sand epitomized a new generation of affluent, independent women determined to conquer public space. Her reference to strolling with her hands in her pockets alludes to her habit of cross-dressing in order to walk freely about town, a practice she shared with like-minded women of her class such as Rosa Bonheur or the feminist Louise Michel. "No one paid any attention to me or doubted my disguise," Sand wrote. "Furthermore, in order not to be noticed as a *man*, you must already be used to being overlooked as a *woman*."[28]

A generation earlier, Frances Trollope, who had visited Paris in 1835, was horrified at the sorry state of the streets: "In a city where every thing intended to meet the eye is converted into graceful ornament; where the shops and coffee-houses have the air of fairy palaces, and the markets show fountains wherein the dainty naïads might delight to bathe—in such a city as this, where the women look too delicate to belong wholly to earth, and the men too watchful and observant to suffer the winds of heaven to visit them too

roughly;—in such a city as this, you are shocked and disgusted at every step you take, or at every gyration that the wheels of your chariot can make, by sights and smells that may not be described."[29] And the pedestrian should consider himself happy, she continues, "if his eye and nose alone suffer from these ejectments; happy, indeed, if he comes not in contact with them, as they make their unceremonious exit from window or door."[30] Like Sand, with whom she was acquainted, Trollope resented the difficulties of moving about dirty and congested streets. Admittedly, she was a foreigner, and even less likely to be at home in dark passageways where her French peers feared to tread. Despite her conservative ideological convictions, so radically different from Sand's leftist leanings, she too saw the city's old streets as a threat to her freedom. Wealthy women could not afford to mourn the picturesque twists and turns of the vieux Paris when safety and respectability were at stake. They would have great difficulty threading their way through the tangle of gnarled alleys, even when accompanied by men, or in trousers. Women's response to Haussmann's infrastructure depended largely on social status. For working-class women, left to fend for themselves and their children, old streets functioned as extensions of home: the locus of their transactions (buying and selling goods or services); the place where their children played; where they found entertainment, and passed free time talking to neighbors. If they worked, they walked to their jobs. In times of hardship, they foraged in the urban environment like hunters and gatherers, surreptitiously cutting branches for firewood.[31]

STREETS AND BOULEVARDS

La rue, c'est le désordre.
—Henri Lefebvre, *La Révolution urbaine*

"In the nineteenth century," wrote Jacques Rougerie, "a Parisian insurrection is the confrontation of two spaces, if not of two cities. Paris of the people against Paris of 'bourgeois aristocracy,' in the parlance of the age."[32] It was as much a question of different conceptions of urban space, at times overshadowed by issues of gender, as of two clear-cut geographical areas. This clash played itself out in the arena of everyday life, as different social groups fought to control public space, or what came to be seen as such. The *peuple*, convinced that urban space was in effect public, traditionally had a closer relationship to the street.[33] A brief but striking passage in *Les Misérables* expresses this view succinctly. "Rentrons dans la rue," says Gavroche, the novel's streetwise, unforgettable urchin, to two abandoned children whom he had taken under his wing. *Rentrer*—to enter, to go home—is not used in situations such as this, in which the protagonist is actually going outside. By this masterstroke, Hugo calls attention to the exteriority that marked the lives of the urban proletariat, and to the streets that served as home and destination.[34] For the authorities, workers' intemperance in the greater Paris region had a clear source: it was the "absence of an interior and consequently the material obligation to live outside which leads them to frequent cafés and bars," stated an 1872 inquiry on the lives of the ouvriers.[35]

Streets had traditionally been places of sociability, constantly overrun by traffic, saturated by noise, encumbered by beggars, peddlers, jugglers, and itinerant musicians. Authorities frowned on such unregulated commerce, which the sedentary tribe of shopkeepers considered a threat to their income. It was in the street that the poor bought

most of their staples from other impoverished denizens, and use value could dominate exchange value.[36] Trades and occupations, not just social class, colored specific areas with their particularities. Despite dampness, filth, and poverty, the city's old streets were places where impromptu forms of entertainment unexpectedly illuminated the everyday. Spectators and spectacle mingled. For the poor, the street was an important locus of social interaction, a complement to cramped and inadequate homes.

In the eyes of the municipality and the moneyed classes, the intricate morphology of the old center fostered social practices that acted as a brake on modern commerce. By enforcing new codes of usage through surveillance, rules, fines, and special legislation, the authorities hoped to limit the rights of the poor in newly renovated enclaves. Dictating a sharp separation between public and private in upscale areas, the municipality discouraged the raw activities enjoyed by the disadvantaged: the dogged pursuit of livelihood, explosive nature of popular joys, and the organic ways in which small shops and entertainment meshed. These fell short, in the view of the authorities, of the genteel and profitable pursuits of capitalist commerce or cultivated idleness. In some neighborhoods, modest forms of retail characteristic of the poor continued to thrive; in others, they were replaced by high-end shops.[37] Department stores, aimed at a mass public, sprung up on both sides of the river, ruining small businesses with limited inventory and earnings. Secondhand clothing (*friperie*) was transferred to the new Carreau du Temple far from the center. Wine moved to a large entrepot at Bercy, then at the edge of the city.[38] The laboring poor, of course, resisted the increasing specialization and partitioning of urban space.

Broad, lined with spacious sidewalks and elegant buildings for residence, commerce, and consumption, Second Empire boulevards were based on a radically different concept of the *voie publique*.[39] Both more and less public than before, they underscored the discontinuity between the poorer and wealthier parts of Paris. The goal was to make Paris comprehensive for urban governance and attractive for consumption. Sidewalks, trees, street furniture, and house numbering helped tame the wayward disorder of narrow, insalubrious streets suspected of harboring or engendering revolutions. A stylistically uniform architecture, encouraged (though not dictated) by the municipality, now functioned as a clear-cut partition between the private realm of the house and the public arena of the street. No longer built to the scale of the pedestrian, roads were redesigned to sustain heavy traffic whose accelerated tempo marked them out as places of passage as much as, if not more than, social exchange. These trends were hardly limited to Paris and had to do with the social and economic forces that followed on the heels of industrial capitalism. New streets and boulevards superimposed on the fractured spaces of the city a mesh that allowed for faster circulation. Boulevards could also operate as a buffer, protecting the wealthier classes from the spaces of the laboring poor.[40] Broad thoroughfares acted as a check that controlled the complex and heterogeneous textures of the city, isolating specific neighborhoods far more effectively than military strategy could.[41]

Social cleavages left their stamp on these two rival street cultures: reactions to the city's arteries, old and new, depended largely on one's affiliations and position in life. Younger generations were often more tolerant of the metamorphosis of the capital that so shocked their elders. What for some were anomic and anonymous spaces, where older citizens felt lost and uprooted, for others spelled freedom from constraints and the ability to mingle freely with different social groups. Many liberals associated streets to lack of

surveillance. George Sand's praise of the new axial thoroughfares contrasts sharply to Hugo's requiem for crooked lanes in *Les embellissements de Paris*, a poem about Haussmann's transformations of the capital:

> That old Hydra Lutèce is dead; gone
> Are the anarchic streets running about in freedom.[42]

The emancipatory potential of streets—as opposed to the boulevards favored by the bourgeoisie—appears even more forcefully in *La Rue* (1866), written by the Republican Jules Vallès.[43] Streets could be made to serve questionable or unjust ends, but they could also stand for freedom, unfettered by the straight line. Broad thoroughfares inhibited the unpredictability of the old capillary network, beloved of writers and poets. Not surprisingly, after the Second Empire began its sweeping urban transformations, the death of the street became a favorite cliché of the opposition: "The street existed only in Paris, and it agonizes," wrote Charles Yriarte in 1867; "it is the reign of the boulevards and the advent of the broad arteries."[44] In fact, Haussmann left innumerable streets undisturbed. Renovation largely bypassed enclaves like the Marais and faubourg Saint-Germain. Old Roman roads like Rue Mouffetard, Rue Galande, Saint-Denis, Saint-Martin, and Saint-Jacques remained in use.[45] The obituary was premature: the street survived to die again and again, at the hands of more ruthless practitioners of redevelopment.

Haussmann's arteries served as much to divide as to connect different parts of the city.[46] Several streets and neighborhoods found themselves isolated by new boulevards and deprived of their former importance. Paris had always had its divisions, many of them dear to bohemians and modest literary circles, who dangled uncertainly between the affluent and the disenfranchised. Education gave them connections to the beau monde, poverty empathy with the poor. For these troubled souls, a growing uniformity threatened the entrenched characteristics of picturesque. Well-known writers and journalists also complained: "All this made for so many distinct little cities within the capital," wrote Fournel bitterly, "a city of study, a city of commerce, a city of luxury, a city of retirement, a city of popular activity and pleasure—yet linked to one another by a series of nuances and transitions. That is what is being effaced under the monotonous homogeneity of a banal magnificence that imposes the same livery on all the old neighborhoods, cutting everywhere the same geometric and rectilinear street that prolongs its rows of similar houses along an endless perspective."[47] The introverted preindustrial city had to make way for the extroverted metropolis.

Nevertheless, there was no clear-cut dichotomy between streets and boulevards. The clash between the two different concepts was partly a conflict over representations.[48] Boulevards were not impervious to the polymorphous pleasures extolled by some as typical of old streets alone. Baudelaire and his peers left eloquent records of the wild unrestraint of the imaginary, the joys of self-fashioning and adventure, and the escapist temptations made possible in and by the boulevard. And Surrealists and Situationists later found plenty of opportunities for phantasy and freedom in Haussmann's monotonous thoroughfares.[49] The capital's narrow streets were neither the exclusive haunts of thieves and vice, nor places of joyous release. The view of the old street as a locus of liberty, where home and shop overlapped, and classes brushed up against one another without friction, was itself an ideology, fueled by those who wrote about rather than actually resided in them. At times, this Romantic yearning for a mythical vieux Paris implied a political rebuttal of

the regime, whether from the Right or the Left. The pained realization that the affective, symbolic, and ludic potential of old streets was somehow at risk in the vast new spaces created by the municipality could also betray a rejection of modernity. Repudiation of the new took many forms.

While many lamented the death of the street, Napoleon III thought Haussmann did not go far enough and accused him of sacrificing the needs of circulation to his obsession with perspective: "'In London,' he used to tell me, 'one tries to solve as much as possible the requirements of circulation.'—My answer was invariably: 'Sire, Parisians are not English: they have higher aspirations.'"[50] The emperor's charge would be repeated in modern times. Half a century later, Haussmann's enlarged scale came to be seen as insufficient by Le Corbusier, who advocated rebuilding Paris without streets in his *Précisions* of 1930: "One must kill the 'corridor-street.'"[51] Haussmann's champion Sigfried Giedion concurred, expressing his appreciation for Haussmann's spatial practices in terms remarkable for their sexual overtones: "When Haussmann undertook the transformation of Paris, he slashed into the body of the—as a contemporary expressed it—with saber strokes. Cleanly he drew the blade, cutting keen, straight thoroughfares through the congested districts, solving his traffic problems by single daring thrusts. In our period even more heroic operations are necessary. The first thing to do is to abolish the *corridor-street* with its rigid lines of buildings and its intermingling of traffic, pedestrians, and residences."[52]

Narrow, often deprived of sidewalks and cleft in the center by an open gutter, the old streets required urgent attention (see fig. 2.9). Mrs. Trollope, who visited the French capital under Louis-Philippe, recorded her horror and disbelief at the survival of these pockets of decay: "On the subject of that monstrous barbarism, a gutter in the middle of the streets expressly formed for the reception of filth, which is still permitted to deform the greater portion of this beautiful city, I can only say, that the patient endurance of it by men and women of the year one thousand eight hundred and thirty-five is a mystery difficult to understand."[53] When it rained, pedestrians found themselves severely inconvenienced: downpipes poured water into the gutters; these, clogged by refuse, became swollen streams that rushed downhill until they found a sewer—which overflowed and backed up into the streets. Parisians were familiar with these improvised torrents that appeared regularly whenever it rained. In Balzac's *La Fille aux yeux d'or*, when the protagonist is kidnapped and blindfolded, the narrator observes that any Parisian would have discovered where he was being taken, simply by counting the number of streams crossed by the carriage as it sped along the boulevard in the rain.[54]

Mud, another problem that pedestrians had to contend with during much of the year, figures prominently in the literature of nineteenth-century Paris as part of the city's identity.[55] A telltale sign of poverty, mud singled out those who walked as opposed to those who rode. In *Les Misérables*, Marius would not go to the ball unless it was freezing "for he could not afford a hackney cab, and wanted to be seen only with boots [polished] like mirrors."[56] As usual, the laboring classes were more exposed than others to the indignities of trudging through mire, unable to pay the price of public transportation and often carrying heavy loads. Women had a harder time even without cumbersome crinolines, as they negotiated streets and traffic, and hoisted themselves onto omnibuses on rainy days when mud invaded the pavement. In Zola's *L'Assommoir*, Nana was given twenty minutes to walk from her home in the working-class neighborhood of La Goutte d'Or to her job

in Rue du Caire, center of the clothing trade. She took longer, of course, "trotting through the mud, bespattered by carriages, blinded by resplendent window displays."[57] Haussmann did much to remedy this state of affairs, but the vast building yards disseminated all over the city complicated the situation, and mud remained the norm in both the center and the outskirts, where most streets were still unpaved. Even in good weather, pedestrians had to wedge their way with difficulty through the city's web of winding streets, awash in water and refuse, dodging traffic, and skirting the walls of nearby buildings to protect themselves from overflowing gutters.

In order to improve the lot of pedestrians, old and new streets had to be provided with sidewalks, introduced under the ancien régime. Ironically, their etymology had nothing to do with pedestrians: *trottoirs* (sidewalks) came from *trotter* (to trot), a reference to the elevated paths built along the quays for horses and riders.[58] Rue de l'Odéon, whose elegant stores required space for window-shopping, was the first to receive sidewalks, in 1781, but they remained scarce until the Restoration, when Chabrol emphasized the need to make streets safer: "Embellished with admirable monuments, the capital of France, which has so many useful establishments, offers pedestrians nothing but an extremely arduous and even dangerous road network that seems to have been conceived exclusively for vehicles."[59] Commenting on some unusual benefits of sidewalks, the Comte de Laborde, director of the Ponts et Chaussées, observed in 1811: "Busy people, no longer having to focus their attention on which stones to walk on as they pick their way through the street, will devote all the more thought to their own interests, their work, and will enlarge their ideas accordingly."[60]

During the July Monarchy, Rambuteau began a campaign that effectively provided Paris with 195,000 meters of sidewalks.[61] They were expensive and took a considerable amount of space away from the city's constricted streets, already choked with handcarts, tumbrils, cabriolets, omnibuses, and riders (fig. 3.8).[62] Unlike the low, flat sidewalks of

FIG. 3.8. Les Halles, Rue Rambuteau. Roger-Viollet.

London, those of Paris were higher and edged with curbstones to protect pedestrians from wheels.[63] Drivers consequently gave them wide berth and complained that they contributed to the formation of traffic jams, as fewer vehicles could drive side by side. The first sidewalks were about eighteen centimeters high, and contemporaries often declared them unsafe for women and children, who ran the danger of falling off.

It is hard, today, to understand the largesse inherent in those broad, generous sidewalks that Haussmann bequeathed to Parisians: to make room for automobiles, many have been cut in half, and the double rows of trees planted on each side of his wider thoroughfares, reduced to one. Sidewalks changed not just the ways in which streets were used but also the typologies adjacent to them. Arcades or *passages* ceased to be built as it was no longer necessary to shield pedestrians from the drawbacks of old streets.[64]

WALKING

Sidewalks were not merely a technical solution to problems of urban circulation but reflected momentous social changes as well. Under the ancien régime and the Restoration, the nobility considered walking in public to be a stigma, the mark of those who could not afford horse and carriage. In his *Tableau de Paris*, Louis Sébastien Mercier devotes a short chapter to walking ("Aller à pied"), where he analyzes the hypocrisy of a society that overestimated those who rode: "Merit, talent, genius, virtue and all the virtues imaginable, count for nothing in the man who goes on foot."[65] Almost half a century later, Louis-Philippe was mocked for walking down the streets *bourgeoisement* with his wife on his arm, and an umbrella in his hand.[66] During the Second Empire, sidewalks came to be associated even more closely with the rising middle classes. With their elegant shops and cafés, boulevards conferred respectability on the pedestrian, whose status rose steadily throughout the century. The fact that all classes—aristocrats and moneyed elites sparingly—now walked along the street led them to differentiate themselves socially by their dress.[67] Elevated sidewalks led men to adopt trousers instead of breeches, and low rather than high heels.[68]

Yet even with sidewalks, moving through the streets of Paris remained hazardous because of the disastrous state of traffic. In the late eighteenth century, Mercier had painted a terrifying portrait of the situation: "The rich and the grandees who possess horse and carriage, have the barbaric right to crush and mutilate the people in the streets. Each year, one hundred victims expire beneath carriage wheels."[69] In case of accidents, he explains, the law protected the perpetrator: "After you have been ground alive by a coachman, one examines at the police commissioner if it is [the result] of the large or the small wheel. The coachman is responsible exclusively for the small one; and if you expire beneath the large wheel, there is no financial compensation for your heirs. Then there is a tariff for the arms, the legs, and the thighs; and the price is fixed beforehand."[70]

Fashionable streets and boulevards inherited this urban ideology that privileged those who rode, even though Paris had changed significantly since the preindustrial days of the ancien régime. Countless prints and paintings show the fast pace of the metropolis, with its sleek equipages and stylish horsemen. Well-heeled men and women crowd the broad sidewalks, but their presence on the streets of Paris was often limited to getting in and out of elegant carriages as they made their way into fashionable establishments. Those who

FIG. 3.9. Traffic island for pedestrian crossing between the Boulevards des Capucines and de la Madeleine. *Le Monde illustré*, March 11, 1865. Bibliothèque nationale de France, Paris.

walked on foot continued to be at risk, perhaps more so than before, since improved road conditions made for greater speed and a heavier volume of traffic. Horse-drawn vehicles jostled with pedestrians. Slow-moving wagons lumbered about, jamming streets and obstructing circulation. Since authorities had not found a way to separate horses from humans, crossing streets was perilous. Human traction remained a visible presence until the first decade of the twentieth century. In 1867, there were eight thousand carts drawn by women.[71] Child labor was rampant: in factories, the legal age established by law in 1841 was eight years.[72] Sand, who approved of the new thoroughfares, was horrified at the sight of men, women, and children pulling heavy loads alongside omnibuses, hackney cabs, and coaches, any of which could crush them like a twig. "They have found a way to forbid dogs in harness, can they not also abolish human yoke?" she asked.[73] Urban renewal itself blocked and endangered circulation as all construction materials had to be transported on overloaded carts that rumbled dangerously through the streets.[74]

It took decades for French cities, thronged by a rapidly escalating number of vehicles, to learn by trial and error to regulate traffic with appropriate laws. Not until 1851 was driving on the right side of the road enforced, as Mercier had first suggested.[75] Solutions like elevated iron bridges fell on deaf ears. Traffic islands, which helped pedestrians negotiate treacherous street crossings, were not introduced in the French capital until 1865, in imitation of those of London, but remained a rarity until the twentieth century (fig. 3.9).[76] And Parisians had to wait until after 1905 for traffic lights, an American invention, to be institutionalized.[77]

FIG. 3.10. *Une rue souterraine de Paris*, in Edmond Texier, *Tableau de Paris*, vol. 2, 1852. Bibliothèque nationale de France, Paris.

REDESIGNING STREETS

As the old walled city gradually lost its characteristics to acquire the edgy traits of a metropolis, the very notion of the street had to be reinvented. Significant improvements had already been undertaken under Rambuteau when the engineer Henri-Charles Emmery replaced the concave V-shaped thoroughfare that sloped toward the center (*chaussée fendue*) with a slightly convex surface, the *chaussée bombée*, with gutters along the sides between the carriageway and the sidewalk (fig. 3.10).[78] Connected to the sewers below, they prevented water from accumulating along the sides of the road. As Haussmann's engineers well knew, streets had to be designed not only on plan but in section. Countless illustrations of the time reveal the public interest in the new thoroughfares, which now acquired an underground component.[79]

The appearance of the omnibus, with its heavy, cumbersome structure, made broader and more resilient roadbeds imperative. Both the design and the materials of the traditional street had to be overhauled. The July Monarchy had experimented with new technologies, emulating British engineers such as Thomas Telford and John Loudon McAdam, who literally "built" their roads piling layer upon layer.[80] Over the years, Parisian administrators had experimented with different kinds of pavements for streets and sidewalks.[81] Engineers had to take into account the weight sustained by Parisian roadbeds, durability, and construction and maintenance costs.[82] Pedestrians and horses required user-friendly road surfaces. Granite or sandstone paving had the disadvantage of permitting little traction and being notoriously hard on horses. Worn by constant use, stones became smooth and slippery when wet.

Noise—the percussion of wooden wheels on cobblestones—constituted a serious handicap of all forms of lithic pavement. With their harsh, unforgiving surfaces, cobblestones amplified the sound of wheels, hoofs, and footfalls. Baudelaire rightly bemoaned the "deafening street" (*la rue assourdissante*).[83] At night, citizens were woken by heavy carts making their way ponderously through the deserted streets. Family members often threw straw in front of their houses to soften the roar of the traffic for the sick or the dying.[84] Acutely aware of the issue, Haussmann and his experts gave a great deal of thought to new kinds of pavement, trying out different experiments.[85] In some streets, municipal engineers turned to macadam, a mixture of compressed sand and gravel superior to stone in some respects. Macadam muffled the clatter produced by animals and vehicles on the echoing streets. It also facilitated traffic and speed, as horses fell less frequently.

Invented in the eighteenth century by the Scottish engineer John Loudon McAdam (1756–1836), macadam had previously been employed chiefly on military roads. Rambuteau used it on streets surrounding hospitals, courthouses, and theaters, because of its noise-absorbing properties.[86] An expert horseman, Napoleon III generalized its usage, although macadam caused major problems for pedestrians. Constant erosion produced so much dust that road surfaces had to be hosed down several times a day, blocking sewers with sand and gravel. Dusty and brittle in good weather, hopelessly muddy when wet, its upkeep was expensive.[87] Macadam also affected the trees that lined the boulevards, clogging the pores of young leaves.[88] Some hygienists claimed it caused or aggravated lung disease.[89] Haussmann tried to dissuade the emperor from using it, but Napoleon III loved to ride and stubbornly refused to consider alternative forms of paving on his favorite boulevards. "An accomplished rider like the Emperor," wrote the prefect in his memoirs, "would not hear of asphalt, nor of wood, nor above all of granite or porphyry pavement for our great arteries. In these, His Majesty would only permit macadam, this exorbitant, dirty method, often intractable for pedestrians; I accepted it gladly in our avenues and parks closed to heavy vehicles and bordered with paths, but I considered it a scourge in the interior of a large city like Paris."[90]

Politics often dictated the choice of pavement. As cobblestones were the prime material used for building barricades, they became synonymous with revolution. After the uprisings of the 1830s and 1848, dozens of contemporary epigrams sprang up linking cobblestones to urban warfare (fig. 3.11). "Macadam," wrote Fournel, "has abolished *le pavé*, that essential element of barricades."[91] Hugo, an eyewitness of the revolutions of 1830, 1832, and 1848, also underscored the connection between pavement and insurgency: "The government has found a way to prevent revolutions. Revolutions spring from barricades, it said, and barricades spring from paving stones. It is now covering the boulevards and the faubourg Saint-Antoine with macadam."[92] The popular classes themselves came to be associated to cobblestones by metonymy: "Just as one calmly

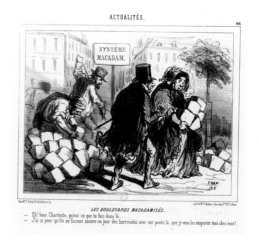

FIG. 3.11. Cham (Amédée de Noé), *Macademized Boulevards*, 1850. Bibliothèque nationale de France, Paris.

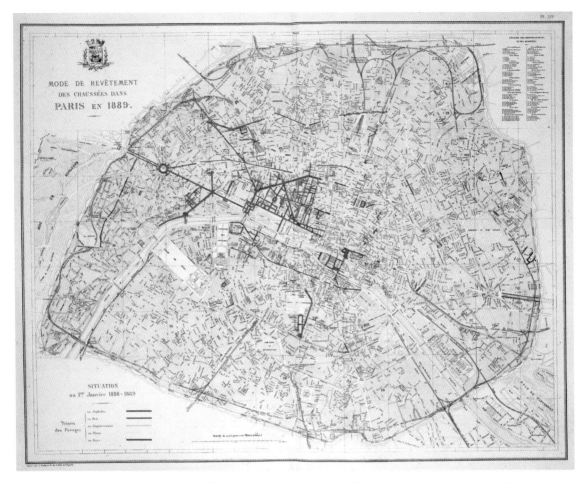

FIG. 3.12. Plan of Paris showing different types of pavement. Asphalt and wood (more expensive than cobbles) appears only in the western part of Paris. Alphand, *Les travaux de Paris, 1789–1889*. Courtesy of the Yale University Library.

replaces today the cobblestones that had been used as a weapon in July, so as to erase all trace of revolution," wrote the German poet Heinrich Heine, "so too are the people being shoved back into their old lowly place, and trampled underfoot as before."[93]

Although liberals saw macadam as a political ploy to forestall insurgency, cost alone ensured that it would be used primarily in the richest part of the capital: Rue de Rivoli, Rue Castiglione, Rue de la Paix, Boulevard Malesherbes, Boulevard des Italiens, Avenue de l'Opéra (finished in 1878), Boulevard Saint-Germain, and other well-traveled roads. The city's eastern half continued to be defined largely by paving stones rather than bourgeois macadam (fig. 3.12). Adopted autocratically by Napoleon III, macadam disappeared after the Commune, when it was replaced by sandstone.[94]

Wood was also used to face roads and sidewalks.[95] Horses slipped less frequently on wood than on compressed asphalt and could thus carry heavier loads. In humid weather, however, it swelled, pushing the curb of the sidewalk outward.[96] Fire constituted a far more dangerous hazard. As French engineers were later to find out, it was because the streets

themselves were combustible that the great Chicago fire of 1871 was so devastating: the inflammable wooden surfaces helped propagate the fire and prevented water pumps from arriving.[97] Wood paving was expensive, though less so than macadam.[98] Asphalt, equally costly, could be found exclusively toward the west, around the opera, and the Palais-Royal. In *Le Diable à Paris*, Balzac laments the mixture of asphalt and stone that characterized street pavement in his day, "for in Paris one also thinks with one's feet, and this change in pavement, jostles the head."[99] Despite the attention and enormous sums lavished on the urban network under Haussmann, Parisian streets remained poorly paved and maintained throughout the Second Empire.[100]

Paving was another component of streets and boulevards that had a bearing on women's presence in public space, although women did not always agree on what was best. Madame Baroche, wife of one of the emperor's ministers, observed that during the 1867 exposition, women raised clouds of dust as they swept the pavement with their voluminous dresses.[101] Not all women were opposed to macadam, however. Mrs. Trollope criticized the noisy cobbled streets and regretted the lack of macadam, which, for a conservative such as herself, had the added advantage of deterring revolution: "I feel that the Macadamized streets of London ought to become the subject of a metropolitan jubilee among us. The exceeding noise of Paris, proceeding either from the uneven structure of the pavement, or from the defective construction of wheels and springs, is so violent and incessant as to appear like the effect of one great continuous cause,—a sort of demon torment, which it must require great length of use to enable one to endure without suffering. Were a cure for this sought in the Macadamizing of the streets, an additional advantage, by the bye, would be obtained, from the difficulties it would throw in the way of the future heroes of a barricade."[102]

Old and new streets had to be constantly cleaned, paved, and mended. Their maintenance played an important role in the iconography of nineteenth-century Paris. *Cantonniers*, in charge of cleaning streets, were ubiquitous figures, accompanied by long brooms and watering cans, sporting their blue livery in summer, wrapped in sheep-skins in winter.[103] When streets had to be hosed down during hot months, huge barrel-shaped reservoirs would pass through the city, spraying water as they went. "Only the principal thoroughfares of Paris, as the Boulevards and the Rue de Rivoli, are watered by carts," wrote William Blanchard Jerrold; "the rest are damped by the cantonniers, who may be seen wielding huge cans in the middle of the road, and dexterously sprinkling water from them from one kerb to the opposite kerb."[104] Such cans were a sure sign of poverty, as the municipal services demanded a large security deposit for watering carts, which street cleaners could ill afford.[105] Since they were paid a pittance for their labor, the job attracted the poorest workers, usually Alsatian or Hessian immigrants, and often women.[106] They lived in grinding poverty, either in the fifth arrondissement or in the German colony at La Villette, one of the city's many ethnic villages. Before dawn, noted writer Amédée Achard, "squads of *balayeuses* fantastically accoutered in rags and tattered clothes like the grotesques of Callot" were busy sweeping streets before the public awoke.[107] Trash and manure from horses was left in neat little piles on the side of the road so they could be swept into carts by the *boueur*, who bought them from the city and sold them as fertilizer.[108] Street pavers, equally visible in urban space, appear in Manet's *Street Pavers, Rue Mosnier*, of 1878 (fig. 3.13; see also fig. 2.4). These were remunerated somewhat better.[109] Unseen was the back-breaking, dangerous labor of those

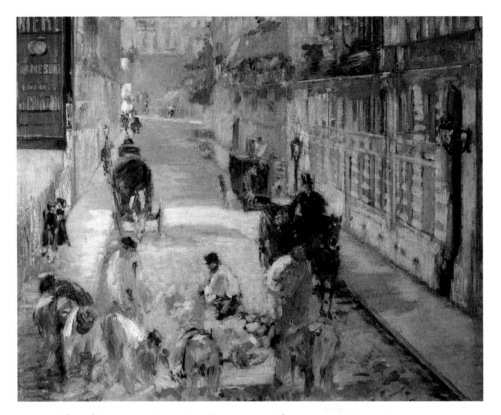

FIG. 3.13. Edouard Manet, *Street Pavers, Rue Mosnier*, 1878. Oil on canvas, 25 ¾ × 31 ½ in. (65.4 × 80 cm). Fitzwilliam Museum, Cambridge.

who broke up stone into blocks, and inhaled alarming quantities of dust. Courbet recorded their labor in *Les casseurs de pierres* (1849), destroyed during World War II, and Seurat depicted them several times. New machines powered by steam were being devised to replace stone breakers, whose strikes threatened to bring municipal works to a halt.[110]

SOUND

It is at street level, where it intersected with everyday life, that the new infrastructure of Second Empire Paris must be studied to capture the social richness of old streets and neighborhoods. Morphology is not sufficient. "The places we have known do not belong only to the spatial world where we situate them for the sake of convenience. They were merely a thin slice in the midst of contiguous impressions that formed our life at that moment," wrote Proust.[111] Space is textured by superimposed experiences of the human sensorium— the tactility and close view enabled by proximity, as well as the disembodied panoramic vision made possible by distance. Acoustic perception complicates this pattern by establishing its own cadences in counterpoint to the city as seen, drawing the distant close in ways impossible for the eye. Space can be heard before it is seen.[112] Aural landscapes interrupt and contradict the architectural legato of the street, superimposing another scenario of discontinuous sounds, not necessarily proximate to one another.[113] Pedestrians walking about the city could hear, simultaneously, a flock of birds flying high above, bells pealing in

the distance, and the cries of peddlers hoarsely hawking their wares. Sounds also served as semiotic markers, "helping people locate themselves in space as well as time."[114]

With their crooked itineraries and picturesque impracticalities, the old arteries were accompanied by a street culture eulogized by the city's literati, who feared that this rich urban lore was being threatened by the grands travaux. The intimate scale of the close-grained urban fabric with its unhurried pace, stamped with the particularities of sound and smell, contrasted with the abstractions of the clean-swept boulevards whose vastly enlarged scale entailed perceptual shifts, making new demands on the eye and the ear. Increased traffic, new patterns of consumption, and hygienic reform probably did as much as urban renewal to wipe out old street trades and local usages. Among the most notable were the famous *cris de Paris* chanted by itinerant street vendors plying their trades: organ grinders, knife sharpeners, ragpickers, and other small-time "entrepreneurs." Over the centuries, their melodies were codified into easily recognizable formulas. Dressed in the attire characteristic of their profession, and announced by vocal or instrumental accompaniment, their colorful figures came to be much admired when they could no longer be taken for granted. Although street life hardly died out with Haussmannization, peddlers depended on special permits, which were increasingly hard to come by: an 1863 ordinance, for example, forbade clowns and organ grinders.[115]

The polyphony of the city had unlikely sirens. A growing literature, which reached its high-water mark at the turn of the last century, set out to record this rich oral history, the culmination of a trend that had begun centuries earlier: the Renaissance composer Clément Janequin (ca. 1485–1558) had already found a place for them in his music. In 1857, composer and musicologist Jean-Georges Kastner published the symphony *Les Voix de Paris*, based on his research on extant and long-vanished cries. Thirty years later, Fournel's book *Les Cris de Paris* attempted a history of these street vendors and their chants.[116] Gustave Charpentier introduced Parisian street cries to his acclaimed opera of 1900, *Louise*. Proust, that specialist on memory, speaks lovingly of the *récitatifs* sung by the people and the "popular themes finely written for varied instruments, from the horn of the porcelain mender, to the trumpet of the upholsterer of straw seats."[117] In a memorable article published in 1944, Leo Spitzer traced the pedigree of one of these raucous chants, used by both Proust and Charpentier, back to the Middle Ages, showing their astonishing longevity.[118] Though threatened, the dramaturgy of the street did not cease. It is interesting to compare this lyrical evocation of the vanishing cries to Mercier's irritable dismissal of the shrill, discordant tunes of his day, unintelligible to all but servant girls "who have a far more discriminating ear than the academician."[119] Modernity had rendered them picturesque and all the more acceptable for being embellished with a docile, apolitical stance. Quaint individuals who sold their wares and services singly did not have the same threatening connotations as the *peuple*. The *cris de Paris* engendered an urban ethnography heavily tinged with the melancholy glow of nostalgia, an antidote to the bewildering Paris of the nineteenth century.

Some unusual street occupations accompanied by chants had originally come into being in response to the sorry state of the capital's urban network. Rain itself called forth a series of trades. Strategically positioned *passeurs* facilitated the crossing of streets and open sewers with portable planks. Women were helped across these rudimentary bridges, with one of those cries: *"Passez, beauté."*[120] There were also *décrotteurs*, who removed mud spatters with pail and brush once pedestrians had arrived at their destination, and ubiquitous

water carriers, whose precious merchandise was even more necessary when it poured and alleyways gurgled with mud and refuse. Itinerant peddlers and tradesmen elicited a certain amount of voyeuristic curiosity, not least because those who carried out these menial tasks came traditionally from the provinces. According to Mercier, who chronicled their stories with great sympathy at the end of the ancien régime, "The Savoyards are *décrotteurs, frotteurs* [those who scrub and polish parquets] and woodcutters; the Auvergnats are almost all water carriers; the Limousins, construction workers; the Lyonnais usually pick locks and carry sedan chairs; the Normans are stone breakers, lay cobblestones, and sell yarns."[121] These forgotten dimensions of the old Parisian network show the limitations of visual approaches to urban space, with their exclusive interest in form, to the exclusion of hearing, "this delicious sense that brings us the company of the street," Proust wrote admiringly.[122] One cannot accord an ontological priority to space: it is not a neutral container that precedes social content but is continuously shaped by it even as it molds it in turn.

ARTIFICIAL ILLUMINATION

To boost circulation and security, Haussmann modernized street lighting. When gaslight made its first appearance in the Passage des Panoramas in 1817, under Louis XVIII, opponents railed against its smell, toxic properties, and potential danger (fig. 3.14).[123] Gas emitted a terrible stench, ruined trees and vegetation, and reached its full potential only after midnight, when most of the population was asleep.[124] It would be years before the first public space was artificially illuminated, the Place du Carrousel in 1829.[125] Politics may have colored the initial opposition to gas, since it was associated with Great Britain, the leading country in this domain. Who shall defend us from gas? asked writers Charles Nodier and Amédée Pichot rhetorically: "truly patriotic men who prefer France to England, national to foreign industry, public safety to the success of a few speculators."[126] Artificial illumination also met with strong hostility from the church, which condemned it as a simulacrum that reproduced God's alternating cycles of light and darkness.[127] Science and technology replaced Providence in dispensing—for a fee—basic services like light and heat, now felt to be rights to which all citizens were entitled.

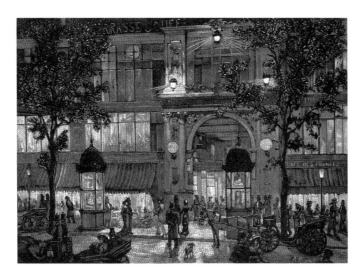

FIG. 3.14. The Passage des Panoramas lit with gaslight. *La Lumière électrique*, July 9, 1881. Bibliothèque nationale de France, Paris.

FIG. 3.15. Charles Marville, lamp-post, courtyard of the Louvre, 1878. Bibliothèque historique de la Ville de Paris.

The industrialization of light did not immediately sever its connection to nature. Initially, street lighting depended on the season and on the moon, just as it did when candle-lit lanterns were the norm. Gaslight was used systematically from October to the end of March when both permanent and impermanent lamps were lit; during the rest of the year, many city lamps would be lit exclusively during part of the night or not at all, if they could be replaced by moonlight.[128] "A cloud is all it takes for a man to be robbed," quipped an observer in 1835.[129] Only slowly did public lighting emancipate itself from the seasons and yoke itself to the rhythms and requirements of the modern city.

Haussmann improved the quality and quantity of street lighting significantly. It 1857, mains were installed beneath the roadbeds to light boulevards by gas.[130] At dusk, an army of lamplighters would appear, and begin its task street by street, lamp by lamp—a job, Nadar notes, that in his youth was done by women.[131] Haussmann took special interest in the variety of candelabra used throughout the city, though he perceived these in terms of social class. Davioud designed them according to need and context. In the wealthiest parts of the city, their elegant detailing exceeded utilitarian function.[132] Marville's photographs record

FIG. 3.16. Edward Radclyffe after Eugène Lami, *Boulevard des Italiens*, 1843. Lithograph. Musée Carnavalet, Paris.

the striking originality and variety of Davioud's cast-iron structures, many of which have disappeared (fig. 3.15).[133] New forms of lighting also reflected capitalist concerns. In 1856, to control the quantity of gas supplied to the city, Haussmann unified the different companies in one overarching monopoly, the Compagnie parisienne d'éclairage et de chauffage par le gas.[134] Paris's prefect of police, Pierre-Marie Piétri, had already combined six lighting companies under the direction of a single consortium owned by the Péreire brothers.[135] Haussmann changed the treaty to include the annexed territories and increase revenue for the municipality. Personally scrupulous when it came to money matters, Haussmann was nevertheless sensitive to corporate interests within the imperial entourage. By awarding crucial services to private enterprises or cartels, Haussmann did not always pursue the municipality's best interests. Transportation, gas, postal services, and the city's own railroad were all privatized under his tenure.[136] There were advantages to placating powerful lobbies.

In these early experimental years, "public" lighting was distributed unevenly over the urban territory in ways that mirrored the capital's social divisions. The civilizing aim of gaslight served primarily the interests of the propertied classes and the forces of law and order. As a powerful deterrent to crime, gaslight had acquired a well-established connection to consumption (fig. 3.16). Lit by gas, the center became an enormous display window, teaming with commodities including light itself. Already in 1835, Mrs. Trollope had complained of "the profound darkness of every part of the city in which there are not shops illuminated by the owners of them with gas. This is done so brilliantly on the Boulevards by the *cafés* and *restaurans* [sic], that the dim old-fashioned lamp suspended at long intervals across the *pavé* is forgotten. But no sooner is this region of light and gaiety left, than you seem to plunge into outer darkness; and there is not a little country town in England which is not incomparably better lighted than any street in Paris which depends for its illumination upon the public regulations of the city."[137] Forty years later, much of the light that flooded the center still came from the private sector, wrote Maxime Du Camp in 1875: "Our old boulevards, arcades, the galleries of the Palais-Royal, and a few streets belonging to rich neighborhoods receive, until ten or eleven o'clock at night, more light from private sources than from the municipal administration; some squares are still very dark, and one would do well to supply them with candelabra; the absence of shops seems to condemn them to perpetual shadow."[138]

Annexation of the outlying suburbs aggravated the east-west polarity that had divided the city into zones that differed greatly in terms of income, and thus, lighting. Those who resided outside the old excise walls had little or no capital to invest in stores and restaurants that could afford dazzling illumination. At night, the periphery seemed permanently mantled in obscurity. Although all the city's gas plants were situated in the outskirts, its residents could not count on much public lighting. Yet the Second Empire's prefects were hardly the first to neglect the periphery. Rambuteau installed nine thousand gas lamps in the center, while the outlying quartiers had to make do with three thousand atavistic lanterns that lasted well into the Third Republic.[139] In the laissez-faire climate of the July Monarchy, private companies were free to provide light for whom they chose. Writing in 1843, Perreymond had already exposed the circular thinking that trapped the poor in areas that the private sector had no interest in servicing: "We thus arrive at this absurdity: the more districts are commercially active, the more abundant the light furnished by the city; the more districts lack liveliness and stagnate, the weaker the illumination."[140]

Gaslight did away with some of the traditional patterns of temporality that distributed citizens in urban space during specific slots. Social life now extended into the early hours of the morning, allowing wealthy customers to claim urban space for ludic purposes, as they did during the day. The boundaries of time were thus pushed further and further back, heightening class distinctions.[141] Gaslight had no such connotations for the laboring classes. The abundance of light with which Haussmann flooded certain parts of the city served to compartmentalize them in areas that were poorly illuminated. Their residents' enjoyment of its leisure-related benefits was limited to special holidays when Paris was lit up. Colonized by light, wealthy areas could now discourage undesirables who posed a threat for consumption. "The clarity of gaslight that supplanted lamps and lanterns [. . .], the vast new arteries of communication that replaced the tenebrous alleys that favored crime and where our fathers groped their way about, have done more for urban security than all the homilies of moralists," observed Du Camp.[142]

Gaslight revolutionized the experience of urban life and urban space. Benjamin once remarked that the appearance of gaslight transformed the street into an interior.[143] With its architectural embankments rising on either side, punctuated by glowing candelabra, the corridor-street was sharply defined as an exciting container, both protective and protected, heightening the appeal of a city that could now be consumed by night. Day no longer had a limit. Flickering gas jets transfigured buildings in the public and private sectors, reinforcing the notion of Paris as spectacle. In 1829, Meynadier tried out, at his own expense, a new system of illumination along one side of the Palais-Royal. Conceived as a practical way of lighting the street, his invention was criticized because, he acknowledged, the source remained invisible; despite its utility, it had the disadvantage "of not being a spectacle."[144]

On special holidays, the regime used gaslight to dramatize important landmarks and create breathtaking displays. Darkness blotted out the everyday, yielding urban space to the reign of fantasy and the pleasure principle. Nocturnes were a specialty of Haussmann, who loved to organize magnificent fireworks from the splendidly illuminated Hôtel de Ville, once a symbol of communal liberties, and now eagerly inscribed in imperial narratives on important dates. He had mastered the craft of urban cosmetics as a young subprefect in the Gironde, when he had the banks of the Garonne magnificently illuminated in honor of Louis-Philippe's sons.[145] With the help of Alphand, a *metteur-en-scène* of genius,

FIG. 3.17. Jules Gaildrau, "Chinese" illumination at Place de la Concorde, August 15, 1858, during the Second Opium War against China, 1858. Bibliothèque nationale de France, Paris.

he later transformed Bordeaux into a spectacle grand enough to receive the new president-elect, Louis Napoleon. Like bread and circus, power and spectacle went neatly hand in hand. Contemporaries rhapsodized over the theatrical pageantry of nocturnal illumination and imperial scenography. Du Camp records the oneiric effect generated by one of these ephemeral gaslit celebrations, which drew huge crowds to the center, where "long ribbons of fire highlighted the crown of the Arc de Triomphe, reproduced the contours of the Hôtel de Ville, prolonging themselves like glittering strands of pearls along the Champs-Élysées."[146] Imperial time followed a cyclical pattern. On Saint-Napoléon (August 15), the most important *fête impériale*, dazzling fireworks lit up the sky. Theatrical tableaux recapitulated the Napoleonic legend, military victories, and colonial conquests.[147] Invented by Napoleon Bonaparte to honor a dubious saint, the holiday fell (not coincidentally) on both his birthday and the Feast of the Assumption.[148] Hours of entertainment—fireworks, illumination, and elaborate theatrical displays across the city—required an occasionally tense collaboration between architects of the emperor and those of the Hôtel de Ville.[149] Napoleon III sometimes intervened in planning the ambitious son et lumière pageants. At Place de la Concorde, the epicenter of the festivities, lavish decors, often Orientalist, evoked the French colonial empire overseas (fig. 3.17).[150] For the regime, the stakes were high: to produce legitimacy while channeling popular emotions in harmless directions to forestall opposition.[151] At night, when the unwanted scaffolds and building yards were magically obliterated by darkness, the city became a dreamlike spectacle thanks to the operatic splendor of this triumph of appearance over substance, a sumptuous exaltation of surfaces and façades, and the use of crowds as consumers rather than participants. By hammering their messages across through iconography, style, location, and sound (whether military bands or Te Deums), the great fêtes sought to foster allegiance to the Bonapartist cause.[152] With their emphasis on military exploits, they underscored the regime's "essentially masculine conception of the public sphere."[153] There was also free food distribution for the poor, and free opera for others. The festivities also staged new representations of urban space based on spatial hierarchies having to do with the capital, the nation at large, and the colonies, passing over unimportant areas of the city or the empire.

The "administered" *fête impériale*, handed down to the populace like a giant artifact, offered a challenge to the spontaneous and unconstrained *fête populaire*.[154] Yet binaries like these, Alain Corbin rightly points out, tend to erase continuities: subversion and derision were always present in the regimented fêtes of the regime while popular forms of entertainment often borrowed from the structures of power that they set out to ridicule and subvert.[155] Nevertheless, the modern division of labor introduced new rules that slowly eroded the population's traditional celebrations.[156]

The industrialization of light had a profound impact on both architecture and urbanism. Thanks to gas, apartment buildings became larger and wider, as stairways and corridors could now be lit artificially.[157] Preindustrial apartment buildings, by contrast, were either reduced to thin wedges running parallel to the street, or pierced by light wells and courtyards, in themselves damp and dark. Gaslight thus contributed, albeit indirectly, to the creation of the long, uniform façades that defined the boulevards.

Yet such was the opposition to gaslight that only gradually was it allowed inside the privacy of the home. Gas, wrote Edgar Allan Poe in 1840, "is totally inadmissible within doors. Its harsh and unsteady light offends. No one having both brains and eyes will use it."[158] It could perhaps be used in the hall and maybe the dining room, concurred Du Camp, but never in the salon.[159] Reluctance to adopt it was prompted by fears that gas would discolor curtains and wall hangings, tarnish metal, and darken ceilings.[160] Indoors, gaslight had a terrible effect on women's faces and on their dresses. "This abominable gas should be systematically thrown out of all restaurants, theaters and all public places," wrote another contemporary. "At best, one might tolerate it in stairwells. Its true place is outside. It may be useful when it comes to illuminating streets, but indoors it is intolerable. It is the absinth of the eyes [. . .], the worthy counterpart to photography."[161]

Initially perceived as garish and vulgar, gas eventually became an object of nostalgia when it was edged out by electricity. In his wistful evocation of gaslight, written at the close of the nineteenth century, Robert Louis Stevenson regretted that a single switch could suddenly light up an entire city with the glare of electricity.[162] He ached for the softness of gaslight and its relation to temporality: the slow rhythm of lamplighters as they made their way about town, turning on the hissing gas jets one by one. Perhaps, too, he missed the sense of human agency implied by gaslight. "The word *electricity* now sounds the note of danger," he wrote in 1895. "In Paris, at the mouth of the Passage des Princes, in the place before the Opera portico, and in the Rue Drouot at the *Figaro* office, a new sort of urban star now shines out nightly, horrible, unearthly, obnoxious to the human eye; a lamp for a nightmare! Such a light as this should shine only on murders and public crime [. . .]. To look at it only once is to fall in love with gas."[163] Memory mellowed gaslight's effects; it could be savored retrospectively, like the muted and subtle world of Whistler: a symphony of twilit hues.

The first attempts at public lighting with electricity took place under Haussmann. In 1856, the Champs-Élysées were illuminated for four consecutive hours from an arc lamp placed on top of the Arc de Triomphe.[164] This remained an isolated experiment until the Third Republic, when the Avenue de l'Opéra was lit by electricity in 1878. As Haussmann noted, the first electric lamps gave out a strong unpleasant glare that changed the appearance of the city at night.[165] Because gas lamps had to be placed closer together, they produced a softer light, the "old mild lustre" that so enchanted Stevenson in later years.[166]

Public lighting established clear-cut social and psychological thresholds that regulated urban space according to class and gender. Time, as marked by gaslight, was a critical index of status and respectability for women. If they were middle or upper class, their presence in public, alone, depended on daylight. When darkness fell and the lurid glare of the gas lamps was turned on, prostitutes swept down punctually from the slopes of Montmartre: "At six o'clock, great commotion! the faubourg comes flouncing down the hill! From the quartiers of Bréda and Notre-Dame-de-Lorette, women sail forth in conquest of the Boulevards. That area can be heard from afar by the jingling of jet-stones, the smell of musk, and silk swishing by."[167] Even before the Second Empire, gaslight had considerably enhanced prostitution's brazen visibility. Haussmann's well-lit boulevards, lined with cafés and restaurants, assured it an even stronger presence in the urban realm, offering it an elegant venue where it could be both displayed and contained within spatial and temporal boundaries. "Today," fumed the Goncourt brothers, "prostitution is well-established in Paris, planted squarely in the boulevard cafés, fully [illuminated] by gas, lined up in ranks facing the passers-by, both insolent with the public and friendly with the waiters in white aprons."[168] This unintended result of the spread of gaslight went against the wishes of the upholders of law and order, who strove to clean up the center and curb unwanted functions.

Laboring women could not afford to limit their wanderings to daylight hours. They used space and time differently from their affluent peers and crossed the city at all times. Necessity made them mobile. They had to breach the erotic frontier of night and were often subject to harassment, as Julien Lemer noted in 1861: "Everywhere around here [the new Boulevard de Sébastopol], between eight and ten at night, the laborious ouvrière leaves her job in a modest work outfit; we often see her half-close her ears to the gallant propositions of the followers of women [suiveurs de femmes] who obstinately seek adventures, offer them their arm in good weather, their umbrella if it rains, at times dinner, their heart and a hackney cab always."[169] The spatial-sexual division of labor entailed adversarial temporal relations between classes and between sexes. Nocturnal space was construed taking men's wishes into account, exposing poor women to risk.[170]

If the impact of artificial illumination on the lives of the population differed according to gender and class, it was in the world of labor that it brought about the most striking changes. By prolonging daylight, gaslight lengthened the proletariat's working day. As Engels had argued in The Condition of the Working Class in England (1845), the social unrest that occurred in a factory at Manchester after 1844 was a direct result of the introduction of gaslight to increase productivity.[171] In Paris, artificial light "made night disappear" and was immediately co-opted by construction, given the feverish pace of building activity under the Second Empire.[172] First adopted by the Péreire brothers, whose luxurious Grand Hôtel du Louvre had to be completed in time for the 1855 World's Fair, it allowed workers to toil through the night. Within a few years, arc lighting, and later electricity, replaced the use of gaslight in all major construction sites. These huge nocturnal chasms with their violent chiaroscuro became an attraction in their own right, as attested by the high number of illustrations of different projects by night—one of the repositories of the urban sublime (fig. 3.18).

Light's symbolic power as a commodity was not limited to artificial illumination. Sunlight had been perennially absent, wrote Julie de Marguerittes in 1855, in the "immeasurably high houses, situated in the narrow bye-streets of old Paris, into which the sun can

FIG. 3.18. Construction work on the Grand Hôtel du Louvre, Rue de Rivoli. *L'Illustration*, September 30, 1854. Bibliothèque nationale de France, Paris.

scarcely ever penetrate, and from which in many places it is entirely excluded, owing to the houses having a friendly inclination to meet at the top, nowise satisfactory to those bold enough to look overhead."[173] Whether natural or artificial, domestic light was an expensive proposition that the poor could ill afford, and it remained an important index of social class well into the early twentieth century.

Before gaslight and electricity became affordable, the lower middle class used oil or kerosene lamps while the laboring poor made do with candlelight.[174] Even this was beyond the paltry resources of the most destitute part of the population, who relied on daylight savings. In *Les Misérables*, Fantine, who has fallen on hard times, learned to economize her scant provisions by snuffing out her candle when the neighbors lit up, eating her meager fare by the uncertain light of the house next door.[175] Though fictitious, Hugo's character underscored the plight of those who lived in darkness once the sun had set. Du Camp heard of a similar case, when preparing his six-volume anatomy of Paris, written during the Second Empire: in one of the city's charitable institutions for fallen women, inmates remembered having to go to bed at sundown since there was no money for candles.[176] Half a century after gaslight was finally introduced into the private sector under Louis-Philippe, it was still beyond the reach of the underprivileged. Although it was cheaper than oil or candles, the poor could not afford the expensive equipment and installment costs involved. Throughout the second half of the century, the petite bourgeoisie itself had great difficulty in procuring fire and light, particularly in winter. Hence the importance of semipublic spaces like cafés, where both could be had for a few sous.[177]

In Paris, this correlation of light and class was mostly visible at night. Despite the initial reluctance to make use of gas, the bourgeoisie eventually embraced it wholeheartedly: affirmation of status through ostentatious display of light was no longer the preserve of the aristocracy. On plan, Paris resembled a star of great intensity that faded progressively toward the periphery. In section, this pattern was countered by another: buildings, and often entire streets, became darker as the eye traveled up the façades. Before elevators bestowed the same real estate value to all floors by making them equally accessible, Parisian apartment houses were characterized by decreasing incomes from the first floor up (fig. 3.19). When gaslight became widespread, the symbolism attaching to the abundance

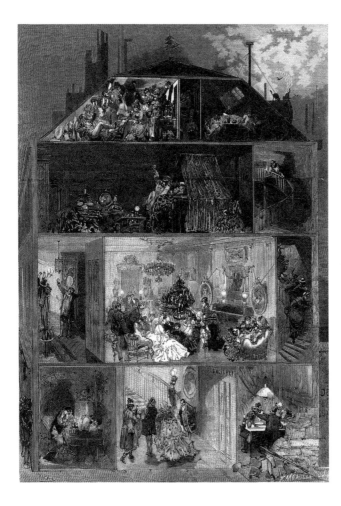

FIG. 3.19. Fortuné Louis Méaulle, Christmas Eve in the different floors of a Paris apartment building. *Le Monde illustré*, December 28, 1872. Bibliothèque nationale de France, Paris.

of light ceased to differentiate the upper classes.[178] The nobility clung to candlelight as a last token of social difference until the ubiquity of electricity eliminated the possibility of expressing status through illumination.

Public as opposed to private light had other changing connotations. For centuries, street lighting was seen by the poor as a police institution and emblem of absolutist rule.[179] In prerevolutionary days, smashing public lanterns, a common form of popular protest, was a serious offense that condemned perpetrators to the galleys.[180] This equation of street lighting with the coercive power of the state would reappear whenever uprisings rocked the city. A blackout in any part of Paris spelled the takeover of the area by insurgents, who snuffed out candles or gaslight to prevent the army from knowing their whereabouts. Hugo drew attention to the importance of darkness for barricades: "To drown the small number [of revolutionaries] in a vast darkness and multiply each combatant by the possibilities inherent in this darkness, such is the necessary tactic of insurrection."[181] Fear of revolution expressed itself partly through the obsession with public illumination, which came to stand for political stability, and not simply freedom from crime.

With time, the industrialization of light brought about its gradual depoliticization. Traditionally associated with the forces of security, public lighting had always fallen under the jurisdiction of the prefect of police rather than the prefect of the Seine.[182] Haussmann

clearly disliked this overlap of functions in his territory and, in 1859, took control of the Service de l'Éclairage by transferring it to the Service des Promenades, directed by his closest collaborator, the engineer Jean-Charles-Adolphe Alphand. The connection that for centuries had bound public lighting to police surveillance was slowly beginning to fray.[183] Eventually, as the collective fear of barricades was left behind and street lighting became generalized, public light came to be perceived increasingly as a neutral force, linked largely to consumption rather than surveillance.

STREET FURNITURE

Haussmann's new geography of consumption required an unprecedented number of urban amenities to better service the crowds that were the addressees of the new boulevards and squares: fountains, benches, kiosks, streetlamps, and public conveniences, all mass produced in cast iron. These were sprinkled throughout the city irregularly, according to a largely class-specific semiotic. The Second Empire's street furniture was inscribed in a long history of municipal practices and private initiative, but it was Haussmann who took full advantage of industrial reproducibility in his new infrastructure. Public chairs, introduced by Rambuteau, had formerly been left to private companies, who rented them to pedestrians.[184] Although Haussmann lined new squares, parks, and boulevards with hundreds of benches, these were unevenly apportioned across the urban perimeter. Lazare complained about the paucity of resting places in the eastern half of the capital: "The worker's wife, who goes for a walk with her children along these dispossessed boulevards, cannot find, in a trajectory of over five thousand meters, a single bench on which to rest and seat her little family, whereas benches for the rich or well-off, who never use them, have been showered on the pampered western part of Paris."[185] According to Antoine Granveau, a former ouvrier who walked long distances to work every day, "in certain areas such as the heights of Ménilmontant, for example, which has a large population, the worker sits on the ground like a peasant; on Sundays, he spreads his handkerchief on the sand in order to sit without besmirching his trousers."[186]

Public lavatories made their first appearance in the city under Charles X, shortly before the revolution of July 1830, when some were used in building barricades.[187] Known by several euphemisms—water closets or simply *waters*, *vespasiennes*, or, more crudely, *pissoirs* or *pissotières*—they were another urban service popularized by Rambuteau (fig. 3.20).[188] In 1841, after a brief trial period, Gabriel Delessert, Louis-Philippe's prefect of police, introduced rudimentary cast-iron structures papered with advertisements in the interior so as not to encumber the sidewalk. Rambuteau had several hundred installed all over Paris, to the horror of the educated elite, who considered the *colonnes Rambuteau* a permanent offense to public morality, particularly since theaters, cafés, and bars were compelled to place them in front of their establishments for the convenience of their male clients.[189] César Daly thundered against the idea of linking two different functions in such an inelegant cylindrical design, adding that they would bring shame to Laplanders.[190] Considered unseemly if not obscene, these crude lavatories were soon replaced by a range of different models designed to avoid any reference to bodily needs (fig. 3.21).

"Public" water closets were for men only, of course, and by the end of the Second Empire, this differential treatment had become intolerable. Granveau expressed his

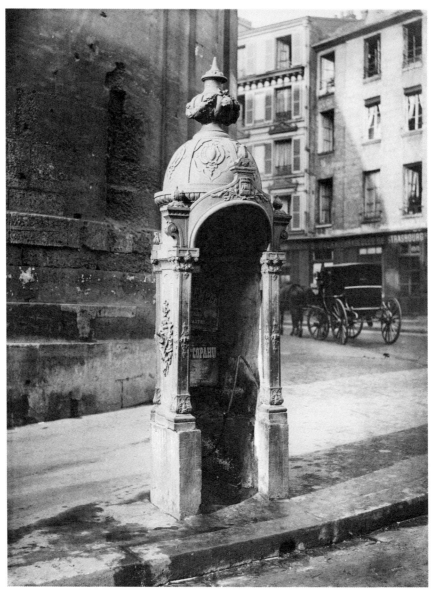

FIG. 3.20. Charles Marville, urinal, known as a "colonne Rambuteau," Rue du Faubourg Saint-Martin, 1865. Bibliothèque historique de la Ville de Paris.

outrage at the indignities to which poor women were subjected in public, given the lack of such facilities for their convenience. "In view of these human miseries, honest citizens turn their heads away respectfully so as not to embarrass the people, but children and youth stare with impudence, and sometimes even shout!"[191] "Had the wives and daughters of ministers, senators, deputies, and municipal councilors been forced to present themselves in such a humiliating posture in public," he added angrily, "it is more than probable that a solution to such problems would readily be found."[192] Architect Hector Horeau demanded the construction of water closets "for both sexes in all public buildings, under the quays and wherever appropriate, without transforming them into ornaments as at the Tuileries and the Champs-Élysées."[193] These last were private *chalets de nécessité* for wealthy

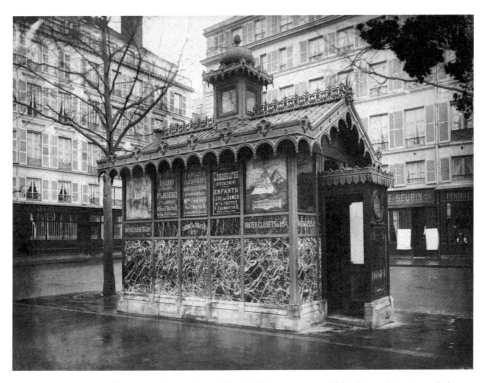

FIG. 3.21. Charles Marville, water closet Place de la Madeleine, 1870–75. Bibliothèque historique de la Ville de Paris.

citizens who could afford the fees, but a quarter of a century would elapse before the Société des Colonnes Doriot finally proposed a prototype of *chalets d'aisance* for women in 1893.[194] By the beginning of the twentieth century, water closets for the female sex, largely in the wealthy western part, were still rare enough to be listed by location in Alice Ivimy's *A Woman's Guide to Paris*.[195]

The fact that the first cast-iron lavatories were outfitted with advertising columns shows how closely boulevards were linked to consumption even before the Second Empire. When public outcry caused publicity to be unyoked from the *pissoir*, the beautiful *colonnes Morris* came into being, named after the Morris advertising agency (fig. 3.22). Given their success, the firm was granted a monopoly in 1868, and large numbers were erected along the main boulevards and squares, bringing considerable revenue to the municipality. Posters for theatrical and musical spectacles thus migrated from the interior of a lavatory to the exterior of an iron cylinder designed exclusively for publicity. Women could now read theater advertisements without appearing to hover around the men's *colonnes-urinoirs*.[196] Some were surmounted by glass lanterns for illumination; others were coupled with newspaper stands. Used mainly for cultural events, they were erected in the most privileged parts of Paris.[197] In the colonnes Morris, Haussmann found one of his most successful and long-lasting strategies for controlling the avalanche of signs that threatened the integrity of the urban landscape that he had worked so hard to produce.

Designed by Davioud and his assistants but built by different firms, kiosks, water closets, benches, columns, candelabra, and tree guards form a coherent urban semiotic, linking

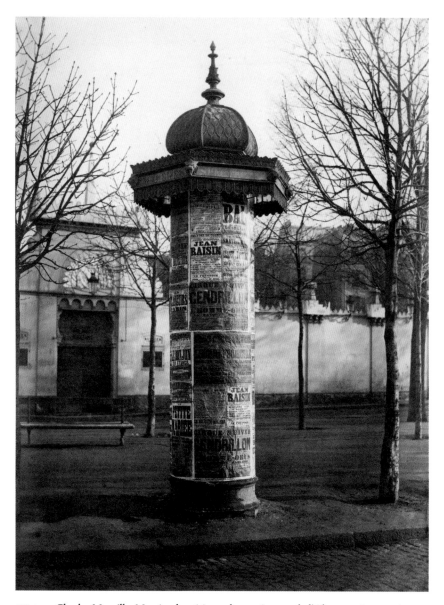

FIG. 3.22. Charles Marville, Morris advertising column, Avenue de l'Observatoire, ca. 1870, Montrouge. State Library of Victoria, Melbourne.

different areas of Paris by means of similar material and color, and promoting a clear code of use. In his attempt to create legible urban surfaces, the prefect had his experts codify the signage system and experiment with different designs for disparate contexts. Standardization did not preclude flexibility and inventiveness; endless variations in ornament and typology undercut the monotony inherent in seriality.[198] Aware of the need to streamline design meant for mass production, Davioud criticized French industry for lacking taste, as art appeared only "as a superimposed ornament, added arbitrarily" without contributing to the overall concept of the piece.[199] Despite differences in scale and function, he

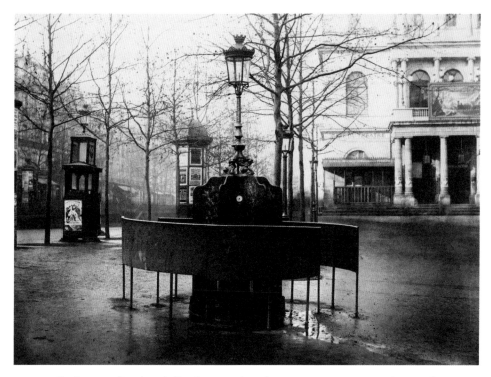

FIG. 3.23. Charles Marville, Place de l'Ambigu, Boulevard Saint-Martin, ca. 1862–64, showing three different kinds of mass-produced urban furniture by Davioud. Musée Carnavalet, Paris.

managed to confer stylistic unity on all the different pieces, greatly aided by the city's remarkable metallurgic industry, which produced everything from urban furniture to locomotives. Manufactured on the assembly line, these works constitute an early example of architecture's potential for reproducibility that Hector Guimard was to exploit so successfully in his remarkable subway stations of 1900. Cost-effective and carefully calibrated according to context, Davioud's small-scale cast-iron structures sparkle with the liveliness and ingenuity that his large-scale architecture lacks, marred by the cautious approach of the obeisant municipal servant. Still in use, they have worn remarkably well, as well loved today as they were over a century and a half ago. Charles Marville, and later Eugène Atget, captured different aspects of this mass-produced environment of cast-iron kiosks, urinals, and candelabra that punctuated streets and squares (fig. 3.23).

With their miniature domes and Turkish etymology, Davioud's kiosks evoke a certain fantastical Orientalism and were also known as *colonnes moresques*, Moorish columns.[200] Not everyone relished their emphatic exoticism: "This kind of architecture," objected writer Paul de Kock, "is reminiscent of the minarets of the Orient, and I cannot see why our new columns should aim at recalling the Turks."[201] Turkey had been very much in evidence during the Second Empire; its dignitaries had been welcomed with lavish hospitality both at court and at the Hôtel de Ville. After his departure from office, Haussmann worked in Istanbul, at the invitation of the viceroy of Egypt, Ismaïl Pacha, whom he had twice received in Paris. Even before his stay in Turkey, the imperious prefect was known in Paris as Osman Pacha, Haussmann and Osman being homophonous in French.

Despite the success of the colonnes Morris, Haussmann could not control the cacophony of signs and publicity that covered the city. This, too, was part of a long tradition of visual urban culture. Already in the ancien régime, Mercier had compared Paris to a large advertisement (affiche), though without the angry note that characterized his nineteenth-century counterparts, citizens of an industrial society predicated on mass production: "The placard! It covers, colors, it clothes Paris [. . .] and one could even call it *Paris-affiche*, to distinguish it from other cities of the universe by its most striking garb."[202] Advertisements were part of the street's idiomatic argot, slapped onto walls and façades, avidly sought out by different social groups. Many listed work opportunities, eagerly read by construction workers, seamstresses, and milliners.[203]

Half a century later, when the city's scenic prospects were being disfigured by torrents of advertisements screeching for attention, Mercier's benevolent attitude toward publicity had largely disappeared. Sandwich men filled the sidewalks of busy boulevards with their cumbersome harness. Every morning, *colleurs* pasted their posters on walls, and the chiffonniers removed them at night. A more permanent menace came from painted advertisements that defaced architecture. An entry in Hugo's journal of April 28, 1848, notes that to attract the passerby, it had become customary "to transform entire gables into posters, painted with enormous uppercase letters."[204] "Today," moaned Fournel, "Paris is nothing but an immense wall of advertisements, comprised from chimneys to sidewalks, of pieces of paper of every color and shape, not to mention simple inscriptions which nonetheless often have a certain merit; a gigantic bazaar, where advertising lies in wait for you on every sidewalk, stops you, besieges you, tracks you down and snares you by the eye or by the ear, insinuates itself into your pocket."[205] Haussmann's kiosks and publicity columns were an attempt to regulate and contain this semiotic landslide, but they could not keep up with the proliferation of images required by the market.

FIG. 3.24. The lion of Belfort, Paris, 1889. The image, by an unknown illustrator, wrongly shows Frédéric Auguste Bartholdi's sejant statue standing. *L'Illustration*, January 26, 1889. Bibliothèque nationale de France, Paris.

Architects denounced the perceptual overload and constant assault of garishly colored advertisements that threatened their façades. "I cannot hope to study a monument without being distracted in my observation by the monstrous advertisements of the *Belle Jardinière*, the *Maison du Pont-Neuf*, or the *Teeth-at-Five-Francs!*" Charles Garnier protested angrily.[206] Another disgruntled citizen expressed his outrage at the sorry state to which the stately Place des Victoires was reduced: "Faced with this barrage of posters, one might well ask what the equestrian statue of Louis XIV is doing in the middle of the square; and why the local entrepreneurs have not yet obtained the authorization (which they have no doubt requested) to

paper over the very statue and, if need be, the horse."[207] It was a rhetorical question. In electoral campaigns—during and after the Second Empire—virtually every statue in the city, equestrian or otherwise, was plastered with publicity (fig. 3.24). Some critics admired the garrulous nature of urban advertisements. Balzac's friend Laurent-Jean de Lausanne held that "the most beautiful spectacle of nature will never rival that of a wall placarded with posters."[208]

TRANSPORTATION

During the July Monarchy, the arrival of the railroad had a pronounced effect on urbanism. Circulation, one of the mainstays of the economy, received a strong impetus from the Saint-Simonians' faith in progress and desire to stimulate industrial production.[209] It fell to Haussmann to expand systems of transportation within the city and coordinate different forms of public transport by rail, animal traction, and boat. Yet the prodigious development of the railroad surpassed the expectations of Napoleon III and his prefect. Despite their efforts, Paris is still mostly served by the railway stations founded by Louis-Philippe just outside the old tax wall, though all have been rebuilt and enlarged many times. Surrounded by narrow streets, none can effectively channel the dense stream of passengers disgorged by the trains. The fact that they are poorly connected to the center is generally attributed to Haussmann's formalist penchant for considering them as little more than terminating vistas for sight lines.[210] But politics also played a role. In 1857, the emperor wrote Eugène Rouher, minister of public works, saying that the stations had to remain far from the center to keep workers at bay.[211] The Second Empire's sole contribution to railroads within the city had little to do with Haussmann: the Petite Ceinture or circular line, connecting all the city's railway stations, built between 1852 and 1867. It too was triggered by security, accompanying the perimeter of the fortifications to enable troops and matériel to be transported swiftly.[212] Sunk below grade, it was open to the sky to make it more agreeable to passengers. Though crucial for the development of the periphery, its fees remained too high for workers.

The emergence of the French railroads was the result of the laissez-faire attitude of the state under Louis-Philippe, which allowed private companies to take over the railroad system and carve the national territory into hermetically sealed regional fiefs.[213] All major lines belonged to the great Parisian bankers. James de Rothschild, "the most powerful lord of the jungle," had important business enterprises in Britain and Belgium and owned the Chemins de Fer du Nord and its monumental train station, designed by Jacques Ignace Hittorff, the Gare du Nord.[214] Together with the Fould family, the Rothschilds also controlled the Paris-Versailles line. The railways of the west and of the south, as well as the Gare Saint-Lazare, fell to the Péreire brothers, while François Bartholony and associates owned the Compagnie d'Orléans.[215]

Railroads destroyed the closed form of the prerevolutionary polis and the town/country contrast that so interested thinkers from Balzac to Marx: capitalist economy demanded an open city linked to national and international networks. By unifying all regions, the railroad created a new configuration that was perceived not only as a social, political, and economic entity, but as a psychological and semiotic one as well. Zola captured this shift vividly in his great novel *La bête humaine* (1890), where he describes the railroad as "a

gigantic being lying across the earth, its head in Paris, its vertebrae all along the line, its limbs stretching out into branch lines, with feet and hands in Le Havre and the terminals of other cities."[216] The shrinking of regional space to the profit of national space was accompanied by a magnification of the railway itself.

As the frontispiece to the capital, train stations were vested with symbolic meaning. It was in these nodal points that rail and vehicular traffic, city and nation, came together. "We enter Paris through fifty-one gates and four posterns when arriving from those few villages that surround the great city, and twelve railroad stations when we come from the rest of the world. We can thus say that the stations are the true doorways to Paris," wrote economist Léon Say, who opposed and later replaced, Haussmann.[217] Gautier voiced a similar thought: "Railroad stations are the antechambers and salons of the nations that visit one another, and can never be too sumptuously ornamented."[218] Architects devoted a great deal of attention to the design of the terminus, which had to address the pageantry of departures and arrivals, the geographies of itinerary and destination, and the intertwining of time and space. Railroads forced architecture to confront and express motion while reassuring passengers with the stasis and solidity of their buildings. Stations were thus a hybrid typology that spoke of both permanence and transience, split between the fixity of the façade and the sleek modern train sheds in iron and glass that evoked the frenzy of the journey (fig. 3.25).[219]

As railways brought thousands of visitors into Paris daily, increasing public transportation within the city became an urgent issue. As usual, the Second Empire wanted to regulate transportation and, in 1855, unified all omnibus companies into a single monopoly, which would lapse only in 1910: the Compagnie Générale des Omnibus (CGO).[220] The

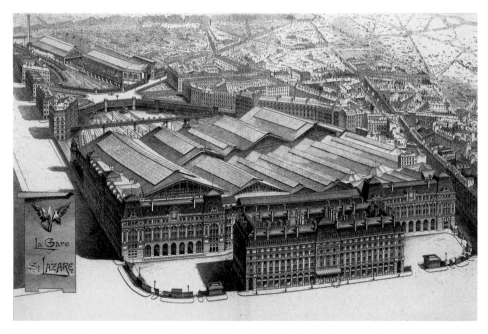

FIG. 3.25. The Gare Saint-Lazare, and the Hotel Terminus, after the station was enlarged by Juste Lisch, showing the historicist front and the iron-and-glass sheds behind. *Le Moniteur des architectes*, 1890. Bibliothèque nationale de France, Paris.

merger was backed by Paris's most powerful bankers such as the Rothschilds, the Lafittes, and the Péreire brothers, who already owned the country's main railway lines and now invested heavily in crosstown transportation.[221] Members of the emperor's entourage also lobbied for a stake in the profits. The same year, all hackney cabs were consolidated as the Compagnie Impériale des Voitures de Paris. Pragmatic and transactional as far as the elites were concerned, Haussmann himself derived no personal profit from these ventures.

As the city embraced its new vocation as a place of circulation and consumption, it accelerated the transition from a society that moved largely on foot to one that relied increasingly on public transportation. In Louis-Philippe's day, poor citizens walked to their place of destination. During the Second Empire this slow-paced pattern began to change. After annexation, the omnibus became, for those who could afford it, the most important means of public transportation intramuros. Under Haussmann, the number of passengers rose from 34 million to 120 million a year.[222] Mass transit increased the mobility of the population and significantly enhanced women's capacity to move about the city. Old mores died hard, however; as late as 1867, Paris still had a fleet of sedan chairs![223]

An inseparable counterpart to the boulevard, the omnibus was an ambivalent icon. Striking contemporaries as more than a means of transportation, it was widely perceived by both defenders and detractors as an emblem (if not an agent) of democracy that confounded social classes.[224] Its presumed etymology—*omnes* (for all)—was redolent of democratic connotations, but it had a more prosaic and apolitical origin. Stanislas Baudry, who founded the first omnibus company in Nantes, took the name from a shop where the first stop was located. Owned by a Monsieur Omnès, it was called "Omnes Omnibus."[225] Those who could permit themselves the luxury of horse and carriage frowned on such demotic means of transportation, which could also propagate disease. Writing in 1842, Édouard Gourdon declared that "three hundred coaches at six *sous* are almost the equivalent of one eighth of permanent cholera."[226] Flaubert's assessment was equally gloomy: "Since the invention of the omnibus, the bourgeoisie is dead," he wrote to Louise Colet in 1854.[227] Disapproval could also be freighted with racism: "The omnibus driver does not give the impression of a human being: he is an Ahasuerus of the running-board, an errant Jew in braided jacket."[228] Liminal by nature, omnibuses crisscrossed Paris, carrying people of different social strata in close proximity to one another, violating social and geographic boundaries. Overturned omnibuses were often used for barricades, further encouraging this pointed ideological reading, despite the preponderance of middle-class passengers.

Such fears were built into the itineraries of the omnibus, which at first served primarily the central parts of the city where government buildings and upscale commerce and residence were located.[229] Traffic was heaviest along the grands boulevards. As a highly successful investment, the Compagnie Générale des Omnibus avoided less profitable neighborhoods, delaying social and spatial integration. By linking specific parts of the city and ignoring others, the early forms of mass transit in effect ratified the spatial division of labor. Workers were also deliberately excluded by fares. Tickets for the enclosed lower level cost thirty centimes (with the right to a transfer), a price the poor could ill afford. In 1853, the company introduced the uncovered upper level, or *impériale*, which was at half price, but it held only twelve seats, was difficult to access, and allowed no transfers.[230] Affluent passengers thus got to ride in comfortable conditions twice. Timetables, too, were calculated so as to exclude workers: the earliest omnibuses left too late to be of use.

FIG. 3.26. *Omnibus of Les Dames Blanches*, 1828. Lithograph by Gihaut after Denis-Auguste Raffet. Bibliothèque de la Ville de Paris, ca. 1830.

This was one of the stratagems by which the municipality invested certain parts of the city with value, while neglecting others. Although the CGO was originally given permission to operate on the grounds that it would serve all parts of the city, authorities never held the company to these conditions. In Paris, public transportation—owned by wealthy groups—never served all citizens equally.[231]

For the middle classes and well-remunerated workers, the omnibus helped organize space and time, in many instances taking passengers through areas they had never crossed before. A new metropolitan culture of mobility, speed, and cultivated distance was emerging, However slow, by our standards, it transformed the experience of the city and engendered new forms of perception of urban space, speeding up the continuities that unfolded sequentially and compressing different parts of the city. "The trajectory of an object as well as the subject," writes Paul Virilio, "carries an often unnoticed value, and the arrival of a new infrastructural-vehicular system always revolutionizes a society in overthrowing both its sense of material and its sense of social relationships—thus the sense of the entire social space."[232]

In the mixed society of the omnibus, female passengers ran the risk of being importuned by men who were unaccustomed to seeing women traveling on their own. The atmosphere could be highly charged.[233] To prevent such problems, railroads set aside special compartments for women.[234] Well aware of the problem, the first omnibus companies did what they could to make their service attractive to ladies from lucrative neighborhoods. With their emphasis on speed, sleekness, and femininity, the very names of their firms—Les Hirondelles, Les Gazelles, Les Sylphides, Les Orléanaises, Les Algériennes, Les Écossaises—were chosen to appeal to the female sex. Elegance was indispensable to offset the inevitable threat of both social and sexual promiscuity.[235] Les Dames blanches, Paris's first omnibus company, was named after the hugely successful opera by François-Adrien Boieldieu (1825), based on one of Walter Scott's Waverley novels (fig. 3.26). Coachmen in livery and top hat drove white carriages, pressing a mechanism with their feet that reproduced an aria from the opera, "La Dame blanche vous regarde."[236] Codes of usage for middle-class women required avoiding anything that might attract attention. Unpretentious clothing alone was compatible with respectability, recommended Julie de

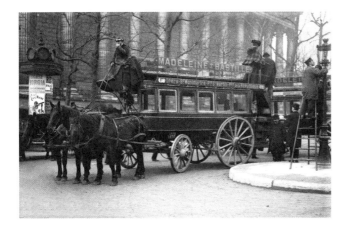

FIG. 3.27. Albert Harlingue, horse-drawn omnibus *Madeleine-Bastille* in front of the Madeleine. Roger-Viollet.

FIG. 3.28. Maurice Delondre, *On the Omnibus*, 1880. Oil on canvas. Musée Carnavalet, Paris.

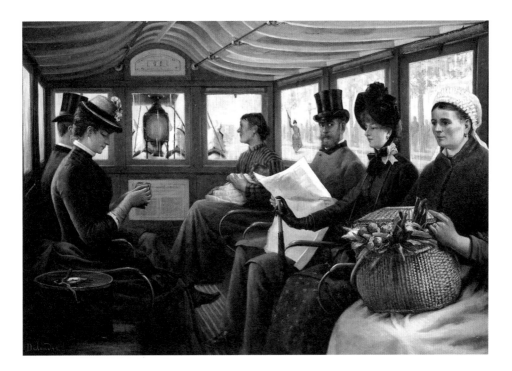

Marguerittes: "French women have a hatred of public conveyances; and then, it is supreme bad taste to go in an omnibus in anything but the simplest dress."[237]

Initially, working-class women were restricted to the interior of the omnibus and thus had to pay higher fares. Only in 1878, when the ladder that led to the upper deck was replaced by a staircase, were women allowed to ride above and pay half price (fig. 3.27). Working women increasingly made use of the omnibus, partly because the Second Empire and the Third Republic slowly improved the quality and range of public conveyances. Representations of the omnibus call attention to the tensions generated by social and sexual difference in the interior of the Parisian omnibus (fig. 3.28). Unused to close proximity to

women whom they did not consider equals, ladies are sometimes shown recoiling from the odor of the less privileged.[238]

For those who were not sufficiently wealthy to have horse and carriage, but whose means placed them above the need to take public transportation, there were hackney cabs or *fiacres*, which could be found in the main squares, outside train stations, theaters, and hotels. In 1866, Haussmann bought back, at great cost, the Monopole des Petites Voitures (horse-drawn cabs), which the government had ceded to a former prefect of police, François-Joseph Ducoux. If monopoly was the most expedient way of ensuring collective transportation, he convinced the emperor that individual travel was best served by free enterprise.[239] Consequently, cabriolets of all shapes and sizes, old-fashioned and new, could be seen on the streets of Paris.

After the revolution of 1848, the elites in power were determined to upgrade circulation in order to improve the economy and guarantee political security. Broad new thoroughfares, lined with elegant shops, banks, and cultural institutions, threatened the traditional function of the old urban fabric as a mixed-use, multifunctional space. Many streets shed their old viscosity in the banal dramas of gentrification. Their self-contained characteristics and circumscribed, neighborhood-driven dynamics were pressed into the service of vast networks of exchange where road and rail linked the city to the nation, and the nation to the world beyond—a Saint-Simonian dream come true. Yet street culture was resilient and survived in the interstices of the big city. Frequented by different social groups, streets continued to sustain a vibrant and evolving culture made up of widely divergent practices that often challenged and transgressed the norms imposed by the municipality. Ultimately, the roadbed, paving, sidewalks, street furniture, and trees lining the new thoroughfares exceeded instrumentality and served several contradictory purposes at once. During the Commune, workers swept down from the heights of Montmartre and Belleville by means of Haussmann's great arteries and their tributaries, where they set up barricades. Despite Napoleon III's attempts to prevent the recurrence of 1848, the new streets and boulevards of the capital were powerless to prevent the greatest urban uprising in the history of France.

Water

It has been said that Providence placed beautiful rivers in the heart
of great cities.

> —Louis Sébastien Mercier, *Tableau de Paris*

In the beginning was the river, a vast inland sea that covered the Île-de-France some fifty million years ago. As temperatures rose, the receding waters left behind a string of tributaries and a tiny archipelago that conditioned the city's urban development for centuries to come.[1] By the time Haussmann took office, the ancient river, shrunk to its present size, was showing signs of age: strangled by too many bridges, its bed choked by the accumulated debris of two thousand years. Improving navigation was a major priority, but in this case the wily prefect met his match. Capricious and autocratic, the Seine had on its side thousands of years of hydrological history. Haussmann could claim only a fallible technology and considerable determination. Although the municipal administration engaged in a protracted struggle to adapt the river to the requirements of modernity, the prefect's functionalist agenda could not entirely eradicate an older culture of water stretching back to Gallo-Roman times.

Street names retain traces of the city's aqueous past: Rue des Cascades, Rue des Rigoles (rivulets), Rue de la Mare (pond), Rue de la Duée (spring). Rue Chantereine, now Rue de la Victoire, evoked the frogs that sang in that muddy wetland.[2] The very term Marais (marsh) recalls the river's old bed. This was the same swamp, long since drained, that temporarily stopped the Roman legions of Caesar's lieutenant Titus Labienus, who finally conquered Lutèce in 52 BCE.[3] In 1711, construction work in the choir of Notre-Dame brought to light a Gallo-Roman marble altar to Jupiter, built during the reign of Tiberius by the city's water merchants, the Nautes. In the Middle Ages, their powerful successors, the *marchands de l'eau* (water merchants), chose the ship as the city's enduring coat of arms.[4] The very motto of Paris, *fluctuat nec mergitur* (it is tossed [by waves] but does not founder), adopted by Haussmann in 1853, speaks to the city's amphibian origins.

It was this long-forgotten, latent river that Haussmann had to deal with in his attempt to rid the city of the damaging floods that invaded the center every winter, when rising waters appropriated the old fossil bed, bringing commerce to a halt (fig. 4.1).[5] The city's mysterious, submerged waters were felt to threaten the visible certainties of the upper realm. In 1863, when Charles Garnier began construction of the opera house, groundwater surged through the foundations, forcing him to create a huge underground reservoir, currently used to store water in case of fire. This was the source of the fictitious subterranean lake immortalized in Gaston Leroux's 1910 novel *The Phantom of the Opera*.

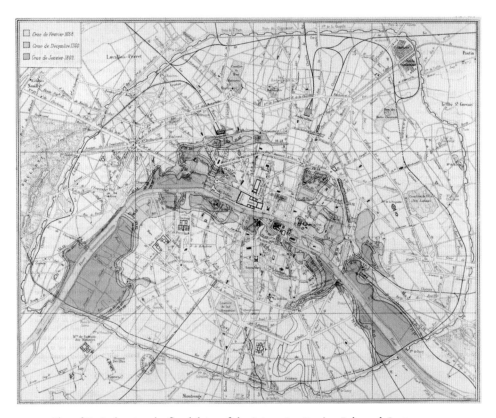

FIG. 4.1. Plan of Paris showing the floodplains of the Seine, 1845. Eugène Belgrand, *Les travaux souterrains de Paris*, vol. 1, 1872. Bibliothèque nationale de France, Paris.

Lutèce (Lutetia), the name of uncertain etymology given to the settlement by the Romans, itself designates a swamp or a marsh. Other testaments to the vast body of water that once covered the area include the city's numerous wells. Water pouring down from the heights of Montmartre and Belleville eased its way into the spongy, flood-prone Right Bank. When the Prussians cut the aqueducts that supplied Paris during the Siege of 1870, the emergency government ordered an inventory of the city's wells. To their surprise, it found thirty thousand, mostly on the Right Bank. Only streets names recall their labile, shadowy past: Puits-Mauconseil (well of bad council); Puits-qui-Parle (the talking well); Puits-de-Fer (iron well); Puits-du-Chapitre (well of the Chapter); Puits-Certain; Bon-Puits.[6] Other names recall long-vanished fountains: fontaine-à-Mulard (Mulard's fountain), fontaine-au-Roi (the king's fountain), fontaine-du-But (fountain of the Buttes), fontaines-du-Temple (fountains of the Templars), fontaine-aux-Clercs (clerics' fountain). Paris rested on this water-logged base, where myth and history meshed beneath the surface of Haussmann's rationalist grid of networks.

Of the city's primeval rivers, offshoots of the originary body of water, the Seine alone remains visible today. Its symbolic importance can scarcely be overestimated. In the past, the water was not visually cut off from Paris: the banks sloped gradually down to the river, which was broader and shallower than it is now (fig. 4.2).[7] Instead of a sharp contrast between the liquid surfaces and the lithic walls that contain them, river and city were closely

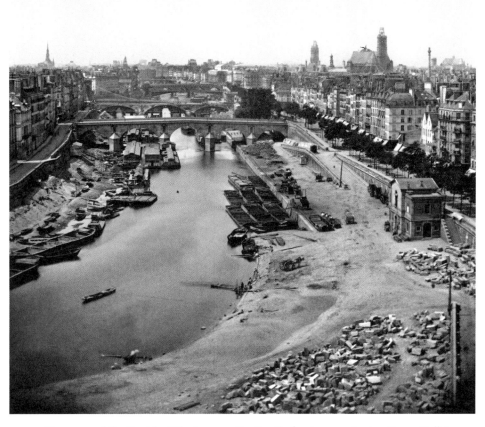

FIG. 4.2. Panorama of the Quai des Célestins, ca. 1860. Detail of a stereoscopic view. Roger-Viollet.

intertwined "in a play of mutual seduction."[8] The water itself looked different. Before it was partly canalized, two streams of different color ran side by side. The darker, marl-rich waters of the Marne entered the Seine just before Bercy, merging only when they reached the Pont Neuf.[9] The two currents could also be distinguished by temperature: the city's numerous fish tanks were stationed on the right arm, which received colder, fresher water from the Marne.[10] The polluted Bièvre, that "river in rags" according to Joris-Karl Huysmans, fed tanners, dyers, distilleries, and paper mills (fig. 4.3).[11] A threat to Haussmann's plans of embellishment of the capital, part of it was downgraded to a sewer and canalized.

The city derived its raison d'être and its livelihood from the river and the cluster of eyots that served the first inhabitants as stepping stones to ford the water. These established the crossing as a promising site of exchange that enabled the city's gradual development. The Seine thus served as a catalyst for urban form, dictating the main axes of circulation.[12] From the Middle Ages on, the greater abundance of water on the Right Bank determined its rapid economic growth and helped connect it to the rich industrial provinces and

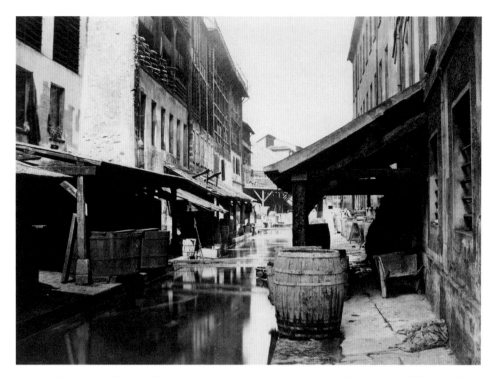

FIG. 4.3. Charles Marville, the Bièvre River near the Gobelins, ca. 1865. Bibliothèque de l'Hôtel de Ville.

important ports of northern Europe. On the opposite bank, water was scarce, and there were fewer sources of wealth. As a result, the Seine divided Paris into two unequal economic zones. Raw materials sailed down from the upper Seine to the eastern ports where the city's workers lived and toiled. Merchandise of higher economic value came to Paris from Le Havre or Rouen on more powerful vessels that had to be towed against the current at considerable expense. Commerce along the river thus brought about a distinction between the Paris of work, characterized by the busy bridges and ports to the east, and the Paris of economic power to the west, where the Crown and the aristocracy laid out magnificent parks and villas—the one densely settled, the other green and airy.[13]

ROMANCING THE RIVER

For centuries, the Seine served as Paris's drinking fountain and its sewer; its main route of circulation and means of transportation; its market place and source of energy. A site of both labor and leisure, its surface was treated very much like urban space, cluttered by water mills, washhouses, baths, fish tanks, pumps, and fishing nets. Paris was a walled city until the twentieth century, and land was at a premium. Mills attached themselves to bridges to harvest the energy of the quickening currents beneath the arches. Lacking space on the quays, floating markets offered their goods to customers along the shore. Wooden toll gates (*pataches*) barred the Seine at both ends, marking city limits and the beginning and end of the octroi. In prime locations, floating wooden establishments offered a homespun counterpoint to the elegant stone-fronted buildings that lined the riverbanks. The

FIG. 4.4. Adolphe Rouargue, *The Pont au Change*, showing long rafts of logs. Steel engraving, 1846. Jacques-Antoine Dulaure and L. Batissier, *Histoire de Paris et de ses monuments* (Paris: Furne, 1854).

history of Paris, represented by its monuments, was "reflected" on water, wrote a contemporary sarcastically during the July Monarchy: "The *Institut* by public baths, the Hôtel-Dieu by a washhouse, the Place de Grève by a fisherman with his line."[14]

Patois-speaking longshoremen, laundry women, fishermen, and boatmen darted in all directions. Ships loaded with wine, wheat, or hay maneuvered with difficulty, trying to avoid the quicksilver agility of the dinghies; empty boats struggled slowly upstream, towed by horses. Construction materials were sent by water, the cheapest means of transportation at the time. Huge steam-operated cranes hoisted construction material onto quays. All the wood consumed in Paris, too heavy to come by rail, floated downstream so it could be readied for winter. Long rafts of crude wooden logs were a familiar sight as they slid beneath the bridges, after making their way from the timbered slopes of the Morvan, manned by Limousins (fig. 4.4). Not by chance did James Fenimore Cooper once observe, regarding the lively scenes along the Seine, that "there is no *still* life in France."[15]

Navigation within the city was fiendishly difficult. Pilots had to thread their way through a maze of moving and sedentary crafts. Moreover, the islands are not situated on the same axis of the current that skirts the southern side of Île Saint-Louis, turns brusquely to the right between the two islands, and continues its course past the northern side of the Île de la Cité.[16] Bridges hampered river traffic, particularly the closely spaced ones around the Cité (fig. 4.5).[17] As their arches were not aligned, the widest one was assigned to navigation (the *arche marinière*). To avoid treacherous currents and sandbanks, boats had to take a bridge pilot (*maître de pont*), carefully dodging floating mills, washhouses, baths, and boats. In this respect, the Seine resembled the city's narrow streets teeming with obstacles.[18] Navigation was possible only during roughly half the year; ice ruled it out in winter, and low water levels in summer. Since the Middle Ages, it was strictly regulated: ships had to await their turn at the edge of the city, like airplanes before takeoff. Entrances and departures were carefully timed to avoid gridlock. Red flags cautioned log rafts that they could not pass.[19] Sailing upstream was expensive, as boats had to be dragged along the towpath. Goods such as coal or wood sailed down on flat-bottomed boats called *marnois* or *sapines*, which were taken apart and sold as firewood after a single journey downstream. It did not pay to send them back.

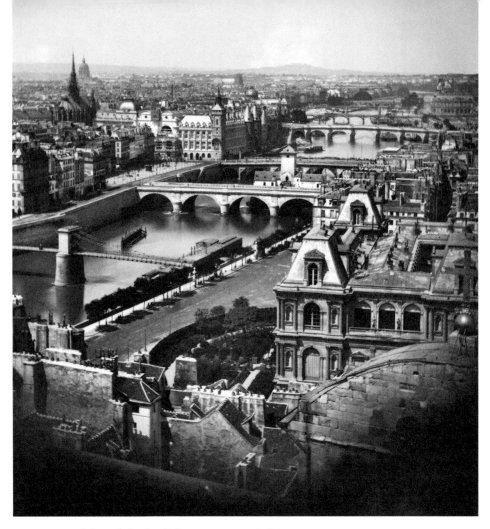

FIG. 4.5. View of the eight bridges before 1860. Roger-Viollet.

Initially, the entire city lived according to the tempo imposed by the river.[20] Wash-houses reopened in spring and operated until winter. Baths peaked in summer. When the high waters arrived at the end of January, endless rafts appeared punctually, bringing cord-wood to be dried and sold as fuel for the next winter. It was the worst of times for those who lived along the shore: the sullen river overflowed the embankments and flooded the city. A huge entrepôt for goods, Paris had over twenty ports that received different kinds of merchandise: wine at the Quai de la Rapée, wheat and hay at the port Marie, foodstuffs from Rouen, the Havre, Dieppe, and Holland at the port Saint-Nicolas. Of these, the most important was the city's original port, the port de Grève, a patch of gravel between the Hôtel de Ville and the église Saint-Paul (fig. 4.6). As no warehouses were permitted on the waterfront, and the quays never had sufficient space, merchants sold their wares to the public from boats or floating markets. With its ships, rigging, masts, and mariners, Balzac noted in *Ferragus*, Paris had a whiff of the maritime.[21]

By the late eighteenth century, the urban stretch of the Seine had reached saturation point. The viscous texture so characteristic of the ancien régime with its colorful cacoph-ony of boats, tradesmen, sounds, and smells, gradually began to disappear. Modernity was not compatible with the unruly mélange of rural and urban ways, that vitality so central

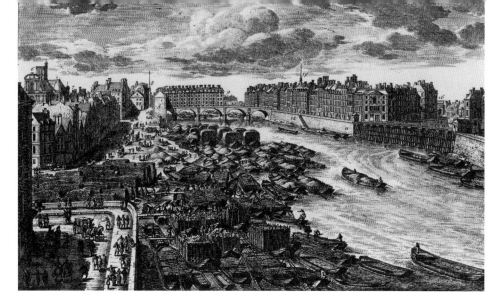

FIG. 4.6. Adam Perelle, *The Pont Marie, the Port de Grève, and the Tip of the Île Saint-Louis*, seventeenth-century etching published by Nicolas Langlois. Bibliothèque nationale de France, Paris.

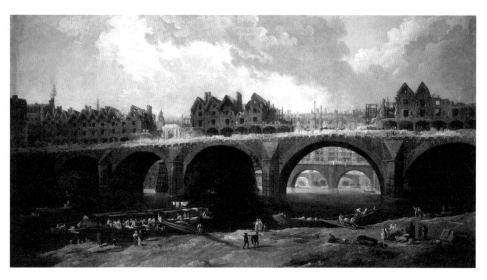

FIG. 4.7. Hubert Robert, *Demolition of the Houses on the Pont Notre-Dame*, 1786. Oil on canvas, 28.7 × 55.1 in. (73 × 140 cm). Musée Carnavalet, Paris.

to, and disruptive of, everyday life. Mercier once claimed that the Pont Neuf was to the city "what the heart is to the human body: the center of movement and circulation."[22] But even as he wrote, the houses that lined the bridges, blocking the view, were being demolished (fig. 4.7). Between 1760 and 1791, successive administrations systematically bought land along the banks to unify the quays, and Rambuteau later joined them in one continuous sweep from the Louvre to Bercy.[23] He did much to improve navigation along the Seine, adding several ports, and throwing five suspension bridges and two stone-arched ones across the water. The abolition of the tolls that made bridges inaccessible to most Parisians also contributed to unify the city. After the revolution of 1848, the government began to revoke concessions to private owners. By 1853, all the city's bridges had become public. In 1838, a mobile dam, the Écluse de la Monnaie, was built in the narrow arm of

the Seine to facilitate the task of towing boats with horses. These were replaced by steam when the dam was upgraded in 1854.

The Second Empire thus inherited from previous administrations a river in process of transformation, and it aggressively pursued its own bold and costly program of reform, which evolved over the years. Following the precepts of Saint-Simon, it saw the Seine as part of a broader transportation network conceived on a territorial rather than a purely urban scale. Ungainly sedentary establishments began to be removed. The importance now given to communications heralded the "new vocation of the river" as a place of circulation rather than commerce.[24] Trades that produced pollutants or took up too much space on water were forced to relocate further and further downstream, until they disappeared altogether. Their former presence along the Seine survives in toponyms such as the Quai de la Mégisserie (tanners) or Quai des Orfèvres (jewelers).

Haussmann's reorganization of the Seine was part of his policy of reordering Paris, cropping heights, filling low-lying areas, and improving circulation. From the start, the administration worked to create long-term solutions to the Seine's pervasive problems. To facilitate navigation, Haussmann lowered and dredged the riverbed, removing the silt deposited over the centuries, and the remains of collapsed bridges and houses destroyed by fire and flood. Encased in cement like a canal, the narrow left arm no longer courses through Paris in its natural bed.[25] Like most urban rivers, the Seine was, to a certain extent, an artifact.

Experts were aware of the causes and consequences of the floods that harassed the city. Streets and buildings rendered the soil impermeable; after heavy rains, runoffs had nowhere to go except the old bed of the giant quaternary river that served to contain the overspill. And while stone, wood, asphalt, and macadam prevented stagnant water from accumulating along the street, they also kept rainwater from replenishing aquifers.[26] Old bridges, perched on thick supporting piles and narrow arches, had to go. So did Louis-Philippe's suspension bridges, structurally unsound and too lightweight to sustain modern traffic (fig. 4.8).[27] By 1870, twenty-five new or newly rebuilt bridges spanned the Seine, wider and lower than their predecessors. Ever since the sixteenth century, quays had been constructed high above the flood lines. Yet here and there the original riverbanks had survived, sloping down to the water's edge. Haussmann streamlined both the upper and the lower parts of the quays, fronting them with stone, allowing space for overflow; close to the water, he paved promenades as well as drinking places for horses. This is the two-tiered Paris that has come down to us: narrower but deeper, hemmed in by high stone walls, the river now flows far beneath the city, remote and impersonal.

With its urban sailors and fishermen, its floating wooden buildings, and its dependency on an unpredictable nature, the culture of the river did not square with the policies of the imperial administration, eager to facilitate commercial exchange on a national and international scale. Following a trend that began with the Enlightenment, Haussmann and his predecessors did away with the awkward encumbrances that obstructed river traffic and disfigured the sweeping views of the river and monumental buildings along its banks.[28] In order to become a navigation channel rather than a marketplace, the Seine had to shed its bustling activities. For a while, the little trades lingered and agonized. The last watermill had disappeared in 1807. In 1813, the venerable pump of the Samaritaine, built in 1608, was torn down, much to the chagrin of Parisians. The pump attached to the bridge

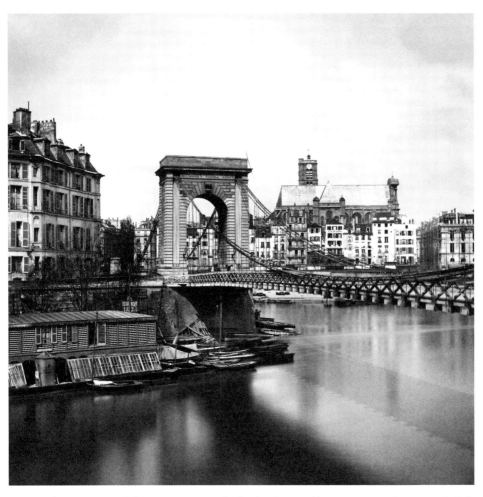

FIG. 4.8. The Pont Louis-Philippe, a suspension footbridge destroyed between 1861 and 1862. On the left, the Île Saint-Louis; on the right, the church of Saint-Gervais. Roger-Viollet.

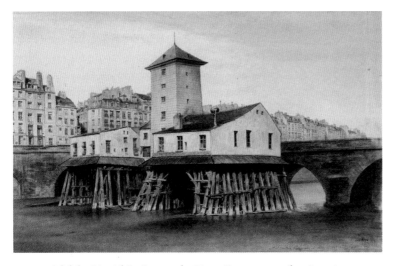

FIG. 4.9. Adolphe Martial Potémont, the Notre-Dame pump, drawing, 1855. Musée Carnavalet, Paris.

of Notre-Dame was dismantled in 1858, when Haussmann had the whole bridge rebuilt (fig. 4.9). After the destruction of the pumps, boats no longer inched their way through the city trying to avoid overcrowded traffic on water. It now took three hours, observed Rambuteau, rather than three days, to sail from the bridge of Iena to the bridge of Austerlitz.[29] Towing boats with the use of oxen was abolished in 1845. The long rafts of logs being driven to market would vanish from sight at the end of the nineteenth century. Slowly and reluctantly, the old, premodern ways of life along the river were disappearing, along with scenes of riparian labor. The departure of so many establishments spelled the end of that ancient civilization of wood that had characterized France for centuries, when lumber was used for construction, transportation, fuel, heat, and illumination. Exhausted and domesticated at last, the old river now flows obediently past the city toward the sea, its uncontrollable, mercurial nature seemingly relegated to the past.

Yet the Seine was not yet the museum it would become by the twentieth century.[30] Though reduced in number, floating establishments still covered much of the river's urban stretch. Baths and washhouses continued to thrive. So did tanks where fish was kept to be sold live to consumers. The flower market and the *marché aux pommes* survived until World War I. Rebuilt several times and several times destroyed, the wooden palings of the passerelle de l'Estacade, joining the Right Bank to the Île Saint-Louis, did not disappear until 1932: they protected ships from the destructive fury of ice floes. In the 1870s, the *bateau-broyeur* anchored off the Île de la Cité still turned its large wooden wheels, grinding pigment into color with energy from the currents.[31]

BATHS AND WASHHOUSES

Baths played an important role in riverine architecture well into the late twentieth century (fig. 4.10). All addressed the social and economic status of their patrons. There were expensive and inexpensive baths, cold baths and elaborate hot baths, baths for men and for women, Turkish baths as well as Russian steam baths. Two Jewish baths are also known to have existed earlier in the century, but their exact dates and details are not known.[32] Swimming schools, separated by sex, were often incorporated into floating baths. Proust, like Haussmann before him, used to frequent the Deligny pool, which did not sink until 1993. By the end of the Second Empire there were nineteen floating baths along the river, thirteen for men and six for women.[33] These could be quite large, with a capacity for several hundred bathers at one time. Citizens could also opt for individual showers (*bains douche*), or order portable baths to be brought to their apartments: *thermophores*—bath carriers from the rental service—crossed the city, pulling carts with bathtubs and large containers of water from the Ourcq canal, which they lugged up the stairs.[34]

Public baths, which still exist in Paris, began to dwindle in number only when the distribution of water improved significantly at the end of the century. By then, these establishments were seen with revulsion by part of the population that now considered them unclean, linked to louche practices.[35] All these different modalities inscribe bathing practices in the history of representations.[36] On one hand, the proliferation of city baths signaled the rise of bourgeois notions of cleanliness and sportsmanship (swimming) and reflected new ways for the leisure classes "of experiencing one's body."[37] Nevertheless,

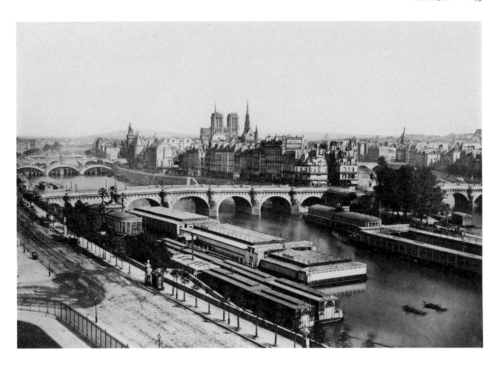

FIG. 4.10. Édouard Baldus, panorama of Paris, with floating baths, ca. 1860s. Courtesy Library of Congress.

FIG. 4.11. Honoré Daumier, *Aux bains Deligny*, 1858. Lithograph on newsprint. Metropolitan Museum of Art, New York.

public baths also underscored the fact that it required an expensive commodity: "For most people," wrote Alain Corbin, "the use of water remained collective."[38]

Baths for the upper end of the social spectrum were sumptuous affairs with private dressing rooms, cafés, smoking parlors, and elegant carpets and wall hangings.[39] A form of leisure as much as hygiene, floating baths were places where clients spent several hours, alone or entertaining friends. One could rent a private room with a bathtub or take a dip in communal pools. Cold water baths attracted the less affluent part of the population and were often set up where water was already polluted and proprietors paid smaller fees to the municipality.[40] Luxurious or Spartan, baths and swimming pools were a boon to caricaturists who loved to lampoon bathers (fig. 4.11).

FIG. 4.12. Aimé-Henri-Edmond Sewrin-Bassompierre, *The Deligny Baths in 1842*. Pastel, 16.5 × 21 in.
(42 × 53.5 cm). Musée Carnavalet, Paris.

The indolent, languorous pleasure of the bath triggered the Westerner's insatiable
exotic fantasies predicated on its favorite stereotypes: "At the bath," wrote a mid-nineteenth-
century specialist, "the bourgeois of Paris dreams of the Orient, of its delights and volup-
tuousness, its perfume, odalisques, opium and ecstasies."[41] This tenacious link to the East
could be seen in other fields, from Ingres's sumptuous *Turkish Bath* (1862) to an opera buffa
by Hervé (Louis Auguste Florimond Ronger), *Le bain des odalisques* (1870). Over the decades,
these associations bred a distinctive Orientalist typology that transformed the most expen-
sive baths into opulent wooden palaces. The elegant Vigier and Deligny baths were extrav-
agant "Moorish" affairs, with kiosks, divans, cafés, and restaurants. A veritable "floating
Alhambra," said a contemporary of the Deligny (fig. 4.12).[42] With its prominent zinc palm
trees, the Bains de la Samaritaine also displayed a fantastical vocabulary (fig. 4.13). Oriental-
ism occasionally appeared in baths on dry land, such as the deliriously eclectic "Chinese"
baths, built in the eighteenth century, on the corner of Boulevard des Italiens and Rue de la
Michodière (fig. 4.14).

Although standards of personal cleanliness rose steadily throughout the nineteenth
century, they remained rudimentary even among well-to-do echelons of society. The city's
numerous bathing establishments serviced a relatively small part of the population. Many
considered baths a useless luxury associated with women of easy virtue, since prostitutes
required frequent ablutions. Modern hetaeras, wrote a critic, "transform their boudoir

FIG. 4.13. The public baths of the Samaritaine, with washhouses in the background, ca. 1865–70. Roger-Viollet.

FIG. 4.14. The Bains Chinois, built by Samson Nicolas Lenoir, 1787 (destroyed in 1853). Drawing, 19.7 × 25.6 in. (50 × 65 cm). Musée Carnavalet, Paris.

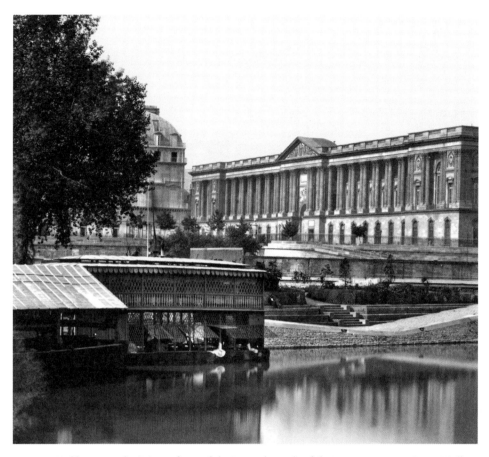

FIG. 4.15. Washhouse on the Seine in front of the East colonnade of the Louvre, ca. 1865. Roger-Viollet.

into a thermal cabinet and their staircase into a veritable cascade, to the desperation and horror of the poor porter, condemned to permanent mopping by such cleanliness."[43] Water thus had an ambivalent correlation to gender, some authors going so far as to caution against the dangers of daily baths.[44] For its part, the old landed aristocracy resented the bourgeoisie's effort to homogenize and deodorize, considering it part of the new bourgeois culture of cleanliness and upper mobility. The Comtesse de Pange (née de Broglie) relates the surprise of her family when the doctor ordered her to take a bath after she contracted the measles: "It was quite an event, and much talked of for several days. There was, of course no bathtub in the house [. . .]. No one in the family took baths!"[45] Deeply suspicious of bathing, which involved the whole body, the Catholic Church feared it would lead to voluptuousness.[46]

Washhouses, also made of wood, could be seen all along the Seine, their style often echoing that of the nearby baths. Beautifully painted and detailed, the higher-priced *bateaux-lavoirs* had two stories: an open ground floor permitted women to wash directly in the river, while green lattice-screened hangars on the second floor provided ample space for drying (fig. 4.15). Orientalism had overtaken them as well. The more elaborate ones, wrote Eugène Briffault (fancifully) in 1844, often resembled "kiosks from the Bosphorus, and the floating pavilions of Chinese rivers."[47] The largest of these could accommodate over two hundred women. Like baths, washhouses were seasonal structures that disappeared in

winter, when they were towed to calmer areas. The distribution of floating establishments along the water was contingent on social class. Washhouses were usually found in less fashionable parts of the river unless they were well designed. Baths, on the other hand, depended on the social provenance of their clients and were situated accordingly.

Formerly, clothes had been washed where water was available and free, along the streams and rivers of France, including the Seine and its tributaries.[48] In the nineteenth century, when washing clothes was institutionalized as a profession, washhouses became one of the places where poor women intersected with public space. By 1858, sixty-four washhouses were anchored between the Pont Marie and the Pont des Invalides, and seventeen along the Canal Saint-Martin. Together with the ninety-one situated on dry land, they gave work to some seventy thousand women.[49] Sending clothes out to be washed was hardly inexpensive. In a small town, a family could get by on what laundry would have cost them in a city.[50] Laundry was also a marker of economic capital, since linens constituted an important part of the dowry.[51]

Washing clothes for a living was an inhuman job on par with the harshest factory work. In the 1840s, Flora Tristan (Gauguin's grandmother) visited a washhouse in Nîmes where three to four hundred women toiled with water up to their waist, soaked in soap, potassium, and bleach: "Would one ever condemn a convict to suffer for only eight days the torture that these poor women have had to go through for the last three hundred years since this washhouse was built! [...] And yet these miserable laundresses, who have committed no crime, who work night and day, who courageously sacrifice health and life for the good of humanity [...] cannot find a single philanthropist or journalist to plead on their behalf!"[52] Inevitably, washhouses constituted a major cause of water pollution.[53] While bleach and other chemicals were known to contaminate the river, their toxic effect on the women's health was rarely mentioned. Since washerwomen had to pay a daily fee for their place in the floating *bateaux-lavoirs*, they often preferred to work at home, in poorly ventilated hovels rendered even more humid and insalubrious.[54]

Washerwomen (*poules d'eau*) were notoriously loud, aggressive, and courageous in battle, as Zola showed in *L'Assommoir*, wielding invective with gusto. Like construction workers, they turned up in search of work every day, in their case at Rue Montorgueil and at the former tollbooth of Monceau.[55] Strong and independent, meeting daily at the washhouse, they organized themselves easily. It was they who held the principal women's strikes in Paris.[56] To fight dampness and cold, they often resorted to eau-de-vie, a fact that concerned the middle classes far more than the terrible conditions under which these women labored.[57] In an effort to reform the morals of the profession, Napoleon III subsidized a model washhouse, the Lavoir Napoleon, built by British engineers in the working-class Quartier du Temple. It was a paternalistic institution, with individual cubicles where women could wash clothes without losing time talking to one another.[58] As far as the authorities and the affluent sectors were concerned, morality took precedence over health. The goal of this initiative, wrote a contemporary, is "to exert a felicitous influence on the moralization of the masses and on the health of the working-class population."[59] Washerwomen thought otherwise and boycotted the emperor's authoritarian experiment, which failed financially and was soon demolished.[60]

In an attempt to clean up public space on the Seine, Haussmann suppressed two washhouses in 1867. There was a tremendous outcry, and when the Franco-Prussian war broke

out three years later, the women returned to the Seine with a vengeance, despite several attempts to dislodge them.[61] Nevertheless, washhouses did diminish in number. By the end of the Second Empire, only twenty-two were left on the river.[62] A familiar sight in art, from Daumier to the *Ballet Mécanique* (1924), they survived well into the 1940s.

As floating wooden buildings slowly disappeared, the newly cleared river was increasingly used to transport passengers. Now a vast waterborne conveyor belt, it expanded the possibilities of transportation within the city. Boatsmen no longer sculled passengers from one bank to the other. In preparation for the World's Fair of 1867, the Compagnie des Bateaux Omnibus from Lyon provided a flotilla of boats, known as *bateaux-mouches*, which could transport up to 150 passengers.[63] Such was their success that two other companies appeared, predictably ending in the usual monopoly granted by the municipality.[64] They plied the waters between Auteuil and Bercy, linking the historic center to its immediate vicinity. On the Left Bank, ferries carried passengers from Paris to Saint-Cloud.[65] The mobile dam of Suresnes, built downstream in the mid-1860s, elevated the river's water level, providing passage for larger ships. Steam revolutionized traffic along the water, enabling effortless navigation upstream and international travel. Steamboats berthed at the port Saint-Nicolas in front of the Louvre and maintained regular service to London. Ships of greater tonnage sailed as far as Rio de Janeiro (fig. 4.16).[66] The city's waterways now allowed it to forge transnational networks beyond the confines of its hinterland.

By the late nineteenth century the romance of the river was dead. A centuries-old dialogue had come to an end. As the Seine lost its centrality as an ebullient place of commerce, its importance gradually shrank to a largely symbolic role: a rich and inextinguishable repository of national and municipal memory. Transformed into a great liquid boulevard, showing its imposing buildings to best advantage, it became a template for the city's

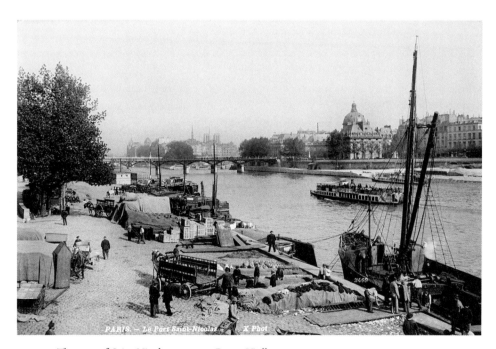

FIG. 4.16. The port of Saint-Nicolas, ca. 1900. Roger-Viollet.

great thoroughfares. Ever alive to all urban aspects of the city, Balzac once referred to the boulevard as "that second, dry, Seine."[67]

CANALS

Part of the vitality lost by the Seine was gained by the city's three artificial rivers: the canals. Built in the early nineteenth century, the Ourcq, the Saint-Martin, and the Saint-Denis gradually displaced the primacy of the river, until they in turn were overtaken by the railway. Their creation betrayed the influence of the physiocrats, who privileged agriculture over industry, and were keen to develop new networks of fluvial transportation.[68] Given the cost, complexity, and slow pace of navigation through the city, canals were necessary to link the upper and lower Seine, bypassing the historic center altogether and syphoning heavy commercial traffic away from this congested area. Begun by the Consulate, completed by the Restoration, backed by the Saint-Simonians, and neglected by the previous regime, the canals of Paris stood in need of repair and modernization.

Napoleon, the driving force behind the three canals, fell from power before any of them were completed. They were finished by his enemies, Louis XVIII and Charles X: the Saint-Denis in 1821, the Ourcq in 1822, and the Saint-Martin in 1825. Their nonutilitarian features added a great deal to the city, offering a wonderful counterpoint to the architecture, and maintaining to this day vestiges of the bustling river life of the *gens de l'eau* or water people. All three converge near the beautiful bassin de La Villette (1809), dominated by Ledoux's powerful rotunda (fig. 4.17), once part of the tax farmers' wall of 1784, and reminiscent of the monumentality with which infrastructure was conceived in the late eighteenth century. Enlarged and equipped with modern facilities, La Villette became a major port.

Another goal of the First Empire's urban agenda was to enhance the magnificent panorama of the Seine's waterfront. Several ports and marketing activities were transferred to the canals, where warehouses and silos, often of imposing size, were eventually built to

FIG. 4.17. Claude Nicolas Ledoux, the Rotonde de la Villette, 1784–88. View taken from the Bassin de la Villette, 2020.

house merchandise transported by water. Commerce contingent on interpersonal contact gave way to large-scale enterprises that conducted their business at a distance, invisible to the passerby, threatening the small economies that eked out a living along the river. Situated in the eastern part of the Right Bank, the three canals reinforced the labor-oriented atmosphere of the entire area and contributed to its development. The animation that previously characterized the river and gave it a human scale still survives here and there, particularly along the Saint-Martin.

Work on the Ourcq canal began in the sixteenth century, when the first locks were built. Originally an affluent from the left bank of the Marne, it gradually fell into disuse. During the French Revolution, the Consulate decided to increase the city's water supply and confiscated it from the Orléans in 1802. The project moved forward only when Napoleon became first consul, and had the engineer Pierre-Simon Girard, head of the École des Ponts et Chaussées, extend the Ourcq to Paris to provide the city with abundant water. A consummate tactician accustomed to thinking on a broad scale, Napoleon believed that the Ourcq could also serve as a major navigable artery. His dream was to link the capital to the great ports of the North Sea via other canals. The rich mining territories and coal basins of France and Belgium would also be within reach. In case of a blockade, he thought, Antwerp and Rotterdam could be reached through internal shipping channels.[69] The longest and most beautiful of the three canals, the Ourcq attracted writers like Baudelaire, who loved to stroll along its banks outside the city walls.[70] With its screen of poplar trees and scenic beauty, it is now largely given over to tourism (fig. 4.18).

Coursing through a harsh landscape of factories, loading docks, wharves, and warehouses, the Saint-Denis flows from Paris to nearby Saint-Denis. A purely urban canal, the Saint-Martin linked two city ports, the port de l'Arsenal and La Villette. It had a far more complex history than the others. Planning alone entailed over one thousand expropriations.[71] To reach La Villette, the canal passed daringly below the Bastille, or more precisely, beneath the funerary crypt of the July Column—a void surmounted by a huge monument. The Saint-Martin had been expressly designed to occupy the old, fossilized arm of the Seine, part of which had always been visible in historic times. In the fourteenth century, Charles V used it to create a moat around the Bastille. During the reign of Napoleon I, the canal was vaulted underneath Place de la Bastille. Two superimposed halls were built above the vault of the canal to house the fountain's machinery. After the emperor's fall, these were transformed into the crypt for the victims of the revolution of 1830.[72]

During the insurrections of 1830, 1832, 1848, and 1851, the Saint-Martin offered a measure of protection to the working-class faubourg Saint-Antoine, obstructing the path of the troops sent to subdue it. To destroy this barrier, Haussmann asked the engineer Eugène Belgrand to lower the canal and cover it between the Bastille and the Rue du Faubourg-du-Temple, a task facilitated by the fact that the municipality had bought back the Saint-Martin, originally built by private enterprise. Belgrand also enlarged the bed, to permit navigation underground. Eighteen oculi bring air to the interior and create dramatic contrasts of light and shadow, giving these underground spaces a haunting, tenebrous beauty (see fig. 2.17). In 1907, another part of the canal was covered and now passes beneath Boulevard Jules Ferry. From there on to La Villette, the canal runs unconstrained, open to the sky.

Narrow, flush with the street level, the Saint-Martin is perfectly integrated, visually

FIG. 4.18. The Ourcq canal at Tremblay-en-France (twelve miles northeast of Paris).

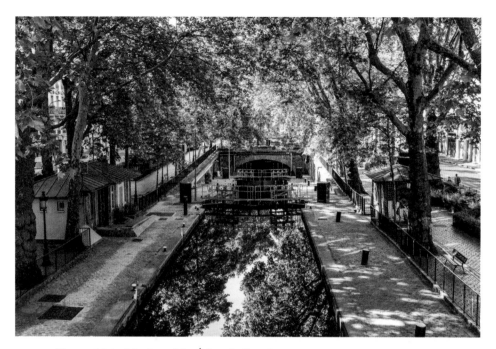

FIG. 4.19. The canal Saint-Martin and the Écluse du Temple.

and socially, into its neighborhood's everyday life. Boats and barges, barely fitting into the canal's thin channel, brush slowly past the trees that line it on both sides, encouraging animated exchanges with the locals strolling by the water (fig. 4.19). With its sluicegates and little hunchback footbridges somewhat reminiscent of Holland, the Saint-Martin passed through a gritty, densely built district, enlivening it with an ever-changing scenery that has always been popular with artists, writers, and film directors. Unlike the Seine, pushing hurriedly toward the sea, the glaucous waters of the Saint-Martin are slowed down by locks. Since the 1950s, the neighborhood's tough urban poetry has become the favorite haunt of the film noir. Marcel Carné's celebrated *Hôtel du Nord* of 1938, starring the unforgettable Arletty, was shot here, as well as Georges Franju's *Sang des bêtes* (1949), set amid the slaughterhouses and warehouses of La Villette, with their dark, foreboding atmosphere—now being gentrified.

Navigation along the three canals was hardly ideal. As they function to this day by means of locks, it took over a week, for example, to reach Le Havre. Over time, the canals failed to solve the city's economic problems or provide an efficient link to the rest of the nation. In Paris, the transfer of heavy traffic to the canals, all situated in the northeast of Paris, contributed to the economic stagnation of the Left Bank.[73] The appearance of the railroad spelled their gradual decline.

WATER PRACTICES

Despite the modernizing policies that transformed the city's waterways, nineteenth-century Paris was still a city of waters—rivers and canals—that helped shape its identity. These were scenes that impressionists and postimpressionists loved to paint: the Seine, gray green at

times, at times yellow or brown, plowed by steamboats trailing clouds of smoke, the *blan-chisseuses* hard at work along the water; or the melancholy grisaille of the canals in winter.

Yet throughout the nineteenth century water remained a luxury.[74] Expensive, polluted, and insufficient, it dogged previous administrations in their attempt to lower costs and generalize its use. When it came to potable water, new technologies had to vie with old *mentalités*. Citizens clung stubbornly to traditional patterns of water consumption shaped by centuries of scarcity. It was in this area that Haussmann's greatest challenge lay, and here, too, that he broke new ground, vaulting over a long list of rulers and prefects who sought to ameliorate the complex situation of a city cleft in two unequal halves by a large river, yet paradoxically poorly provided with water. Increasing water supply was a major challenge that Haussmann embraced with great confidence and skill. Previous administrations, most notably those of Napoleon I and Louis-Philippe, had made significant gains in their attempt to bring more water into Paris. But the measures adopted earlier in the century could not keep pace with the needs of a rapidly expanding city, particularly after annexation.

At the beginning of the Second Empire, water distribution in the capital had fallen far below acceptable standards with regard to both quantity and quality. After annexation of the periphery, authorities tried to secure supplies for a growing population but could not keep pace with demand. As a precious commodity, water had always been apportioned unevenly. Politics dictated different distribution networks. Traditionally, the waters of Paris had been either royal (*eaux du Roi*) or municipal (*eaux de la Ville*). Each party had its own pump: the Samaritaine on the Pont Neuf belonged to the king, and the Notre-Dame on the eponymous bridge, to the city. In addition, the royal house owned several sources outright, including the Ourcq, given to the Orléans in perpetuity. Nepotism and abuses worsened the situation; concessions to the nobility and rich religious orders allowed them to siphon off part of the city's meager supplies. By Haussmann's day, things had changed, of course, but Paris still had both public and private waters, run by companies, a new version of the old dichotomy that would continue under his watch in another guise.

After familiarizing himself with the problems and armed with a certain level of expertise, Haussmann set about to remedy the situation. It did not take long to map out the city's available sources. The Ourcq served primarily the Right Bank, an area already equipped with more water than the Left Bank thanks to its aquifers and wells. In the Middle Ages, wealthy abbeys built two small underground aqueducts, Belleville and the Pré-Saint-Gervais, to capture the waters that rushed down from the heights in search of the old bed of the Seine. Characterized by their poor quality, these bodies of water were still known as the sources du Nord in Haussmann's day. On the Left Bank, the little Gallo-Roman aqueduc de Lutèce (known as the aqueduc d'Arcueil at the time), brought water from Rungis to the baths of Cluny and the surrounding area. In 1612, Marie de Médicis, who needed water for her gardens at the Luxembourg palace, not far from the Roman baths, ordered her engineers to build an aqueduct, and they chose to follow the trajectory of the Roman one.

Hopelessly contaminated, these sources could not quench the growing city. Moreover, they were largely situated on the porous and water-rich Right Bank. Topography was partly to blame for this asymmetry. There the water table—the old riverbed of the Seine—could be reached just below the surface: a huge impermeable clay plateau kept it

from seeping. Devoid of sources of its own, the Left Bank depended on water carriers, and the little aqueduct of Marie de Médicis. This north/south split weighed heavily on the development of Paris, atrophying one side and spurring the other to greater urban and economic growth.

Quality constituted another major stumbling block. From time immemorial, Parisians had gotten their drinking water from the Seine, which was highly polluted. Clouded and murky during much of the year, it received a staggering amount of waste as it flowed through the capital. "Who has not beheld with disgust this dark, slimy water, mixed with rotting substances, more suitable for fertilizing a wheat field than quenching a human throat?" asked Henri Lecouturier in 1848; "Yet it is in this mire that the Parisian soils his body under the pretext of bathing; it is this sludge that goes into all things served to him as drink. If filtered, he pronounces it excellent, and would hardly think of exchanging it for spring water."[75] The Ourcq, no less suspect, had been built to increase water supply, but by making it navigable Napoleon inadvertently led to its befoulment. Wells suffered contamination from nearby cesspools, tanneries, and dyers that infiltrated the water table. As usual, the poor suffered most. Until the end of the nineteenth century, clean water remained the preserve of the wealthy: "The rich citizen, the prosperous man, hardly suffers from the poor quality of drinking water, always having the means to correct the problem," wrote one of Haussmann's contemporaries; "he owns up-to-date filters which purify the water acquired from the water carrier, that is to say, taken from *fontaines marchandes* where it has already undergone its first treatment."[76]

Drawing water from the Seine was also costly. By the time it was destroyed, the arthritic pump of Notre-Dame (see fig. 4.9), dating from 1672, barely functioned. A perpetual nuisance to navigation, it took up two of the five arches of the bridge. The eighteenth-century fire pumps of Chaillot, Gros Caillou, and Austerlitz lifted water from the river and distributed it to the fountains at street level but required expensive coal and highly trained workers.[77] In 1834, Paris opened the Puits de Grenelle, its first artesian well, so called because its technology had first been introduced in the Artois.[78]

Supply, of course, was one thing, access quite another: once provisions were secured, they still had to be delivered to consumers. Wealthy or salaried Parisians preferred to subscribe to a monthly service since private water companies charged far less for their water, comprehensively, than did water carriers. As few households could afford the fees, most of the population depended on water carriers. With their two buckets slung from a shoulder harness, their loud, raucous shout of "À l'eau! À l'eau!" could be heard all over Paris. Most came from the Auvergne or from Normandy. A colorful, quarrelsome bunch, water carriers were extremely popular in art, literature, and even music (Cherubini's opera *The Water Carrier* of 1800 scored a great success). In principle, they could draw water only from municipal fountains that sold it to them for a fee, the *fontaines marchandes* (fig. 4.20). They cheated, of course, and preferred to get it free from public fountains or even water plugs, monopolizing the thin trickle of water with their buckets, jostling and intimidating the poor citizens waiting in line.

Water sellers had a difficult life. Living at the margins of the law, they depended on the authorities for permits to operate. Those who succeeded bought horses and huge barrels to deliver larger quantities faster. Most had only two buckets, roughly twenty liters of

FIG. 4.20. Broux, for-pay fountain in the marché Saint-Martin, for filtered water from the Seine. Engraving by Navellier. Roger-Viollet.

water each, which they often had to carry to the top stories of a building. Averaging thirty-five to forty trips a day, they worked like human packhorses.[79] Hoping, like other immigrants, to save enough money to return home and buy land, the insular Auvergnats retained their own customs and language. The communal lodgings where they lived seemed like "a village immersed in urban society."[80] Resisting assimilation, wrote La Bédollière, who espoused traditional views of migrants, "they remain isolated like the Hebrews in Babylon, in the midst of the large population that tends to absorb them."[81] Ever since the early nineteenth century, the trade proved increasingly unacceptable to the enlightened bourgeoisie, outraged "that the capital of France should be subservient to an army of water carriers who drag their barrels through the streets like beasts of burden, and demote human dignity below the status of a faucet."[82] A voice of the past, water carriers fought all new forms of water supply that dispensed with their services.

Water's monetary worth was significant. In Eugène Sue's *Les Mystères de Paris*, Rigolette, a young *grisette*, exclaims: "Two pails of lovely, clear water! Oh, that is my luxury."[83] Two buckets of water per diem, the average expenditure of workers and artisans, cost two sous. In the impoverished labyrinths of the inner city, few could afford such rates, and the burden of fetching water from the nearest fountain often fell to women and children, who had to carry the heavy load up the stairs. Poor women thus had a twofold association to water, both as "producers" and as consumers.

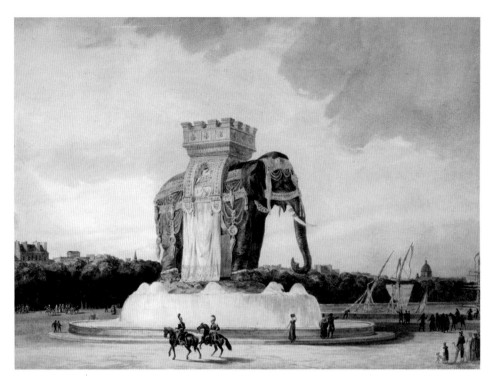

FIG. 4.21. Jean-Antoine Le Chevalier Alavoine, the Elephant fountain, Place de la Bastille. Watercolor, 10.6 × 7.9 in. (26.8 × 20 cm). Musée Carnavalet, Paris.

FOUNTAINS

Water usage was divided by class. Those who could not afford to have it delivered to their doorstep depended on fountains. Quality varied greatly. Whereas the municipality's fontaines marchandes sold filtered water, thanks to an ingenious system of sponges, gravel, and wool, public fountains and water plugs delivered a mediocre fare from the Ourcq.[84] In Haussmann's day, there were 113 fontaines marchandes in the city; three years after his fall, Maxime Du Camp noted that only twenty-six remained, a tribute to the prefect's success in freeing a large number of Parisians from their daily struggle to buy small supplies of what remained, for many, an expensive staple.[85]

As gifts from the ruling potentate to the population, monumental fountains resonated with the voice-over of power. Their iconography was charged with political and religious significance: military victories, coats of arms, the redemption of saints, and above all, the magnanimity of rulers. In 1829, when a group of artists and writers attempted to honor Molière with a fountain near the Théâtre-Français, where the dramatist had attained some of his greatest successes, the Comte de La Bourdonnaie, minister of the interior, refused to grant permission: only sovereigns could be memorialized in public space.[86] Postponed several times, the project was finally built by Ludovico Visconti in 1844, not altogether successfully. Napoleon Bonaparte alone built a fountain to a commoner: his companion in the Egyptian campaign General Louis Charles Antoine Desaix.

Imbued with selective ideals of the First Republic, Napoleon I wanted to endow Paris with free running water for all citizens: "My goal is to have the fifty fountains of Paris flow

FIG. 4.22. Ludovico Visconti, fontaine des Quatre Evêques, 1843–48, and the church of Saint-Sulpice in the background.

day and night [. . .] so that their water will no longer be sold and all may take as much as they wish."[87] Foreseeing the arrival of water from the Ourcq canal, he commissioned François-Joseph Bralle to build two fountains evoking his expedition to Egypt: the fontaine du Palmier in Place du Châtelet (1806) and the fontaine du Fellah in Rue de Sèvres (1810). Another monumental fountain linked to Bonaparte was moved from the Château d'Eau to La Villette in 1869: the fountain of the Lions of Nubia, designed by his engineer Girard, with its eight bronze lions cast by Creusot and flowing cascades. Yet Napoleon's most famous contribution in this respect may well have been a fountain that was never built— the controversial elephant of the Place de la Bastille by Jacques Cellerier and Jean-Antoine Alavoine, which lives on undyingly, as home to Gavroche, the unforgettable gamin of *Les Misérables*.[88] Its larger-than-life plaster cast remained in situ for decades until its crumbling, rat-infested remains were carted away (fig. 4.21).

While the French Revolution encouraged the creation of secular fountains dedicated to commoners, the Restoration, the July Monarchy, and the Second Empire inherited from both republican and royal traditions. Rambuteau commissioned several fountains, including two monumental ones by Hittorff in Place de la Concorde, and a few by Visconti. Visconti's fontaine des Quatre-Évêques (1843–48) in Place Saint-Sulpice, that most Italianate of Parisian fountains, was designed as much for its aural as for its visual qualities (fig. 4.22). Few monumental fountains, however, were situated in the eastern part of the city. Rambuteau built his exclusively in the western half.[89] So did Haussmann, with the exception of

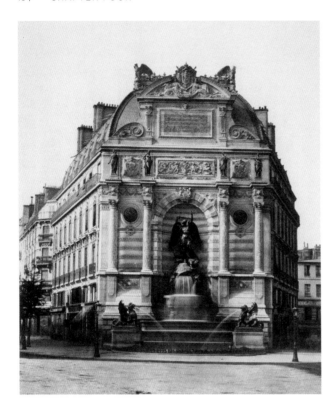

FIG. 4.23. Édouard Denis Baldus,
fontaine Saint-Michel, ca. 1860.
Designed by Gabriel Davioud,
1858–60. Musée Carnavalet,
Paris.

the fountain in Place de la République. This policy reinforced yet again the socioeconomic disjunction between the richer and poorer parts of Paris.

Water splashing down the fountain's marble lip produced a much-needed counterpoint to the deafening roar of the traffic. Freestanding fountains like these had traditionally been reserved for parks and gardens; they took up too much space and, given the cost of urban real estate, rarely appeared in French cities before the nineteenth century. If not quite as dramatic as Rome's, the flowing fountains of Paris had a richly evocative tradition, even in their abbreviated form, of the grand art of French formal gardens. Occasionally sonorous, they served as a meaningful foil to the surroundings, their whimsical murmur adding a note of fantasy to the hard-driven pace of the metropolis. Gaston Bachelard once observed that brooks and rivers give sound to silent landscapes. In cities, the reverse is true: noisy in themselves, large urban environments depend on fountains to soften the urban soundtrack.[90]

Despite his efforts on behalf of water supply, Haussmann's contributions in terms of fountains could not rival Rambuteau's in matters of design—in part, one suspects, because the new scale of the city ruled out traditional building types. In Haussmann's hands, fountains too often became place markers, traffic islands, or misplaced objects. Those designed by Davioud, have a certain sameness as one can see in the Observatory, the Théâtre-Français, and the Château d'Eau. The prefect did better with engineering than with architecture, where his taste ran to the banal and the formulaic.

Completed in 1860, the fontaine Saint-Michel was built to a Roman scale with an un-Roman sensibility (fig. 4.23). Haussmann had deliberately planned the Boulevard Saint-Michel with the perspective of the Sainte-Chapelle in view, hence the slight deviation of

its north-south axis. Once past the Pont Saint-Michel, however, the perspective was barred by a block of houses. To hide their ungainly gables and create one of those prospects that were dear to him, Haussmann asked Davioud to design a large fountain. Making use of cartouches, garlands, text. and statuary to fill the vast façade, the architect tried to sustain comparison with the scale of the Boulevard Saint-Michel. But the fountain's heavy-handed symbolism—the Archangel Michael astride the devil—shocked a generation on the verge of naturalism. The bellicose reference to Napoleon III also rankled: after the Fronde, Louis XIV placed Raphael's *Saint Michael Vanquishing Satan* above his throne, allegoriz-ing the triumph of authority over anarchy. The burdensome iconography, moreover, bore no relation to the theme of water. Architectural form should express its function clearly, wrote a noted art critic disapprovingly: "A foreigner arriving at the city and perceiving the building from afar, at the end of the street or in the middle of a public square, should be able to say after merely glancing at the general configuration: This is a fountain."[91] In fairness to Davioud, it must be said that his designs were submitted to many committees, stipulations, and revisions before a final version was approved.[92]

Changes in urban scale and increased circulation made the availability of potable water for pedestrians and horses a matter of urgency. Haussmann disseminated numerous fountains along major arteries and public spaces. Monumental and expensive fountains such as Saint-Michel were built largely for visual consumption, as terminating vistas for the capital's new boulevards. Others, sited in the middle of smaller squares, galvanized sur-rounding space with their centripetal pressure, tying together disparate scales and urban elements. Like other regimes before it, the Second Empire restored numerous fountains. Plumbing deteriorated rapidly owing to constant use, and fountains had an average life span of ten years. Those that survive have been repeatedly rebuilt on the same spot.[93]

Under Haussmann's watch, the city itself became a major consumer of water: new streets, squares, parks, and gardens depended on increasing supplies of municipal water. Rambuteau alone had installed close to seventeen hundred *bornes-fontaines* (water points similar to hydrants) as well as *bouches sous trottoir* (water plugs) that had to be turned on daily to wash streets, as one can still see today.[94] Haussmann added a great number of these. Fed with unfiltered water from the river, they found unforeseen clients: "I have often stopped," wrote Du Camp, "to watch poor women too destitute to pay for their two buckets [of water], too busy taking care of their children to run to the fountain, waiting for the water [under the sidewalk] to lose its most conspicuous impurities in order to gather the necessary provisions hastily with a pot. What a painful spectacle."[95] Louis Lazare also complained of the humiliating posture of the poor, trying to get water from the meager stream that trickled from the sidewalk: "This municipal water flows to clean the gutter, not to slake the thirst of the poor. If they want it fresh and limpid, they must pay for it; if they have no money, let them crouch to drink it."[96]

A strong presence in the public realm, fountains drew a great many people through-out the day, generating a particular kind of urban space that attracted those who could not afford to pay for water supply, above all housewives. Like washhouses, fountains were places of female sociability, which women knew how to exploit for their own needs.[97] Long lines made them places of popular discontent; places too, of humor, fantasy, and political resilience. When it came to labor, poor women had always been visible and active in public space. If, in their case, water helped constitute a public sphere of sorts, it also

defined some of its social thresholds, marking those who fetched water at the fountain as being too poor to afford the water carrier.

At the heart of the matter lay not only the greater or lesser availability of water for all classes, but also the values attached to it. The link between personal and social hygiene—the body and the body politic—had gained common currency among the industrious urban elites of nineteenth-century France. Hence the successive governments' efforts to increase and improve the distribution of water to the capital's unwashed multitudes: it was a question of morality. Both top-down efforts to dictate the discipline of hygiene and the resistance they provoked were partly class driven. Personal cleanliness, encouraged by society in a number of ways, was often perceived by the poor as a coercive measure to impose order and regulate behavior. Cleanliness and dirt came to define a polarity separating wealthier echelons from the laboring poor.

Yet the Second Empire's attempts to increase water supply and intake were also aimed at bringing the poor within the pale of the modern world. For the ruling classes, water was increasingly related to modern concepts of the body. Entailing a newfound sense of privacy, it signaled a gradual shift from public and collective hygiene to personal and private forms of cleanliness.[98] As such, it clashed with premodern conceptions of the body still prevalent in the countryside, where the peasants' sense of their own odor confirmed their belief in a healthy constitution.[99] The reluctance to bathe was also prompted by a more legitimate concern. Water was expensive because it was scarce. Soap cost money, as did wood to heat water. Consumption of water thus served as yet another index of social class. Its symbolic, political, social, and economic meanings preclude it from being read according to a single register.[100]

WATER SUPPLY

In the first half of the century, every administration had to deal with the disastrous state of the capital's water supply due to insufficient sources, antiquated infrastructure, and sharp demographic expansion. All had benefitted immensely from the inestimable help of the elite corps of engineers from the Ponts et Chaussées. Entrusted with hydraulic matters since the First Empire, engineers had left an impressive legacy of technical and scientific expertise. Haussmann understood the urgency of the situation. Securing new sources of supply was all the more important since cholera returned in 1854. His tenure would be characterized by the enormous importance and power he accorded municipal engineers. Inequality of access, on the other hand, endemic to the capital's successive regimes, would continue to haunt Parisians until the early twentieth century.

Soon after he took office, Haussmann assembled a remarkable team of professionals. Rather than relying on specialists from the Hôtel de Ville, he reserved the most important jobs for brilliant outsiders with no ties to the political machinery of Paris, men whose professional competence he knew firsthand, and whose loyalty he trusted. Among the most important were Eugène Belgrand (1810–78), in charge of water supply and sewerage, and Jean-Charles-Adolphe Alphand (1817–91), who was to take over parks and gardens. Answerable to him alone, they were in a better position to carry out the sweeping reforms he had in mind without being swayed by the internecine squabbles of entrenched municipal bureaucrats.

Both Alphand and Belgrand were company men, loyal to the emperor and to the prefect to whom they owed their high office. Belgrand, a first-rate engineer from the Ponts et Chaussées, came from a family of master ironsmiths from Burgundy.[101] Interested in music and painting, immensely learned but lacking political ambition, he was the ideal *fonctionnaire*. A member of the Academy of Sciences, Belgrand left several scholarly volumes that covered a wide range of subjects including hydrology, geology, archaeology, and prehistory, often enriched by his striking use of modern photography. His volume on Roman aqueducts reveals a profound knowledge of historical treatises and a passion for archaeological research. Alphand, by contrast, was the perfect courtier, adept at riding out turbulent political storms. His efficiency, expertise, and organizational skills (he too studied at the Ponts et Chaussées) were matched by suave diplomatic skills, and he rose as high as Haussmann himself, whom he later replaced at the helm of public works. His marriage to a member of a prestigious merchant family from Bordeaux (like that of Haussmann) gave him important connections to the city's oligarchy.[102] No one, wrote a contemporary, pushed "political eclecticism" as far as Alphand, who served the monarchy, the empire, and the republic with equal ease.[103] Alphand believed in a strong regime, the embodiment of order and hierarchy, whose authoritarianism he both respected and emulated. Augustin Filon, one of the preceptors of the "prince imperial" (son of Napoleon III), recalled having tea with the empress in the presence of several members of the royal circle, including Viollet-le-Duc and Alphand.[104] It is hard to imagine Belgrand at court: he would have felt more at ease in the academy.

The Second Republic had already divided the municipal services into two branches, one encompassing water and sewers, and the other, streets (*le pavé*). Haussmann maintained this sharp division, placing the upper part of the city in Alphand's hands, and reserving the lower depths to Belgrand, who inherited the thorny problem of finding new water sources for Paris. Altitude was a crucial part of the equation. Only the fire pumps at Chaillot and the Gros Caillou, reliant on coal, could provide water to the highest districts of the capital though at great expense to the municipality. For a government reluctant to raise taxes, this was no simple matter. Haussmann had dealt with water supply at a much smaller scale in his early years as subprefect in the south of France and, as his writings of the 1850s testify, had acquired over the years a certain grasp on issues such as altitude, geology, and the average rainfall during storms. Dry and unimaginative perhaps, Haussmann's technical expertise seems astonishing, even if largely borrowed from Belgrand and his technical staff. Previous prefects had left no record of their knowledge of materials used in pipes, siphons, and aqueducts, the quantities of water required for different parts of Paris, nor the temperature of water at the source.

Since all sources used in Paris were polluted, it was necessary to find pure, limpid spring water situated at a certain altitude, and if possible, tapped directly from its underground origin before it became contaminated.[105] Haussmann knew what he needed but not where to get it, so in 1854 he turned to a former acquaintance from his days as prefect of the Yonne. At the time, Belgrand brought abundant sources of fresh water to two small towns, Auxerre and Avallon. Since then, the engineer had moved to Paris, where he headed navigation services for the lower Seine. Given Belgrand's expertise in hydrology, Haussmann asked him for a detailed study of the river basin so that they could get a clear picture of the region's resources. As adept at empirical work on the terrain as at scholarly research in the library, Belgrand was the right man for the job.[106] He would be the

mastermind behind Haussmann's ambitious plans to modernize the infrastructure of the capital's water supply and sewage disposal. His detailed study of the hydrological basin of the Seine was crucial for the municipality's quest for water.[107]

Finding the right quality in sufficient quantities turned out to be a herculean task. Belgrand went in search of large watersheds, which he finally found, like a modern shaman, in one of the country's driest regions. Water had to come from sources at high altitude to be propelled by gravity, and at a temperature that remained cool when it reached Paris. The Somme and the Soude, two streams in Champagne, ran into the left bank of the Marne between Châlons and Épernay and could flow easily down to Paris by aqueduct, without the aid of pumps. Belgrand calculated that this source would provide almost as much water as the Ourcq canal. Haussmann presented Belgrand's report to the municipal council in 1855 and had him appointed director of the city's Service des Eaux et des Égouts.

The Somme-Soude project turned out to be more complicated than either Belgrand or Haussmann had foreseen. A long-standing cultural prejudice predisposed Parisians against spring water, and the proposal met with strenuous opposition in the municipal council and in the press. Opponents like Charles Merruau and Louis Figuier pointed out that since the Seine was open to the sky, it was always oxygenated and thus lighter than spring water.[108] The expense incurred by pumping water from the river was negligeable compared to the exorbitant sums needed to build the requisite aqueducts and reservoirs. Parisians remained partial to the Seine. Only in the Third Republic, when Robert Koch and others identified the cholera bacillus, and studies revealed the propagation of cholera and typhoid fever by water, did popular sentiment finally change, thanks in part to Louis Pasteur. Belgrand, strongly supported by Haussmann, discerned the superiority of spring water before Pasteur and others pointed out the role of water in transmitting bacteria.[109]

Annexation compounded the problem, not only by increasing the number of consumers and industries, but also by including within the city districts like Montmartre, Belleville, and Ménilmontant that were above the level of the Somme-Soude streams. Faced with this new obstacle, Belgrand proposed tapping the Dhuis River, situated even higher up. In this regard, Belgrand was walking in the footsteps of a celebrated predecessor, the engineer Pierre-Simon Girard, who had taken part in Bonaparte's expedition to Egypt. At Fayoum, Girard observed that the canals arrived at the city's highest point to facilitate distribution. Like Belgrand four decades later, this learned engineer had been in charge of Paris's water supply and had written extensively about the city's water sources.[110]

Once the new project was accepted, Belgrand built an aqueduct that ran through tunnels and bridges for eighty-one miles until it arrived at the great reservoir at Ménilmontant on the Right Bank.[111] Unfortunately, he had seriously overestimated the capacity of this particular source. When the volume of water proved insufficient for the needs of the capital, he found another excellent spring in the Champagne and began a second aqueduct, to carry water from the Vanne to an even larger reservoir on the Left Bank, Montsouris. Since the new aqueducts were far from ready, Haussmann had to find a way to pump more water from the Seine for public use. In 1863, after dismantling the eighteenth-century steam pumps at Chaillot and Gros Caillou, he built new ones upstream between Bercy and Austerlitz. In addition, several artesian wells were drilled within the city, including the Puits de Passy, the Puits de la Butte-aux-Cailles, and the Puits de la Place Hébert.[112]

To alleviate the situation, Belgrand advocated the use of two distinct networks that

carried water for public and private use. Polluted water from the Seine, the Ourcq, and the city's three old aqueducts (Arcueil/Lutèce, Belleville, and Pré-Saint-Gervais) would be used for streets, gardens, and industry in general. Water for domestic consumption, on the other hand, was to come from new sources brought in from great distances.[113] This system marked a thorough change from prevailing usage. Basing himself on Frontinus, Haussmann later claimed that he had gotten the idea from Trajan.[114] To convince Napoleon III of the wisdom of bringing spring water to the capital, Haussmann cited the example of the great aqueducts of ancient Rome.[115] Patte had already called attention to Roman aqueducts, as had Girard, and Belgrand was doing research on the Roman aqueduct of Sens (Burgundy) while looking for water in the southern basin of the Seine.[116]

Haussmann involved himself deeply in the search for water. His second book-length disquisition on water, delivered to the municipal council in 1858, was no doubt heavily indebted to Belgrand, if not, in fact, written by him.[117] Citing Cato, Frontinus, Procopius, and Cassiodorus, as well as a host of modern commentators from Edward Gibbon to Paul Marie Letarouilly, Haussmann traced the development of the imperial system of water distribution from the Republic to the last days of the Roman Empire. By inviting comparison to Rome, Haussmann undoubtedly magnified his own achievements, giving them the patina of the ancients, and he was often ridiculed for his pedantry. But part of his concern with the past was a ploy to enlist the assent of the emperor, who was more interested in the embellishments of the capital than in questions of infrastructure. Imperial precedent was bound to interest the self-made emperor, as did the reign of that oversized little uncle whose memory and accomplishments were both a boon and a burden to his nephew: he too had worked hard to bring more water to the capital. It did not hurt the cause that the aqueduc de Lutèce that fed the thermal baths of Cluny, now known to be a Gallo-Roman work, was then attributed to the Roman emperor Julian the Apostate, who had lived in Paris for a few years.

HYDROLOGICAL ARCHITECTURE

Mindful of the need to rein in costs, Haussmann declared that there was no reason to seek the monumentality of Roman constructions, which would encumber future generations with onerous debts: "The well-being of the popular masses should take precedence over the satisfaction of fastidious eyes and refined tastes."[118] Belgrand knew from Roman examples, however, that it was never merely a question of utilitarian buildings that addressed concrete needs but of representation: the meaning of the waterworks had to be expressed in a way that squared with the city's view of itself, and with the symbolic values attached to them by modern society.[119] His structures had to stand the test of culture. Although Haussmann complained of Belgrand's indifference to expense, the new aqueducts and reservoirs were characterized by daring technology and elegant simplicity. Belgrand was a minimalist who admired the clarity and lapidary aesthetics of hydraulic architecture built, he wrote, with "a minimum of materials."[120] For the Vanne, he used as his foundations the elegant seventeenth-century *pont aqueduc*, built for Marie de Médicis by Jean Coing (fig. 4.24). With its taut arches and crisp detailing of almost vernacular sensibility, Belgrand's aqueduct makes a powerful impression as it sweeps across the landscape, ferrying his "modern waters" to Paris.[121]

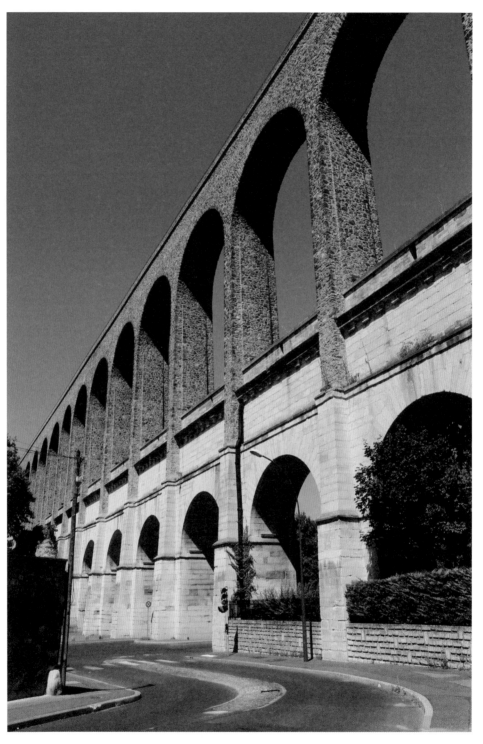

FIG. 4.24. Francine Allard, aqueduct of the Vanne by Belgrand (1867–74), built above the seventeenth-century aqueduct built for Marie de Médicis by Jean Coing.

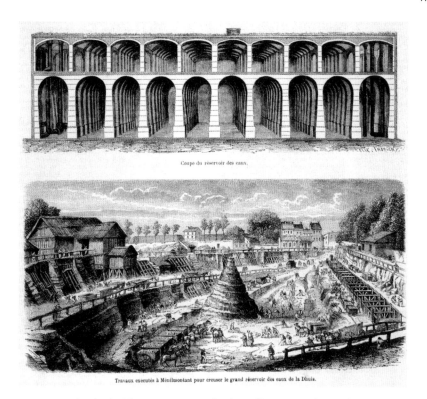

Coupe du réservoir des eaux.

Travaux exécutés à Ménilmontant pour creuser le grand réservoir des eaux de la Dhuis.

FIG. 4.25. Peulot / Felix Thorigny, section of Belgrand's reservoir de Ménilmontant, 1863–65. Alphand, *Les promenades de Paris*, 1867–73.

Belgrand endowed Paris with striking examples of hydrological architecture. Storing huge amounts of water called for a radical revision of the underground cisterns in use at the time. These now had to be constructed according to up-to-date technology and rigorous safety coefficients. Situated at a certain altitude, his new reservoirs required two stories to house water from different sources. To preserve the water's original temperature and purity, the structure had to be perfectly insulated from external conditions. Ménilmontant, built from 1863 to 1865, contained two artificial underground lakes, boldly superimposed: the upper level received spring water from the Dhuis, and the lower one, river water from the Marne (fig. 4.25).[122] Only a thin membrane of brick and cement separated the two stories. Haussmann and Belgrand had first seen this kind of construction years earlier in Avallon, when both lived in the south of France.[123] Du Camp considered Ménilmontant "one of the most impressive spectacles that it is given to man to contemplate."[124] Although it was not open to the public, it received its share of royal visitors.

Across the river stood an even more daring cistern, which received water from the Vanne under its own weightless vaults: Montsouris, then the largest covered reservoir in the world (fig. 4.26). Begun in 1867, it was not completed until 1874 owing to the Siege and the Commune. It was a technological feat, resting above quarries that had to be consolidated while work was being carried out above. To ensure thermal insulation, the roof of the reservoir was planted with grass.[125] The overall effect was striking. Du Camp

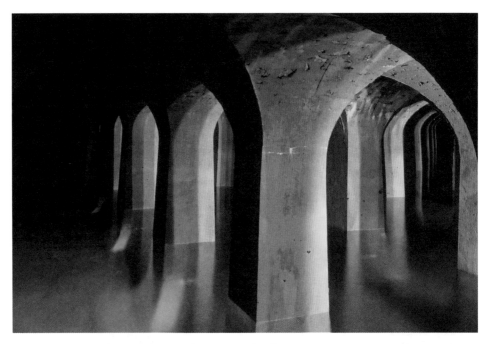

FIG. 4.26. Reservoir of Montsouris by Belgrand, completed in 1874.

commented admiringly of the gleaming cement columns that shone like silvered stucco.[126] Not by chance does this cistern bring to mind the Byzantine basilica cistern built by Justinian in Constantinople, well known to Belgrand.

Haussmann could not have succeeded in increasing the capital's provision of water without Belgrand's impressive expertise. The engineer must have challenged his superior's ideas on numerous occasions; but he would not have been able to solve such complex problems had he not been supported by Haussmann and seconded by first-rate colleagues. Together, both men succeeded in modernizing the hydraulic infrastructure of Paris, still in use today, though much expanded and updated. The opposition was formidable, coming from different constituencies within the political spectrum. Writing when the Third Republic was completing his oeuvre under the direction of Alphand, Haussmann worried about his place in history and stubbornly insisted on his "authorial rights" (*droits d'auteur*). Neither water supply nor sewage disposal were originally part of the emperor's ambitious plans for the capital, geared largely toward circulation and embellishments. "I insist with pride on this considerable body of work, [. . .]" he wrote in his memoirs, "for the main reason that it is mine alone. I did not find it in the Emperor's agenda for the Transformation of Paris."[127] Overwhelmed by political and economic problems, the emperor tired easily of details like water and gas.[128] Even though it took all Haussmann's patience and perseverance to implement such a vast project, it was Belgrand who found the means to endow the city with huge amounts of water. No one, Haussmann admitted, "could have furnished me with a deeper and more rigorous science; a more sincere conviction, or greater and absolute dedication. I shall even admit that the manner in which he fulfilled his task, perhaps warrants greater merit than that of the prefect."[129] This task, however, was

beyond the reach of two individuals and depended on a large number of superb municipal engineers whose identity is not entirely known.

Yet the new system never worked in an egalitarian manner. The center was fed by fouled waters of the Ourcq canal, while some parts of Paris received purified water even for nondomestic purposes.[130] Water ran plentifully enough in the elegant new districts of the capital, eagerly served by private companies. Workers suffered the most from class-driven politics of uneven water distribution, particularly after many were forced to relocate to the outskirts.[131] Belgrand himself acknowledged that when the outskirts were annexed, they consumed 13,000 cubic meters of water, while the central core, whose surface was slightly smaller, consumed 140,000 cubic meters.[132] In Ménilmontant, which had a magnificent new reservoir, observed Lazare, "the poor outnumber the rich five hundred to one, the worker's wife pays two pennies for two buckets of water which do not suffice when the good housewife has to do the family's laundry. In these sadly neglected places, the water carrier carries off forty francs a year from each laboring family."[133]

Before Ménilmontant and Montsouris became operational, Paris had to make do with other reservoirs—public and private, covered and uncovered—which varied widely in quality. Eugène Bouchut, professor at the School of Medicine, studied the difference between closed and open reservoirs. These last had an abundant fauna, clearly visible to the naked eye. At a private reservoir near the Panthéon, the water pullulated with living organisms that one could take up "by the spoonful, as in a soup."[134] More alarmingly, Bouchut examined five reservoirs built by Belgrand at Passy, two of which were open. One of these, he noticed, was full of "blackish mold like excrement."[135] Bouchut's bleaker perspectives differ from the municipality's triumphalist rhetoric, though he reported that some reservoirs delivered excellent water to the inhabitants of the area.

Although the capital's water supply improved greatly, by the end of the Second Empire, more than half the houses of Paris still lacked running water.[136] One might say that Haussmann failed better than his predecessors. Looking back over his achievements at the end of his life, he remarked ruefully that Parisians in his day still received significantly less water than the Romans of imperial times, and that his contributions fell short of the remarkable achievement of the ancients: "We have invented nothing. We are but imitators," he concluded.[137] Yet he never saw this shortcoming in terms of social class or equality of access.

THE POLITICS OF WATER AND THE PRODUCTION OF SCARCITY

Water governance was now firmly in the hands of the municipality. To deal with the escalating needs of the capital, Haussmann initially thought of unifying all private water companies into a monopoly, as he had done with gas and with transportation, but he ran into a powerful interest group: the Compagnie Générale des Eaux (CGE), founded in 1853, and directed by Count Siméon.[138] Shareholders included, predictably, members of the capital's powerful banking dynasties: the Rothschilds, the Foulds, the Lafittes, the Péreires, and the Hottinguers, as well as Persigny, several members of the imperial entourage, and the Saint-Simonian Barthélémy-Prosper Enfantin.[139] Well aware that fortunes could be made from selling water directly to the public, they lobbied hard to provide services for the city. Siméon's words to shareholders in 1853 sound almost like those of Saccard, the rapacious

financier in Zola's novel *The Kill*: "During the period that lies ahead, gentlemen, you may be sure that millions will be allocated to the distribution of water, just as millions were formerly allotted to railways, roads, navigation, and the marines. Our ambition is to be the pioneers in this new field, together with you, knowing we can count on the support of the government which foresaw the future that this type of work portends."[140] Siméon was well informed. The emperor was on their side and signed the decree of authorization on December 14, 1853. Haussmann, who had taken office a few months earlier, disagreed. One could not simply grant distribution of water within Paris to a private consortium, he argued, and risk compromising the well-being of the population for years to come. Haussmann's position on this score is surprising, since he was on good terms with all these powerful personalities, including Siméon.

Faced with the prefect's unyielding opposition, the CGE first obtained a concession to supply water to Lyon, then began to buy up several companies that delivered water to the faubourgs of Paris outside city limits but within the fortifications. When these were annexed, Haussmann found himself in a difficult position. On one hand, he had to honor the legal contracts obtained by the CGE; on the other, he found himself having to expand the water network before new sources became available. Realizing that it was not in his best interest to touch the consortium, he made a deal: they were to transfer ownership of their infrastructure to the municipality in exchange for a fifty-year concession to serve the banlieue. In the outskirts, water supply became contingent on the commodification and privatization of natural resources. As with gas, the periphery paid more for water that in fact came from the Seine, a highly polluted source that Haussmann refused to allow for domestic purposes in the center.[141] The deepening public-private divide underscored the fact that the quality of water and its forms of distribution depended on social class. Now a multinational owned largely by Vivendi, and operating in all continents under the name Veolia, the CGE demonstrates the longevity and reach of this oligarchy's hydro-imperial power, amassing fortunes and outliving several different regimes.[142]

Although Haussmann did not personally profit from the deal, his patrons and supporters certainly did. The political benefits were not negligible. Haussmann claimed to have fought the privatization of water so that Paris could retain ownership of all water destined for public use, on which the municipality depended; the company had rights only to water reserved for domestic, that is, private, use.[143] Nevertheless, it gained a foothold in Paris, where selling water was a lucrative business. Haussmann ultimately managed to increase water supply, but he did so with all the ambivalence characteristic of Bonapartism, both appropriating water for public use and privatizing it for domestic consumption. The deficiency faced by the poor was not due to an accident of nature: scarcity was naturalized by the municipality's priorities. Water was never simply a given. It was socially produced, as were the technologies that made it available.

Haussmann's measures met with hostility among the disadvantaged: to obtain running water at home cost money whereas they had always before gotten it free of charge. Rambuteau, who had also worked with private companies, observed, with a sense of humor only the wealthy could afford: "Everyone has a right to drink from the river, but it is reasonable to pay a price if you expect the river to come to your doorstep."[144] Vested interests played their part. Water carriers fought tooth and nail to block the municipality's policies

of distribution. Landlords were more ambivalent, loath to incur costs but eager for tenants. The way "modern" water was distributed challenged cultural practices ingrained for centuries and revolutionized established custom: before, it was mediated by face-to-face contact with an Auvergnat who brought paltry provisions to one's door. In the new dispensation, water arrived from a distant source, invisible and impersonal, linked to municipal (or private) entities rather than royal power as in the past. The social use of water was changing, but only slowly did it come to be accepted as a mass-produced commodity.

Nevertheless, the privatization of public water—in the sense both of a private company and of individual consumers who received it in the privacy of their homes—ultimately marked a turn in social attitudes to water. Despite the inequalities mentioned by contemporaries, the strong correlation between water and class began to erode as one witnessed what Jean-Pierre Goubert termed the "slow democratization of water."[145] And although the Compagnie Générale des Eaux charged high prices for its product in the outskirts, the costs of distributing water to the consumer dropped steadily: it was in the interest of the private sector to join forces with the municipality to provide running water, promoting new attitudes toward its use.

Haussmann's indefatigable effort to supply Paris with water undoubtedly looked to the future, coming at a moment when water was being converted from a favor due to the generosity of rulers to a commodity bought and sold over the market. While he presided over the shift from an older, artisanal culture of water to a modern industrial product, it was emphatically not a public service. In its inability to deliver the goods to all classes of society, the municipality looked backward to that "ancien régime of water."[146] The Second Empire's hydro-politics were the culmination of a long process that had begun with Lavoisier's chemical analysis of water and would end with Pasteur's discoveries of the waterborne nature of cholera and typhoid fever. Both eventually helped demystify and secularize water.[147] Nevertheless, the very fact that it came to many Parisians from the hand of a private enterprise with ties to the regime reiterated its old status as a political product.[148]

In the end, alternative sources of water and new forms of distribution weaned Parisians from their dependency on traditional forms of water supply. As water became a service, fountains gradually took on a purely decorative role. "The old fountains, so celebrated in their time, so carefully monitored by our fathers, disappear one after another without being cared for," Belgrand remarked sadly. "When I am gone, along with three or four collaborators [...], not a single memory of these old things will remain."[149] As for the Seine, it refused to go quietly. Dispossessed of its historic preeminence by the cold logic of economics, it went the way of old rivers, apparently subdued but unbowed in fantasy: it lived on in the work of poets, painters, photographers, and, later, film directors. And yet an unseasonal flood, a torrential downpour that temporarily scuttled the city's familiar appearance, reconnected citizens with their waterlogged history and unleashed the torrents of the imaginary, just as powerful and as threatening as the churning waters that had for centuries felled the city's bridges and embankments.

De Profundis

Ancient Paris is distinctly visible under present-day Paris,
as the old text between the lines of the new.
—Victor Hugo, *Paris Guide*

Paris rests on a pedestal of bewildering complexity, honeycombed with crypts and cata-combs, sewers and quarries, wells and canals. The dark disorienting labyrinth beneath the city was the obverse of the new Rome that emperor and prefect were building on the surface. Here was another Paris to be colonized and brought within the civilizing pale of the law. Haussmann's attempt to improve water supply and sewage disposal was predicated on the complete overhaul of the capital's underground; he longed to sanitize the illegible spaces below and incorporate them into the infrastructure required by the modern metropolis above. Yet this intractable realm stubbornly resisted the prefect's call to order far more strenuously than did the old city higher up. Although previous admin-istrations had already made modest incursions underground in their effort to improve sewerage, the city's subterranean regions remained a jumble of discontinuous spaces that were the antithesis of modern Paris, the domain of the phantasmatic and the uncanny rather than rational instrumentality.[1] Devoid of façades, the underground constituted a world of pure interiority whose mysterious recesses threw into sharp relief the contrast between the archaic and the new, darkness and light, the organic and the inorganic.

After the first few years in office, Haussmann redefined his earlier plans of renovation of the capital, focusing less on embellishments and monumentality than on infrastruc-ture.[2] With regard to sewerage, his achievements ushered in a new era in thinking about waste management that earned him international recognition. The initiative, though not the result, was largely his: the emperor's plan, as articulated in the Siméon report, made no reference to underground infrastructure. Nevertheless, like all the Second Empire's urban interventions, the prefect's battles on behalf of sewerage must be seen as part of larger social forces that were transforming the nineteenth-century city. Ever since the first part of the century, the capital's municipality had dealt with sewerage according to the needs, fears, and economic interests of its ruling classes. As Paris had to pay for the ser-vices it farmed out to private companies, proprietors and entrepreneurs stood to gain or lose significantly, depending on the methods used to remove human waste. These groups constituted an effective lobby that had a pronounced effect on municipal policy.

Despite the July Monarchy's improvements, Paris was not properly sewered. Most streets had old-fashioned gutters running down the middle, often filled with slops or

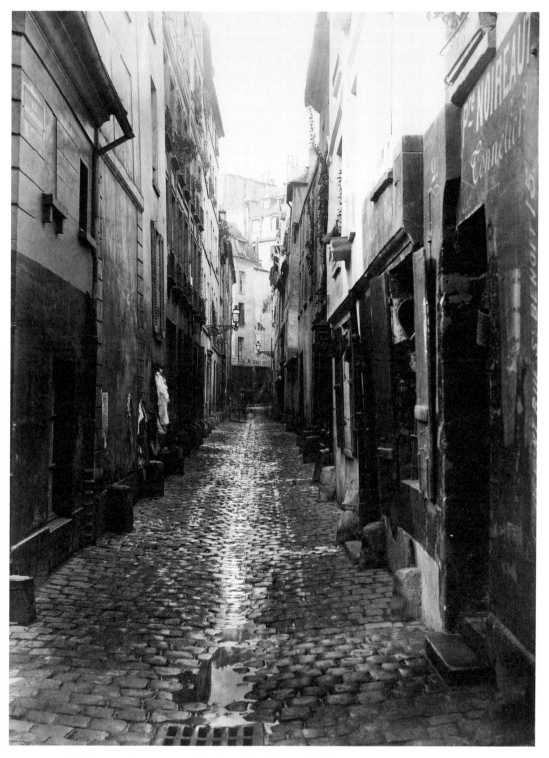

FIG. 5.1. Charles Marville, Rue Bernard Palissy (from the Rue de l'Égout), ca. 1865–68.
Bibliothèque de l'Hôtel de Ville, Paris.

stagnant water. Storm drains connected the gutters to archaic sewers, which clogged easily during heavy downpours and spilled their foul contents onto streets (fig. 5.1). In most neighborhoods, human refuse was still collected in overflowing privies and cesspools, which continually polluted groundwater. In the dead of the night, reeking carts clattered through the empty streets, removing human waste from cesspits, advertising their presence as much by stench as by noise. At the new municipal dump at La Villette, the barrels of night soil were loaded onto ships and dispatched upstream. The expense of this labor-intensive system was considerable. Unable to defray such costs, the poorest segments of the population often left refuse to accumulate and slowly decompose.[3] Even these inadequate measures thinned out toward the walls that surrounded the city, where wild and chaotic urbanization often lacked the most rudimentary forms of sanitation.

As dumps were located in the more desolate tracts of the periphery, the "pestilential belt" of filth and nauseating odor surrounding the city preoccupied authorities, particularly after the recurrence of cholera.[4] Rapid population growth further strained the city's antiquated sewer system. By the end of the century, ninety-eight thousand horses were stabled in Paris, and the quantity of manure left behind caused serious problems to pedestrians and street cleaners.[5] With annexation, the amount of human and animal waste inside the city grew sharply. Haussmann's attempt to improve water supply automatically increased the volume of gray water, requiring more sewers to channel effluence. Sewers, wrote the great French geographer Élisée Reclus, did the work of aqueducts in reverse.[6] The more water flowed in, the greater the amount of refuse that flowed out: the ebb and flow of the daily rhythms of a big city. In this respect, the demolitions required for urban renewal facilitated the task of building new sewers.

BENEATH PARIS

What is curious in this land of Iceland is not what lies above the surface but what lurks below.
—Jules Verne, *Journey to the Center of the Earth*

Haussmann's underground networks and prophylactic measures were the culmination of a long and uneven history stretching back to the beginning of the nineteenth century.[7] Napoleon I had paid great attention to infrastructure in his projects of urban renewal: "I thus spent up to thirty million [francs] on sewers for which no one will ever give me credit," he wrote.[8] Yet though the First Empire favored engineers over architects, it still thirsted after grandeur. The imposing sewers built by Napoleon Bonaparte under the new Rue de Rivoli and the even grander one beneath Rue Saint-Denis already revealed a concern with monumentality and spectatorship that would reappear in Belgrand's far more efficient models. A form of publicity for the government, they were executed with an expense that startled contemporaries: the very choice of materials, wrote Belgrand, demonstrated "a luxury that was wholly out of place in such constructions."[9] A few decades later, these very galleries were found to lack the necessary slope and dimensions needed for an expanding city; it was clear from their technical shortcomings that they merely continued in a more dramatic way the sewers built by the ancien régime.[10] Poorly designed and costly

to operate, many were like a replica of the streets above, with a gutter running down the center where slow-moving slurry inched its way toward the river.

Pierre Emmanuel Bruneseau (1751–1819), inspector of public works under the Consulate, and of sewers under Napoleon I, epitomized the fearless engineers whose empirical explorations foreshadowed the great advances of the second half of the century. It was Bruneseau, immortalized by Victor Hugo in *Les Misérables*, who first embarked on protracted, life-threatening explorations of the underground in order to provide a reliable inventory of the city's sewers.[11] From 1805 to 1812, he spent considerable time mapping the trajectory of the galleries, deciphering old inscriptions, dating the different branch lines that forked off the main conduits.

The Restoration made significant efforts to renovate the city's sewage system thanks to the engineer Alphonse Duleau, whom Belgrand called "the inventor of the modern sewers of Paris."[12] In 1823, Duleau replaced the old flat-bottom sewers, which blocked the flow of refuse, by new ones with a sharper gradient and near-human proportions. He also introduced materials such as cement mortar that rendered the use of thick walls obsolete, cutting labor costs.[13] Another key figure of the last years of Bourbon rule was Alexandre-Jean-Baptiste Parent-Duchâtelet (1790–1835), who in 1824 published his influential study *Essai sur les cloaques ou égouts de la ville de Paris envisagés sous le rapport de l'hygiène publique*.[14] A physician with a specialization in public health, armed with solid expertise in history, statistics, and chemistry, he too spent time underground studying the dismal condition of the sewers, the life of sewermen, even directing operations when the notorious Amelot sewer was blocked by refuse in 1826. This brilliant, shy, and unusual man, whose identification with society's untouchables clamors for psychoanalytical explanation, seems to have taken the city unconsciously for a large body, devoting his life to the sociological study of its scatological organs. Much of his work focused on those who dealt with refuse either literally or figuratively: sewermen, ragpickers, prostitutes, and knackers.[15] The wealth of observation displayed during hours of interviews and the wide sweep of his fields of inquiry make his treatises milestones of modern empirical research. Parent-Duchâtelet had much in common with the engineers who came of age during the July Monarchy, men endowed with an almost utopian fervor and a vision of the city as something that could be improved without revolution. Like them, he used his experience to advocate the use of modern materials to prevent seepage and water pollution, new forms of ventilation, and the adoption of chemical disinfectants.[16] His work remained a benchmark during the second half of the century, although younger generations questioned his empiricism.[17]

Key to the whole question was not just the number and location of the sewers, as in the days of Bruneseau, but the practicality of the design, the materials and equipment used for maintenance, and of course, expense. Under the July Monarchy, the engineer Henri-Charles Emmery, who had worked with Duleau, introduced new profiles and enlarged the sewers' dimensions to facilitate cleaning. Despite the innovative approach of these pioneers, many problems remained.[18] Their sewers did not operate according to a single system but as separate enclaves each served by a different collector. A single sewer was foreseen for every two streets, which meant that soiled and stagnant water flowed along the gutters in search of drains rather than reaching them directly. Furthermore, many of their new galleries disgorged directly into the Seine as it passed through the city.

As any increase in size automatically led to greater expenditure, cost remained a considerable obstacle. Every year, the July Monarchy added seven thousand to eight thousand meters of sewers to the network, but this was hardly sufficient for a rapidly expanding city.[19] Predictably, the new sewers were situated precisely in the wealthiest areas of the city; poor neighborhoods continued to be neglected. Despite these shortcomings, the Restoration and the July Monarchy left behind a substantial corpus of work of enormous importance to Haussmann's engineers.

The outbreak of cholera of 1848 and 1849 served as a decisive catalyst for change. The Second Republic's offensive against the disease played out on several fronts at once.[20] It built six new sewers and renovated twenty-three kilometers of old ones, under the direction of the economist and engineer Jules Dupuit. Until his falling out with Haussmann, he was instrumental in relaying the know-how of the Second Republic to the Second Empire.[21] Dupuit was also responsible for an impressive collector underneath the Rue de Rivoli that gathered waste from new sewers and discharged it into the river just below the Place de la Concorde (thereby polluting the water flowing past the city's most luxurious suburbs to the west). The large number of unemployed workers in the capital, organized into *ateliers nationaux*, provided the manpower needed for these projects. In 1849, the short-lived Republic passed a vital new law on insanitary housing and closed down the infamous sewage dump at Montfaucon.

Haussmann himself felt the pressure of cholera when, shortly after taking office, the virus made its second deadliest incursion into Paris. When it came to services such as sewage disposal, politicians, municipalities, and even the public were moved to action only when threatened by imminent danger.[22] Cholera, hygienist discourse, technological advances in construction and chemistry, and sharp demographic increase all contributed to shape different responses to a problem that took successive regimes to solve. By midcentury sewerage practices had greatly improved, and a more analytical attitude replaced the empirical methods of the past. Seconded by the municipality's elite corps of engineers, Haussmann and Belgrand benefitted greatly from a long line of enlightened administrators and technicians. Nevertheless, tenacious prejudices would remain a stumbling block to modern sanitation until the twentieth century: unwillingness to accept human waste in the sewers, unequal distribution of the system over the urban territory, and indifference to environmental pollution.

Because of his debt to the July Monarchy, Haussmann has sometimes been dismissed as the heir to progressive practices handed down by its administration.[23] Yet to write him off as a purely epigonal figure is to redress one wrong at the expense of another. During his formative years as a subprefect in the south of France, he built roads and bridges, opened schools, and provided running water for his constituents, though on a far smaller scale than in Paris. He spent over twenty years in the trenches—more than he did as prefect of the Seine. Furthermore, although the Siméon report—the blueprint used by Haussmann to transform the city—did not deal with infrastructure, it was more up to date with regards to the urban needs of the capital than the policies carried out by the July Monarchy. Haussmann's different memoranda on urban issues no doubt drew heavily on the experience of his experts, yet they reveal a breadth of knowledge in geology and hydrology that was unusual for a layman. One has only to compare Haussmann's memoirs to those of Rambuteau, which were also published posthumously and are equally self-serving, to see the difference in approach. Cities like London, Hamburg, Edinburgh, and Boston were

experimenting with advanced methods of sewerage, confronted by similar demographic expansion and fear of contagious diseases. In his crusade to improve hygiene and rationalize services in Paris, Haussmann, like other farsighted planners before him, was part of broad societal and economic trends of which he may have been only partially aware.

The creation of interconnected networks of water supply, sewerage, and gas on an unprecedented scale transformed Paris into an experimental testing ground where a new urban culture was being forged.[24] The presence of large numbers of engineers within the municipal government, heirs to both national and transnational practices, provided a critical mass of technicians. As population densities soared, engineers across Europe felt the urgent need to broaden their expertise in order to face the challenges of a radically altered urban environment. Their Parisian counterparts in Haussmann's day, more cosmopolitan in outlook than their predecessors, represented a new breed, highly trained in mathematics and hydraulic science.[25] They visited foreign countries to learn how other cities solved urban problems, often acting as consultants themselves. Oblivious to the machinery of power, they embodied the very model of the French civil servant.[26] The fact that municipal engineers were active on many fronts simultaneously—streets, sewers, water supply, parks, all of which required different technologies and approaches—was impressive: work on specific projects often stopped for months as nearby streets were being finished or water mains and sewers installed. Daly acknowledged their role: "One fact, Gentlemen, must greatly elevate in our esteem the profession of the engineer: today he is the outstanding creator of public wealth, that wealth without which a highly civilized nation can neither cultivate the arts on a grand scale nor devote itself to the high-minded enjoyment they provide."[27]

MASTER OF THE UNDERGROUND

The prefect's extraordinary cadre of engineers was led by the faithful Eugène Belgrand, "le grand maître du Paris souterrain."[28] For an engineer, Belgrand had received a scientific education without equal in Europe.[29] *Les Travaux souterrains de Paris* (1872–87), his monumental five-volume work on underground Paris, sprinkled with Latin quotations in the original, attests to his extraordinary erudition and strong background in both science and the classics.[30] The lengthy publication also explains in depth the modern equipment and methodologies he devised to improve and maintain sewers. Yet Belgrand's impressive achievements owe a huge debt to the municipality's superbly trained experts, named and nameless, whose role and contributions are not sufficiently known.

Belgrand's pioneering work on the hydrology of the Seine basin helped him understand the chain of natural water supply in the Paris region, from a sudden shower to the moment when water, after reaching the Seine by different routes, rejoined the atmosphere through evaporation.[31] None of the municipal engineers who preceded him had his panoramic grasp of the region's geology and hydrology since prehistoric times, nor his knowledge of archaeology and paleontology. By correctly identifying the major urban problems caused by rainfall, and bringing together all the wastewater flowing away from the city into a single source that emptied itself downstream, he went further than his French predecessors—though like them, he displaced pollution further downstream.

Pressured by Haussmann, always concerned with funding, Belgrand studied the costs of the old piecemeal palliatives exhaustively before coming up with his own overarching

solutions, which involved laying two interrelated underground networks, water and sewers, simultaneously without interrupting circulation. As both fresh water and sewage had to be propelled by the force of gravity alone, pipes and sewers had to be built on an incline, the former sloping toward the river, the latter away from it in the direction of the great collectors that removed wastewater from the city and pushed it downstream. Underground drains had to dovetail with the network of water distribution in order to be flushed properly, and both systems had to be closely connected to the streets above. Despite Belgrand's vast scientific knowledge, younger colleagues traveled abroad more frequently. Their specialization was perhaps narrower than his but more attuned to what was happening elsewhere, and they occasionally found themselves at odds with his views. Haussmann seems to have been aware of the need for both approaches and in 1854 sent the gifted young engineer Adolphe Auguste Mille to study the British and Scottish sewer systems (Belgrand went to England only in 1864).[32]

On his return from his 1854 trip, Mille wrote a remarkable report to Haussmann, calling for the concentration of water and sewerage in the hands of a single municipal body. In his view, the city had to be considered part of a larger territory.[33] He also advocated the use of the *tout-à-l'égout*, which entailed throwing all waste into the sewers, a solution that pitted him against both Haussmann and Belgrand who claimed, with some reason, that Paris did not yet have sufficient water to flush the drains.[34] Arguing that clean water that flowed into the city became a dangerous source of infection once it had been used, Mille managed to convince the municipality of the need to dispose of liquid household waste by sending it directly into the sewers.[35] This was a radical departure from established custom. Until then, sewers were utilized exclusively for rainwater; following Mille's proposal, they would also receive household waste. According to a municipal ordinance passed in 1852, before Haussmann's investiture, all new buildings had to be hooked up to sewers (when these existed) so that gray water could be removed. Landlords had to subscribe to the service, an unwanted expense that they constantly tried to circumvent. Belgrand therefore opted for a dual system: stormwater and liquid waste from households would flow into the new sewers while solid waste would have to be removed manually from archaic sumps that kept the city permanently in the grip of foul effluvia.

At the time, the most advanced sewers in Europe were to be found in Hamburg. After the old Hanseatic city was partly destroyed by fire in 1842, the British engineer William Lindley devised an ingenious comprehensive system flushed by the tide and relatively free of odors.[36] A model for similar experiments in Europe and the United States, Hamburg had much to offer Second Empire Paris in terms of sewerage. Lindley was a follower of Edwin Chadwick, a social reformer close to Jeremy Bentham. Chadwick's writings covered in great detail many of the questions faced by Haussmann such as road pavement, water supply, drainage, and urban sanitation. His reformist but conservative ideological underpinnings resonated with the government and the municipality.

Grounded on his strong knowledge of geology, Belgrand designed a network of sewers of varying sizes and profiles.[37] Installing 430 kilometers of new sewers was a feat.[38] It entailed slipping a vast system of conduits beneath the maze of closely knit streets in the older parts of the city, threading them through a huge area tunneled with underground quarries at different levels. By institutionalizing the use of new materials and up-to-date methodologies, he reduced costs significantly. After the Great Exhibition in London of

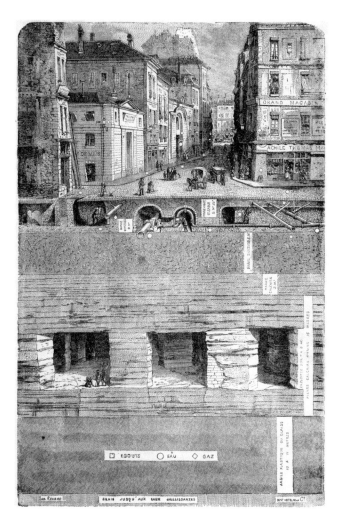

FIG. 5.2. Édouard Renard, "Le dessus et le dessous de Paris," n.d. Print. Musée Carnavalet, Paris.

1851, French engineers had already advocated the adoption of a thin ovoid shell in Portland cement, which they introduced to Paris the following year. Conceived as a single system, the different parts of Belgrand's sewers communicated with one another: gone were the hermetically sealed enclaves of the past.[39] To create a holistic, smooth-functioning system above and below ground, sewers and water mains had to be synchronized throughout the city. With time, the new underground infrastructure changed the very concept of the street: cutaway sections became popular precisely because they allowed each road to be seen together with its subterranean counterpart (fig. 5.2). In an attempt to correlate upper and lower Paris, sewers were identified by blue signs indicating the names of the streets and house numbers above.[40]

With Haussmann's support, Belgrand and his colleagues gradually overhauled the design, construction methods, and maintenance of the city's sewers. To prevent contamination of the river as it flowed through the city, Belgrand suggested bypassing the center and taking advantage of the long detour of the Seine (an idea Haussmann attributed to himself).[41] Nine huge collectors were built to carry the soiled waters from the city downstream to Asnières, where the Seine flips back on itself six miles from Paris (fig. 5.3). The linchpin of the entire network was a giant collector on the Right Bank, built in record time

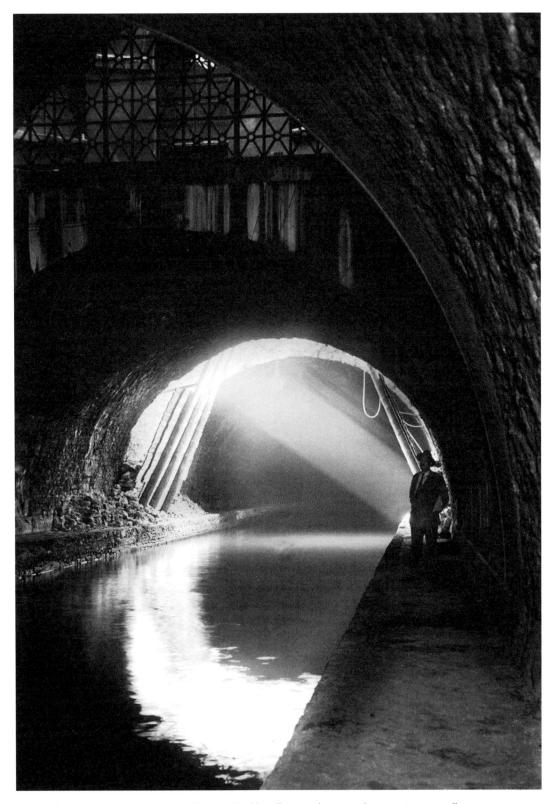

FIG. 5.3. One of the collectors of Paris, photographed by Albert Harlingue in the 1920s. Roger-Viollet.

FIG. 5.4. Sewer profiles for sluice boats (first row), and Mille's ovoid profiles (second and third rows). Alphand, *Les promenades de Paris.* *Marquand* Library of Art and Archaeology, Princeton University.

from 1857 to 1858. It received the foul waters from the Left Bank collectors before flowing toward Asnières. Haussmann compared its imposing dimensions to those of Rome's Cloaca Maxima.[42] On the Left Bank, the Bièvre collector, completed in 1868, crossed the Seine under the Pont de l'Alma before joining up with its huge counterpart.

Pipes, siphons, sections, cleaning equipment, and machinery had to be entirely redesigned, and new materials introduced to prevent seepage and pollution. Belgrand enlarged the sewers' dimensions to absorb the extraordinary amount of water that rushed into the galleries during downpours and to accommodate multiple functions (fig. 5.4). Thanks to a gradient of three centimeters per meter, sewage could be flushed away from Paris by gravity alone.[43] Building on the legacy of the July Monarchy, Belgrand revolutionized the approach to maintenance. Sewermen could finally move easily underneath Paris to dredge its ducts, now well-lit and ventilated.[44] In case of deadly flash floods, vertical tunnels spaced at regular intervals led to manholes at street level.[45] As older sewers had been cleaned by hand or left to nature, Belgrand and his experts devised new equipment to flush drains and remove obstacles. On either side of the *cunette* (central channel), footpaths facilitated access. Cleaning was vastly simplified thanks to the use of rails for sluice wagons or sluice boats.[46] Of varying size and design, these were specifically adapted to different kinds of sewers (fig. 5.5).[47]

Maintenance of the new underground infrastructure was still premised on a considerable labor force: 572 workers, including an inspector, several comptrollers, and subcomptrollers.[48] The pay of two francs a day that had so scandalized Parent-Duchâtelet had now gone up to three francs, still a very low sum.[49] Thanks to a long line of zealous reformers, from Bruneseau and Parent-Duchâtelet to Emmery and Belgrand, sewers had been redesigned to prevent accidents and threats to workers' health. Nevertheless, cleaning sewers remained a hazardous occupation.[50] Belgrand did not believe, "as certain hygienists do, that the atmosphere of the sewers, whose temperature maintains itself constantly at about 14 degrees on average, is favorable to health and produces a sort of immunity against epidemics." But he may have underestimated the situation, adding that the city's corps of sewermen "includes

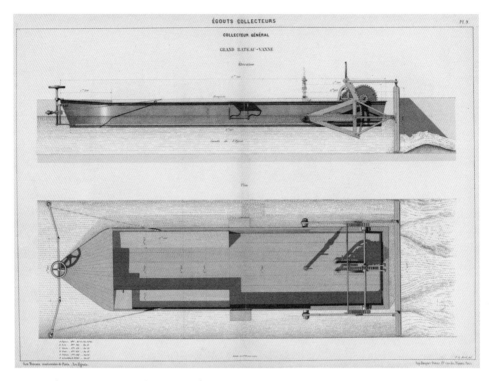

FIG. 5.5. Sluice boat in use in the sewers of Paris. Eugène Belgrand, *Les travaux souterrains de Paris*, atlas, vol. 5, 1887. New York Public Library, New York.

a large number of workers who have been toiling in the sewers for twenty to thirty years, and whose constitution is excellent and unaltered by the atmosphere in which they live."[51]

Technological innovations did not dislodge the centrality of nature in the design of the sewer system. The hydrological basin of the Seine, carefully studied by Belgrand, became the model for his modern network, with innumerable sewers running into gigantic collectors. Like rivers, they were situated in the city's natural valleys, so that sewage could flow into them by gravity.[52] Clearly aware of the crypto-naturalism of his overall design, Belgrand mentioned "the striking analogy between the sewer system and that of streams and even large rivers with impermeable margins."[53]

History served as another model, at least discursively. Belgrand and Haussmann were fond of invoking Roman precedent, even though Paris had few sewers dating back to Roman times. Haussmann's thirst for classical precedent expressed the exceptionalism rampant in his day: Paris, as he put it, was the "Rome Impériale de nos jours,"[54] In ancient Rome, he wrote in his memoirs, the names of the administrators of water supply and sewerage, inscribed on the old aqueducts, defy time: *Curatores alvei Tiberis et cloacarum sacrae Urbis*.[55] According to Pliny, Haussmann noted, Agrippa transformed the sewage system so that it could dispose of all the water brought in by aqueduct, and his great hydraulic works were bound to endure.[56] Haussmann's own interventions, by implication, would likewise survive the ravages of time.

Despite the ongoing modernization of the sewers, its associations changed slowly. Even a technocrat like Haussmann found it easier to describe a system of such complexity

by analogy to the human body, a persistent architectural trope since Vitruvius, and a common leitmotiv in literature.[57] In the seventeenth century, William Harvey's theories of circulation brought about a major shift in urban perception. Cities, according to this view, had streets, water mains, and sewers, as well as green spaces, whose functions resembled circulation and respiration. Echoing older theories, Haussmann argued that "underground galleries, organs of a great city, would function like those of the human body, without revealing themselves; pure, limpid water, light and heat would circulate like different fluids whose motion and maintenance enhance life. Secretions would mysteriously regulate themselves there, and preserve public health without impairing exterior beauty."[58] The fastidious prefect, known for his aversion to filth, apologized for dealing with a scatological topic in terms that bring to mind a thaumaturgical king: "I beg you therefore, in consideration to the usefulness of the ends, not to be put off by the abject details and remember that the administrator, like the doctor or the sister of charity responsible for touching numerous sores, must harden himself and rise above all repugnance by the sentiment of duty."[59] Haussmann shared with Parent-Duchâtelet, that other urban pathologist, a belief in the urgent need to supervise and contain all points of trouble in the urban body. His task at the bedside of the city was to purge urban viscera and maintain the metropolis in perfect health. From this perspective, urban problems were a result of some sort of social disease rather than economic factors and divisive class politics.[60] Anxieties about the city's concealed underground ducts could only be exorcized by being naturalized.

Body metaphors were linked to class fears. For Maxime Du Camp—who anatomized Paris in his famous six-volume work appropriately entitled *Paris, ses organes, ses fonctions et sa vie*—the capital was a living body: "The hidden organs of its functions never rest."[61] As a metaphor for the social order, the body politic had also been a staple of hygienist thought, which made morality contingent on physiological cleanliness. "The cleanliness of the body is the image of the purity of the soul," wrote the legendary engineer Bruneseau during the First Empire; "the cleanliness of a house is the image of the order that reigns therein; I believe I am thus well-founded in saying that the cleanliness of a city is the image of the purity of the mores of its inhabitants."[62] For Chadwick, who oversaw the sewers of London in 1848 and 1849, "the promotion of civic, household, and personal cleanliness, is necessary to the improvement of the moral condition of the population; since sound morality and refinement in manners and health are not long found co-existent with filthy habits amongst any class of the community."[63]

Overhauling the city's superannuated and inefficient sewerage carried with it a barely veiled attempt at social control. Sewers had been associated to surveillance in the very way the service had been originally set up. Traditionally, sewers fell under the jurisdiction of the prefect of police, though maintenance was the responsibility of the prefect of the Seine. When annexation was announced in 1859, the service passed to Haussmann, who was now solely in charge of their upkeep; the hook-ups that linked buildings to sewers continued to be the preserve of the prefect of police. Preceding Pasteur in the great undertaking of purifying Paris, Haussmann imbued the task with disciplinary overtones, aimed at combating political antibodies, which were considered dangerous sources of contagion. Contemporaries acknowledged the connection between the Second Empire's exemplary sewers and political security: "On one hand, they wanted to favor the circulation of ideas, and on the other, to assure the circulation of regiments," wrote Louis Veuillot acidly in

1867. "A clever network of sewers fulfills this double aim [. . .]. As for the regiments, should the street be barred for any reason, they could maneuver just as easily below ground, which would ensure their advantage."[64] Du Camp, whose words sometimes seem almost like a paraphrase of Haussmann's, was particularly clear in this respect: "Populous cities have their secret organs which are no less indispensable to life for being hidden. This is one of the most important: it polices material things and purges the city of all impure elements."[65] Yet sewers were beginning to accommodate a more strictly utilitarian view, though the link to morality and security had not disappeared.[66] A wholly depoliticized concept would not emerge until the twentieth century.

THE CONSUMPTION OF WASTE

Haussmann's hardest battle with regard to sewerage had to do with human waste. In Paris, most houses and especially those of the poor, had fixed cesspools that stank, leaked, and had to be emptied. To prevent explosions, long pipes linked them to the roofs, allowing dangerous gases to escape but spreading their fetid exhalations throughout the city. There were also mobile cesspools (*fosses mobiles*), which were periodically removed and replaced, and later latrines that retained solids (*tinettes filtrantes*) but allowed liquids to fall directly into sewers. All three kinds of cesspools depended on workers who removed waste from the stinking pits with buckets and spades, transferred it to carts, and drove it to the municipal dump by night. This task was carried out by poorly skilled sewermen, "as undesirable as they were indispensable," despised and discriminated against for their degrading contact with the abject.[67] Night soil was removed from the city and deposited at La Villette, then sent by boat to the new municipal dump at Bondy, six miles northeast of Paris. Liquid waste, removed by steam pump, arrived in Bondy by pipelines along the Ourcq canal.[68]

Before the dump was moved to Bondy, human refuse from Paris was spread out to dry in shallow open air basins in the notorious pits at Montfaucon. The upper quasi-liquid part was transformed into ammonia sulphate, a source of revenue. The solids eventually hardened and were cut into pieces to be sold as poudrette, a dry, odorless fertilizer much favored by local farmers.[69] This kind of constant recycling, characteristic of the ancien régime, persisted in Haussmann's day: excreta, horse carcasses, offal, carrion, maggots—everything could be recuperated for profitable use. Yet at the same time, there was a real revolution of ideas and practices regarding the meaning and economic value of waste. The ways in which societies deal with refuse are indicative of sociopolitical, technological, and economic issues that are inescapably class bound. It is no accident that enlightened engineers and the laboring classes in general were largely in favor of the new all-purpose sewers into which both night soil and gray water could be discharged. Fixed cesspools, which required little water, could be found primarily in the eastern part of Paris; the wealthier western half of the city relied on tinettes filtrantes, which filtered solids and got rid of household waste instantly. The poor favored the new system because it depended on a generous distribution of water, a luxury they had never been able to afford and that could improve their unhealthy housing conditions.[70]

By midcentury, cesspools of all varieties were an anachronism in many cities of Europe and the United States, where such cumbersome and unhealthy practices had long since given way to the water-carriage or combined system: the tout-à-l'égout.[71] When Mille

returned from England advocating a single drain for all forms of refuse, the prefect and Belgrand balked, though Belgrand would later qualify his position. Haussmann did not want fecal matter to defile his antiseptic sewers after working so hard to make them accessible for maintenance.[72] In the end, he settled for a "partial modernity."[73] On this point, he stood solidly with public opinion. The prefect was also well aware of the enormous power and political leverage of sewage treatment companies, whose profit margins would dwindle drastically with the new system. Only after a violent campaign would Paris adopt the combined system, a quarter of a century after the end of the Second Empire, and even then imperfectly.

The consequences of this incomplete system of sewage removal were not only unsanitary outhouses and overflowing privies but also environmental pollution. Since sewers were no longer allowed to disgorge in the river as it flowed through Paris, waste and contamination were displaced to Asnières, where two giant emunctories merged just before emptying their noxious contents. On the Right Bank, the Saint-Denis collector received the most toxic waters of the city, from animal markets, gas plants, slaughterhouses, and industrial establishments in Montmartre, La Villette, Belleville, Saint-Denis, and even Bondy before it too reached the Seine.[74] During the Third Republic the Council of Public Health expressed alarm at the contamination of the Seine. Cholera struck again in 1873, 1884, and 1892, and typhoid fever killed seven thousand people in Paris between 1872 and 1877.[75] Smallpox, measles, and malaria reappeared. Long after Haussmann fell from power, pollution continued to infect the beautiful area around Asnières, Bougival, and Chatou, which the impressionists immortalized in images of leisure during those very years.

Mille was determined to combat the contamination of the river. In 1867, he was again sent to England and returned an ardent advocate of sewage farms (épandage). For centuries the Scots had used wastewater to irrigate fields with excellent results. Chadwick had championed its use, calling attention to the natural circularity of the process: water from the countryside would irrigate cities whose wastewater would in turn fertilize fields.[76] Joseph Paxton, Mille wrote enthusiastically, "the illustrious gardener, author of the Crystal Palace, irrigated greenhouse plants, strawberries, melons, pineapples, with all the soiled waters of his Chatsworth house."[77] Given the costs of piping waste, it was little wonder that it succeeded mostly in the greenhouses of the rich. On Mille's return, in 1869, he began an experiment in the dry peninsula of Gennevilliers, five miles from Paris, where sewage irrigated the fields and purified itself by being filtered through soil. Waste, too, had to circulate to produce wealth. Despite violent opposition from local farmers and even scientists like Pasteur, who considered sewage farms a grave danger to the population, the arid plains soon became a lush vegetable plantation. The experiment's success led local residents to clamor for liquid waste to water their crops. "They transform sand into the promised land," wrote Du Camp.[78] Though impressed with the results, Haussmann remained squeamish about the whole operation. Gennevilliers, however, only minimized pollution: most of the waste from Paris still ended up in the Seine.

Vested interests conspired for decades to stall the tout-à-l'égout. Opposition stemmed from both public and private sectors, openly partisan or unconsciously so. The municipality provided services by means of contracts with powerful sewage management companies that had their own dumps. For years these companies imposed their will on Paris: faced with the nauseating stench and dangerous waste piling up at Bondy, administrations

often caved in to their demands, ignoring the complaints of residents exposed to noxious fumes and pollution. Shareholders included well-known bankers and entrepreneurs, as well as members of the press, who sometimes unleashed virulent campaigns against the new system. Instead of receiving money for waste, these groups were now compelled to pay taxes for their removal.[79] Landlords were equally opposed: they would have to shoulder the costs of installing and maintaining the new procedure and pay the corresponding taxes. The combined system also depended on increased water supply whereas they had always tried to limit the amount of water distributed to tenants, and often forbade the use of water in common privies. Their recalcitrance was not due to the price of water alone but to that of cleaning cesspools, which would fill too quickly.[80]

There were other angry opponents to contend with. Manufacturers of chemical products feared for their future, and villages situated downstream from the capital complained angrily at the thought of having to cope with sewage from Paris. Residents from elegant suburban areas west of the city feared that contamination would decrease the value of their magnificent properties along the river.[81] Scientists and physicians were split over the issue: many opposed the combined system for fear of contamination. It was on these grounds that Pasteur lent his prestige to the naysayers. The municipality was ambivalent. Although most of its engineers embraced the new ideas, the municipal council was apprehensive about future expense: Mille's proposal called for increased water to flush conduits, the cost of which would be absorbed by landowners. The combined system thus collided with ingrained prejudices; threatened the financial gains of chemical plants and sewage disposal companies; alienated property owners; and challenged physicians and scientists.

The main motive behind the opposition, however, was profit. Human fertilizer was worth millions to the firms that removed night soil and transformed it into merchandise. A few decades earlier, Girard and Parent-Duchâtelet estimated the value of poudrette produced at Bondy at several hundred thousand francs.[82] Shortly after Haussmann left office, Alphand set the amount of human waste lost to agriculture at about six hundred million francs.[83] Several million kilos of ammonia sulphate and poudrette, plus the millions paid to sewage treatment companies for cleaning cesspools brought in a handsome sum of six million francs.[84] The city itself would lose money, since it earned income from the sewage deposited in municipal dumps. Alphand calculated the amount of nitrogen that would be swallowed up by the tout à l'égout system annually at twenty million francs.[85]

Different ways of dealing with human refuse reflected social class as well as economics. Company owners and shareholders belonged to the moneyed elites, while products like poudrette were used largely by the working class and by local farmers from semi-rural areas surrounding the capital. Human waste rich in nitrogen (and thus profit) came largely from areas inhabited by poor residents whose nourishment was not overprocessed or diluted in large quantities of water.[86] The droppings of the rich yielded less revenue.

Not all opponents of the tout-à-l'égout were venal. Human fertilizer had been used in agriculture for centuries and had numerous adherents in France. For those like Parent-Duchâtelet, the therapeutic value of excrement had not died out.[87] Decades before Freud, Hugo equated human waste and gold, bemoaning with purple prose the tons of night soil, squandered by sewerage, that might have been transformed into wealth.[88] Chadwick made no reference to the human body but articulated a similar thought: "All smell of decomposing matter may be said to indicate loss of money."[89]

The heated controversy touched off by the crusade for the tout-à-l'égout reached its high point in the summer of 1880, during the Third Republic, when the stench that inexplicably filled the capital and the rise of epidemics brought the issue to popular attention. The tout-à-l'égout was finally passed into law in 1894, mandated by the prefect of the Seine, Eugène René Poubelle, aided by the engineer Georges Bechmann, after protracted juridical skirmishes, press campaigns, and endless municipal deliberations.[90] That it succeeded at all was thanks to the indefatigable zeal of Alfred Durand-Claye, a hygienist and engineer who defended the combined system in courageous professional publications, and went on to devise sanitation systems for several French cities and for Budapest, Odessa, and Geneva.[91] The violence stirred up by the subject was unprecedented. Municipal engineers, at the forefront of the reforms, were far more exposed than Haussmann, Belgrand, and their successors. A few years after Durand-Claye's untimely death at the age of forty-seven, an article in the right-wing *Le Petit Journal* stated that since he was dead, one could no longer "demand that he be shot. But to be frank, in the somber days of revolutions, popular wrath lynched men who were but minor criminals compared to those who have outraged Paris in such a manner."[92]

The violence of the response unleashed by the tout-à-l'égout and the opposition of scientists of the caliber of Pasteur and Paul Brouardel suggest that the sense of painful dispossession cut across different social strata. The disappearance of night soil into invisible underground conduits triggered anxieties of loss and separation.[93] The ensuing displacement of affect to money, a symbolic (and unconscious) substitute for profit derived from human waste, reveals an attempt to retrieve what is lost. With the tout-à-l'égout, sublimation brought no visible rewards, no gratification such as vegetables grown with human fertilizer, or money. Forfeiture of even so abject a thing as excreta was compounded by radical changes introduced by modernity. Refuse was now monitored by the municipality in giant networks that reached into homes, violating private space.[94] A wide distance came between citizens and their excretions that was increasingly mediated by specialists.[95] Sewers became a site where state, body, and city intersected. Technical jargon now designated the new system purging it of affective charge.[96] "The words that designate the sewer in administrative language are sonorous and dignified," wrote Hugo ironically. "What was once called gut [*boyau*] is now called gallery."[97]

That the battle for all-inclusive sewers dragged on for so many years attests to the raw nerve that they touched, and the resistance of citizens, property owners, and sewage treatment companies who made use of every legal stratagem to maintain their privileges and revenues. As late as 1928, more than half a century after Haussmann's fall from power, only 81 percent of the houses were hooked up to sewers; Paris still had almost twenty thousand cesspools of various sorts, largely in working-class areas.[98] Ultimately, in an economy fueled by demand, more and more landlords gave in to the new system, as tenants actively sought housing in upgraded buildings.[99] By then sewers had largely lost their former social, political, and economic significance and had become utilitarian instruments of sanitation.

Cleanliness and personal hygiene were not a question of voluntarism but reflected education and financial means. Few buildings in Paris had running water—that other systemic sanitation problem that took decades to solve—or bathrooms and bathroom fixtures. New rituals of hygiene entailed greater consumption of water, deodorants, and detergents.

Signaling class differentiation and social distancing, these also implied the valorization of privacy, as opposed to the communal baths and privies of the laboring classes. In both the domestic and the public spheres, the "privatization of waste," analyzed by Alain Corbin, brought about urban and architectural transformations.[100] Within wealthier homes, closed spaces guaranteeing individual seclusion were set aside for bathing and defecating.[101]

The municipality's need to control waste disposal also reveals modern society's growing intolerance of bad odor. "All smell is disease," Chadwick declared sententiously.[102] It was up to the state to eradicate this pathological agent. Smell was not a merely natural fact; it was a cultural construct and the reflection of economic necessity.[103] By the second half of the nineteenth century, it had become a class marker, a tool of social discrimination that established clear boundaries separating one's peers from "outsiders." Upwardly mobile men and women learned to repress and domesticate body odors.[104] "The bourgeois," wrote Corbin, "projected onto the poor what he was trying to repress in himself."[105]

Insufficient water supply and improper sewerage condemned the poor to lack of cleanliness, reinforcing social divisions and class-driven *mentalités*. The division of the city into "the foul and the fragrant," to use Corbin's incisive formulation, was largely due to the unequal division of water supply and sewage disposal across the urban territory.[106] Workers' defiant attachment to unhygienic practices could also express resistance to the imposition of order from above. Nevertheless, times were changing. If older generations attached distinctively social and political connotations to smell, for technocrats and specialists smell was fast becoming a purely chemical reaction. As Mille had already noted in 1855, "The odor of fertilizer does not constitute its strength, but only signals its loss."[107] For Georg Simmel, writing at the beginning of the twentieth century, this olfactory sense of revulsion and social distancing was "one of the sensory foundations for the sociological reserve of the modern individual."[108] Linked to animal behavior, olfaction ranked last in the hierarchy of the human sensorium alongside the sense of touch.[109]

THE INTESTINE OF LEVIATHAN

And then there was Hugo, magnificent and unbowed, hurling imprecations at *Napoléon le petit*, every book a best seller, every tract instantly translated, a specialist in the depths as well as the heights of Paris. Just as he had left an indelible bird's-eye view of the city in *Notre-Dame de Paris*, so too he wrote memorably on sewers, tapping the unease attaching to the subject with the powerful chords of *Les Misérables*. This greatest of all books touching on underground Paris was published in 1862, at the peak of Haussmann's campaign to renovate the city. In a celebrated chapter, "The Intestine of Leviathan," the hero Jean Valjean saves a wounded insurgent from the forces of order during the revolution of 1832 by escaping through the old sewers. Writing from his sanctuary in the Channel Islands, Hugo was not interested in Haussmann's infrastructure. His novel is set during the Restoration and the early years of the July Monarchy: it was the older sewers that he wished to portray, drawing on the papers of Bruneseau.[110]

The grim, decrepit sewers of the ancien régime had not entirely disappeared in Haussmann's day, and Hugo was keen to explore their older, sinister associations. Deliberately ignoring Belgrand's impeccable galleries, he rejected pedestrian associations of refuse with the everyday and insisted, with commanding anachronism, on the sewers as the last

repository of the sublime in the modern metropolis. His evocation of the archaic drains is cloaked in the dramatic language of Romanticism, its surplus of signifiers issuing forth like a salvo: "Tortuous, fractured, unpaved, cracked, rent by potholes, churned by bizarre turns, rising and falling without reason, rank, savage, fierce, plunged in obscurity, its slabs scarred, its walls slashed, terrifying—such, in hindsight, was the ancient sewer of Paris."[111] For an exile like Hugo, the Second Empire's immaculate sewers concealed the far more toxic filth of a regime that had come to power by overthrowing a republic, dissembling its true nature behind a spotless façade. "In spite of all the processes of disinfection," he wrote of Belgrand's modern sewer, "it exhales a vague, suspicious odor, like Tartuffe after confession."[112] Sewage stood revealed as all that society had repressed: traces of bygone eras and different social classes; unwanted memories masquerading as matter—an anticipation of Freud's unconscious. "A sewer is a cynic. It reveals everything."[113] It was just this forthright transparency of underground Paris, baring the city's secrets, that made it invaluable for Hugo. What was important lay below. The modern surface of Haussmann's city was merely the bitter rind left behind by an authoritarian regime.

THE VISIT

Such was the interest generated by the empire's new sewers that they became an elite tourist destination. "No foreign sovereign, no important personage, left Paris without having visited the collectors," wrote Belgrand with understandable pride.[114] In 1867, accompanied by Haussmann, he led Tsar Alexander II, traveling incognito, on a guided tour of the sewers and the Ménilmontant reservoir, as he did King Wilhelm I and Field Marshall von Moltke.[115] Visits, first instituted during the World's Fair of 1867, offered a memorable *spectacle son et lumière*, with theatrical lighting and dramatic sound effects. As sluice carriages were not suitable for carrying passengers, Belgrand had little train compartments built expressly for the purpose; pulled by sewermen, they could seat up to twelve people each. To accommodate the high number of visitors, two tours a day departed from the Madeleine and two from the Châtelet simultaneously; to his great regret, they could accommodate only four hundred persons each time.[116] There were also vessels with carpets and cushioned seats, gentrified versions of the sluice boats used by sewermen (fig. 5.6).[117]

With his love of mise-en-scène, Haussmann made sure visits were a suitable showcase for the empire. Contemporaries rhapsodized over the theatricality of the lighting. The galleries, wrote an enthusiastic tourist, were "magnificently lighted up with some thousands of moderator lamps, each provided with its silvered reflector" (fig. 5.7).[118] "Now imagine," observed another, "the lights of the train plunging in the immense underground gallery, casting their pale reflections on the travelers and drawing on the walls the silhouette of the sewermen, and you will have seized the picturesque side of the voyage."[119] Sewermen dressed in white handed the ladies into train compartments. A trumpet sounded the signal for departure, reverberating through the darkness; the convoy moved up the galerie de Sébastopol, turned toward the Rivoli collector at a turntable, continuing until the general collector under Place de la Concorde. There, visitors disembarked and moved quietly until they arrived at a waiting room where, wrote Frances White, "every tongue, silent heretofore, broke out in a perfect babel of speech, like the noise ensuing upon the fall of the curtain after the first act of a new play."[120] Workers in blue-and-white uniforms then

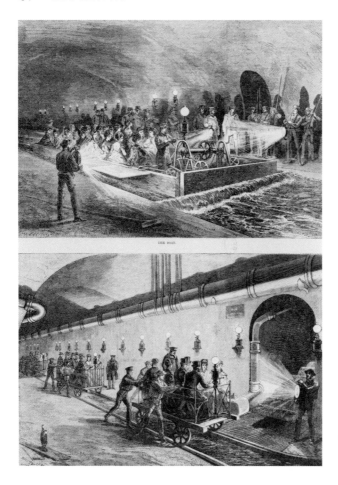

FIG. 5.6. Jules Pelcoq, a visit to the sewers of Paris. *Illustrated London News*, January 29, 1870. Bibliothèque nationale de France, Paris.

ferried passengers in their Dantesque voyage by boat through the epicenter of the system, the *grand collecteur d'Asnières*, a veritable underground river.

Despite their increasing popularity, corroborated by innumerable articles in the press and nineteenth-century guidebooks, relatively few people could take these once-monthly tours, which required writing the municipality for tickets. The experience was therefore largely vicarious, but perhaps all the more powerful for being heavily mediated by representations, first and foremost, Hugo's extraordinary description of the dark, oozing spaces underground. Visitors had first encountered an older version of the sewers in *Les Misérables* (fig. 5.8).[121] During the tours, the archaic grimace of the ancient sewers were pointed out to them as a foil to the new technological wonders of underground Paris. Every so often, observed a journalist, "somber cavities bared their jaws: it was the old sewer that came to lose itself in the modern one, the way filthy, infectious, miserable alleyways disgorge in our boulevards and triumphal avenues."[122] Haussmann's battles on behalf of hygiene and sewage disposal were also waged against representations. On one level, the prefect was fighting the image of sewers so powerfully evoked in *Les Misérables*, stamped indelibly by the violent chiaroscuro of Hugo's imagination. And Hugo was vividly present during these visits. As Lucy Hooper wrote about Jean Valjean in 1875, "What matters it that he never existed? that he owes his being merely to the fertile brain of a romance-writer? Do

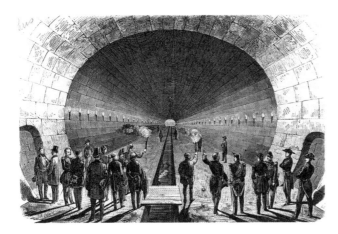

FIG. 5.7. Valentin, inauguration of the great collector beneath the Boulevard de Sébastopol, in the presence of General Charles-Marie Esprit Espinasse, minister of the interior. *Le Monde illustré*, April 17, 1858. Musée Carnavalet, Paris.

not these shadowy shapes of fiction often take form and substance, and thrust the pale ghosts that once were real, living creatures from their places."[123]

Trains and sluice boats reinvented as transportation vehicles pulled by sewermen were a reversal to the preindustrial past.[124] With their heeled tourists, they had a whiff of the ancien régime. Belgrand's spotless galleries sustained the social hierarchy that undergirded the very notion of empire. The servant spaces of the great city, manned by subalterns, showed their newly designed surfaces to the leisured classes, pruned of all unpleasantness, odor included. At the same time, this gradual appropriation of the underground by the wealthy classes also signaled a revolution of sorts. These spaces were frequented not only by tourists and sewermen, but also by engineers, technicians, and hydrologists. For them, the new galleries were no longer the intestinal tracts of the great urban Leviathan, as in *Les Misérables*, but pragmatic and unsentimental modern drains.

Moreover, visits to sewers and catacombs attracted women who figure conspicuously in illustrations of underground tours. "The presence of lovely women can add a charm to the sewer," wrote Thomas Knox (apparently without irony) in his 1880 book on the underground.[125] This constituted a noteworthy change: in the literature of nineteenth-century Paris, the heroic, rugged underworld was the preserve of men, not only of Hugo's fictitious Jean Valjean or the heroes of Jules Verne, but of the engineers who built or designed them, such as Bruneseau, Dupuit, Belgrand, or Durand-Claye. Yet sewers, like boulevards, museums, and department stores, also played a role in the gradual conquest of public space by women, at least by those who had the means and the leisure to do so. These entered the world of sewers not only as consumers of new sights but also as authors who published accounts of their visits underground.[126]

FIG. 5.8. Fortuné Louis Méaulle, illustration for "The Intestine of Leviathan," in Victor Hugo's *Les Misérables*, book 2. Wood engraving, ca. 1879. Maison de Victor Hugo–Hauteville House.

Belgrand did not live to see the completion of his two networks of water supply and sewage disposal. He continued to direct the Service des Eaux et des Égouts under the Third Republic until his death in 1878, when he was replaced by Alphand.[127] Despite their cutting-edge technology, so widely admired and emulated, Belgrand's famous sewers were not entirely severed from hygienic practices of the past, as attested by their uneven distribution across the urban territory and by the pollution of the Seine. Nor did he manage to do away with the barbarous cesspools. Sordid barrels of human waste continued to rumble through the city at night, leaving nauseating effluvia in their wake, as Haussmann acknowledged.[128] Such anachronistic drawbacks reflect society's stubborn resistance to change, ingrained psychological prejudices, and the economic interests of powerful groups.

QUARRIES

Paris sits improbably above immense chasms. A web of intricate tunnels, used to quarry stone and gypsum, stretches far beneath the capital, whose palaces, theaters, churches, and monuments were built with stone torn from its entrails. In this it resembles Beauvais, Chartres, Poitiers, and so many other French cities, which also sit on the quarries that once served to build them.[129] Over the years, the location of many of Paris's underground shafts, dating back to antiquity or the Middle Ages, was forgotten. Only in the early twentieth century did the exact extent of the urban quarries become known. There are at present about three hundred kilometers of underground galleries within city limits: one tenth of Paris is suspended above underlying voids.[130] Since Roman times, the city had sought quarries just beyond its walls. As the veins became depleted, masons sought stone beds further and further away. From the sixteenth century on, reference to underground quarries began to appear in maps, usually marked by the great wheels *à cheville*, still in use in the nineteenth century. But these plans showed quarries only in the outskirts of Paris; the oldest, near or beneath the historic center, had long since fallen into oblivion, swallowed up by the expanding city.

Paris had always prided itself on the quality of the stone and plaster that enabled its finely jointed architecture and elegant detailing. Its rich, varied geology produced everything required for construction; above a chalk plateau, four hundred meters thick, lie layers of limestone, gypsum, clay, and sand. Limestone and plaster, the two most important products of the city's subsoil, came from very different beds on opposite sides of the Seine. Gravel and sand, needed for making glass or mortar, came from open-air quarries and riverbanks, as did clay for bricks and tiles.[131] Gypsum, found exclusively on the Right Bank, was mostly exploited in open-air quarries in the southern and western flanks of Montmartre, which stood outside city walls until 1860. Heated in kilns at a high temperature, it yielded the fine plaster for which Paris is famous and led to the popular adage: "There is far more Montmartre in Paris, than Paris in Montmartre!" More ductile than stone, gypsum was easier to extract, and its quarries were much more imposing in size than the limestone counterparts across the river. Their colossal, cathedral-like vaults, supported by massive pillars, often towered far above the ground and were wide enough for horses to circulate with their heavy loads (fig. 5.9).

Gypsum's labor-intensive exploitation was characteristic of the periphery, a convenient reservoir of building materials and manpower. Loaded carts and horses crisscrossed

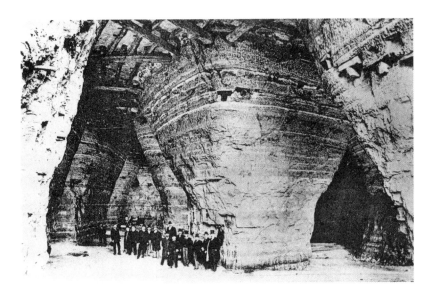

FIG. 5.9. Entrance to the plaster quarries at Bagnolet, ca. 1900, taken from an old postcard. Roger-Viollet.

the stony landscape, marred by gaping holes and plumes of smoke left by the burning kilns. These sites of extraction were recent. As Parisians had always dug beyond the walls for plaster, old gypsum quarries were constantly overtaken by the growing city. Street names alone record their location: Rue du Plâtre (plaster street), Rue des Plâtrières (plaster deposits), Rue des Carrières-d'Amérique (the America quarries), and the Impasse des Carrières (cul-de-sac of the quarries).[132]

Limestone, far more important for construction than plaster, provided stone for temples, baths, theaters, churches, and palaces. On the Left Bank, the oldest quarries burrow underneath the populous faubourgs Saint-Germain, Saint-Jacques, and Saint-Marcel, as well Montrouge and Vaugirard, incorporated to Paris in 1860.[133] To a lesser extent, limestone had also been mined beneath Chaillot and Passy on the Right Bank. Though harder than gypsum, stone called for less transformative labor and could be easily dressed to specification. Unlike the lofty gypsum quarries, the underground shafts on the Left Bank had low ceilings (ciels), so that limestone seams were usually exploited in galleries of two and sometimes three stories.

For the Crown, the church, and the nobility, stone-clad façades were a badge of power and status: "Until Henri IV," wrote the historian Henri Sauval in 1724, "houses were made simply of wood and plaster; those of the Pont Notre-Dame were only built in brick under Louis XII [. . .]. And until Louis XIII, it was only for bridges, the Hôtel de Ville, public buildings, and the residences of princes and grandees that one delved into these deep and vast quarries, creating a void as large as Paris itself."[134] Rich abbeys and religious orders often exploited quarries in their own domains in order to build their churches and chapter houses. Val-de-Grâce, the old Luxembourg convent (now replaced by the Senate), and the church and hospital of the Salpêtrière all rise above old quarries; so do numerous other monuments such as the Observatoire, the École Normale, the École de Pharmacie, and the Jardin des Plantes. The city itself looked to quarries as a source of wealth. When it bought land to enlarge the Père-Lachaise cemetery, the expropriation jury had to factor in the price of the underground gypsum quarries, which the prefect of the Seine wanted to

use to recuperate part of the cost. Annexation, however, thwarted this project, since the cemetery found itself within the city where quarrying was forbidden.[135]

Until the nineteenth century, the city's underground was not readily accessible to the public. Well-connected aristocrats and literati were sometimes lucky enough to descend into the cavernous depths. In 1575, Bernard de Palissy, the sixteenth-century polymath, geologist, and artist, recalled being led by two quarrymen through the maze beneath the faubourg Saint-Marcel.[136] Comte d'Artois, the future Charles X, visited them in 1787, along with ladies of the court.[137] Most Parisians, however, knew of the enigmatic underground only indirectly. Literary descriptions record miles of strange rock formations with haunting light effects, stalactites half a meter long, and echoes that reverberated eerily through the warped spaces.[138] Underneath Val-de-Grâce on the Left Bank, the quarries from which the great church was built offered the occasional visitor an unearthly spectacle: candlelight magnified the slightest relief of the walls and cast fantastical shadows, creating the illusion of an endless abyss.[139] Sporadic visitors thrilled to the lure of the unfamiliar, disoriented by the sinuosity of the telluric spaces beneath the urban surface. "Unfortunately, the great quarries are closed nowadays," wrote Gérard de Nerval in 1852. "There was one in the direction of Château-Rouge which resembled a druidic temple with its huge piles holding up square vaults. The eye delved into the deep, from where, trembling, one feared to see Esus, Thot, or Cerunnos appear, those formidable gods of our fathers."[140]

Dug up by masons at different moments in history, the galleries meander at different levels, circle back, intersect one another. As their approximative location was not known until the Second Empire, buildings and streets were sometimes built on dangerous sites: a thin crust separated them from unknown cavities below.[141] The fact that quarries often have two or even three stories made a complete plan of the city's underground spaces very difficult. Subterranean Paris thus remained vaguely disquieting because impossible to visualize; its slanted, crooked, amorphous voids seemed to exist outside the predictability of Euclidean space. Differing widely in height, itinerary, and age, they stretch in all directions, on different levels, underneath public and private properties. As more than half of the quarries were in private hands, the authorities could shore up only what lay under public space.[142] According to the law, proprietors possessed the land beneath their lots, but ownership entailed both rights and responsibilities. Although it was forbidden to exploit underground quarries within city limits, grasping landowners sometimes extracted stone from their properties surreptitiously, or, gnawing away underneath parcels that did not belong to them, threatened the stability of nearby buildings or streets.

By the last years of the eighteenth century, the uncharted spaces beneath the city aroused great apprehension. It had become something of a cliché, and wild exaggeration, to say that the entire city built above ground could fit into the cavernous spaces below.[143] Inspectors appointed to supervise the quarries and gauge the immense voids that threatened the heavy buildings above undertook detailed plans of the galleries beneath Paris. The task of monitoring the underground continued under Haussmann, the first prefect to have a reasonably clear idea what lay below. The systematic mapping of the entire area was completed under his watch by Michel-Eugène Lefébure de Fourcy, who published his remarkable *Atlas souterrain de la ville de Paris* (1859), subsidized by the municipal council (fig. 5.10).[144] A few copies were distributed among members of Haussmann's entourage; the rest, warehoused at city hall, burned during the Commune, along with the original maps.[145]

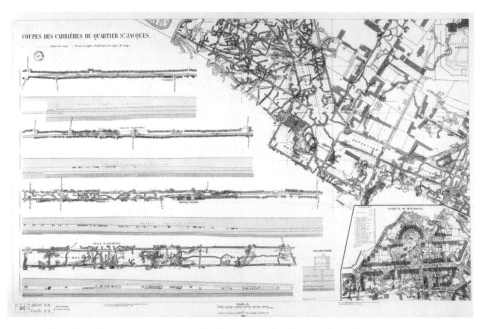

FIG. 5.10. Plan of the limestone quarries under the Left Bank and Passy from the *Atlas souterrain de la ville de Paris*, 1841–59. Bibliothèque nationale de France, Paris.

After annexation, several quarries found themselves within city limits. L'Amérique, the largest and most important, was a barren, desolate terrain northeast of the city (fig. 5.11). Plaster from its flanks was exported to the United States, hence its name.[146] Only the destitute frequented its cheerless, scarred surroundings: tramps, drunkards, and homeless people in search of temporary refuge near the warm kilns at night, or those trying to stay clear of the law.[147] In Eugène Sue's *Les Mystères de Paris*, Le Chourineur, a former worker and criminal, recalls: "The stones of the Louvre, the plaster kilns at Clichy and the quarries of Montrouge, those were the hotels of my youth."[148] This dismal area haunted the bourgeoisie, fearful of the uncertain topography subjacent to the city and of those they considered the "classes dangereuses." Rare and costly, Lefébure's huge atlas did not include villages annexed in 1860. Vague, ominous rumors about the mysterious underground spaces fed class fears, inspiring different interpretations. For the moneyed elites, safely ensconced within their sheltered precincts, the underground quarries were the redoubt of *la pègre* (the underworld), ever ready to disrupt the lives of law-abiding citizens.[149] What lay below made a mockery of Haussmann's rectilinear grids and belied the glittering metropolis of rationality and modernity. "By night, Paris is terrifying; it is the moment when the subterranean nation begins to march," wrote the journalist Jules Janin in 1843. "A vile bohemian world, horrifying, a purulent wart on the face of this great city."[150] For others, the unfathomable voids and the sense of dread to which they gave rise were not entirely evil: "Since you have a taste for dangerous enterprises and strange adventures," wrote Alfred Delvau, "take leave of your house and embark boldly across this Parisian ocean where, at certain depths, monsters toss and thrash about in sinister convulsions—along with pearls and corals."[151]

In the ever-popular feuilletons, which emerged during the July Monarchy, it was human drama that mattered, cut to the measure of short, publishable articles. A visit to the quarries,

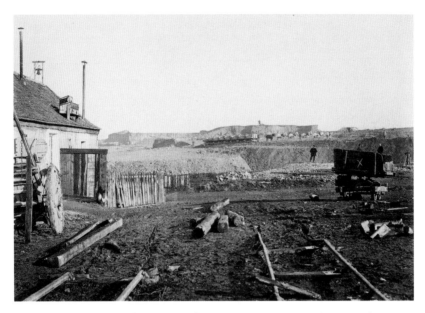

FIG. 5.11. Charles Marville, the quarries of L'Amérique, 1872–82. Musée Carnavalet, Paris.

preferably after sundown, attracted journalists drawn to the lure of the unknown. Night heightened the pleasurable frisson of the crypt-like spaces underground. Pierre-Léonce Imbert described the ragpickers that he saw in L'Amérique as living caricatures, "men who seemed to have been engendered by Daumier's pencil."[152] Like other intellectuals who occasionally found their way into these haunts only to confirm their preconceived ideas, Imbert was fueled by ethnographic voyeurism as much as by curiosity. Louis Simonin, another feuilleton writer who visited L'Amérique, tried to interview the shifting population that slept there at night. One vagabond, covered in rags, reminded him of a lice-ridden beggar by Murillo; others napped on the ground amid dirty blankets "like Arabs intoxicated with hashish."[153] Misery became a pretext for a delicious shudder at the expense of the poor, exoticized by art and Orientalism.

Nerval, who elevated the feuilleton to new heights, left a series of brilliant sketches of his nocturnal escapades among the down and out. Claiming to report his experience as one who endeavors to "daguerreotype truth," he saw the denizens of the last "habitable quarries" as workers or vagabonds, or drunks who could go no further.[154] At the same time, he played on the older, traditional associations of the underground. "Let us plunge deeply into inextricable circles of Parisian hell," he wrote, even though many of his wanderings often took place in the old streets of the center.[155] Unlike the surrealists, who would later seek the unfamiliar in the territory of the everyday, Nerval sought thresholds leading to the strange in the dark corners of the city or the rim of the periphery, remote from the reassuring world of bourgeois Paris, yet within the same ideological pale.[156] In his view, a close connection existed between the dark underground of the city and the equally somber depths of the self.[157]

While most journalists and writers tarred the underground quarries with the black pitch of melodrama, the sad reality of everyday labor in those very spaces largely escaped

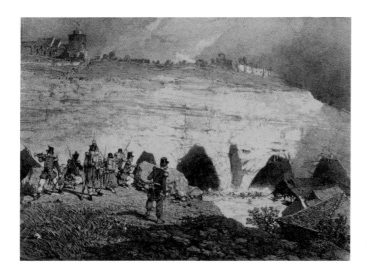

FIG. 5.12. Charles-Édouard de Beaumont, General Louis-Eugène Cavaignac pursuing insurgents in the quarries of Montmartre, where they were killed, June 1848. Lithograph. Musée Carnavalet, Paris.

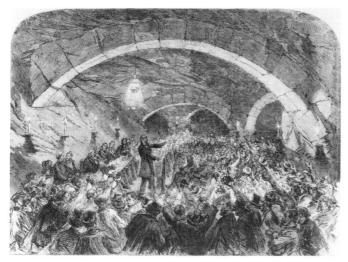

FIG. 5.13. Political meeting held in an underground quarry. *Illustrated London News*, November 27, 1869. Bibliothèque nationale de France, Paris.

attention. Quarries like L'Amérique were a place of toil for those who had no alternative but backbreaking and dangerous work. In the gypsum quarries, wrote a specialist, laborers had a choice between "different kinds of death: by drowning, asphyxiation, or heat from the kilns."[158] Most kiln workers, remarked a journalist falling back on the usual stereotypes, were "foreigners" from Normandy, Picardie, Burgundy, the Limousin, or Brittany; unlike the "bons ouvriers," these turbulent men "squander their salary in wine, observe the 'lundi' [Monday hangovers] religiously, and go on strike willingly."[159]

Given its well-established associations to insurgency, the underground acquired overt political connotations. In 1848, the troops of General Cavaignac massacred about one hundred revolutionaries who had taken refuge in the quarries of Montmartre (fig. 5.12). Under Napoleon III, quarries were occasionally used by the opposition for political meetings. In 1860, hundreds met in a huge quarry in the periphery to hear Étienne Arago, Alphonse Gent, and Ferdinand Hérold, a future prefect of the Seine (fig. 5.13).[160] During the Commune, eight hundred Communards, shot near the Buttes Chaumont, were buried in the carrières d'Amérique, which did not close until 1873.[161]

Unease concerning the subsoil of Paris cannot be considered purely political or class driven. There were also religious overtones related to hell and teratology, as well as connections to death and burial. Equally important were deeply disturbing psychological connotations. Quarries, catacombs, and sewers all shared the same dark, uterine typology. It was its very semiotic instability that rendered underground Paris so disquieting—and so appealing to commentators like Nerval for whom its indeterminacy, transgressive aura, and unheimlich qualities offered freedom from a society seen as literally and figuratively superficial as well as repressive. Its many associations could not neatly resolve themselves under one overarching label. Despite Haussmann's efforts to sanitize the city's underground, he could not quite rid it of the latent Romanticism that lurked below the city: his modern infrastructure had to coexist with chthonic darkness.

CATACOMBS

Underground Paris had other spectral spaces that weighed heavily on the residents' imaginary: the "catacombs." The term, which brings ancient Rome to mind, is a misnomer. It was the ancien régime that first used quarries to inter the bones of millions of Parisians buried inside the city through the ages. Before the Enlightenment rose up against the uninhibited appeal of the macabre, death was a popular spectacle. Burial processions through the streets, the Office des Morts, and public executions brought the body of the deceased into close contact with the living. The cult of death was ubiquitous, and the city of the dead, that larger metropolis, was inextricably linked to the city of the living. Entombing corpses in consecrated ground in churches or charnel houses, where bones were placed after being exhumed, exposed the population to pestilential miasmas. Churchgoers were often overpowered by the stench of putrefaction and the noxious gases of festering cadavers as flagstones were lifted to bury "fresh" bodies. Underground Paris was constantly oozing and rejected the attempts at order and closure imposed from above. Putrid effluvia and other unwanted intimations from below constantly obstructed the smooth functioning of the city. In the church- and graveyard of the Holy Innocents on the Right Bank, which housed the most notorious charnel house of Paris, the ground had risen several feet above street level, as layers of bodies were added one above the other. Like the cities of the living, cemeteries had to be constantly rebuilt.[162]

The Enlightenment frowned on such practices, which offended its notions of hygiene and decorum. "While human waste," Voltaire declared wryly, "is transported one league away from the city, for twelve hundred years the bodies that produce that very waste are piled up within the city itself."[163] New ideals of urban hygiene were incompatible with the ostentatious display of death and dying, although families still clung to rituals of filial piety. Modernity's fight against physical decay, the devolution of the body, and what it considered unseemly familiarity with death and putrefaction was anchored in secular faith in science and medicine. Viewing with repugnance any intimacy between the quick and the dead, it insisted on a clear-cut separation between the two. As the philosophes advocated ostracizing the dead, vast necropolises situated in the outskirts began to appear in beautiful architectural drawings by Étienne-Louis Boullée, Claude-Nicholas Ledoux, Jean-Jacques Lequeu, Jacques Molinos, and Pierre Giraud among others.[164] Their scale alone would make them impossible to build. The great eighteenth-century landscape

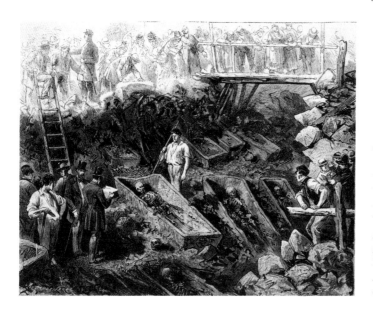

FIG. 5.14. Louis-Joseph
Amédée Daudenarde
and Frédéric Lix, sar-
cophagi discovered in
the Rue de la Montagne
Sainte-Geneviève in 1873,
while workers were dig-
ging sewers and laying
gas pipes. Engraving.
Photo: *Le Monde illustré*,
August 23, 1873. Private
collection.

parks strewn with classical temples, paintings with Greco-Roman tombs surrounded by
nature, and the ideas of Rousseau and French *paysagistes* such as Claude-Henri Watelet
and Jean-Marie Morel also helped change prevailing attitudes toward memorializing the
dead.[165] Shorn of the traditional and often macabre iconography of death, the Elysian
fields exuded a sense of peaceful repose in nature.

Whereas the Enlightenment wished to relocate the dead extramuros, the Crown and
the church compromised and dispatched them beneath the city.[166] In 1780 it was decided
to transfer all bones from the charnel house of the Holy Innocents to the underground,
a task that fell to the inspector of quarries, Charles-Axel Guillaumot. Guillaumot chose
the galleries of the Tombe-Issoire underneath the plain of Montrouge, then outside city
limits, and had them drained to receive their new occupants. After the catacombs were
consecrated in 1786, more than one thousand cartloads of bones were taken to the Tombe-
Issoire in long processions lit by torches and accompanied by hooded priests in black inton-
ing the Office des Morts. Roughly six million Parisians, the accumulated remains of nine
centuries, are now estimated to rest underground.[167] The Revolution interrupted and then
resumed the removal to the ossuary, dispossessing the clergy and putting cemeteries up for
sale as nationalized properties confiscated by the state.[168]

Haussmann had no choice but to continue moving all bones found in Paris to the
catacombs.[169] Although it took place in the dead of the night to forestall opposition, the
translation of bones to the quarries was quite a spectacle. In 1853, Delacroix saw a heap of
skeletal remains removed from their burial ground near the Tour Saint-Jacques and noted
in his diary: "The soul loves these spectacles and can never sate itself."[170] Older attitudes
toward death did not give way overnight. Years after Haussmann's departure, workers
and engineers digging sewers or laying gas pipes continued to unearth unknown burial
grounds and unmarked graves, dislodging bodies from their immemorial sleep (fig. 5.14).
Some of these interment sites were Jewish; others may have been due to the revocation of
the edict of Nantes (1685), which obliged Protestants to bury their dead in secret.[171] Moving
bones to the underground dragged on until the twentieth century.

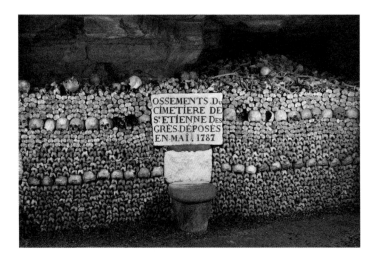

FIG. 5.15. Catacombs with bones from the Church of Saint-Étienne-des-Grès. Musée Carnavalet, Paris.

In contrast to class-bound tombs and cemeteries, catacombs parade the implacable equality of death. The bones' only form of identification are tablets affixed to the wall, giving the provenance of each lot, church, or graveyard (fig. 5.15). Jansenists and Jesuits, sans-culottes and royalists, their bones confounded, rest peaceably side by side. The anonymity of the dead, absence of hierarchy, and brutal exposure of what was once hidden offers up a tableau both old and new, as if a society reeling from the effects of revolution, but still inured to the spectacle of death, was uncertain as to how to memorialize its dead under such changed circumstances. A *lieu de mémoire*, certainly, but an unsettling one. Death had not lost its sting in modern times, when it had to be "both represented and rejected."[172] Nor had it shaken off the disquieting connection to refuse. Underground Paris was the repository of another form of waste, which, like sewage, was cast off from the realm of the living for fear of contamination. The authorities had the idea, wrote Élie Berthet in 1856, "of using the quarries of Paris by pouring into them this human detritus that polluted the air of the living and threatened the city with deadly epidemics."[173] The connotations of the underground—inorganic, unlit, life denying—persisted.

Under Napoleon I, Frochot had ordered his personnel to make the catacombs more appealing to the eye by arranging skulls, ulnas, and tibias into neat geometric patterns.[174] The ornamental use of bones provided an appropriately lugubrious setting for the celebrants of the cult of death. When he took over the directorship of the quarries, Louis-Étienne Héricart de Thury continued to "embellish" them, giving them the spare, somber simplicity characteristic of the First Empire, the "fearful symmetries" that brought regularity to the formless heaps of bones thrown down by the cartload. Another kind of symmetry was also at work here. In an attempt to make the world of the dead resemble the world of the living topographically, Héricart de Thury numbered the galleries and indicated their exact location within Paris: "In our work, we took particular care to establish the most rigorous relation [...] between the details of the surface and the state of the voids."[175]

With their dramatically staged skeletal remains and carefully chosen literary allusions, the catacombs were a vast memento mori, a meditation on time, mortality, and the vanity of earthly things. This was not a place of mourning, however, nor did it reflect a single religion or ideology. Christian iconography clashed with a purely civic conception of

death. Verses culled from Homer, Virgil, Racine, Rousseau, Delille, and Chateaubriand, among others, and masonic symbols are interspersed with references to the French Revolution and its victims. Melancholy verses redolent of Romanticism coexist uneasily with the geometrical disposition of the bones. These ambiguities seem to express a hesitant break with premodern mentality: a place of contemplative thought overshadowed by the insolent grimace of death, a modern inferno, sadly banal, and lacking the threat of brimstone.

Despite the revulsion aroused by their ghoulish contents, the sepulchral spaces underneath Paris attracted considerable attention. They too were a form of spectacle, half cemetery, half museum. Guided tours had already taken place during the Restoration. Visits began, fittingly, through the Rue d'Enfer (now Denfert-Rochereau), which heightened the trope of a descent into hell.[176] Rows of grimacing skulls and yellowed bones, made ghastlier still by the tallow of the visitors' candles, flaunted the theatricality of death. For a fee, eternal darkness became entertainment, and the corruptibility of the flesh an occasion for sightseeing rather than *leçons*

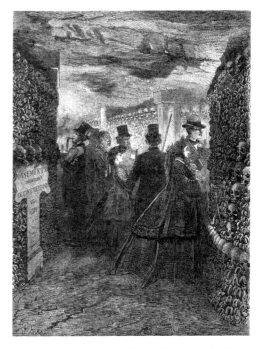

FIG. 5.16. Henry Linton and Jules-Descartes Férat, *Visit to the Ossuary of the Catacombs of Paris* (based on a photograph taken with electric light by Nadar). Musée Carnavalet, Paris.

de ténèbres. Rambuteau forbade tours on the grounds that "it might be immoral to offer a spectacle so unworthy of a civilized nation to public curiosity."[177] They resumed when Napoleon III authorized four collective visits a year. By 1867, year of the World's Fair, the number was increased to one a month owing to popular demand (fig. 5.16). Héricart de Thury installed two museums in the catacombs, a curious throwback to the old tradition of the *Wunderkammer*. Geological specimens taken from the quarries were exhibited in a *cabinet de minéralogie*. A *cabinet pathologique* displayed misshapen bones found among the skeletons transferred from the cemeteries.[178] The deformities in this collection, gathered before the heyday of phrenology, carried ideological implications, suggesting the normative as what was above ground, and as anomalous or deviant what lay beneath.

Just as Haussmann's engineers were trying to modernize the underground, writers capitalized on the lurid spell of the dark continent below ground. In these works, eagerly devoured by an avid readership, subterranean Paris appears largely as a den of thieves and rogues forever hiding in the furrows of the earth. Sensationalist novels conjured up cloak-and-dagger narratives of arcane cults and illicit assignations underground. Eugène Sue had already plunged the malevolent characters of *Les Mystères de Paris* in damp caves and basements, where they took on, by metonymy, the tenebrous characteristics of their surroundings. In Élie Berthet's popular novel *Les Catacombes de Paris*, written in 1854 but set in the 1770s, bands of counterfeiters, arcane sects, and brigands rendezvous in the quarries. Alexandre Dumas's best seller *Les Mohicans de Paris* (1854–59) includes fanciful, overscaled images of Parisian catacombs (fig. 5.17). *Les Misérables*, with its gothic, rat-infested sewers,

FIG. 5.17. Henri Felix Emmanuel Philippoteaux, illustration in Alexandre Dumas's novel *The Mohicans of Paris*, 1863. New York Public Library, New York.

FIG. 5.18. Nadar, mannequin appearing to finish a façade made with bones, 1862. Bibliothèque national de France, Paris.

dates from 1862, as does Pierre Zaccone's *Les Drames des catacombes*, followed, in 1867, by Pierre-Léonce Imbert's *Les Catacombes de Paris*.[179]

The premodern spaces subjacent to the metropolis also attracted forms of visual representation. Opera and ballet sets regaled spectators with oppressive cavernous voids, such as Luigi Cherubini's *Ali Baba and the Forty Thieves* (1833), Ernest Reyer's *La Statue* (1861), and the overture *Le Corsaire* (1856) by Berlioz. Nadar, who had taken to the skies in his balloon in order to photograph the city from above, embarked with his camera on a remarkable exploration of the underground at the invitation of Belgrand.[180] Like the municipal engineers, Nadar confronted the lower depths of the city with modern technology: "We shall attempt *the first* underground use of photography with artificial lights that has already supplanted solar light so successfully in our portrait studio."[181] At a time when photography—etymologically, the writing of light—was considered a reflection of nature, Nadar severed its link to sunlight in a move that proclaimed its independence as artifice. Not by chance did he sometimes foreground the electric lines and lamps needed to illuminate the scene, a self-reflexive comment on his innovation.[182] Given the difficulties of shooting underground, and the long exposure time required, Nadar made use of mannequins, staged in photographic tableaux, to give a sense of scale to his photos (fig. 5.18).[183] Mannequins also underscored the work carried out underground by the ouvriers.

Sewers led Nadar to a new vocabulary of haunting, highly charged images where modernity and Romanticism vied in an unresolved struggle (fig. 5.19). The machinery

FIG. 5.19. Nadar, sewer junction, 1861. Bibliothèque nationale France, Paris.

thrown into relief by electric light and the everyday connotations of mannequins seemingly involved in labor coexist with the suggestive phantasmagoria of spaces tunneling into the distance. As his evocative photographs show, Nadar remained torn between technology and an older, lingering aesthetic that favored dark tints and dramatic contrasts. There is something of Meryon here, in the way darkness threatens to corrode the image, like acid biting into a deeply etched plate. Viewers reacted strongly to this affect-laden side of his works: "More recently, an artist rich in mysterious or bizarre ideas photographed with electric light the main aspects of the sinister labyrinth: it is hard to imagine anything more moving and strange than the effects produced and reproduced by this fantastical lighting! A veritable sun in the land of the dead!"[184] The same ambivalence can be seen in Nadar's remarkable essay about visits to the underground published in the 1867 guide to Paris. Wagons, boats, sluices—the paraphernalia of modernity—flit dimly in the background, without dominating the discourse. But the old sewers still cast a sinister spell with their "oozing, leprous walls" and the "gnarled entanglement of bilge and guts that would have defied the imagination of a Piranesi."[185] Nadar's words betray the weight of his sources: Hugo's mighty, muscular prose.[186]

CEMETERIES

Catacombs, reserved for bodies removed from the city's graveyards, hardly solved the problem of the growing number of dead, which increased steadily with the expansion of the capital. As the First Empire forbade all burials within the city, Napoleon I's prefect of the Seine, Nicolas Frochot, ordered four new cemeteries to be built outside the walls: the cemetery of the east (Père-Lachaise), of the south (Montparnasse); and of the north (Montmartre); Passy, to the west, was added only later. Over the years, they were enlarged thanks to land acquisitions by successive municipal administrations. When Haussmann annexed the outlying territory, all four found themselves within city walls. By then, surrounded by urbanization, they could no longer expand. The most famous of these was the Père-Lachaise, named after the confessor of Louis XIV, who once owned the land on which it was built (fig. 5.20). By the time the cemetery was completed, the cold majestic necropolises of the late eighteenth century had given way to the meandering English landscape garden and Rousseau's prelapsarian vision of nature, tinged by the aesthetics of melancholy cultivated by Romanticism.

With its elegiac setting, panoramic view of Paris spread out below, and mausolea memorializing celebrities, Père-Lachaise became part of the city's civic life, a mixture of bereavement and social ritual, mourning and fashion. Its monuments, carefully spaced out amid trees and shrubs, recall the garden of Alexandre Lenoir's Musée des monuments français, which had struck contemporaries with its wistful beauty (fig. 5.21). At Père-Lachaise, death-haunted concepts of the cemetery gave way to the plangent notion of sleep borrowed from antiquity.[187] A consolatory and redemptive view of nature replaced the fascination with the macabre characteristic of the ancien régime, now repressed below ground. Père-Lachaise became a tourist destination, a "museum of death," as it is to this day.[188] Guidebooks published in 1854 and 1865 helped visitors locate tombs of well-known figures.

FIG. 5.20. Léon Jean-Baptiste Sabatier, the cemetery of the Père-Lachaise, 1861. Lithograph. *Paris dans sa splendeur*, vol. 1, 1861. Marquand Library of Art and Archaeology, Princeton University.

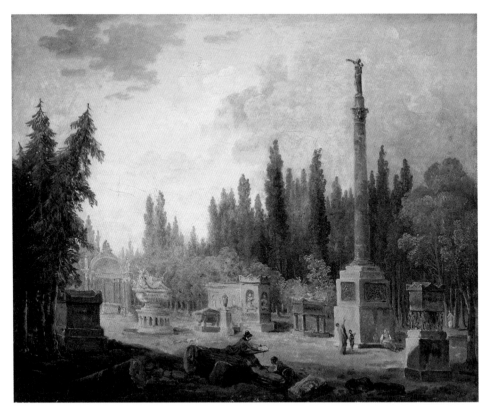

FIG. 5.21. Hubert Robert, *Le Jardin du Musée des monuments français*, 1803. Oil on canvas, 19.5 × 23 in. (49.5 × 59 cm). Musée Carnavalet, Paris.

In an increasingly secular society, fame and posterity became an important form of afterlife. The cult of the *grands hommes* "gave new political meaning to the dead body in the public domain."[189] Epitomized by the transformation of Sainte-Geneviève into the Panthéon, it competed with the Christian idea of life after death.[190] While catacombs drove home the leveling power of death, the cemetery flaunted social inequality even after annihilation. Wealthy families commissioned signature architects to design mausolea that vied with one another in monumentality. Situated on a hill in Belleville, the preserve of the working class, Père-Lachaise was an ironic resting ground for the rich. "The high society of the West," wrote Michel Ragon, "had ended up adopting this cemetery of the East."[191] Furthermore, it allotted space to Jews, Muslims, and Protestants as well as Catholics. Given the importance of France's alliance with Turkey during the Second Empire, Haussmann ordered the construction of a little mosque within the Muslim enclosure (fig. 5.22).[192] Unlike the Bourbons and the Orléans, closely allied to the Catholic Church, Napoleon III had members of other religions in his cabinet. Haussmann was Protestant; Fould, Jewish (though converted to Protestantism).[193] The emperor donated land to the city for building the Grande Synagogue in Rue de la Victoire. It took more than allotments of space, however, to destroy prejudice. Fournel displaced his anger at class divisions to Jews. Père-Lachaise had two Jewish cemeteries: one for the poor, tucked away behind a

FIG. 5.22. Marie-Gabriel Jolivet, the mosque at Père-Lachaise (destroyed), 1855–57. *Le Monde moderne*, July–December 1896.

fence, and another for concessions in perpetuity that seemed, he wrote, like a "funeral branch of the stock exchange."[194] Far greater discrepancies than these separated the tombs of the Catholic elites from the common graves of the paupers.

Haussmann took over Frochot's cemeteries as he did the catacombs. The return of cholera persuaded him of the urgent need to disentangle the cemetery from the city. Estimating that Paris would reach three million inhabitants in the next half century, the prefect realized that the four major cemeteries would soon be saturated and began searching for a long-term solution.[195] The problem was not simply the number of bodies but the forms of burial that varied widely depending on the socioeconomic status of the deceased. The corpses of the rich could rest undisturbed for all eternity, thanks to lots bought in perpetuity, but those of the poor, buried in mass graves at the expense of the municipality, were disinterred every five years and transferred to underground ossuaries to make room for more paupers. This miserable end, Haussmann declared, awaited three quarters of the city's population.[196] Bodies of indigents thus went from one anonymous mass grave to another. "For here the dead have as little time as space to rot: one claims their slot before the bones acquire the color and age of stone, before the years have erased in them a trace of humanity and the memory of a body," wrote the Goncourt brothers.[197]

Napoleon III decreed grandly that under his reign the poor had the right to be buried individually rather than in collective heaps, but this only compounded the problem of space in the cemeteries, since he left intact the provision that allowed their bones to remain interred for only five years.[198] Haussmann, on the other hand, wanted to prolong this window to at least thirty years or more in order to assure them of a "'relative eternity,' the only one that the frailty of human things allows."[199] The prefect may have wanted to spare his administration the cost of digging up the remains of the poor and transporting them to catacombs. But it is possible that his puritanical aversion to dirt and disorder, which reached quasi-pathological proportions, was offended by this mingling of corpses deprived of a casket, both in the cemeteries and in the ossuaries. Politics helped fuel the repugnance felt by the propertied classes toward common graves, where, wrote a journalist, "the most horrid communism reigns amid commingled and anonymous remains."[200] Even in death, the poor continued to be associated to ordure—and revolution.

Annexation of the surrounding territory worsened the situation, adding four hundred thousand inhabitants to Paris, and eleven additional cemeteries. Built just beyond

the old walls, these cemeteries now found themselves within city limits and in violation of the decree of 23 Prairial, year II, which forbade burials within all French cities. Haussmann calculated that with annexation, the number of dead in need of interment would fall between forty-four and forty-seven thousand a year.[201] The prefect and his municipal experts followed closely what was happening in Britain, where Chadwick had written at length about the dangers posed by the disposal of dead bodies. Those most at risk of contamination, he remarked, were the poor, who lacked the wherewithal to transport bodies to a mortuary and were usually forced to keep them for a long time, in one-room homes where entire families slept and ate.[202]

HAUSSMANN'S NECROPOLIS

In 1864, Haussmann created a special committee to report on the condition of the city's burial grounds. It concluded that Frochot's cemeteries were dangerous sources of contamination for the city's groundwater: as the soil near the river was full of clay, they consumed bodies with difficulty. Noxious substances from graves thus infiltrated the water table beneath heavily populated neighborhoods, polluted wells, and discharged their fouled contents into the Seine. Their conclusions were wrong: corpses, we now know, do not cause contamination.[203]

The committee, which included Belgrand, went far afield in search of the right terrain for a vast new cemetery. They found it in the sandy plains near Pontoise, twenty-two kilometers away, where land was inexpensive. In order to preempt speculation and opposition, Haussmann discretely bought up several hundred acres of land in Méry-sur-Oise.[204] Given the distance from the capital, the prefect asked the committee to study access to the site by rail. With their input, he decided to create a railway line administered by the city that would transport bodies and mourners from the capital to Méry-sur-Oise. The idea of a necropolis linked to Paris by rail came from Siméon, who no doubt got it from the Brookwood necropolis, connected to London by train.[205] Only in April 1867, when he was in possession of all their findings, did Haussmann finally reveal to the Senate his plans for the "Grande Nécropole." Cognizant of the need to "preserve intact the cult of the dead, so active in Paris," wrote Haussmann, the new plan enabled mourners to go from the home of the deceased "to the Church, the Temple, or the Synagogue."[206] From there, they would make their way to one of the three cemeteries of the city, each of which would have its own mortuary railway station. Modern death no longer came on the pale horse.

Passengers would take the girdle line (*chemin de fer de ceinture*) to Montmartre, where a funeral train would transport them to Méry-sur-Oise, seated in first, second, or third-class compartments, according to their economic possibilities. Although the prefect denied it vehemently, social segregation would continue after death as it did in the city's other cemeteries.[207] Workers were deeply affected by distance, and the time it would take to reach Méry-sur-Oise. As they wrote to the emperor in 1867, "The Ouvrier insists on accompanying his parents, employers, friends, and companions to their last resting place, on foot, with head uncovered if possible," and they liked to renew these "pious visits" that strengthened family bonds.[208] Though they welcomed the suppression of mass graves, they opposed the creation of a cemetery so far from the capital that it involved losing time and money they could ill afford: "A round trip of fifty kilometers, without counting the

distance required to reach the common station [. . .] would entail the loss of an entire day, even if the City provided free transportation."[209]

Haussmann's bold proposal to create a necropolis extramuros met with fierce resistance at all levels of society. In a virulent pamphlet, *The Deportation of the Dead*, Fournel compared the expulsion of the dead from the city to that of inhabitants dispossessed of their homes.[210] Politicians from the Right and the Left also objected. When the Chamber of Deputies interpellated Haussmann over the projected cemetery in 1868, the most obstreperous opponents were liberals, who attacked him as a proxy for the empire. For statesman Jules Simon, the separation of classes expressed in Haussmann's proposal did not go far enough: "I will not mention, gentlemen, the accidents that may occur, and the extreme gravity of their consequences; I will not mention these ten or twelve convoys of rich and poor, and the difficulty of keeping them apart."[211] Real estate was another crucial, if unconfessed, component of the debate. The newspaper *Le Siècle* led the campaign against the necropolis. Tied to an insurance company that owned the forest of Montmorency, not far from the proposed necropolis, it wanted to operate the railway line itself in order to sell real estate at higher prices.[212] Small property owners in the area, on the other hand, feared that funeral trains carrying corpses would lower the value of their land.

Workers conveyed their concerns to the emperor: "The enormous distance to be covered would render visits to the cemetery less frequent, and would quickly bring the cult of the dead to an end."[213] In Paris, argued Simon, almost one million people visited cemeteries on All Saints' Day and on All Souls' Day, a number he feared would dwindle drastically.[214] Fournel's angry diatribe revealed his religious intolerance: "Here lies the great crime of the project: its natural and inevitable result will be to weaken, hamper, and perhaps suppress in many, this cult of the dead, the only religion that remains for most Parisians." Protestantism, Haussmann's religion, may have been the target: "In the Englishman, as in the American," Fournel continued, "the dead are a nonvalue [*non-valeur*]; it is capital suppressed from circulation."[215] The prefect's pragmatic, cold-eyed vision of the cemetery seemed to his contemporaries to be lacking in redemptive gestures.[216]

The issue continued to resonate under the Third Republic, which inherited the unresolved situation of the Parisian cemeteries. That the dead should be carried to their final resting ground by train was a conception altogether too secular, too modern, and too technical for Haussmann's fellow citizens, ambivalent about the place of death in modern society. "The dead, to him, are like ciphers; his business is to organize death," wrote Balzac in *Ferragus*, of the porter of the Père-Lachaise.[217] To his contemporaries, the words might have applied just as easily to the prefect. The French Revolution had accelerated the process of secularization while modernity was whittling away at what was left of the *ars moriendi*. And although railroads were used for mortuary purposes in England, the French flatly rejected the industrialization of funeral rites. More and more, society wanted the urban dead at a safe remove from the city of the living, increasingly associated to health and happiness, but it did not want to see itself as lacking piety. The past still exacted its dues.

For all the public outcry, attitudes were changing. The spectacle of death had already been banished to the edge of the city: in 1832, public executions moved from the square of the Hôtel de Ville to the quartier Saint-Jacques across the river. The cult of the dead, culminating on All Saints' Day and All Souls' Day (November 1 and 2), was seen with distaste by younger generations, appalled at the crowds and vendors of mortuary wares that filled the

cemeteries. "As for those [families] whose concern for the dead takes hold exclusively on All Souls' Day, I attach little importance to their punctual outburst of sorrow. Their tears go off like the cannon of the Palais-Royal," wrote Lucien-Victor Meunier in 1884.[218] Death was beginning to be thought of as something offensive best left unseen: "If in thinking of the beloved dead," Meunier continued, "you had before your eyes what is [actually] in the grave, you would shudder with disgust; rot, filth; stench; bones to which a bit of flesh still clings, and dark scraps of skin; later, a few amorphous residues mixed with the rusty nails of the coffin; later still, nothing at all. You doff your hat to this void."[219] Modernity recoiled from the spectacle of death familiar to the ancien régime.

Impersonal and technocratic, Haussmann's proposal was indicative of modern times. By the time the battle for the cemetery came to the fore, the prefect's star was waning. Napoleon III himself, weakened by recent gains of the opposition, could no longer support his prefect, and the projected necropolis was put aside in 1869. In his memoirs, Haussmann proudly mentions that his successor, Ferdinand Hérold, tried to resuscitate the plan with the help of Alphand and Belgrand, who were still active in city hall but met with the same vehement opposition.[220]

PROFIT

Before they were modernized, the vast underground spaces of Paris were still seen by many as God given and unchangeable. They spoke to the French of their past, a past both historic and mythical, shaped by literature and fiction as well as history and geology: a place, too, of regression and rejection of the forces of industrial capitalism. After the completion of Haussmann's new sewers, the old fears of the premodern maze under the city gradually began to give way to a sanitized conception of the urban underworld as modernity dispelled, or perhaps displaced, the Gothic mystique of subterranean Paris.[221]

Despite its updated technology and army of technocrats, Second Empire Paris was a great synthesis of old and new. The perception of the city's underground as a place of dread and mystery was an anachronism, if a persistent one. In the age of capitalism triumphant, enterprising figures in search of valuable assets clashed with the limited views and modest profits of tenacious preindustrial *mentalités*. For ambitious, upcoming entrepreneurs, the traditional products of Parisian quarries and their surroundings—stone, plaster, animal glue, human fertilizer—squandered valuable space and resources. Looking to the future, or at least to their future, they thought of alternative strategies so that the somber subterranean spaces could be pressed into service of wealth. Economic rationale and enhanced productivity began to challenge timeworn associations. Leased to private companies, underground space raised revenue for the municipality. Water mains, steam pipes, and telegraph lines enclosed in gutta-percha tubes—the circuitry of the modern city— were bundled, coursing through different conduits along with compressed air, which sent pneumatic post hurtling through pipes (fig. 5.23).[222] Circulation, as crucial for the underground infrastructure as for the city above, meant power as well as profit. Sewers enabled information flows in ways that reflected changing concepts in the modern metropolis, where time itself was a form of currency.

Urbanism was another major force that challenged the timeworn concepts of the underground. Sewers and water mains were not enough. Already under the July Monarchy,

2174 — PARIS SOUTERRAIN.
Les Egouts, Service de l'Assainissement ; Collecteur du Boulevard Sébastopol. **ND Phot.**

FIG. 5.23. Collector beneath Boulevard de Sébastopol showing water mains and electricity. Postcard, ca. 1900. Roger-Viollet.

Saint-Simonian economists, engineers, and architects had called for a revolution in transportation to connect means of transportation within the city and the nation as a whole. During the second half of the century, they turned their attention to subterranean Paris, the largest available piece of real estate in the center, foreseeing the need to transport goods and passengers at affordable prices underground. Yet their bold plans and urban vision of a comprehensive system of transportation were rooted in the urban goals of the capitalist elites. Workers' needs were not taken into account even when the ouvriers were mentioned in the proposals.[223]

Hector Horeau, an architect of unusual originality, left an impressive critique of Baltard's plans for Les Halles. His own project, of 1845, moved the markets closer to the Seine and included an underground railroad that connected the river to other train stations to facilitate the arrival of merchandise.[224] In its comprehensive sweep and attention to details such as lighting and ventilation, it was a remarkable attempt to integrate different services, circuits, means of transportation, and actors. While his project would undoubtedly have helped the population as a whole, his plans were premised on widespread destruction of "dirty neighborhoods" and "dirty houses" in the center, which would have required the relocation of large numbers of workers.[225] Like Haussmann and the other engineers, he was prompted by fear of the impoverished residents of the area whom he considered "potential revolutionaries."[226] In 1868, Horeau also left an impressive study of Paris stressing the need for underground railways, covered streets, shopping areas, green spaces, and demountable portable structures.[227] He even designed a tunnel beneath the sea linking France to England.[228] Imaginative and and intellectually curious, Horeau did not always have the technical background required by his projects.

Édouard Brame and Eugène Flachat, two brilliant, experienced engineers who worked for the state, advanced ingenious proposals to improve circulation by means of an urban railroad that led from the girdle line (the Petite Ceinture) to the central markets. To decongest the center, already crammed with slow-moving vehicles drawn by horses,

it would run partly underground. Imbued with impressive technological expertise, they grasped the importance of tying the city together by public transportation.[229] True to their class, however, they admitted the possibility of carrying workers who, "as a result of the transformations carried out in the central neighborhoods, will be obliged to live at the extremities of the city."[230] Louis Le Hir, a lawyer by training, tried to interest Haussmann in his own bold idea of running six railways lines under the city's main boulevards and access roads.[231] Even more than the proposal of Brame and Flachat, Le Hir's was instrumental in later years, when the Metro was finally built under the Third Republic. The prefect was aware of all these plans, already mentioned in the report of the Siméon committee.[232] Haussmann, too, believed in an underground radically transformed by technology, although he ultimately turned down both proposals, failing to see their visionary aspects.

By the time Haussmann set to work on sewers, a demystified and rational view of the underground had already gained currency among engineers, industrialists, and economists who believed that this other Paris had a crucial role to play in political economy. For the municipal administration too, subterranean Paris, once the preserve of dark, mysterious spaces, was to be invested with purely secular and instrumental meaning as part of the city of flows. Haussmann had little use for the dark and fanciful views of the novelists and wanted to eliminate suspicious activities below the earth. Sanitized and properly overseen, sewers, catacombs, and quarries had to exemplify the order that now reigned overhead. Yet the layered complexities of the underground proved impossible to domesticate within his lifetime.

BEFORE PARIS

> What seest thou else in the dark backward and abysm of time?
> —Shakespeare, *The Tempest*

In 1866, accompanied by two British colleagues, Belgrand visited a sand quarry at Vincennes, where he found the humerus of what he took to be a prehistoric elephant, now known to be a *Mammuthus primigenius*, a woolly mammoth.[233] Haussmann donated the bones to the Muséum d'histoire naturelle, where they were reconstructed and identified (wrongly) as an *Elephas primigenius*.[234] "Paris is, in effect, the place of the globe, from which the resurrection of extinct animals has issued forth," declared with Gallic pride Antoine Étienne Serres, professor of comparative anatomy at the museum. "The creation of paleontology, a French science whose influence has encompassed two worlds, is thus attached to the City of Paris and its geological site."[235] Claiming Paris as the birthplace of paleontology, and paleontology as a French science, was a jab at the British, the leaders in the field, who had already made major discoveries in this domain. French scientists had their laboratory right beneath their feet. From the heights of Montmartre to the low-lying center of the city, the stratigraphy of the soil yielded evidence of the great sea that once covered the region, and of alternating ice ages and tropical climes, and their respective fauna and flora.

Fossils had been found in Paris ever since the days of Bernard de Palissy, preserved in beds of soft clay and gypsum. Although Herodotus had argued that the presence of marine shells on mountaintops showed that they had once been covered by the ocean, the fact that Paris, capital of France, was an ancient seabed proved hard to accept. Even

Voltaire famously stated that shells found along the Alps must have been dropped by pilgrims on their way to Rome.[236] By the mid-nineteenth century, the controversy could no longer be thought of in terms of an opposition between religion and science, though the public might well have seen it that way.[237] Whether or not the church officially accepted the growing challenges to scriptural authority as related in Genesis, many prelates did. Debate could no longer be stifled. The naturalist Georges-Louis Leclerc, Comte de Buffon (1707–88), Voltaire's contemporary, had already attempted to date the earth to seventy-five thousand years, a leap of great theoretical audacity in his time, for which he was condemned by both the church and the Sorbonne.[238] In Buffon's view, man was a newcomer, a contingency, the fruit of other uncreated acts in a planet that came into existence as a ball of fire that took eons to cool.

By the last years of the eighteenth century, bigger catch than petrified shells had been found within city limits, and important new theories put forth. In 1809, the French naturalist Jean-Baptiste Lamarck (1744–1829), a friend of Buffon, had published *Philosophie zoologique* (1809), the first attempt to theorize biological evolution.[239] Species evolve over time as they adapt to the environment in order to survive. As animals adjust themselves to a changing milieu, they shift from simpler to more complex organisms. Lamarck's brilliant insights brought him into conflict with Georges Cuvier (1769–1832), the celebrated professor of comparative anatomy. Together with the distinguished geologist Alexandre Brongniart, Cuvier published a seminal book on the geology and stratigraphy of the surroundings of Paris, showing the alternation of fresh water and marine deposits beneath the ground.[240] Their conclusion that the sea periodically washed over the area was instrumental for paleontology. In Montmartre Cuvier found traces of several species: "This rich collection of the bones and skeletons of the animals of a former world is doubtless an enviable possession. It has been amassed by nature in the quarries which environ our city, as if reserved by her for the research and instruction of the present age [. . .]. There is scarcely a block of gypsum, in certain strata, that does not contain bones. How many millions of these bones have been already destroyed in working these quarries for the purposes of building!"[241] What most astonished contemporaries was not only the prehistoric bestiary emerging from the mists of time, but also Cuvier's remarkable powers of observation. Making use of deduction, he brilliantly (if not always correctly) reconstructed entire skeletons from fragments: "In a word, the form of the tooth implies the form of the condyle; that of the shoulder blade that of the claws, just as the equation of a curve implies all its properties."[242]

Rummaging through the primeval sludge preserved in seams of gypsum, Cuvier found evidence of vanished species, thereby proving (in his eyes) the existence of waves of extinction—he called them catastrophes—that destroyed entire groups of animals. Cuvier was aware, half a century before Belgrand found his mammoth, that prehistoric megafauna once roamed the Île-de-France, mentioning those found near Argenteuil and even within city limits close to the Salpetrière, where one was discovered in 1811. Remains of other mammoths came to light during the construction of the Ourcq canal in the forest of Bondy, where Cuvier had the opportunity to study them.[243] Because Cuvier's notion of extinction was compatible with the biblical version of creation, he has often been accused of caving in to the church. A courtier as well as a scientist, he took pains to reconcile his finds with religion, mindful, perhaps, of what had happened to Buffon, who was forced

to recant. "With an eye on Genesis and another on nature," Hugo observed sarcastically, "Cuvier tried to please the bigoted reactionaries by making the fossils accord with the texts, and flattering Moses with the mastodons."[244] Nadar was equally critical, mentioning "the pterodactyls and the plesiosaurs that have just tripped Cuvier and are heading directly for a confrontation with Genesis despite the homilies and prohibitions of bishops."[245] After Cuvier's discoveries, above and below ground came to define two very different realms: the thin layer on the surface—the preserve of history and those frenetic bipeds, latecomers to the great saga of creation; the deep unfathomable regions underneath—the domain of prehistory and slow time.

The extraordinary impact of paleontology on the humanities escalated with the excitement unleashed by the famous *querelle des analogues* that pitted Cuvier against his colleague Étienne Geoffroy Saint-Hilaire in 1830.[246] Cuvier, who championed a rigorous empiricism, held that all species could be classified into four distinct groups or *embranchements*, thus effectively severing the great chain of being. Though evolution as such had not yet been fully theorized, the implications of his theories ruled out the possibility of a continual transformation of any species. Horizontally, species were compartmentalized into different unrelated groups; vertically they were cut off from each other by the periodical catastrophes that according to Cuvier destroyed all signs of life on the planet. Saint-Hilaire, like Cuvier a professor at the Museum of Natural History, and equally talented, boldly affirmed that all organisms shared an underlying unity. In direct opposition to Cuvier, he tried to show that complex links and analogies existed between the embranchements. The quarrel attracted attention far beyond France. Intellectuals were polarized by the epistemological iconoclasm inherent in both positions: Goethe wrote an analysis of the exchange shortly before his death; Ralph Waldo Emerson captured some of the passion triggered by the debate when he visited the Muséum during his visit to Paris in 1833; Elizabeth Gaskell's *Wives and Daughters*, published in 1866, has characters discussing the two French paleontologists.[247]

Balzac's frequent references to Cuvier and his great antagonist Saint-Hilaire (to whom he dedicated *Le Père Goriot*) reflect the prestige enjoyed by paleontology. "Have you ever plunged in the immensity of space and time by reading the geological treatises of Cuvier?" asked Balzac. "Borne away by his genius, have you glided over the bottomless abyss of the past, as if sustained by the hand of a magician? [...] Is not Cuvier the greatest poet of our century?"[248] During his escapades in the quarries of Montmartre by night, Nerval inquired about "antediluvian animals," seeking out the quarriers who had helped Cuvier in his research: "These abrupt but intelligent men will listen for hours, by the light of glowing embers, to the story of the monsters whose traces they still uncover, and the panorama of the primitive revolutions of the globe."[249]

By the mid-nineteenth century, paleozoologists and paleobotanists were much admired for their dazzling capacity to recreate the past. As the geologist Adolphe Watelet wrote in his 1866 treatise on prehistoric vegetation in the Parisian basin, "often, in fossilized plants, every vestige of the organism has disappeared. We find nothing but a fragmentary trace fossil."[250] Thanks to paleontology, new models of the production of knowledge emerged, which held that entire organisms, zoological or cultural, could be reconstituted from fragments or even grooves left in the rock. Deduction-driven methodologies exerted a vast influence on a humanistic culture. Cuvier's modus operandi was

dangerously seductive. "You know that I have worked on America a little like Cuvier on ante-diluvial animals," wrote Tocqueville to a friend, "making use at each step of philosophical deductions and analyses."[251]

Such models, predicated on synecdoche, became particularly important for architectural preservation.[252] "Thus," wrote Viollet-le-Duc confidently, "just as one can infer an entire plant from a single leaf, and an entire animal from a single bone, so too can one deduce the architectural elements from examining a profile, and the complete building from an architectural member."[253] In *Histoire d'un dessinateur* (1879), published toward the end of his life, he illustrates skeletons of a man and of an upright chimpanzee clearly inspired by a plate in Cuvier's *Lessons in Comparative Anatomy* (fig. 5.24).[254] Gottfried Semper, who attended the debates between Cuvier and Saint-Hilaire, was profoundly influenced by Cuvier: "When I studied in Paris it was my habit to stroll in the Jardin des Plantes, and I was always attracted, as

Fig. 55. — Squelette d'homme, squelette de chimpanzé.

FIG. 5.24. Eugène-Emmanuel Viollet-le-Duc, illustration from *Histoire d'un dessinateur*, 1879. Private collection.

if by a magical force, from the sunny gardens into the room where the skeleton and fossil remains of animals from former ages were arranged in a long row with the skeletons and shells of the present creation. [...] A method analogous to that which guided the great Cuvier in his comparative osteology, but applied to architecture, will by necessity greatly facilitate an overall view of this field, and [...] will also permit an architectural theory of invention to be based on it, one that teaches the way of nature and avoids both characterless schematism and thoughtless caprice."[255] Cuvier's discoveries also had an impact on Belgrand, who immersed himself in the study of geology and paleontology. The first volume of his great work on the Seine in prehistoric times cites Darwin, Lyell, Édouard Lartet, Boucher de Perthes, and several other natural historians.[256]

New advances in prehistory and discoveries of fossilized remains were followed enthusiastically in fiction, newspapers, and guidebooks.[257] It is not by chance that the most celebrated French novel written in praise of geology and paleontology appeared at the height of the Second Empire. Though supposedly set in Iceland, Jules Verne's fictitious *Journey to the Center of the Earth*, first published in 1864, was shot through with references to Paris, from actual paleontologists cited in the text—Armand de Quatrefages, Henri Milne-Edwards—to newly found species such as the *Mammuthus meridionalis*.[258] The novel's mixture of hoary antiquity and forward-looking science fiction emblematized the new Paris wedded so inextricably to the old. Like many of his contemporaries, Verne wanted to have it both ways, cloaking himself in the mantle of science, with its bleak retrospective prognostication concerning humanity, and the secular religion of the sublime, which made room for transcendence and the consolatory powers of the imagination.

Cuvier died in 1832, but the succession of breathtaking discoveries continued. Since the publication of Charles Lyell's influential *Principles of Geology* (1830–33), stratigraphy had become a reliable way of dating the earth by means of fossils and shells found in successive layers. Lyell's studies on geological strata, showing that the earth was the product of a

gradual development over millions of years, helped shape Darwin's own ideas on evolution. "The idea of a continuously changing earth," Alan Mann observed, "was fundamental to the ideas of animal change over time and the development of evolution by natural selection."[259] In 1846, Boucher de Perthes's discovery of prehistoric flint tools made by humans, contemporaneous with extinct fossil mammals, assigned to humanity an antiquity that took years to be accepted. Édouard Lartet followed suit, providing even more evidence that humans coexisted with megafauna in 1861.[260]

But it was Darwin who exacerbated the controversy with *On the Origin of Species*, published in 1859, which claimed that species transform themselves over time thanks to natural selection. For Darwin, all organisms developed from a common source: "When I view all beings not as special creations, but as the lineal descendants of some few beings which lived long before the first bed of the Cambrian system was deposited, they seem to me to become ennobled."[261] It was change, and change alone, that drove "history," now deprived of both its human and its divine engine. Permanence turned out to be a geological and zoological impossibility. Darwin's theories met with fierce resistance in France.[262] The first French translation (1862) was extremely controversial, and Darwin corrected its errors for the second French edition, which came out in 1863. Although evolution per se (*transformisme*) was not accepted in France until the end of the century (and even then with reservations), Darwin's ideas dealt a major blow to scientific theories institutionalized in the academy. In 1856, the discovery of the Neanderthal partial skeleton in a quarry of the Neander valley in Germany raised the stakes. In 1866, the first Congrès International d'Anthropologie et d'Archéologie Préhistorique took place in Paris, which saw itself as one of the centers of the discipline. In 1868, workers laying railroad tracks in a small village in the Dordogne found, in the rock shelter of Cro-Magnon, the bones of extinct animals accompanied by human skeletons and stone-age artifacts and tools, the first of many such finds in southwest France.

Since the formation of the earth, the geological site of the city had been subject to endless change. Shaken by natural cataclysms, the vague outlines of the topography of "Paris" emerged only slowly from the long night of the past. During the Tertiary, a vast shallow ocean covered the area. For millennia, its warm waters teemed with life, and its tropical or subtropical climate fostered particular forms of plant and animal life. Palms flourished in this humid world, noted Cuvier.[263] Only the tips of Montmartre, Belleville, and the Montagne Saint-Geneviève stood out: islands above the huge expanse of water. Fish sported in the sandy shallows. Periodically the sea would withdraw, leaving behind lagoons of fresh water with their own fauna and flora, only to return a few million years later. Each of these marine and freshwater cycles left behind rich layers of sediment that formed the beds of chalk, limestone, marl, and gypsum on which Paris rests.[264] Héricart de Thury, inspector general of the quarries under Napoleon, had already worked on the stratigraphy of the soil. Basing himself on shells, he made clear distinctions between the cycles of saltwater and freshwater.[265] These balmy eons were followed by an ice age during the Pleistocene (early Quaternary), when the human species appeared, struggling for survival in an inhospitable environment overrun by megafauna like the mammoth found by Belgrand: their life was, indeed, "solitary, poor, nasty, brutish, and short."[266] It was only then that Paris began to acquire its present relief, as the waters receded, leaving a mighty river behind—the early incarnation of what is now the Seine.

If the underpinnings of humanism faltered under the weight of accumulating evidence, the tidings were not altogether bad. Geology, too, was destiny, and for some intellectuals the astonishing prehistoric finds beneath the city were proof of the "predestination" of Paris. The discourse of exceptionalism betrayed the deep anxieties that troubled the intellectual establishment, the fear that compared to Britain and Germany, their nation was not so special after all.[267] Others drew a more pessimistic assessment of the city, a recent shoal on an ancient body of water. Although few prehistoric human remains were found near the city, the origins of Paris were perceived to be enmeshed with the origins of the species. Thanks to new discoveries, the distant past came to be seen as exotic, enabling a sense of estrangement and wonder, a far cry from the gray annals of everyday existence. For those disillusioned with modernity, the exciting finds thrown up by the earth had the power to reenchant the metropolis. In the recesses of the earth lay the debris of nature's convulsions, the remains of enormous, unlovely beasts, and a disconcerting form of devolution that foreclosed empathy and melancholy.

The prehistoric sites beneath Paris confirmed the underground as a vast resting ground for both extant and extinct species, establishing a symmetry of sorts between fossils and their descendants: "There everything is tepid, motionless, silent," wrote Berthet in 1856, "and stone from the quarries retains the imprint of fossil animals, of antediluvian shells, as if nature itself had always predestinated these depths to serve as a necropolis."[268]

THE SLEEP OF REASON

For nonspecialists, the implications of the prehuman world of ages past were both exhilarating and terrifying. At the very moment when Haussmann and his engineers were subjecting the urban environment to a radical transformation that epitomized human agency, contemporaries were confronted by a sullen, impersonal process of change that bypassed humanity altogether. Instead of a universe long held to be purposeful, scientists proposed an abstract trajectory in which different genera reacted to environmental conditions, "*a world without thought* in which man is absent," as a contemporary of Belgrand put it.[269] The sleep of reason did, indeed, produce monsters. The gigantomachy lodged underground and the equally bewildering miniaturization of certain species suggested something less than linear progress, the great religion of the age. A form of rationality was at work here, but one that disempowered the *Homo sapiens*. Cuvier's brilliant theories kept the more devastating consequences at bay with its inbuilt safety valve of catastrophism. For a while at least, his followers could take comfort in denial.

By the 1850s and 1860s, even before they accepted the inescapable conclusions of evolution, many French thinkers realized that the anthropocentric edifice, built throughout the ages to exorcize death, had been dealt a blow, along with its corresponding eschatology. Far from being willed by divine intervention, humanity had far more modest origins as the product of blind, unintentional forces. By spelling the end of the discontinuity between man and animal, evolution heightened the fear of origins and threatened to dismantle the epistemological foundations that had been taken for granted. The shock took decades to be absorbed. The Second Empire's herculean attempt to level hills, lower streets and bridges, and dig up the riverbed paled into insignificance compared to the great geological drama unfolding beneath the city. From the perspective of the *longue durée*, the

city's great monuments and historic landmarks turned out to be a thin veneer, ephemeral reflexes thrown up by an all too transient population tethered to risible notions of immortality. The geohistorical traces of deep time drove home inexorably the impermanence and insignificance of the human species and its notion of history—a hiccup in the glacial pace of deep time.

And it was time, on a hitherto inconceivable scale, that held the attention of both scientists and amateurs in its vise. Buffon had already noted that the numbing temporality of prehistory was hard to accept, perhaps because the brevity of human existence affected the way we measure duration.[270] Fossils, however, made time visible. In the world of pure opacity, where they slumbered encased in clay or gypsum, time prevailed over space. Thanks to them, the successive layers of the earth, obliterated by natural upheavals rather than catastrophes, were finally coming into view. Yet the pasts unearthed by geologists and paleontologists did not square with the ruins found by archaeologists that inscribed Paris into a reassuring humanist and anthropocentric temporality divided into centuries. Contrasted with the monstrous duration recorded by prehistory, the quick tempo of the metropolis dissolved into nothingness.

As Haussmann's engineers tore up the city, modern Paris found itself constantly brushing up against prehistoric vestiges. Workers digging the foundations of the Boulevard Malesherbes found traces of carapaces belonging to giant chelonians.[271] Similar finds continued to emerge until the beginning of the twentieth century, when excavations for the new subway system revealed important remains along the old fossil arm of the Seine, where herds of prehistoric pachyderms descended to the wide river to drink.[272] Haussmann founded the Service des fouilles et substructions and ordered specialists to pursue all findings concerning the distant past. "By digging deeper than archaeologists, piercing the thin layer that the works of civilized man have wrought on the current surface of the earth, they have arrived without abrupt transitions and by imperceptible degrees so to speak, at prehistoric ages," Belgrand wrote in the introduction to his volume on prehistory.[273]

Haussmann began, but could not entirely complete, the sanitation and secularization of underground Paris that simmered under his reassuring bourgeois city. Like other technocrats before him, he longed to bring it up to date with the dictates of modernity. But subterranean Paris proved resilient, its very location hard to define: partly underground, partly in the imaginary. Overloaded with a range of troubling associations, often stretching back to a hoary, prehuman antiquity, it gave way only slowly to Haussmann's efforts to introduce new forms of urban governance. Geology inscribed the city in an altogether different timescale, far older than ancient Lutèce, that could not be plotted along a linear path. As the haphazard finds below ground were made public during the Second Empire's transformation of the city, interest in prehistory moved from educated circles to the daily press, and from there to the streets. As far as the public was concerned, Paris had suddenly aged.

Disenchanted Nature

The machine *is* the garden.
—Scott Bukatman, *Visual Display: Culture beyond Appearances*

Modernity revolutionized city dwellers' relation to nature, which could now be produced like other manufactured goods. By midcentury, the very scale of the metropolis precluded traditional methods of horticulture, requiring serial propagation of vegetation, as well as an efficient infrastructure to accommodate water mains and sewers to support a vastly expanded and complex network of municipal gardens. A wide gamut of vegetal species from all corners of the globe, enabled by colonial exchange, was now available; innovative techniques allowed a variegated vegetation to survive the stress of large urban environments and diverse climates. This urban nature, a contradiction in terms, was not a purely industrial product but a hybrid compromise contingent on cultural, economic, and political factors. In the big city and its hinterland, the lost and lamented nature, slow growing and unrepeatable, could not be retrieved except as ideology.

That ideology proved obdurate. Part of the urban population was reluctant to give up its dreams of pastoral purity uncontaminated by industry. The old nature, restorative and redemptive, survived as myth in the discursive order and artistic representations. Fantasies of an unspoiled *natura naturans* resonated even in the opposition.[1] Their constant criticism of the artificiality of the regime's green spaces implied a firm belief in the existence of undefiled realms elsewhere. It is when nature is threatened that it beckons irresistibly as ideology. "Do not expect to find the charms of nature in the vast spaces that Paris has given over to this fiction," wrote George Sand. "The smallest rock of Fontainebleau or the wooded hills of Auvergne [. . .] have an altogether different aspect, appearance, and penetrating power from the most sumptuous compositions by our Parisian *paysagistes!*"[2] Sand did not dislike the empire's parks and gardens, which were open to multitudes; she just found them lacking in the telluric aspects of "real" landscapes like Fontainebleau. Yet Fontainebleau had long ceased to be a slice of nature. Thinned out into graceful tableaux, it had been edited for mass tourism, following the success of the artists of the Barbizon school who painted it repeatedly (fig. 6.1).[3]

Sand's criticisms, common at the time, ignored the aims of Second Empire gardens. Distributed across the city on an unprecedented scale, they foregrounded unambiguously their connection to modernity, industry, and urbanism. New technologies, visible throughout the grounds, were put into place to irrigate, trim, and transport plants. Far from

FIG. 6.1. Gustave Le Gray, tree. *Forest of Fontainebleau*, ca. 1856. Museum of Fine Arts, Houston.

being intended as simulacra of nature, the Second Empire's greenery offered a faithful representation of industrial forms of production: artificial lakes and waterfalls, macadam roads, cement rocks. Reactions from the city's diverse public varied widely. Ambivalence concerning municipal greenery was partly rooted in the changes and challenges brought about by modernity. Many intellectuals and aristocrats, angered by the coup that brought an upstart to power, dismissed the manufactured gardens contemptuously or, like Sand, contrasted their own cultured and well-traveled views to the swaths of mass-produced scenery. Patricians and landed gentry with strong connections to the countryside found them inauthentic. Others, grateful for new public spaces, suspended disbelief and consumed them distractedly, content to see in the cement-edged lakes and fabricated greenswards the cherished myths of the past.

The new nature so stridently mediated by technology had its admirers. In various Parisian circles, it had become fashionable to extol artifice over nature, and rate purely urban landscapes above Arcadian idylls. As he beheld the trees at Bougival, Degas remarked wistfully that "they would have been beautiful if painted by Corot!"[4] For some, the excitement of big-city life offered greater rewards than the consolations of nature: "Every calumny is leveled against this promenade," wrote Gustave Claudin of the Bois de Boulogne. "They say it is rouged, *maquillée*. I prefer this artificial beauty to the coarse realities of our fields

and forests which wither before they even start to grow."[5] Like many others, Claudin preferred botanizing on the asphalt.

Concepts of urban greenery could also be veined with contempt toward the taste of the masses that was seen as pedestrian. "The Parisian loves nature platonically," scoffed Émile Zola. "He rhapsodizes over the cascade of the Bois de Boulogne and then declares that he no longer needs to see Switzerland. He craves nature fashioned in a certain way, practical to behold, in cardboard paste, painted and varnished, that can be enclosed within four rows of houses."[6] Victor Fournel agreed: "For nothing in the world," he quipped with heavy irony, "would the real Parisian enjoy a house in the country from where he could miss the whistle of the locomotive. Showing you his garden, he exclaims proudly: 'The railroad passes a few feet from here; I can hear all the trains.' His dream would be to build cities in the countryside, or transport the countryside to Paris. Squares are meant precisely to respond to this dream. [. . .]. Had they provided more foliage and shade he would complain bitterly that the trees prevented him from seeing the omnibus go by."[7]

At the same time, a wholly novel concept of nature was beginning to emerge, the *paysage urbain*.[8] Although Baudelaire never used the term, he forcefully articulated its antinaturalist message in his salon of 1859, castigating traditional landscape painters for ignoring the modern world. Landscape, as he understood with penetrating insight, had long since moved to the city, to the ravines and beetling cliffs of tall buildings overlooking urban chasms. What he found lacking in the paintings on display was "a genre that I would gladly call the landscape of big cities, that is, the assemblage of grandeur and beauty that emerges from a powerful agglomeration of men and monuments, the profound and complex allure of an old capital that has aged amid the glories and tribulations of life."[9] Fascinated by the transient beauties of modernity, artists such as Manet and Monet would record the crush of throngs and traffic along boulevards, the busy squares, the disorienting panorama of railroad stations half obliterated by steam and smoke. The gray monotony of the banlieue with its dilapidated shacks and pervasive sense of dereliction revealed yet another definition of *urban* landscape. This medley of old and new, chimney stack and steeple, suburb and city, *was* modernity.[10] The metropolis was all embracing. For Baudelaire, the dubious magic of dioramas was preferable to the realism of the artists of his day: "Because they are false, these things are infinitely closer to the truth, whereas most of our landscape artists are liars, precisely because they have neglected to lie."[11]

This split between "natural" and fabricated gardens divided contemporaries. When the Comtesse d'Agoult showed her elder brother and his schoolmate her little table gardens made of twigs, miniature figures, and pieces of mirror, they criticized her appeal to artifice and planted berries and red currants outdoors, along a trickle of water. "I don't know why, but these real gardens did not have the same attraction for me as my fictitious ones, and I soon tired of them," she recalled years later. "Was it not precisely because they had too much reality, because they confounded art and nature, because the imagination did not have enough share in our pleasure and because, instead of a free invention, we had before us a diminished reproduction of the things that surround us?"[12] Landscape—and not only in paintings—was an artifact rather than a servile copy of nature, obeying the dictates of fantasy. The Second Empire's extensive and ingenious green spaces were an attempt, fraught with contradictions, to deliver a nature that advertised its man-made origins without altogether breaking with the codes and myths of the past.

SOURCES

In the past, the aristocracy had built its chateaux and parks outside the city walls. Nesting amid fields and forests were the domains of the church and tightly massed villages. Within Paris, only the nobility and religious orders could afford orchards and gardens. Records of these enclaves survive in street names: Courtille (small garden), la Cerisaie (cherry orchard), and Beautreillis (beautiful trellis).[13] The word "clos" (enclosed) designated the private gardens such as the Clos des Chartreux (Carthusians) near the Luxembourg, confiscated along with the adjoining convent during the French Revolution. Speculation did the rest, as parks were divided into lots and sold. The abolition of primogeniture during the French Revolution dealt another blow to urban greenery: the size and number of gardens left within the city dwindled.[14]

After the Industrial Revolution urban density increased, and the demand for greenery took on added gravity. Parisians bemoaned the increasing "petrification" of the city, exhorting the government to provide more green spaces for the population.[15] "Paris suffocates within its stony prison house whose walls extend further every day," complained a disgruntled citizen in 1854, adding that the city's gardens were distributed unevenly throughout the city.[16] The same year, Gérard de Nerval lamented the loss of his old apartment in Rue du Mail from which he could see "something one doesn't find in the center of Paris:—the sight of two or three trees."[17] As it became clear that the municipality had to provide relief from the great mass of buildings lining the streets, the notion of public rather than private gardens gained in importance. Since the Enlightenment, architects and hygienists had underscored the importance of air and sunlight in the interests of public health, ideas taken up by Alphand: "With regard to health, public gardens, broad planted streets where air circulates freely, are absolutely imperative in the interior of large cities."[18] Those old aerist arguments received a strong endorsement from Michel-Eugène Chevreul, the great French chemist. Provided they are planted correctly, he claimed, trees and shrubs increase healthfulness by drawing water with their roots and releasing it into the atmosphere.[19] Parks and gardens were no longer considered mere urban embellishments as in the past.

Concern for hygiene, however, was laced with the usual paternalistic concerns characteristic of reformist theories. Partisans of urban change within an unchanging class structure usually saw nature as the embodiment of God's purpose and goodness that elevated the morals of those who came into contact with it. William Robinson, the Irish landscape gardener and horticulturalist who wrote two books on the Second Empire's parks and gardens, claimed that exercise in the open air "improves the morals of the people."[20] Edwin Chadwick, who occasionally advised Louis Napoleon on social matters, also underscored this point in his influential writings: "The want of proper spaces as playgrounds for children is detrimental to the morals as well as to the health in the towns, and it probably is so generally. The very scanty spaces which the children both of the middle and the lower classes, the ill as well as the respectably educated, can obtain, force all into one company to the detriment of the better children, for it is the rude and boisterous who obtain predominance."[21]

Overshadowing these social theories were the doctrines of Henri de Saint-Simon, whose enthusiastic belief in the beneficent power of industry and economic trade entailed an equally optimistic view of nature if subjected to human control: "French soil in its entirety should become a superb park à l'anglaise, embellished by all that the fine arts

can impart to the beauties of nature," he wrote.[22] The great networks engineered by Haussmann's experts, aimed at facilitating circulation and exchange, clearly reflect Saint-Simonian ideals. The mastery of industrial and horticultural technologies that they implied—the ability to bend nature to human purpose and enhance the city's capacity to produce and consume by improving infrastructure and boosting the health of its citizens—echoed the ideology of progress characteristic of the age. Napoleon III thought of himself very much as a reformer in this sense, capable of changing society without altering the status quo. Parks would benefit the greater part of the population, which now had a refuge from stifling tenements. Open land would allow workers to restore their strength and help reproduce them as a labor force.

A contributing factor to the interest in greenery was the rising popularity of horticulture, whose annual salons, like those of the Beaux-Arts, attracted a large audience. In an age obsessed with social mobility, horticulture placed exotic trees, flowers, and shrubs—formerly the preserve of the aristocracy—within reach of the middle classes, enabling them to emulate a much-admired aspect of high-society life. Specialized journals and how-to publications proliferated: *Revue Horticole*, *Mouvement Horticole*, *L'Horticulteur français*, *Annales forestières*, *L'Illustration horticole*. British magazines such as *Paxton's Flower Garden* and *Paxton's Magazine of Botany* were highly regarded in France, as was John Claudius Loudon's the *Gardener's Magazine*. The professionalization of the landscape architect undoubtedly helped fuel the vogue for garden design.

The growing interest in parks and gardens also mirrored the taste for travel. Steam changed modern society's relation to nature, gradually making distant places more accessible.[23] Prints and photographs of lush, tropical vegetation were frequently reproduced in the press, which supplied an eager public with riveting accounts of voyages throughout Africa, Asia, and the Americas, whether scientific expeditions or colonialist endeavors undertaken by Western nations in search of spoils. Readers could now share vicariously in dangerous journeys in faraway lands exemplified by Alexander von Humboldt's voluminous publications, Darwin's *Voyage of the Beagle* (1839), or *A Journey in Brazil* (1868) by Louis Agassiz and Elizabeth Cabot Cary Agassiz, among so many others. This material made its way into print culture, gardens, and even opera, where luxuriant papier-mâché sets regaled the public with the equatorial splendor of the tropics.[24]

Overseas territories supplied both exotic plants and the know-how required to cultivate them. As the empire expanded, the number of botanical gardens (*jardins d'essai*) in France's colonial domains grew and would reach its high point under the Third Republic: among others, the botanical gardens of Pamplemousses in Mauritius (1735–36) and Saint-Denis in Réunion (1769); the Jardin Royal des Plantes in Cayenne, French Guiana (1778); the botanical gardens of Saint-Pierre in Martinique (1803) and in Pondicherry, India (1827); and the *jardin d'essai* du Hamma in Algiers (1832).[25] Throughout France, material and immaterial resources from the colonies enriched horticultural research.

The proliferation of urban parks also brings to mind the rise of landscape as a genre that rivaled the supremacy of history painting in the salons. Marginalized under the July Monarchy, the Barbizon school came into its own after the revolution in 1848, when the notion of *paysage vérité* or *paysage portrait* began to win adepts at the École des Beaux-Arts.[26] Their artists' beloved forest of Fontainebleau became a model to be copied, and not only on canvas. With its prescribed itineraries, famous vistas, and guided tours, the old forest

too had become a spectacle served up for consumption and subject to forms of modern management. Barbizon, in fact, had a strong influence on Alphand's conception of the Bois de Boulogne.[27]

Previous administrations had already begun to provide verdure for the expanding city. Under the Restoration, Chabrol had underscored the need for large public gardens at the cardinal points of the city walls but never got the chance to implement his goals.[28] The July Monarchy gave a strong impetus to municipal greenery. Rambuteau, of whom it was said that he had rather pull out a tooth than a tree, planted hundreds of trees in Paris.[29] He also completed two small public gardens that Haussmann later transformed into squares, the square Louvois and the square of the Archevêché beside Notre-Dame. Haussmann's engineers never forgot Rambuteau's urbane motto: to give Parisians "water, air, and shade."[30]

In 1839, Nicolas Vergnaud published an extremely interesting book that devoted a chapter to public gardens, enjoining authorities to turn the dreary Bois de Boulogne into a beautiful park.[31] Three years later, and with extraordinary foresight, Meynadier proposed the creation of parks, gardens, squares—the program eventually adopted by the Second Empire. Like Louis Napoleon a decade later, he looked to England for inspiration. Regretting the absence of public amenities such as Regent's Park, Hyde Park, or Saint James Park, Meynadier suggested that the municipality provide green *squarres* after the English manner.[32] To better serve the population, the Bois de Boulogne, accessible only to those equipped with horse and carriage, should be carefully redesigned, while the Parc Monceau should be acquired from the Orléans, and transformed into a public promenade.[33] His lucid proposals circulated among the experts surrounding the emperor, including the Siméon committee, disparaged and derailed by Haussmann.

THE GARDENER-PRINCE

When Louis Napoleon was elected president, he was fired by an ardent wish to modernize Paris, inspired by his readings and travels during years of exile. Public parks played an important role in his agenda from the start.[34] The revolution that swept him into office had shown the force of the restive masses, and he was keen to make visible gestures that benefitted a shifting population of workers forced to relocate according to the requirements of the economy. His plans, which evolved gradually, accelerated when he became emperor and began building a paternalistic and authoritarian state. The regime's green spaces thus formed a crucial part of the imperial politics of appeasement but reflect a wider constellation of social, political, and cultural issues.

An inventory of the capital's public gardens yielded only the Tuileries, the Luxembourg, and the Jardin des Plantes (Jardin du Roy before the Revolution): about 148 acres of greenery for a population of 1.8 million after annexation.[35] A property of the Crown, they were open to the public on sufferance. The tiny Palais-Royal, also in private hands, was owned by the Orléans. None of these gardens were proportionate to the needs and size of modern Paris.[36] After 1848, access to public spaces became crucial.[37] The aristocratic *hortus conclusus*, sequestered behind high walls, gave way to a more democratic formula that entailed a radical rethinking of the very concept of urban greenery now aimed increasingly at all social classes. It fell to Haussmann and his engineers to carry out this transition from private to public parks and gardens in a systematic way and on a broad scale.

Both emperor and prefect had a touch of the parvenu. Napoleon III relished the patina conferred by immemorial trees and landed properties that spoke of a lineage he affected but lacked. An amateur gardener, Napoleon III had some experience in horticulture when he embarked on his ambitious project to refurbish the capital. Years of residence in Britain had familiarized him with the aristocracy's long-standing interest in landscape gardening, which he embraced with passion. Thomas Evans, his American dentist, recalls a visit to the Duke of Hamilton's Brodick Castle in Scotland. When Evans praised the way the vista opened up around the old building, his host replied that this was carried out following the instructions of Louis Napoleon. "'When he was in exile in England, he used to come here occasionally, and was very fond of the place. But he was always suggesting changes, which, he said, would greatly improve it—the removal of trees from certain places and the planting of others elsewhere—with flowers here and shrubbery there. I, and my father before me, allowed the Prince to carry out his suggestions, and you now see with what excellent and very beautiful results. He was a wonderful landscape gardener; and,' he added laughing, 'if he should ever lose his place, I should like to take him as my head gardener.'"[38] Haussmann's taste in gardens was more pedestrian, although he received an excellent education. His lifelong interest in horticulture began early, when he spent several years at his grandfather's estate at Chaville, on the road to Versailles.[39] At his private boarding school near Sceaux, each student had to identify trees and shrubs and care for a piece of land.[40] During his long stint in the provinces, he pursued this passion, planting trees along several roads leading to Bordeaux, as he remarked with satisfaction when he saw them again, thirty-eight years later.[41]

As prince-président, Louis Napoleon sent experts to Britain in 1851 to study urban questions including public gardens, given its success in providing greenery for its citizens.[42] Having lived in London from 1837 to 1840 and 1846 to 1848, he was aware of its division into an impoverished East End, and a western half carpeted with sumptuous parks, urban iterations of an aristocratic theme for the rising middle classes: Hyde Park, Regent's Park, Saint James, Green Park. As in Paris, fear of deadly epidemics in the overcrowded eastern part of London was perceived as a constant threat to its privileged western counterpart and served as a catalyst for new initiatives. John Claudius Loudon, Joseph Paxton, and James Pennethorne had already completed important public parks. Battersea and Victoria, Pennethorne's two parks in South and East London, were begun in the 1840s. Situated at the center of a profit-oriented residential development funded by the state, Victoria was designated as a public park in 1842, opening to the public four years later. An extraordinary success from an economic point of view—the rise in value of the surrounding real estate helped finance construction—it was rather less interesting as landscape design, though the lucrative combination of public promenade and suburb was not lost on Second Empire planners.[43] Public parks served as a profitable anchor to expensive real estate, bringing revenue to the municipality, which sold the adjacent lots.

Paxton's pathbreaking and influential Birkenhead, near Liverpool, was financed by an act of Parliament and finished in 1847, while Louis Napoleon was still in Britain. Frederick Law Olmsted, who visited it in 1850, was overwhelmed: "I was glad to observe that the privileges of the garden were enjoyed about equally by all classes," he reported enthusiastically. "The poorest British peasant is as free to enjoy it in all its parts as the British queen."[44] Olmsted took great interest in the way Birkenhead was financed: "The remaining sixty

acres, encircling the park and garden, were reserved to be sold or rented, after being well graded, streeted, and planted, for private building lots."[45] Louis Napoleon knew all too well how difficult it had been to bring these two projects to fruition, given the reluctance to underwrite public works in the heyday of laissez-faire capitalism.[46] In the eyes of the British government, such nonprofitable undertakings were best left to philanthropists and private enterprise. Benjamin Disraeli, for example, had strongly opposed the creation of Battersea Park.[47]

An emperor who rose to power thanks to a coup d'état, fearful of the urban masses, needed to claim credit for public parks himself, and Napoleon III followed the greening of the French capital closely, occasionally intervening in person (fig. 6.2). But princes tend to privilege grand projects rich in symbolic capital and political dividends. Administrators follow less lofty paths. Haussmann's reliance on engineering and modern technology distinguished him from the emperor's voluntarist approach. The prefect realized that the city's green spaces had to be linked to a citywide infrastructure that included streets, water supply, and sewerage; provide food and shelter for thousands of visitors a day; and accommodate roads capable of sustaining heavy vehicular traffic. With the emperor's support, Haussmann and his experts created or retrofitted five parks, two gardens, and over twenty

FIG. 6.2. Fortuné de Fournier, Napoléon III's study in the Tuileries, 1862. The giant map on the wall shows the Bois de Boulogne on the left and the unfinished Bois de Vincennes on the right. Watercolor. Château de Compiègne.

squares, which they gradually forged into a networked system, adapted to different neigh-borhoods, scales, and diverse social constituencies. The pressing need for urban greenery was an issue that the Second Empire tackled firmly, even if its contribution in this field was no more egalitarian than its other municipal services.

ALPHAND AND HIS COLLABORATORS

Engineering alone, the prefect well knew, could solve the problems of providing vast areas of greenery and delivering them to the population fully equipped with trees and flower beds, lakes and waterfalls, drainage and roads of access. To oversee the greening of Paris, he handpicked Alphand, his old acquaintance from Bordeaux (fig. 6.3).[48] Alphand's career followed that of Haussmann closely, save for his greater political longevity. Born in Grenoble, Alphand studied at the Polytechnique and the École des Ponts et Chaussées in Paris, before moving to Bordeaux, where Haussmann, then prefect of the Gironde, met him in 1852.[49] With his help, Haussmann stage-managed the visit of Louis Napoleon to Bordeaux with great success. In Paris, Alphand's position was unprecedented, and he rose higher in the municipal service than had any other engineer. Haussmann created a special department for him, the Service des Promenades et des Plantations de Paris. Alphand's luxurious publication *Les promenades de Paris* (1867–73), funded munificently by Haussmann, shows his skill at promoting his own work.[50] When the Second Empire fell, Alphand turned down the post of prefect of the Seine but became director of public works, taking charge of roads, lighting, and water supply after Belgrand passed away. In 1891, Alphand was given a magnificent funeral in Notre-Dame and was buried, like Hauss-mann, at the Père-Lachaise.

Alphand was a perfect representative of the elite corps of French engineers of the Ponts et Chaussées. Like Paxton, he was a superb organizer with a proven aptitude for developing new technologies and a capacity to get things done. An engineer, Alphand straddled the line between consulting "the Genius of the place in All," as Alexander Pope had recommended, and ignoring the existing topography.[51] His parks were manufactured, often to great effect, according to interventionist practices that often eroded—some might say improved—the particularities of place. Massive earthworks were undertaken to give scenic relief to uninflected terrain. Hills were leveled or created with the spoils of newly excavated lakes; low-lying areas were filled in, streams and waterfalls plotted on the draft-ing table. Alphand's writings and practice suggest the influence of eighteenth-century landscape theory, especially the work of Christian Hirschfeld, René-Louis de Girardin, Claude-Henri Watelet, and Jean-Marie Morel.[52]

Only recently has the lack of scholarly monographs on the Second Empire's excep-tionally qualified engineers begun to change.[53] However, we do not know the exact roles played by all the municipal experts who worked on parks and squares, and we undoubt-edly attribute a far greater share to Haussmann, Alphand, and Belgrand than is their due. If Alphand's career, like Belgrand's, has been overshadowed by Haussmann's oversize life and works, he in turn leaned heavily on collaborators whom he never credited in *Les prom-enades de Paris*. Like Haussmann, he downplayed his debt to former administrations, par-ticularly the July Monarchy, and was taken to court by a former chief of staff, Jules Prat.[54] A highly educated lawyer (he had translated Spinoza's *Theological-Political Treatise* from

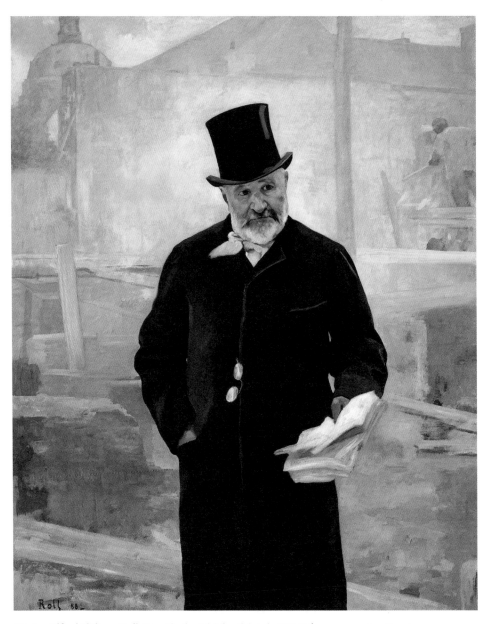

FIG. 6.3. Alfred Philippe Roll, *Jean-Charles-Adolphe Alphand*, 1888. Oil on canvas, 62.5 × 50 in. (159 × 127.5 cm). Musée des Beaux-Arts de la Ville de Paris, Petit Palais.

Latin), Prat claimed that he had put considerable amount of work into the publication and the proofs, and written the lengthy introduction to the book together with architect Émile Hochereau, one of the illustrators of Alphand's publication.[55] We do not have conclusive evidence, one way or the other, and continue to cite Alphand, perhaps wrongly, as author of *Les promenades de Paris*. Belgrand was far more generous. In his extraordinary study on the hydrology of the basin of Paris, he acknowledges the work of several fellow engineers and even entrepreneurs whose firms contributed to his projects.[56] Haussmann

himself showered praise on many architects, engineers, and industrialists in his memoirs, however self-serving. With regard to the parks of Paris, the question of authorship must remain open. Doubts concerning Haussmann's role in the renewal of Paris should equally be raised with regard to Belgrand and Alphand, superb professionals both, but who could not have implemented on their own the vast oeuvre currently attributed to them.

Among the many experts passed over in silence by Alphand was the man responsible for horticulture in the city's parks and gardens: Jean-Pierre Barillet-Deschamps (1824–73), another acquaintance from Bordeaux whom Haussmann summoned to Paris.[57] An auto-didact from a rural background, Barillet-Deschamps originally came to the capital to work and study at the Jardin des Plantes.[58] With its superb library, erudite professors, and rich collection of plants, France's premier arboretum and seed bank was the ideal place for him to familiarize himself with rare species and learn how to propagate them. When Barillet-Deschamps had gained a strong background, he returned to Bordeaux and opened a suc-cessful establishment in horticulture that specialized in producing exotic species. It was there that he met both Haussmann and Alphand.

Despite his growing fame and status as head gardener of the Service des Promenades et Plantations, Barillet-Deschamps's humble background stood in the way of his advance-ment, and he was often slighted by those who owed him the most. When Louis Napoleon visited Bordeaux just before his coup d'état, Haussmann gave him a magnificent reception. Seeing a promenade planted with magnificent tropical fruit trees and shrubs, Louis Napo-leon asked for the name of the magician responsible for this feat. Haussmann remembered only Alphand, then a municipal engineer, forgetting Barillet-Deschamps.[59] Haussmann did, however, cite him several times in his memoirs, while Alphand shamefully omitted Barillet-Deschamps's name from *Les promenades de Paris*.[60] The city's horticultural milieus criticized Alphand strongly for failing to attend his funeral or participate in a subscription for a memorial to Barillet-Deschamps in the Père-Lachaise, that great meeting ground of friends and foes of the Second Empire.[61]

Alphand was assisted by several engineers including Alfred Foulard, tasked with the greening of streets and squares, and Jean Darcel (1823–1906), a graduate of the Ponts et Chaussées. Darcel, a highly cultivated practitioner and published author, designed three major parks in Paris and eventually replaced Alphand, who was appointed director of pub-lic works after the Commune.[62] Édouard André (1840–1911), who had studied horticulture, joined Alphand's team of experts in 1860. A friend of Olmsted and Robinson, he prided himself on his humanist education and was at pains to distinguish himself from horticul-turists like Barillet-Deschamps by referring to himself as *paysagiste* or *architecte-paysagiste*.[63] Barillet-Deschamps's hands-on approach must have seemed unlettered for someone with a strong humanist background like André or a highly trained technocrat like Alphand. Land-scape, when done justice, had to do with the fine arts, André argued.[64] The very title of his remarkable treatise, *L'art des jardins* (1879), affirms a belief in his high calling and shows the impressive level attained by the French in this field.[65] Barillet-Deschamp was seconded by gardeners Georges Aumont and Joseph Laforcade. In a letter to his own gardener, writ-ten in 1854, Prince Hermann von Pückler-Muskau also claimed to have had a hand in the design: "After we last saw each other, I have worked, literally, with the emperor of the French at the Bois de Boulogne."[66] The German nobleman's beautiful park at Muskau, Saxony, attracted many visitors and was illustrated in Alphand own treatise.[67]

Louis Napoleon's first undertaking in this field was the transformation of the Bois de Boulogne into the city's most fashionable promenade. Situated just beyond city limits, in the elegant west end, it was all that remained of the old forest of Rouvray, once a royal hunting preserve of the Merovingian kings. Francis I had it enclosed, reforested, and stocked with deer. At the edge of the grounds, he built the Château de Madrid, clad in colorful ceramic tiles. The sixteenth-century Château de la Muette, rebuilt by Louis XV, also flanked the Bois. So did Bagatelle, erected by the Comte d'Artois, the future Charles X. All three princely residences spoke to the park's strong connection to the Crown and the aristocracy.

Over the centuries, the royal forest had suffered grievously. The French Revolution decimated trees, destroyed the Château de Madrid, and mutilated La Muette.[68] Napoleon I, who lived nearby at Saint-Cloud and saw the desolation firsthand, tried to improve it with new cuttings and reforestation. When his enemies camped there in 1814 and 1815, trees were cut down to build shelters and procure fuel. The Restoration repaired the damages inflicted by the invasion, creating nurseries for shrubs and trees. For his part, Louis-Philippe continued to fund the regeneration of the Bois, but the fortifications of Thiers, built on his orders, nibbled away considerable portions of the grounds, including the Jardin du Ranelagh.[69] By the time Louis Napoleon took office, the old forest, once teeming with game, had become barren and sparse. Revolutions had taken their toll. Even so, the walled enclave was a favorite watering hole of the nobility, who frequented it to exhibit their elegant equipages. Cut at right angles by rectilinear *allées* so hunters could spot their prey, its arid glades and shriveled trees were a far cry from France's great eighteenth-century parks (fig. 6.4). "Inaccessible to the petty bourgeoisie on foot and to working people owing to its great distance," wrote the Comtesse d'Agoult, the Bois de Boulogne "was used exclusively by the aristocracy—the sickly, decrepit, enfeebled aristocracy, that haunted this pitiful wasteland trailing its trials and tribulations."[70]

Prescient for once, Louis XVI (or his councilors) had refused to alienate part of the forest, arguing that in case of insurgency the Bois da Boulogne could serve as a buffer between Paris and Versailles.[71] During the Second Empire, the presence of the court at the Tuileries rather than Versailles changed the area's political liability. In July 1852, Louis Napoleon donated the property to the city on condition that the municipality transform it into a public park and assume responsibility for its upkeep. Jacques Ignace Hittorff supervised the work, which was to be ready for the World's Fair of 1855. The monotonous allées and scrawny vegetation themselves suggested the remedy: open horizons, free-flowing paths aimed at focal points, and luxuriant vegetation. In the eighteenth century, Marc-Antoine Laugier had already advocated designing cities along the lines of royal parks, with clean-cut arteries, elegant geometric patterns, *carrefours*, and *pattes d'oie*.[72] Haussmann followed this precept, adopting rectilinear avenues and pattes d'oie for the city, while his engineers reserved the Picturesque's meandering paths and streams for parks.[73] Yet endemic problems remained. Although the site was surrounded by great forests—Saint-Cloud, Montmorency, Ermenonville, and Fontainebleau—its dry topsoil determined a puny tree cover that ruled out verdant woodlands.[74]

The Bois de Boulogne turned out to be an arduous task that Napoleon III embraced with passion, often supervising the work in person.[75] The single-minded attention and

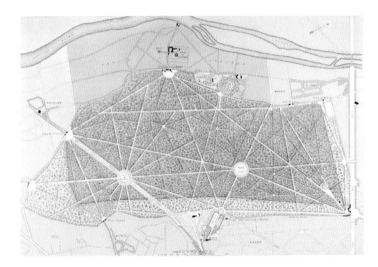

FIG. 6.4. Plan of the old Bois de Boulogne. Alphand, *Les promenades de Paris*. Marquand Library of Art and Archaeology, Princeton University.

meticulous organization with which the president-turned-emperor pursued his goals struck at least one contemporary for their resemblance to military campaigns. Ushered into the emperor's study, the politician Édouard de Beaumont-Vassy was surprised to see several large maps on the floor, marked by tiny colored pins that he took for representations of Belgium or the banks of the Rhine. As he moved closer, Beaumont-Vassy realized with surprise that they were plans of the lakes and allées of the Bois de Boulogne. "Imitating Napoleon I, Napoleon III consulted them by lying on the floor, just like the great man whose name he bore."[76] The emperor was perhaps following Meynadier, who had advised urban planners to make use of little flags "as strategists do with military maps."[77]

Louis Napoleon had originally wanted something along the lines of Hyde Park, with a Serpentine to enliven the area. Louis-Sulpice Varé (1803–83), the well-regarded gardener chosen for the job, had been in the service of the Louis Napoleon's mother, Hortense de Beauharnais. Varé's grandfather Marcellin Best had worked for the Bonapartes at Saint-Leu-la-Forêt and Mortefontaine.[78] Unlike Alphand, Varé was not an engineer and had a much lighter touch, seeing landscape gardening as a dialogue with the site. After studying the lay of the land, Varé would accentuate the natural features of the landscape, saving rare trees as points of visual interest and tracing winding paths in the manner of the Picturesque. "He is from the realist school, which takes God as its master," wrote Édouard Gourdon.[79] In his memoirs, however, Haussmann claims that in his attempt to carry out Louis Napoleon's Serpentine, Varé neglected to study the relief of the terrain when he began digging the watercourse. Since the two extremities were not on the same level, one end of the artificial stream would be full while the other would run dry. Varé, wrote Haussmann, had a certain talent for landscape design, but "was not at the level required by his mission," Varé was dismissed in 1853.[80] Whether or not Varé had been at fault, the emperor's Serpentine had to be transformed into two lakes separated by a causeway, according to an idea Haussmann attributed to himself. In fact, René-Louis de Girardin had already recommended that the *trop-plein* of the lake become a waterfall.[81] Varé himself had proposed such a stratagem before being sent away.[82]

Haussmann's contemptuous dismissal of Varé as incompetent should thus be taken with caution. Varé went on to work for extremely distinguished patrons: Sir Richard

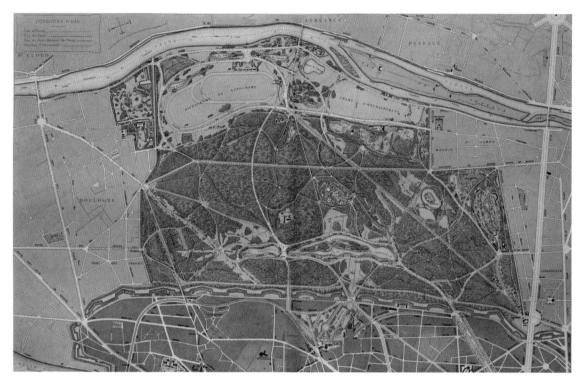

FIG. 6.5. Plan of the new Bois de Boulogne, redone by Alphand and his team. Alphand, *Les promenades de Paris*.

Wallace asked for his help at Bagatelle; the Péreire brothers had him design the park at their estate in Crécy; Baron James de Rothschild required his services, as did Achille Fould, one of the emperor's ministers. Varé was awarded the Legion of Honor by the emperor.[83] And he received the highest accolades for his work at the Bois de Boulogne from his professional peers and from the press.[84] His empirical approach may have seemed anachronistic to Haussmann, who in any case preferred his own trusted engineers. When Alphand and Barillet-Deschamps arrived on the scene, the tangle of undergrowth had been cleared, the old walls razed, and the outline of many paths and lakes already established.[85]

Transforming the flat, uneventful surface of the Bois de Boulogne into a variegated landscape of hills, vales, lakes, and streams required immense earthworks, and an army of twelve thousand navvies (fig. 6.5). Streams and lakes called for a considerable volume of water, both above and below grade. Lawns had to be watered, paths and roads hosed down. As no single source could provide for all the park's needs, Alphand and Belgrand devised two independent systems. Water for lakes, streams, and cascades was piped mainly from the Ourcq. Even so, there was never enough, initially, and the Grande Cascade de Longchamp was timed to coincide with the afternoon promenade, when elegant visitors stopped by on the *tour des lacs* (fig. 6.6). A waterfall that gushed according to schedule would have horrified a Capability Brown, but the Second Empire was true to its age, preferring a docile urban nature tamed by modern technology and staged by engineers proud of what Sand termed their "hydraulic trinkets."[86] To supply the elevated parts of the park, the old pump at Chaillot lifted water from the Seine at considerable expense. When these

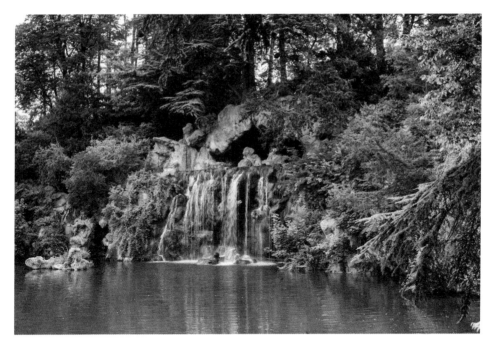

FIG. 6.6. Gilles Targat, the Grande Cascade in the Bois de Boulogne, 2015.

two sources, the Seine and the Ourcq, proved insufficient to feed lakes situated seventy-seven meters above sea level, Alphand drilled a new artesian well: the Puits de Passy, begun in 1854 and finished in 1866. Richly endowed by the emperor and his prefect, and honey-combed by underground conduits, the park had far more water at its disposal than most of Paris, still served by water vendors and unwieldy horse-drawn barrels.[87] The Bois de Boulogne consumed more than 15 percent of the city's total volume of water.[88]

To minimize construction costs, lakes and reservoirs were built in old quarries and dry riverbeds despite considerable risks. In 1854, a few months after the park was inaugurated, the lakes began to subside. Cracks appeared, and their beds had to be covered with a thick coat of concrete.[89] Alphand claimed their edges were surmounted by topsoil so grass could render the concrete invisible, but perceptive viewers objected to the exposure of concrete throughout the park.[90] Alphand's use of synthetic rocks throughout the Bois de Boulogne also scandalized purists, although such set pieces had been a mainstay of French garden design since the Bains d'Apollon at Versailles or, within the very limits of the Bois, at Bagatelle, where they look equally unnatural. At the Bois, they were made up of huge blocks of sandstone sent down from Fontainebleau by boat, welded together with cement to hide the sutures (fig. 6.7). As sandstone was an anomaly in the area, Alphand himself considered them a geological contradiction and resorted to them only when there was no alternative.[91]

Haussmann enlarged the park considerably. Looking at the city as a whole from the vantage point of his giant map, he persuaded the emperor to extend the Bois all the way to the river by acquiring the plains of Longchamp and Bagatelle: "I need the Seine to provide closure rather than a horrible wall blocking both the view and circulation."[92] To finance the acquisition of this large stretch of land, Haussmann sold off other chunks of

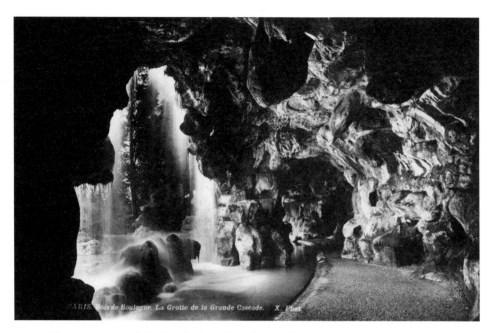

FIG. 6.7. The lower grotto of the Grande Cascade at the Bois de Boulogne, ca. 1890–1900. Roger-Viollet.

the forest to speculators. On the advice of the Duke of Morny, the emperor's half brother and president of the influential Jockey Club, Haussmann built the racecourse of Longchamp, so often painted by Degas. On excellent terms with Haussmann, Morny got a fifty-year lease on very generous terms. Haussmann charged the Jockey Club twelve thousand francs a year for their use of the racecourse—a trifle, as he acknowledged in his memoirs.[93] Throughout his tenure, politics often trumped the interests of the municipality, which lost money when it was most needed.[94]

Foliage now provided closure for the grounds when needed. Ha-has along the perimeter dissimulated the park's true limits, allowing an uninterrupted view of the countryside while protecting rare plants and animals. Alphand and his collaborators treated natural elements according to Haussmann's urban precepts. Trees and ruins were instrumentalized as vistas at the end of an allée. Sylvan tableaux, manufactured for collective appreciation, were to be seen from particular points of view. Thanks to modern equipment, trees were moved about like furniture: an old cedar was hoisted fifteen meters above the new hill of Mortemart to serve as an eye-catcher.[95]

Not far from the racetrack stood the remains of the old abbey of Longchamp, founded by Isabelle de France, sister of Louis IX. The abbey, the most important building erected in the forest, became a place of worldly pilgrimage in the eighteenth century when the city's wealthiest citizens attended its celebrated religious fêtes. A thirteenth-century windmill and an old dovecote were all that survived, and Haussmann had them reconstructed of whole cloth. Replaced by a pastiche, the old mill now serves to lift water from the reservoir of the Grande Cascade. Naturalists like Zola were quick to brandish the subject of authenticity: "What will real windmills think, those that whirl on hills and toil like honest laborers?" he asked acidly.[96] The dovecote had an even more dubious destiny, reinvented as a defense tower incongruously fitted with crenellations.

Circulation was as central to the park as it was to Paris itself. Carriage drives, bridle paths, and allées were planned to channel crowds effectively. Older roads and footways were upgraded or destroyed. In Alphand's well-managed parks, modern technologies and green prospects coexisted in a state of tension. Newfangled watering devices—hoses that snaked through lawns supported on casters to protect grass, mechanisms to sift gravel for roads—were ostentatiously displayed and published, a foil to the fiction of elegiac prospects. Rarely mentioned by critics, they appear in paintings by Manet and Renoir, showing that the public was aware of their novelty.[97]

VEGETATION

Barillet-Deschamps was responsible for the choice of trees and shrubs, for the design of allées, and for shaping flat ground into rounded hills and hollows. His compositions were structured in terms of opposing areas of light and shade, mound and vale, colors and textures.[98] Vast surfaces had to be grassed, trees grouped into graceful units (*massifs*), wide horizons, contrasted to the restricted views of dells and groves. Gently rolling greenswards were fashioned with spoils removed from digging lakes. The cupped lawns (*vallonnements*) were partly borrowed from Paxton, who was at that very moment designing the nearby gardenesque park and château de Ferrières for James de Rothschild.

By offering sequential vistas and changing points of view that varied depth of field, Barillet-Deschamps emulated the relaxed, meandering alleys of the Picturesque so different from French formal gardens, where the entire composition could be grasped at first glance. His modus operandi became legendary: "A large-scale plan of the grounds was prepared for him, made up of several sheets of paper glued to one another. He placed it on the floor, removed his shoes, and *walked* down the allées. Then, when he had conceived his plan, he took a large carpenter's pencil, and crouching, drew with broad strokes. A chair represented a house or the palace. A paving stone marked the spot where he wanted relief."[99] Not all were pleased with the results. Robinson, admittedly an advocate of native plants, must have envied Barillet-Deschamps's ability to coax tropical and subtropical plants and trees into bloom but wrote scornfully (without citing names) that "it is quite ridiculous to see the way the walks wind about in symmetrical twirlings, and, when they have entwined themselves through every sweep of turf in the place, seem to long for more spaces to writhe about in."[100] Even an admirer like Haussmann criticized "ce pauvre Barillet-Deschamps" for his excessive number of allées.[101]

Such criticisms, only partly true, reflect class differences. Paths that constantly crisscross one another could already be found in the work of Gabriel Thouin (1747–1829), a former director of the Jardin des Plantes.[102] If Barillet-Deschamps was treated with condescension by some of his peers and superiors, he was greatly admired in the capital's horticultural circles. Horticulture was his true province, and here his mastery was unrivaled. He knew how to offset exotic trees and shrubs on a slight elevation and contrast smaller plants like cannas against broad-leaved paulownias and catalpas.[103] Sensational foliage began to dominate compositions; the visual gained primacy over the olfactory.[104] His demotic approach led him to enrich the palette of available plants with innumerable cultivars from other countries: "Our goal," he wrote, "is to spread and popularize the taste for the cultivation of flowers by making it accessible to all."[105]

Contemporaries lacked a single word with which to describe the Second Empire's green spaces, the fruit of specialists from diverse backgrounds. Robinson described them variously as Picturesque and gardenesque; others, as *jardins anglais*.[106] In time, the term *jardin paysager* came to define this heterodox style of gardening, Barillet-Deschamps being acknowledged as one of its creators.[107] Yet none of these terms do justice to the modern nature of these spaces and their ostensible traces of civil engineering that challenged traditional modes of representation. With the defeat of Napoleon I, the influence of neoclassicism waned. The French borrowed winding paths and streams from the English landscape garden, caves, and waterfalls from the Picturesque. The more predictable irregularities came from Loudon's gardenesque, which showed "distinctness in the separate parts when closely examined, but, when viewed as a whole, governed by the same general principles of composition as the Picturesque style, the parts, though not blended, being yet connected."[108] For Loudon, gardens should advertise the fact they are artifice: "As every garden is a work of art, Art should be everywhere avowed in it. The idea that nature is the great object of imitation in what are called English gardens has led to much error, from the expression not being correctly understood. Nature is to be imitated; but, as we have repeatedly stated, neither in gardening, nor in painting, nor in any other art considered as a fine art, is it to be imitated in such a manner as that the result shall be mistaken for nature itself."[109] This frank exposure of the means appealed to Alphand, who never allowed the gardener in him to suppress the engineer.

The introduction of equatorial vegetation with brightly colored leaves transformed the French landscape garden. Expensive and labor intensive, these luxury items could now be easily propagated thanks to scientific and technological advances. Barillet-Deschamps favored eye-catching plants, like cannas, yuccas, palms, or agaves, that flaunted their distant origins in France's far-flung domains overseas (fig. 6.8). Artfully grouped, exotic species such as banana trees or sugarcane, he declared, "will change the aspect of the garden entirely, evoking, in a way, that of the colonies."[110] Tropical plants blooming in the harsher climate of Paris represented the "civilizing mission" of the white man and his horticultural prowess.[111] But the know-how required was clearly premised on lessons learned from colonized peoples. Such green imperialism was sometimes shot through with barely veiled racialized language. In a passage on grafting, a contemporary author says that shrubs planted close together could merge naturally if from the same species. "But should one conjoin two trees foreign to one another, an ash and an elm, for example: how much stranger the mixture then becomes!"[112] The colonialist-tinged ecology of the new parks also differed sharply from the traditional view of French forests as the repository of nationhood. Historians like Jules Michelet had written at length on their importance—fiercely local, life-giving, and uncultivated.[113]

Throughout the park, flowers were given great prominence, partly as an attempt to appeal to women. Brilliant parterres with colorful paisley-shaped designs evoked cashmere shawls.[114] But the difficulty of distinguishing wealthy ladies from lavishly kept demimondaines elicited a certain amount of anxiety. Both came to the promenade attired in the latest models of the couturiers of Rue de la Paix. "You may recognise 'nos élégantes,' the women of the best society in France and Paris by the quiet taste of their clothes, and the absence of rouge on their cheeks and 'Kohl' on their eyes," wrote Alice Ivimy.[115] This was an old cliché. Édouard Gourdon contrasted the flowers worn by upper-class ladies who frequented the

FIG. 6.8. *Colocasia bataviensis*, illustrated by Alphand in *Les promenades de Paris*. Chromolithograph. Marquand Library of Art and Archaeology, Princeton University.

Bois, followed by a valet in livery, to those worn by loose women who went only to flaunt their provocative face and clothes. The latter, he wrote, need "overheated products of our most famous greenhouses. In December, white lilacs, lilacs of Persia, violets, camellias and carnations; in January, violets of Parma and heliotropes; in February, the king's rose and the moss-rose."[116]

The park's horticultural variety was staggering. During the ancien régime, André Michaux, a naturalist sent to the United States by Louis XVI, planted a large number of specimens from America in the Bois de Boulogne, to prove that trees could be acclimatized in France and enrich its flora.[117] Over 330 samples from this American garden were still extant.[118] Such diversity resulted in a rather artificial and institutional display of specimens, "a sort of museum," as Alphand acknowledged lamely.[119] The Bois de Boulogne was "like those zoological gardens where one sees an assemblage of different flora and contrasting landscapes," wrote Proust; it brought together "diverse, hermetic little worlds—where a farm planted with red trees, American oaks, somewhat like an agricultural exploitation in Virginia, is followed by a pine plantation on the shores of the lake."[120]

The new Bois de Boulogne was not an updated version of the old royal forest but a new kind of park that addressed itself to a wider public. The fact that "nature" was placed under the aegis of leisure accounted for the high number of concessions given to restaurateurs and purveyors of entertainment. The Pré Catelan, an ingenious pleasure garden built in a quarry, had an open-air amphitheater surrounded by flowers, a restaurant, a puppet theater, a photography studio, and a dairy, where women in Swiss clothing sold fresh milk. Leased to private concessionaires, it staged concerts and performances. Exposed

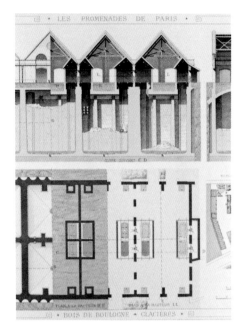

FIG. 6.9. Alphand and Jean Darcel, the icehouses of the Bois de Boulogne, destroyed in 1899. Marquand Library of Art and Archaeology, Princeton University.

to the elements, it closed after a few years. Since the park was destined for city people, the goal was to wed the rusticity of the Picturesque with more ludic, urban attractions. In winter, the exclusive Cercle des Patineurs (skating club) was patronized by the imperial family, the aristocracy, and the Slav colony of Paris, who made use of it even at night when it was brilliantly illuminated. The lovely grounds of the little Château de Bagatelle, laid out by the Scottish gardener Thomas Blaikie in the eighteenth century, were restored. Gabriel Davioud was responsible for the park's restaurants and guardhouses, seconded by architect Alphonse Hugé, and for urban furniture—the beautiful benches, gates, and railings in cast or wrought iron. At the tip of the lower lake, he erected an Orientalist kiosk for the emperor's personal use, a marvel of wooden joinery.

With its restaurants, skating rink, and racing track, the great urban park was calculated to bring in revenue to offset the exorbitant maintenance costs. Construction materials and food for workers and animals were subject to the octroi.[121] Hay was sold for forage, and wood pruned from trees for fuel. Fish and fowl fetched good prices at Les Halles.[122] At the end of winter, workers harvested ice, maneuvering long poles to break it up and push the floes to the shore. Taking advantage of the peculiar geological soil of the forest, Alphand's experts designed ingenious cooling sheds with double walls covered with thatch to control temperature (fig. 6.9).[123] With a capacity of six hundred thousand kilograms, these warehouses allowed the city to break the monopoly of two companies that supplied Paris with ice, and lower the price, while receiving taxes from supplies entering the city.[124]

The Bois de Boulogne included the Jardin d'Acclimatation (formerly Jardin Zoologique d'Acclimatation), a park within the park, founded and maintained with private capital heavily backed by the government (fig. 6.10). An institution contingent on applied science, the Acclimatation was one of the centers of neo-Lamarckian doctrines.[125] Directed by the zoologist Isidore Geoffroy Saint-Hilaire, son of Cuvier's great adversary, the Acclimatation had a strong utopian streak: "a conquest of civilization over nature," wrote Louis Énault in 1856.[126] Saint-Hilaire hewed to an adaptive model of nature, which could be perfected under the guidance of man. Just as horses, cattle, and sheep had become acclimated to France over the centuries, so too would useful animals such as kangaroos, ostriches, llamas, and yaks.[127] Housing a menagerie, a botanical garden, aviaries, a greenhouse, an aquarium, fish-breeding tanks, and an arboretum, the garden also boasted a magnificent collection of vines, with two thousand specimens largely transferred from the Luxembourg gardens.[128]

Napoleon III played an important role in Paris's acclimatization society.[129] His cousin Prince Jérôme Bonaparte, governor of Algeria, was honorary president. Members rubbed shoulders with titled aristocrats and financiers like James de Rothschild, ministers of the government, and officials from the colonies. Haussmann (no doubt spurred by the

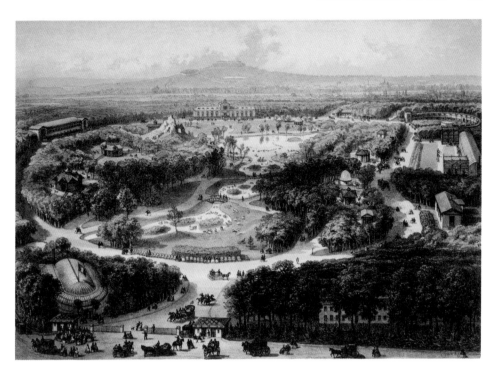

FIG. 6.10. Théodore Muller, general view of the Jardin d'Acclimatation at the Bois de Boulogne. Musée Carnavalet, Paris.

inevitable Morny) granted them a forty-year lease at extremely favorable terms (one thousand francs a year) and contributed almost one million francs to the buildings. Acclimatization societies, highly popular at the time, were characteristic institutions of colonial France. They studied animal husbandry and techniques for propagating crops from other climates with a view to exploiting their empire and importing fauna and flora that could be made to flourish in the metropole. "The whole of colonization is a vast deed of acclimatization," wrote Auguste Hard, director of the jardin d'essai in Algiers.[130] This enclave became one of the places in which metropolitan France put on display its ideological relation to the colonial empire. Like World's Fairs, which it resembled in miniature, the Jardin d'Acclimatation exhibited "human races" such as Patagonians, Sudanese, and Sinhalese. Though this happened largely under the Third Republic, there were plenty of colonialist pastimes under Napoleon III.[131]

ACCESS AND EXCLUSION

Haussmann made sure that the Bois de Boulogne was well connected to the center with approach roads that showed the appropriate decorum concerning the elites. The main road of access, the Avenue de l'Impératrice (now Foch), led directly to the Tuileries by means of the Champs-Élysées. Inaugurated in 1865, it was the city's grandest thoroughfare, almost one mile long and over 450 feet wide. Such generous dimensions left ample room for a clear separation between vehicular and pedestrian traffic. A broad median strip for carriages was flanked by two broad green strips. There were bridle paths for riders and

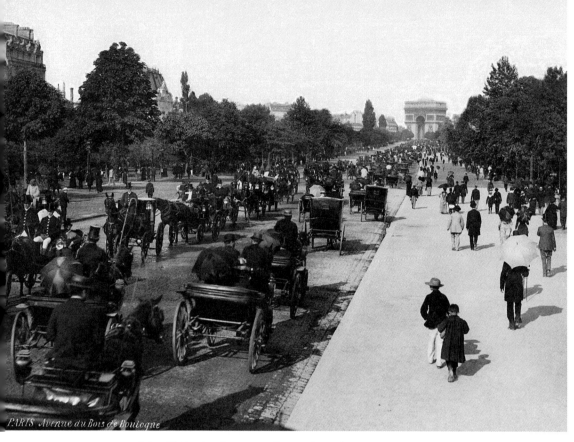

FIG. 6.11. Léopold Mercier, the Avenue du Bois de Boulogne, Paris, ca. 1900. Roger-Viollet.

alleys for pedestrians, and a superb arboretum, planted with twenty-four hundred rare species that served as a nursery for grafts and stock regeneration.[132]

The popularity of the Bois de Boulogne forced the municipality to increase public transportation to the site. Two omnibus lines led to the gates. For a slightly larger fee there were private vehicles, which had the advantage of screening out the "irritating proximity" of undesirables in an omnibus.[133] To link the park to the city, engineer Eugène Flachat oversaw the construction of a new railroad line owned by the Compagnie de l'Ouest (proprietors of the omnibus lines). In a thrice, wrote Gautier, steam could transport "those without four wheels or four feet at their service."[134] Modest strollers poured into the park on Sundays, when workers had their day off. Tariffs were higher on that day, shamefully, another factor that limited the presence of the working class.[135]

The upper echelons of society did everything to avoid overlapping with the laboring poor. Nature was one of the terrains over which class skirmishes were fought. The beau monde came during the week: conspicuous leisure during work hours was a class marker the rich flaunted with gusto. Jockeys and sportsmen arrived early in the morning to exercise their horses, as an army of workmen went about their labor, mowing huge expanses of lawn by hand, pruning trees, watering plants, hosing down paths. From Monday to Friday, between two and four o'clock in winter and five and seven in summer, a long line of sumptuous carriages slowly made their way to the park. Titled aristocrats arrived promptly in serried ranks, accompanied by liveried footmen (fig. 6.11).[136] In good weather, the empress Eugénie came with her entourage. The haute bourgeoisie also appeared, and

elegant demimondaines. They went by fleetingly, gazing down at the park from beautifully groomed horses or elegant equipages, determined to avoid the teeming omnibuses and colorful crowds "that once a week *spoil* our boulevards, the Tuileries, the Champs-Élysées, and also spoils the Bois de Boulogne," complained Gourdon.[137] "That is why something within us revolts when we come across the Sunday multitudes," he continues, "honest, but lacking style; decent, but poorly dressed; respectable, but smoking pipes; endowed with all the family virtues, but sporting impossible hats and hobnailed shoes."[138] Gourdon's prejudices underscore the upper classes' symbolic ownership of the Bois, ratified by the municipality, who underwrote the extravagant costs. For the poor, long working hours and the price of transportation limited access to the park to those who lived nearby or could afford the omnibus. Even so, the huge crowds that so offended upper-class sensibilities reached on average twenty to twenty-five thousand people on Sundays and holidays.[139]

The real estate market received a major boost from the Bois de Boulogne. Green spaces were part of capitalist patterns of urbanization, the ideal complement to land values, and an index of status and wealth. Greenery increased plus value and maximized revenue, a boon to speculators. In the fashionable western half of Paris, properties bordering new parks and gardens saw a steep increase in value. According to Alphand, the price of lots surrounding the park, bought off from peasants and middle-class owners before it was restored, rose from 1.5 to 6 francs per meter to 20 to 100 francs.[140] The cold, hard jingle of cash could be heard behind the elegant new promenades produced by the Second Empire, leading to similar initiatives in the private sector.

Neither segregated outright, nor easily accessible, parks advertised their relation to social class through rare cultivars, expensive waterworks, and high-quality design, as well as means of access and codes of use. As in all the city's green spaces, surveillance played a crucial role: fifty guards in uniform patrolled the grounds.[141] Alphand also had large barracks built, ostensibly for housing guards, but their location suggests strategy.[142] In this respect, Alphand's gardens offered a striking contrast to their British counterparts. "No porter appears, and the gates are freely open to the public," Olmsted noted with satisfaction when he arrived at Birkenhead.[143] Alphand defended the municipality's strict vigilance, claiming that its sole purpose was to prevent damage by children and "unscrupulous people," but the opposition chafed under what they saw as a costly, class-driven practice.[144] Protecting property and propriety had to do with the imperial obsession to police the population and ensure that new urban spaces were not used for seditious purposes. To ascertain that rules of good conduct were observed, regulations were affixed to cast-iron panels. There were prohibitions even against smoking, Nadar pointed out angrily.[145] As a result, a large portion of Alphand's parks and squares was conceived largely for the eye alone, following French classical tradition.[146]

BOIS DE VINCENNES (1860–63)

Neither the government nor Haussmann ignored the potential for class confrontation represented by the Bois de Boulogne, so richly furbished for the wealthy and so laboriously serviced by the poor. In 1860, the emperor decided to transform another royal property into a public park: the Bois de Vincennes, conveniently located at the opposite end of Paris, and also outside the walls. The donation was couched in the usual lofty terms: "The idea,"

wrote Haussmann sententiously, "was to create to the East of Paris, and for the hard-working population of the new eleventh and twelfth arrondissements and the ouvriers of the Faubourg Saint-Antoine in particular, a promenade equivalent to that with which the rich elegant neighborhoods of the West of our Capital had just been endowed, according to the generous aims of the Emperor."[147] The opposition interpreted this seemingly mag-nanimous gesture as a ploy that under the guise of benevolence removed the unwanted part of the population from the favorite playground of the rich.[148] At the Bois de Vin-cennes, the poor could slake themselves on greenery without adding to the government's fears of social insurrection. Although Napoleon III gifted the land to the city, he never showed the same enthusiasm for this project as he did for the Bois de Boulogne. The exe-cution of the new park was left largely to the municipality.

Illustrated in a hunting scene of the fifteenth-century manuscript *Très riches heures du duc de Berry*, Vincennes had a noble pedigree stretching back several centuries. It had originally been part of the same Ur-forest as the Bois de Boulogne, before Lutèce, and later Paris, established themselves between the two. Rousseau botanized in its grounds, and Watteau depicted it several times. Vincennes was in some respects better suited for a park, boasting a leafy canopy of magnificent oaks and horse chestnuts that its counterpart so signally lacked.[149] Yet it too had long since joined the ranks of urban forests.

Whether or not Vincennes was meant as a convenient escape valve that syphoned the poor off from the cosseted western end of Paris, class issues plagued it from the start, and it would never acquire the gilded social patina of the Bois de Boulogne. Admittedly, Vincennes cost a great deal more, as Alphand and Haussmann were fond of pointing out in their eagerness to prove the regime's concern for the disenfranchised. Since the land bordering the forest was owned by industries, the city paid high prices for it, hoping to recoup costs by reselling surrounding lots once the park was finished. But the east end of the capital was not as attractive as its western half, and they remained unsold for years. Since Napoleonic times, a huge area had been set aside for military maneuvers. As the artillery polygon included drill grounds and a shooting range in the very center of the park, Vincennes was constantly under the baleful eye of the army. Alphand bristled with indignation at the military easements that disrupted the flow of the promenade and put the public at risk.[150] To screen the huge void, he installed an imperial *ferme ornée* provided with hundreds of sheep and cows and experimental plantations of rye, oats, and alfalfa.[151] But nothing could change the fact that the military enclave divided Vincennes into two parts poorly connected to one another.

The contrast to the Bois de Boulogne was glaring. As a contemporary remarked, while one of the parks is reached "by a grandiose avenue sown with palaces and monuments that begins at the very threshold of a royal residence [Tuileries], the other is approached through the windings of a faubourg whose houses have to do with labor. Here be no sumptuous villas, no carriages embossed with coats of arms, no leisurely strollers; only factories, hangars, tall brick chimneystacks spewing clouds of smoke, stalls, heavily laden carts, tumbrels weighted with manufactured products, and workers in overalls."[152]

As the Marne ran close to the forest, the emperor asked the city to extend the park all the way to the river by acquiring the necessary land, as Haussmann had done so success-fully at the Bois de Boulogne. But the municipality balked at the expense: its finances were tied up in urban projects it considered more urgent.[153] In the end, the Bois de Vincennes

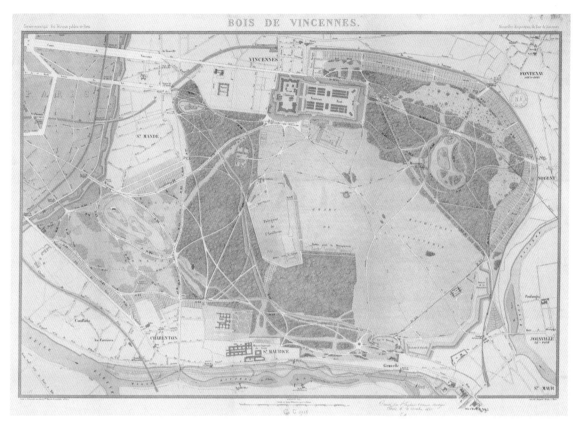

FIG. 6.12. The Bois de Vincennes after it was reconfigured, 1862, with the army's huge enclave in the center. Alphand, *Les promenades de Paris*. Bibliothèque nationale de France, Paris.

was completed with an eye to economy. Darcel, who redesigned it, was forced to retain the general outlines of the old park without access to the river (fig. 6.12). He also had to accept the presence of preexisting properties and industrial buildings. Where possible, Darcel added meandering paths, rockery, and waterways in the tradition of the Picturesque, which was more forgiving with regard to ready-mades. The engineers dug lakes with their respective islets, reserving the spoils to create relief. To feed lakes and streams, water had to be lifted from the river, an expensive task simplified by the new pumping station at Saint-Maur.

Great attention was paid to the studied irregularity of landscaped lakes and ornamental brooks, carefully contoured for maximum effect. Streams tied different parts of the composition together, winding through the park like silver ribbons. Drawing from the English landscape garden and eighteenth-century practice, Darcel was attentive to both the visual and the aural properties of water. Sound, as much as form, was half the pleasure. White water was contrasted to still water, the roar of cascades to the quietude of ponds and marshes. "Water is to landscape what the soul is to the body," Jean-Marie Morel had once remarked, adding that it gives life and freshness to the scene.[154] For Gautier, echoing Morel, water was "the soul of landscape, imparting movement to a motionless place and giving it a voice. Should the bird fall silent or the leaf refuse to rustle, if the insect slumbers

FIG. 6.13. Hervé Hughes, tempietto and grotto on the lac Daumesnil, Bois de Vincennes, 2016.

on the grass, and nature—as sometimes happens—lets the conversation fall and an embarrassing silence reign, water has always something to whisper to the reeds; it murmurs to the pebbles, chatters as it plashes down the stairways of cascades, and solitude ceases to be mute around you; water lightens the opaque heaviness of earth by framing fragments of sky, now gray, now blue; it bids the sun and the moon descend amid the rushes."[155]

Furrowed by rolling *vallonnements*, Vincennes had its share of beauties. From the heights one could enjoy the vast panorama of the Marne flowing in the distance; close by were lakes, meadows spangled with flowers, and compact clumps of trees. For Gautier, the grotto and tempietto on one of the lakes were reminiscent of Hubert Robert (fig. 6.13).[156] A chalet, built for the World's Fair of 1867, was reerected on one of the islands. Suspension bridges, updated versions of an old Picturesque theme, linked the islands to the surroundings. Two railway lines passed through the park, "enlivening the landscape with the undulating plumes of smoke from their locomotives," Alphand observed approvingly.[157] He admired the decorative role of steam, as would Monet almost two decades later, when he painted his great Gare Saint-Lazare series. In the distance, Alphand rhapsodized, one could see "the magnificent viaduct of the Mulhouse railway line that silhouettes its tall arches against the azure of the sky."[158] Far from being the antithesis of the city, Alphand's new nature deployed similar materials and methods of production, a new version of the old dream of *rus in urbe*.

Despite its model farm, its arboretum, a horticulture school run by the municipality, and a hippodrome, Vincennes could hardly compare with the expensive amenities showered on its elegant counterpart. César Daly, a staunch supporter of the regime (and of Haussmann), published a cost comparison of the two parks in 1863. Though slightly larger than the Bois de Boulogne, Vincennes fell short of it by twenty-five kilometers of waterways,

sixty-four hectares of lawns, and two thousand cubic meters of water per day. While the Bois de Boulogne had 239 people to tend it, Vincennes had only 94. The city spent 628,000 francs a year on maintenance at Boulogne, and only 235,500 francs at Vincennes.[159]

In terms of transportation and urban design, Vincennes was cautiously joined to the city. Most visitors arrived by rail or omnibus and visited the grounds on foot.[160] The main thoroughfare created to link the park to the center, Avenue Daumesnil, bore no resemblance to the magnificent Avenue de l'Impératrice. Unsurprisingly, the Vincennes railway line led to the strategic Place de la Bastille, heavily guarded by a garrison. Located in the working-class part of Paris, the park languished during the week and picked up only on weekends, unlike the Bois de Boulogne, which filled during weekdays.[161] As Haussmann ruefully acknowledged, "In spite of all my efforts to make these two splendid parks extra-muros, the Bois de Boulogne and the Bois de Vincennes, easily accessible to all classes of the population of Paris which appreciate them so highly, I could not manage to make them benefit from them except on Sundays and Holidays, because of the distance, the time necessary to get there and return, and transportation costs."[162]

In horse-racing season, the upper classes frequented Vincennes to see steeplechases in the English tradition. Members of the elite described Vincennes according to the usual class-bound views. The two fine parks at the opposite poles of Paris are in keeping with those who frequent them, wrote the Count of Lasteyrie: "One, well combed, well groomed, always freshly shaved and smelling of art as much as of nature, offers a setting that is marvelously attuned to these equally well coiffed and no less artificial people that promenade their leisure there, every day at the same time." The other, he continues, "more rustic and expansive, where lawn becomes grass and is mown twice a year rather than shaved every eight days, is perfectly suited to the rugged and hardworking population that in its rare moments of free time, comes to breathe deeply with open lungs."[163] The sad picture painted by the Goncourt brothers in their novel *Germinie Lacerteux* makes one wonder if they ever set foot in Vincennes: "Everything was stamped with the misery and scrawniness of a downtrodden vegetation that could scarcely breathe, the sadness of greenery at the edge of the city: Nature seemed to sprout from the pavement."[164]

PARC MONCEAU (1860–61)

Parc Monceau, the most exclusive promenade within city limits, had a checkered history. The old princely pleasure garden, designed by Louis Carrogis de Carmontelle for Philippe d'Orléans, father of Louis-Philippe, changed hands many times.[165] With each new owner, Monceau deteriorated further. During the French Revolution, the Convention seized it and opened it to the public. Louis XVIII restored the park to Louis-Philippe. Expropriated again in 1848, it was used as headquarters for the ateliers nationaux. A year after the 1851 coup, Louis Napoleon confiscated it unceremoniously, ignoring the rightful claims of the Orléans. This placed Haussmann in an awkward position. Not only had he once sworn fealty to the July Monarchy, but he had also studied with one of Louis-Philippe's sons at the prestigious Lycée Henri IV.[166]

Twenty years earlier, when the artist Rosa Bonheur frequented the area to paint from nature, the grounds offered a sorrowful sight: "Left to itself, Monceau was no more than a grandiose ruin overrun with weeds; creepers, wild flowers, and tousled trees blended into

a virgin forest; the little lake was a marsh and most of the columns of the Naumachia lay scattered on the grass."[167] When the old village of Monceau found itself within city limits after annexation, its meadows and vacant lots offered tantalizing prospects for developers, foremost the Péreire brothers, whose bank financed the Second Empire's grands travaux. Haussmann was not one to miss an opportunity to raise funds without raising taxes. In 1860, the city of Paris bought half the property expropriated by the emperor and sold the other half to the Péreires for eight million francs—a huge sum at the time—which Haussmann paid to the Orléans in an attempt to redress the situation. Part of the city's share was sold off as lots to finance the restoration of the park. Another portion was shaved for access roads. Only one-third of the original surface was left for the public.[168] Haussmann thus transformed the aristocratic park into a public promenade, but at a price. When it opened in 1861, the opposition was livid. Half of the park was lost to a speculator; the city itself speculated on the remaining half to pay for costs: "Instead of a magnificent park, a precious lung for Paris, we have nothing but a square," wrote Louis Lazare angrily.[169]

Monceau, lavished so magnanimously on the wealthiest part of Paris, which already had access to the nearby Bois de Boulogne and the Jardin du Ranelagh redesigned by Alphand, was to be the hub of a fashionable new neighborhood built by the Péreires. Davioud's exquisite entrance grilles signal the enclave's exclusivity (fig. 6.14). To open the Boulevard Malesherbes, which provided the new area with a dignified means of access to the center, the beautiful residences of Talleyrand, Lafayette, and Destutt de Tracy vanished under Haussmann's wrecking ball. So did Boullée's superb Hôtel de Monville. Concealing the park's boundaries was a selling tool: the grounds seemed to be the seamless extension of the palatial mansions surrounding it. In this, Monceau compared poorly to Birkenhead, where Paxton determined that the houses adjacent to his park should not appear to own it.[170] In a rich palimpsest like Paris, however, urban spaces have to be read through different prisms. Over the years, this opulent new quartier became home to many Jewish bankers from Russia and the Levant, patrons of art and music such as the Camondos; and the Cernuschis, who bequeathed their fabled art collections to the city of Paris; the Ephrussis, the Rothschilds, the Cahen d'Anvers, the Reinachs, the Furtado-Heines, and the Péreires. Under the Third Republic many of their descendants would be sent to their deaths in German concentration camps.

Under Alphand's supervision, the terrain was covered with lush turf sprinkled with magnificent, rare species. Water was piped in and the Naumachia repaired (fig. 6.15). A grotto with artificial stalactites was built, along with the inescapable cascade.[171] An eighteenth-century theme park to begin with, Monceau retained many of its former follies; but with two-thirds of its surface gone, its scale was not large enough for new additions: the minuscule bridge over an insignificant stream, the tiny truncated triumphal arch, and piles of rocks rising incongruously from lawns. The overall space shrunk to the detriment of the follies, which now seem to crowd the grounds. Monceau is still beautiful, but parts of it smack of the empire's parvenu taste. Huysmans, who lampooned the era's penchant for the ornate, called the diminished park, "le square maquillé."[172]

FIG. 6.14. Entrance gate to the Parc Monceau, 1905. It was designed by Gabriel Davioud, in 1861. Roger-Viollet.

FIG. 6.15. The Naumachia at Parc Monceau, ca. 1880–90. Roger-Viollet.

BUTTES CHAUMONT (1863–67)

And then night falls, and the parks rebel.
—Louis Aragon, *Le Paysan de Paris*

Unlike the Bois de Boulogne, Vincennes, and Monceau, Haussmann's two intramural parks, Buttes Chaumont and Montsouris, were built ex nihilo. At Buttes Chaumont, Alphand's experts succeeding in creating one of the most exciting urban gardens in Europe. And yet, no site in Paris had worse associations. On its highest point had stood the gibbet of Montfaucon, erected by Philippe le Bel in 1312, and suppressed in 1760. Night soil ended up in this bare, dismal hill.[173] Offal and carrion from an equine slaughterhouse sent their pestilential stench downwind, toward Paris. Although horse rendering closed down in 1845 and the festering depot of human excrement in 1849, the awful connotations lingered. Less malodorous, but highly suspect as far as the government was concerned, were the numerous quarries that dotted the area, dominated by the bleak wastes of L'Amérique.

Haussmann longed to bring what he saw as a redoubt of lawlessness under his control. When this wasteland was annexed in 1860, argued Alphand, the government refused to leave "such a deserted, dangerous, and unhealthy place within the limits of the new Paris."[174] Economics provided another major incentive. The Buttes lay in an unfashionable no-man's-land at the edge of the city, between Belleville and La Villette. Because of subjacent quarries, the land was not suitable for construction and represented a huge loss in

FIG. 6.16. Charles Marville, the Buttes Chaumont in 1865. To the right, the train tracks used to cart materials to the site. Bibliothèque historique de la Ville de Paris.

real estate.[175] A public park would valorize surrounding properties and bring revenue to the municipality, though in this distant and desolate part of Paris, Haussmann could hardly hope to amortize costs and maximize returns right away.

Centuries of mining had left behind a barren, pockmarked terrain. Converting limestone and gypsum quarries into a verdant park required the full panoply of modern technologies, massive earthworks, and site engineering. Technological bravura was one of the attractions of Buttes Chaumont, an ideal microcosm to test innovations in science, technology, and horticulture. Work began in 1863 and proceeded at a furious pace so the Buttes Chaumont could be inaugurated during the World's Fair of 1867. Almost one thousand navvies used explosives to blast the lake out of the ground and force caves out of hills. Spoils from the excavations were removed by rail (fig. 6.16). Huge quantities of topsoil were carted to the area at great expense. Hydraulic pumps lifted water from the Ourcq canal to feed streams and cascades. In its ruthless colonization of nature, the park seemed like a throwback to the old absolutist days of the Sun King and his great gardener André Le Nôtre.

Entrusted with designing the park, Darcel exploited the abrupt changes of level left by quarries, building on the main features of the site (fig. 6.17). The uneven terrain was pared away to achieve sculptural peaks and ravines. Artificial rock was piled above natural formations to dramatize effect. Uneven surfaces were graded and seeded. The resulting relief is a tour de force: a tightly packed mountainous landscape enclosing the crags and chasms of alpine scenery at a small scale, with dramatic contrasts between lawn and woodland, closed and open spaces, vale and mountainside. In the center of the grounds, a huge promontory

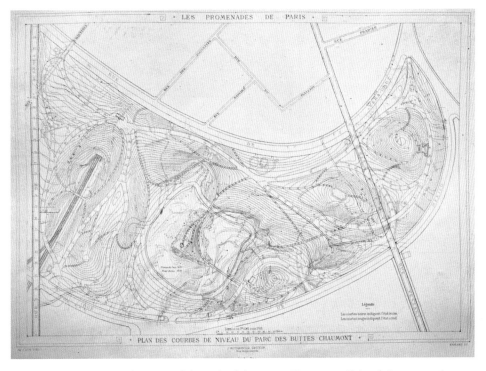

FIG. 6.17. Plan des courbes de niveau of the Park of the Buttes Chaumont. Alphand, *Les promenades de Paris*.

FIG. 6.18. The promontory of the Buttes Chaumont, overlooking the lake, crowned by the tempietto.

FIG. 6.19. Gustave Courbet, *The Rock at Bayard*, Dinant, ca. 1856. Oil on canvas, 22 × 18.5 in. (56 × 47 cm). Fitzwilliam Museum, Cambridge, UK.

rises to a height of 131 feet, offering different views to pedestrians: here a sheer cliff crowned by a classical tempietto; there a steep path winding through greenery (fig. 6.18). At the foot of the escarpment the great liquid mirror of the lake reflects and amplifies the climactic topography. Here, engineers produced a breathtaking modern sublime, suggesting a hostile, uncultivated nature while exhibiting conspicuous traces of the human hand. Even Robinson, ever eager to criticize, declared that the park was "the boldest attempt at what is called the picturesque style that has been attempted either in Paris or London."[176]

The Buttes Chaumont conspicuously staged its labor-intensive, manufactured nature as spectacle that could take a variety of forms.[177] Parks reflected the popularity of landscape as the destination of tourist excursions.[178] The beetling rock that rises from the

FIG. 6.20. Grotto with concrete stalactites, detail of a stereoscopic view, ca. 1875. Roger-Viollet.

water like a needle seems to evoke a specific site, the Bayard rock on the banks of the river Meuse (Belgium), painted by Courbet in 1856 (fig. 6.19).[179] Both André and Ernouf underscored the importance of painting as a source of inspiration for landscapes. More than any other park in Paris, the Buttes Chaumont shows an attempt to elicit strong responses from visitors. Rocks, lakes, caves, and cascades were common enough, but not the abrupt way with which they were juxtaposed. Different scales were applied to each enclave of this relatively small park (twenty-four hectares). When needed, details could take on enormous proportions: the grotto's concrete stalactites, over twenty-six feet long, increase the spectator's sense of immediacy (fig. 6.20).

Municipal gardeners echoed eighteenth-century practice by offering changing views so pedestrians could see the panorama sequentially, in the tradition of Watelet and the

Picturesque.[180] To enhance the element of surprise, points of view were imaginatively contrived to draw in distant vistas or block them altogether. Landscapes, Alphand suggested, should have different planes like theater sets.[181] Lawns sloped sharply owing to the steep grade, a welcome relief from the clichéd undulations of many Second Empire gardens. Alphand loved Paxton's elegantly contoured sunken paths, which from the distance disappeared from view so that people seemed to be walking on grass.[182]

The park marked a turning point in garden design thanks to the revolutionary use of cement and concrete. Rocaille, an artificial form to begin with, improved markedly when experts turned to Portland cement, introduced in Britain during the 1820s. It had been used in gardening, not just in grottoes but also in balustrades, bridges, and rustic pavilions. *Rocailleurs*, who became professionalized in the mid-nineteenth century, pioneered the use of reinforced cement and concrete.[183] As new public destinations for crowds, parks required tough industrial materials resistant to the wear and tear of daily use. Dramatized by stalactites, the grotto represented the end of a long process of trial and error. After the withering criticisms of the artificial rocks of the Bois de Boulogne, transported from Fontainebleau, every care was taken to reproduce the "texture of coarse limestone and Parisian gypsum" characteristic of the area.[184] Eugène Combaz, who had worked in Alphand's office, was responsible for the grotto's spectacular stalactites, produced by spraying layers of liquid cement onto an iron armature, a method not unlike reinforced cement.[185] Hilaire Muzard, another rocailleur, was responsible for many of the park's most successful pieces produced by coating disparate rocks with *stuc ciment*.[186] The visibility of the means and materials had its critics. "In one case," Robinson noted archly, "the streamlet instead of coming from any probable source of higher rock or brushwood, starts out of a plastered hole in the grass."[187]

Darcel spoke of the park in associationist terms that recall Morel: "The spatial relation of water, lawns, plantations, and rocks also affects the sensations experienced by the visitor. The predominance of darker areas such as woods and rocks inspires melancholy, while lawns, the lighter parts of the landscape, provoke cheerfulness. The vast luminous and tranquil surfaces of the waters inspire contemplation and serenity."[188] Thanks to sensory cues devised by gardeners and engineers, the Buttes Chaumont addressed the entire human sensorium. Water, pumped to the top of a ravine, crashes through the echoing grotto with the capricious drama of a mountain torrent and pools in the lake below. Obstacles were expressly placed in its path for greater visual and aural effect.[189] Babbling rills ripple cheerfully through the grounds. Carefully chosen trees and shrubs attracted birdsong; color and scent, butterflies.

Second Empire parks were extroverted, open to a city that was never allowed to be forgotten. Alphand illustrated La Villette's smokestacks belching soot in *Les promenades de Paris*. They appear even more clearly in old photographs (fig. 6.21).[190] The shriek of locomotives cutting through the Buttes Chaumont also connected it to modern Paris. By mid-century, harmonizing parks with their surroundings was not unusual.[191] As Baron Alfred-Auguste Ernouf noted in a book rewritten with Alphand's collaboration, "One can also take advantage of the view of a station, an industrial building or any other construction, provided it is suitably framed within the landscape."[192] By contrast, Paxton always used walls of verdure to separate his parks from the encroaching city.[193] Olmsted also insisted that the view of the city should be occluded.[194] Influenced by the English landscape garden,

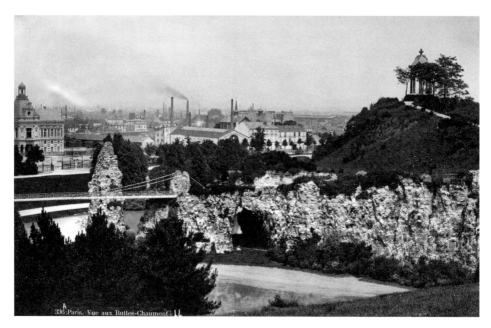

FIG. 6.21. The Buttes Chaumont with factories belching smoke in the background, 1875. Roger-Viollet.

he saw parks as a refuge from the storm and stress of urban life. He had met Alphand on a fact-finding mission after winning the competition to design Central Park and visited the Bois de Boulogne eight times in 1859.

The park's obtrusive infrastructure and manufactured wilderness reflected the Saint-Simonian view of nature as something to be conquered, patently revealing human intervention. The same interest in eliding nature and modernity into a single composition can be seen in the Buttes Chaumont's bridges.[195] Darcel heightened the drama with a stone Pont des Suicidés, flung across a chasm with a spectacular drop. Nearby, a striking suspension bridge connects the promontory to the "mainland," flaunting its cables far above the lake (see fig. 6.16).[196] Nearby, a metal viaduct passes over one of the park's main roads. Bridges had been a staple of garden repertoire since the eighteenth century, and Paxton had used them to great effect at Birkenhead. But this montage of natural and man-made features—bridge and mountain, trees and trains—was something new: "While the unfolding incident in the Buttes Chaumont may stem from Picturesque landscape theory," wrote John Merivale, "its stunning vertical scale belongs more to the contemporary railways and bridges of the civil engineers."[197]

It is noteworthy that this most modern and memorable park was situated in the poorest part of Paris. In the nineteenth arrondissement, Haussmann's engineers could afford to be experimental. Asphalt paths and metal hardware did not look out of place against a background redolent of labor and industry. Alphand was rather more ambivalent in print. According to the book written in collaboration with Baron Ernouf, "In large parks as in small ones, rustic bridges are almost always more agreeable than those in intricate woodwork or metal. If however, one prefers these last because of their solidity, one must at least dissimulate their thin and angular lines with creeping plants."[198] At the Buttes Chaumont, the engineers refused to disguise their iron ossature with greenery.

Today, hemmed in by the city, the park offers exciting contrasts between the canopy of trees and the surrounding high-rise buildings. In the nineteenth century, the view was different. From the summits, towns and villages stretched into the distance: Versailles, Saint-Germain, Mantes.[199] The Buttes Chaumont, declared a contemporary observer, "combines two marvels: *the Park* and *the panorama*."[200] Close by, the view was less bucolic. La Villette was a depressed area, home to an impoverished population, including the little colony of Hessians with its schools, asylum, and Lutheran church.[201] Sugar refineries and industries, established in the area before annexation, interrupted the view with their tall chimney-stacks. At the time of inauguration, the unpaved streets surrounding the park were still half empty. Construction was complicated by the nature of the subsoil. As the municipality often used quarries as foundations, the lake and lawns had to be redone after collapse due to subsidence.[202]

The Buttes Chaumont was not finished in time for the 1867 exposition. Photographs show an arid terrain covered by sparse vegetation. Boreal rather than tropical, its greenery initially disappointed many visitors. As Barillet-Deschamps was hard at work on the gardens of the 1867 World's Fair, the horticultural palette was completed by Édouard André, seconded by Charles Delaville.[203] Flowers played a limited role here, compared to their abundance at Monceau or the Bois de Boulogne.[204] Robinson deplored the park's aridness: "By trickling a little streamlet over the face of the cliffs here and there, and by scattering a few packets of seeds over the face of the cliffs in spring, they would have given rise to an alpine vegetation of great beauty."[205] Yet the Buttes Chaumont cost a fortune: one-fourth of what the municipality paid for the Bois de Boulogne, though it was only one thirty-fourth the size. Its popularity today justifies its reputation as the crowning achievement of the Second Empire's green spaces.

MONTSOURIS (1864–78)

Montsouris, like Buttes Chaumont, was built on undeveloped land in an equally harsh setting near the fortifications. Underground quarries determined the low price of the land, ill-suited for construction and interrupted by a railroad and an aqueduct. Here too topsoil had to be brought in to sustain planting. The view, however, was breathtaking, encompassing the domes of the Panthéon, Val-de-Grâce, and the Observatory. The idea of creating a park in the southern part of Paris dates from a few years after annexation, when the area fell within city limits. Haussmann claimed he chose a site that he had known since childhood.[206] Darcel produced an early sketch, and the city acquired the land in 1864, although work did not begin until three years later.[207] The importance accorded Buttes Chaumont, and its well-publicized expense, probably encouraged the city to endow the Left Bank with its first public park.

Smaller than Buttes Chaumont, and lacking its spectacular pyrotechnics, Montsouris was nevertheless a magnificent urban pastorale. Carefully chosen to frame distant views, according to Haussmann's usual preferences, the park's main roads also dovetail with surrounding streets (fig. 6.22).[208] Thanks to the tight budget, the grounds were spared the platitudes of the municipal style. Its man-made relief is just right for the scale of the park. Idyllic undulations expand the surface of the grounds; blocked perspectives add an element of surprise by screening different sections from one another. Montsouris's beautiful

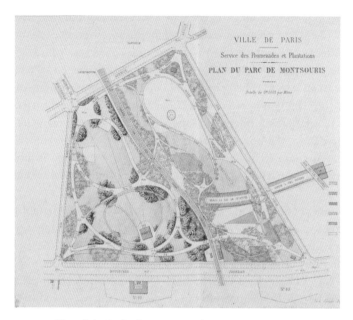

FIG. 6.22. Plan of the Park of Montsouris showing perspective lines framing distant views, 1875. Print with watercolor. Bibliothèque de l'Hôtel de Ville.

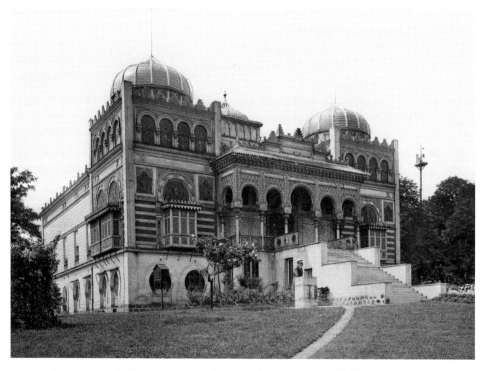

FIG. 6.23. Jacques Boyer, Palais du Bardo, Parc Montsouris, in 1912. Roger-Viollet.

trees are expertly contrasted in terms of texture, color, and foliage. Closed and open spaces surround a huge lake built above a quarry, which swallowed it up just after inauguration. Water came from the city's largest reservoir, built nearby by Belgrand a few years earlier.

The Petite Ceinture railroad ran through the park in a deep cutting, its importance emphasized by the construction of a station within the grounds. A second station was built just outside the grounds. Bridges connect the two halves of Montsouris, severed by the railroad. On the heights rose an Orientalist folly, the Bardo, designed by architect Alfred Chapon (fig. 6.23). Originally commissioned by the bey of Tunis as a small replica of his summer palace, it had represented Tunisia at the World's Fair of 1867.[209] Davioud reconstructed it here, aided by Tunisian workers, to serve as a meteorological observatory.[210] War interrupted work on Montsouris, which suffered the usual damage, losing trees to the population while the National Guard installed itself in the Bardo. The park was not finished until 1878, the year of an international exposition, when several politicians spoke up on its behalf, defeating those who opposed the creation of a public promenade in a relatively unpopulated part of the city.

SQUARES

In addition to parks, the municipality was also hard at work on new squares. These little urban lungs opened up the tightly knit urban fabric to light and air and were all the more important as dust from innumerable building yards engulfed Paris. Some twenty-four squares (seven in the annexed zones) completed the city's green network.[211] The flexible system of nature management put in place by Alphand's experts allowed them to adapt their designs to different scales and budgets and varied urban ecologies. Each square was connected to the infrastructure being built above and below ground. Even when squares were bermed or enclosed by railings, the engineers never tried to blot out the view of the city, heightening the contrast between the geometry of the surrounding buildings and the free-form greenery of the little enclaves, often using the city hall of the district as a focal point.

Haussmann credited the emperor with introducing squares to Parisian urbanism in emulation of London's elegant precedents, known to Napoleon III since his exile. In fact, they had a longer history.[212] Although the English term "square" betrayed the Anglophilia of the French ruling classes, the word itself came from the old French *carré* or *quarré*, as one can see in Versailles and in France's former colonies (the Vieux Carré in New Orleans or Montreal's Carré Saint-Louis).[213] The oldest Parisian example, Square d'Orléans, was begun in 1830 by the English architect Edward Cresy but acquired its island of verdure only in 1856. The tiny Square Vintimille (now Berlioz), so often painted by Édouard Vuillard, was built in 1840 on the site of the old Tivoli gardens. Designed, like its British counterparts, to be used exclusively by tenants from surrounding buildings, it became public in 1858 after Haussmann's administration took the owners to court.[214] Another private square on the Right Bank, the beautiful Cité Trévise, designed by Édouard Moll, was completed in 1841.

In 1842, the farsighted Meynadier argued that for a modest price, the city could make space for small public gardens for its citizens by razing decrepit buildings.[215] The Siméon committee took this up in their report to the emperor.[216] Prompted by Napoleon III, Haussmann put this agenda into effect, decentralizing the municipality's green spaces, though the periphery would lag far behind the central and western parts of Paris.[217] Squares were open

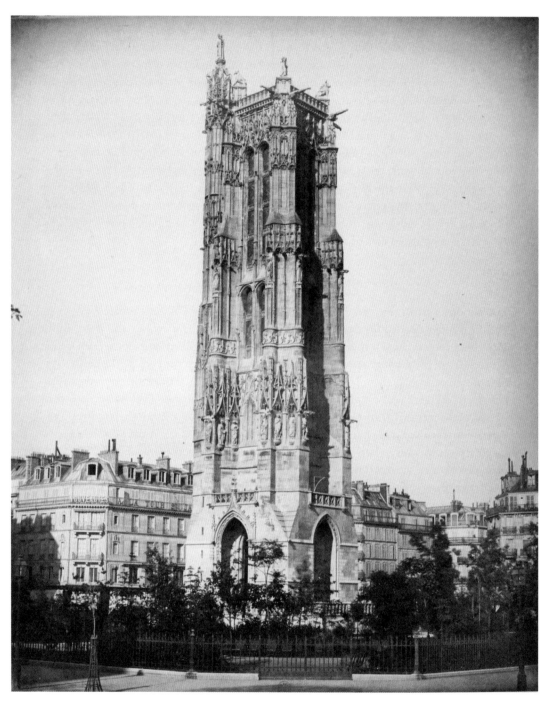

FIG. 6.24. Gustave Le Gray, the Tour Saint-Jacques, ca. 1859. Bibliothèque nationale de France, Paris.

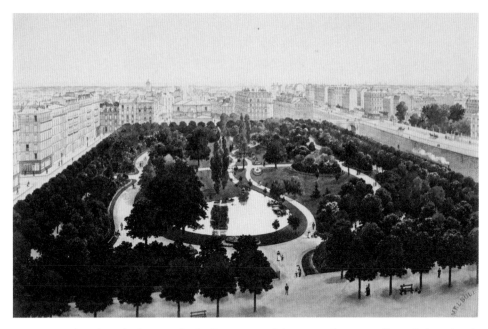

FIG. 6.25. Attributed to Charles Marville, bird's-eye view of the Square des Batignolles with the railroad to the right, ca. 1877. State Library of Victoria, Melbourne.

to all—a marked departure from London's islands of segregation and privilege, isolated from their surroundings by railings and locked gates. Even Robinson compared the English squares unfavorably to Parisian ones: "At present the gardens in our squares are painful mementoes of aristocratic exclusiveness."[218] Haussmann's landscaped and wooded squares were also planted with exotic shrubs and flowers, once the preserve of the moneyed classes.

Given the cost of real estate, public squares rarely reached large proportions. The municipality's first endeavor was built in 1855 around the old tower of Saint-Jacques-de-la-Boucherie, whose church was destroyed during the French Revolution (fig. 6.24). As the entire area was elevated to the same level as the prolongation of Rue de Rivoli, the tower was hoisted on a new pedestal. Roughly two hundred houses were razed, and their inhabitants evicted.[219] Centrally located, the square caused a sensation when it was unveiled: it was here that exotic plants like wigandias, palms, cannas, and broad-leaved Abyssinian musa were first introduced.[220]

At Batignolles, a village annexed in 1860, Alphand built one of the city's largest urban squares, in a neighborhood later frequented by the impressionists. Equipped with superb sloping lawns, a cascade, and a diminutive serpentine, the square was beautifully scaled and planted with magnificent trees, including a giant sequoia, Japanese persimmons, and honey locusts from America. It had all the trappings of a small botanical garden without the museum-like atmosphere. Robinson himself could not withhold his approbation: "The absence of all attempt to make a species of extensive coloured cotton handkerchief of the place makes it almost as fresh and free from vulgarity and gaudiness as a ferny dell in a forest."[221] Finished in 1862, Batignolles was one of the most modern of the new squares, bordered by highly visible railway lines (fig. 6.25).

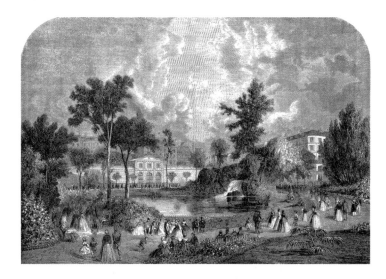

FIG. 6.26. Auguste Anastasi, Square du Temple, engraving, ca. 1870. *L'Illustration*, May 7, 1870.

Squares were carefully though unevenly situated throughout Paris to serve different social groups, anchor new neighborhoods, and insert them in a legible network.[222] Class-bound strategies determined location, quality, and expense, reflecting Haussmann's divisive urban politics. Fewer than one-third were in the annexed periphery. "I would rather they be distributed with greater discernment among different neighborhoods of the capital, and more attuned with the needs of the populations," complained the Count of Lasteyrie.[223] André, Alphand's man, disagreed: "The zeal and care lavished on the gardens remain the same everywhere. Those of the poor and those of the rich are identical."[224] Costs contradicted this sunny appraisal, though they were contingent on a number of factors. Size varied widely; some squares were built almost two decades after others. A few were created on land belonging to the city; others required onerous expropriations. Still, the tiny square of the Trinité in the heart of the financial district cost 420,000 francs—twenty-one times more than the square of Place Sainte-Geneviève (19,908 francs), which was roughly three times larger but situated in the working-class neighborhood of Belleville.[225] Square Victor, also in the annexed zone, had no water or rockery, only lawns and trees. It is worth noting that in 1855, when Queen Victoria visited Paris to see the World's Fair, Haussmann gave a sumptuous fête in her honor at city hall; the flowers alone cost 350,000 francs.[226] Haussmann was always willing to subsidize the court and its entourage.

Rare cultivars and expensive waterworks were visible mainly in the wealthiest areas of Paris. Squares in the eastern part (but within the old city limits) were treated with greater generosity than those in the annexed zone. On the site of the scowling fortress of the Knights Templar, a huge enclosure where Louis XVI and his family were once imprisoned, Alphand and Barillet-Deschamps built the beautiful Square du Temple, with lawns, lake, grotto, waterfall, and corbeilles, elliptical flower beds with slightly convex surfaces for greater effect (fig. 6.26).[227] Situated in the industrious third arrondissement, it attracted a large population of artisans, workers, and local residents. Yet Fournel observed that here the modest public had to pay for chairs, in contrast to the free benches provided by the municipality at the Place Royale, the Champs-Élysées, and the Place du Châtelet.[228] All

new parks and squares brought benefits to the population, but they also naturalized class-based forms of urban landscape.

Urban space is always burdened with codes, norms, and expectations. Squares were expected to conform to bourgeois standards of propriety.[229] As such, they could serve as schools of condescending civility. Guardians of law and order policed the grounds, enforcing upper- or middle-class mores, often making the disadvantaged feel unwelcome. Jules Claretie saw a guard chide a worker asleep on a bench at the square of Tour Saint-Jacques.[230] For many workers and their families, cantoned in cramped and inadequate dwellings, the indeterminacy of the outskirts and their lack of surveillance spelled freedom, unlike the squares' constricted view framed by buildings. Railings, gates, and gendarmes established firm boundaries, clearly signaling that these small enclaves were under the aegis of the law, and subject to opening and closing hours. Even Daly, a staunch apologist for the regime, regretted that squares in working-class areas closed early even in summer, "for it is only after eight in the evening, once his workday is over and his dinner finished, that the worker can allow himself to breathe freely and give himself the luxury of a promenade of relaxation and hygiene."[231]

In contrast to the great suburban parks, the urban intimacies of the squares had a strong connection to domesticity. Despite their uneven distribution across Paris, they were increasingly accessible through public transportation and gave women a place to relax. Built to the scale of the neighborhood rather than the city, they were one of the first urban spaces earmarked for children. Alphand gave a great deal of thought to how squares would be used by them, recommending special materials that would not harm them, and accepting suggestions from mothers.[232] Before public gardens became available, children rarely left home, and their mothers did not bother to wash them, Robinson remarked patronizingly; fear of what others would say led them to dress their offspring better, for cleanliness was "the ornament of the poor."[233] Squares also served to moor newly refurbished neighborhoods by giving them an urban centerpiece. Yet they were divided by class: "When the public of the square is mixed, hardly a rare occurrence," noted Claretie, "lines of demarcation impose themselves naturally in this minuscule garden: maids here, mothers there, the aristocracy on one side, democracy on the other."[234]

Alphand's squares were not always successful from the point of view of landscape design. With its relentless syntax, the municipality's formulaic gardening style was partly dictated by the high number of works under construction. The sublimity of the Picturesque, employed to such great effect at Buttes Chaumont, could not be shoehorned into the common coinage of municipal squares where the miniaturization of the style reduced its main features—lake, grotto, and waterfall—to a scale out of proportion to their natural referents.[235] "Is it not childish to raise mountains and dig valleys in a space where there is barely room for a few rhododendron bushes?" asked Alphonse de Calonne scornfully.[236] His words bring to mind Napoleon Bonaparte's critique of the labored gardens of his day: "These little lakes, for the most part without water, these tiny miniature rocks, these immobile rivulets, all these inanities are but bankers' whims," he declared. "My jardin anglais is the forest of Fontainebleau, and I want no other."[237] Similar criticisms were often leveled at Alphand's gardens: inadequate sense of scale, contrived rock formations, overwrought artifice. In his lengthy introduction to the *Promenades de Paris*, however, he faults

Chinese gardeners—using racialized language—for their inability to produce memorable landscapes because "their intellectual faculties are weaker than those of the Aryans."[238]

Napoleon III's ambitious plans for Paris included a green belt that was to encircle the city, connecting the Bois de Boulogne and the Bois de Vincennes. The emperor had his eye on the *non aedificandi* zone, a swath of land 250 meters wide beyond the fortifications.[239] A continuous promenade around Paris would have been a remarkable contribution to urban (and environmental) planning, but despite Haussmann's vehement defense, the opposition thwarted the emperor's project in 1859, when he was fighting in Italy.[240] Napoleon III's Italian campaign led to another casualty. The Champs-Élysées, one of the city's most important promenades, had often been reconfigured since first laid out by Le Nôtre. Under the July Monarchy, the seedy aspect of the area and its lack of security at night worried the municipality. At its request, Hittorff redesigned it, along with the Place de la Concorde, adding several carrés, as well as the circus of the empress and the Panorama rotunda.[241] When Napoleon left for Italy, Haussmann razed Hittorff's green squares, replacing them with Picturesque gardens designed by Barillet-Deschamps and punctuated by rare trees: Chinese rice-paper, papyrus of the Nile, and weeping sophoras. The destruction of the beautiful old quincunxes shocked the emperor, who was powerless against this fait accompli.[242]

PLANTS AND TREES

The greening of Paris required such huge quantities of plants and trees that the municipality founded one of the most advanced nurseries in the world: Le Fleuriste de la Muette, "the largest plant factory in existence," wrote Daly.[243] Situated in Passy, near the Bois de Boulogne, it was inaugurated in 1855. A huge success, it eventually opened to the public. By 1863, it boasted twenty-four different kinds of greenhouses, in addition to housing for its fonctionnaires. Almost one hundred workers toiled at the Fleuriste; many more serviced the municipality's other nurseries. As more parks and squares were added to the municipal agenda, Barillet-Deschamps opened greenhouses for deciduous trees at Longchamp and for palm trees at Auteuil. Petit-Bry, on the left bank of the Marne, specialized in seedlings for streets and boulevards. Annuals were grown at Vincennes.[244] The output of the municipal nurseries was astonishing: close to three million plants a year for the city's diverse needs.[245] To train specialized personnel, Barillet-Deschamps founded a horticulture school at the nursery, which attracted students from all over Europe.

At La Muette, vegetal species grew in ingenious forcing houses. Beautifully designed, the sleek iron-and-glass conservatories had special wooden shutters that provided insulation. Each had its own form of heating in winter (hot water, gas, or coke), depending on the needs of particular plants (fig. 6.27).[246] One of the hothouses harbored 230 kinds of camellia trees; others over 500 different kinds of palms or 100 species of ficus.[247] Temperate greenhouses protected hardy plants, and cold ones, eucalyptus and mimosas. In nearby quarries, two hundred thousand tubers and rhizomes from all over the city spent their winters. Lit by gas, the cavernous warehouses with seven-foot ceilings maintained an even temperature throughout the year.[248] To transport flowers for the imperial fêtes in winter, Barillet-Deschamps invented special carts heated by stoves and equipped with hot-water pipes.[249] In spring, newly bedded plants from La Muette were returned to the city's public gardens so

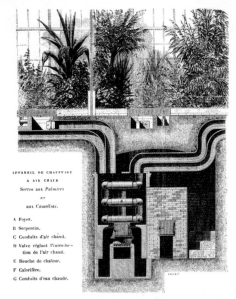

APPAREIL DE CHAUFFAGE
A AIR CHAUD
Serres aux *Palmiers*
ET
aux *Camellias.*

A Foyer.
B Serpentin.
C Conduits d'air chaud.
D Valve réglant l'introduc-
 tion de l'air chaud.
E Bouche de chaleur.
F Calorifère.
G Conduits d'eau chaude.

Fig. 154. Coupe sur le calorifère
Échelle de 0^m,02 p. m.

FIG. 6.27. Detail of the forcing houses in the Fleuriste de la Muette, designed by Jean-Pierre Barillet-Deschamps. Alphand, *Les promenades de Paris*. Marquand Library of Art and Archaeology, Princeton University.

Parisians could enjoy the "beneficial luxury of verdure and flowers, a gentle habit to which the municipal administration has accustomed them."[250]

Barillet-Deschamps's plants came from all over the world—Brazil, China, the Himalayas, Japan, New Zealand. Since they were taken in during winter and bedded out in spring, they entailed higher maintenance costs than native plants. Exotic species required specialized personnel and a great deal of labor, although advances in horticulture greatly facilitated the process. There were precedents in eighteenth-century aristocratic parks like Bagatelle, where Blaikie had planted bananas, sugar cane, palms, and coffee.[251] By displaying rare species from distant lands, often French colonies, the municipality publicized new horticultural trends and underscored the empire's geopolitical reach. Trees and plants were highly profitable merchandise; private nurseries made fortunes selling exquisite cultivars. Parks functioned as a marketing apparatus, staging costly commodities and freighting them with associations. Rare flowers were a mark of distinction and an index of social class, particularly during the cold months, when fashionable salons flaunted "aristocratic flowers" such as camellias and gardenias.

To unify the city fabric and provide shade, Haussmann unraveled great spools of greenery along his thoroughfares. Tree-lined streets had a long pedigree. Throughout the seventeenth century, planted allées first made their appearance as princely promenades (the *mails* or pall malls), and eventually as boulevards at the edge of the city.[252] From there, they began migrating toward unbuilt parts of Paris as in Le Nôtre's Avenue des Tuileries, now the Champs-Élysées. At Versailles, radial avenues issuing from a *rond point* were adopted from the striking model used by Pope Sixtus V in Rome. The *patte d'oie* became a crucial structuring element of Baroque urbanism and an emblem of princely power, which France first tested at Versailles. Laugier's injunction about following the layout of the great parks for city planning stems from these precedents.[253] In Haussmann's Paris, "green" boulevards retained their umbilical cord with autocratic privilege and tradition.[254]

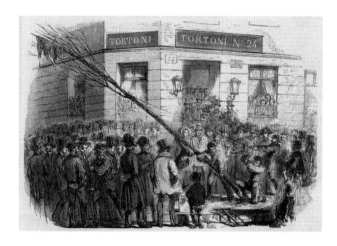

FIG. 6.28. Henri Valentin, destruction of the Liberty Trees. *L'Illustration*, February 9, 1850. Brown University.

During the French Revolution, liberty trees became a potent political symbol for both the cause of freedom and the cult of nature.[255] Common trees like oaks or elms were ideal representatives of revolutionary rituals. Poplars (*peupliers*), a relatively recent addition to French landscape practice, also gained in importance owing to their name's resemblance to the word people (*peuple*).[256] Yet revolutions were hardly charitable toward trees. Waves of vandalism destroyed thousands in 1789.[257] Rambuteau's zeal in planting so many trees had to do with the need to replace those used in the barricades of 1830 that brought Louis-Philippe to power. By contrast, liberty trees planted during the 1848 revolution were cut down in 1850 by order of Pierre Carlier, Louis Napoleon's prefect of police (fig. 6.28).[258] Their political association severed, Haussmann was free to treat trees as merchandise.

It was Rambuteau who brought streets canopied with trees to the center of Paris. Haussmann followed him in this respect, but more systematically. In an attempt to supply new parks and gardens, he mass-produced a new urban nature. Trees softened the angularity of the cityscape, erasing or establishing thresholds, acting here as suture, there as screen, mediating between the scale of the buildings and that of the passerby.[259] Although its trees could hardly compare in size and beauty with the stately old specimens that were swept away, the Second Empire's record is impressive: between eighty and one hundred thousand trees were planted along the city's thoroughfares.[260] Streets wider than thirty-six meters received a double row of trees, to the horror of Haussmann's engineers, who claimed that shade brought humidity to macadam surfaces.[261] Since the cholera epidemic, hygienists and urban reformers debated at length on the benefits of urban trees.[262] They had to sustain heavy urban stress from traffic, gas, and xylophagous insects. Chevreul's work on the toxic effects on urban trees, which perished when their roots come into contact with soil or water infected by gas, was crucial for the municipality.[263] Exposed to so many dangers, the mortality rate of trees in Paris was extremely high.[264] To offset such problems, Alphand provided topsoil for boulevard trees, hooked them to sewers, and fitted each one with pipes that took air and water down to its roots. Davioud's tree guards permitted water and air to percolate, shielding roots from soil compaction.[265]

Alphand and his collaborators experimented with different kinds of trees, both native and foreign. Mature trees gave instant shade and were more beautiful than younger ones. Most were transplanted from the surroundings or from expropriated properties; others

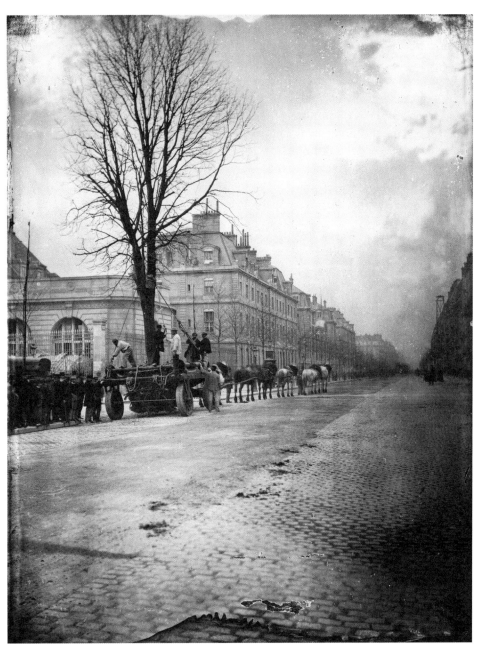

FIG. 6.29. Charles Marville, trees being transported on Boulevard Saint-Michel, 1877. Bibliothèque historique de la Ville de Paris.

from municipal or commercial nurseries.[266] To transport large trees with their root balls, Barillet-Deschamps designed special vehicles (fig. 6.29). Despite precautions, many trees withered, died, and had to be replaced. Seeing etiolated specimens shriveling along busy thoroughfares, Fournel lamented the plight of the "poor emaciated trees, living on a diet like consumptives, deplorable products of industry substituted for nature."[267]

The *arbres voyageurs* were moved about the city like the peripatetic buildings that Haussmann's experts dismembered and recycled.[268] Citizens rued the sight of large trees passing in front of third- or fourth-story windows, ferried in horse-drawn vehicles: "Today," bemoaned Fournel, "monuments and trees are parcels; they are tied up, packaged, and compelled to wander, at times in a single block, like the Palmier fountain, on the place du Châtelet."[269] As late as 1908, Lucien Augé de Lassus pitied the roving tree that found no resting place: "They made him travel, though it was hardly appropriate for his age; dragging behind him, lamentably, along with sparse hair that a pitiless rape had profaned, his long roots which had never yet seen daylight."[270] The searing pain and sense of dislocation felt by Parisians faced with redevelopment were displaced onto the desolate, asthmatic trees.

THE OLD ROYAL GARDENS

Paris still had its royal gardens: the Tuileries, the Luxembourg, the Jardin des Plantes, and the small Palais-Royal. These contrasted with the regime's green spaces as old money to new. The Jardin des Plantes boasted magnificent collections of rare specimens, exotic

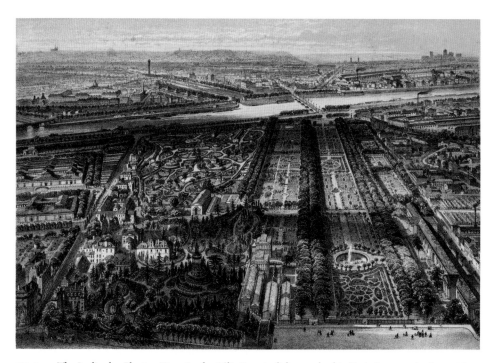

FIG. 6.30. The Jardin des Plantes. Drawing by Félix Benoist lithographed in *Paris dans sa splendeur*, 1861. Bibliothèque nationale de France, Paris.

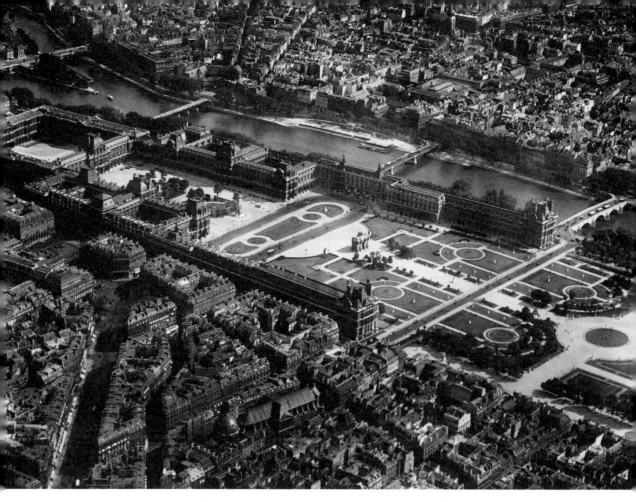

FIG. 6.31. The Louvre and the Tuileries, aerial view taken before the current pyramid was built. Roger-Viollet.

animals (both living and dead), a museum of natural history, and a cabinet of curiosities that included the Hottentot Venus and the mummified body of Turgot (fig. 6.30).[271] Its scientific pedigree was associated with the great conservators of the past. Buffon, Lamarck, Saint-Hilaire, Cuvier, and Thouin had enriched it with books, scientific theories, and priceless cultivars: a cedar from Lebanon, paper mulberries from Tahiti, pear trees from Judaea, among others. Mentioned in Balzac's *Le Père Goriot*, Michelet's *Ma Jeunesse*, and Flaubert's *Bouvard et Pécuchet*, the Jardin des Plantes lacked funds to maintain its collections. Since the garden did not belong to the city, it could not profit from the prefect's largesse.[272] Robinson was astonished to see workers watering plants with anachronistic copper pots rather than Alphand's cutting-edge technologies.[273]

The Tuileries and the Luxembourg had originally been attached to princely residences. Built in the sixteenth century by Catherine de Médicis and several times enlarged, the Tuileries acquired a magnificent French formal garden laid out by Le Nôtre (fig. 6.31). Napoleon Bonaparte tore down the wall that separated it from his new Rue de Rivoli, replacing it with graceful wrought-iron grilles.[274] Louis-Philippe annexed the grounds close to the Tuileries to create a buffer between the palace and the public part of the garden. Napoleon III privatized yet another portion, to create a large jardin anglais tastelessly juxtaposed to Le

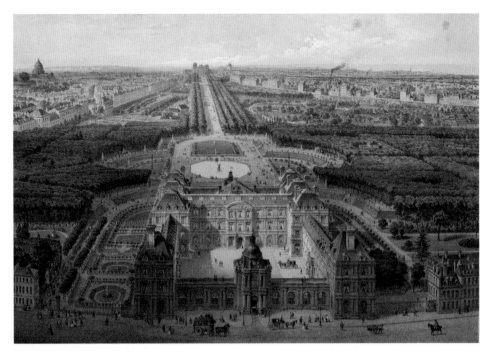

FIG. 6.32. Jules Arnout (after Félix Benoist) and Jules Gaildrau, bird's-eye view of the Luxembourg palace and gardens, lithograph. The background shows the nursery on both sides of the central allée. *Paris dans sa splendeur*, 1861. Bibliothèque nationale de France, Paris.

Nôtre's elegant *parterres à la française*. Several old horse chestnuts were cut down to build the Jeu de Paume as a twin to the earlier pavilion, the Orangerie. The level of the soil was raised, partly burying the seventeenth-century trees.[275] Despite these changes for the worse, the garden retained its air of courtly stylishness, and it remained a favorite promenade of Parisian elites thanks to the presence of the royal family at the Tuileries.

One of city's most delightful gardens, the Luxembourg once formed part of Marie de Médicis's palace. As the queen enlarged her property, the design became less Italianate and assumed a more formal French manner. When the adjoining church and cloister of the Carthusians were destroyed during the French Revolution, a remarkable nursery, the *pépinière*, took their place. It included vines from Bourgogne, Champagne, Gironde, the Rhine, Greece, Persia, and Asia, probably the finest such collection then in existence (fig. 6.32).[276] Always full of birds, the nursery was an extremely popular place of promenade and reverie. Its unstructured charm and appearance of open countryside offered a welcome contrast to the disciplined greenery of the garden's *parterres en broderie* and clipped hornbeam hedges. The Luxembourg appealed to a broader spectrum of society than the Tuileries. Aristocrats from the faubourg Saint-Germain, mothers, and nannies preferred the flowers and fountains of the central allées; students, artists, and artisans from the Quartier Latin cherished the relative privacy of the nursery.

This idyllic corner of Paris was now threatened by the municipality's ambitious plans. First came the cutting of a new street, Rue Corneille, which destroyed several buildings belonging to the Senate, installed in the Luxembourg palace by Bonaparte, including the

FIG. 6.33. Bisson brothers, the fontaine Médicis, ca. 1854, before it was moved. Bibliothèque nationale de France, Paris.

stables, the *orangerie*, and officials' houses.[277] When it came to moving the popular Médicis fountain (fig. 6.33), the Senate asked its architect, Alphonse de Gisors, for a counterproposal that respected the fountain's original location.[278] As the government disregarded Gisors's project, the opposition tried to enlist the help of Delacroix, a member of Haussmann's municipal council. Delacroix refused: "It is only within the [municipal] council itself that I can defend the reasons which, in the name of taste, militate in favor of the preservation of the beautiful fountain and of the alley."[279] Other petitions failed, and the fountain was moved. Since it had become freestanding, another fountain was appended to its back: the fontaine de Léda, uprooted by the cutting of the Rue de Rennes.

Worse was to come. In 1865, Napoleon III authorized the amputation of a sizeable portion of the gardens that would do away with the eastern and western parts of the nursery.[280] This led to a flurry of protests from prominent politicians and intellectuals who knew that the proposed cuts had the sole aim of generating revenue for the municipality.[281] Newspapers were almost unanimous in their defense of the garden. A petition to the Senate carried ten thousand signatures. Adolphe Joanne, a well-known lawyer, denounced the emperor's decree as unconstitutional: "The government is but an administrator; it is the nation that is the proprietor."[282] The Luxembourg gardens could no more be cut than Veronese's *Wedding Feast at Cana* in the Louvre, wrote another critic.[283] In February 1866, after the emperor and the empress were jeered at a public appearance, Napoleon III

published a letter in *Le Moniteur universel* instructing his minister of the interior to save the western part of the garden.[284] Three days later the same newspaper exposed the full extent of what contemporaries called the mutilation of the Luxembourg. Not only would the nursery be destroyed, but also the beautiful avenue of plane trees and possibly another allée that skirted the garden to the southwest: Napoleon III had gone back on his word. The final plan approved by the emperor saved part of the nursery, which Alphand promptly transformed into a jardin anglais.[285] The beloved pépinière was destroyed, its vines transferred to the Jardin d'Acclimatation.

MANUFACTURING NATURE IN THE AGE
OF TECHNICAL REPRODUCIBILITY

> Nature is imitated, for example, but only *seemingly* reproduced: what are
> produced are the *signs* of nature.
> —Henri Lefebvre, *The Production of Space*

Municipal parks and squares gave one answer to a vexed question of the times: What did nature signify in an age of technical reproducibility? Instead of its presumed immediacy, visitors were faced with a landscape boldly mediated by technology, brazenly flaunting faux-wood balustrades, prosthetic rocks, concrete stalactites. Everything could now be manufactured.[286] Landscape had become a form of merchandise that could be duplicated at different scales and with endless permutations, not only in the details but in the aggregate.[287] Reproductive technologies enabled both the commodification of nature and (more rarely) the commodification of place.

Whereas time had been a major component of old landscapes, everything in the new parks was synchronic. With their trees *ex machina*, exotic plants from other continents, and prefabricated rocaille, the empire's greenery had no past, reflecting all too clearly the mobility and uprootedness of modern life. This was hardly "Nature, red in tooth and claw."[288] Snow still blanketed the parks in winter, and foliage reddened every fall, but plants and shrubs, serially produced in nurseries, were now unyoked from nature's calendar. "No more seasons!" Haussmann is reported to have said.[289] Serially produced or transplanted trees were not historical records or supports for reminiscence. Given the parks' shortfall of memory, the spatial took precedence over the temporal.

Artifice ruled. Synthetic materials and frank exposure of machinery exemplified the idea of progress dear to the age. Railroads cut through four out of five municipal parks and one of the squares. Vegetation itself could evoke the municipality's industry-driven approach. Robinson—that prophet of wildflowers and native species—referred approvingly to the "wrought-iron texture" of the wigandia in Parisian parks.[290] Critics who faulted the parks as paltry surrogates for the real thing failed to see that the engineers who produced them were not imitating nature but constructing it according to the precepts of modernity. Far from being an exercise in mimicry, concrete grottoes and lakebeds were in fact parading their own truths: they were not unique, but reproducible. A new urban semiotic was at work here. If reinforced-concrete railings imitating branches were so successful, it was not because the engineers attempted to pass them off as wood, but because they played on ambiguity, parading both artificiality and mimesis.

Such ostentatiously manufactured scenery, often compared to the papier-mâché decor of operettas, offended the naturalist sensibilities of those for whom duplication and duplicity were synonymous. "Monsieur Alphand," fumed Zola, "tells us calmly how his stagehands installed each set design in its place, even going so far as to report how much each of these sets cost: so much for that oak, so much for that stream, so much for that rock."[291] Others were troubled by the ostensible lack of realism in features that defied laws of logic and gravity. "In the northern tip of the great lake," scoffed the Count of Lasteyrie, "one is surprised to see a sheet of water situated higher than the surrounding soil, somewhat defying the laws of natural physics."[292] These plaintive voices thirsted for a lost authenticity uncontaminated by the fruits of the Industrial Revolution. Modernity's simulacra did not offer the same consolatory returns as the old humanist concept of a pastoral and restorative *natura naturans*. Yet such criticisms could also express legitimate political concerns: "All these manicured greenswards, these trees so carefully shorn of parasites, groves without shrubs, rocks lacking asperities, allées devoid of relief, cascades with no foam, enameled lawns, have an irritating aspect of perfection. The hand of man is everywhere; liberty is nowhere to be seen," wrote Alphonse de Calonne in 1866."[293]

Alphand himself was deeply conflicted about the role of nature in his work. Although he foregrounded his networked surfaces in his writings and practice, he clung uneasily to the old discourse of nature. "Nothing is beautiful but truth," declared this purveyor of concrete-lined lakes and artificial rocks. "One does not rebel with impunity against the truth that governs nature."[294] For all their technical innovations, Alphand's parks usually respected the main outlines of the terrain before imposing his own topography. His ambivalence reflects the anxieties of an age torn between the cornucopia of mass-produced commodities and a deep-seated yearning for the unique and unrepeatable. Parks were a modern Gesamtkunstwerk, exhibiting signs of traditional landscape—greenery, waterworks, rocks, flowers—along with the technical means used to produce them. Immanent and fungible, modernity's nature had done away with this last link to the sacred. Part museum, part World's Fair, part department store, the empire's green spaces served as marketing tools for goods and services that became desirable by being associated to their underwriter, the imperial-municipal government.[295] Parks played a crucial role in the universal expositions of 1855, 1867, and 1878, which were themselves national, transnational, and colonialist exercises in salesmanship, publicity, and product display.

By any standards, Alphand's lavish *Promenades de Paris* must rank as a milestone in the history of landscape architecture and also of publishing, and it was used as a fitting gift to kings and potentates. The exceptional quality of the plates and detailed observations about the empire's green spaces and tree-lined streets are astonishing. Alphand deliberately demystifies his new nature with detailed drawings of the equipment, recording the costs of production, maintenance, and the amortization of the initial capital. As scholars have noted, the plans of the Bois de Boulogne and the Buttes Chaumont are extraordinary for their time. Alphand believed in reliable topographic plans based on rigorous knowledge of the terrain.[296] A wealth of technical information is translated into clearly legible, two-dimensional form: before and after aspects of the topography of the park (Buttes Chaumont); the underground water conduits in the Bois de Boulogne (see figs. 6.5 and 6.17).[297] As representation, these two plans broke new ground. However, we do not know who really designed them, as they are stylistically quite different from one another. A brilliant

engineer, Alphand was also an extremely busy man, and it is more likely that these carefully detailed, high-quality plans were the work of engineers from the municipality. Throughout the book, elevations of Davioud's buildings and small-scale structures appear without any caption identifying their author. Only the names of the draftsmen are indicated.

An influential primer that helped propagate Paris's landscape style around the world, the text was a major contribution to urban planning as several scholars have pointed out.[298] The publication gave an encyclopedic, if partisan, view of the municipality's green spaces and is equally noteworthy for what it left out. Vignettes did the silent work of ideology, showing idyllic views of squares and gardens even in working-class areas, with elegantly attired men and women strolling with insouciance amid the greenery. Nevertheless, parks were at the service of contending ideologies of nature, nation, gender, and even ethnicity. Gender stereotypes were common. The severe formal gardens of the past, remarked André, sought "to reveal man's handiwork and to tame nature," while contemporary gardens borrow from nature and, "with the pretext of imitating it, make it play a ridiculous role—I was about to say an effeminate one."[299] Unsurprisingly, the manifest artificiality of the new parks led to a predictable syllogism equating women with unnatural plants. "The landscape gardeners of the last century," wrote Max Nordau during the Third Republic, "had the habit of pruning and training trees into shapes like statues, walls and architectural designs. But with all their efforts, they never succeeded in developing the tree into forms so entirely at variance with its natural laws of growth as the abnormal deviation from the natural type that woman has become in the atmosphere of Paris."[300] Class could override gender. Fallen women, claimed Gourdon, had a profound dislike of wildflowers: "Could it be because these flowers recall the modesty of their birth and bitterly reproach them for not having remained pure and unaffected?"[301] Even race, understood as a social construct, could be involved in a value system centered around "nature." Seeing birds eating prettily out of a stranger's hand at the Tuileries, Robinson asserted that he was "evidently of the Jewish persuasion," adding that "however much I may regret to admit it [...] not one sparrow approached within ten inches of the hand of a Gentile."[302] The empire's gardens served as a prism that reflected and refracted society's beliefs and prejudices.

Haussmann's urban ecology was keyed to the political and economic exigencies of the Second Empire. Local industries and commercial enterprises received a boost from parks and squares where everything was a commodity that promoted their products and services. Real estate speculators saw earnings rise from the sale of properties bordering greenery. Parks and squares made room for leisure available to different social classes, women and children as well as men, but they also reproduced and sustained the ideologies that undergirded the regime. Far from being an alternative to an alienating existence in the city or in its periphery, these green spaces offered the working poor a nature that was itself mass-produced by cheap labor. Their success depended on their ability to conceal the social relations of production.[303]

Societies create their own nature, tailored largely—but not exclusively—to the needs and fantasies of those in power. Although Napoleon III and Haussmann sought to upgrade and beautify the city in the name of the industrial and mercantile classes whom they represented, these green spaces were created, used, and interpreted by a diverse population. Egalitarian ideals were not altogether lacking: municipal gardens may well have been

decreed by fiat, but they were carried out for the benefit of the public rather than the prince and were mediated by bourgeois know-how and technology. By providing places of urban and suburban leisure and relaxation, they fulfilled the unprecedented function of initiating a diverse public to the use of time and space.[304] With the rise of engineers within the municipality, older idioms gave way to demotic ones; traditional forms of representation familiar to the elite, predicated on mythological iconography or classical allusions, dwindled in importance. Professionals like Alphand and Darcel epitomized "a possible transfer of power from traditional political offices to new groups claiming their rights as technical experts."[305] The fruit of collective endeavor, parks represented a range of political, cultural, and economic ideas, as the division of labor required by urban landscapes depended on collaboration among different disciplines.

In their choice of first-class experts from across the political spectrum, Haussmann and Alphand let themselves be guided by pragmatism. Darcel, who designed Vincennes, Buttes Chaumont, and Montsouris, was interested in scientific color theory, culled from the works of Newton, Goethe, and above all Chevreul.[306] Landscape practitioners, Darcel wrote, "will be greatly helped by the theory of complementary colors developed in depth by Chevreul; these experiments have shown that two hues harm or enhance one another depending on whether they are further or closer to complementary colors, that is, from the two colors whose combination produces white."[307] For André, by contrast, gardening was a humanist endeavor. Landscape, he held, "should take its inspiration from the compositions of great painters."[308] The paysagiste was an artist: "The soil is his canvas; trees, flowers and lawns, his colors."[309] Ever eager to prove himself an intellectual, André, in his important book *L'art des jardins*, nevertheless appealed to a class-bound language that inevitably excluded those who could not understand allusions to a Claude Lorrain or a Hobbema. A patrician like Ernouf also highlighted the importance of painting, enjoining landscape architects to consult works by the Barbizon school's Narcisse Virgilio Díaz to see the effects of light filtered through trees, and Poussin for the overall composition.[310] François Coignet, follower of Fourier and Saint-Simon, worked on different parks and projects for the municipality, patenting several forms of *béton armé* (prestressed concrete).[311] As a new, affordable material, concrete embodied the hopes for a new society that fired socialists such as Victor Considerant.[312] Coignet's political opinions were hardly to regime's liking, but they cannot have worried the emperor, who sympathized with Coignet's embrace of utopian ideals that left the class structure intact. Socialism, wrote Coignet, *"wants the rich to remain rich provided that the poor partake of the wealth."*[313]

Such varied ideological approaches, from an autocrat like Napoleon III and his complaisant lieutenants to a socialist like Coignet, make the Second Empire's green spaces susceptible to a variety of interpretations: a medium of expression for progressive engineers; a place of promenade and reverie; a site of freedom or transgression for others. Landscape can challenge as well as sustain the ways we think about the world.[314] Designed as political propaganda for the regime and as a homeopathic attempt at social harmony, parks and gardens had not been designed to question the status quo. Nevertheless, they exceeded the intentions of their planners and reflect just as much the social and economic aspirations of the rising middle classes. Although they had less leverage, workers frequented the parks in great numbers and interpreted them according to their own needs and desires. Teeming

with merchandise, undergirded by ideologies of nature and empire, they addressed specta-
tors as consumers of goods and services and, depending on their location, as classed sub-
jects. Whether or not the authorities hoped for a consensual response from the public, one
cannot collapse their goals with the response of the viewers, whose diverse reactions mir-
rored the heterogeneity of both the population and the "authors" of the municipal gardens.

As an environmental model, however, Second Empire parks were obsolete. Exotic
trees and plants from other continents relied on expensive, labor-intensive means to sur-
vive and required huge amounts of water in a city that never had enough for human
use. Municipal nature, subject to modern management, entailed serious problems. Clear-
ing old forests like Boulogne or Vincennes of underwood impoverished the soil by doing
away with nutrients and flora that helped protect and propagate trees. Same-age trees
predominated, often from a single species, which were more likely to be felled en masse
by storms.[315] Old-growth forests, sustained by greater biodiversity, had far more resil-
ience. Robinson, who always championed indigenous vegetation, scoffed at the "costly
green toys" of Parisian parks, which needed considerable maintenance and had to win-
ter indoors.[316] Wildflowers and hardy plants, the Irishman argued, showed "the immense
superiority of permanent embellishment over fleeting annual display."[317]

———————

Critics had often faulted the empire for destroying more gardens than it created.[318] Yet the
gardens they razed were private, while the ones they created were public.[319] Haussmann
whittled the Jardin du Luxembourg by a third, sacrificed two-thirds of the Parc Monceau
to real estate, and sold off chunks of the Bois de Boulogne to finance the plains of Long-
champ. In all this, the emperor was a willing accomplice, engaging in his own acts of
vandalism at the Tuileries. Had he had his way, the Rue des Écoles would have slashed
through the Jardin des Plantes to reach the Gare d'Orléans.[320] Countless private gardens
were razed to make way for new streets and squares. Renoir, whose home on the Place du
Carrousel was destroyed when the Louvre was enlarged, remembered sadly that "behind
every house there was a garden."[321] As Huysmans put it, "those who don't live on the street
suffocate; the air was once behind the façades and is now in front of them; the same goes
for the trees: they leapt over the houses and now agonize, in single file, on the sidewalks,
their feet shackled in cast iron."[322] And yet, in eighteen years, the Second Empire created
roughly 88 percent of the city's current green spaces.[323] Parks and gardens, brooks and
lakes, presented a refuge for wildlife and brought citizens shade, beauty, and birdsong.
Robert Moses—that second Haussmann—rightly claimed that the *grand préfet* gave Paris
"the finest park system in the world of the nineteenth century."[324] That Haussmann suc-
ceeded, of course, was due to the extraordinary quality of his experts.

Was there an alternative to the nature so efficiently promoted by the municipality?
Only mass production could deliver a network of parks, gardens, and squares ready-made
to the public. Reproducibility, however, did not necessarily determine this particular solu-
tion. Paxton's parks, Birkenhead in particular, and Olmsted's were more or less predicated
on the same technologies as Alphand's but followed a more democratic template. Arti-
ficial waterworks and unsustainable exotic plants became emblematic of the precarious

nature of an empire cantilevered over a social chasm: one that would overplay its hand in global politics and lose its means of support. Whatever they may have meant to the diverse population of nineteenth-century Paris, the Second Empire's green spaces were a fitting metaphor for imperial statecraft: a well-oiled machinery resting on an efficient modern infrastructure that ultimately failed to sustain the modern society it had hoped to create.

The end came quickly. In 1870, fearing the Prussians, Alphand was forced to chop down a huge curtain of trees he himself had planted in 1854 to mask the view of the fortifications.[325] That winter, enemy soldiers bivouacked in the Champs-Élysées and plundered the Bois de Boulogne, cutting 13,200 oaks (fig. 6.34).[326] A freezing, hungry population cut trees planted along the streets and boulevards for fuel. "In January 1871," wrote Victor Hugo derisively, "a Prussian bomb chose to fall on this corner of the earth, to continue the embellishments, and this Mr. Bismarck completed what Mr. Haussmann had begun."[327]

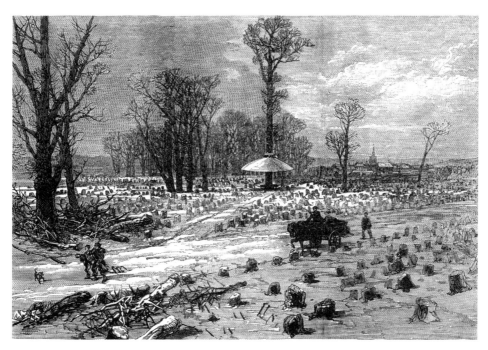

FIG. 6.34. The Bois de Boulogne during the Siege of Paris, 1870–71. *Illustrated London News*, January 28, 1871.

The Periphery

The centres of our great cities must be pulled down and rebuilt. [. . .]
The wretched existing belts of suburbs must be abolished and carried
further out; on their sites we must constitute, stage by stage, a protected
and open zone, which when the day comes will give us absolute liberty
of action, and in the meantime will furnish us with a cheap investment,
whose value will increase tenfold, nay, a hundred-fold.
　　—Le Corbusier, *The City of Tomorrow*

Nineteenth-century Paris was no melting pot. Already under Louis-Philippe, thousands of laborers, mostly from northern France, flocked to Paris on foot in hopes of finding work in construction. The Second Empire continued to absorb surplus labor in its vast machinery of public works. Railroads lent a strong impetus to immigration, breaking down the isolation of the provinces and diversifying the city's mass of residents. Split (like all cities) by social and economic segregation, the capital's huge mass of workers could be distinguished from one another by ethnic particularisms such as regional dress, dialect, and occupation.[1] Ostracized for their different customs and patois, recently arrived migrants were often forced to work for lower wages, attracting the ire of Parisian workers. Immigrants were outsiders twice over, rejected both in elegant areas of the city and by their locally born peers, welcomed mostly by those from the same village or province. Even a liberal like Louis Lazare made no secret of his discriminatory views: "The Parisian worker creates, invents; the provincial worker executes."[2] The presence of Russian, German, Belgian, Polish, Swiss, and Italian workers exacerbated the situation and in times of economic downturn led to outbursts of xenophobia.[3] Although migrant communities revealed an extraordinary capacity to improvise and organize themselves, insertion cannot have been easy. Yet one cannot underestimate the city's extraordinary powers of assimilation and urban integration through professional work, despite the forms of social exclusion to which its heterogeneous labor force was subjected.[4]

Workers formed a highly diverse group subject to economic and seasonal fluctuation: skilled and unskilled, French and foreign, Parisian and provincial. Hailing from different provinces or countries, a few came to put down roots, many to make money and return home. Others used the city as a stepping-stone to other destinations. Their experience as uprooted peasants or artisans often clashed with the urban views and lifestyle of their Paris-born counterparts, usually literate and well trained.[5] Provincials accepted menial

FIG. 7.1. Workers waiting to be engaged in the Place de l'Hôtel-de-Ville. *Illustrated London News*, May 1, 1869. Bibliothèque nationale de France, Paris.

jobs or worked in factories, where they survived thanks to mutualist organizations and networks of support. Not all were unskilled emissaries from *la France profonde*: specialized workers were also drawn to the great metropolis. Our knowledge of the lives of the laboring classes is uneven and relies on the survival of tangible sources and traces, inflected by scholarly protocols and traditions. Nor do we have a neutral vocabulary at our disposal. The words currently used for "workers"—*ouvriers*, *peuple*, *prolétaires*—are inadequate umbrella terms for a constellation of extremely different profiles.[6]

Migrants from the same province usually chose similar jobs: the Auvergnats took over the water trade; the Creusois supplied most of the capital's masons. It was a mason from La Creuse, Martin Nadaud, who rose to become a member of Parliament during the Second Republic, and a senator under the Third, when he and Haussmann (a senator himself) sparred over the restoration of the Tuileries. Nadaud's autobiography sheds light on the difficulties of the building trade, and the lifestyles and resilience of the immigrant class as a whole. The Creusois came to Paris in hordes, unaccompanied by their wives.[7] Lodgings were sought in the tenements of Rue de la Mortellerie near Place de Grève, where thousands turned up every morning in search of work (fig. 7.1).[8] By saving every sou, masons earned enough money to support their families back home, returning during winter or when there was a lull in construction. In the *chambrée* that Nadaud shared with his compatriots, "there were six beds and twelve tenants. We were so crammed that only a gap fifty centimeters wide was left to provide a passageway through this room."[9] Nadaud's contemporary Pierre Mazerolle, who studied the capital's patterns of indigence, explained that by forsaking privacy and comfort in these unhygienic quarters often without heat or even windows, migrants were able to lodge for very little, saving money to remit home: men paid five francs for a bed, and women three francs for theirs.[10] Close-knit social networks both protected them and delayed their integration in the big city.

FIG. 7.2. Honore Daumier, "Mr. Vautour: I cannot sufficiently impress upon you, that I want neither children, dogs, nor canaries in my house..." Lithograph, published in *Le Charivari*, October 20, 1856. Metropolitan Museum of Art, New York.

HOUSING THE LABORING POOR

If an earlier generation of town councilors had worried about the shift of commerce and wealth to the west, in Haussmann's day the underprivileged and their advocates were deeply concerned with the displacement of part of the working class to the outskirts.[11] Overcrowding in the inner city began under Louis-Philippe, when hundreds of houses were destroyed to make way for Rambuteau's public works. Those who were evicted in the process, explained Perreymond, "were driven back to the districts of Arcis, Grève, the Cité, Saint-Denis [...] whose filthy homes—narrow, humid, lacking courtyards or air— accommodated in their obscure crannies, the newcomers who came to squeeze themselves beside the all too numerous inhabitants of these unhealthy areas."[12] Thousands of workers, expelled from their homes with little warning, were scattered throughout the city. Daumier, whose mordant political cartoons were forced to veer off into social satire under Louis-Philippe, left an eloquent record of the expropriations of the July Monarchy and the Second Empire. His great series *Locataires et Propriétaires* (Renters and landlords) shows the poor evicted by demolitions or facing unreasonable restrictions imposed by their rapacious landlord, *Monsieur Vautour* (Mr. Vulture) (fig. 7.2).[13] Under the Second Empire, this volatile situation was aggravated by the broader scope of the grands travaux, which attracted more ouvriers, while demolishing the old housing stock. By the prefect's own reckoning, 27,478 buildings were destroyed during his tenure.[14] Workers were the main casualty of gentrification: when possible, Haussmann pushed his new streets through impoverished areas where the municipality paid less for expropriated properties.[15]

For the poor, urban removal followed on the heels of urban renewal. Numerous low-income residents were dispossessed of their dwellings to make way for the Boulevard de Strasbourg, the new Place du Châtelet, the clearing of the Cité, and, on the Left Bank, the Boulevards Saint-Michel and Saint-Germain, among others. Berger had already dislodged between thirty and forty thousand people in various parts of the center.[16] Those who lost their homes had no choice but move to overcrowded areas nearby, or to the sprawling periphery where rents were cheaper. On the whole, workers were reluctant to leave the center, where jobs were more readily available. "In such cases," wrote Antoine Granveau (a former ouvrier), "one calculates the difference between the price inside and outside [the

city]; many families would rather pay 400 to 450 francs inside, near their work, than 300 in the outskirts."[17] When rents rose beyond their meager budget, the only option left was to migrate to the edge of Paris, where chaotic urban growth became the norm. Nadaud accepted a job in the periphery only as a last resort: wages there tended to be lower and employment opportunities limited.[18] The exodus of so many workers reinforced the divide between center and periphery, as buffer zones began to disappear under the pressure of real estate.

Despite the erosion of the historic center during the Second Empire, thousands of workers continued to live there during and after Haussmann's tenure, even though density reached dangerous levels. An invisible population, immured in windowless basements and asphyxiating, "murderous" attics, struggled in the interstices of the cosseted city being rebuilt under Napoleon III.[19] With demolitions, the capital's modestly priced housing stock dwindled, outpaced by a steady stream of workers from other parts of the city, the provinces, or other countries. Available buildings, already dangerously crowded, were divided and subdivided into suffocating wedges unfit for human habitation. Living conditions in the center worsened, as hordes of workers wormed their way into overcrowded tenements left standing in the cracks of Haussmann's splendid new streets. According to the politician Othenin d'Haussonville, who wrote on poverty in Paris, the grands travaux produced two different kinds of misery: "the old one that conceals itself, packed into six-story houses in the center of the city; the new kind that spreads and proliferates in the outlying quartiers."[20]

The connivance of the authorities, who cast a blind eye on the stupefying squalor of workers' housing, aggravated the situation.[21] In the infamous garnis or cheap lodging houses vividly described by contemporaries, marchands de sommeil (sleep merchants) rented out slivers of space in filthy rooms crammed with tired bodies. Despite their appalling reputation, the number of garnis rose after the beginning of urban renewal and would grow even more during the Third Republic.[22] Redevelopment thus led to a rapid increase in urban density and intensive land use in the poorest districts of the city. "Workers stifle in the narrow and muddy districts where they are obliged to crowd themselves," Zola noted ruefully. "They inhabit the dark alleys near the Rue Saint-Antoine, the burrows of the low-lying Rue Mouffetard. It is not for them that the city is sanitized."[23] Even Belgrand criticized the municipality: if nothing were done to curb speculation, "half the people involved with commerce will live underground," he wrote, referring to the widespread custom of renting basement apartments to the poor. "I believe that the Administration should resist these inhuman trends with all its might [. . .] so that it will be impossible to build an underground city which, in a few years, would replace with disadvantage the old insanitary lodgings of the demolished streets."[24]

Outraged at having to leave their homes, those evicted by "public" works clung to tenements notorious for lack of hygiene and privacy. Their lives, if not their personalities, were inextricably bound up with the rich social networks that surrounded them, and they experienced an acute sense of loss when forced to leave. "In Paris," wrote Victor Hugo, "the identity that links an individual to himself, is broken off from one street to the other."[25] In order to remain in the center, workers were ready to live in terrible conditions that bewildered affluent sectors of society.[26] The poor seemed to rate the city above the quality of housing. Streets and buildings served as anchoring points for personal life. Resistance to moving was rooted in shared memories and complicities, in interlocking

networks that were not only spatial but social. Working-class districts, wrote Yves Lequin, teem "with the sound of reassuring intimacies, the warmth of neighborhoods and the familiarity of streets and courtyards, through the camaraderie bred in vacant lots, the fraternity of the stairwell, the companionship of routes undertaken together, in short with all the opportunities bestowed by everyday life to meet and exchange ideas."[27] Such politics of contiguity were particularly important for women. While men often worked at a certain distance from home, many women had no jobs, relying on forms of "horizontal sociability" that rarely went beyond the immediate neighborhood.[28]

This is not to romanticize living conditions in the center. In our day, "neighborhood ideology" has been strongly criticized. Henri Lefebvre in particular has denounced the normative implication of a belief that transforms a specific aspect of social life into an essence when this attitude toward the surroundings is in fact produced.[29] Lefebvre was admittedly speaking of a later period, when the scale of the city had transformed the traditional structure of urban life and destroyed the slow, incremental growth that marked towns of previous eras. Even in nineteenth-century Paris, however, powerful solidarities rooted in propinquity cannot be seen exclusively in affirmative terms. Urban violence took several forms that affected all facets of everyday life, although its workings often remained invisible.[30] Lack of water supply, adequate sewage disposal, and decent schooling for children, along with constant humidity due to the narrow width of the streets were the sad concomitants of life in the same high-density tenements that the urban poor were loath to leave. The city's dense, derelict districts were neither dangerous warrens of incivility and disease, nor happy communities where endemic problems and shortages could be magically sublimated by warm neighborhood ties.

RELOCATING THE POOR

The empire described the relocation of the poor in glowing terms: "Thus," remarked Haussmann in 1861, "in all directions, the exuberant population of Paris will soon find new neighborhoods, as vast as many cities, and it will be able to spread itself among them according to its needs and tastes; for speculation, which is remarkably well informed as to its interests, will surely stop building luxury homes whenever it realizes that the city already has enough."[31] The fact that so many workers were forced to leave the new city that they themselves were building rankled the urban proletariat. Why drive the poor away, asked the workers at the 1867 exposition, "after making them contribute generously to the embellishments of the city of Paris for twenty years?"[32] In the same report, the copper workers equated the outskirts "with those plebeian districts that our forefathers called *truanderies*, something similar to the Ghetto of Catholic Rome. It is unconscionable, we insist, to warehouse the worker in this manner, outside the center of social life."[33] What the laboring poor left behind were not just their homes, however inadequate, but their workplace. In back alleys and half-hidden courtyards, housing overlapped with cottage industries: workshops and forges coexisted noisily with livestock that supplemented the residents' diet and income. Haussmann and his predecessors were determined to deindustrialize central Paris, as reformers and hygienists had advocated for decades, and remove to outlying areas all establishments that polluted and constituted health hazards, or simply shocked the sense of decorum of wealthier strata, a trend pursued by the Third Republic.

For immigrants fresh from the provinces, the edges of the city, where the urban fabric began to fray, served as a liminal zone: no longer agrarian, nor entirely urban, it mediated between the built-up center and a countryside that had long since begun to show signs of urbanization. By contrast, residents shunted to the fringes often experienced the move as a regression to a form of life they had left behind, if they had ever known it, using terms such as "exile," "expatriation," and "deportation" to describe the traumatic experience of leaving homes, neighborhoods, and networks of social solidarity. Those most at risk of being uprooted were workers and even the salaried middle classes, who had far fewer options than the propertied strata, who had no need to relocate to the margins. Everyone complained, of course: "Soon," wrote Dr. Akerlis in 1861, "one will have to be a millionaire to live in Paris, or accept to expatriate oneself in some obscure village beyond the fortifications, fifteen or twenty kilometers from the center of the capital. Forced, in the name of public utility, to exile myself from the modest domicile where I had ensconced myself for twenty years in hopes of finishing my days there, I [...] had to settle for newly built housing."[34]

Granveau described the wrenching pain involved as communities split up, losing familiar surroundings and acquaintances: "They left behind their friends, changed their habits; tore, destroyed social bonds. Moreover, their departure exposed to everyone the family's means. People are bound to say that their poverty does not permit them to inhabit the interior [of the city] and that they must exile themselves to the frontier along with the dregs of society."[35] Large families compelled to move, he added, often had to accept the social stigma of living on the fifth or sixth floor.[36] Place also had to do with social standing, with what people would think. The violence of eviction was not only social but symbolic. Akerlis fulminated against the *cages à poulets* (chicken cages) and speculators "who coop up the whites of Paris as the blacks of Africa are cooped up aboard a slave ship."[37] His melodramatic and racialist pathos were typical of the middle classes, fearful of being priced out of the sites and trappings associated with their rank. A wide gulf existed between the actual exile of those who had to vacate the center often for a distant and desolate periphery, and the relocation of the middle classes who also had to face the ordeal of moving, but did so to housing of good or better quality, and closer to the center.

The staggering majority of those evicted by demolitions were workers, and the social ills awaiting them in the urban borderlands weighed heavily on their families. Haussmann acknowledged this in retrospect, though he symptomatically faulted the poor for their inability to understand the need for their removal in the grand scheme of things: "One does not dislodge 350,000 people and the industrial or commercial establishments with which many of them are involved, without causing a general upheaval that wearies the masses easily, unable as they are to appreciate its inexorable necessity, above all when it prolongs itself for the duration of seventeen years."[38] Rambuteau had said as much when traveling along the new Simplon Road in Switzerland. Hearing that it had not been well received by locals, he expressed the views of his class toward those ingrates who could not understand the benefits of great projects: "They do not realize the advantage that these entail, nor know how to profit from the initial results; they are upset with the need to break with time-honored traditions [...]. They grasp nothing but the unwelcome problems of the present."[39]

Urban renewal altered the social and political topography of Paris dramatically, even if poor inhabitants could be found in every district, either in segregated buildings or in

mixed areas.[40] The middle and upper classes felt less and less at ease east of the Boulevard de Sébastopol, preferring elegant areas where they could be among themselves.[41] Though not so well equipped as the rich districts to the west, the eastern part had the advantage of being within the city and thus fared much better than the hinterland of Paris. Increasingly freed of its middle-class residents, the faubourg Saint-Antoine became more homogeneous. It had always been characterized by modest workshops employing a small number of artisans, in contrast to the larger industrial establishments of the periphery, where the proletariat proper lived. On the whole, the laboring classes were made up of two broad strands, those who lived within the city, and those who lived in the outskirts, whose politics differed. The Internationale would recruit its cadres largely from the old faubourg Saint-Antoine, known for its artisanal trades, lively street life, and vivid memories of the barricades. La Villette and Belleville, with their concentration of factories, would furnish the rank and file of the Communards.[42]

The fact that some working-class enclaves fell neatly inside the old tax walls of the Farmers General had a pronounced effect on their residents' politics. During the revolution of 1848, some of the very first barricades sprang up around the Arts et Métiers, just east of what would later become the Boulevard de Sébastopol (see fig. 1.11). By 1871, the same area offered almost no resistance to the vengeful Versaillais in their bloody attack on the Commune under General Patrice de Mac-Mahon. This transformation from political militancy to passivity cannot be attributed to a change of tenants: the arrondissement witnessed no significant population shift. In all probability, its residents adapted with greater conformity to the higher profile of the neighborhood after it was renovated.[43] Gentrification paid political dividends. In the case of the once-revolutionary faubourg Saint-Antoine, its inertia in 1871 was due to its being hermetically sealed within the Second Empire's strategically placed boulevards and military barracks: "Judging from recent events," wrote the correspondent for the *Illustrated London News* in 1870, the faubourg appeared "to have no longer any sympathy with its ancient traditions, as latterly it has never shown the slightest disposition to take part in the various disturbances of which Paris has been the theatre."[44]

The more social classes were separated spatially, the more they came to fear and resent one another. Despite the presence of workers in every district, class lines hardened as the eastern half of Paris reacted to exclusion and dispossession with a rejection of its own, making the bourgeoisie uncomfortable. "The two spaces thus distinguished do not 'coexist,'" wrote Jacques Rougerie; "each—and this is especially true of popular space in 1871—finds itself in the position of both the aggressed and the aggressor."[45] Yet turf wars and intramural squabbles began long before the Commune. Already in 1845, Balzac had described the eastern half of the city as foreign territory, frequented by "inelegant and provincial masses, mercantile and poorly shod."[46] Three years later, Engels noted that the faubourgs du Temple and Saint-Antoine were inhabited almost entirely by workers. When the revolution broke out, he continued, the insurgents "immediately began to separate their territory, the Paris of the workers, from the Paris of the bourgeoisie, by two main fortifications—the barricades at the Porte Saint-Denis and those of the Cité."[47] Gone was the illusion of neutral space. Although the Second Empire did not bring about the partition of the city into a working-class east and a wealthy west, it certainly heightened the contrast between the two, deepening the rent in the city's social fabric, now subject to increasing segmentation.

Notwithstanding abundant documentation, there is no consensus as to the extent of the housing crisis during this period. Statistics show that with regard to the historic center, problems had been worse during the July Monarchy, when immigration from the provinces peaked: Rambuteau's public works included the new fortifications surrounding the city, a huge project requiring a considerable labor force.[48] Haussmann strenuously denied that there was a housing shortage: "The number of new buildings exceeded that of demolished houses substantially; and the number of new dwellings ready for habitation, that of destroyed ones, so that the total number of vacant lodgings offered to the public was constantly increasing rather than decreasing; this was bound to moderate the rise in rents caused by the decline in the value of money, which could not assuredly be attributed to my administration."[49] However, the difficulties faced by the poor were not merely available housing but affordable rent. The destruction of tenements in the inner city drove up the price of extant lodgings, real estate, and property taxes. While salaries went up 30 percent under Napoleon III, the cost of living went up at least 45 percent.[50] In 1856, Haussmann himself admitted that rents in the center doubled after 1851, rising even in the poorest areas.[51] Inflated rents undoubtedly contributed to the relocation of thousands of poor residents. Spatial dislocation increased social stratification.

Toward the end of the nineteenth century, rent represented on average between 10 and 12 percent of workers' actual wages.[52] But it loomed large in the preoccupations of the class as a whole. The suspension of the moratorium on rents and debts played an important role in the origins of the Commune.[53] Bad harvests, fluctuations in the labor market, illness, and work-related accidents constituted threats that all too easily ended with eviction and the need to relocate. Mass migration from the provinces further complicated this unsettling pattern. Nadaud's memoirs show how he moved to a different location every time he returned from his yearly visit home to La Creuse.

Denis Poulot, a republican whose book on the laboring classes was published the year Haussmann left office (1870), explains how rent destroyed families:

> The impossibility of finding reasonably priced lodgings, the rapacity and pretentiousness of certain landlords, are very often the cause of unbelievable despondency, of implacable hatreds, and the source of terrifying misery and shameful degradation.
>
> In order to pay their rent, the ouvrière prostitutes herself, the married woman deceives her husband, the mother dishonors herself; the husband, discouraged at being unable to raise money for rent, wallows in drink, unemployment and illness having made it impossible for him to face the situation.[54]

Large families were particularly at risk. It is important not to have children, wrote Alexandre Weill in 1860, "for in the center of Paris each child costs between 12 and 1,500 francs in rent a year, not to mention the fact that the child is an obstacle to finding a domicile to rent."[55] Homelessness was all too common an experience among the most fragile elements of society who got by on the bare minimum. Hundreds of abandoned children were found in Paris every year, sleeping wherever they could find some space together (fig. 7.3).

Haussmann tried to gloss the exodus of workers from the center as an attempt to seek more space and fresh air at lower cost, describing the periphery as "a sort of America open

FIG. 7.3. Edmond Morin, nest of "swallows" (homeless children) sleeping on the Pont d'Arcole, *Le Monde illustré*, August 11, 1860. Private collection.

to pioneers."[56] In the faubourgs beyond the tax walls, land was cheaper than elsewhere; there, he declared brightly, speculation "builds houses that in certain aspects have as fine an appearance as those of the center, and where equally comfortable apartments are also less expensive; on the other hand, houses are subdivided into small lodgings with prices proportionate to more modest budgets. Speculation thus follows and favors the movement of the population toward the new city, and responds to the needs of all classes."[57] Far from contributing to the rise of the rental market, he asserted, public works in the center in fact increased competition, a factor that could only be advantageous to renters. Scrupulously honest with regard to his own money, Haussmann could lie outright when it came to defending policies that affected those he considered the undeserving poor: "In Paris, one builds even more for the underprivileged classes than for the others," he remarked.[58] But in a report to the emperor, he disavowed this proletarian pastorale, claiming that it was necessary "to accept in a just measure the high cost of rent and food, unavoidable in every great population center, as a useful tool in defending Paris against the growing invasion of workers from the provinces."[59] Workers, of course, understood all too well that the cant about more space in the villages ringing the city was a cynical feint: they were not wanted in the urban core.

Haussmann was fully aware of the extent of poverty affecting the majority of the population and, like his predecessors, paid substantial sums to keep the more vulnerable from utter destitution. In a report on the finances of the city for the year 1862, he gave a devastating assessment of the situation: over one million residents—more than half of the population—stood in need of bread rations (*bons de pain*); 435,210 people were exonerated from paying most of their rent because they could not afford it; 141,135 received some sort of help to defray housing costs; overall, 70 percent of the population was poor, and over one million lived close to indigence.[60] So dire was the condition of the urban masses that several philanthropic and commercial organizations initiated projects to help with education and housing. Alarmed at the volatile situation of the capital after 1848, public and private sectors joined hands, fearful of yet another uprising.[61] But these palliatives could not keep up with population increase, housing shortage, and the escalating costs of living.

Among the mass of workers desperately searching for rental apartments, single women stood out, subject to discrimination on account of both class and gender. By 1860, the capital had one hundred thousand female workers.[62] On the whole, women earned less than half the salary of their male counterparts for equal work.[63] Resistance to the presence of women in the labor market soared when they were admitted to the same workshops as men, particularly during strikes. It is not women we oppose, declared workers in a report of 1862, but "an instrument for reducing wages, a lower-priced worker."[64] While opinions of women varied widely among male workers according to a broad spectrum, there is no question that women had to face discrimination within their own social strata.[65] In his book on working-class women (1861), Jules Simon concluded that apart from manufactories, single women could not find a way to live.[66] Married women could still get by, thanks to their husbands' salaries. "But the ouvrière without a husband, alone, unable to feed or clothe herself decently with her 20 sous, suffers, drinks, or sells herself," wrote Lazare.[67] Landlords invariably asked prospective female tenants if they were married; if not, they often turned them away since, usually involved in sweated labor, they did not earn enough to support themselves. Life on the fringes meant depressed wages or punishing treks to work. Although rents cost less than in the center, the ouvrière would have to spend more time getting to work and back and considerably more money on shoes. Those who failed and lost the means to return home had to seek shelter in gender-specific refuges. In such places, 79 percent of the women came from the provinces, showing the huge obstacles women faced when migrating to Paris.[68] Given the circumstances, all female professions "paid their tribute to prostitution," wrote the German physician Henri Meding in 1852.[69]

The most destitute families moved into the *cités*: dismal, jerry-built shacks improvised mostly at the edge of Paris, near or beyond the fortifications. Their numbers rose sharply after the July Monarchy. Every time an old street or rookery was destroyed, new cités sprang up further and further away. Built privately, without the slightest attention to hygiene, they remained outside the compass of the law. These dreadful structures were thrown together with refuse salvaged from the city's waste: the Cité des Kroumirs, whose misery fell to such low levels as to earn it an exotic name; the Cité de Gand, Cité Philippe, Cité du Tarn, Cité Delambre, La nouvelle Californie, or the notorious Cité Doré (fig. 7.4).[70] As they were poorly documented, their precise number and location is unknown. Rents were paid to the owner of the land or of the hovel. In some cases—the Cité des Kroumirs, for example, or La Fosse aux lions—the landowner who pocketed money from the impoverished tenants was none other than Public Assistance.[71] When asked why they did not prefer to live in the upper stories of tenement houses, inhabitants of the Kroumirs answered that "many landlords refused to rent to large working-class families."[72]

The cités housed indigent families with numerous children, the infirm, and those whose familiarity with the abject made them unacceptable to society, such as the chiffonniers, the untouchables of the city. A source of preoccupation to authorities and the leisured classes, ragpickers lived primarily in the poorest parts of the Left Bank near the Montagne Sainte-Geneviève, the Rue Mouffetard, or the miserable faubourg Saint-Marceau. Annexation would hurl many to the periphery or beyond the fortifications on both sides of the river.[73] Considered outcasts, members of fringe communities like these survived largely on their own, in precarious endogamic groups, lodged in conditions of unspeakable destitution. Yet they played a large role in print culture, where they were exoticized.

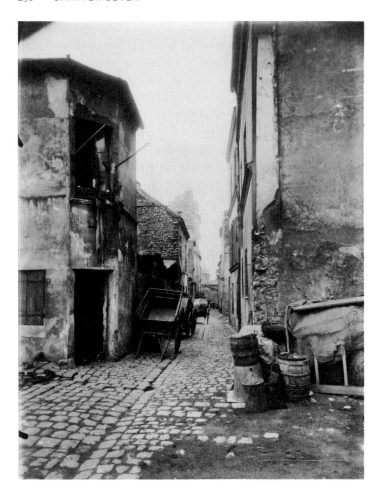

FIG. 7.4. Eugène Atget,
Cité Doré, 1913.
Musée Carnavalet,
Paris.

The cités lasted well into the Third Republic. Many had no windows: window taxes, instituted by the Revolution, disappeared only in 1926. In 1890, a chronicler of Parisian poverty left a detailed description of these horrific hovels, ridden with vermin and lacking the most basic sanitary services. The Cité Maupy, wrote Alfred Coffignon, was "a large vacant lot entered through a breach made in the surrounding wall; at the end of the lot [rise] bizarre constructions, where over six hundred people live, jumbled structures, some made of plaster tiles, others of simple planks, yet others of the most disparate materials haphazardly assembled and covered over with beaten earth. Zinc sheets, placed on joists, form the roof which a gust of wind would suffice to remove, had they not been secured by large stones."[74]

Although there was a great deal of writing on poverty at the time, we know very little about how most impoverished Parisians lived, especially those drifting uncertainly at the edge of the capital. Representing the poor and their lodgings was no easy task. The documents that have come down to us, heavily mediated by middle- or upper-class sensibilities, "tell us more about the mentality of the researcher than of the lived reality of the migrants," wrote Alain Corbin.[75] The leisured classes had only just begun to question the causes of poverty and did so in terms characteristic of their milieu, torn between

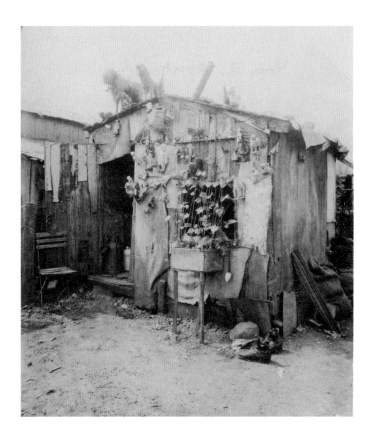

FIG. 7.5. Eugène Atget, ragman's house, Porte de Montreuil, outside the fortifications, 1910. Musée Carnavalet, Paris.

fear and ethnographic voyeurism. Workers did represent themselves but were more often spoken for. Researching poverty in Paris a few years after the Commune, Pierre Mazerolle complained that "few among these authors who have tried to portray the disadvantaged classes have frequented the people of whom they speak. They hardly know the language of the workers, their mores, needs, virtues, vices, the depth of the misery into which they can sink, and the very different causes of this extreme misery."[76] Describing the abject Cité Maufry in Montmartre, for example, Coffignon noted patronizingly that "the general aspect of this cité is miserable, for sure, but not sad; one must underscore a thousand details that render it picturesque. Here, a stuffed raven placed above the entranceway in a grotesque manner; there a window curiously garnished with shells; further still, a wall covered with tiny scintillating bits of mirror."[77] As late as 1912, Atget photographed a rag-picker's house that showed a clear intention to decorate the exterior (fig. 7.5). Coffignon and Atget both represent a hovel, but Atget does so through nondiscursive means, without aestheticizing poverty and without condescending paternalism.

BUILDING FOR THE WORKING CLASS

Once elected to office, Louis Napoleon launched several initiatives on behalf of workers. In 1849, while still prince-président, he gave five hundred thousand francs to the Fourierist Société coopérative immobilière des ouvriers de Paris, under the leadership of engineer Joseph Eugène Chabert, to help finance new *cités ouvrières*.[78] The same year, he sent

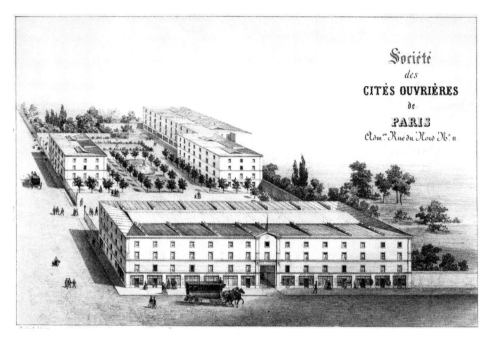

FIG. 7.6. The Cité Napoléon, designed by Marie-Gabriel Veugny, 1849–51. Musée Carnavalet, Paris.

a delegation to London to study low-income housing in Britain that included architect Charles-Pierre Gourlier, a specialist on the subject.[79] When Henry Roberts's book *The Dwellings of the Labouring Classes* came out in 1850, Louis Napoleon had it translated into French and distributed among his prefects.[80] Roberts's collaboration with industry resonated strongly in France, as did his adoption of advanced technology "to transform the house into an industrial product" suitable for the modern age.[81] In 1852, Louis Napoleon allocated ten million francs for workers' housing in France, with money raised from properties confiscated from the exiled Orléans.[82] These initiatives must be seen in light of a debate that had begun years earlier, concerning the squalor and overcrowding of working-class housing that threatened the social order.[83]

Although the Société coopérative initially hoped to erect a cité ouvrière in each of Paris's twelve arrondissements, only one came to fruition, eventually called the Cité Napoléon. Designed by city architect Marie-Gabriel Veugny for the Société des cités ouvrières de Paris, it was situated at a certain distance from the center, on a sparsely populated street that Proust later called, disdainfully, "la si populaire et vulgaire rue Rochechouart."[84] Given the difficulty of raising funds, only four of the original five buildings were built around a central courtyard, planted with trees (fig. 7.6). The main wing, parallel to the street, was ingenious. An unpretentious façade hid an extremely innovative interior, which Veugny designed in the manner of Fourier's *rue-galerie*: two long parallel buildings were linked by galleries springing from stairwells at either end. Footbridges led from these to the individual apartments.[85] Glass roofs covered the stairwells, transforming them into airy spaces lit by zenithal light, luxuries traditionally absent from working-class housing, and crucial components of salubrious dwellings (fig. 7.7). The circulation system bears some resemblance to that of the model prison of Mazas in Paris, whose construction Veugny was overseeing as inspector.[86]

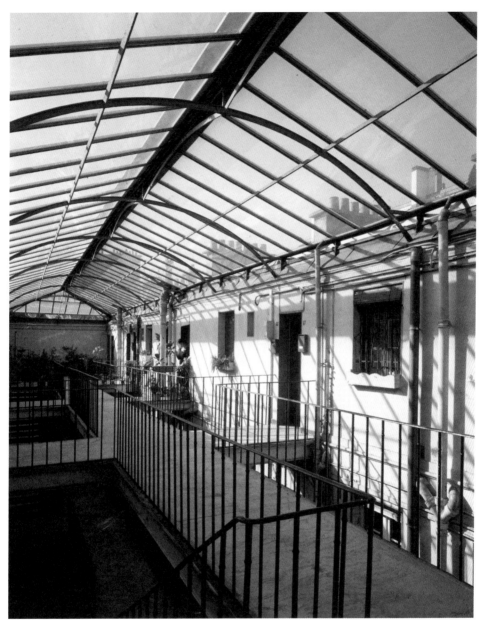

FIG. 7.7. Stefano Bianchetti, interior of the Cité Napoléon.

Sinks and toilets could be found on every floor, though not in individual apartments. Water had to be fetched from the patio. Baths, a washhouse, and a nursery were provided for a fee. Communal services such as these, a radical departure from bourgeois apartment buildings, represented nothing short of "a new form of living."[87]

Inaugurated in November 1851, shortly before the coup d'état, the Cité Napoléon was not fully completed.[88] Roughly six hundred tenants soon occupied the two hundred apartments of varying size. For all its modern amenities, class dictated the way it controlled the lives of its tenants. Built according to precepts of modern technology and hygienist reform, the institution was run in an anachronistic manner reliant on coercive rather

than consensual measures. Constant surveillance angered and humiliated tenants, who felt infantilized by a concierge guarding the single entranceway, the curfew, and a long list of one hundred rules. In their report to the 1867 World's Fair, workers had no qualms in articulating what they thought of such initiatives: "This establishment was an example of the ideal that certain philanthropists dream up for the worker. These vast barracks, composed of 200 apartments, had baths, a washhouse, a nursery, and a good number of policemen, all for the safety and well-being of the residents. One had to be home *militairement* by ten o'clock; water could only be had with permission from the concierge; unaccompanied children were not allowed to be seen in the courtyard nor in the stairways."[89] Furthermore, they added angrily, "those who had refused to let themselves be locked up in this way were accused of ingratitude."[90] Draconian discipline of this sort had already appeared in the agricultural colonies devised by Louis Napoleon in his tract *L'Extinction du paupérisme* (1844): "All workers will be housed in barracks like those of our military camps," supervised by a "severe discipline," to prevent urban poverty from becoming "seditious."[91] These buildings, of course, did not resemble barracks except in the authoritarianism of their regulations.

Known as *la barraque*, the Cité Napoléon was a resounding failure among workers. Thereafter, the urban poor tended to avoid dwellings sponsored by the authorities, eyeing with suspicion anything that smacked of regimented housing and rejecting the segregation involved in class-specific buildings.[92] When economist Armand Audiganne asked them why they so disliked the cités ouvrières, workers answered: "We leave the workshop where we are under a regime of inexorable regulations; have masters and countermasters, incur fines and other penalties; then, on returning home, we would find yet another regulation posted to our door which would affect almost all our private actions; the administrators of the cité would be yet other surveillants; we would not be masters in our own house."[93] Moreover, only highly skilled workers could afford the rent.

Even so, the Cité Napoléon had its admirers. For Paul Taillefer, the physician of the housing complex and full-throated apologist for the regime, the Cité Napoléon was the best of all possible worlds thanks to its strict ordinances: a school for virtue and a warranty against urban strife. Providing good housing for the worker, he continued, is "the best way to keep him from politics, and even to procure employment, thus ensuring that industry and capital receive the trust they demand; it will restore social harmony among all classes of society and end the era of revolutions."[94] In his view, "those whom we generally call the people, have never wanted and never will want to command. They would much rather be led [. . .]. They will gladly leave the responsibility for their conduct to whomsoever has the firm willpower to make them happy."[95] Workers proved him wrong in word and deed. Within a decade or so, not a single one was left on the premises. "While we acknowledge the value of such initiatives, we affirm, as partisans of liberty, that we want to take responsibility for our own affairs; the only thing we need is freedom," they declared flatly.[96]

The idea of segregating the laboring classes was unacceptable to liberals and conservatives, though for different reasons. Conservatives strenuously opposed any concentration of large numbers of workers under one roof, which they saw as an incentive to revolt. Progressive sectors of the middle classes took issue with the overall conception of the Cité Napoléon, though they rarely focused on architecture, and never on the interior. Daly's *Revue générale de l'architecture*, usually so favorable to the regime, pronounced it satisfactory

from the point of view of hygiene but faulted the unadorned simplicity of the elevations, which resembled "the garrison, the hospital or the cloister."[97] Jean-Baptiste Godin, a social reformer who had not yet begun his own great foray into the field, the Familistère at Guise, condemned not only the idea but the very term *cité ouvrière*, which presupposed "the separation of those who create wealth through their work, from those who enjoy it thanks to the accident of birth or speculation."[98] Chadwick gave a devastating review of the Cité Napoléon: "But of the cité ouvrière it must be said that, although devised with a view to economy, its construction was ill advised and unfortunate; for, with the aspect of a barrack, it had not the complete independence of each tenement," he wrote in the *Illustrated London News*. "The result of this well-intended effort has, I apprehend, been to retard progress."[99]

Undeterred, Napoleon III undertook several other projects.[100] In 1852, he sponsored a well-publicized competition for working-class housing that would both be affordable for workers and serve as templates for the private sector by guaranteeing profit. Entries had to insure "a healthy, airy lodging, reasonably well heated, provided with light and water, in which each family would live separately."[101] When his son was born in 1856, he bought a large tract of land on the Boulevard Mazas to build seventeen low-income houses for the working class. A decade later, he commissioned forty-one model homes for workers on the Avenue Daumesnil and had a hand elaborating the plans. These reflected the gradual change in public opinion concerning workers' housing that emerged in the late 1860s. The cité ouvrière, with its communal facilities, had been left behind. Although the withering criticisms of the Cité Napoléon seem to have been taken into account, the houses were not altogether successful. Greater attention was paid to the individuation of the façade: the volume was broken up into smaller units, and different materials ruled out the institutional look of serial housing.[102] Families were accorded greater privacy; each had its own floor and water inside rather than outside the apartment. But the humiliating discipline embodied in regulations was still present, and workers' delegations criticized the emperor's projects forcefully.[103] Like other initiatives for the laboring classes subsidized by the government, the Daumesnil buildings were soon given over to a real estate cooperative to increase profits. At Vincennes, the sixteen buildings designed by Eugène Godeboeuf and funded by the state were also turned over to speculation, which raised rents above what workers could afford.[104] As for the Cité Napoléon, it passed within a few years from the Société des cités ouvrières to private hands, which sought tenants of higher income and whittled some of the common spaces to create more rental space.

Napoleon III's main efforts on behalf of workers' housing culminated in the 1867 World's Fair. In response to his wishes, the commissioner for the exposition, the socially oriented but conservative engineer Frédéric Le Play, devoted a large section to model houses for the laboring class. The emperor's involvement in this venue clearly echoed that of Prince Albert, who had asked Henry Roberts to erect a group of workers' houses displayed to great acclaim at the Crystal Palace exposition of 1851.[105] The French exhibit included ten models, including six life-size housing prototypes designed by the workers themselves without the help of architects, and funded by Napoleon III.[106] In their projects, there was no concierge to oversee the tenants, while boutiques along the street brought in revenue. They also published a remarkable report wherein they outlined the harsh conditions under which they toiled and candidly castigated many experiments, including the Cité Napoléon. Architect Joseph-Eugène Lacroix erected four housing units built with the

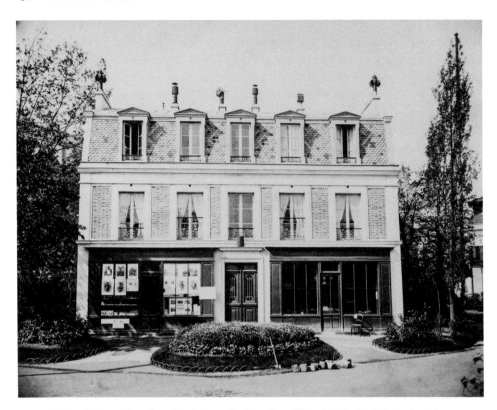

FIG. 7.8. Pierre Petit, workers' housing designed by Napoleon III at the World's Fair, Paris, 1867. Bibliothèque historique de la Ville de Paris.

help of Napoleon III in Rue de Monttessuy. Executed with care, and provided with shops on the ground floor, they were well received by workers.[107] Émile Muller contributed a prototype of his houses for the Dolfuss company at Mulhouse, while other architects presented single-family houses. Predictably, the emperor received a gold medal for his entry. His small, two-story building with boutiques below, designed along the lines of bourgeois prototypes, received a stern critique from Roberts, who faulted the inadequate layout and found nothing "which appeared to me meriting special commendation" (fig. 7.8).[108]

Influenced by Roberts and Chadwick, the emperor also tried to incentivize the private sector by providing subventions to low-income housing for workers, along the lines of British building consortiums.[109] Save for a few projects, he argued, the state could not do so directly: "Individual initiative, exercised with indefatigable ardor, frees the Government from being the sole promoter of the vital forces of a nation."[110] Many low-income housing projects, for the most part unremarkable, were erected by bankers, financiers, and philanthropists, including aristocrats, some of whom received subsidies from the ten million francs set aside by the emperor for such initiatives.[111] Expecting returns on their investment, they either cut corners or delivered a better product beyond the reach of workers. In the case of an apartment building erected at Batignolles by the Péreires, its lodgings were soon subdivided and converted to an *hôtel garni*.[112] We know little about private endeavors like the Cité des Gobelins, built by a developer in 1854 in an impoverished district. On the whole, however, Napoleon III's projects and those by the private sector remained trapped

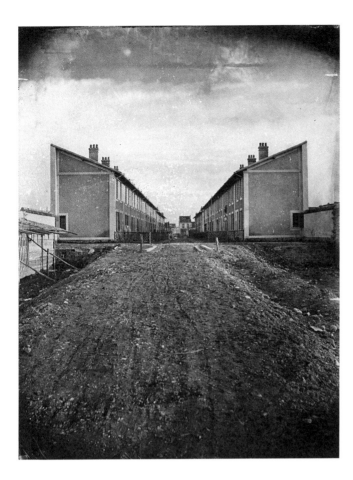

FIG. 7.9. Charles Marville,
Maisons Jouffroy-Renault,
built in 1865. Bibliothèque
historique de la Ville
de Paris.

within a reformist ideology that saw the house as an instrument of social control. Permanent lodgings for a transient population, condemned to move by the vagaries of the labor market and housing shortage, preoccupied the government and the propertied classes. Whether built in Paris or in the industrial north, individual houses for the laboring poor obeyed the same ideology of productivity predicated on social engineering. In the words of Manfredo Tafuri, the house "produces production" in its attempt to "to stabilize the family cell in places that are themselves predetermined by the demands of production."[113]

For a few years, speculators and real estate promoters toyed with the notion of the *maison ouvrière*, "conceived," wrote a contemporary, "in isolation like the detached bourgeois house, but with uniformity overall and appropriate rent."[114] The idea that property kept revolution at bay by tying workers to the land was a sacrosanct tenet of the elites. It is crucial that the ouvrier own his house, claimed Edmond Demolins: "Soon it will be his house that "owns" him; it moralizes him, roots him, and transforms him."[115] In northern France, private industry had taken the lead by building individual *maisonnettes*, another model favored by Roberts.[116] Company housing was attractive to capitalists because it greatly reduced workers' bargaining power with regard to their landlord-employers.[117] Le Play's impressive monographs on the laboring class made a strong impression on social reformers.[118] Ever fearful of revolution, he preferred a cautious, gradualist approach. In 1865, a Madame Thénard erected a well-reviewed group of seventy-six one-family houses with tiny gardens in the outskirts at Clichy: the Cité Jouffroy-Renault (fig. 7.9). It received

a gold medal at the 1867 exhibition and is still in excellent shape today.[119] While cottages seemed less authoritarian to workers than large blocks reminiscent of barracks, the prohibitive cost of real estate in Paris did not guarantee private entrepreneurs sufficient returns.[120] Large apartment buildings thus remained the norm.

If Napoleon III tried so often, and so often failed, in his attempts to improve working-class housing, it was partly because he wanted to reconcile populism and authoritarianism; to increase standards of living so workers could live productively in the modern industrial world, relatively free from hardship but controlled at work and at home.[121] Both interested and disinterested, his contributions were restrained by dynastic ambitions and political fears. Located in or near the periphery, his projects reinforced established patterns of segregation and marginalization of the proletariat. Conceived partly as an insurance policy against insurrection, they attempted to solve social problems without getting at their root. A pacified, domesticated laboring class could not be had at such low cost. Napoleon III had few direct contacts with workers. On the rare occasions when he received them, he made no attempt to redress the wrongs brought to his attention.[122] During the 1867 exhibition, the workers' delegation never got a chance to meet him, nor did he attend the inauguration of the Cité Napoléon. The imperial ear remained distant. He preferred grandiose pronouncements beamed at the proletariat from the center of power. The emperor's disengaged interest in workers often expressed itself as part of his and his wife's private philanthropy.[123] It was more than the perfunctory charity of kings, perhaps, but less than justice. With respect to the needs of the laboring poor, Napoleon III was both well read and sadly out of touch with those he intended to help.

For all the limitations of his approach, the emperor was the first French statesman to show concern for working-class housing.[124] Immersing himself in the available literature on the topic, he drew architectural plans, exchanged ideas with acknowledged specialists in the field, and undoubtedly encouraged the construction of low-income lodgings. Although research is far from complete, roughly fifteen hundred low-income lodgings are known to have been built under his watch in Paris—a negligible sum, serving a tiny fraction of workers.[125] Yet when it came to the proletariat, Napoleon III was far more liberal than his prefect, who did not volunteer the help of the administration in any of the imperial housing projects. Since the city owned land along streets and boulevards, it could have easily donated a few plots for low-cost housing.[126] While many thought the city should build directly for the poor, Haussmann always refused.[127] Even weighed down by its baggage of paternalism and social engineering, the emperor's housing concerns remained far beyond the reach of his prefect.

Afflicted with incurable myopia toward the poor, Haussmann never lost his fear of the vulnerable part of the population whom he considered potential enemies of the regime, lacking fixity in jobs or housing: "Paris belongs to France, and not to those Parisians by birth or by choice who reside here, nor above all to the mobile population of its lodging houses, that distorts the results of the ballots with the oppressive burden of unintelligent votes; [nor] to this tribe of 'Nomads,' according to an expression for which I was reproached, but whose accuracy I maintain."[128] It was the unavoidable mobility of the poor that led the sedentary middle and upper classes to dismiss them with an Orientalist term.[129] Like many of his contemporaries, Haussmann had a visceral, racialized view of the "dangerous" classes, whom he criminalized and tried to contain with preemptive

punitive measures.[130] In a speech to a political club delivered years earlier, when he was prefect of the Gironde, Haussmann made his thoughts on the matter perfectly clear:

> I first spoke of the Slavery of the Blacks, fed better, housed better, and treated better, materially happier, all in all, in the dwellings of plantation owners than they surely would have been in their countries of origin, and who nevertheless had no other thought than to reconquer their lost freedom. Then, passing from this issue to that of the Organization of Labor, I asked how the same men who rightly rose up against the odious slave trade, could dream here at home of reducing the whites to servitude by advocating socialism, the most absolute negation of one of the first liberties: that of individual labor.[131]

Despite their differences, emperor and prefect were the willing enablers of an entire class that had been shaping urban policy for decades, seeking to put a greater distance between themselves and the underprivileged whose uprisings they dreaded. On his trip to Paris in 1867, Field Marshall Helmuth von Moltke understood this perfectly: as new palaces displaced dwellings, "the poorer class has to be accommodated elsewhere, and the emperor does that indisputably and on a grand scale. This means, of course, that workers are expelled to the suburbs. The consequences for a vigorous management of public order and security are easy to see."[132]

The Second Empire's authoritarian form of urbanism, partly shaped by fear, was also indebted to thinkers fired by the progressive ideals of Saint-Simon and Fourier, drawn largely from the École Polytechnique.[133] These oscillated between modern, productivist goals and disciplinarian control, never reaching a consensus as to how or where workers should be housed. Daly proposed relegating them to the countryside along with factories: "Paris," he wrote, "contains within its bosom, a horde of thirty thousand enemies, active, restive, both faithless and lawless, constantly plotting in the shadows some conspiracy against property, or attacks against the safety of its citizens."[134] By contrast Lanquetin, an influential municipal councilor, believed emphatically in the need for a diverse city where social classes coexisted peaceably, writing in 1840: "Municipal interest, general interest, and political interest require [...] that all classes of the population live spread out and inter-mingled in all the districts of Paris. Yes, I declare with conviction, the day when we permit ourselves to govern in such a way that these classes are separated, when we have aristocratic and proletarian districts, wealthy and indigent districts [...] we shall have destroyed the essential foundation of public order, and prepared frightening calamities for our country."[135]

Lanquetin's warnings were eerily prescient, as the tragic bloodshed of the Commune would show. Yet his commendable ideals of social diversity cannot be taken at face value. There are no apolitical utopias. The propertied classes, republicans included, remembered all too clearly the urban revolutions of the 1830s and 1848, and their words of urban recon-ciliation were clearly overshadowed by class fears. It was, after all, a republic that ruthlessly extinguished the uprising of 1848, and one still to come would far surpass it in ferocity, in 1871. The guilt-ridden, reformist ideals of the polytechniciens were unconsciously moti-vated by the same fears as those of the emperor and his entourage. Lanquetin's pious rea-soning is close to that of an autocrat like Napoleon I, who declared his opposition to large agglomerations of workers unequivocally, and proposed a strategy of class allegiances to secure the capital against insurrection:

In a cité ouvrière, if the worker falls ill or lacks employment, who will assist him? If he resides, on the other hand, in a lodging where there is wealth and ease, someone will lend him a hand, come to his aid without fail, because each class that makes up the Parisian family has an interest in this mutual understanding, in this fraternal assistance.

The idea of building working-class cities is obviously a revolutionary one; it was undoubtedly put forth in order to have within reach a poor and compact population to unleash on the nobility and the rich, once the signal is given.[136]

Not by chance does Perreymond mention the "population dangereuse" in his studies on Paris.[137] There was, wrote Nicholas Papayanis, "a great degree of fluidity between socialist and nonsocialist approaches to urban problems."[138]

ANNEXATION

Relations between the municipal administration and the working class would become even more fraught after annexation. The idea of incorporating the belt of land surrounding Paris had been discussed by previous administrations. Taxation was a crucial issue since all goods entering the city were subject to fiscal duties. In times of revolutionary upheaval, tariffs levied on chattels often led to violence. The ineffectual tax wall of the ancien régime, punctuated by Ledoux's beautiful customs gates, had been completed in 1790. Irrelevant from a military point of view, it still marked the urban limits of the city in Haussmann's day, serving as an economic filter that allowed the poorest segments of the population to live within walking distance from the center. When the Conseil d'État raised the idea of pushing the tax wall further back, Napoleon I opposed it vigorously on political grounds: if the octroi were not maintained where it was, he told his prefect Nicolas Frochot, "your luxurious city will become a Cité ouvrière."[139]

During the July Monarchy, Perreymond and Considerant had both advocated annexation: sooner or later, when demographic pressure forced the government to expand city limits beyond the excise walls, it would have to pay dearly to straighten roads and crop protruding buildings.[140] Although Rambuteau refused to engage in the complex and expensive operations involved, it was the July Monarchy that sealed the fate of the periphery.[141] In 1841, fearing foreign invasion, or so he claimed, prime minister Adolphe Thiers ordered the erection of a continuous line of fortifications far beyond the perimeter of city (fig. 7.10).[142] When villages that had sprung up around Paris, including Batignolles, Montmartre, La Villette, Belleville, Vaugirard, and Montrouge, found themselves sandwiched between the two enclosures, annexation became all but inevitable.[143]

Napoleon III recognized this before Haussmann assumed office, instructing the Siméon committee to treat the city and its suburbs as a whole: the plan d'ensemble of Paris should be extended "all the way to the fortifications."[144] This was an explosive issue. In the last years of the Restoration, Chabrol had already warned Charles X that if his prefects allowed the capital to be encircled by factories, Paris would be "strangled."[145] Now that this was a fait accompli, it was imperative to annex the periurban zone in order to complete the task of urban colonization. Haussmann expressed his views on the matter with characteristic bluntness: it is necessary to include within the administration of Paris "this populous region, poorly administered, badly policed, disorganized, that chokes the

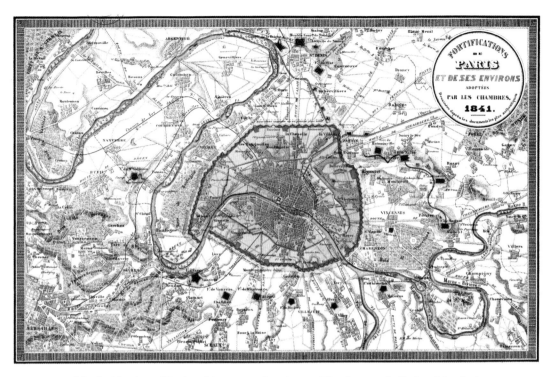

FIG. 7.10. The fortifications of Paris and its surroundings in 1841. They became the limits of the city in 1860; the pink part is bound by the old eighteenth-century tax walls. Bibliothèque nationale de France, Paris.

city instead of attaching itself to it, and which will soon resemble, lest we provide some form of remedy, the swollen encampment of a confused army of assailants rather than the normal configuration of a unique city."[146] These considerations reflected the political worries of the emperor, members of the government, and the haute bourgeoisie, which Haussmann and other cabinet members exploited, painting the banlieue in lurid colors. Whereas the police was a visible and forceful presence in the center—one agent per hectare and 360 inhabitants—its footprint in the outlying faubourgs was minimal, he warned: one gendarme for fifty-six hectares and 5,165 residents in the outskirts.[147] Attempts to bridle the working class merely through spatial dislocation were no longer sufficient.

Louis Napoleon had originally wanted to include Saint-Cloud, Sèvres, and Meudon within city limits as well.[148] But when Berger broached the topic in 1852, reactions were so violent that *Le Moniteur universel*, the empire's official journal, had to publish a disclaimer.[149] It fell to Haussmann to let out the tight-fitting seams into which the city had squeezed itself. Although he had initially opposed annexation, perhaps because of cost, he prepared for the inevitable move cautiously.[150] In 1856, he named a committee of magistrates, senators, deputies, and councilors of state to study the issue. They came up with six different proposals, which he pared down to one. There was vehement opposition. Conservatives resented this sudden incorporation of the annular periphery deemed undesirable on social and political grounds. So did liberals, who advocated free trade. The inhabitants of the "exterior" also disapproved, some more vocally than others. The impending tax increase drew the wrath of workers and captains of industry alike. Roughly one-fifth of the capital's industries were situated in the outskirts.[151] With its numerous factories, La

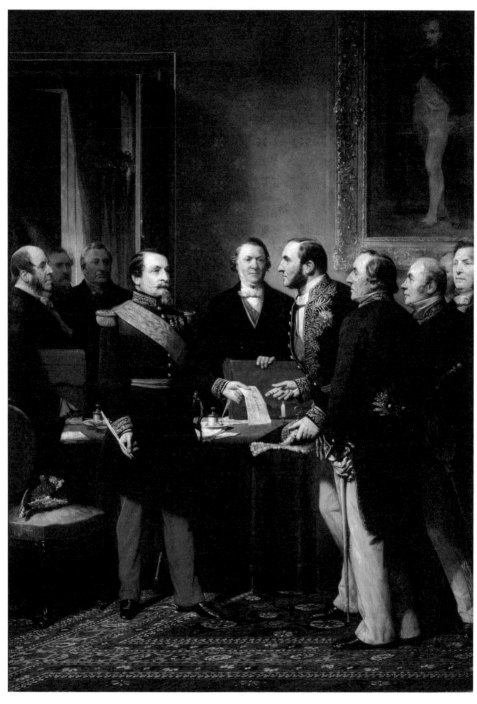

FIG. 7.11. Adolphe Yvon, *Napoleon III Handing the Decree of Annexation to Haussmann*, 1865. Oil on canvas, 129 × 90.5 in. (327 × 230 cm). Musée Carnavalet, Paris.

FIG. 7.12. Claude
Nicolas Ledoux,
tollbooth at the
Place de l'Étoile,
photographed by
Charles Marville
in 1859. Musée
Carnavalet, Paris.

Villette offered the greatest resistance, along with Bercy and Ivry, followed by Montrouge, Vaugirard, Grenelle, and Auteuil though for different reasons.[152] Property owners, on the other hand, generally favored the move, since they stood to gain the most from the extension of the limits of Paris to the outer communes.[153]

Haussmann undoubtedly wanted to broaden the city's fiscal base, given the huge expense incurred by his two unfinished networks. The final push toward annexation, in fact, took place just after the municipality lost the right to sell expropriated land not actually used in public works.[154] Circulation was another prime concern: it was useless to improve streets in the center unless they could dovetail with the maze of roads in the outskirts. On June 16, 1859, the legislature voted 228 to 13 to incorporate the area between the tax wall and the fortifications, a decision effective on January 1, 1860 (fig. 7.11).[155] Customs were to be transferred to the outer fortifications, thus raising the number of arrondissements from twelve to twenty. The old fiscal walls, which now constricted the city, were to be torn down, along with Ledoux's tollbooths (fig. 7.12). Invisible thresholds between the center and the outer fortifications would take their place, as Paris continued to be locked up behind a further set of ramparts.

Known at the time as the *enceinte de Thiers* (and popularly as *les fortifs*), the military fortifications caused an uproar when they were built.[156] For the opposition, the new walls that ringed the city, punctuated by sixteen detached forts, had no connection to defense. These, charged the scientist and politician François Arago, had more to do with the interior than the exterior; if taken, they could become "a powerful weapon against the capital and consequently, a terrifying instrument of oppression."[157] Construction workers and stonecutters went on strike to protest this return to the feudal concept of the closed city.[158] They lost, of course, and the broad strip of land outside the city, formerly associated to freedom, became an inside, subject to surveillance. Once more, "le mur murant Paris" curtailed popular liberties. Its anachronism would be proven by the Franco-Prussian war.

Until then, the old tax walls served as a buffer, demarcating an area of popular subcultures and countercultures at the fringe of Paris, where goods were cheaper. Estaminets (drinking places) and guinguettes (popular restaurants) multiplied, drawing a large public

particularly on weekends and holidays. For workers, this "pleasure belt" that ringed the bourgeois city was a boon, sought out for its freedom and class-based forms of entertainment.[159] A libidinal enclave beyond the repressive rule of law was bound to alarm authorities. With the extension of the octroi all the way to the fortifications, the price of cheap wine rose, dealing yet another blow to working-class culture. Beyond and adjacent to the walls—the ultimate urban frontier—stretched the no-man's-land known as *la ceinture noire* (the black belt). Classed as *non aedificandi*, it was subject to the jurisdiction of the military. *La zone*, as it was called, was home to a shifting population of ragpickers and destitute families who could not afford to live within city limits after these extended to the fortifications.[160]

As roughly 60 percent of the capital was now situated in the area between the old walls and the fortifications, annexation engendered a great deal of anxiety about spatial and social boundaries by redefining the city's relation to its surroundings. "It is only by exaggerating the difference between within and without, above and below, male and female, with and against, that a semblance of order is created," observed Mary Douglas.[161] Like other terms in these antinomies, interior and exterior became metaphors for social class. In a city undergoing rapid and unprecedented change—spatial, social, political, economic, cultural—boundaries exacerbated notions of identity and self-definition, exemplifying how much the precarious notion of selfhood had to do with space. Walls and thresholds, whether visible or invisible, served to contain and construct the undesirable and allay fears of social leveling even as they magnified the sense of insecurity. Razed but indelible, the eighteenth-century walls between the center and its outskirts became a psychological barrier that divided the city into two unequal parts: "Paris" continued to designate the kernel bound by the old tax walls, destroyed to be sure, but not forgotten.

Walls and thresholds did not necessarily imply impermeability. There is another history to be written about annexation, one that dwells not only on ruptures but on the porous and variable interface between the two concentric cities, without minimizing the all too real effects of spatial marginalization. The very solidity of the fortifications discouraged historians from pursuing other stubborn patterns of everyday life that functioned to knit the two parts of the city before 1860, such as the well-traveled roads taken by the human tide of workers that streamed in and out of the center every day.[162] These exerted a countervailing pull to the more obvious impact of social segregation. Cities are made up of contradictory movements of continuity and discontinuity that challenge and complement one another. For the wealthier echelons, Paris was still coterminous with the enceinte of 1784, no longer extant but vividly present in consciousness. Workers who lived beyond it eyed the banlieue's liminality with ambivalence: if it offered lower prices it also signaled separation. Families forced to relocate there experienced it as a form of "spatial alienation."[163]

With annexation, the surface of Paris more than doubled, and the population rose from roughly one million in 1848 to just under two million in 1867.[164] Formerly, the villages situated outside fiscal limits also had to pay customs duties, but at a much lower rate. Almost four hundred thousand people, most of them workers, now found themselves within city limits and thus subject to taxation.[165] "Here," wrote a young shop clerk, "we are linked by bonds of kith and kin, as many of us have long lived in la Villette; it is our Homeland [*Patrie*] and we will be forced to move away…the government could have counted on us, for those who have jobs do not want revolutions."[166] Annexation thus led, Haussmann acknowledged, to yet another wave of emigration.[167] Large numbers of

impoverished inhabitants moved beyond the fortifications to avoid higher prices, creating a periphery of the periphery.

Industries in the annexed territories, largely underregulated, were also affected. To ease the transition, Haussmann offered to abate their taxes for five years.[168] There was no respite for individuals, however, and duties imposed on food, drink, coal, and construction materials were very high for a struggling population unused to such expense. "It is merely the old expedient to tax the poor, by laying impositions on food and necessaries," James Fenimore Cooper had written of the octroi in 1837.[169] A rise in fiscal duties meant that residents of the periphery were in effect subsidizing the grands travaux in the center and even spatial segregation itself. "One should not have submitted it [the working class] to the taxes of the octroi, and make it pay, now and in years to come, its part in the ransom of the embellishments of Paris," fumed the politician Charles-Alfred Janzé.[170] Michel Chevalier thundered against the institution of the octroi, which went against the free market ideals enshrined in the Cobden-Chevalier treaty, which he coauthored, marking the beginning of free trade and the end of protectionism. It was signed between France and Britain in January 1860, the very month the territories were folded into the city. Haussmann, Chevalier wrote, "subordinates everything to the chimerical plan he has hatched to make of Paris a capital that is exclusively, like old Versailles, a city of luxury and pleasure, brimful with palaces and monuments, and exempt from industry, a vile and pedestrian thing in his eyes."[171] Not to be outdone, Lazare wrote in accusatory tones: "Your municipal administration will inevitably lead to this iniquity: because of the octroi of Paris, *the poor will pay proportionally more than the rich.*"[172] In working-class areas such as Belleville, the neglect to which the periphery was subjected earned the Commune many supporters.[173]

Haussmann was not responsible for annexation—it figured prominently in the emperor's agenda—but only for the harsh way with which it was implemented, a responsibility he shares with other members of government. It was an ambitious "territorial reform, at once administrative, political, and fiscal."[174] The cost of incorporating the outskirts was high. It was necessary to pry villages loose from the haphazard paths that isolated them from one another and from the center of Paris. To improve crosstown communications, the new radial arteries of the center had to be threaded through the tangled web of the periphery. Concentric roads had to be built to link different districts. Three decades earlier, Cooper was spending the summer at Saint-Ouen, then outside the old fiscal boundaries, and described what he saw: "I found the vast plain intersected by roads as intricate as the veins of the human body. The comparison is not unapt, by the way, and may be even carried out much further; for the *grandes routes* can be compared to the arteries, the *chemins vicinaux*, or cross-roads, to the veins, and the innumerable paths that intersect the fields, in all directions, to the more minute blood vessels, circulation being the object common to all."[175] Much had happened in the intervening years, but Cooper's flashback gives an idea of the different scale of rural paths and the difficulty of linking them to roads from the historic center. All this fell under the aegis of Haussmann's third network, to be paid exclusively by the city.

Annexation was a brutal act of colonization that ignored the needs of the population summarily incorporated to the city by fiat but kept at arm's length. While many of the annexed villages had been incorporated in their entirety, seven others were split by the fortifications; all now lost their municipal autonomy.[176] Predatory attitudes toward the laboring

classes were hardly unprecedented, nor was relocation in the banlieue: what was new was the exodus of large number of workers to the outskirts, and the funding now available to carry out discriminatory policies. Haussmann borrowed money supposedly for work to be carried out in the periphery but in fact used them for his networks within the old city.[177] Many changes implemented in the annexed areas were purely symbolic.[178] Town halls were built in each area, but only as representatives of Haussmann's more powerful one in the center. New names were given to the old districts, though the population continued to use the old appellations.[179] Only roads serving the center or the nation were given priority. The contrast between the newly minted amenities showered on the historic city and the services parsimoniously parceled out to the poor in the outskirts reveals the deliberate negligence of the municipality and the empire. "For residents of the annexed communes, the extension of the limits of Paris was characterized primarily by a deterioration of their material situation."[180]

And yet, one must resist the facile contrast between the two cities, a representation that has contributed to reify a complex, unequal, and ongoing process of interaction. If annexation threw into sharp relief the topography of fear that now divided the city, one should not underestimate the role of contingency. Not everything that happened in the hinterland was consciously planned by authorities. As Jacques Rancière lucidly remarks, the state's vigilance of the working class was prompted less by deliberate strategy than by "a gigantic lack of knowledge [non-savoir] concerning what might provoke disorder, by the impossibility of mastering the aleatory and the unpredictable which make of every site of popular presence—and particularly of all sites of *representation*—a possible locus of trouble."[181]

THE BANLIEUE

The immediate periphery surrounding Paris, or *petite banlieue*, offered a mosaic of contrasting tableaux.[182] For centuries, its villages had supplied the capital with food, though by 1860 their vineyards, fields, and orchards were laced with smokestacks and industrial establishments. Thirty years earlier, the area presented an entirely different picture. Nearly one hundred villages surrounded the city, "all gray, picturesque, and clustering round the high nave and church tower, like chickens gathering beneath the wing," wrote Cooper.[183] Some were quite old, once harboring princely residences and monastic buildings dating to the Middle Ages. The town-country contrast was sharp. More often than not, the fields came right up to the walls "and there," Cooper noted with delight, "the buildings cease as suddenly as if pared down by a knife."[184] From the abstract perspective of maps, the hamlets around Paris still looked like a seamless swath of land interrupted only by roads and rivers. In fact, the mottled villages grafted onto the city were often quite different from one another in appearance, natural resources, and economic background. Rich communes like Auteuil and Passy had little in common with half-industrialized and depressed areas where stretches of rural landscape overlapped with the grimy dissonance of factories and warehouses.

Change had been gradual but drastic. By 1843, Considerant and Perreymond left a devastating picture of the surroundings, which they nevertheless wanted to include within city limits: "a chaos of churned-up fields, sunken paths, collapsed quarries, stagnant water, arid deserts, thwarted plantations; [...] a scattering of houses, hovels, factories and constructions of all kinds, in the greatest disorder conceivable."[185] A decade later, Audiganne

FIG. 7.13. Charles Marville, Rue d'Hautpoul and entrance to the quarries of the Rue Compans, 1871–72. Bibliothèque historique de la Ville de Paris.

also commented on the banlieue's industrial aspect: "Paris has become a vast industrial metropolis. Its outskirts and faubourgs surround it with a girdle of factories, manufacturing plants, and ateliers of every kind."[186] Cooper's peaceable panorama had given way to jarring contrasts, as houses, fields, and industrial plants mingled without clear frontiers (fig. 7.13). By 1860, the smokestacks mentioned by contemporaries dotted the area. Noxious fumes hung low over the horizon. Writing after the Commune, Othenin d'Haussonville described the polluted areas around Saint-Denis (with a jab at Zola) as "that hideous, stench-filled plain, rightly dear to the naturalists' descriptions, with its rubble paths strewn with bottle shards, its vegetable patches watered with slurry, its heaps of manure and dirty linen dangling from ropes."[187]

Apart from agriculture, the banlieue served to house heavy industry, to process sewage, and as a place from which to extract plaster and limestone. Industries provided jobs and salaries, attracting workers. Since manufacturing plants had to be situated close to the railroad and canals north of the city, the Right Bank was more heavily industrialized than the Left. Places like La Villette and Belleville were now booming towns. With 57,669 inhabitants in 1856, Belleville was one of the largest cities of the empire.[188] Over the preceding quarter of the century, its population had increased by 697 percent, while a few miles away, Montmartre had grown by 850 percent.[189]

The history of Belleville and Ménilmontant illustrates the shifting class relations that were slowly reshaping the political geography of the capital. For centuries, Paris had been

encircled by rich monasteries, châteaux, and magnificent parks, its highest points avidly sought out for their spectacular panoramic views. But even before the French Revolution did away with large estates, many had begun to disappear owing to rising costs of maintenance. The surroundings passed through the hands of all social strata. Middle-class residents gradually replaced the nobility and the haute bourgeoisie, building eclectic summer chalets and country villas in the ruins of the great properties, subdivided into affordable lots by speculators. Urban renewal in the center put an end to this pursuit of summer homes, as large contingents in search of housing invaded the area with ateliers, forges, and the obligatory trappings of working-class life. The area's very ecology changed. When the immemorial trees and seignorial architecture had gone—signs that spelled ease and gentility—the symbolic capital was spent. Once an Arcadian enclave dedicated to leisure, Belleville had become a place of labor, its scenic beauty eroded by industry and demographic pressure.

Describing the beauties of Ménilmontant just before annexation, Émile Gigault de Labédollière urged Parisians to come visit soon: "The calm of this bourgeois Eden has almost entirely disappeared: ever since a good number of workers, driven from Paris by demolitions, arrived in search of refuge, vacationers, tempted by the lure of profit, ceded their place and moved further away; today, castles, chalets and cottages have become workshops where from morning to night, one hears the roar of the lathe, the humming of the saw, and the whistle of the jointer plane."[190] Ménilmontant, which abuts Belleville from the southeast, exemplified the checkered social landscape and the patchwork of political fiefs that would become increasingly homogeneous after the Second Empire's reorganization of the capital, and even more so after the Commune.

Yet the sprawling edge of the city was hardly a place of unrelieved horror. The grimiest of villages still retained strong rural ties, quilted with vegetable patches and orchards.[191] On the summits of Montmartre, Montrouge, and Belleville, dozens of windmills could still be seen, "whirling their ragged arms."[192] At Romainville, once famous for guinguettes and lilac bushes, semirural stretches of land alternated with a scattering of houses and plaster quarries. In the western part of the city, the faubourgs were richer. A village full of rustic charm like Auteuil seemed "made for tenors," noted Amédée Achard, disappointed to discover that its inhabitants did not "dress like shepherds set to music by Grétry or Monsigny."[193] On the Left Bank, pockets of village life survived almost intact. A little hamlet like Maison-Blanche dissolved lazily into the countryside, all prettiness and unaffected grace. Othenin d'Haussonville, who visited it in 1881, admired its whitewashed walls and quaintly named streets: Moulin-des-Prés, Fontaine-Mulard, Butte-aux-Cailles.[194] Red currants and lilacs bloomed in the hedges, and in its pastoral fields, sheep could safely graze. Nearby, however, the unstudied chaos brought about by rapid industrialization destroyed much of the landscape. Grenelle alone had over sixty industrial plants. Chemical and metallurgic industries had established themselves in the area, and lovely old villages like Romainville and Les Lilas had been partly disfigured.[195] In his book on the twenty arrondissements of Paris (1860), La Bédollière painted an optimistic picture of part of the Left Bank but could not keep modernity altogether out of the picture:

> The stroller who, after following the rue Mouffetard turns right toward the Petit-Gentilly, finds himself unexpectedly facing one of the most beautiful landscapes in Paris. Before his eyes stretches a valley irrigated by the Bièvre which is not so

close that he can smell its noxious and nauseating fumes; in the meadows along the river, washerwomen spread their laundry to dry with stakes; cows graze as in the countryside; here and there, gardens planted in the eighteenth century by wealthy gentlemen in pursuit of leisure and rest in these distant districts, raise the green tips of their fruit trees, or trace arcs of verdure with the branches of their numerous fronds.[196]

Even though La Bédollière and d'Haussonville were not describing the same part of the periphery, such radically divergent descriptions of the banlieue are a comment on its multiple particularities, impossible to summarize; but they also reflect class. None of these accounts, moreover, were authored by residents of the banlieue.

With its bewildering mixture of field and factory, village and quarry, the banlieue challenged traditional representations of the city no less than the center, obscured by scaffolds and earthworks. From Gautier and the Goncourt brothers to Huysmans and Zola, literati tried to make sense of the swath of land encircling Paris with its disheveled scenery and diverse inhabitants.[197] At the edge of the city "where Paris ends," wrote the Goncourts in 1865, one sees "what sprouts where grass disdains to grow, one of those arid landscapes that large cities create around themselves, [...] where nature is withered, the earth devastated, and the countryside sown with oyster shells."[198] Though captivated by the surroundings they struggled to describe, not all succeeded in coining a language with which to evoke the monotony of semiurban stretches perceived as anomic wastelands yet interspersed with idyllic views.

Painters also focused on the nondescript no-man's-land between factories and quarries, drawn by its very lack of visual coherence. Even here, wrote Hugo, there were bucolic spots "where a Ruysdael would have been tempted to sit."[199] It was the intrusion of industry in the countryside that was new: sun-filled vegetable patches alternating with the grisaille of vacant lots. Van Gogh, Camille Pissarro, and Jean-François Rafaëlli, among others, tried to convey both the cheerful meadows and the melancholy surroundings of northern Paris, whose scrawny vegetation and uncertain paths lent it an apparent lack of purposefulness and climax.[200] Like many contemporary descriptions, their work often reveals a nagging sadness, a sense of indirection that hung over featureless houses and rutted, mud-soaked roads, implacably rendered by a Huysmans or a Raffaëlli, intent on capturing the mournful banality and cheerless indeterminacy of the periphery—the obverse of the spectacular capital—as well as its brighter aspects and sites of popular entertainment (fig. 7.14).

THE MUNICIPAL ORIENT

When [...] we behold the sun set behind the observatory of Montsouris, whose dome recalls the cupola of a mosque, and the steeple of Saint-Pierre of Petit-Montrouge silhouette itself against the reddening sky with the elegance of a minaret, we are overcome by a sort of illusion of the Orient.
—Othenin d'Haussonville, "La misère à Paris"

Tensions between center and periphery escalated after annexation, as class divisions became more sharply drawn. By incorporating the zone surrounding Paris, the government sharpened the polarity between the city's two unequal parts, giving greater visibility

FIG. 7.14. Jean-François Raffaëlli, *Faubourgs parisiens*. Oil on cardboard, 12.2 × 15.5 in. (31 × 39.4 cm). Private collection.

to the working-class enclaves bracketed between traces of the old tax wall and the fortifications, and complicating the city's east-west divide. Gradually abandoned by a portion of their middle-class residents, some outlying villages became increasingly class specific. The overwhelming presence of workers outside the city invested the new military fortifications with political connotations, fears of invading armies being transferred to the poorest segment of the proletariat. By the mid-nineteenth century, the innocuous old term *faubourg* acquired ominous connotations.[201] A ring of proletarian settlements encircling Paris could be viewed only with anxiety by the sheltered classes. For them, the old excise walls, torn down but still keenly felt, continued to function as an invisible but palpable seam that marked the limits of the city.

Paris lies at the heart of a great natural amphitheater. On the Right Bank, Montmartre, Belleville, and Ménilmontant rise abruptly from the plain like a citadel, dominating the city spread out at their feet. Across the river, Montsouris and the Butte-aux-Cailles also gaze down on Paris from the heights. Topography heightened the political insecurity felt by the dominant classes, underscoring the radical discontinuity between two concentric cities. The elevated ground occupied by these annexed villages translated easily into representation, preying on the imaginary of the propertied and salaried classes. The laboring poor were all the more alarming for the wealthier strata, since the percentage of Parisian-born citizens dropped steadily during the July Monarchy and the Second Empire.[202] The wealthier groups' sense of entrapment was matched by the feeling of marginalization

experienced by the laboring poor for whom relief itself seemed to naturalize and legitimize segregation. For residents of the center, the belt of heaving working-class districts kept the city in its vise. In their view, Thiers's enceinte, flung around the capital to defend it against foreign forces, now signaled its imprisonment at the hands of a well-known opponent. "The impoverished class," wrote the ouvrier Anthime Corbon, "is like a huge cordon encircling the wealthy one."[203]

Not one to overlook potential problems, Haussmann took defensive measures to minimize political threat according to his disciplinary view of the urban territory. It was imperative to control this alien space coiling itself around the historic core. As annexation entailed the reorganization of the entire city, which now had twenty districts rather than the original twelve, he seized the occasion to split the most worrisome ones, just as he had done with the faubourg Saint-Antoine.[204] Spurred by class fears, the administration rammed an important road through Belleville and Ménilmontant, the better to supervise two populous working-class areas. The strategic Rue des Pyrénées, which slices through the densest part of Belleville, undoubtedly helped the troops of Versailles in their savage repression of the Commune.[205]

If the possibility of insurgency fueled the middle and upper classes' attitude toward the periphery, the anxiety was laced with voyeuristic fascination and racialized overtones. For the Goncourt brothers, "the populace, the rabble if you will, has for me the same attraction as unknown and yet to be discovered populations, something *exotic* which travelers take pains to seek out in distant lands."[206] To cross the boulevards built outside the old customs wall was to enter terra incognita, according to a long-lasting cliché. As late as 1912, a commentator could write: "Anthropology [. . .] is silent about the distance that separates a man from the Stock Exchange from the citizen who, at the edge of the Butte-aux-Cailles, handles animal skins in tanners' buckets." To walk "from the Boulevard to the Faubourgs," he continues, "is equivalent to an exploration in Central Africa!"[207]

INTERNAL COLONIES

Living conditions in the periphery were grim, continuously pressured by a double migration, from the provinces and from the center.[208] Haussmann's grands travaux procured jobs but not housing or services. While the government spent a fortune to provide central Paris with air and sunlight by means of broad boulevards, wrote Lazare, "at the extremities of the city, workers are being squeezed into clumps of narrow, insalubrious houses by a detestable speculation."[209] The suffocating, disease-ridden slums of the inner city that so alarmed hygienists and social reformers were merely displaced to the periphery, where high occupancy rates continued to be the norm, despite greater amounts of space and greenery. "In such a society," Engels observed bitterly in 1872, "the housing shortage is no accident; it is a necessary institution."[210] Expropriations entailed generous indemnities for those who had money to begin with. When a building was torn down, owners were well remunerated and merchants compensated for the loss of their clientele; tenants received a pittance, which they spent on moving.[211] The responsibility of building for the working class was largely delegated to the private sector, which aggravated the situation by making profit rather than need the determining factor. Wealthy speculators eagerly embraced upscale apartment buildings in the center but hesitated to risk investments in the suburbs,

where modest salaries limited revenue.[212] Although the municipality eventually built new roads of access and retrofitted existing ones, there was never any attempt to match the quality of the amenities doled out so prodigally to the coddled spaces of the bourgeoisie. The goal, after all, was not to transcend social conflict, but to contain it.

The periphery thus had to make do with spasmodic, haphazard interventions, improvised fitfully without an overall plan. Where there were no villages, architecture fell woefully short of what characterized strong urban environments: a coherent network of streets and squares, the civility of landmarks, visible connection to a shared history, an appropriate sense of scale. The great sweeping prospects of the center with their stately domes and majestic piles could not be matched, of course, by these underserviced areas, where a drab semiurban fabric seemed to spell out the city's diminished expectations regarding its inhabitants. Lack of funding entailed piecemeal solutions that determined the substandard urbanism characteristic of the ragged edges of the city. Initially, densities were low: most houses were one or two stories high; large apartment buildings began to appear only after 1860. The very materials used in construction were indexes of social status. Brick and rubble, recycled from demolitions, predominated; stitched together with other makeshift materials, they lacked the low-key warmth of the vernacular.[213]

Roads were often unpaved, poorly lit even where marked by steep inclines. Outside the old tax walls there was no interest in leveling the terrain and straightening streets unless they served the center or the nation. When the Péreire brothers originally acquired land around the Parc Monceau and subdivided it for real estate, they chose street names taken from the history of art: Ruysdael, van Dyck, Murillo, Velasquez.[214] In the outskirts, streets were often old rural paths, designated by the pedestrian names of proprietors or speculators who bought the parcels of land: Navarre, Puteaux, Lemercier.[215] The infrastructure was lamentable. The octroi, wrote Lazare, "affected our artisans and ouvriers in the old banlieue, brutally annexed. They were flung to these localities, veritable Siberias, crisscrossed by narrow lanes and tortuous paths, without paving, light, markets or water, where ultimately everything was lacking."[216] And yet, it would have cost the administration far less to improve the situation in areas where land fetched lower prices.

Old villages such as Montmartre, Belleville, and Charonne, perched on the rim of the city, had retained distinctive physiognomies: their lovely old churches and village squares suffused surroundings with meaning. But the vast expanse between one commune and another, straddling the breach between town and country, was often dreary and featureless. Wild urbanism offered no visual point of interest or anchorage for memory. Lazare-Maurice Tisserand, who took over the series on the topography of Paris underwritten by Haussmann, explained the process of conferring value on the past: "The radical transformation that [the city] has undergone imparts to what remains a relative antiquity that assimilates it to old Paris and inducts it each day into the domain of history."[217] Placelessness—the absence of storied remains or picturesque vernacular—must have been profoundly demoralizing for those inhabitants eager to assimilate and refashion themselves as "Parisians." In large tracts of the periphery, the laboring poor were deprived not only of decent infrastructure and urban planning, but of the center, with its river views and beautiful monuments. Along with their foothold in the heart of the old city, workers lost cultural capital. Yet one must be careful not to idealize the center: the lack of an "administered" history in the banlieue had its own emancipatory side—being outside the

glare of power may have brought workers, both constrained and empowered by distance, a dearly bought sense of relief.

Part of the desolate appearance of the more industrialized communes was due to the near absence of greenery. Over the years, the area's great parks had been sold off, their trees cut down for wood or transported to the municipality's new squares and boulevards. Writing in 1843, Meynadier mentioned somewhat condescendingly the "love of rubble and plaster and horror of the tree" that in his view characterized the banlieue.[218] Landscape, a product of successive generations, had slowly molded the ecology of the outskirts. Environmental erosion due to industry and demographic expansion despoiled the surroundings and made for the tepid monotony and grayness so often mentioned by contemporaries. In many places, this happened long before the Second Empire. In others, the green reserves disappeared precisely under Haussmann's watch. Speculators cut up beautiful manorial properties at Raincy, Neuilly, and Issy.[219] The Château de Bercy, built by Louis Le Vau, was demolished; what remained of its magnificent park, laid out along the Seine by Le Nôtre, was put up for sale in 1860 and destroyed a year later.[220]

Social indicators such as health and education designated the suburbs as spaces of exclusion. What wealth the *faubouriens* produced belonged largely to others. Markets, a vital element in the lives of the poor, were unfairly distributed: since the marchandes were made to pay as much for their space as their counterparts in the center, they passed the cost on to their impoverished consumers who preferred to buy their staples elsewhere.[221] Churches and confessional schools were built in all annexed districts. The Protestant prefect, who once confessed he could not bring himself to contemplate a mixed marriage, got along swimmingly with the Catholic hierarchy, who approved of the government's use of religion to shore up the empire. In reaction to the ultramontane policies of the Restoration, which favored religious education, secular schools had received top priority under Louis-Philippe. Napoleon III in turn eyed public schools warily and soon after his election backed the Falloux Law, which gave ample powers over education to the Catholic Right. Thereafter he patronized religious establishments, which tended to be less republican in outlook, and Haussmann thus built Catholic schools in the banlieue.[222] Leaders of the opposition angrily denounced the role religion was made to play in the oppression of the poor. "The most disloyal and at the same time the most useless of initiatives," wrote the statesman-philosopher Jules Simon, "is to preach religion while being an unbeliever, and to transform God into an instrument of domination."[223] Not surprisingly, during the anticlerical interlude of the Commune, the population would reappropriate the houses of worship and transform them into popular clubs.[224]

All in all, Haussmann's contribution to schooling in the periphery was shockingly modest.[225] Following his Hobbesian logic, he made the poor pay dearly for what little they received, masking his dislike of the working class with utilitarian concerns. As he stated in 1859, "Schooling for children is a religious and social duty for the father. . . . Free schools weaken family ties, detach parents from part of their obligations, diminish the gratitude of children, lower the value of instruction in the eyes of both parties (for one only appreciates that which costs a certain sacrifice), and lastly, gives credence to the false notion of the right to instruction."[226]

Urbanism had been well subsidized during the July Monarchy, when earmarked for the rich. "Thus," bemoaned Perreymond in 1843, we have on the one hand, "a squandering

of common wealth, handfuls of gold being tossed to the rich, prosperous, luxurious part of the capital, for adornment and embellishments; on the other, a squandering of common wealth in order to contain, by means of arms and prisons, all other areas, where a dreadfully indigent population vegetates, unemployed, lacking everything, compelled to live by alms, theft and prostitution, swarming in isolated districts, ravaged by age, infested by thousands of insects, and infected by putrid emanations."[227] Comparatively speaking, rich and poor did not live that far apart in Perreymond's day. Twenty years after annexation, d'Haussonville surveyed the outskirts and concluded sadly: "The old Paris, that once had only twelve arrondissements, is today surrounded by a belt of misery that invests it from every side and takes up all the space between the old external boulevards and the fortifications. It would not be fair to place the responsibility for this change exclusively on the cuttings undertaken by the empire in the populous quartiers of the old city [. . .]. But one cannot deny that those cuttings accelerated the movement a little more than was desirable, and that whatever good they produced has been outweighed by harm."[228]

Haussmann was initially opposed to the idea of a greater Paris, for he believed in a *"fatal* center of Paris," as Marcel Raval put it.[229] A seamless city would challenge this reservoir of manpower to be used when needed, and warehoused indefinitely when not. In his view, Paris required both served and servant spaces, a monumental kernel surrounded by a utilitarian ring. It is easy to understand Paris as a city of luxury, a financial, commercial, and cultural center, Haussmann wrote to Persigny; "but it is sheer barbarity to transform it into a workshop, a patchwork of long chimneystacks spewing black smoke, and it is the acme of political insanity to pack it with gross and stupid masses of ouvriers with hammers, willfully creating an insurrectional center."[230] If Haussmann's indifference toward workers' living conditions differed sharply from his solicitude toward the leisured classes, it was partly because as prefect of Paris, he was the de facto executor of an entire class whose proprietary stance toward the center increased with the dislocation and dispersal of part of the working class to the periphery.

Maxime Du Camp recorded the blatant disparity between center and periphery—and blamed it on the poor:

> It is in the outlying districts, once part of suburban villages, that this rather particular population must be understood in its milieu. Toward the customs gates of Italie, Fontainebleau, and the boulevard d'Ivry [. . .] in streets that were never paved and where old oil lanterns still dangle from ropes, one realizes that misery propagates and perpetuates itself among careless beings [. . .]. This entire area, which is attached to Paris like a suppurating excrescence, exhales a peculiar odor, generated by emanations of animal black, lumps of manure piled up in the courtyards, stagnant waters reeking of old rags and damp cellars.

"For a comparable impression," he adds contemptuously, "one must recall certain villages of Calabria or Jewish towns of the Orient, Hebron, Safeth, and Tiberiad."[231] Du Camp's words echoed and amplified prevailing sentiment. The center also had impoverished enclaves. Meding, who wrote an important medical topography of Paris, claimed that one of the poorest parts of the Left Bank, near Place Maubert, bore "some analogy to the Ghetto, the Jewish quarter in Rome."[232] Even sympathetic critics fell back on prejudice. In the periphery, declared Dr. Auguste-Adrien Ollivier, "the ground is covered with parasitic

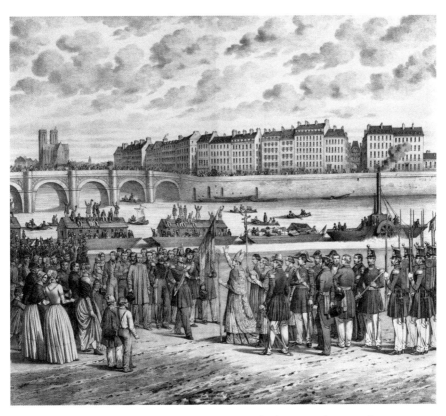

FIG. 7.15. Benediction of workers headed for agricultural colonies in Algeria, with Notre-Dame in the background. Cavaignac, in full regalia, stands behind the archbishop of Paris. Popular print, 1848. Musée Carnavalet, Paris.

dwellings, colonies of poor people driven to the periphery by demolitions and the increase in the price of rents; [. . .] hovels spring from the soil, their hygiene resembling that of the camps of Indians or Arab douars."[233] One form of discrimination elicited another. The poor were classed under a different category: exotic, alien, not quite French. They could be understood only by appealing to familiar, racialized Orientalist tropes, a reassuring ideology equipped with ready-made stereotypes for whatever was perceived as threatening. Like so much else felt to be undesirable, poverty seemed to be synonymous with the East. The "outside" was not easily assimilated.

Anti-Semitic references, whether to Jews or Muslims, were hardly coincidental. Algeria loomed large in the French imaginary, particularly after the revolution of 1848, perceived by many as a class war. In February of that year, Louis-Philippe reluctantly gave Thomas Robert Bugeaud, former governor-general of Algeria, powers to quell the insurrection but eventually restrained the general, whose savagery ran the risk of igniting an even greater conflict. Following the king's abdication, the newly proclaimed Second Republic created the National Workshops, which found jobs for unemployed workers. As costs ballooned, the increasingly conservative Republic closed the ateliers, and workers rioted. Another veteran from Algeria, Louis-Eugène Cavaignac, was brought in and crushed the June insurgency with brutality. Cavaignac, wrote the journalist Albert Dresden Vandam in 1893,

"was all buckram; and, in the very heart of Paris, and in the midst of that republic whose fiercest watchword, whose loudest cry, was 'equality,' he treated partisans and opponents alike, as he would have treated a batch of refractory Arabs in a distant province of that newly-conquered African soil."[234]

By September, Cavaignac and a third general from North Africa, Christophe Juchault de Lamoricière, hatched a plan, approved by the republican National Assembly, to create agricultural settler colonies in Algeria, using unemployed workers and their families. For some, this was a thinly disguised ploy to remove revolutionaries from the banlieue, but many liberals approved, including Engels, and sectors of the working class.[235] Almost fourteen thousand workers, and 468 June insurgents, left for Algeria (fig. 7.15).[236] They would be joined by 6,247 political prisoners, deported after Louis Napoleon's 1851 coup.[237] The nation's colonial strategy toward North Africa was thus dictated by the government's political aims at home. The ferocity with which popular uprisings were suppressed by generals in charge of Algerian colonization (the *généraux africains*) foreclosed the possibility of negotiation between the parties. Hardened by colonial warfare, they saw the world primitively in terms of binaries, and drowned urban conflicts in bloodshed, as Mac-Mahon (former governor of Algeria) would do during the Commune. "Algerian legitimacy," wrote a modern critic, "was thereby engrafted upon the métropole, and an alien military violence infused into French political life."[238]

All nineteenth-century cities in the throes of industrialization were involved with internal colonization in some measure, establishing patterns of domination over their laboring classes. In the banlieue, ostracism and discriminatory treatment in terms of housing, urbanism, and education were institutionalized. It would be a mistake to see the Second Empire's policies toward the poor exclusively through the lens of French colonization, just as it would be shortsighted to ignore the parallels between the capital and its colonies. "In a sense," observed Étienne Balibar, "every modern nation is a product of colonization: it has always been to some degree colonized or colonizing, and sometimes both at the same time."[239] Parisian workers who left for Algeria exemplified this dilemma: victimized at home, accomplices and enablers abroad, where they were given land seized from Algerians.

For imperial and imperialist France, the outskirts of Paris were a question of neo-colonization, of reordering the metropolitan territory to serve the stability of the regime and the interests of the economy. The social and political topography of the city had to be reconfigured so that the labor force could be produced and reproduced, safely quarantined outside the preserves of exclusivity and privilege if possible. The renovation of the center accelerated the proletarianization of the periphery, which had until then seen mixed patterns of habitation. Yet systematic discrimination against the city's hinterland was not the preserve of a single regime. Work on the fortifications under the July Monarchy accentuated the ancillary status of the surroundings. The difference between the center and the sub-Paris of the surroundings grew during the Second Empire and the Third Republic, when the banlieue was ravaged by deadly epidemics of smallpox, measles, and typhoid fever in the 1880s.[240] Furthermore, the treatment meted out to the periphery of the city cannot be located exclusively in the past. Marginalization continues to be reproduced by the kind of scholarship that focuses on the bourgeoisie while ignoring the periphery annexed in 1860.

THE POLITICS OF DISTANCE

Marginalization had temporal as well as spatial dimensions. In a city rescaled as a metropolis, distance was not a purely quantitative datum. Annexation stamped it with symbolic importance and the connotations of social class. Now measured in terms of travel time, distance was a barrier that effectively hindered workers' access to the center and the possibilities it offered for self-advancement. Forced to cross the city on foot morning and evening, workers shunted to the outskirts by redevelopment found that their day had become longer. "These processes of urbanization of capital," wrote David Harvey, "are paralleled by the urbanization of social relations through, for example, the separation of workplace and living place, the reorganization of consumption processes to meet capitalism's requirements, the fragmentation of social space in relation to labor market demands."[241]

Access to the center of Paris was neither cheap nor easy. "Public" transportation—the privately owned Compagnie Générale des Omnibus—neglected nonprofitable working-class districts, preferring to service middle-class areas, and played a role in the social production of distance. Even where public conveyances were available, the poor could rarely afford fees to and from work on a daily basis and were forced to walk. "I live near the barrière du Trône but work in the Boulevard de Bonne-Nouvelle," explained an ouvrier. "It takes me an hour to get [to my job] and another to return. When it rains or snows, it is very unpleasant. This is because I pay 14 francs a month [for housing] at the Trône, whereas it would cost me 42 francs near my work, that is, three times more."[242] For those who could afford it, the omnibus took even longer: at least two hours from the center to the old fiscal wall.[243] Yet omnibuses began circulating too late in the morning to be of use to the proletariat, remarked Lazare, although Haussmann denied this.[244] Their schedules and itineraries revolved primarily around the needs of the middle classes. And populous areas like Ménilmontant, situated far above the center, were too steep for horse-drawn vehicles.[245] When the circular railway line linking the northern suburbs opened (la Petite Ceinture), the lack of third-class compartments meant that the laboring poor could not afford tickets.[246] This too was organized according to the interests of the private sector, noted Lazare angrily.[247] D'Haussonville underscored the difficult trade-off faced by the resident of the periphery: "If he is housed for less money and in more hygienic conditions, the distance he often has to cover to reach his work represents an increase of expenditure or fatigue."[248]

A famous passage in Zola's *L'Assommoir* shows the long trek of a wedding party, making its way on foot from La Goutte d'Or, a working-class district, to the Louvre. This was no emancipatory *dérive*. Unfamiliar with the historic center, the ouvriers groped their way about as if in foreign territory, derided for their clothing and manners.[249] The agglutinating force of the capital was reserved for those who lived in the center. Zola's characters felt only the centrifugal tug that pulled them back to their precarious homes in the outskirts. Their relation to the center remained distant, poorly connected, inorganic.

The symbolic value of time and its relation to class had long been evident. Balzac had noted how rich and poor related differently to day and night: "Commerce and Labor go to bed when the aristocracy thinks of dining; the former bestir themselves noisily when the latter are asleep."[250] In an age where social mobility opened up frightening perspectives for the upper echelons of society, time, like space, became a class index. The wealthy, who

had it in abundance, could afford to spend it ostentatiously in leisurely pursuits. For the laboring classes, it was a precious commodity they could least afford to squander.[251] Their very bodies were inscribed with the lack of disposable time. In Eugène Sue's *Les Mystères de Paris*, the seamstresses' characteristic gait as they made their way swiftly through the city was partly due to "their constant need to lose as little time as possible in their peregrinations."[252] Time, as produced by the capital's social fractures, also excluded.

The reconfiguration of urban space required by modern industry and commerce entailed the regimentation, and hence the monetization, of time in all its aspects. Urban time—its forms of apprehension, fast-paced tempo, and impact on labor—was more abstract than rural time, still yoked to the cycles of nature. The destruction of familiar ways of measuring time, its atomization into stricter patterns and smaller units, affected the lives of migrants who flocked to Paris from remote villages. Accustomed to task-oriented chores contingent on the seasons, they chafed under the repetitive demands of industrial labor and the stringent schedules that controlled the workday. As it lost its familiar landmarks and associations, time ceased to offer the same cover to identity. Less intelligible and intimate, it provoked new forms of reaction.

Industrial capitalism relied on the secularization of the calendar and the elimination of numerous religious holidays that brought productivity to a halt. For villages beyond the tax wall, special days were a boon, thanks to the presence of large crowds in search of cheap food and entertainment. Even before annexation, the work ethos of capitalism, along with bourgeois morality, began to erode old village customs subjected to the encroachment of the city. Popular feasts considered violent or unseemly were abolished, such as bullfighting at the Barrière du Combat and the notorious carnival of Ash Wednesday, the Descente de Courtille, set to music by Richard Wagner in 1840. The Second Empire dealt a blow to many secular and religious festivals. Limited to specific dates, controlled and contained by the calendar, carnival would no longer invade the everyday as often as before. Lazare urged the magistrates to reestablish holidays eliminated by annexation: "One of the worst measures, and in our view, the most unjust and regrettable, is without doubt *the suppression of feast days in the old suburban Communes*, a suppression that went into effect a few years after their absorption by the city of Paris."[253] The empire substituted what it took away from workers by its own forms of entertainment. Feasts and festivals compatible with genteel sensibilities had been steadily moving west of the city, where they were coopted by the bourgeoisie; undesirable rites moved eastward, along with the guillotine.[254] Yet working-class culture had long since begun to insinuate itself into middle-class pastimes. Writers, artists, and photographers have left abundant records of popular dances and fêtes in the outskirts, where the middle classes could mingle with workers. Carnival itself can no longer be construed as unbridled subordination to polymorphous pleasure but always entertained complex relations with power.[255] As Rancière has argued, it was an exchange in which the poor displayed the body of misery and debauchery to the gaze of the "bourgeois-voyeur."[256] These trends, moreover, were happening elsewhere as popular culture gradually gave way to forms of mass leisure.

Labor in building yards, workshops, and factories required temporal escape valves to compensate for hardship and discipline. Feast days offered reprieve from everyday routines: instead of repetition they allowed for rupture and subversive laughter. Workers responded to the stress and travails of industrial capitalism with a secular holiday of their

own making: Saint-Lundi (Saint Monday).[257] Excessive drink on Sundays, their day off, led men to skip work on Mondays. Although alcoholism among women was on the rise, they usually reported for duty. In certain districts, the rhythms of city life on the first working day of the week thus differed according to gender. Saint-Lundi was observed in Paris and the industrialized north, although it was more prevalent in certain trades than others. Given the resulting economic losses, commercial and industrial establishments often paid a bonus to those who did not take Monday off.[258] Popular with workers because they did not have to dress in their Sunday best to go drinking, the "holiday" had an adversarial relation not just to capitalism but also to the Catholic Church. "Instead of Sundays, Mondays," wrote Augustin Cochin sadly.[259] However self-defeating, Saint-Lundi was a form of resistance to the violence of time: an unconscious reaction to brutal work conditions and demeaning connection to time, reduced exclusively to exchange value. Already widespread under the ancien régime, Saint-Lundi reached its high-water mark in the first decade of the Second Empire and decreased thereafter.[260] By the turn of the century, it had all but disappeared: "Working-class Monday made way for bourgeois Sunday."[261] There were no places of monolithic, autonomous class culture left: acculturation was an ongoing process.

THE CONSTRUCTION OF MARGINALITY

Space is a sociopolitical product.[262] So are its correlates: time, distance, scale. The distant enclaves to which countless workers were consigned made it difficult, though not impossible, for them to develop skills other than those required for public works: Paris's industrial hinterland reproduced them almost exclusively as a labor force. The very mixture of home and factory, living and labor, reinforced a sense of servitude. There was a vast difference between residing in the historic kernel, and laboring there as outsiders who came by day. Those who managed to retain a foothold in the center, the Left Bank, or the faubourg Saint-Antoine could more easily challenge or transgress boundaries, however much they may have been made to feel out of place in parts of the city where their clothing marked them out as subalterns.[263] After a long day toiling in the center, the others had to turn their backs on the well-lit world so elegantly upholstered by Haussmann. "Hundreds of thousands of families who work in the center of the capital sleep in the outskirts," wrote Granveau. "This movement resembles the tide: in the morning the workers stream into Paris, and in the evening the same flood of people flows out."[264] To them, Haussmann's renovated capital offered nothing but a transient, diurnal citizenship that expired at nightfall, as the army of ouvriers that poured into the center every morning slowly made its way back home, exhaled by the great city.

Workers were acutely aware that life in the banlieue curtailed opportunities for personal growth. For Henri-Louis Tolain, a metalworker and later senator, the experience of the city, with its historic landmarks and rich cultural mix, enabled the amplification of individual potential: "If you expatriate workers beyond the walls and give them a little garden, they will undoubtedly take pleasure in cultivating it and watering plants, but this will not renew their ideas; only contact with beautiful artifacts can facilitate this incessant and ever varied creativity that constitutes the glory of Parisian industry."[265] The same point was brought up by workers in the parliamentary inquiry of 1884 who mentioned the "special taste that Parisian ouvriers acquired living in the center of the capital."[266] Even members

of the liberal bourgeoisie sometimes viewed spatial segregation, as well as the class-bound forms of inequality it engendered, with inquietude although their motivations differed. In a contemporary account of the demolitions around the Opéra, the writer Edmond About explains how the environment helped shape the inhabitants' identities: "And my sons," he has a fictitious proletarian mother ask, "do you think that they would have been so successful if the family had been based in Montrouge or Grenelle? I do not believe that they would have left us, for they are the best boys in the world; but in that case, they would not have lived in the midst of beautiful Parisian views; they would not have seen the museums, spectacles, alluring shops, elegant outfits, everything that shapes taste, awakens the imagination: in a word, that which can sometimes transform a worker into an artist."[267] With limited access to cultural artifacts and landmarks, these young men—and the gendering is significant—would have been denied the forms of apprenticeship and powers of acculturation characteristic of the city. The dispossessed spaces of the periphery did not offer the same cultural possibilities as the historic core.

The contrast between a center quilted with opulence and the chaotic disarray of the periphery played an instrumental role in the construction of marginality *as representation*. For all the glaring class differences that distinguished Paris under Haussmann, one must avoid seeing the great metropolis as a dichotomy: the dystopia of the annexed territories pitted against the pleasurable heterotopia of old Paris. Such a reductive view would pass over in silence the role of fantasy and resilience among workers who were constantly reshaping their environment and would disregard their adaptative capacities as they shuttled between radically different worlds. Unlike the wealthier classes, whose jobs did not require venturing beyond their reassuring precincts, workers' daily exodus from the capital made them amphibians, adept at surviving in two dissimilar environments.[268]

Paris was, and remained long after the Second Empire, a tense syncretism, where different classes and subcultures met, fought, and assimilated. If social antagonisms ran deep, the inhabitants of the periphery did not retreat into quietism and passively accept their secondary status. However disadvantaged, the settlements at the edge of Paris were also places where challenges to the dominant culture were being articulated and new forms of class solidarity and political expression forged.[269] Only a dialectical model that avoids totalizing views and binaries can explain the creative exchange between two areas that were neither sealed into airtight compartments, nor locked into purely adversarial relations, without overlooking the very real discrimination set in motion by the imperial management of urban space and its objectifying spatial practices. Marginality was real enough though not in the sense of a deterministic equivalency between space and identity.[270] The structures that sustained personal growth were not absent in the periphery, where the very lack of landmarks, services, and institutions contributed to shape a vibrant working-class culture and a sense of militancy that would be tested in the decades to come.

Partitioned by visible and invisible thresholds, nineteenth-century Paris was nevertheless porous.[271] Rancière rightly called attention to "the multiplication of these trajectories, real or imaginary, by which workers circulate within the spaces of the bourgeoisie, allowing their dreams to vagabond."[272] If we ignore the potential fluidity of subject positions and workers' sense of agency, we reduce the underprivileged to the same one-dimensional paradigm with which they were treated under the Second Empire. All classes, regardless of their station in life and place of residence, partook of the urban experience. By day,

thousands of ouvriers walked about the city, engaged in countless social transactions that honed their skills and expanded expectations: mobility exposed them to different facets of city life, the center serving as a platform for negotiating cultures and identities. While many lived in a no-man's-land outside the center, urban citizenship, changeable and tenacious, was something they performed in alternative ways and with "multiple identities."[273] If workers from the outskirts often saw their own relations with the historic city in bleak terms, their unhappiness betrayed a yearning for forms of urban belonging that were being denied them, showing how keenly they felt the spectacle of the great city beckoning seductively from below.

In its relative isolation, the periphery functioned as a great catchment area, a crucible awash in ambiguity, marked by polarities and discontinuities yet stubbornly connected to a city that rejected it, a place of both exclusion and resilience. Far more than the center perhaps, the urban hinterland constituted one of the most important facets of the capital's vaunted modernity, which could assume different aspects and disavow the ex-centric asymmetry of the outskirts as a signifier of subordination. With its residents from different regions and countries, and plurality of disparate skills and practices, the banlieue was irritatingly heterogeneous. Entrenched localisms brushed up against progressive sectors of the working class. Such a raucous and creative cacophony was rich in social capital with networks of support, sociability, and professional solidarities. Culturally and politically interpellated by the new Paris, the men and women who straddled two worlds were urban actors who built the so-called capital of the nineteenth century, ran its complex technological systems, made sewers function and water flow, and fixed them when needed. The city's engineered infrastructure cannot be taken as a given: technology, too, is socially constructed.[274] That workers understood the harsh inequality inherent in the empire's acclaimed systems can be seen in the way they tore up roads, eliminated lighting, and destroyed cast-iron structures during the Commune (fig. 7.16).[275]

The urban environment was a medium to which workers, set on discrepant paths to modernity, were deeply responsive. Though housed far from the networked core of the city, workers took their knowledge with them when they returned to their underserviced faubourgs, where, in the absence of modern equipment they themselves built and maintained in the opulent center, they continually devised imaginative strategies and ad hoc solutions for coping with what they lacked. One cannot underestimate the challenges to subjectivities that technology brought about for all, including those who were excluded from its scope and tried to reimagine their lives and futures by making do with the little they had. By the second half of the nineteenth century, the periphery of Paris had become not only a site of constant struggle and oppression but also a great incubator of countercultures that enabled men, women, and children to embrace a role that gave them a sense of agency and empowerment in their collective reactions to the formidable strategies marshaled against them. Nadaud, Tolain, and Anthime Corbon, former ouvriers, rose to become senators; Jérôme-Pierre Gilland, a member of Parliament; Antoine Granveau, Pierre Vinçard, and Émile Souvestre, among many others, respected writers on the lives of the poor, as were working women such as Jeanne Deroin, Désirée Gay, Jeanne Bouvier, and Nathalie Lemel.[276]

Nevertheless, not everything can be explained away in such affirmative terms. The periphery was modern, as well, in the ways with which it was subjected to legal, economic,

FIG. 7.16. Barricade on the Boulevard Puebla, Ménilmontant, 1871, made with Davioud's tree guards (the boulevard commemorated the capture of the Mexican town of Puebla in 1863). Musée Carnavalet, Paris.

social, and infrastructural violence. The poverty that afflicted three-quarters of the city's inhabitants was mass-produced by a modern economy predicated on the use of thousands of workers to overhaul the city without adequate compensation in terms of housing and services. To situate capitalist urban modernity wholly within the technological or the urbanistic—boulevards, water supply, sewerage networks, systems of mass transit—is to ignore the violence that lies at its core: eviction, segregation, and, to use their present names, eminent domain, and gentrification.

In architectural history, "Paris" is still largely equated with the beautiful center and its major monuments, while the belt of working-class settlements that constitutes more than half of the urban territory has always been peripheral to narratives about the city's urbanism. Paris cannot be dealt with by synecdoche, as if the historic kernel constituted the entirety of the city. Center and periphery remained locked in a painful and inseparable relationship. It was precisely the relocation of the poor to the margins that helped foster the ideology of the center: a refurbished urban core endowed with visible connections to the past. The valuation of the historic kernel, and its attendant economic consequences, was complicated by the belief in the special status of the capital, a legacy of absolutism embraced wholeheartedly by the empire, particularly in its early years. "Paris is Centralization itself," Haussmann declared in his memoirs.[277] Members of the opposition such as Charles-Alfred Janzé attacked this view vehemently: "The Empire has managed to exacerbate the system of excessive centralization bequeathed by previous governments; all local influence has been stifled, elective power emasculated and placed under the tutelage of

the administration; today individual or collective initiatives have vanished, along with all communal, departmental, and provincial vitality."[278]

As a result, the national and the municipal often clashed in Paris, sometimes dangerously. Their age-old struggle weighed heavily on the great metropolis.[279] Already in 1848, alarmed by the recent elections that had brought Louis Napoleon to victory and what he saw as the "perpetual antithesis of the State and the city," a disgruntled observer called for the government to be headquartered elsewhere so that it would not be threatened by the impoverished residents from the surrounding faubourgs.[280] During the Second Empire, that wager was clearly resolved in favor of the state. Haussmann spent seventeen years working for the city but only in so far as it could be harnessed to the imperial cause. As he haughtily declared in 1859, the administration of Paris could not serve purely municipal ends: "The State intervenes and must do so directly and continually, in its affairs."[281]

In his masterful study on the ideological nature of urban space, Lefebvre argued that centrality "is constitutive of urban life."[282] The demise of the old classical city and the emergence of a metropolis (or the polynuclear megalopolis of our day) does not invalidate that principle. Second Empire Paris defined its monuments, gardens, and beautiful boulevards as the seat of political, economic, and cultural power. Even reduced increasingly to spectacle, the old Cité and its surroundings still partook of both use value and exchange value, retaining the capacity to engage viewers beyond a purely spectatorial response. The dislocated and decentered laboring poor understood the symbolic violence done to them by their eviction from the vieux Paris. During the Commune, workers swept down from the heights of Montmartre and Belleville and reclaimed the civic center from which they had been expelled.[283] That, at any rate, is one of the many and often conflicted meanings attributed (in hindsight) to the Commune. There was to be no spatial consensus or social integration, let alone reconciliation, under the empire.

Conclusion

" I was struck," wrote Jean Cocteau in 1920, "by how little space she occupied. She had shriveled, like one of those shrunken heads mummified by the savages who killed her son."[1] Cocteau's diminutive interlocutor was none other than Eugénie, former empress of France. Surviving the empire by half a century, she lived to see the rise of cubism, futurism, and Dada, and the appearance of cinema, automobiles, and airplanes. Cocteau's reminiscence, couched in colonialist terms, drives home the artifice of periodization, the paltry seams we establish between different historical ages. They are a serviceable and possibly necessary construction we use to understand the past, but they are not politically neutral. To our ears, "republic" sounds much more appealing than "empire," but the men and women who played a prominent role under Napoleon III did not disappear in 1870, like actors exiting the stage at the end of a play. Officially the Second Empire collapsed after Sedan. Yet many of its high-placed fonctionnaires, including Belgrand and Alphand, went on to serve the Third Republic, that long afterglow of empire, carrying forward what was by then an anachronistic model of urban planning based on the primacy of circulation.[2] Haussmann himself returned to public life after his curtain call in 1870, albeit somewhat incongruously for a Protestant, as senator for Catholic (but Bonapartist) Corsica. It was precisely the persistence of the old in the new that led writer Jean Giraudoux to remark dryly that the Third Republic contented itself "with living in furnished rooms."[3] The reconfiguration of the historic center, and the gradual relocation of a large part of the laboring poor in the outskirts, continued under the Third Republic, which, coming after the Commune, had even more reason to fear the capital's workers. Despite the undeniable gains achieved in education and social mobility after 1871, Paris remained in the grip of a conservative government with Republican trappings—the ideological alignment of the powerful elites of the two regimes.

Similar continuities had marked the shift from the July Monarchy to the Second Empire. Haussmann's superb new infrastructure was grafted onto a political apparatus pressured by the sluggish undertow of the past. Building on the rich urban legacy left by Rambuteau, Haussmann and his collaborators continued to overhaul the capital, retrofitted older structures, and left a city irrigated by water and equipped with gas and light. Yet this seminal debt, well researched in the past few decades, cannot be seen exclusively in affirmative terms. Whereas forward-looking continuities between the municipal policies of Rambuteau and those of Haussmann have been repeatedly underscored, scholarship has been reluctant to acknowledge recursive negative aspects of urban planning. When

the Second Empire rearranged the political surfaces of Paris, it did not depart from the systematic indifference shown to the city's workers by previous administrations except, perhaps, in scale. Its networks, riven with social inequalities and discriminatory practices, brought both access and exclusion. It is easy to demonize Haussmann and paint the difference between monarchy and empire in Manichaean terms, but the unmaking of the working class was due to long-standing complicity of class allegiances that spared no effort in marginalizing the laboring poor to secure the capital against insurrection—before, during, and after the Second Empire. The regime's divisive tactics were not the responsibility of a single man, even one as autocratic as Haussmann. His politically monochrome world was something he shared with an entire class, which always considered certain parts of the city a question of entitlement. Although a defensive use of space had been common practice before Haussmann took office, the political aftermath of 1848 brought irreversible change to the way the city's successive regimes envisaged urban governance. The capital's new geopolitical configuration, with workers crammed in the interstices of the city and in its surrounding faubourgs, clearly expressed the affluent classes' long-standing distrust of the laboring poor.

Haussmann's reliance on urban planners of the preceding half century does not, of course, exonerate his merciless treatment of the working class, nor his brutal erasure of countless landmarks, particularly in the Île de la Cité and the Left Bank. Yet Napoleon III must also take responsibility—as well as credit—for many of the changes implemented by his prefect. Seeing himself as a peace broker who could mollify the working classes with public works, the emperor left intact the exploitative practices that reproduced them as labor. If he was deeply concerned with the welfare of the disadvantaged, his motivations were complicated and far from disinterested; his authoritarian fiats ratified every initiative undertaken by his prefect. Part of his unswerving support of his prefect had to do precisely with the latter's capacity to execute distasteful policies that gave form to imperial Paris, thereby consolidating the emperor's position as an able steward of the French capital. Driven by the regime's dynastic ambitions and the political fears of the leisured classes, the Second Empire's urban strategies constituted class war by other means—urbanism, speculation, and expropriation, among them.

Not everything can be put down to the Second Empire's debt to the July Monarchy, of course. After annexation, the size of Paris more than doubled. Haussmann was thus confronted with a metropolis, something his predecessors never had to deal with. Mass production, the emergence of new technologies, and the radical shift in scale dictated new approaches to urban planning. To carry out the empire's vast program of urban renewal, Haussmann relied on the work of many experts from across the political spectrum, in particular his elite corps of engineers, whose role has never been sufficiently studied. Equally important was the role of thousands of workers, with different degrees of expertise, who were responsible for laying and maintaining the infrastructure. Moreover, the new world order that emerged after 1850 was increasingly cosmopolitan. Accordingly, the municipality introduced innovative, transnational urban practices that made it an incubator for experimentation. Colonialism, no less than steam, had much to do with this gradual expansion of horizons and cornucopia of new products from other lands; the intercultural relations that so richly benefitted the empire were marked by different forms of systemic violence that cannot be wished away by vague notions of an early form of globalization.

Emperor and prefect were at the service of the industrial and mercantile sectors of the economy, whose vision of Paris was shaped by modern forms of production and exchange: the need to free up the urban fabric for circulation, to provide greenery for a growing population, and to edit the historic center in the interests of consumption and representation. The structural transformations that reshaped Paris between 1850 and 1870 were not due to capitalism alone. Yet without taking its evolution into account, they cannot be explained at all. Like other regimes, the Second Empire used space—at the scale of the city, the nation, and the empire—as an instrument of power. "Space," wrote Lefebvre, "is what makes it possible for the economic to be integrated into the political."[4] Laws legitimizing expropriation, ancestors of today's eminent domain, allowed the municipality to seize large tracts of land. Gentrification did the rest, upgrading the fabric while dislocating the original inhabitants as public space was wrested from its former flexible use and increasingly pressed into the service of class-specific interests. Haussmann undoubtedly built strategic streets as insurance against revolution, but his main goal was to make Paris safe for capitalism, and he dutifully embellished the city according to what he saw as the self-imagination of its elites. Although the bipolar world of nineteenth-century Paris did not begin or end with the Second Empire, the coup d'état of 1851 accelerated the process of social stratification already underway.

Both rich and poor felt the consequences of the city's urban fractures, though in markedly different ways. Beyond the line of the old tax walls, destroyed in 1860, a ring of convulsive faubourgs looked down—invidiously, in the eyes of the propertied classes—on all the wealth that they themselves produced but from which they were excluded. Further away rose the specter of la France profonde, wary of the great city, fearful of modernity, and bitter at the extravagant sums being raised to transform it.[5] For their part, the laboring classes forced to move far from their old neighborhoods refused to remain tethered to the distant and dystopic periphery. As the Siege and the Commune would reveal, workers had a great capacity to organize and mobilize, putting their know-how at the service of supra class purposes and ideals. Architectural historians have seldom acknowledged the role they played in the transformation of the capital during the Second Empire, and persistently ignored their neighborhoods and buildings. Modernity has been taken as a given, in an ahistorical way, rather than interpellated, and this too has contributed to silence the contributions of the urban proletariat.

After his dismissal from office in 1870, Haussmann's name came to be synonymous with ruthless, slash-and-burn forms of redevelopment and debt-financed infrastructural improvement, even as his urban policies were being put into practice across Europe, Latin America, and Asia.[6] By the time Camillo Sitte's trenchant critique of Haussmannization was published in 1889, it was too late to stay the hand of destruction.[7] Marseille, Lyon, Toulouse, and Montpellier had already been partly reconfigured in imitation of Paris.[8] Like the old empress, Haussmannization survived long after the prefect's departure from office in 1870, as cities were eviscerated, forcing the poor to relocate further and further from the center, where they formerly lived side by side with other social groups, though admittedly in inferior housing.

In other continents, the situation is more complicated. Haussmannization was never a question of wholesale imitation: even in the overseas territories, urban renewal depended on the economy, the topography, and the vested interests of the local ruling elites. The

term is often applied uncritically to vast swaths of urban destruction around the globe that have little to do with Haussmann. Its impact differed widely. French colonies in Asia were influenced by Second Empire architecture more than urbanism proper.[9] In the New World, the impact was far-reaching and much more destructive. In Rio de Janeiro, hills were razed along with their fine colonial churches; mayor Francisco Pereira dos Passos, who had studied in Paris during the heyday of Haussmannization, cut implacably straight boulevards cut through the urban fabric.[10] Buenos Aires followed suit. In the United States, iron-fisted planners have always admired the headstrong prefect of Paris. "We want a Baron HAUSSMANN," exclaimed Frank Sewall in 1891, addressing the needs of the United States' older cities.[11] "The task which Haussmann accomplished for Paris corresponds with the work which must be done for Chicago," observed Daniel Burnham almost twenty years later.[12] During World War II, Robert Moses expressed his admiration for Haussmann's bold, large-scale approach (characteristically chiding him for not going far enough).[13] Yet by that time, Haussmannization had already passed into history. "This is one of those symbol names with which we generalise events and ideas and so modify their content, to suit our own purposes, that we really make of them common nouns, so little remains of the man and so much of our idea," wrote Elbert Peets knowingly.[14] Lengthy processes like Haussmannization are always overdetermined: justice can hardly be done to the numerous actors and the pressures brought to bear on the complex, layered process that constitutes urbanism, which is shaped by innumerable currents, some so slow moving that they take decades to be identified.

Today, greater Paris has grown beyond its Second Empire perimeter, its center curtailed even more drastically in the interests of automobile circulation, and its sad peripheries teeming with locally born citizens whose ancestors hailed from France's former colonies and with more recent immigrants. Such conditions are no longer limited to Paris. The destruction of the urban fabric and its corollaries—gentrification without social sustainability; the expulsion of the poor from their homes, replaced by unaffordable housing; the class-driven agenda that privileges the richest districts—have all become standard in our postindustrial cities. None of these similarities is the inevitable consequence of inexorable historical forces. Rather, the swollen, polycentric megalopolises of our time, enlarged exponentially by conurbation, could come into being only at the expense of the urban and social fabric of the nineteenth-century metropolis. Our cities today reflect the transformations of late capitalism, which is driven to lower the costs of production by importing cheap migrant labor or outsourcing industries to new global peripheries, implicating us "in the performance of the colonial present."[15] We are haunted by the legacies of nineteenth-century modernity and, even more, by the urban violence of our own making.

FIG. 7.17. Charles Marville, *Étude de ciel*, 1855–56. Metropolitan Museum of Art, New York.

Notes

INTRODUCTION

1. César Daly, "Travaux de Paris," *RGA* 20 (1862): col. 176.

2. The title "prefect of the Seine" disappeared only in 1977, when the new statutes of the city allowed it to elect its first mayor, Jacques Chirac.

3. Robert Moses, "What Happened to Haussmann," *Architectural Forum*, no. 77 (July 1942): 57–66.

4. Le Corbusier (Charles-Édouard Le Corbusier), *Urbanisme* (Paris: Flammarion, [1925] 1994), 247. Sigfried Giedion, *Space, Time and Architecture*, 5th ed. (Cambridge, MA: Harvard University Press, [1941] 1967), 822.

5. James Scott, *Seeing Like a State: How Certain Schemes to Improve the Human Condition Have Failed* (New Haven, CT: Yale University Press, 1998).

6. Guy Debord, "Introduction to a Critique of Urban Geography," in *Situationist International Anthology*, ed. Ken Knabb, trans., collaboration Nadine Block and Joël Cornuault (Berkeley, CA: Bureau of Public Secrets, 1981), 5.

7. David P. Jordan, "Baron Haussmann and Modern Paris," *American Scholar* 61, no. 1 (Winter 1992): 100.

8. Anthony Sutcliffe, *The Autumn of Central Paris: The Defeat of Town Planning 1850–1970* (Montreal: McGill-Queen's University Press, 1971); David H. Pinkney, *Napoleon III and the Rebuilding of Paris* (Princeton, NJ: Princeton University Press, 1972); Pierre Lavedan, *Histoire de l'urbanisme à Paris* (Paris: Hachette, 1975).

9. David Van Zanten, "Mais Quand Haussmann est-il devenu moderne?," in *La Modernité avant Haussmann: Formes de l'espace urbain à Paris, 1801–1853*, ed. Karen Bowie (Paris: Éditions Recherches, 2001), 152–64; Nicholas Papayanis, *Planning Paris before Haussmann* (Baltimore: Johns Hopkins University Press, 2004).

10. François Loyer, *Paris XIXᵉ siècle: L'immeuble et la rue* (Paris: Hazan, 1994); Pierre Pinon, *Le mythe Haussmann* (Paris: Éditions B2, 2018).

11. David P. Jordan, *Transforming Paris: The Life and Labors of Baron Haussmann* (Chicago: University of Chicago Press, 1995).

12. Pierre Casselle, "Les Travaux de la Commission des embellissements de Paris en 1853: Pouvait-on transformer la capitale sans Haussmann?," *Bibliothèque de l'École des Chartes* 155, no. 2 (July–December 1997): 645–89.

13. Casselle himself led the charge: "In contrast to the myth that surrounds his oeuvre, the prefect created practically nothing of the Paris currently attributed to him except, perhaps, its most questionable aspects." Casselle, "Les Travaux de la Commission," 673–74. François Loyer, "Le regard des historiens sur la transformation de Paris au XIXᵉ siècle," in Bowie, *La Modernité avant Haussmann*, 11. The trend had begun even before. See Pierre Pinon, "Le projet d'embellissement de Paris: Napoléon III et Berger," in Jean des Cars and Pierre Pinon, *Paris Haussmann* (Paris: Picard, 1991), 55.

14. Quoted in Joanna Richardson, "Emperor of Paris: Baron Haussmann, 1809–1891," *History Today* 25, no. 12 (December 1975): 844.

15. Georges-Eugène Haussmann, *Mémoires du Baron Haussmann*, vol. 3, *Grands travaux de Paris* (Paris: Guy Durier, 1979), 43.

16. Cars and Pinon, *Paris Haussmann*; Michel Carmona, *Haussmann* (Paris: Fayard, 2000); Nicolas Chaudun, *Haussmann au crible* (Paris: Éditions de Syrtes, 2000); Georges Valance, *Haussmann le Grand* (Paris: Flammarion, 2000); Françoise Choay, "Introduction," in Georges-Eugène Haussmann, *Mémoires*, general intro. by Françoise Choay; technical intro. by Bernard Landau and Vincent Sainte Marie Gauthier (Paris: Seuil, 2000), 29.

17. Jeanne Gaillard, *Paris, la ville (1852–1870)*, ed. Florence Bourillon and Jean-Luc Pinol (Paris: L'Harmattan, 1997).

18. T. J. Clark, *The Painting of Modern Life: Paris in the Art of Manet and His Followers* (Princeton, NJ: Princeton University Press, 1984); David Harvey,

Consciousness and the Urban Experience: Studies in the History and Theory of Capitalist Urbanization (Baltimore: Johns Hopkins University Press, 1985).

19. Pierre Pinon, "Les conceptions urbaines au milieu du XIXᵉ siècle," in Cars and Pinon, *Paris Haussmann*, 46; Bruno Fortier, "L'Atlante di Parigi," part 2, "Le strategie della memoria," *Casabella* 49, no. 518 (November 1985): 40–49.

20. Henri Lefebvre, *The Production of Space*, trans. Donald Nicholson-Smith (Oxford: Blackwell, 1991), 362. See also Papayanis, *Planning Paris before Haussmann*, 208.

21. Marcel Roncayolo et Louis Bergeron, "D'Haussmann à nos jours," in *Paris, génèse d'un paysage*, ed. Louis Bergeron (Paris: Picard, 1989), 231.

22. Michel Foucault, "Truth and Power," in *Power/Knowledge*, ed. Colin Gordon ed., trans. Colin Gordon, Leo Marshall, John Mepham, and Kate Soper (New York: Pantheon Books, 1980), 117.

23. This is the gist of Jacques Rancière's magisterial *Proletarian Nights: The Workers' Dream in Nineteenth-Century France*, trans. John Drury, with an intro. by Donald Reid (London: Verso Books, 2012).

24. Miriam Simon, "Les voix du peuple," in *Le Peuple de Paris au XIXᵉ siècle*, ed. Miriam Simon (Paris: Paris-Musées, 2011), 16. Interestingly, Paul Gauguin, grandson of the great French feminist Flora Tristan, wrote in his memoirs that she was a "socialist bluestocking" who probably did not know how to cook. Paul Gauguin, *Avant et Après, avec les vingt-sept dessins du manuscrit original* (Paris: G. Crès, 23), 133.

25. See the excellent work by Michelle Perrot, *Les femmes ou les silences de l'histoire* (Paris: Flammarion, 1998); and Michelle Perrot in collaboration with Jean Lebrun, *La place des femmes: Une difficile conquête de l'espace public* (Paris: Textuel, 2020).

26. Excellent examples are the exhibition catalog of the Musée Carnavalet: Simon, *Le Peuple de Paris au XIXᵉ siècle*; and, several years ago, *Le Parisien chez lui au XIXᵉ siècle: 1814–1914* (Paris: Archives nationales, 1976).

27. The goal is not to uncover a true Paris behind appearance "but to problematize referentiality altogether." Rosalyn Deutsche, "Boys Town," *Environment and Planning D: Society and Space* 9, no. 1 (March 1991): 21.

28. Walter Benjamin, "Paris—the Capital of the Nineteenth Century," in *Charles Baudelaire: A Lyric Poet in the Era of High Capitalism*, trans. Harry Zohn (London: Verso, 1997), 155–76; Patrice L. R. Higonnet, *Paris: Capital of the World*, trans. Arthur Goldhammer (Cambridge, MA: Belknap Press of Harvard University Press, 2002). Unlike the others, Higonnet presents this as a myth.

29. David Harvey, *Paris, Capital of Modernity* (London: Routledge, 2003).

30. Michael Geyer and Charles Bright, "World History in a Global Age," *American Historical Review* 100, no. 4 (October 1995): 1058.

31. Dipesh Chakrabarty, "Postcoloniality and the Artifice of History: Who Speaks for 'Indian' Pasts?," in "Imperial Fantasies and Postcolonial Histories," special issue, *Representations*, no. 37 (Winter, 1992): 21; and *Provincializing Europe: Postcolonial Thought and Historical Difference* (Princeton, NJ: Princeton University Press, 2000).

32. Peter S. Soppelsa calls attention to the technological failures of Haussmann's networks: "The Fragility of Modernity: Infrastructure and Everyday Life in Paris, 1870–1914" (PhD diss., University of Michigan, 2009), 35–98.

33. Over the past century and a half, a great many scholars have criticized prevailing notions of modernity. For a useful overview, covering different authors and perspectives, see Jane Bennett, "Modernity and Its Critics," in *The Oxford Handbook of Political Theory*, ed. John S. Dryzek, Bonnie Honig, and Anne Philips (Oxford: Oxford University Press, 2006), 211–24. For modernity and Second Empire Paris, see Soppelsa, "The Fragility of Modernity," especially 13–16.

34. *Is Paris Still the Capital of the Nineteenth Century? Essays on Art and Modernity, 1850–1900*, ed. Hollis Clayson and André Dombrowski (London: Routledge, Taylor and Francis, 2016).

35. Robert Aldrich, "Putting the Colonies on the Map: Colonial Names in Paris Streets," in *Promoting the Colonial Idea: Propaganda and Visions of Empire in France*, ed. Tony Chafer and Amanda Sackur (Houndmills: Palgrave, 2002), 211–23.

36. For this issue, see Vincent Droguet, "Empress Eugénie's Chinese Museum at the Château of Fontainebleau," in *Collecting and Displaying China's "Summer Palace" in the West: The Yuanmingyuan in Britain and France*, ed. Louise Tythacott (London: Routledge, Taylor, and Francis, 2018), 138–48. However, there were more pieces from Yuanmingyuan in Paris: the feminist writer Juliette Adam (1836–1936) was told that "Chinese masterpieces looted from the Summer Palace," that were to be on display at the 1867 exhibition, disappeared without a trace. This was attributed to imperial corruption. Juliette Adam, *Mes Sentiments et nos idées avant 1870* (Paris: Lemerre, 1905), 149. See also Meredith Martin, "History Repeats Itself in Jean-Léon Gérôme's Reception of the Siamese Ambassadors," *Art Bulletin* 99, no. 1 (March 2017): 97–127.

37. Christine Howald and Léa Saint-Raymond, "Tracing Dispersal: Auction Sales from the Yuanmingyuan Loot in Paris in the 1860s," *Journal for Art Market Studies* 2 (2018): 1–23.

38. Michael A. Osborne, "Science and the French Empire," *Isis* 96, no. 1 (March 2005): 83.

39. Michael J. Heffernan, "The Parisian Poor

and the Colonization of Algeria during the Second Republic," *French History* 3, no. 4 (1989): 381; Ann Laura Stoler, *Duress: Imperial Durabilities in Our Times* (Durham, NC: Duke University Press, 2016).

40. Rancière, *Proletarian Nights*, xi.

41. For an excellent analysis of the changing use of historical photographs as documents, see Catherine E. Clark, *Paris and the Cliché of History: The City and Photographs, 1860–1970* (New York: Oxford University Press, 2018).

42. Saskia Sassen, "Reading the City in a Global Digital Age," in *Global Cities: Cinema, Architecture, and Urbanism in a Digital Age*, ed. Linda Krause and Patrice Petro (New Brunswick, NJ: Rutgers University Press, 2003), 15.

CHAPTER ONE: THE PRESIDENT, THE EMPEROR, AND THE PREFECT

1. Napoléon-Louis Bonaparte, *Extinction du paupérisme* (Paris: Pagnerre, 1844). Louis Napoleon was sentenced to life imprisonment after trying to overthrow the government of Louis-Philippe with a coup d'état in Strasbourg in 1836, and in Boulogne in 1840.

2. Louis Napoléon, "Fête à l'Hôtel-de-Ville," *Journal des Débats*, December 11, 1850, 1.

3. Pierre Patte, *Monumens érigés en France à la gloire de Louis XV* (Paris: Chez l'Auteur, Desaint, Saillant, 1765), and *Mémoire sur les objets les plus importans de l'architecture* (Paris: Rozet, 1769). Chabrol-Chaméane, *Mémoire sur le déplacement de la population dans Paris*; Perreymond, "Études sur la Ville de Paris," *RGA*, vol. 3 (December 1842): cols. 540–54, 570–79; and vol. 4 (January 1843): cols. 25–37; (February 1843): cols. 72–88; (September 1843): cols. 413–29; (October 1843): cols. 450–58, 458–69; and (November 1843): cols. 517–28. Hippolyte Meynadier, *Paris sous le point de vue pittoresque et monumental; ou, Éléments d'un plan général d'ensemble de ses travaux d'art et d'utilité publique* (Paris: Dauvin et Fontaine, 1843). See also Pierre Pinon, "Les conceptions urbaines au milieu du XIXᵉ siècle," in Jean des Cars and Pierre Pinon, *Paris Haussmann* (Paris: Picard, 1991), 44–50.

4. Georges-Eugène Haussmann, *Mémoires du Baron Haussmann*, vol. 2, *Préfecture de la Seine* (Paris: Victor-Havard, 1890), 3.

5. Claude-Philibert Barthelot Rambuteau, *Mémoires du Comte de Rambuteau* (Paris: Calmann-Lévy, 1905), 372.

6. The municipal council asked the prefect to commission a study "of the road improvements to be carried out in Paris, and to prepare a plan d'ensemble of these improvements." Ernest de Chabrol-Chaméane, *Mémoire sur le déplacement de la population dans Paris et sur les moyens d'y remédier* (Paris: Bouchard-Huzard, 1840), i.

7. Rambuteau, *Mémoires*, 373–74.

8. Jeanne Pronteau, "La Commission et le Plan des Artistes," in *L'Urbanisme parisien au siècle des lumières* (Paris: Délégation à l'action artistique de la Ville de Paris, 1997), 205–17; Roger Kain, "Napoléon I and Urban Planning in Paris," *Connoisseur* 197, no. 791 (January 1978): 44–51; Anthony Sutcliffe, *The Autumn of Central Paris: The Defeat of Town Planning 1850–1970* (Montreal: McGill-Queen's University Press, 1971), 12–15.

9. Letter of the Commissaires Artistes of December 17, 1795, quoted in Louis-Charles Taxil, "Le Plan des Artistes," in *Commission Municipale du vieux Paris: Procès verbaux* (1917) (Paris: Imprimerie Municipale, 1922), 295–96.

10. Maurice Halbwachs, "Les plans d'extension et d'aménagement de Paris avant le XIXᵉ siècle," *La Vie urbaine*, no. 5 (1920): 23.

11. For the Plan des Artistes, see Halbwachs, "Les plans d'extension et d'aménagement de Paris," 11–28; John W. Simpson, "Town-Planning in the French Revolution: Remarks on the 'Plan des Artistes,'" in *Essays and Memorials*, with a preface by Major H. Barnes (London: Architectural Press, 1922), 75–125; Sylvie Buisson, "Le plan des artistes," part 1, *La Vie urbaine*, no. 55 (January–March 1950): 8–21, and part 2, *La Vie urbaine*, no. 57 (July–September 1950): 161–71; Pronteau, "La Commission et le Plan des Artistes," 205–17. A problematic reconstruction of the Plan des Artistes, based on the minutes of the Commission des Artistes, can be found in *Les travaux de Paris, 1789–1889*, ed. Adolphe Alphand (Paris: Imprimerie Nationale, 1889), plate 10.

12. Michel Chevalier, *Des intérêts matériels en France: Travaux publics* (Paris: Charles Gosselin and W. Coquebert, 1838), 20.

13. For the impact of Saint-Simonian ideas on architecture and urbanism, see Antoine Picon, *Les Saint-simoniens: Raison, imaginaire et utopie* (Paris: Belin, 2002), 245–83; Barry Bergdoll, *Léon Vaudoyer: Historicism in the Age of Industry* (Cambridge, MA: MIT Press, 1994), 101–3; Robin Middleton, "The Rationalist Interpretations of Léonce Reynaud and Viollet-le-Duc," *AA Files* 11 (Spring 1986): 29–48.

14. It was under the French Revolution that the notion of urbanism—systematic planning for the city—appears for the first time. Lucien Dubech and Pierre d'Espezel, *Histoire de Paris* (Paris: Les Éditions Pittoresques, 1931), 2:141.

15. Victor Considerant and Perreymond, "De l'unité administrative du département de la Seine," part 2, *La Démocratie pacifique* 1, no. 103 (November 11, 1843): 1.

16. Pierre Pinon, *Le mythe Haussmann* (Paris: Éditions B2, 2018), 20. See also Michel Coste, "Perreymond, un théoricien des quartiers et de la restructuration," *Les Annales de la recherche urbaine*,

no. 22 (April 1984): 47–57; Nicholas Papayanis, "L'Emergence de l'urbanisme moderne à Paris," in *La Modernité avant Haussmann: Formes de l'espace urbain à Paris, 1801–1853,* ed. Karen Bowie (Paris: Éditions Recherches, 2001), 82–94; and Frédéric Moret, "Penser la ville en fouriériste," in Bowie, *La Modernité avant Haussmann,* 95–109; Lloyd Jenkins, "Utopianism and Urban Change in Perreymond's Plans for the Rebuilding of Paris," *Journal of Historical Geography* 32, no. 2 (April 2006): 336–51.

17. Perreymond, "Études sur la Ville de Paris," *RGA,* vol. 3 (December 1842): cols. 540–54, 570–79; vol. 4 (January 1843): cols. 25–37; vol. 4 (February 1843): cols. 72–88; vol. 4 (September 1843): cols. 413–29; vol. 4 (October 1843): cols. 449–69; vol. 4 (November 1843): cols. 517–28.

18. Perreymond, "Deuxième Étude sur la Ville de Paris," *RGA* 3 (1842): col. 573.

19. Marcel Roncayolo, "Mobilités et centralités haussmanniennes: L'expérience, le modèle, la critique," *Lectures de villes: Formes et temps* (Marseilles: Éditions Parenthèses, 2002), 214.

20. Victor Considerant and Perreymond, "De la grande circulation dans Paris," *La Démocratie pacifique* 1, no. 110 (November 18, 1843): 1, emphasis in original.

21. Victor Considerant and Perreymond, "De L'unité administrative du département de la Seine," *La Démocratie pacifique* 1, no. 82 (October 21, 1843): 1.

22. Perreymond, "Cinquième Étude sur la Ville de Paris," *RGA* 4 (1843): col. 86.

23. Perreymond, "Quatrième Étude sur la Ville de Paris," *RGA* 4 (1843): col. 78.

24. "The lack of proportion between the width of streets and the height of buildings, the multiplicity of narrow, meandering streets, necessarily render habitations humid and unhealthy, depriving them from exposure to sunlight and the continuous renewal of air." Chabrol, quoted in Perreymond, "Troisième étude sur la Ville de Paris," *RGA* 4 (1843): cols. 29–30.

25. Perreymond, *Paris monarchique et Paris républicain ou une page de l'histoire de la misère et du travail* (Paris, A la Librarie Sociétaire, 1849). The book was dedicated to Eugène Sue.

26. Perreymond, "Sixième étude sur la Ville de Paris," *RGA* 4 (1843): col. 415.

27. Moret, "Penser la ville en fouriériste," 108–9, ellipses in original.

28. Michel Ragon, *Histoire de l'architecture et de l'urbanisme modernes* (Paris: Points/Casterman, 1986), 1:119.

29. Meynadier, *Paris sous le point de vue pittoresque et monumental,* 35.

30. Meynadier, *Paris sous le point de vue pittoresque et monumental,* 16.

31. Meynadier, *Paris sous le point de vue pittoresque et monumental,* 16.

32. Meynadier, *Paris sous le point de vue pittoresque et monumental,* 148.

33. Meynadier, *Paris sous le point de vue pittoresque et monumental,* 6.

34. Frederick Engels, "The June Revolution," in *The Revolution of 1848–49: Articles from the Neue Rheinische Zeitung* (New York: International, 1972), 50.

35. Engels, "June Revolution," 52. Engels also stressed the importance of winding streets for insurrection (51).

36. Georges-Eugène Haussmann, "Partie Non Officielle," *Le Moniteur universel,* no. 226 (August 14, 1861): 1222.

37. Gustave Nast, "Le nouvel Opéra," part 1, *Le Correspondant* 68 (May 25, 1869), 697.

38. Henri Siméon, Travaux pour la Commission des embellissements de Paris, vol. 2, MS 1780, 114, BHdV.

39. According to a contemporary, the Marquis de Castellane, "The enormous task of 'hausmannization' was always so well carried out by the prefecture of the Seine and by the ministries, [...] that it could not have succeeded without a 'common impulse.'" Quoted in Robert Schnerb, *Rouher et le Second Empire* (Paris: Armand Colin, 1949), 74.

40. Halbwachs, "Les plans d'extension et d'aménagement de Paris," 28.

41. Marcel Raval, "Haussmann contre Paris," in *Destinée de Paris* (Paris: Les Éditions du Chêne, 1943), 49.

42. Unusually, Paris had a second cardo running north/south, Rue Saint-Denis, which eventually led to the royal abbey.

43. The sole surviving plan among the Siméon papers shows not one but four such crossings, which would give greater flexibility to the urban network. Nicolas Chaudun, *Haussmann au crible* (Paris: Éditions de Syrtes, 2000), 90.

44. Charles Merruau, *Souvenirs de l'Hôtel de Ville de Paris* (Paris: Plon, 1875), 364. Georges-Eugène Haussmann, *Mémoires du Baron Haussmann,* vol. 3, *Grands travaux de Paris* (Paris: Victor-Havard, 1893), 60; Micheline Nilsen, "Paris: Haussmann, the Railways, and the New Gates to the City," *Railways and the Western European Capitals: Studies of Implantation in London, Paris, Berlin, and Brussels* (New York: Palgrave Macmillan, 2008), 69–80.

45. Berger himself drew up a series of interventions, which he published in an open letter to the *Journal des Debats* (June 12, 1852): 2 (unnumbered); David Van Zanten, "Mais Quand Haussmann est-il devenu moderne?," in Bowie *La Modernité avant Haussmann,* 155–58.

46. The coup of 1851, wrote Haussmann years after he had left office, "was in the air." Haussmann, *Mémoires,* 2:6.

47. Georges-Eugène Haussmann, *Mémoires du Baron Haussmann*, vol. 1, *Avant l'Hôtel de Ville* (Paris: Victor-Havard, 1890), vii.

48. Quoted in Nast, "Le nouvel Opéra," part 2, *Le Correspondant* 78 (June 10, 1869): 892.

49. Henry W. Lawrence, *City Trees: A Historical Geography from the Renaissance through the Nineteenth Century* (Charlottesville: University of Virginia Press, 2006), 212.

50. Quoted in *Histoire d'un crime*, now in Victor Hugo, *Oeuvre complète*, ed. Jean Massin (Paris: Le Club Français du Livre, 1968), 8:26.

51. Quoted in Thomas W. Evans, *Memoirs of Thomas W. Evans: The Second French Empire*, ed. Edward A. Crane (New York: D. Appleton, 1905), 41. A personal friend of the imperial family, Evans accompanied Eugénie in her flight to England, after the fall of the empire.

52. Henri Lecouturier, *Paris incompatible avec la république: Plan d'un nouveau Paris où les révolutions seront impossibles* (Paris: Desloges, 1848), 89.

53. Haussmann, *Mémoires*, 2:206.

54. The map in question, which is well documented, was unlikely to have been the original: the revolutionary artists worked from tracings, since not all the seventy-two plates of Verniquet's plan had been engraved at the time. Pronteau, "La Commission et le Plan des Artistes," 206–7.

55. Haussmann, *Mémoires*, 3:81.

56. For this aspect, see Pierre Pinon, "Le Plan des Artistes entre grands axes et opportunités foncières," *Les Traversées de Paris: Deux Siècles de révolutions dans la ville*, ed. Pierre Pinon (Paris: Éditions du Moniteur, 1989), 145–54.

57. Patrick Abercrombie, "Paris: Some Influences That Have Shaped Its Growth," part 3, *Town Planning Review* 2, no. 4 (January 1912): 309–10.

58. Georges Pillement, *Destruction de Paris* (Paris: Bernard Grasset, 1941), 223.

59. Legitimists were royalists who remained loyal to the older branch of the Bourbons, i.e., the descendants of Louis XVIII, as opposed to the Orleanists, who supported the younger branch, heirs of Louis-Philippe.

60. But see David Pinkney, *Napoleon III and the Rebuilding of Paris* (Princeton, NJ: Princeton University Press, 1972); André Hallays, "Haussmann et les travaux de Paris sous le Second Empire," *La Revue hebdomadaire*, no. 5 (February 5, 1910): 35; Elbert Peets, "Famous Town Planners I: Haussmann," *Town Planning Review* 12, no. 3 (June 1927): 181–90.

61. Quoted in César Daly, *L'architecture privée au XIXᵉ siècle sous Napoléon III* (Paris: A. Morel, 1864), 1:8.

62. Georges-Eugène Haussmann, *Mémoires du Baron Haussmann*, 3 vols. (Paris: Victor-Havard, 1890–93). The last volume was published posthumously.

63. Haussmann, *Mémoires*, 2:53. Haussmann capitalized all words referring to Napoleon III.

64. Merruau, *Souvenirs de l'Hôtel de Ville*, 365–66.

65. Jean-Gilbert Victor Fialin, duc de Persigny, *Mémoires du duc de Persigny*, ed. and with an intro. by M. H. de Laire, Comte d'Espagny (Paris: E. Plon, Nourrit, 1896), 256.

66. Merruau, *Souvenirs de l'Hôtel de Ville*, 366.

67. During the Commune, an American eyewitness followed the crowds into the Hôtel de Ville: "A splendid plan of Paris, drawn up by Haussmann's engineers and Napoleon's Haussmann, is cut to pieces by the revengeful Reds." Nathan Sheppard, *Shut Up in Paris* (Leipzig: Bernhard Tauchnitz, 1874), 116.

68. André Morizet, *Du Vieux Paris au Paris moderne: Haussmann et ses prédécesseurs* (Paris: Hachette, 1932), 130; André Morizet, "Communication de M. André Morizet sur le plan des travaux de Paris dessiné par Louis-Napoléon pendant la présidence (1848–1852)," Commission du vieux Paris, October 29, 1932. Librarians in Berlin colored Morizet's photos by hand, showing the emperor's streets according to the original. Copies of Morizet's photos can be found in the Bibliothèque de l'Hôtel de Ville in Paris, but the colors are not clear. The Berlin copy had to predate 1860, since it does not include the Opéra and surrounding streets: Pierre Pinon, "Paris-Haussmann: Le prospettive di una mostra," *Casabella*, no. 588 (March 1992): 40.

69. Its director, the late Pierre Casselle, aware of their extraordinary importance, published an incisive scholarly analysis of the documents, proving that most of the thoroughfares built by Haussmann were already in these reports. Pierre Casselle, "Les Travaux de la Commission des embellissements de Paris en 1853: Pouvait-on transformer la capitale sans Haussmann?," *Bibliothèque de l'École des Chartes* 155 (1997): 645–89. See also his "Introduction," in *Commission des embellissements de Paris: Rapport à l'empereur Napoléon III rédigé par le Comte Henri Siméon*, ed. and with an intro. by Pierre Casselle, preface by Michel Fleury (Paris: Rotonde de la Villette, 2000), 5–43.

70. Siméon, Travaux pour la Commission des embellissements de Paris, vol. 4, MS 1782, 20, BHdV.

71. Haussmann, *Mémoires*, 2:55.

72. Casselle, "Introduction," 9. Louis Lazare wrote Siméon chiding him for ignoring barracks, "so useful for the defense of Paris" (21–22).

73. Siméon apparently told Haussmann that he hoped to succeed Berger as prefect of the Seine, another reason for Haussmann to seek the dissolution of the Count's committee. Haussmann had been prefect of the Var where Siméon was later president of the general council. Casselle, "Introduction," 10.

74. While the two sides of the river should be treated with equity, stated the committee, they are comparable neither in extent nor in population; "one should therefore not be surprised if more infrastructure projects are built on the Right Bank." Siméon, Travaux pour la Commission des embellissements de Paris, vol. 1, MS 1779, 12, BHdV.

75. For the committee's plans regarding the faubourgs outside the tax walls, see Florence Bourillon, "À Propos de la Commission des embellissements: La rénovation du Grand Paris à l'intérieur des fortifications," in Bowie, La Modernité avant Haussmann, 139–51.

76. Siméon, Travaux pour la Commission des embellissements de Paris, 1:4.

77. Siméon's own vested interests cannot be overlooked: he was deeply involved in railways and, that very year, 1853, founded with other bankers and industrialists the Compagnie Générale des Eaux, aimed at monopolizing water supply to the capital's residents. He was also embroiled in the scandal involving the banker Jules-Isaac Mirès in 1861. See Casselle, "Introduction," 10.

78. Meynadier, Paris sous le point de vue pittoresque et monumental; Jacques-Séraphin Lanquetin, Question du déplacement de Paris: Opinion d'un membre de la commission minitérielle chargée d'examiner cette question (Paris: Imprimerie de Vinchon, 1842); Denise Delsaux-Gindre, Jacques-Séraphin Lanquetin: Un Franc-Comtois du XIXᵉ siècle à l'Hôtel de Ville de Paris (Paris: Hexamédia, 1998).

79. For Jacoubet, see Michel Fleury's introduction to Aristide-Michel Perrot, Petit Atlas pittoresque des quarante-huit quartiers de la ville de Paris (Paris: les Éditions de Minuit, [1835] 1987), 12–15; Jean Maitron, ed., Dictionnaire biographique du mouvement ouvrier français, first part, 1789–1864 2 (Paris: Éditions ouvrières, 1965), 2:366.

80. Casselle, "Les Travaux de la Commission des embellissements de Paris," 657.

81. Pinon, Le mythe Haussmann, 25–26, 125.

82. Siméon, Travaux pour la Commission des embellissements de Paris, 1:99; see also 2:267; 4:97, 127.

83. Charles-Alfred Janzé, La Transformation de Paris et la question du pot-au-feu (Paris: Sauton, 1869), 29.

84. See the anonymous pamphlet Paris désert: Lamentations d'un Jérémie haussmannisé (Paris: Imprimerie G. Towne, 1868), 6.

85. Haussmann, Mémoires, 2:522. The bridge was built as Haussmann wanted during the Third Republic.

86. Persigny told Haussmann never to engage in anything without the emperor's consent. Persigny, Mémoires du duc de Persigny, 260.

87. Haussmann, Mémoires, 2:58. For the post of minister of agriculture, commerce, and public works, and of the interior, see 2:73.

88. Émile Zola, "Causerie," La Tribune, October 18, 1868, 6.

89. Quoted in Hervé Maneglier, Paris impérial: La Vie quotidienne sous le Second Empire (Paris: Armand Colin, 1990), 19.

90. David Harvey, Consciousness and the Urban Experience: Studies in the History and Theory of Capitalist Urbanization (Baltimore: Johns Hopkins University Press, 1985), 74.

91. Haussmann, "Mémoire présenté par le sénateur, préfet de la Seine, au conseil municipal, au sujet de l'extension des limites de Paris," Le Moniteur universel, no. 71 (March 12, 1859): 288.

92. Haussmann was, however, aware that maps did not always coincide with their implementation: "There are ingenious combinations of the square and the compass that are very much taken for granted, but which, absorbed by space, completely miss their effect. By contrast, there are very difficult, awkward adjustments, whose ungainly effects are much feared, and yet, surprisingly, cannot be faulted when executed, since the distortions of the plan cannot be perceived on the ground." Georges-Eugène Haussmann, "Séance du 1ᵉʳ Mai 1861," Annales du Sénat et du corps législatif, vol. 2, Du 15 Mars au 3 Mai 1861 (Paris: À l'Administration du Moniteur universel, 1862), 336.

93. Ferdinand de Lasteyrie, Les Travaux de Paris: Examen critique (Paris: Michel Lévy Frères, 1861), 66. Lasteyrie played an important part in urban affairs between 1848 and 1851, as member of the Conseil Municipal de Paris.

94. Michel de Certeau, The Practice of Everyday Life, trans. Steven Rendall (Berkeley: University of California Press, 1984), 92.

95. James C. Scott, Seeing Like a State (New Haven, CT: Yale University Press, 1998), 2.

96. Denis Wood, "Maps Work by Serving Interests," in The Power of Maps (New York: Guilford, 1992), 17. See also J. B. Harley, "Maps, Knowledge, and Power," in The Iconography of Landscape, ed. Denis Cosgrove and Stephen Daniels (Cambridge: Cambridge University Press, 1988), 277–312; Jeremy Black, "Cartography as Power," in Maps and Politics (London: Reaktion Books, 1997), 11–28; James Corner, "The Agency of Mapping: Speculation, Critique and Invention," in Mappings, ed. Denis Cosgrove (London: Reaktion Books, 1999), 213–52. For Paris, see Josef W. Konvitz, "The Nation-State, Paris and Cartography in Eighteenth- and Nineteenth-Century France," Journal of Historical Geography 16, no. 1 (January 1990): 3–16; Antoine Picon, "Nineteenth-Century Cartography and the Scientific Ideal: The Case of Paris," Osiris 18 (2003): 135–49.

97. For the best analysis of Haussmann's three

networks, see Morizet, *Du Vieux Paris au Paris moderne*, 201–72; and Pinkney, *Napoleon III and the Rebuilding of Paris*, 58–70. See also Haussmann, *Mémoires*, 3:59–93.

98. Haussmann, *Mémoires*, 3:47.

99. Haussmann, *Mémoires*, 2:307.

100. The city was responsible for three quarters of this sum, and the state for the remainder. When costs rose to twice the 180 million francs foreseen by Haussmann, he was reduced to different stratagems to raise the necessary funds. For the Second Empire's financing, see Geneviève Massa-Gille, *Histoire des emprunts de la Ville de Paris (1814–1875)*, preface by Michel Fleury (Paris: Commission des travaux historiques. Sous-commission de recherches d'histoire municipale, 1973), 197–306.

101. Louis Lazare, *Les Quartiers de l'est de Paris et les communes suburbaines* (Paris: Bureau de la Bibliothèque Municipale, 1870), 76; Jean Ceaux, "Rénovation urbaine et stratégie de classe: Rappel de quelques aspects de l'haussmannisation," *Espaces et Sociétés* 13/14, no. 1 (October 1974–January 1975): 27.

102. Pinkney, *Napoleon III and the Rebuilding of Paris*, 59.

103. Haussmann, *Mémoires*, 2:304.

104. Persigny, *Mémoires du duc de Persigny*, 256. Haussmann attributed the idea variously to himself and to Voltaire: see Haussmann, *Mémoires*, 2:35–36, 531. For other sources of deficit financing including Saint-Simon, see Roger Kain, "Urban Planning in Second Empire France," *Connoisseur* 199, no. 802 (December 1978): 238. Louis Jean-Marie Daubanton and Meynadier had also suggested it: Pinon, *Le mythe Haussmann*, 19 and 21.

105. The municipality expressed surprise at the fact that "it is the wealthiest classes which manifest the strongest repugnance to new taxes." "The Finances of the City of Paris, 1858–9," *Journal of the Statistical Society* [of London] 23, no. 2 (1860): 234.

106. The debt was not paid in full in until 1929. Morizet, *Du Vieux Paris au Paris moderne*, 330.

107. Rambuteau, *Mémoires*, 375.

108. Haussmann, *Mémoires*, 2:311.

109. On this issue, see Maurice Halbwachs, *Les Expropriations et le prix des terrains à Paris 1860–1900* (Paris: Cornely, 1909); Louis Girard, *La Politique des travaux publics sous le Second Empire* (Paris: A. Colin, 1951); for expropriations in the periphery, see Jeanne Gaillard, *Paris, la ville (1852–1870)* (Paris: L'Harmattan, 1997), 102–3. The classic, if exaggerated source, is Jules Ferry, *Les Comptes fantastiques d'Haussmann* (Paris: Guy Durier, 1979).

110. Haussmann, *Mémoires*, 2:308.

111. Maxime Du Camp, in *Paris, ses organes, ses fonctions et sa vie dans la seconde moitié du XIXᵉ siècle* (Paris: Hachette, 1875), 6:256.

112. Émile Zola, *The Kill*, trans. and with an

intro. by Arthur Goldhammer (New York: Random House, 2004), 74–75, ellipses in original. There would be a third network, Saccard adds: "That one is still too far in the future. I can't envision it very clearly" (75).

113. Haussmann, *Mémoires*, 2:372–74.

114. On the ubiquitous barracks, see Nadar, "Le Dessus et le dessous de Paris," in *Paris Guide* (Paris: A. Lacroix, Verboeckhoven, 1867), 2:1584.

115. Victor Fournel, "Les monuments du nouveau Paris," *Le Correspondant* 61 (April 1864): 873.

116. Zola, *Kill*, 75.

117. Quoted in André Chastel, "Du Paris de Haussmann au Paris d'aujourd'hui," *Paris, présent et avenir d'une capitale* (Paris: Institut Pédagogique National, 1964), 2. Even the *New York Times*, in "The Crusade against Baron Haussmann," claimed that "the new streets afford military advantages in case of revolt" (July 5, 1868, 6).

118. "London and Paris," *Building News*, no. 7 (November 8, 1861): 897.

119. Walter Benjamin, "Paris, Capital of the Nineteenth Century" (1939), in Walter Benjamin, *The Arcades Project*, trans. Howard Eiland and Kevin McLaughlin, ed. Rolf Tiedemann (Cambridge, MA: Belknap Press of Harvard University Press, 1999), 23.

120. "The style of planning marked by cannon-shot boulevards and open traffic-plazas ruled unquestioned throughout Europe until, late in the century, the counter infection of Sitte and his friends wilted the Haussmann tradition in the Teutonic marches." Peets, "Famous Town Planners I: Haussmann," 183. Sigfried Giedion mentions it much later in *Space, Time and Architecture*, 5th ed. (Cambridge, MA: Harvard University Press, [1941] 1967), 739.

121. David P. Jordan, *Transforming Paris: The Life and Labors of Baron Haussmann* (New York: Free Press, 1995), 188.

122. Haussmann, *Mémoires*, 3:54–55. Simeon had described the boulevard as "strategic": Siméon, *Travaux pour la Commission des embellissements de Paris*, 2:267.

123. Jacques Rougerie, "Recherche sur le Paris du XIXᵉ siècle, espace populaire et espace révolutionnaire," *Institut d'Histoire économique et sociale de l'Université de Paris I*, no. 5 (January 1977): 58.

124. Quoted in Bernard Marchand, *Paris, histoire d'une ville* (Paris: Editions du Seuil, 1993), 116.

125. Quoted in Georges Valance, *Haussmann le Grand* (Paris: Flammarion, 2000), 224.

126. Haussmann, "Séance du 1ᵉʳ Mai 1861," 332.

127. Helmuth Graf von Moltke, *Moltke in seinen Briefen: Mit einem lebens-und Charakterbilde des Verewigten* (Berlin: Ernst Siegfried Mittler und Sohn, 1900), 2:99–100; emphasis and English in the original.

128. Morizet, "Communication de M. André Morizet," 119.

129. Dubech and d'Espezel, *Histoire de Paris*, 2:118.

130. Casselle, "Les Travaux de la Commission," 654. This, as Casselle points out, was a somewhat edulcorated version of Siméon's original draft.

131. Casselle, "Les Travaux de la Commission," 659. See also Rosa Tamborrino, "Le Plan d'Hauss- mann en 1864," *Genèses*, no. 15 (March 1994): 133–34.

132. Merruau, *Souvenirs de l'Hôtel de Ville*, 365.

133. Quoted in Rougerie, "Recherche sur le Paris du XIXᵉ siècle, 66.

134. During the Third Republic, the names of all streets and squares referring to the Second Empire were changed, with the significant exception of the Boulevard Haussmann.

135. For these strategic streets, see Peets, "Famous Town Planners I: Haussmann," 184. Hallays, "Hauss- mann et les travaux de Paris sous le Second Empire," 38.

136. T. J. Clark, *The Painting of Modern Life: Paris in the Art of Manet and His Followers* (Princeton, NJ: Princeton University Press, 1984), 59.

137. Christiane Blancot and Bernard Landau, "La Direction des Travaux de Paris au XIXᵉ siècle," in *Le Paris des polytechniciens: Des ingénieurs dans la ville, 1794–1994*, ed. Bruno Belhoste, Francine Masson, and Antoine Picon (Paris: Délégation à l'action artistique de la Ville de Paris, 1994), 155; see also Antoine Picon, "Les Modèles de la Métropole: Les Polytechniciens et l'aménagement de Paris," in Belhoste et al., *Le Paris des polytechniciens*, 137–50.

138. Persigny, *Mémoires du duc de Persigny*, 261.

139. Lazare, *Les Quartiers de l'est de Paris*, 6–7.

140. Pierre Lavedan, "Projets de Napoléon Iᵉʳ pour l'ouest de Paris," *La Vie urbaine*, no. 59 (January– March 1951): 1–10.

141. Lazare, *Les Quartiers de l'est de Paris*, 50–51.

142. The 3,883 barricades of June 1848 were situ- ated largely east of Rue Saint-Denis. Louis Girard, *La Deuxième République et le Second Empire, 1848–1870* (Paris: Hachette, 1981): 36–37.

143. Jacques-Séraphin Lanquetin, *Question du déplacement de la population de Paris* (Paris: Impri- merie de Vinchon, 1842). See Chabrol-Chaméane, *Mémoire sur le déplacement de la population dans Paris* (Paris: Bouchard-Huzard, 1840); L.-J.-M. Dauban- ton, *Du déplacement de la population de Paris* (Paris: Carilian-Goeury, 1843); Auguste Chevalier, *Du déplacement de la population, de ses causes, de ses effets, des mesures à prendre pour y mettre un terme: Ville de Paris* (Paris: Napoléon Chaix, 1850); Pierre Lavedan, *La question du déplacement de Paris et du transfert des Halles au Conseil Municipal sous la Monarchie de Juillet* (Paris: Commission des Travaux Historiques de la Ville de Paris, 1969).

144. Perreymond, "Cinquième étude sur la Ville de Paris," *RGA* 4 (1843): cols. 79–88, and part 6, cols. 413–29.

145. For Merruau's assessment of Rambuteau, see *Souvenirs de l'Hôtel de Ville*, 339–49. For a more pos- itive assessment of Rambuteau's tenure as prefect, see Jean-Marc Léri, "Les Travaux parisiens sous le préfet Rambuteau," *Cahiers du Centre de recherches et d'études sur Paris et l'Ile-de-France* (CREPIF), no. 18 (March 1987): 203–13; and Bowie, *La Modernité avant Haussmann*.

146. Evans, *Memoirs of Thomas W. Evans*, 145. Haussmann himself wrote that the "avenues radiat- ing from the Place de l'Étoile will complete the *West End* of the new Paris." Georges-Eugène Haussmann, "Partie Non Officielle," *Le Moniteur universel*, no. 226 (August 14, 1861): 1222.

147. David Van Zanten, *Building Paris: Architec- tural Institutions and the Transformations of the French Capital, 1830–1870* (New York: Cambridge University Press, 1994), 4. See also Patrick Abercrombie, "Paris: Some Influences That Have Shaped Its Growth," part 2, *Town Planning Review* 2, no. 3 (October 1911): 223: One of the town planning principles that has gradually imposed itself on the city as a whole was "the subordination of the individual building to the general effect."

148. For the urbanization of this area, see Van Zanten, *Building Paris*, 6–45; and François Loyer ed., *Autour de l'Opéra: Naissance de la ville moderne* (Paris: Délégation à l'action artistique de la Ville de Paris, 1995).

149. Nast, "Le nouvel Opéra," part 1, 693–94.

150. Hector Horeau, "Assainissements, embellisse- ments de Paris ou édilité urbaine à la portée de tout le monde," *GAB* 6 (1868): 55.

151. For the complex history of the avenue and the opera, see Christopher Mead, "Urban Contin- gency and the Problem of Representation in Second Empire Paris," *JSAH* 54, no. 2 (June 1995): 138–74.

152. J. M. Chapman and Brian Chapman, *The Life and Times of Baron Haussmann* (London: Weidenfeld and Nicolson, 1957), 191.

153. It was the emperor who decided to name the boulevard in honor of Haussmann. It is one of the few streets named after a high-ranking personality of the Second Empire that the Third Republic did not touch, though there was talk of changing its name to Victor Hugo.

154. In 1867, the *Gare Saint-Lazare* and the *Gare Montparnasse*, belonging to the chemins de fer de l'Ouest, transported more than ten million passen- gers a year, more than twenty-seven thousand per day. Léon Say, "Les chemins de fer," in *Paris Guide*, 2:1659.

155. *Guide sentimental de l'étranger à Paris, par un parisien*, preface by Louis Ulbach (Paris: Calmann Lévy, 1878), 73. Pierre-Joseph Proudhon also grumbled about the "city peopled by Englishmen, Germans, Batavians, Americans, Russians, Arabs;

a cosmopolitan city where the native can no longer be recognized." Proudhon, *De la Capacité politique des classes ouvrières* (Paris: A. Lacroix, Verboeckhoven, 1868), 1–2.

156. *Paris créole: Son histoire, ses écrivains, ses artistes, XVIIIᵉ–XXᵉ siècles*, ed. Érick Noël (Pessac: Presses universitaires de Nouvelle Aquitaine; La Crèche: Éditions la Geste, 2020), 46–55.

157. Noël, *Paris créole*, 37.

158. Meynadier, *Paris sous le point de vue pittoresque et monumental*, 30, emphasis mine.

159. Chevalier, *Du déplacement de la population*, 19.

160. Lecouturier, *Paris incompatible avec la république*, 13, emphasis mine.

161. Julien Lemer, *Paris au gas* (Paris: E. Dentu, 1861), 19. But see Jacques Rancière, *Staging the People: The Proletarian and His Double*, trans. David Fernbach (London: Verso Books, 2011), 15; Eric Hazan, *The Invention of Paris: A History in Footsteps*, trans. David Fernbach (London: Verso, 2010), 84–86.

162. The axis of the Boulevard Malesherbes, begun by Napoleon I, was shifted slightly to provide access to the Parc Monceau and the princely residences being laid out by the Péreire brothers.

163. Lasteyrie, *Les Travaux de Paris*, 203. Not everybody was sorry to see the old theaters go. Baudelaire's friend Alfred Delvau considered them the "Conservatory of bad taste, bad manners and bad examples." Alfred Delvau, "Le Boulevard du Temple," *Paris qui s'en va et Paris qui vient* (Paris: Alfred Cadart, 1859), 4.

164. "Partie Non Officielle," *Le Moniteur universel*, no. 226 (August 14, 1861): 1222.

165. Gabriel Davioud (1824–81) studied at the École des Beaux-Arts with Léon Vaudoyer. Hired when Haussmann created the Service Municipal des Promenades et Plantations under the direction of Jean-Charles-Adolphe Alphand, Davioud gradually rose through the ranks. *Gabriel Davioud* (Paris: Délégation à l'Action Artistique de la Ville de Paris, 1981), 27.

166. Roger Price, *The French Second Empire: An Anatomy of Political Power* (Cambridge: Cambridge University Press, 2001), 193: Haussmann shunted workers to more popular entertainments like the cafés-concerts that could be easily controlled and shut down.

167. C. Détain, "Théâtre muncipal du Vaudeville," *RGA* 27 (1869): 273.

168. For Davioud's two theaters and concert hall, see Thomas von Joest and Claudine de Vaulchier, "Davioud et les places haussmanniennes," *Monuments Historiques*, no. 120 (March–April 1982): 69–70.

169. Paris only housed the "petite industrie"; heavy industry was situated in the rich industrialized provinces in the North of France. Armand Audiganne, *Les populations ouvrières et les industries de la*

France *dans le mouvement social du XIXᵉ siècle*, vol. 2 (Paris: Capelle, 1854), 2:169.

170. Lazare, *Les Quartiers de l'est de Paris*, 60.

171. Paul de Kock, "Les Boulevards de la porte Saint-Martin à la Bastille," in *Paris Guide*, 2:1286.

172. Harvey, *Consciousness and the Urban Experience*, 167.

173. Ferry, *Les Comptes fantastiques d'Haussmann*, 49.

174. *The Times* January 8, 1870; quoted in Joanna Richardson, "Emperor of Paris: Baron Haussmann, 1809–1891," *History Today* 25, no. 12 (December 1975): 843.

CHAPTER TWO: REQUIEM

1. Karl Kraus, *Die demolirte Literatur* (Wien: Verlag A. Bauer, 1899), 3.

2. Henri Siméon, Travaux pour la Commission des embellissements de Paris, vol. 1, MS 1779, 7, BHdV.

3. For Mussolini's destructions in Rome, see Spiro Kostof, "His Majesty the Pick: The Aesthetics of Demolition," in *Streets: Critical Perspectives on Public Space*, ed. Zeynep Çelik, Diane Favro, and Richard Ingersoll (Berkeley: University of California Press, 1994), 9–22.

4. Louis-René Villermé, "De la mortalité des différents quartiers de Paris, et des causes qui la rendent très différents dans plusieurs d'entre eux, ainsi que dans les divers quartiers de grandes villes," *Annales d'hygiene publique et de médecine légale* 1, no. 3 (1830): 294–341; Florence Bourillon, "Changer la ville: La question urbaine au milieu du 19ᵉ siècle," *Vingtième Siècle, Revue d'histoire* 64, no. 1 (October–December 1999): 12.

5. Henri Bayard, *Mémoire sur la topographie médicale du IV arrondissement de Paris: Recherches historiques et statistiques sur les conditions hygiéniques des quartiers qui composent cet arrondissement* (Paris: J.-B. Ballière, 1842), 114.

6. Victor Considerant, *Description du phalanstère et considérations sociales sur l'architectonique* (Paris: Librairie sociétaire, 1848), 42.

7. Georges-Eugène Haussmann, *Mémoires du Baron Haussmann*, vol. 2, *Préfecture de la Seine* (Paris: Victor-Havard, 1890), 34.

8. *Rapport sur la marche et les effets du choléra-morbus dans Paris et les communes rurales du Département de la Seine* (Paris: Imprimerie Royale, 1834), 202.

9. Catherine Jean Kudlick, *Cholera in Post-Revolutionary Paris: A Cultural History* (Berkeley: University of California Press, 1996); David Pinkney, "Napoleon III's Transformation of Paris: The Origins and Development of the Idea," *Journal of Modern History* 27, no. 2 (June 1955): 129.

10. Though the 1854 cholera epidemic killed more

people than the one of 1832, its victims were spread out across eastern France; in 1832 it was limited to Paris and its surroundings. Patrice Bourdelais and Jean-Yves Raulot, with the collaboration of Michel Demonet, "La marche du choléra en France: 1832–1854," *Annales E.S.C.*, 33ᵉ année, no. 1 (January–February 1978): 140.

11. Bernard-Pierre Lécuyer, "L'hygiène en France avant Pasteur, 1750–1850," ed. Claire Salomon-Bayet, with a preface by André Lwoff, in *Pasteur et la révolution pasteurienne* (Paris: Payot, 1986), 95.

12. Louis Lazare, *Les Quartiers de l'est de Paris et les communes suburbaines* (Paris: Bureau de la Bibliothèque Municipale, 1870), 53.

13. Originally an old Gothic house known as the Maison aux Piliers, it was enlarged several times. Louis-Philippe commissioned magnificent paintings by Delacroix, and Napoleon III, by Ingres, all destroyed during the Commune. The present building was reconstructed from 1874 to 1882.

14. Jacques Hillairet, *Dictionnaire historique des rues de Paris* (Paris: Les Éditions de Minuit, 1963), 2:50.

15. Baltard and Félix Callet had been chosen to design Les Halles under Rambuteau; see Victor Baltard and Félix Callet, *Monographie des Halles centrales de Paris, construites sous le règne de Napoléon III et sous l'administration de M. le baron Haussmann, sénateur, préfet du département de la Seine* (Paris, A. Morel, 1863); Charles Merruau, *Souvenirs de l'Hôtel de Ville de Paris* (Paris: Plon, 1875), 383; Christopher Curtis Mead, *Making Modern Paris: Victor Baltard's Central Markets and the Urban Practice of Architecture* (University Park: Pennsylvania State University Press, 2012); Norma Evenson, "The Assassination of Les Halles," *Journal of the Society of Architectural Historians* 32, no. 4 (December 1973): 308–15.

16. "Partie Non Officielle," *Le Moniteur universel*, no. 226 (August 14, 1861): 1222.

17. François de Guilhermy, "Trente ans d'archéologie," *Annales archéologiques* 21 (1861): 255.

18. Charles-René Forbes, Comte de Montalembert, *Du Vandalisme et du catholicisme dans l'art* (Paris: Debécourt, 1839), 209; Yvan Christ, "La Cité telle qu'elle était il y a un siècle," *Le Jardin des Arts*, no. 41 (March 1958): 301.

19. César Daly, "Étude générale sur les grands travaux de Paris," *RGA* 20 (1862): col. 176; Alfred Delvau, "Coup d'oeil rétrospectif sur Paris," in *Paris qui s'en va et Paris qui vient* (Paris: Alfred Cadart, 1859), 2 (the pages in each chapter are numbered separately).

20. In the 1780s, Louis Sébastien Mercier had counted about 240 steeples from the towers of Notre-Dame. Mercier, *Tableau de Paris* (1781), ed. Jean-Claude Bonnet (Paris: Mercure de France, 1994), 2:1034. See also Myriem Foncin, "La Cité," *Annales de Géographie* 40, no. 227 (September 15, 1931): 490.

21. Frederic Harrison, "The Transformation of Paris," *North American Review* 149, no. 394 (September 1889): 328.

22. Louis Réau, *Histoire du vandalisme*, ed. Michel Fleury and Guy-Michel Leproux (Paris: Robert Laffont, 1994), 731–32.

23. Montalembert, *Du Vandalisme et du catholicisme dans l'art*, 216.

24. Prosper Mérimée, inspector general of historic monuments, called the destruction of the Cité "the massacre of mediaeval France." Quoted in Roger Kain, "Urban Planning and Design in Second Empire France," *Connoisseur* 199, no. 802 (December 1978): 245.

25. Quoted in Réau, *Histoire du vandalisme*, 762–63.

26. Haussmann, *Mémoires*, 2:486.

27. Jacques Hillairet, *L'Île de la Cité* (Paris: Les Éditions de Minuit, 1969), 68.

28. Georges-Eugène Haussmann, *Mémoires du Baron Haussmann*, vol. 3, *Grands travaux de Paris* (Paris: Victor-Havard, 1893), 554. This was an old Saint-Simonian dream. See Stéphane Flachat Mony, "Le Choléra à Paris," in *Religion Saint-Simonienne: Le Choléra; Assainissement de Paris* (Paris: Everat imprimeur, 1832), 3.

29. Hillairet, *L'Île de la Cité*, 67; Foncin, "La Cité," 502.

30. Gérard-Noël Lameyre, *Haussmann, "Préfet de Paris"* (Paris: Flammarion, 1958), 44.

31. The Siméon committee had already called for the destruction of Place Dauphine (to be replaced by monumental barracks), and of the Hôtel-Dieu. Siméon, Travaux pour la Commission des embellissements de Paris, 1:133 and 142.

32. Maxime Du Camp, *Paris, ses organes, ses fonctions et sa vie dans la seconde moitié du XIXᵉ siècle* (Paris: Hachette, 1875), 3:41.

33. But see Pierre Lavedan: "It is difficult for us to lament the disappearance of the alleyways of the Cité, the rue des Arcis, or the rue Transnonain." Pierre Lavedan, "Mérites et torts d'Haussmann urbaniste," *La Vie Urbaine*, nos. 3–4 (July–December 1953): 236. Giedion praised Haussmann but did not think he went far enough." Sigfried Giedion, *Space, Time and Architecture*, 5th ed. (Cambridge, MA: Harvard University Press, [1941] 1967), 822.

34. Eugène Sue, *Les Mystères de Paris* (1842–43; Paris: Robert Laffont, 1989), 33.

35. For Cooper's influence in Paris, see Du Camp, *Paris, ses organes, ses fonctions et sa vie*, 3:88, 247, 267.

36. Sue, *Les Mystères de Paris*, 31. Sue, however, had great sympathy toward the working class.

37. Alexandre Dumas, *Les Mohicans de Paris*, vol. 1 (Paris: Alexandre Cadot, 1854).

38. Alfred Delvau, *Les Dessous de Paris* (Paris: Poulet-Malassis et de Broise, 1860), 74, ellipsis in original.

39. Pierre-Léonce Imbert, *Les Trappeurs parisiens*

au XIX siècle (Paris: André Sagnier, 1878); Gustave Aimard, *Les Peaux-Rouges de Paris* (Paris: Dentu, 1888).

40. Honoré de Balzac, *Père Goriot* (1835), trans. Katherine Prescott Wormeley (Boston: Roberts Brothers, 1885), 139. See also George Sand. "Relation d'un voyage chez les sauvages de Paris. Lettre à un ami" in *Le Diable à Paris: Paris et les parisiens* (Paris: Hetzel, 1846), 2:186–212.

41. Maurice Raynal complained of "this asphalt lake that diminishes the majesty of the basilica, destroying the element of surprise triggered by the appearance of its stone vessel at the end of narrow streets." Marcel Raynal, "Haussmann contre Paris," in *Destinée de Paris* (Paris: Les Éditions du Chêne, 1943), 50. Peets claimed that "clearing, irrelevant planting, and inappropriate building harmed both near and distant views of Notre Dame." Elbert Peets, "Famous Town Planners I: Haussmann," *Town Planning Review* 12, no. 3 (June 1927): 189.

42. Stéphane Gachet, *Paris tel qu'il doit être: L'Île de la Cité* (Paris: Bance, 1856), 16.

43. Quoted in Walter Benjamin, *The Arcades Project*, ed. Rolf Tiedemann, trans. Howard Eiland and Kevin McLaughlin (Cambridge, MA: Belknap Press of Harvard University Press, 1999), 526, ellipsis in original.

44. André Chastel, "Du Paris de Haussmann au Paris d'aujourd'hui," in *Paris, présent et avenir d'une capitale* (Paris: Institut Pédagogique National, 1964), 15.

45. Paul Léon, *Histoire de la rue* (Paris: La Taille Douce, 1947), 174.

46. Montalembert, *Du Vandalisme et du catholicisme dans l'art*, 67.

47. Harrison, "Transformation of Paris," 332, italics in original.

48. Marcel Proust, *Le Côté de Guermantes* (Paris: Gallimard, 1988), 441.

49. David P. Jordan, *Transforming Paris: The Life and Labors of Baron Haussmann* (Chicago: University of Chicago Press, 1996), 199.

50. Rudolf Wittkower, *Architectural Principles in the Age of Humanism* (New York: Random House, 1965), 17.

51. François Marie Arouet de Voltaire, "Des Embellissemens de Paris" (1749), in *Oeuvres complètes de Voltaire* (Paris: Antoine-Augustin Renouard, 1819), 26:161 and 162.

52. Henri Lecouturier, *Paris incompatible avec la république: Plan d'un nouveau Paris où les révolutions seront impossibles* (Paris: Desloges, 1848), 98–99.

53. Anthony Sutcliffe, *The Autumn of Central Paris: The Defeat of Town Planning, 1850–1970* (Montreal: McGill-Queen's University Press, 1971), 181.

54. Siméon, Travaux pour la Commission des embellissements de Paris, 1:13.

55. "In certain cases, it is possible that the demolition of unsanitary houses and slums around some monument of historical value will destroy an age-old ambiance. This is regrettable, but it is inevitable. The situation can be turned to advantage by the introduction of verdant areas. There, the vestiges of the past will be bathed in a new and possibly unexpected ambiance, but certainly a tolerable one, and one from which the neighboring districts will amply benefit in any event." Le Corbusier, *The Athens Charter* (1941), intro. by Jean Giraudoux, trans. Anthony Eardley, with a new foreword by Josep Lluis Sert (New York: Grossman, 1973), 88.

56. Quoted in *Mémoires du baron Fain: Premier Secrétaire du cabinet de l'empereur* (Paris: Plon-Nourrit, 1908), 141.

57. Françoise Choay, *L'allégorie du patrimoine* (Paris: Seuil, 1999), 134 and 191.

58. Quoted in Jean-Pierre Babelon and André Chastel, "La Notion de patrimoine," *Revue de l'Art*, no. 49 (1980): 24. See also Paul Léon, *La Vie des monuments français* (Paris: Picard, 1951), 349.

59. Gachet, *Paris tel qu'il doit être*, 24.

60. Haussmann, *Mémoires*, 3:502.

61. Lucien Dubech and Pierre d'Espezel, *Histoire de Paris* (Paris: Les Éditions Pittoresques, 1931), 2:120.

62. Réau, *Histoire du vandalisme*, 735. The church had been secularized and sold after the French Revolution.

63. "Displacing the Medici fountain by a few meters, and removing a few plane trees from the garlanded allée that precedes it, have no more compromised its fine monumental effect than its great artistic merit." Haussmann, *Mémoires*, 3:85–86.

64. César Daly, "La Fontaine du Palmier, de Paris," *RGA* 16 (1858): cols. 42–44; L.-A. Barré, "Déplacement en bloc de la Fontaine du Palmier," *RGA* 16 (1858): cols. 126–30, 169–73.

65. See Meynadier's indignation at the "restoration" of the Hôtel de Sens, which had been bought by a grocer. Hippolyte Meynadier, *Paris sous le point de vue pittoresque et monumental; ou, Éléments d'un plan général d'ensemble* (Paris: Dauvin et Fontaine, 1843), 152–54.

66. Quoted in Nabila Oulebsir, *Les Usages du patrimoine: Monuments, musées et politique coloniale en Algérie (1830–1930)* (Paris: Éditions de la Maison des sciences de l'homme, 2004), 77–78.

67. Victor Hugo, "Guerre aux démolisseurs," *Revue des Deux Mondes* 5 (March 1832): 614–15.

68. Yvan Christ, "Haussmann et son règne," *Jardin des Arts*, no. 132 (November 1965): 21.

69. "It is not a question of palliatives; one must vanquish and eliminate evil, and where there is decay and decrepitude, bring about a fertile sap, a powerful and *durable* virility." Perreymond, "Sixième étude sur la Ville de Paris," *RGA* 4 (1843): col. 417,

emphasis in original. Perreymond's masculinist tone anticipates that of Le Corbusier.

70. "Le Choléra,—Assainissement de Paris," *Le Globe: Journal de la Religion Saint-Simonienne*, April 2, 1832, 1–2.

71. Pierre Patte, *Monumens érigés en France à la gloire de Louis XV* (Paris: L'Auteur, Desaint, Saillant, 1765), 226.

72. Meynadier, *Paris sous le point de vue pittoresque et monumental*, 62–63, ellipses in original.

73. Lecouturier, *Paris incompatible avec la république*, 97–98.

74. Françoise Bercé, *Les Premiers travaux de la Commission des Monuments historiques, 1837–1848* (Paris: A. et J. Picard, 1979), 91.

75. Le Corbusier (Charles-Édouard Jeanneret), *The City of Tomorrow and Its Planning: The Voisin Scheme and the Past*, trans. Frederick Etchells (New York: Dover, 1987), 287. Henri Focillon was the first to call Le Corbusier a follower of Saint-Simon. See his letter to Le Corbusier in *Le Corbusier: Le Passé à réaction poétique* (Paris: Caisse nationale des monuments historiques et des sites, 1987), 235.

76. Even Fournel, an outspoken critic of the administration, thanked it "for the zeal that it employed in freeing landmarks from the encroaching buildings in which they were embedded." Victor Fournel, "Les monuments du nouveau Paris," *Le Correspondant* 61 (April 1864): 900.

77. Théophile Gautier, "Préface," in Édouard Fournier, *Paris démoli* (Paris: Auguste Aubry, 1855), iv–v.

78. César Daly, *L'architecture privée au XIXᵉ siècle sous Napoléon III* (Paris: A. Morel, 1864), 1:6.

79. Alexandre Privat d'Anglemont, *Paris anecdote* (Paris: Chez P. Jannet, 1854), 227.

80. Réau, *Histoire du vandalisme*, 747.

81. Haussmann, *Mémoires*, 3:40.

82. Haussmann, *Mémoires*, 3:535.

83. Georges-Eugène Haussmann, *Mémoires du Baron Haussmann*, vol. 1, *Avant l'Hôtel de Ville* (Paris: Victor-Havard, 1890), x.

84. For this issue, see David Van Zanten, "Mais Quand Haussmann est-il devenu moderne?," in *La Modernité avant Haussmann: Formes de l'espace urbain à Paris, 1801–1853*, ed. Karen Bowie (Paris: Éditions Recherches, 2001), 163.

85. Voltaire, "Des embellissemens de Paris," 171.

86. Voltaire, "Des embellissemens de Paris," 171. Haussmann quoted Voltaire in his report to the emperor (May 20, 1868): Haussmann, *Mémoires*, 2:531–32.

87. "Everything he [Haussmann] has done for the last ten years," wrote Édouard Fournier, "Voltaire had already demanded in 1749." Quoted in Lameyre, *Haussmann*, 281.

88. Pier Luigi Cervellati, "La cultura della

conservazione," in Leonardo Benevolo et al., *Principii e forme della città* (Milan: Scheiwiller, 1993), 382.

89. Cervellati, "La cultura della conservazione," 382.

90. See Babelon and Chastel, "La Notion de patrimoine," 5–32; André Chastel, "La Notion de patrimoine," *Les Lieux de mémoire*, ed. Pierre Nora, vol. 2, *La Nation* (Paris: Gallimard, 1986), 405–50; Choay, *L'allégorie du patrimoine*.

91. Prosper Mérimée, "Des Monuments de la France," *Le Moniteur universel*, no. 1 (January 1, 1853): 3.

92. For the Arènes de Lutèce, see Colin Jones, "Théodore Vacquer and the Archaeology of Modernity in Haussmann's Paris," *Transactions of the Royal Historical Society* 17 (2007): 172.

93. Pierre Pinon, *Atlas du Paris haussmannien: La ville en héritage du Second Empire à nos jours* (Paris: Parigramme, 2003), 82.

94. Haussmann, quoted in "Séance du mardi 29 juillet 1879," *Annales du Sénat et de la Chambre des Députés: Session Ordinaire de 1879* (Paris: Imprimerie et Librairie du Journal Officiel, 1880), 10:13.

95. Eugène Viollet-le-Duc, *Dictionnaire raisonné de l'Architecture française du XIᵉ au XVIᵉ siècle* (Paris: A. Morel, 1866), 8:14.

96. Alois Riegl, "The Modern Cult of Monuments: Its Character and Its Origin" (1903), trans. Kurt W. Forster and Diane Ghirardo, in *Oppositions Reader*, ed. K. Michael Hays (New York: Princeton Architectural, 1998), 631.

97. John Ruskin, *The Seven Lamps of Architecture* (1849; New York: Dover, 1989), 186. Viollet-le-Duc, Ruskin's great nemesis, believed the opposite: "For time and revolutions destroy, but add nothing." Jean-Baptiste Antoine Lassus and Eugène-Emmanuel Viollet-le-Duc, *Projet de restauration de Notre-Dame de Paris* (Paris: Imprimerie de Mme de Lacombe, 1843), 3.

98. Haussmann, *Mémoires*, 3:501.

99. Haussmann, *Mémoires*, 3:501.

100. Haussmann, *Mémoires*, 3:492–93.

101. See Yvan Christ, "Documents, témoins d'une architecture disparu," *Monuments historiques*, no. 110 (1980): 74; and *Le Louvre et les Tuileries: Histoire architecturale d'un double palais* (Paris: Éditions Tel, 1949), 129. See also Jean-François Pinchon, "Charles Garnier et l'hypothétique," *Monuments Historiques*, no. 177 (November 1991): 43–49.

102. Haussmann, quoted in "Séance du mardi 29 juillet 1879," 12.

103. "Séance du mardi 29 juillet 1879," 12. See also Haussmann, *Mémoires*, 3:44–45. On the destruction of the Luxembourg, see chapter 6.

104. The palace was an ambivalent monument, irreducible to a single reading. See Kirk Varnedoe, "The Tuileries Museum and the Uses of Art History

in the Early Third Republic," in *Saloni, gallerie, musei e loro influenza sullo sviluppo dell'arte dei secoli XIX e XX*, ed. Francis Haskell (Bologna: CLUEB, 1981), 63–68.

105. Catherine Granger, *L'Empereur et les arts: La Liste civile de Napoléon III* (Paris: École des Chartes, 2005), 101.

106. Louis-Napoléon Bonaparte, *Histoire de Jules César*, 2 vols. and atlas (Paris: Henri Plon, 1865). The emperor was following his uncle who had also written on Caesar: *Précis des guerres de César: Écrit par Marchand à l'île Sainte-Hélène sous la dictée de l'Empereur* (Paris: Chez Gosselin, 1836).

107. Adolphe Berty, *Topographie historique du vieux Paris*, 6 vols. (Paris: Imprimerie Impériale, 1866–97). See also Ruth Fiori, *L'invention du vieux Paris: Naissance d'une conscience patrimoniale dans la capitale* (Wavre: Mardaga, 2012), 67–77; Catherine E. Clark, "Imagination and Evidence: Visual History at Paris's Municipal Historical Institutions," in Clark, *Paris and the Cliché of History: The City and Photographs, 1860–1970* (New York: Oxford University Press, 2018), DOI:10.1093/oso/9780190681647.003.0002.

108. Haussmann, *Mémoires*, 3:28–29.

109. Quoted in Bercé, *Les Premiers Travaux de la Commission des Monuments historiques*, 343.

110. Jean-Pierre Babelon, "Les relevés d'architecture du quartier des Halles avant les destructions de 1852–1854: Une source inédite sur l'iconographie parisienne entre le Louvre et l'Hôtel-de-Ville," *Gazette des beaux-arts* 70 (July–August 1967): 3.

111. For this shift, see Maurice Samuels, "Illustrated Historiography and the Image of the Past in Nineteenth-Century France," *French Historical Studies* 26, no. 2 (Spring 2003): 253–80.

112. Haussmann, *Mémoires*, 2:90; see also 2:61.

113. Haussmann, *Mémoires*, 3:54. For the surgical metaphors used at the time, see Anthony Vidler, "The Scenes of the Street: Transformations in Ideal and Reality, 1750–1871," in *On Streets*, ed. Stanford Anderson (Cambridge, MA: MIT Press, 1986), 91. One might add Le Corbusier: "The formidable oeuvre of this decisive man was all surgery; he cut mercilessly through the city." Le Corbusier (Charles-Édouard Jeanneret), *Urbanisme* (Paris: Flammarion, [1925] 1994), 247.

114. James Corner, "The Agency of Mapping: Speculation, Critique and Invention," in *Mappings*, ed. Denis Cosgrove (London: Reaktion Books, 1999), 232.

115. Haussmann, *Mémoires*, 2:318. Bernard Lemoine, "Un boulevard sopra una volta," *Rassegna*, no. 29 (March 1987): 61–65.

116. Haussmann, *Mémoires*, 2:318.

117. For depoliticized views of the sunken canal, see Adolphe Alphand, *Les promenades de Paris* (Paris: J. Rothschild, 1867–73), 239. See also François Loyer,

"Avant-Propos," in Jean des Cars and Pierre Pinon, *Paris Haussmann* (Paris: Picard, 1991), 13: "Finally, he [Haussmann] understood early on that the isolation of the popular quartiers was not a response to the social crisis: the highly symbolic initiative of lowering the waterway and creating a planted boulevard above the vaults of the Canal Saint-Martin was meant to transcend this cleavage between rich and poor that now threatened the city."

118. Lazare, *Les Quartiers de l'est de Paris*, 58. For the canal's name, see Georges Hartmann, "Le Boulevard Richard-Lenoir et le Canal Saint-Martin," *La Cité*, January 1939, 220.

119. Haussmann, *Mémoires*, 2:318.

120. For the original islands that coalesced to form the Île de la Cité, see Félix-Georges De Pachtère, *Paris à l'époque Gallo-Romaine: Étude faite à l'aide des papiers et des plans de Théodore Vacquer* (Paris: Imprimerie nationale, 1912), 17. The Île aux Juifs, where Jews had been executed during the early Middle Ages, belonged to the Abbey of Saint-Germain-des-Prés. In the early fourteenth century, several knights templar, including their grand master, were burned at the stake there.

121. This paragraph owes much to Frédéric Lock, "Les ponts, les ports et les rues," in *Paris Guide* (Paris: A. Lacroix, Verboeckhoven, 1867), 2:1412–45.

122. Considerant, *Description du phalanstère*, 42.

123. Théodore de Banville, "Le Quartier Latin et la Bibliothèque Saint-Geneviève," in *Paris Guide*, 2:1357.

124. In contrast to rectilinear streets, wrote Edmond About, "obstacles, encumbrances, steep slopes, narrow crossroads quadruple distances and waste everyone's time without profiting anyone." Edmond About, "Dans les ruines," in *Paris Guide*, 2:916.

125. Henry W. Lawrence, "Origins of the Tree-Lined Boulevard," *Geographical Review* 78, no. 4 (October 1988): 370.

126. Were the train stations situated "in a relation of horizontality with the adjacent neighborhoods? Would one arrive at these stations by broad and horizontal thoroughfares? On the contrary, the stations are on heights, the city is in the valley." Victor Considerant et Perreymond, "De l'unité administrative du département de la Seine," *La Démocratie pacifique* 1, no. 82 (October 21, 1843): 1.

127. Haussmann, *Mémoires*, 2:520–21.

128. Christ, "La Cité telle qu'elle était il y a un siècle," 306.

129. *Journal de Eugène Delacroix* (Paris: Plon, 1893), 2:69.

130. Pierre Patte, "Observations sur le mauvais état du lit de la Seine à travers Paris, et sur ses conséquences par rapport à sa navigation, à la grande étendue de ses débordemens [*sic*], à l'exhaussement

successif de son sol, et à nombre de causes relatives à sa constitution physique," in *Mémoires qui intéressent particulièrement Paris* (Paris: Artus Bertrand, an IX), 14.

131. Pierre Pinon, "Paris en relief," in *Paris d'ingénieurs*, ed. Bertrand Lemoine and Marc Mimram (Paris: Editions du Pavillon de l'Arsenal / Picard, 1995), 69.

132. Cham (Charles Amédée de Noé), *Bouffoneries de l'Exposition* (Paris: Michel Lévy frères, libraires éditeurs, 1868), n.p. The French had captured the Spanish island of Trocadero in 1823.

133. Léon, *Histoire de la rue*, 182. Rambuteau had acted similarly when he leveled roads. Eric Hazan, *The Invention of Paris: A History in Footsteps*, trans. David Fernbach (London: Verso, 2010), 83.

134. Léon Pagès, *La Déportation et l'abandon des morts: Cimetière de Méry* (Paris: Olmer, 1875), 15.

135. Gustave Nast, "Le nouvel Opéra," *Le Correspondant* 70, part 2 (June 10, 1869), 877.

136. Édouard Fournier, *Histoire de la Butte des Moulins* (Paris: Frédéric Henry et J. Lepin, 1877), 14–15.

137. Henri Clouzot, *Des Tuileries à Saint-Cloud: L'art décoratif du Second Empire* (Paris: Payot, 1925), 70.

138. Victor Fournel, *Paris nouveau et Paris futur* (Paris: Jacques Lecoffre, 1865), 221.

139. Isabelle Backouche, "Projets urbains et mémoire du fleuve (1840–1853)," in Bowie, *La Modernité avant Haussmann*, 111.

140. Le Corbusier, *Urbanisme*, 253.

141. Patte, "Observations sur le mauvais état du lit de la Seine," 14.

142. Perreymond, "Sixième étude sur la Ville de Paris," col. 417.

143. For Daly, see Nicholas Papayanis, "César Daly, and the Emergence of Modern Urban Planning," *Planning Perspectives* 21 (October 2006): 325–46.

144. Jean-Pierre A. Bernard, *Les Deux Paris: Les Représentations de Paris dans la seconde moitié du XIXᵉ siècle* (Seyssel: Champ Vallon, 2001), 86.

145. For an excellent study of the old underlying network, see A. Chastel, F. Boudon, H. Couzy, and F. Hamon, *Système de l'architecture urbaine: Le Quartier des Halles à Paris* (Paris: Centre national de la recherche scientifique, 1977).

146. Françoise Choay, "Sémiologie et urbanisme," *L'architecture d'aujourd'hui* 132 (June–July 1967): 8; Choay, *L'allégorie du patrimoine*, 106. See also Françoise Choay, "Introduction," in Georges-Eugène Haussmann, *Mémoires*, ed. and with an intro. by Françoise Choay; technical intro. by Bernard Landau and Vincent Sainte Marie Gauthier (Paris: Seuil, 2000), 26.

147. Haussmann, *Mémoires*, 3:27.

148. Fournel, "Les monuments du nouveau Paris," 903.

149. Daniel Milo, "Street Names," *Realms of Memory: The Construction of the French Past*, ed. Pierre Nora, trans. Arthur Goldhammer (New York: Columbia University Press, 1997), 363–89. Milo demystifies the supposed "collective memory" inherent in street names.

150. Jules Claretie, "Les Places publiques, les Quais et les Squares de Paris," in *Paris Guide*, 2:1386.

151. Dubech and d'Espezel, *Histoire de Paris*, 2:71.

152. Dubech and d'Espezel, *Histoire de Paris*, 2:125; Robert Aldrich, "Putting the Colonies on the Map: Colonial Names in Paris Streets," *Promoting the Colonial Idea: Propaganda and Visions of Empire in France*, ed. Tony Chafer and Amanda Sackur (New York: Palgrave, 2002), 211–23.

153. Thomas W. Evans, *Memoirs of Thomas W. Evans: The Second French Empire*, ed. Edward A. Crane (New York: D. Appleton, 1905), 144.

154. Hector Horeau, "Assainissements, embellissements de Paris ou édilité urbaine à la portée de tout le monde," *GAB* 6, no. 7 (1868): 56. For a more recent perspective on Second Empire street names, see Hazan, *Invention of Paris*, 219.

155. Jacques Rougerie, "Recherche sur le Paris du XIXᵉ siècle, espace populaire et espace révolutionnaire," *Institut d'Histoire économique et sociale de l'Université de Paris I*, no. 5 (January 1977): 77.

156. Benjamin, *Arcades Project*, 516.

157. Fournel, *Paris nouveau et Paris futur*, 264–65, italics in original.

158. Raymond Bruker, "Le Plan de Paris," in *Nouveau Tableau de Paris au XIXᵉ siècle* (Paris: Mme. Charles-Béchet, 1835), 6:391.

159. Helmuth Graf von Moltke, *Moltke in seinen Briefen: Mit einem lebens- und Charakterbilde des Verewigten* (Berlin: Ernst Siegfried Mittler und Sohn, 1900), 2:100.

160. "Memory attaches itself to sites, whereas history attaches itself to events." Pierre Nora, "Between Memory and History: *Les Lieux de mémoire*," *Representations* 26 (Spring 1989): 22.

161. Fournel, *Paris nouveau et Paris futur*, 76–77, emphasis in original.

162. Chastel, "La Notion de patrimoine," 446.

163. Nadar (Gaspard Félix Tournachon), "Le Dessus et le dessous de Paris," in *Paris Guide*, 2:1585.

164. Hubert Damisch, *Skyline: The Narcissistic City*, trans. John Goodman (Stanford, CA: Stanford University Press, 2001), xiv.

165. Victor Hugo, *Les Misérables* (1862), ed. Yves Gohin (Paris: Gallimard, 1995), 1:578.

166. Charles Supernant, quoted in Jacques Rancière, *Proletarian Nights: The Worker's Dream in Nineteenth-Century France*, trans. John Drury, with an intro. by Donald Reid (London: Verso, 2012), 69, translation modified.

167. Maurice Halbwachs, *On Collective Memory*,

ed., trans., and with an intro. by Lewis A. Coser (Chicago: Chicago University Press, 1992), 51.

168. Rosalind Williams, *Notes on the Underground* (Boston: MIT Press, 1990), 2.

169. Pierre Citron, *La poésie de Paris dans la littérature française de Rousseau à Baudelaire* (Paris: Éditions de Minuit, 1961), 2:320. For the Bohemians, see Jerrold Seigel, *Bohemian Paris: Culture, Politics, and the Boundaries of Bourgeois Life, 1830–1930* (New York: Viking, 1986).

170. Citron, *La poésie de Paris*, 2:295.

171. For Saint-Simonians, the distinctive nature of different urban areas curtailed the possibility of progress. "Thus, the city has lost its force of unity, of cohesion; Paris is no longer homogeneous: it is made up of several cities under a common designation." Perreymond, "Deuxième étude sur la Ville de Paris," *RGA* 3 (1842): col. 571.

172. Privat d'Anglemont, *Paris anecdote*, 8.

173. Fournier, *Paris démoli*, lviii.

174. Privat d'Anglemont, *Paris anecdote*, 171.

175. Honoré de Balzac, "Ce qui disparait de Paris," in *Le Diable à Paris*, 2:13.

176. Charles Baudelaire, "Le Public Moderne et la photographie," in *Curiosités esthétiques* (1859), now in *Écrits sur l'art* (Paris: Gallimard, 1971), 2:23.

177. Walter Benjamin, *Charles Baudelaire: A Lyric Poet in the Era of High Capitalism* (London: Verso, 1997), trans. Harry Zohn (London: Verso, 1999), 87.

178. Marie De Thézy, "Charles Marville et Haussmann," *Monuments Historiques: Photographie et Architecture*, no. 110 (1980): 13–121. See also Eugenia Parry Janis, "Demolition Picturesque: Photographs of Paris in 1852 and 1853 by Henri Le Secq," in *Perspectives on Photography: Essays in Honor of Beaumont Newhall*, ed. Peter Walch and Thomas F. Barrow (Albuquerque: University of New Mexico Press, 1986). According to Peter Barberie, an internal memo of 1873, written by an unidentified employee, declared that the city administration had commissioned 425 views of old streets from Marville. Peter Barberie, "Conventional Pictures: Charles Marville in the Bois de Boulogne" (PhD diss., Princeton University, 2007), 52. See also Sarah Kennel with Peter Barberie, Anne de Mondenard, Françoise Reynaud, and Joke de Wolf, *Charles Marville: Photographer of Paris* (Washington, DC: National Gallery of Art, 2013). Significantly, Mussolini also ordered photographs of streets and neighborhoods about to be destroyed: Kostof, "His Majesty the Pick," 10.

179. Bernadille (Victor Fournel), *Esquisses et croquis parisiens* (Paris: E. Plon, 1876), 309.

180. Bernadille, *Esquisses et croquis parisiens*, 309–10.

181. Claude-Philibert Barthelot Rambuteau, *Mémoires du Comte de Rambuteau* (Paris: Calmann-Lévy, 1905), 375.

182. Richard Terdiman, "Baudelaire's 'Le Cygne': Memory, History, and the Sign," in *Present Past: Modernity and the Memory Crisis* (Ithaca, NY: Cornell University Press, 1993), 119.

183. The vignette by Bertall (Charles Albert d'Arnoux), "Les cinq étages du monde parisien," in *Le Diable à Paris* (Paris: Hetzel, 1845), was republished in *L'Illustration*, January 11, 1845, 293, and in Edmond Texier, *Tableau de Paris* (Paris: Paulin et Le Chevalier, 1852), 1:65. See also the drawing by Karl Girardet, "Scènes de la vie privée dans un immeuble," *Le Magasin pittoresque* (December 1847): 401. These sections contrast sharply with those of the 1880s: see "Paris qui travaille," *Le Magasin pittoresque*, 2nd ser., vol. 1 (1883), 384 and 385. By increasing the value of the upper stories, electricity and elevators brought about greater social homogeneity to apartment buildings.

184. Fabrice Laroulandie, *Les Ouvriers de Paris au XIXᵉ siècle* (Paris: Éditions Christian, 1997), 125.

185. Jules Ferry, *Les Comptes fantastiques d'Haussmann* (Paris: Guy Durier, 1979), 8. The reference to hotels was a jab at the Péreire brothers, who built the Grand Hôtel du Louvre on Rue de Rivoli and the Grand Hôtel beside the Opéra.

186. *Exposition universelle de 1867, à Paris: Rapports des Délégations ouvrières* 3 (Paris: A. Morel, 1869), 21.

187. Émile Zola, *Pot-Bouille* (Paris: Gallimard, 1982), 147. Villermé, whose work Zola knew, had already stated that "in view of the first and costly experiments, speculation abandoned this kind of building, blaming the unsuccessful outcome on the difficulty of bringing together under one roof, widely divergent circumstances and income." Louis-René Villermé, *Sur les Cités ouvrières* (Paris: J.-B. Baillière, 1850), 17–18.

188. Du Camp, *Paris, ses organes, ses fonctions et sa vie*, 4:125. On the afterlife of place, see Esther da Costa Meyer, "The Place of Place in Memory," in *Spatial Recall: Memory in Architecture and Landscape*, ed. Marc Treib (New York: Routledge, 2009), 176–91.

189. Lameyre, *Haussmann*, 146.

190. Marcel Proust, *Albertine disparue* (Paris: Gallimard, 1992), 138.

191. Rosalyn Deutsche, "Analyzing Space: A Response to Victor Burgin's *In/Different Spaces: Place and Memory in Visual Culture*," *Parallax* 3, no. 2 (September 1997): 183–90, esp. 184.

192. Louis Chevalier, *Classes laborieuses et Classes dangereuses* (Paris: Hachette, 1984), 505. See also T. J. Clark, *The Painting of Modern Life: Paris in the Art of Manet and His Followers* (Princeton, NJ: Princeton University Press, 1984), 50.

193. Mercier, *Tableau de Paris*, 2:1034–38.

194. Victor Hugo, *Notre-Dame de Paris* (1831) (Paris: Flammarion, 1967), 144–45; English translation

(New York: P. F. Collier and Son, 1917), emphasis in original.

195. Considerant, *Description du phalanstère*, 39–40.

196. Haussmann, *Mémoires*, 3:76. Built on a convex surface that slopes away from pedestrians, Place de l'Étoile cannot be perceived as circular from the ground. Peets, "Famous Town Planners I: Haussmann," 188.

197. Haussmann, *Mémoires*, 3:41.

198. Bernard Comment, *Le XIXᵉ Siècle des panoramas* (Paris: Adam Biro, 1993), 51.

199. Nadar, *Quand j'étais photographe* (Paris: Seuil, [1900] 1994), 98.

200. Lecouturier, *Paris incompatible avec la république*, 19–20.

201. Du Camp, *Paris, ses organes, ses fonctions et sa vie*, 1:7.

202. Françoise Chenet-Faugeras, "L'invention du paysage urbain," *Romantisme*, no. 83 (1994): 33.

203. The publication of such books soared in the 1860s: *Paris démoli*, *Paris qui disparaît*, *Paris qui s'efface*, *Paris oublié*, *Paris qui s'en va*, *Paris perdu*, *Paris disparu*, *L'agonie du vieux Paris*. For a fuller list, see Jean-Pierre A. Bernard, *Les Deux Paris: Les Représentations de Paris dans la seconde moitié du XIXᵉ siècle* (Seyssel: Champ Vallon, 2001), 177.

204. Clark, *Painting of Modern Life*, 36.

205. Fredric Jameson, "Postmodernism, or the Cultural Logic of Late Capitalism," *New Left Review* 146 (July–August 1984): 90.

206. Clark, *Painting of Modern Life*, 36, emphasis in original.

207. Terdiman, "Baudelaire's 'Le Cygne,'" 106.

208. Contemporaries cherished the distortions brought about by human intervention in popular prints, seeing them as expressions of human agency and control over the course of events. Anne-Claude Ambroise-Rendu, "Du Dessin de presse à la photographie (1878–1914): Histoire d'une mutation technique et culturelle," *Revue d'histoire moderne et contemporaine* 39 (January–March 1992): 10–11.

209. Roland Barthes, "The Eiffel Tower," in *The Eiffel Tower and Other Mythologies*, trans. Richard Howard (Berkeley: University of California Press, 1997), 11.

210. James Fenimore Cooper, *Gleanings in Europe*, with an intro. by Thomas Philbrick; ed. Thomas Philbrick and Constance Ayers Denne (Albany: State University of New York Press, 1983), 65.

211. Henri Lefebvre, *La Révolution urbaine* (Paris: Gallimard, 1970), 35.

212. David Harvey, "Between Space and Time: Reflections on the Geographical Imagination," *Annals of the Association of American Geographers* 80, no. 3 (September 1990): 425.

CHAPTER THREE: STREETS AND BOULEVARDS

1. Francois Loyer, *Paris XIXᵉ siècle: L'immeuble et la rue* (Paris: Hazan, 1994), 117.

2. Henry W. Lawrence, "The Neoclassical Origins of Modern Urban Forests," *Forest and Conservation History* 37, no. 1 (January 1993): 33.

3. Douglas Klahr, "Le Développement des rues parisiennes pendant la monarchie de Juillet," in *La Modernité avant Haussmann: Formes de l'espace urbain à Paris, 1801–1853*, ed. Karen Bowie (Paris: Éditions Recherches, 2001), 224.

4. Nadar, "Paris souterrain," in *Paris Guide* (Paris: A. Lacroix, Verboeckhoven, 1867), 2:1584.

5. Loyer, *Paris XIXᵉ siècle*, 113.

6. Honoré de Balzac, "Histoire et physiologie des boulevards de Paris," in *Le Diable à Paris: Paris et les parisiens* (Paris: Hetzel, 1845), 2:98.

7. Victor Hugo, *Les Misérables* (1862), ed. Yves Gohin (Paris: Gallimard, 1995), 2:541.

8. Rambuteau had originally asked for a street width of eighteen meters, which the municipal council rejected. Jean-Marc Leri, "Les Travaux parisiens sous le préfet Rambuteau," *Cahiers du Centre de recherches et d'études sur Paris et l'Ile-de-France* (CREPIF), no. 18 (March 1987): 208. According to Persigny, "the Parisian population had been deeply impressed by the appearance of this new thoroughfare which crossed a miserable and insalubrious quartier, to which it brought air, light, and health; the popularity of this initiative was of the kind to encourage imitation." Jean-Gilbert Victor Fialin, duc de Persigny, *Mémoires du duc de Persigny, ed.* and with an intro. by M. H. de Laire, Comte d'Espagny (Paris: E. Plon, Nourrit, 1896), 237.

9. *Les grands boulevards* (Paris: Paris: Musées de la Ville de Paris, 1985), 5. See also *Les grands boulevards: Un parcours d'innovation et de modernité*, ed. Bernard Landau, Claire Monod, Evelyne Lohr, and Géraldine Rideau (Paris: Action artistique de la Ville de Paris, 2000); Eric Hazan, *The Invention of Paris: A History in Footsteps*, trans. David Fernbach (London: Verso, 2010), 71–87.

10. David Van Zanten, *Building Paris: Architectural Institutions and the Transformation of the French Capital, 1830–1870* (Cambridge: Cambridge University Press, 1994), 74–121.

11. Walter Benjamin, "Paris, Capital of the Nineteenth Century" (1935), now in Walter Benjamin, *The Arcades Project*, trans. Howard Eiland and Kevin McLaughlin, ed. Rolf Tiedemann (Cambridge, MA: Belknap Press of Harvard University Press, 1999), 11–12.

12. Matthew Truesdell, *Spectacular Politics: Louis-Napoleon Bonaparte and the Fête Impériale, 1849–1870* (Oxford: Oxford University Press, 1997), 90–92.

13. René Descartes, *Discourse on Method and Related*

Writings, trans. and with an intro. by Desmond M. Clarke (London: Penguin, 2003), 11–12.

14. "In a city where the minutes are counted by those who gain hours as well as those who lose them, the ideal would be to start from any given point and arrive at another, always having a straight line ahead." Hippolyte Meynadier, *Paris sous le point de vue pittoresque et monumental; ou, Éléments d'un plan général d'ensemble* (Paris: Dauvin et Fontaine, 1843), 4.

15. Alexis de Tocqueville, *The Ancien Régime and the French Revolution* (1856), ed. Jon Elster, trans. Arthur Goldhammer (New York: Cambridge University Press, 2011), 167.

16. Georges-Eugène Haussmann, *Mémoires du Baron Haussmann*, vol. 3, *Grands travaux de Paris* (Paris: Victor-Havard, 1893), 530. Joris-Karl Huysmans was so incensed that he proposed setting fire to the building, along with several others: Huysmans, "Le Musée des arts décoratifs et l'architecture cuite," in *L'art moderne: Certains* (Paris: Union Générale d'Éditions, 1975), 338.

17. Elbert Peets, "Famous Town Planners I: Haussmann," *Town Planning Review* 12, no. 3 (June 1927): 187.

18. For Haussmann's dependence on previous plans for his boulevards, see Pierre Pinon, *Le mythe Haussmann* (Paris: Éditions B2, 2018), 18–41.

19. Jeanne Pronteau, "La Commission et le Plan des Artistes," in *L'Urbanisme parisien au siècle des lumières* (Paris: Délégation à l'Action Artistique de la Ville de Paris, 1997), 208. For the importance given to sunlight by hygienist discourse during the Enlightenment, see Richard Etlin, "L'air dans l'urbanisme des Lumières," *Dix-huitième Siècle* 9, no. 1 (1977): 123–34.

20. Comte Henri Siméon, Travaux pour la Commission des embellissements de Paris, vol. 2, MS 1780, 162, BHdV.

21. Florence Bourillon, "Changer la ville: La Question urbaine au milieu du XIX siècle," *Vingtième Siècle, Revue d'histoire*, no. 64 (October–December 1999): 18.

22. Charles Baudelaire, "The Eyes of the Poor," in *Paris Spleen, 1869*, trans. Louise Varèse (New York: New Directions, 1947), 53, emphasis in original. See also David Harvey: "It is the sense of proprietorship over public space that is really significant, rather than the all-too-familiar encounter with poverty." Harvey, *Consciousness and the Urban Experience: Studies in the History and Theory of Capitalist Urbanization* (Baltimore: Johns Hopkins University Press, 1985), 204.

23. Louis Chevalier, *Classes laborieuses et Classes dangereuses* (Paris: Hachette, 1984), 409–10. For statistics, see Toussaint Loua, *Atlas statistique de la population de Paris* (Paris: J. Dejey, 1873), 13–17.

24. This preponderance of women in the wealthier western half of the city did not change until 1950. Jean Daric, "La Repartition des sexes dans les populations urbaines: Cas de Paris et du département de la Seine," *Population* 7, no. 4 (October–December 1952): 593–616.

25. Alain Corbin, *Women for Hire: Prostitution and Sexuality in France after 1850*, trans. Alan Sheridan (Cambridge, MA: Harvard University Press, 1990), 199–200 and 409. Corbin took "sexual ghettos" from Jean-Louis Flandrin, *Les Amours paysannes: Amour et sexualité dans les campagnes de l'ancienne France (XVIe–XIXe siècle)* (Paris: Gallimard/Julliard, 1975), 160.

26. Chevalier, *Classes laborieuses et Classes dangereuses*, 413–14.

27. George Sand, "La Rêverie à Paris," in *Paris Guide*, 2:1196–97.

28. George Sand, *Oeuvres autobiographiques*, ed. George Lubin (Paris: Gallimard, 1971), 2:118, emphasis in original.

29. Frances Trollope, *Paris and the Parisians in 1835* (London: Richard Bentley, 1836), 1:112–13.

30. Trollope, *Paris and the Parisians*, 1:116.

31. "For her, the street is not only a circulation route but a means of existence which must, for example, provide her with fuel. An indefatigable forager, the city beneath her feet is like the forest of old, where she gathered kindling and many other substances for subsistence." Michelle Perrot, "La Ménagère dans l'espace parisien au XIXe siècle," *Les Annales de la recherche urbaine* 9, no. 1 (October 1980): 11. One of the characters from the Goncourts' novel *Germinie Lacerteux* crept unseen into the Luxembourg on winter evenings, to strip bark for fuel. Edmond and Jules Goncourt, *Germinie Lacerteux* (Paris: Flammarion, 1990), 99.

32. Jacques Rougerie, "Paris des barricades, un espace populaire," in *Les Traversées de Paris: Deux siècles de révolutions dans la ville* (Paris: Éditions du Moniteur, 1989): 47.

33. Michelle Perrot, "Les Ouvriers, l'habitat et la ville au XIXe siècle," in *La Question du logement et le mouvement ouvrier français*, ed. Jean-Paul Flamand (Paris: Éditions de La Villette, 1981), 38.

34. Hugo, *Les Misérables*, 2:276. This point is made by Jean-Paul Flamand, who nonetheless misquotes the original: Flamand, *Loger le peuple: Essai sur l'histoire du logement social en France* (Paris: La Découverte, 1989), 50.

35. *Enquête sur les conditions du travail en France pendant l'année 1872*, Département de la Seine (Paris: La Chambre de Commerce, 1875), 21.

36. Henri Lefebvre, *La Révolution urbaine* (Paris: Gallimard, 1970), 30.

37. Florence Bourillon, "Rénovation 'haussmannienne' et ségrégation urbaine," in *La ville divisée: Les ségrégations urbaines en question, XVIIIe–XXe siècles*, ed. Annie Fourcaut (Grâne: Créaphis, 1996), 102.

38. Perrot, "Les Ouvriers, l'habitat et la ville," 37.

39. For the "voie publique," see Haussmann, *Mémoires*, 3:133–71.

40. David P. Jordan, "Baron Haussmann and Modern Paris," *American Scholar* 61, no. 1 (Winter 1992): 100.

41. Françoise Boudon, "L'architecture à Paris de 1850 à 1940: Revue des publications récentes," *Revue de l'Art*, no. 29 (1975): 107.

42. Victor Hugo, *Les Années funestes, 1852–1870: Dernière gerbe* (Paris: Albin Michel, 1941), 136.

43. Jules Vallès, *La Rue* (Paris: Faure, 1866), now in Jules Vallès, *Oeuvres*, ed. Roger Bellet (Paris: Gallimard, 1975), 1:1857–70.

44. Charles Yriarte, "Les Types parisiens—les clubs," in *Paris Guide*, 2:929.

45. Bernard Rouleau, *Villages et faubourgs de l'ancien Paris: Histoire d'un espace urbain* (Paris: Seuil, 1985), 134.

46. André Chastel, "Du Paris de Haussmann au Paris d'aujourd'hui," in *Paris, présent et avenir d'une capitale* (Paris: Institut Pédagogique National, 1964), 6.

47. Fournel, *Paris nouveau et Paris futur*, 220–21.

48. On this issue, see Jacques Rancière, "Le Bon Temps ou la barrière des plaisirs," *Les Révoltes logiques*, no. 7 (Spring-Summer 1978): 61.

49. "The street, which I believed could furnish my life with its surprising detours; the street, with its cares and its glances, was my true element: there I could test like nowhere else the winds of possibility." André Breton, *The Lost Steps*, trans. Mark Polizzotti (Lincoln: University of Nevada Press, [1924] 1996), 4.

50. Georges-Eugène Haussmann, *Mémoires du Baron Haussmann*, vol. 2, *Préfecture de la Seine* (Paris: Victor-Havard, 1890), 523.

51. Le Corbusier, *Précisions sur un état présent de l'architecture et de l'urbanisme* (Paris: G. Crès, 1930), 167.

52. Sigfried Giedion, *Space, Time and Architecture*, 5th ed. (Cambridge, MA: Harvard University Press, [1941] 1967), 822, emphasis in original.

53. Trollope, *Paris and the Parisians*, 1:116–17.

54. Honoré de Balzac, *Histoire des Treize, Ferragus, La Duchesse de Langeais, La Fille aux yeux d'or* (Paris: Livre de Poche, 1999), 408.

55. Quoted in Pierre Citron, *La Poésie de Paris dans la littérature française de Rousseau à Baudelaire* (Paris: Éditions de Minuit, 1961), 1:429.

56. Hugo, *Les Misérables*, 1:871.

57. Émile Zola, *L'Assommoir* (Paris: Flamarion, [1877] 1969), 365 and 376.

58. André Guillerme, "Le Pavé de Paris," in *Paris et ses réseaux: Naissance d'un mode de vie urbain, XIXe–XXe siècles*, ed. François Caron, Jean Dérens, Luc Passion, and Philippe Cebron de Lisle (Paris:

Bibliothèque Historique de la Ville de Paris, 1990), 67.

59. *Recherches statistiques sur la Ville de Paris*, 1823. Quoted in Luc Passion, "Marcher dans Paris au XIXe siècle," in Caron et al., *Paris et ses réseaux*, 31.

60. Guillerme, "Le Pavé de Paris," 68.

61. Claude-Philibert Barthelot Rambuteau, *Mémoires du Comte de Rambuteau* (Paris: Calmann-Lévy, 1905), 376.

62. In 1846, Rambuteau established rules concerning sidewalks' height, width, materials, and pavement. Bernard Landau and Annie Térade, "La Fabrication des rues de Paris," in *Paris d'ingénieurs*, ed. Bertrand Lemoine and Marc Mimram (Paris: Editions du Pavillon de l'Arsenal / Picard, 1995), 94.

63. Louis Sébastien Mercier, "Trottoirs," in *Tableau de Paris* (1781), ed. Jean-Claude Bonnet (Paris: Mercure de France, 1994), 1:1202.

64. On the advantages of sidewalks, see François Bédarida and Anthony Sutcliffe, "The Street in the Structure and Life of the City: Reflections on Nineteenth-Century London and Paris," *Journal of Urban History* 6, no. 4 (August 1980): 386.

65. Mercier, "Aller à pied," in *Tableau de Paris*, 2:409.

66. Daniel Stern (Marie d'Agoult), "Le Faubourg Saint-Germain," in *Paris Guide*, 2:1318.

67. Richard Sennett, *The Fall of Public Man* (New York: W. W. Norton, 1992), 65.

68. Bédarida and Sutcliffe, "Street in the Structure and Life of the City," 385; Maxime Du Camp, *Paris, ses organes, ses fonctions et sa vie dans la seconde moitié du XIXe siècle* (Paris: Hachette, 1875), 5:320.

69. Mercier, "Le Bourgeois," in *Tableau de Paris*, 1:62.

70. Mercier, "Le Bourgeois," 1:109.

71. Gérard-Noël Lameyre, *Haussmann, "Préfet de Paris"* (Paris: Flammarion, 1958), 221.

72. Fabrice Laroulandie, *Les Ouvriers de Paris au XIXe siècle* (Paris: Éditions Christian, 1997), 29.

73. George Sand, "La rêverie à Paris," in *Paris Guide*, 2:1197.

74. Louis Véron, *Paris en 1860: Les Théâtres de Paris depuis 1806 jusqu'en 1860* (Paris: Librairie Nouvelle, 1860), 34.

75. Cited in Nicholas Papayanis, *Horse-Drawn Cabs and Omnibuses in Paris: The Idea of Circulation and the Business of Public Transit* (Baton Rouge: Louisiana State University Press, 1996), 30.

76. "Refuges pour les piétons, à Paris," *Le Monde illustré*, March 11, 1865, 148.

77. Marshall Berman, *All That Is Solid Melts into Air: The Experience of Modernity* (New York: Simon and Schuster, 1982), 159.

78. Landau and Térade, "La Fabrication des rues de Paris," 91–105.

79. Patte had illustrated the section of a street hooked up to the sewer. Patte, *Mémoires sur les objets les plus importans de l'architecture*, plate 2.

80. Pierre Léon, "La Conquête de l'Espace National," in *Histoire Économique et Sociale de la France*, ed. Fernand Braudel and Ernest Labrousse, vol. 3, *L'avènement de l'ère industrielle (1789–années 1880)*, part 1 (Paris: Presses Universitaires de France, 1976), 246–47.

81. The Compagnie Parisienne des Tramways et Omnibus commissioned a study of the impact on horses of different types of pavement: "Comparaison des différents pavages," *Semaine des Constructeurs* 9, no. 14 (October 4, 1884): 164–65.

82. According to statistics taken during the Third Republic: in 1876, more than 11,600 vehicles passed on the Boulevard Sébastopol per day; 11,700 on the Champs-Élysées, 13,900 in Rue de Rivoli; 16,100 in Rue Royale; and more than 19,000 in Boulevard des Capucines. "Le Pavage en bois à Paris," *NAC*, 3rd ser., 8, no. 342 (June 1883): col. 89.

83. Charles Baudelaire, "À une passante," in *Les Fleurs du mal*, now in *Oeuvres complètes*, ed. Claude Pichois (Paris: Gallimard, 1975), 92.

84. Alfred de Musset, *La Confession d'un Enfant du Siècle* (Lausanne: Rencontre, 1968), 66. Under the ancien régime, it was manure, with far worse results for pedestrians. Mercier, *Tableau de Paris*, 1:108, 834.

85. During the Third Republic, Haussmann criticized the use of iron in a viaduct built above the cemetery of Montmartre because of the din produced by traffic. Haussmann, *Mémoires*, 3:100. For praise of the "noiseless" new streets of Paris, see William Robinson, *Gleanings from French Gardens* (London: Frederick Warne, 1868), 105.

86. Rambuteau, *Mémoires*, 376.

87. "Le Pavage en bois à Paris," col. 89.

88. Jules Clavé, "Les Plantations de Paris," *Revue des Deux Mondes* 55 (February 1, 1865): 784.

89. *The Health of Nations: A Review of the Works of Edwin Chadwick with a Biographical Dissertation by Benjamin Ward Richardson* (London: Longmans, Green, 1887), 2:24–25.

90. Haussmann, *Mémoires*, 3:142.

91. Fournel, *Paris nouveau et Paris futur*, 37.

92. Victor Hugo, *Choses Vues*, vol. 2, *1849–1885*, ed. Hubert Juin (Paris: Gallimard, 1972), 242.

93. Heinrich Heine, *De la France* (1833) (Paris: Michel Lévy Frères, 1872), 29. Heine lived in Paris from 1831 to 1856.

94. *Les grands boulevards*, 206.

95. Wooden blocks, made of fir or elm, ten to twelve centimeters thick, were soaked in tar and placed on the roadbed, which had been covered with a foundation of asphalt and cement. "La construction du nouveau pavage en bois de l'avenue des Champs-Élysées," *L'Univers illustré*, April 21, 1883, 250. See also "Le Pavage en bois," *NAC*, 4th ser., 1, no. 356 August 1884, 126–28.

96. Lieutenant-Colonel G. Espitallier, "Le sol de nos routes et de nos rues," *Bulletin de la Société d'Encouragement pour l'Industrie Nationale* 106 (May 1907): 544.

97. The Chicago fire received ample coverage in Paris, still recovering from the conflagrations of the Siege and the Commune. See C.-P. D., "Incendie de Chicago," *L'Illustration* 58, no. 1497 (November 4, 1871): 303–4; Ernest Bosc, "Étude sur les chaussées dans les grandes villes," *GAB*, 2nd ser., 9, no. 4 (1873): 25.

98. "La construction du nouveau pavage en bois de l'avenue des Champs-Élysées," 250.

99. Balzac, "Histoire et physiologie des boulevards de Paris," 2:93.

100. Du Camp, *Paris, ses organes, ses fonctions et sa vie*, 6:263.

101. Céleste Baroche, *Second Empire: Notes et souvenirs*, preface by Frédéric Masson (Paris: G. Crès, 1921), 367.

102. Trollope, *Paris and the Parisians*, 1:117–18.

103. William Blanchard Jerrold, *Imperial Paris, Including New Scenes for Old Visitors* (London: Bradbury and Evans, 1855), 239.

104. Jerrold, *Imperial Paris*, 240.

105. Jerrold, *Imperial Paris*, 243.

106. Pierre Mazerolle, *La Misère de Paris: Les Mauvais gîtes* (Paris: Sartorius, 1875), 51–53. For the Hessians in Paris, see Barrie M. Ratcliffe and Christine Piette, *Vivre la Ville: Les Classes populaires à Paris, 1ère moitié du XIXᵉ siècle* (Paris: La Boutique de l'Histoire, 2007), 408–16.

107. Amédée Achard, *Les Rêveurs de Paris* (Paris: Librairie Nouvelle, 1859), 3. For the German colony at La Villette, see Germaine Boué, *The Squares and Gardens of Paris: The Buttes-Chaumont* (Paris: At All the Booksellers, 1878), 14.

108. Jerrold, *Imperial Paris*, 242.

109. Jerrold, *Imperial Paris*, 244–45.

110. "The ouvriers responsible for this painful chore inevitably inhale a highly unhealthy dust; a great many eventually die of phthisis; but they are working on machines that would replace stone breakers." Véron, *Paris en 1860*, 22–23.

111. Marcel Proust, *Du côté de chez Swann* (Paris: Gallimard, 1988), 419.

112. Henri Lefebvre, *The Production of Space*, trans. Donald Nicholson-Smith (Oxford: Blackwell, 1991), 199–200.

113. Jean-François Augoyard, "La vue est-elle souveraine dans l'esthétique paysagère?," in *La Théorie du paysage en France 1974–1994*, ed. Alain Roger (Seyssel: Champ Vallon, 1995), 338–39. For a perspective on

the contemporary city, see Jean Paul Thibaud, "The Sonic Composition of the City," in *The Auditory Culture Reader*, ed. Michael Bull and Les Back (Oxford: Berg, 2003), 329–41.

114. Mark M. Smith, *Sensing the Past: Seeing, Hearing, Smelling, Tasting, and Touching in History* (Berkeley: University of California Press, 2007), 44.

115. H. Hazel Hahn, "Furnishing the Street: Urban Rationalization and Its Limits," in *Scenes of Parisian Modernity: Culture and Consumption in the Nineteenth Century* (New York: Palgrave Macmillan, 2009), 145.

116. Victor Fournel, *Les cris de Paris, types et physiognomies* (Paris: Firmin-Didot, 1887).

117. Marcel Proust, *La Prisonnière* (Paris: Gallimard, 1989), 107. Proust clearly took inspiration from Fournel, who mentions the "classic and jerky recitative" of the woman who sold cardboard. Victor Fournel, *Ce qu'on voit dans les rues de Paris* (Paris: E. Dentu, 1867), 319.

118. Leo Spitzer, "L'Étymologie d'un 'Cri de Paris,'" (1944) in *Études de Style: Précédé de Leo Spitzer et la lecture stylistique, par Jean Starobinski*, trans. Éliane Kaufholz, Alain Coulon, and Michel Foucault (Paris: Gallimard, 1991), 474–81. Spitzer was analyzing the street cries of an artichoke vendor transcribed by Proust in *La Prisonnière*, 109. Proust had grasped their resemblance to liturgic music, which Spitzer confirmed.

119. Mercier, *Tableau de Paris*, 1:1050–51.

120. Du Camp, *Paris, ses organes, ses fonctions et sa vie*, 5:328.

121. Mercier, *Tableau de Paris*, 1:1008.

122. Proust, *La Prisonnière*, 107.

123. Du Camp, *Paris, ses organes, ses fonctions et sa vie*, 5:290; Henri Maréchal, *L'éclairage à Paris* (Paris: Baudry, 1894), 8.

124. Lameyre, *Haussmann*, 240.

125. Jeanne Pronteau, "Construction et aménagement des nouveaux quartiers de Paris (1820–1826)," *Histoire des Entreprises*, no. 2 (November 1958): 16; for the gradual introduction of gaslight, see Wolfgang Schivelbusch, *Disenchanted Night* (Berkeley: University of California Press, 1988), 111.

126. Charles Nodier and Amédée Pichot, *Essai critique sur le gas hydrogène et les divers modes d'éclairage artificiel* (Paris: Charles Gosselin, 1823), xv.

127. Sarah Milan, "Refracting the Gaselier: Understanding Victorian Responses to Domestic Gas Lighting," in *Domestic Space: Reading the Nineteenth-Century Interior*, ed. Inga Bryden and Janet Floyd (Manchester: Manchester University Press, 2000), 93.

128. Edmond Texier, *Tableau de Paris* (Paris: Paulin et Le Chevalier, 1853), 2:237.

129. Raymond Bruker, "Le Plan de Paris," in *Nouveau Tableau de Paris au XIXᵉ siècle* (Paris: Mme. Charles-Béchet, 1835), 6:386.

130. Lameyre, *Haussmann*, 239.

131. Nadar, "1830 et environs," in *Quand j'étais photographe* (Paris: Seuil, [1900] 1994), 341.

132. Elegant models were installed in Place de la Concorde, Place Vendôme, and the Champs-Élysées. Philippe Trétiack, "Un mobilier de style pour la rue," *Architecture intérieure-Crée*, no. 192/193 (January–March 1983): 84; "Le mobilier urbain," *Les grands boulevards* (Paris: Musées de la ville de Paris, 1985), 206–9.

133. François Loyer noted the richness and variety of the seventy-eight different types of design. Loyer, *Paris XIXᵉ siècle*, 306–12.

134. E. Servier, "Le gaz à Paris," in *Paris Guide*, 2:1632.

135. For the Péreires, see Helen M. Davies, *Emile and Isaac Pereire: Bankers, Socialists and Sephardic Jews in Nineteenth-Century France* (Manchester: Manchester University Press, 2015).

136. Michel Carmona, *Haussmann* (Paris: Fayard, 2000), 453; Lenard R. Berlanstein, *Big Business and Industrial Conflict in Nineteenth-Century France: A Social History of the Parisian Gas Company* (Berkeley: University of California Press, 1991), 11.

137. Trollope, *Paris and the Parisians*, 1:118, emphasis in original.

138. Du Camp, *Paris, ses organes, ses fonctions et sa vie*, 5:307–8.

139. Rambuteau, *Mémoires*, 382–83.

140. Perreymond, "Neuvième étude sur la Ville de Paris," *RGA* 4 (1843): col. 522–23.

141. Simone Delattre, *Les Douze heures noires: La Nuit à Paris au XIXᵉ siècle* (Paris: Albin Michel, 2003), 178.

142. Du Camp, *Paris, ses organes, ses fonctions et sa vie*, 6:323.

143. Walter Benjamin, *Charles Baudelaire: A Lyric Poet in the Era of High Capitalism*, trans. Harry Zohn (London: Verso, 1997), 50. "The appearance of the street as an *intérieur* [. . .] is hard to separate from the gaslight"; emphasis in original.

144. Meynadier, *Paris sous le point de vue pittoresque et monumental*, 28.

145. Georges-Eugène Haussmann, *Mémoires du Baron Haussmann*, vol. 1, *Avant l'Hôtel de Ville* (Paris: Victor-Havard, 1890), 227.

146. Du Camp, *Paris, ses organes, ses fonctions et sa vie*, 5:306–7.

147. See Olivier Ihl, "Les territoires du politique: Sur les usages festifs de l'espace parisien à la fin du XIXᵉ siècle," *Politix* 6, no. 21 (1993): 15–32.

148. Alain Corbin, "La Fête de souveraineté," in *Les Usages politiques des fêtes aux XIXᵉ–XXᵉ siècles: Actes du colloque organisé les 22 et 23 novembre 1990 à Paris*, ed. Alain Corbin, Noëlle Gérôme, Danielle Tartakowsky (Paris: Publications de la Sorbonne, 1994), 26; Sudhir Hazareesingh, *The Saint-Napoleon:*

Celebrations of Sovereignty in Nineteenth-Century France (Cambridge, MA: Harvard University Press, 2004), 3.

149. The best source on these festivities is Truesdell, *Spectacular Politics*.

150. Years ago, Dolf Sternberger had already called attention to the "oriental character" of festive nocturnal illumination: Benjamin, *Arcades Project*, 570.

151. Alain Corbin, "Préface," *Les Usages politiques des fêtes aux XIXᵉ–XXᵉ siècles*, 9.

152. For the celebration of the Saint-Napoleon in Paris and in France, see Hazareesingh, *Saint-Napoleon*.

153. Hazareesingh, *Saint-Napoleon*, 20.

154. Alain Leménorel, "Rue, ville et sociabilité à l'époque contemporaine: Histoire et prospective," in *La Rue, lieu de sociabilité?* (Rouen: Publications de l'université de Rouen, no. 214, 1997), 437.

155. Corbin, "Préface," 11.

156. For the causes of this gradual disappearance, see Laroulandie, *Les Ouvriers de Paris*, 19–24.

157. Loyer, *Paris XIXᵉ siècle*, 189.

158. Poe, "The Philosophy of Furniture" (1840), in *The Works of Edgar Allan Poe*, ed. Edmund Clarence Stedman and George Edward Woodberry (Freeport, NY: Books for Libraries Press, 1971), 9:217.

159. Camp, *Paris, ses organes, ses fonctions et sa vie*, 5:309.

160. Nodier and Pichot, *Essai critique sur le gas hydrogène et les divers modes d'éclairage artificiel*, 75.

161. Gustave Claudin, *Paris* (Paris: Dentu, 1862), 126.

162. Robert Louis Stevenson, "A Plea for Gas Lamps," in *The Travels and Essays of Robert Louis Stevenson* (New York: Charles Scribner's Sons, 1895), 13:168.

163. Stevenson, "Plea for Gas Lamps," 168–69, emphasis in original. Schivelbusch's *Disenchanted Night* analyzes this disillusionment with artificial forms of illumination that began with gaslight.

164. William T. O'Dea, *The Social History of Lighting* (Routledge and Kegan Paul, 1958), 99.

165. Haussmann, *Mémoires*, 3:163–64.

166. Stevenson, "Plea for Gas Lamps," 169.

167. Émile Gigault de La Bedollière, "Les Boulevards: De la porte Saint-Martin à la Madeleine," in *Paris Guide*, 2:1296.

168. *Journal des Goncourts: Mémoires de la vie littéraire*, vol. 2, *1862–1865* (Paris: G. Charpentier, 1888), 176.

169. Julien Lemer, *Paris au gas* (Paris: E. Dentu, 1861), 32, italics in original.

170. Delattre, *Les Douze heures noires*, 483.

171. Frederick Engels, *The Condition of the Working Class in England* (1845), trans. and ed. W. O. Henderson and W. H. Chaloner (Stanford, CA: Stanford University Press, 1976), 339. David Harvey discusses this in *Consciousness and the Urban Experience* (Baltimore: Johns Hopkins University Press, 1985), 7.

172. C.-C. Soulages, "L'Éclairage électrique appliqué aux travaux de construction," *La Lumière Électrique* 6, no. 12 (March 25, 1882): 278.

173. Julie de Marguerittes, *The Ins and Outs of Paris* (Philadelphia: Wm. White Smith, 1855), 92.

174. Part of the Tuileries was illuminated by gas, supplemented by huge chandeliers; the rest was lit by oil lamps. At night, Napoleon III often crossed the palace with a candle. William H. C. Smith, *Napoleon III* (London: Collins and Brown, 1991), 41.

175. Hugo, *Les Misérables*, 1:253.

176. Things had changed by the time Du Camp visited the institution. Du Camp, in *Paris, ses organes, ses fonctions et sa vie*, 3:373.

177. Du Camp, *Paris, ses organes, ses fonctions et sa vie*, 6:244.

178. Milan, "Refracting the Gaselier," 89.

179. According to Du Camp, public lighting was first promoted by Nicolas de La Reynie, chief of police under Louis XIV. *Paris, ses organes, ses fonctions et sa vie*, 5:273.

180. Wolfgang Schivelbusch, "The Policing of Street Lighting," *Yale French Studies* 73 (1987): 65.

181. Hugo, *Les Misérables*, 2:482–83.

182. Haussmann, *Mémoires*, 2:221.

183. Delattre, *Les douze heures noires*, 149.

184. Rambuteau, *Mémoires*, 377.

185 Louis Lazare, *Les Quartiers de l'est de Paris* (Paris: Bureau de la Bibliothèque Municipale, 1870), 92.

186. Antoine Granveau, *L'Ouvrier devant la société* (Paris: Hélaine, 1868), 71.

187. "Nouvelles et faits divers," *RGA*, April 1841, col. 219.

188. For this issue, see Roger-Henri Guerrand, *Les Lieux: Histoire des commodités* (Paris: Éditions La Découverte, 1986).

189. "Colonnes-Affiches des spectacles," *NAC* 14, no. 162 (June 1868): col. 52–53; *Les grands boulevards*, 207. They remained until 1877, when they were destroyed.

190. César Daly, "Nouvelles et faits divers," *RGA*, June 1842, 276.

191. Granveau, *L'Ouvrier devant la société*, 72.

192. Granveau, *L'Ouvrier devant la société*, 73.

193. Hector Horeau, "Assainissements, embellissements de Paris ou édilité urbaine à la portée de tout le monde," *GAB*, no. 7 (1868): 53.

194. Trétiack, "Un mobilier de style pour la rue," 88.

195. Place de la Concorde, the Louvre, the *passages*, and Place de l'Etoile. Alice M. Ivimy, *A Woman's Guide to Paris* (New York: Brentano's, 1910): 11.

196. Hervé Maneglier, *Paris Impérial: La Vie*

quotidienne sous le Second Empire (Paris: Armand Colin, 1990), 126.

197. Hahn, "Furnishing the Street: Urban Rationalization and Its Limits," 149–50.

198. Alphand gives details of the three hundred benches of two different models used in the Bois de Boulogne. Adolphe Alphand, *Les promenades de Paris* (Paris: J. Rothschild, 1867–73): 80.

199. Gabriel Davioud, *L'art et l'industrie* (Paris: Veuve A. Morel, 1874): 101.

200. Carmona, *Haussmann*, 528.

201. Paul de Kock, *Paris au kaleidoscope* (1845), quoted in Guerrand, *Les Lieux*, 92–93.

202. Mercier, *Le Nouveau Paris*, quoted in Citron, *La poésie de Paris*, 1:118, brackets and ellipses in Citron.

203. Laroulandie, *Les Ouvriers de Paris*, 21.

204. Hugo, *Choses vues*, vol. 1, *1830–1848*, ed. Hubert Juin (Paris: Gallimard, 1972), 663–64.

205. Fournel, *Ce qu'on voit dans les rues de Paris*, 315.

206. Charles Garnier, "Les affiches agaçantes," *CM* 2 (November 13, 1886): 49.

207. "L'architecture et la réclame commerciale," *CM* 7 (December 19, 1891): 124, signed by "Un parisien de Montmartre."

208. Cited in Maxime Du Camp, "Souvenirs littéraires," part 12, *Revue des Deux Mondes* 52 (July 1882): 263.

209. Marcel Blanchard, "Aux origines de nos chemins de fer: Saint-simoniens et banquiers," *Annales d'histoire économique et sociale*, March 31, 1938, 97–115.

210. Pierre Lavedan, "Mérites et torts d'Haussmann urbaniste," *La Vie Urbaine*, nos. 3–4 (July–December 1953): 235; David Pinkney, *Napoleon III and the Rebuilding of Paris* (Princeton, NJ: Princeton University Press, 1972), 217.

211. Jeanne Gaillard, "Les migrants à Paris au XIX^e siècle: Insertion et marginalité," in "Provinciaux et provinces à Paris," special issue, *Ethnologie française* 10, no. 2 (1980): 130.

212. Jean-Denis G. G. Lepage, *The Fortifications of Paris: An Illustrated History* (Jefferson, NC: McFarland, 2006), 180.

213. Blanchard, "Aux origines de nos chemins de fer," 101.

214. Blanchard, "Aux origines de nos chemins de fer," 103.

215. For the history of the railways and their battle for control, see Karen Bowie, *Les Grandes gares parisiennes au XIX siècle* (Paris: Délégation à l'Action Artistique de la Ville de Paris, 1987).

216. Émile Zola, *La Bête humaine*, preface by Gilles Deleuze (Paris: Gallimard, 1977), 75.

217. Léon Say, "Les chemins de fer," in *Paris Guide*, 2:1657. An economist close to the Rothschilds, and thus opposed to the Péreires, Say later became prefect of the Seine. For this issue, see Micheline

Nilsen, "Paris: Haussmann, the Railways, and the New Gates to the City," in *Railways and the Western European Capitals: Studies of Implantation in London, Paris, Berlin, and Brussels* (New York: Palgrave Macmillan, 2008), 69–80.

218. Théophile Gautier, "Revue des Théâtres," *Le Moniteur universel*, no. 195 (July 13, 1868): 1031.

219. For the best source of this split, see Wolfgang Schivelbusch, *The Railway Journey: The Industrialization of Time and Space in the 19th Century* (Berkeley: University of California Press, 1986), 171–77.

220. This entire part on public transportation in Second Empire Paris draws heavily from Papayanis, *Horse-Drawn Cabs and Omnibuses in Paris*.

221. The Péreires' Crédit Mobilier owned part of the city's omnibuses, gas, and substantial real estate holdings. "Credit Mobilier Society at Paris—Condition and Operations in 1859," *Journal of the Statistical Society* [of London] 23, no. 2 (1860): 243.

222. André Morizet, *Du Vieux Paris au Paris moderne: Haussmann et ses prédécesseurs* (Paris: Hachette, 1932), 279.

223. Benjamin, *Charles Baudelaire*, 129.

224. *Paris-en-omnibus* (Paris: Alphonse Taride, 1854), 11.

225. Papayanis, *Horse-Drawn Cabs and Omnibuses in Paris*, 60.

226. Édouard Gourdon, *Physiologie de l'omnibus* (Paris: Terry, 1842), 51.

227. Gustave Flaubert, Letter to Louise Colet, *Correspondance*, ed. Jean Bruneau (Paris: Gallimard, 1980), 2:518.

228. *Paris-em-omnibus*, 39.

229. Papayanis, *Horse-Drawn Cabs and Omnibuses in Paris*, 63.

230. Du Camp, *Paris, ses organes, ses fonctions et sa vie*, 1:204.

231. Papayanis, *Horse-Drawn Cabs and Omnibuses in Paris*, 5.

232. Paul Virilio, *Bunker Archaeology*, trans. George Collins (New York: Princeton Architectural Press, 1994), 19. For the associations attaching to the omnibus, see Masha Belenky, "From Transit to *Transitoire*: The Omnibus and Modernity," *Nineteenth Century French Studies* 35, no. 2 (Winter 2007): 408–21.

233. Papayanis, *Horse-Drawn Cabs and Omnibuses in Paris*, 65. For issues of class and gender, see Masha Belenky, *Engine of Modernity: The Omnibus and Urban Culture in Nineteenth-Century Paris* (Manchester: Manchester University Press, 2020).

234. Zola, *La bête humaine*, 104.

235. *Les grands boulevards*, 200.

236. Nadar, *Quand j'étais photographe*, 355–56.

237. Marguerittes, *Ins and Outs of Paris*, 32.

238. See "Types et physionomies de Paris: L'intérieur d'un omnibus," *L'Illustration*, July 18, 1874.

239. Haussmann, *Mémoires*, 2:322.

CHAPTER FOUR: WATER

1. Roger Dion, "Le site de Paris dans ses rapports avec le développement de la ville," in *Paris, croissance d'une capitale* (Paris: Hachette, 1961), 17–39.

2. Laure Beaumont-Maillet, *L'Eau à Paris* (Paris: Hazan, 1991), 53.

3. *Commentaires de Jules César sur la guerre des Gaules avec les réflexions de Napoléon I^er, suivis des Commentaires sur la guerre civile, et de la vie de César par Suétone*, trans. Nicolas-Louis Artaud, ed. Félix Lemaistre, with a study of Caesar by Jean Pierre Charpentier (Paris: Garnier Frères, 1867), 1:293.

4. The remains of the temple of Jupiter in the Cité carry the dedication of the *nautae Parisiaci* on the pillars. Simon Lacordaire, *Les Inconnus de la Seine: Paris et les métiers d'eau du XVII^e au XIX^e siècles* (Paris: Hachette, 1985), 53.

5. For the Seine's old bed, see Auguste Dufresne, "Utilité pratique de la géographie ancienne à propos d'un fait récent," *Bulletin de la Société de Géographie*, 6th ser., 5 (January–June 1873): 67.

6. Maxime Du Camp, *Paris, ses organes, ses fonctions et sa vie dans la seconde moitié du XIX^e siècle* (Paris: Hachette, 1875), 5:263.

7. Beaumont-Maillet, *L'Eau à Paris*, 23.

8. Lacordaire, *Les Inconnus de la Seine*, 299.

9. Pierre Patte, "Observations sur le mauvais état du lit de la Seine à travers Paris, et sur les conséquences par rapport à sa navigation, à la grande étendue de ses débordemens [sic], à l'exhaussement successif de son sol, et à nombre de causes relatives à sa constitution physique," in *Mémoires qui intéressent particulièrement Paris* (Paris: Artus Bertrand, an IX), 8.

10. François Beaudouin, *Paris/Seine* (Paris: Éditions de La Martinière, 1989), 112.

11. Joris-Karl Huysmans, "La Bièvre," in *Croquis parisiens* (Paris: Bibliothèque des Arts, 1994), 110.

12. Beaudouin, *Paris/Seine*, 181.

13. Beaudouin, *Paris/Seine*, 167 and 184.

14. "Paris au bord de l'eau," *L'Illustration* 1, no. 23 (August 5, 1843): 362.

15. James Fenimore Cooper, *Gleanings in Europe*, with an intro. by Thomas Philbrick, ed. Thomas Philbrick and Constance Ayers Denne (Albany: State University of New York Press, 1983), 193, emphasis in original.

16. Lacordaire, *Les Inconnus de la Seine*, 62.

17. Bargé, "Travaux de Canalisation du bras gauche de la Seine," *L'Illustration* 18, no. 460 (December 20, 1851): 385–86.

18. Beaudouin, *Paris/Seine*, 80.

19. Lacordaire, *Les Inconnus de la Seine*, 124–25.

20. For the "time of the river," see Isabelle Backouche, *La trace du fleuve: La Seine et Paris (1750–1850)* (Paris: Éditions de l'École des Hautes Études en Sciences Sociales, 2000), 344.

21. Honoré de Balzac, *Histoire des Treize, Ferragus, La Duchesse de Langeais, La Fille aux yeux d'or* (Paris: Livre de Poche, 1999), 69.

22. Louis Sébastien Mercier, "Le Pont-Neuf," *Tableau de Paris* (Paris: Mercure de France, 1994), 1:135.

23. Claude-Philibert Barthelot Rambuteau, *Mémoires du Comte de Rambuteau* (Paris: Calmann-Lévy, 1905), 377.

24. Backouche, *La trace du fleuve*, 366.

25. Bargé, "Travaux de Canalisation du bras gauche de la Seine," 386.

26. E. [Michel-Eugène] Chevreul, "Mémoire sur plusieurs réactions chimiques qui intéressent l'hygiène des cités populeuses," *AHPML* 50 (1853): 30. Chevreul refers to Benjamin Franklin's memoirs, which had already noted this fact; Eugène Belgrand, *Les Travaux souterrains de Paris* (hereafter *TS*), 5 vols. (Paris: Veuve Charles Dunod, 1872–87), 1:71; Georges-Eugène Haussmann, *Second Mémoire sur les eaux de Paris présenté par M. le Préfet de la Seine au Conseil Municipal* (Paris: Charles de Mourgues Frères, 1858), 53.

27. Jean-Marc Léri, *Les berges de la Seine: Politique d'urbanisme de la Ville de Paris, 1769–1848* (Paris: Bibliothèque historique de la ville de Paris, 1981), 23.

28. The British gardener William Robinson, who spent time in Paris, wrote of the Seine that the "ugliest things to be seen from its banks in summer are the floating baths, which in some places half cover its surface." Robinson, *The Parks, Promenades and Gardens of Paris, Described and Considered in Relation to the Wants of Our Own Cities and of Public and Private Gardens* (London: John Murray, 1869), 136.

29. Rambuteau, *Mémoires*, 379–80.

30. Annie Fourcaut with the collaboration of Mathieu Flonneau, "Les relations entre Paris et les banlieues, une histoire en chantier," in *Paris/Banlieues: Conflits et solidarités*, ed. Annie Fourcaut, Emmanuel Bellanger, and Mathieu Flonneau (Paris: Créaphis, 2007), 20.

31. Du Camp, *Paris, ses organes, ses fonctions et sa vie*, 1:329.

32. Backouche, *La trace du fleuve*, 321.

33. Du Camp, *Paris, ses organes, ses fonctions et sa vie*, 1:327. Henri L. Meding claimed that Paris had 125 public baths, not all of them on water: Meding, *Essai sur la topographie médicale de Paris, examen général des conditions de salubrité dans lesquelles cette ville est placée* (Paris: J.-B. Baillière, 1852), 259. For swimming and bathing in the early nineteenth century, see Sun-Young Park, *Ideals of the Body: Architecture, Urbanism, and Hygiene in Postrevolutionary Paris* (Pittsburgh: University of Pittsburgh Press, 2018), 255–68.

34. Paul de Kock, "Bains à domicile," in *La Grande Ville: Nouveau Tableau de Paris* (Paris Au Bureau Centrale des Publications Nouvelles, 1842), 1:17–32.

35. Julia Csergo, *Liberté, égalité, propreté: La Morale d'hygiène au XIX^e siècle* (Paris: Albin Michel, 1988), 204.

36. Csergo, *Liberté, égalité, propreté*, 196.

37. Davide Lombardo, "Se baigner ensemble: Les corps au quotidien et les bains publics parisiens avant 1850 selon Daumier," *Société française d'histoire urbaine*, no. 31 (August 2011): 52.

38. Alain Corbin, *The Foul and the Fragrant: Odor and the French Social Imagination* (Cambridge, MA: Harvard University Press, 1986), 72; Lombardo, "Se baigner ensemble," 47–68.

39. The École Impériale de Natation on the Quai d'Orsay, largest of the cold baths, had 350 dressing rooms, a vast lounge, and several café rooms. Adolphe Joanne, *Paris-Diamant* (Paris: Hachette, 1867), 618.

40. Before the Second Empire's reforms, cold baths and washhouses were established in insalubrious water. Belgrand, *TS*, 5:346.

41. Eugène Briffault, *Paris dans l'eau* (Paris: J. Hetzel, 1844), 38.

42. "Paris au bord de l'eau," *L'Illustration* 1, no. 23 (August 5, 1843): 362. The Deligny baths, wrote Meynadier in 1843, had "rejuvenated itself with a Moorish decoration of truly great magnificence." Hippolyte Meynadier, *Paris sous le point de vue pittoresque et monumental; ou, Éléments d'un plan général d'ensemble de ses travaux d'art et d'utilité publique* (Paris: Dauvin et Fontaine, 1843), 164.

43. F.M., "Paris au bain," *L'Illustration* 10, no, 245 (November 6, 1847): 150. Meding also mentions the association of prostitutes to hot baths. Meding, *Essai sur la topographie médicale de Paris*, 96.

44. In his study of prostitution, Parent-Duchatelet warned against the dangers of daily baths, which he characterizes as "washing habits that one might consider excessive." Alexandre-Jean-Baptiste Parent-Duchâtelet, *De la prostitution dans la ville de Paris* (Paris, J. B. Baillière, 1836), 1:136.

45. Pauline de Pange, *Comment j'ai vu 1900* (Editions Bernard Grasset, 1962), 1:195–96.

46. Csergo, *Liberté, égalité, propreté*, 32.

47. Briffault, *Paris dans l'eau*, 17.

48. For washhouses in Paris, see Jaimee Grüring, "Dirty Laundry: Public Hygiene and Public Space in Nineteenth-Century Paris" (PhD diss., Arizona State University, 2011).

49. Jean-Pierre Goubert, *The Conquest of Water: The Advent of Health in the Industrial Age*, intro. by Emmanuel Le Roy Ladurie, trans. Andrew Wilson (Cambridge, UK: Polity, 1986), 74; Michelle Perrot, "La ménagère dans l'espace parisien au XIX^e siècle," *Les Annales de la recherche urbaine*, no. 9 (October 1980): 15.

50. Émile Gigault de La Bédollière, *Les industriels, métiers et professions en France* (Paris: Veuve Louis Janet, 1842), 106.

51. Perrot, "La ménagère dans l'espace parisien," 15.

52. Flora Tristan, *Le Tour de France (1843–1844)* (Paris: Indigo et Côté-femmes éditions, 2001), 2:108. When using well water, washerwomen consumed chloride of lime, to the detriment of their health: J. Moisy, *Les lavoirs de Paris* (Paris: E. Watelet, 1884), 46.

53. Adrien Gastinel, *Les Égouts de Paris: Étude d'hygiène urbaine* (Paris: Henri Jouve, 1894), 38.

54. Meding, *Essai sur la topographie médicale de Paris*, 151.

55. "Paris Workmen Waiting for Hire," *Illustrated London News* 54, no. 1536 (May 1, 1869): 432.

56. Michelle Perrot, "Femmes au lavoir," *Sorcières* 19 (January 1980): 130.

57. Gigault de La Bédollière, *Les industriels, métiers et professions en France*, 108; Michel Chevalier, "Variétés," *Journal des Debats*, July 7, 1852; Huysmans, "La Blanchisseuse," in *Croquis parisiens*, 87–90.

58. "Bains et lavoirs du Temple," *Le Moniteur universel* 133 (May 13, 1855): 525. The establishment commissioned by the emperor included a bathhouse.

59. Alexandre Bourgeois d'Orvanne, *Lavoirs et bains publics gratuits et à prix réduits* (Paris: Maison, 1854), 7.

60. Perrot, "La ménagère dans l'espace parisien," 16.

61. Lacordaire, *Les Inconnus de la Seine*, 196.

62. Du Camp, *Paris, ses organes, ses fonctions et sa vie*, 1:328.

63. *Mouches* (flies), their peculiar nickname, came from the humming noise of the engines. Lacordaire, *Les Inconnus de la Seine*, 50.

64. Michèle Merger, "Les bâteaux-mouches, 1867–1914," in *Métropolitain: L'autre dimension de la ville* (Paris: Bibliothèque historique de la Ville de Paris, 1988), 19.

65. Frédéric Lock, "Les ponts, les ports et les rues," in *Paris Guide* (Paris: A. Lacroix, Verboeckhoven, 1867), 2:1420; Du Camp, *Paris, ses organes, ses fonctions et sa vie*, 1:322.

66. Élisée Reclus, *Nouvelle Géographie Universelle: La Terre et les hommes*, vol. 2, *La France* (Paris: Hachette, 1877), 730.

67. Honoré de Balzac, "Histoire et physiologie des boulevards de Paris," in *Le Diable à Paris: Paris et les parisiens* (Paris: Hetzel, 1845), 2:94.

68. Antoine Picon, "Le Canal de l'Ourcq: Une controverse technique révélatrice," *Les Canaux de Paris*, ed. Béatrice de Andia and Simon Texier (Paris: Délégation à l'action artistique de la Ville de Paris, 1994), 99.

69. Napoleon I, quoted in Janic Gourlet, "Les canaux de la ville de Paris," *Seine et Paris*, no. 72 (4th semester 1974): 32.

70. Alexandre Schanne, *Souvenirs de Schaunard* (Paris: G. Charpentier, 1887), 232.

71. Yves Lefresne and Jean-Pierre Dubreuil, "Création des canaux Saint-Denis et Saint-Martin," in de Andia and Texier, *Les Canaux de Paris*, 107.

72. *Atlas du Paris souterrain: La Doublure Sombre de la Ville Lumière*, ed. Alain Clément and Gilles Thomas (Paris: Éditions Parigramme, 2001), 109, 147.

73. Victor Considerant, "Note sur les intérêts generaux de la ville de Paris, et spécialement du dixième arrondissement," *RGA* 5 (January 1844): cols. 25–29.

74. Julia Csergo, "L'eau à Paris au XIXᵉ siècle: Approvisionnement et consommation domestique," in Caron et al., *Paris et ses réseaux*, 137.

75. Henri Lecouturier, *Paris incompatible avec la république: Plan d'un nouveau Paris où les révolutions seront impossibles* (Paris: Desloges, 1848), 22.

76. Louis Figuier, *Les Eaux de Paris: Leur passé, leur état présent, leur avenir* (Paris: Michel Lévy Frères, 1862), 282, italics in original.

77. Haussmann, *Second Mémoire*, 21.

78. Goubert, *Conquest of Water*, 54.

79. Émile Avalle, "Porteur d'eau de Paris," in *Les Ouvriers des deux mondes*, ed. Frédéric Le Play (Paris: Au Siège de la Société Internationale, 1858), 2:327.

80. Alain Corbin, "Les paysans de Paris," *Ethnologie Française* 10, no. 2 (April–June 1980): 172. Jeanne Gaillard complicates this picture, calling attention to different forms of assimilation: "Les migrants à Paris au XIXᵉ siècle: Insertion et marginalité," in "Provinciaux et provinces à Paris," special issue, *Ethnologie française* 10, no. 2 (1980): 132.

81. Gigault de La Bédollière, *Les industriels, métiers et professions en France*, 55. Racialized interpretations of the Auvergnats proliferated: "These men constitute a population apart. They are as exclusive a race as are the Quakers at Hackney. They speak a language incomprehensible to the Parisian; they have barrière balls where only Auvergnats are admitted—they hold to their own province, and regard Paris only as some foreign place upon which they may prey, to return to their native village, with a heavy purse." William Blanchard Jerrold, *Imperial Paris, including New Scenes for Old Visitors* (London: Bradbury and Evans, 1855), 247. For a critique of this attitude, see Barrie M. Ratcliffe, "Classes laborieuses et classes dangereuses à Paris pendant la première moitié du XIXᵉ siècle? The Chevalier Thesis Reexamined," *French Historical Studies* 17, no. 2 (Autumn 1991): 542–74.

82. Alexandre de Laborde, quoted in Backouche, *La trace du fleuve*, 297.

83. Eugène Sue, *Les Mystères de Paris* (Paris: Robert Laffont, 1989), 468. Dressed in gray (*gris*), the *grisette* was usually the companion of students but lived by her trade as a seamstress or milliner.

84. Csergo, "L'eau à Paris au XIXᵉ siècle," 139.

85. Georges-Eugène Haussmann, *Mémoires du Baron Haussmann*, vol. 3, *Grands travaux de Paris* (Paris: Victor-Havard, 1893), 287; Du Camp, *Paris, ses organes, ses fonctions et sa vie*, 5:261.

86. Émile Gigault de La Bédollière, *Le Nouveau Paris: Histoire de ses vingt arrondissements* (Paris: Gustave Barba, 1860), 11.

87. Quoted in Du Camp, *Paris, ses organes, ses fonctions et sa vie*, 5:264.

88. The elephant, wrote Hugo, "was somber, enigmatic, and huge, a powerful, visible phantasm, looming upright beside the invisible specter of the Bastille." Victor Hugo, *Les Misérables* (1862), ed. Yves Gohin (Paris: Gallimard, 1995), 2:282.

89. Louis Lazare, *Les Quartiers de l'est de Paris et les communes suburbaines* (Paris: Bureau de la Bibliothèque Municipale, 1870), 51.

90. Gaston Bachelard, *L'eau et les rêves: Essai sur l'imagination de la matière* (Paris: José Corti, 1942), 22.

91. Jules-Antoine Castagnary, "La Fontaine Saint-Michel," Alfred Delvau, Arsène Houssaye, Théophile Gautier, et al., *Paris qui s'en va et Paris qui vient* (Paris: A. Cadart, 1860), 3.

92. The fountain was originally to be dedicated to peace. Dominique Jarassé, "La fontaine Saint-Michel: Le classicisme controversé," *Archives d'architecture moderne*, no. 22 (1982): 83; *Gabriel Davioud* (Paris: Délégation à l'action artistique de la Ville de Paris, 1981), 46–47. For Haussmann's opinion of the fountain, see Haussmann, *Mémoires*, 3:534–36.

93. Lacordaire, *Les Inconnus de la Seine*, 266.

94. Rambuteau, *Mémoires*, 378.

95. Du Camp, *Paris, ses organes, ses fonctions et sa vie*, 5:257. Rambuteau was struck by similar scenes: *Mémoires*, 380.

96. Lazare, *Les Quartiers pauvres de Paris*, 57.

97. Perrot, "Femmes au lavoir," 130. See also Michelle Perrot, "Les Ouvriers, l'habitat et la ville au XIXᵉ siècle," in *La Question du logement et le mouvement ouvrier français*, ed. Jean-Paul Flamand (Paris: Éditions de La Villette, 1981), 27.

98. Csergo, *Liberté, égalité, propreté*, 209.

99. Jacques Léonard, *Archives du corps: La Santé au XIXᵉ siècle* (Rennes: Ouest France, 1986), 115.

100. Erik Swyngedouw, "The City as Hybrid: On Nature, Society and Cyborg Urbanization," *Capitalism, Nature, Socialism* 7, no. 2 (June 1996): 77.

101. For Belgrand's education, see Pierre-Alain Roche, "Belgrand: Homme de science et ingénieur," in *Eaux pour la ville, eaux des villes: Eugène Belgrand, XIXᵉ–XXIᵉ siècle*, ed. Jean-Claude Deutsch and Isabelle Gautheron (Paris: Presses des Ponts, 2013), 44–57.

102. David Jordan, *Transforming Paris: The Life and Labors of Baron Haussmann* (Chicago: University of Chicago Press, 1995), 281.

103. Paul Strauss, "M. Alphand et les Travaux de

Paris," *Revue bleue, politique et littéraire* 48, no. 24 (December 12, 1891): 761.

104. Augustin Filon, *Recollections of the Empress Eugénie* (London: Cassell, 1920), 54.

105. For an excellent account of Haussmann's fight to improve water supply, see David H. Pinkney, *Napoleon III and the Rebuilding of Paris* (Princeton, NJ: Princeton University Press, 1972), 105–26.

106. Adolphe Auguste Mille, "M. Belgrand," *Revue Scientifique*, no. 50 (June 15, 1878): 1190–94; Léon Lalanne, *Notice sur la vie et les travaux de M. E. Belgrand* (Paris: Dunod, 1881); Philippe Cebron de Lisle, "Belgrand et ses successeurs: Les eaux et les égouts de Paris," in *Le Paris des polytechniciens: Des ingénieurs dans la ville, 1794–1994*, ed. Bruno Belhoste, Francine Masson, and Antoine Picon (Paris: Délégation à l'action artistique de la Ville de Paris, 1994), 175–83; Deutsch and Gautheron, *Eaux pour la ville, eaux des villes: Eugène Belgrand*.

107. Eugène Belgrand, *La Seine: I. Le bassin parisien aux âges antéhistoriques*, 3 vols. (Paris: Imprimerie impériale, 1869); Eugène Belgrand, *La Seine: Études hydrologiques sur le Régime de la Pluie, des Sources, des Eaux Courantes*, 2 vols. and atlas (Paris: Imprimerie impériale, 1869). Funded by the municipality, both books were part of the *Histoire générale de Paris*.

108. Beaumont-Maillet, *L'Eau à Paris*, 175.

109. The idea probably came from Adolphe Auguste Mille, *Rapport sur le mode d'assainissement des villes en Angleterre et en Écosse présenté à M. Le Préfet de la Seine* (Paris: Vinchon, 1854), 7–8.

110. Pierre-Simon Girard, *Recherches sur les eaux publiques de Paris* (Paris: Imprimerie impériale, 1812), and *Mémoires sur le canal de l'Ourcq et la distribution de ses eaux*, 2 vols. (Paris: Carilian Goeury and Victor Dalmont, 1843). See also Gabrielle Joudiou, "Du Nil à la Seine: Pierre-Simon Girard," in de Andia and Texier, *Les Canaux de Paris*, 90–94.

111. Pinkney, *Napoleon III and the Rebuilding of Paris*, 121.

112. For Paris's artesian wells, see Beaumont-Maillet, *L'Eau à Paris*, 157–65; Cebron de Lisle, "Les eaux et les égouts à Paris au XIXᵉ siècle: Évolution technique," Caron et al., *Paris et ses réseaux*, 107.

113. John von Simson, "Water Supply and Sewage in Berlin, London and Paris: Developments in the Nineteenth Century," in *Urbanisierung im 19. und 20. Jahrhundert*, ed. Hans Jürgen Teuteberg (Cologne: Böhlau Verlag, 1983), 436–37; Haussmann, *Mémoires*, 3:346.

114. Haussmann, *Second Mémoire sur les eaux de Paris*, 8. The *Commentaries* of Frontinus had been translated into French by Jean-Baptiste Rondelet, and Haussmann probably owed this reference to Belgrand.

115. Haussmann, *Mémoires*, 3:296.

116. Pierre Patte, *Monumens érigés en France à la gloire de Louis XV* (Paris: Chez l'Auteur, Desaint, Saillant, 1765), 215; Girard, *Mémoires sur le canal de l'Ourcq*, 1:318; Belgrand, "Les Aqueducs romains," in *TS*, 2:16–114.

117. Haussmann, *Second Mémoire sur les eaux de Paris*.

118. Haussmann, *Mémoires*, 3:271.

119. For a now-classic study of the myriad associations of water, see Gaston Bachelard, *L'eau et les rêves* (Paris: José Corti, 1997).

120. Mille, "M. Belgrand," 1193.

121. Mille, "M. Belgrand," 1194.

122. Belgrand's reservoirs received a great deal of attention. William R. Hutton, "The Water Supply of Paris," *Engineering News* 8 (January 1881): 13–16; Charles H. Swan, "Covered Reservoirs," *Journal of the New England Water Works Association* 3 (September 1888–June 1889): 51–53.

123. Haussmann, *Mémoires*, 3:111–14.

124. Du Camp, *Paris, ses organes, ses fonctions et sa vie*, 5:250.

125. *Atlas du Paris souterrain: La Doublure Sombre de la Ville Lumière*, ed. Alain Clément and Gilles Thomas (Paris: Éditions Parigramme, 2001), 155.

126. Du Camp, *Paris, ses organes, ses fonctions et sa vie*, 5:265.

127. Haussmann, *Mémoires*, 3:261.

128. Georges-Eugène Haussmann, *Mémoires du Baron Haussmann*, vol. 2, *Préfecture de la Seine* (Paris: Victor-Havard, 1890), 59.

129. Haussmann, *Mémoires*, 3:262. Haussmann also criticized Belgrand strongly. See Michel Carmona, "Haussmann et Belgrand," in Deutsch and Isabelle Gautheron, *Eaux pour la ville*, 32–43.

130. Not until 1892 did a law forbid industrial establishments from using spring water. Csergo, "L'eau à Paris au XIXᵉ siècle," 145.

131. In 1873, there were only thirty-eight free fountains in Paris, Du Camp remarked, and 170 in the annexed zone. Du Camp, *Paris, ses organes, ses fonctions et sa vie*, 5:256.

132. Belgrand, *TS*, 5:180–81. The annexed zone was actually larger than the center.

133. Lazare, *Les Quartiers pauvres de Paris*, 57.

134. Eugène Bouchut, *De l'Emmagasinement et de la salubrité des eaux de Paris* (Paris: Henri Plon, 1861), 6.

135. Bouchut, *De l'Emmagasinement et de la salubrité des eaux de Paris*, 9.

136. Pinkney, *Napoleon III and the Rebuilding of Paris*, 126.

137. Haussmann, *Mémoires*, 3:351.

138. For Siméon's involvement, see Pierre Casselle, "Les Travaux de la Commission des embellissements de Paris en 1853: Pouvait-on transformer la capitale sans Haussmann?," *Bibliothèque de l'École des Chartes* 155 (July–December 1997): 648.

139. For the *Compagnie Générale des Eaux*, see

Alain Jacquot, "La Compagnie Générale des Eaux, 1852–1952: Un siècle, des débuts à la renaissance," *Entreprises et Histoire*, no. 30 (September 2002): 32–44; Goubert, *Conquest of Water*, 175–80; Liliane Franck, *Eau à tous les étages: L'aventure de l'eau à domicile à travers l'histoire de la Compagnie Générale des Eaux* (Châtenois-les-Forges: Imprimerie du Lion, 1999).

140. Quoted in Franck, *Eau à tous les étages*, 42–43.

141. Franck, *Eau à tous les étages*, 101–2.

142. For this issue, see Sara B. Pritchard, "From Hydroimperialism to Hydrocapitalism: 'French' Hydraulics in France, North Africa, and Beyond," *Social Studies of Science* 42, no. 4 (August 2012): 591–615.

143. Beaumont-Maillet, *L'Eau à Paris*, 176.

144. Rambuteau, *Mémoires*, 380.

145. Goubert, *Conquest of Water*, 23.

146. Guy Thuillier, *Pour une histoire du quotidien au XIXᵉ siècle en Nivernais* (Paris: Mouton, 1977), 20.

147. Emmanuel Le Roy Ladurie, "Introduction," in Goubert, *Conquest of Water*, 2.

148. "In effect, water has been a manifest 'political' product, above all in a capital city where all power is tempted to leave its mark and impose control." Cebron de Lisle, "Les eaux et les égouts à Paris au XIXᵉ siècle," 103.

149. Belgrand, *TS*, 3:ii.

CHAPTER FIVE: DE PROFUNDIS

1. Matthew Gandy, "Sewers and the Urban Uncanny," in *The Fabric of Space: Water, Modernity, and the Urban Imagination* (Cambridge, MA: MIT Press, 2014), 47–51.

2. David Van Zanten, "Mais Quand Haussmann est-il devenu moderne?," in *La Modernité avant Haussmann: Formes de l'espace urbain à Paris, 1801–1853*, ed. Karen Bowie (Paris: Éditions Recherches, 2001), 163.

3. Edwin Chadwick, *The Health of Nations: A Review of the Works of Edwin Chadwick*, ed. and with a biographical dissertation by Benjamin Ward Richardson (London: Dawsons, [1887] 1965), 2:14.

4. Eugène Belgrand, *Les Travaux souterrains de Paris* (hereafter *TS*) (Paris: Veuve Charles Dunod, 1872–87), 5:245.

5. Bernard Marchand, *Paris, histoire d'une ville: XIXᵉ–XXᵉ Siècle* (Paris: Seuil, 1993), 173.

6. Élisée Reclus, *Nouvelle Géographie Universelle: La Terre et les hommes*, vol. 2, *France* (Paris: Hachette, 1881), 730.

7. For an excellent account of the Paris sewers, see Donald Reid, *Paris Sewers and Sewermen: Realities and Representations* (Cambridge, MA: Harvard University Press, 1991).

8. Quoted in Emmanuel-Auguste-Dieudonné, Comte de Las Cases, *Mémorial de Sainte-Hélène: Journal de la vie privée et des conversations de l'Empereur Napoléon à Sainte-Hélène*, vol. 3, part 5 (London: Henry Colburn / M. Bossange, 1823), 138–39.

9. Belgrand, *TS*, 5:31.

10. Fabrice Laroulandie, "Les égouts de Paris au XIXᵉ siècle: L'Enfer vaincu et l'utopie dépassée," *Les Cahiers de Fontenay: Idées de villes, villes idéales*, no. 69/70 (March 1993): 121.

11. Victor Hugo, *Les Misérables* (1862), ed. Yves Gohin (Paris: Gallimard, 1995), 2:653–62; Charles Kunstler, *Paris souterrain* (Paris: Flammarion, 1953), 197–98.

12. Belgrand, *TS*, 5:34.

13. Alfred Mayer, "La canalisation souterraine de Paris," in *Paris Guide* (Paris: A. Lacroix, Verboeckhoven, 1867), 2:1608; Laroulandie, "Les égouts de Paris au XIXᵉ siècle," 122.

14. Alexandre-Jean-Baptiste Parent-Duchâtelet, *Essai sur les cloaques ou égouts de la ville de Paris envisagés sous le rapport de l'hygiène publique et de la topographie médicale de cette ville* (Paris: Crevot, 1824).

15. During the Restoration, hygienists such as Parent-Duchâtelet were interested in the "untouchables of the city: those who worked with sludge, filth, excrement, sex." Alain Corbin, "L'hygiène publique et les 'excreta' de la ville préhaussmannienne," *Ethnologie française* 12, no. 2 (1982): 128. "It is very clear that a social physiology of excretion constitutes the guiding thread of Parent-Duchâtelet's thinking." Bernard-Pierre Lécuyer, "L'hygiène en France avant Pasteur, 1750–1850," in *Pasteur et la révolution pasteurienne*, ed. Claire Salomon-Bayet, with a preface by André Lwoff (Paris: Payot, 1986), 126.

16. Parent-Duchâtelet, "Rapport sur le curage des égouts Amelot, de la Roquette, Saint-Martin et autres," *AHPML* 2 (1829): 5–124.

17. Parent-Duchâtelet, noted Belgrand, wrote "one of the most remarkable books published on this topic." Belgrand, *TS*, 5:30–31.

18. Belgrand, *TS*, 5:42–44.

19. Claude-Philibert Barthelot Rambuteau, *Mémoires du Comte de Rambuteau* (Paris: Calmann-Lévy, 1905), 376.

20. This paragraph draws heavily from Laroulandie, "Les égouts de Paris au XIXᵉ siècle," 123.

21. Willi H. Hager, "Jules Dupuit—Eminent Hydraulic Engineer," *Journal of Hydraulic Engineering* 130, no. 9 (September 2004): 843–48; Konstantinos Chatzis, "Jules Dupuit, ingénieur des ponts et chaussées," in *Jules Dupuit: Œuvres économiques complètes* (établies et présentées par Yves Breton et Gérard Klotz) (Paris: Economica, 2009), 1:615–92.

22. Barrie M. Ratcliffe, "Cities and Environmental Decline: Elites and the Sewage Problem in Paris from the Mid-eighteenth to the Mid-nineteenth Century," *Planning Perspectives* 5, no. 2 (May 1990): 202.

23. See, for example, Ratcliffe, "Cities and

Environmental Decline," 189–222; Nicholas Papayanis, *Planning Paris before Haussmann* (Baltimore: Johns Hopkins University Press, 2004), 9; Van Zanten, "Mais Quand Haussmann est-il devenu moderne?," 153–64.

24. Christiane Blancot and Bernard Landau, "La Direction des Travaux de Paris au XIXᵉ siècle," in *Le Paris des polytechniciens: Des ingénieurs dans la ville, 1794–1994*, ed. Bruno Belhoste, Francine Masson, and Antoine Picon (Paris: Délégation à l'action artistique de la Ville de Paris, 1994), 162.

25. Konstantinos Chatzis, "Eaux de Paris, eaux de Londres: Quand les ingénieurs de la capitale française regardent outre-Manche, 1820–1880," *Documents pour l'histoire des techniques* 19 (2010): 212–13; Blancot and Landau, "La Direction des Travaux de Paris au XIXᵉ siècle," 171.

26. Sabine Barles, *La Ville délétère: Médecins et ingénieurs dans l'espace urbain XVIIIᵉ–XIXᵉ siècle* (Seyssel: Champ Vallon, 1999), 119.

27. César Daly, quoted in "Congrès National des Architectes," *RGA* 34 (1877): col. 187. On the importance of engineers in the nineteenth century, see also Stephen Graham and Simon Marvin, *Splintering Urbanism: Networked Infrastructures, Technological Mobilities and the Urban Condition* (New York: Routledge, 2001), 44–45.

28. Maxime Du Camp, in *Paris, ses organes, ses fonctions et sa vie dans la seconde moitié du XIXᵉ siècle* (Paris: Hachette, 1875), 5:330; Philippe Cebron de Lisle, "Belgrand et ses successeurs: Les eaux et les égouts de Paris," in Belhoste et al., *Le Paris des polytechniciens*, 175–83.

29. George Atkinson, "Eugène Belgrand (1810–1878): Civil Engineer, Geologist and Pioneer Hydrologist," *Transactions—Newcomen Society for the Study of the History of Engineering and Technology* 69, no. 1 (1997): 98.

30. Belgrand, *TS*.

31. Eugène Belgrand, *La Seine: Le Bassin parisien aux âges antéhistoriques* (Paris: Imprimerie Impériale, 1869).

32. Adolphe Auguste Mille, *Rapport sur le mode d'assainissement des villes en Angleterre et en Écosse présenté à M. le Préfet de la Seine* (Paris: Vinchon, Imprimeur de la Préfecture de la Seine, 1854).

33. Blancot and Landau, "La Direction des Travaux de Paris au XIXᵉ siècle," 168.

34. Cebron de Lisle, "Belgrand et ses successeurs," 183.

35. Mille, *Rapport sur le mode d'assainissement des villes*, 13.

36. David Van Zanten, "William Lindley im Internationalen Vergleich," in *William Lindley und Europa, 1808–1900* (Hamburg: Dölling und Gallitz, 2008), 276–97; and David Van Zanten, "What Might Have Been at Stake in City Building c. 1842–1853:

The Case of Hamburg after the Great Fire," in *Études transversales: Mélanges en l'honneur de Pierre Vaisse*, ed. Leila El-Wakil, Stéphanie Pallini, and Lada Umstätter-Mamedova (Lyon: Presses universitaires de Lyon, 2005), 107–17.

37. An engineer of the Ponts et Chaussées, wrote Belgrand, should be a geologist as well as a geometer. *TS*, 1:iii–iv.

38. Cebron de Lisle, "Belgrand et ses successeurs," 179. Under the Second Empire, the sewer system in Paris grew from 143 to 773 kilometers. Reid, *Paris Sewers and Sewermen*, 30.

39. Belgrand, *TS*, 5:44.

40. Nadar, "Le Dessus et le dessous de Paris," in *Paris Guide*, 2:1576; J. J. Waller, "Under the Streets of Paris," *Good Words*, no. 35 (1894): 496.

41. "I then realized that it would be possible to take advantage of the long detour of the Seine which flips back on itself, to direct the sewage wastewater downstream by a shorter gallery." Belgrand, *TS*, 5:50.

42. "The construction of this *Cloaca Maxima* of modern Rome [Paris], begun at the end of June 1857, is today completely finished between Place Laborde and the bridge of Asnières." Georges-Eugène Haussmann, *Second Mémoire sur les eaux de Paris présenté par M. le Préfet de la Seine au Conseil Municipal* (Paris: Charles Mourgues Frères, 1858), 107, italics in original.

43. Reid, *Paris Sewers and Sewermen*, 30.

44. Pierre-Yves Mauguen, "Les galeries souterraines d'Haussmann: Le système des égouts parisiens, prototype ou exception?," *Les Annales de la recherche urbaine*, no. 44–45 (1989): 169–71.

45. Du Camp, *Paris, ses organes, ses fonctions et sa vie*, 5:337–38.

46. Dupuit actually built a small underground railroad, following the suggestion of one of his engineers, to clean the Rivoli sewer. Belgrand, *TS*, 5:41, 184–85.

47. In narrow sewers, steep slopes and abundant water to flush conduits largely took care of maintenance. Older sewers required manual labor. Belgrand, *TS*, 5:156.

48. Belgrand, *TS*, 5:195; Reid, *Paris Sewers and Sewermen*, 114.

49. Parent-Duchâtelet, *Essai sur les cloaques ou égouts de la ville de Paris*, 204; William Blanchard Jerrold, *Imperial Paris, Including New Scenes for Old Visitors* (London: Bradbury and Evans), 246.

50. For the lives of these workers, see Reid, *Paris Sewers and Sewermen*, 149–68.

51. Belgrand, *TS*, 5:196–97.

52. Du Camp, *Paris, ses organes, ses fonctions et sa vie*, 5:331.

53. Belgrand, *TS*, 5:224.

54. Georges-Eugène Haussmann, *Mémoires du*

Baron Haussmann, vol. 3, *Grands travaux de Paris* (Paris: Guy Durier, 1979), 351.

55. Haussmann, *Mémoires*, 3:352.

56. Haussmann, *Mémoires*, 3:352. Roman precedent had also been amply cited in Georges-Eugène Haussmann's *Second Mémoire sur les eaux de Paris*, 107.

57. For the analogy of the city to the body, see Rudolf Wittkower, *Architectural Principles in the Age of Humanism* (New York: W. W. Norton, 1971); Françoise Choay, "La Ville et le domaine bâti comme corps dans les textes des architectes-théoriciens de la première Renaissance italienne," *La Nouvelle revue de psychanalyse* 9 (Spring 1974): 239–51.

58. Georges-Eugène Haussmann, "Premier Mémoire sur les eaux de Paris présenté par le Préfet de la Seine au Conseil Muncipal," [1854], now in Préfecture de la Seine, *Documents relatifs aux eaux de Paris* (Paris: Imprimerie administrative de Paul Dupont, 1861), 78. See also Haussmann, *Mémoires*, 3:297. Hector Horeau also claimed that circulation "was to cities what the circulation of blood was to the human body." Hector Horeau, "Assainissement, embellissements de Paris: Édilité urbaine, mise à la portée de tout le monde," *GAB*, part 1, no. 6 (1868): 47.

59. Haussmann, "Premier Mémoire," 69.

60. Henri Lefebvre, *The Production of Space*, trans. Donald Nicholson-Smith (Oxford: Blackwell, 1991), 99.

61. Du Camp, *Paris, ses organes, ses fonctions et sa vie*, 5:335.

62. Quoted in Ratcliffe, "Cities and Environmental Decline," 211 (but translation mine).

63. Chadwick, *Health of Nations*, 2:155.

64. Louis Veuillot, *Les Odeurs de Paris* (Paris: Palmé, 1867), v.

65. Du Camp, *Paris, ses organes, ses fonctions et sa vie*, 5:312–13. On this passage, see David L. Pike, *Subterranean Cities: The World Beneath Paris and London, 1800–1945* (Ithaca, NY: Cornell University Press, 2005), 247.

66. "It is because the houses of London required water, that it became necessary to create this network of sewers and conduits that transforms the underground of the City into an arterial system, with veins everywhere." Mille, *Rapport sur le mode d'assainissement des villes*, 29.

67. Pierre-Denis Boudriot, "Au temps de maître Fifi," *L'Histoire*, no. 53 (February 1983): 70.

68. Haussmann, "Premier Mémoire," 70.

69. According to Belgrand, 0.71 percent of nitrogen was lost "by this barbarous procedure." Belgrand, *TS*, 5:302–3.

70. Gérard Jacquemet, "Urbanisme parisien: La bataille du tout-à-l'égout à la fin du XIXᵉ siècle," *Revue d'Histoire Moderne et Contemporaine* 26, no. 4 (October–December 1979): 519, 528.

71. Jacquemet, "Urbanisme parisien," 507.

72. "I was reluctant to allow the sewers of Paris to be infected by the incessant arrival of fermentable matter." Haussmann, *Mémoires*, 3:115.

73. Matthew Gandy, "The Paris Sewers and the Rationalization of Urban Space," *Transactions, Institute of British Geographers* 24 (April 1999): 35.

74. Du Camp, *Paris, ses organes, ses fonctions et sa vie*, 5:331.

75. Cebron de Lisle, "Belgrand et ses successeurs," 182.

76. Reid, *Paris Sewers and Sewermen*, 56.

77. Mille, *Rapport sur le mode d'assainissement des villes*, 12. Mille erroneously calls Paxton "John."

78. Du Camp, *Paris, ses organes, ses fonctions et sa vie*, 5:351.

79. Peter Reinhart Gleichmann, "Des villes propres et sans odeur: La vidange du corps humain: Ses équipements et sa domestication," *Urbi* 5 (April 1982): xcvii. For the best account of the fight for comprehensive sewers, see Jacquemet, "Urbanisme parisien," 505–48.

80. Georges-Eugène Haussmann, *Premier Mémoire sur les eaux de Paris présenté par le Préfet de la Seine au Conseil Municipal* (Paris: Impr. de Charles de Mourgues frères, 1858), 70. Most often, wrote Belgrand, the proprietor "obstinately refuses his tenants the benefit of water distribution, not because of the expense [. . .] but in order to delay as much as possible filling the cesspool." Belgrand, *TS*, 5:322.

81. Roger-Henri Guerrand, "La bataille du tout-à-l'égout," *L'Histoire*, no. 53 (February 1983): 72.

82. Pierre-Simon Girard and Alexandre-Jean-Baptiste Parent-Duchâtelet, "Des puits forés ou artésiens employés à l'évacuation des eaux sales et infectes et à l'assainissement de quelques fabriques," *AHPML* 10 (1833): 333. Barles, *La Ville délétère*, 284.

83. Jacquemet, "Urbanisme parisien," 510.

84. Guerrand, "La bataille du tout-à-l'égout," 70. Du Camp claims that between 100,000 and 150,000 francs' worth of fertilizer and other chemicals were now lost to the river. Du Camp, *Paris, ses organes, ses fonctions et sa vie*, 5:349.

85. Adrien Gastinel, *Les Égouts de Paris: Étude d'hygiène urbaine* (Paris: Henri Jouve, 1894), 37.

86. Alain Corbin, *The Foul and the Fragrant: Odor and the French Social Imagination* (Cambridge, MA: Harvard University Press, 1986), 119.

87. Alain Corbin, "Présentation," in Alexandre-Jean-Baptiste Parent-Duchâtelet *La Prostitution à Paris au XIXᵉ siècle*, ed. Alain Corbin (Paris: Seuil, 1981), 15.

88. Hugo, *Les Misérables*, 2:645; Sigmund Freud, *The Interpretation of Dreams*, trans. and ed. James Strachey (New York: Avon Books, 1965), 439.

89. Quoted in Reid, *Paris Sewers and Sewermen*, 56. Mille had said something similar: "*In cities, all*

bad smell indicates an affront to public health, and in the countryside, a loss of fertilizer." Mille, *Rapport sur le mode d'assainissement des villes*, 12, emphasis in original.

90. Poubelle, who became prefect in 1884, passed laws regulating cleanliness and mandated garbage collection. Angry landlords retaliated by naming garbage cans *poubelles*.

91. Jacquemet, "Urbanisme parisien," 548.

92. Jacquemet, "Urbanisme parisien," 548.

93. Corbin, *The Foul and the Fragrant*, 116.

94. Guerrand, "La bataille du tout-à-l'égout," 73.

95. Gleichmann, "Des villes propres et sans odeur," xcix.

96. Peter Reinhart Gleichmann, "Vidanges, déjections et machines hydrauliques," *Culture technique*, no. 3 (September 1980): 254.

97. Hugo, *Les Misérables*, 2:661.

98. Jacquemet, "Urbanisme parisien," 544.

99. Jacquemet, "Urbanisme parisien," 542–43.

100. Corbin, *The Foul and the Fragrant*, 101.

101. Corbin, *The Foul and the Fragrant*, 175.

102. "Metropolitan Sewage Committee Proceedings," *Parliamentary Sewage Committee Proceedings*, Parliamentary Papers 10 (London, 1846), 651.

103. Mark M. Smith, *Sensing the Past: Seeing, Hearing, Smelling, Tasting, and Touching in History* (Berkeley: University of California Press, 2007), 17.

104. Gleichmann, "Vidanges, déjections et machines hydrauliques," 254.

105. Corbin, *The Foul and the Fragrant*, 144.

106. Corbin, *The Foul and the Fragrant*, 134–35.

107. Mille, *Rapport sur le mode d'assainissement des villes*, 12.

108. Georg Simmel, "Sociology of the Senses" (1908), in *Simmel on Culture*, ed. David Frisby and Mike Featherstone (London: Sage, 1997): 119.

109. Corbin, *The Foul and the Fragrant*, 7.

110. Georges Verpraet, *Paris, capitale souterraine* (Paris: Plon, 1964), 138.

111. Hugo, *Les Misérables*, 2:660.

112. Hugo, *Les Misérables*, 2:661.

113. Hugo, *Les Misérables*, 2:652.

114. Belgrand, *TS*, 5:209.

115. Helmuth Graf von Moltke, *Moltke's Letters to His Wife and Other Relatives*, trans. J. R. McIlraith, intro. by Sidney Whitman (London: Kegan Paul, Trench, Trübner, 1896), 2:202.

116. Belgrand, *TS*, 5:210.

117. Waller, "Under the Streets of Paris," 496.

118. "The Paris Sewers," *Illustrated London News* 56, no. 1578 (January 29, 1870): 129.

119. Xavier Feyrnet (pseudonym of Albert Kaempfen), "Courrier de Paris," *L'Illustration* 44, no. 1137 (December 10, 1864): 371. See also "Paris Sewers," 129: "Rows of lamps that grow fainter and fainter in the distance, light up the vaulted gallery and cast

their reflections in the black, turbid waters at our feet." Frances White, "A Visit to the Paris Sewers," *Harper's Weekly* 37 (April 29, 1893): 395: "There were others [gas jets] bordering both sides of the canal at short intervals, diminishing in the distance till they became mere pin-heads of lights, a weird and extremely picturesque scene as we stood up a moment and looked back upon it."

120. White, "Visit to the Paris Sewers," 395.

121. For the impact of Hugo, see Fred Radford, "'Cloacal Obsession': Hugo, Joyce, and the Sewer Museum of Paris," *Mattoid*, no. 48 (1994): 72.

122. Feyrnet, "Courrier de Paris," 371.

123. Lucy H. Hooper, "A Visit to the Sewers of Paris," *Appleton's Journal* 13 (New York; April 3, 1875): 430.

124. The workers who pulled his wagon carried out the task of a locomotive, wrote Nadar in *Quand j'etais photographe* (Paris: Seuil, 1994), 145.

125. Quoted in Reid, *Paris Sewers and Sewermen*, 41.

126. See, for example, Hooper, "Visit to the Sewers of Paris," 429–31; White, "Visit to the Paris Sewers," 395.

127. Philippe Cebron de Lisle, "Les eaux et les égouts à Paris au XIXe siècle: Évolution technique," *Paris et ses réseaux: Naissance d'un mode de vie urbain, XIXe–XXe siècles*, ed. François Caron, Jean Dérens, Luc Passion, and Philippe Cebron de Lisle (Paris: Bibliothèque Historique de la Ville de Paris, 1990), 110.

128. Haussmann, "Premier Mémoire," 70.

129. Adrien Blanchet, preface to Philippe Lefrançois, *Paris souterrain* (Paris: Les Editions Internationales, 1950), 11.

130. Émile Gérards, *Paris souterrain*, preface by Charles Pomerol (Torcy: DMI, 1991), 402; Verpraet, *Paris, capitale souterraine*, 70; *Atlas du Paris souterrain*, 7.

131. Gérards, *Paris souterrain*, 239.

132. Édouard Fournier, *Paris-Capitale* (Paris: Dentu, 1881), 23; information on these streets can also be found in Jacques Hillairet, *Dictionnaire historique des rues de Paris* (Paris: Les Éditions de Minuit, 1963), vols. 1 and 2.

133. Pierre-Léonce Imbert, *À travers Paris inconnu* (Paris: Georges Decaux, 1877), 153.

134. Henri Sauval, *Histoire et recherches des Antiquités de la ville de Paris* (Paris: Charles Moette et Jacques Chardon, 1724), 1:25.

135. Gérards, *Paris souterrain*, 481.

136. Bernard Palissy, *Oeuvres*, ed. Anatole France (Paris: Charavay Frères, 1880), 323.

137. Gérards, *Paris souterrain*, 460.

138. Imbert, *À travers Paris inconnu*, 171.

139. Gérards, *Paris souterrain*, 438

140. Gérard de Nerval (Gérard Labrunie), "Les nuits d'octobre: Paris—Pantin—et Meaux," part 1, *L'Illustration* 20, no. 502 (October 9, 1852): 234.

141. Quarries can be found at varying levels, from 2.5 meters beneath Rue d'Alleray to forty meters beneath Montmartre. Gérards, *Paris souterrain*, 403.

142. According to Charles Kunstler, 135 kilometers lay under public property, and 150 kilometers under private property. *Paris souterrain*, 31.

143. "It would not take a very large shock to return the stones to the place from where they were torn away so laboriously." Louis-Sébastien Mercier, "Les Carrières," in *Tableau de Paris* (1781), ed. Jean-Claude Bonnet (Paris: Mercure de France, 1994), 1:37.

144. *Atlas souterrain de la ville de Paris exécuté conformément au vote émis en 1855 par la commission municipale et suivant les ordres de M. le baron G. E. Haussmann, sénateur, préfet de la Seine, par les soins de M. Eugène de Fourcy, ingénieur en chef des mines étant inspecteurs généraux des carrières* (Paris: Charles de Mourgues Frères, 1859).

145. Jean-Timothée Dunkel, *Topographie et consolidation des carrières sous Paris* (Paris: Des Fossez, 1885), 6.

146. In Buffalo, Michel Chevalier, economic adviser to Napoleon III, was surprised to see a boat charged with flint stone from the Paris region, which, he was told, could be found in towns around Lake Erie and, above all, Rochester. M. D. Dalloz and Armand Dalloz, *Répertoire méthodique et alphabétique de législation, de doctrine et de jurisprudence* 42 (Paris: Au Bureau de la Jurisprudence Générale, 1862), 2:832.

147. Nerval (Gérard Labrunie), "Les nuits d'octobre," part 1, 234.

148. Eugène Sue, *Les Mystères de Paris* (Paris: Robert Laffont, 1989), 61.

149. For this issue and the underground in general, see Christopher Prendergast, *Paris and the Nineteenth Century* (Cambridge, MA: Blackwell, 1992), 74–101.

150. Jules Janin, *Un hiver à Paris* (1843) (Paris: L. Curmer, 1844), 201 and 202.

151. Alfred Delvau, *Les Dessous de Paris* (Paris: Poulet-Malassis et de Broise, 1860), 8.

152. Imbert, *À travers Paris inconnu*, 248.

153. Louis Simonin, "Les Carriers et les carrières," in *Paris Guide*, 2:1604.

154. Nerval, "Les nuits d'octobre," part 3, 279, and part 1, 234.

155. Gérard de Nerval, "Les nuits d'octobre: Paris—Pantin—et Meaux," part 2, *L'Illustration* 20, no. 504 (October 23, 1852): 262.

156. It is unclear whether his articles were a work of fiction or whether he actually went on these expeditions. Dietmar Rieger, "'Ce qu'on voit dans les rues de Paris': Marginalités sociales et regards bourgeois," *Romantisme* 18, no. 59 (1988): 24.

157. Karlheinz Stierle, *La Capitale des signes: Paris et son discours*, trans. Marianne Rocher-Jacquin (Paris:

Éditions de la Maison des sciences de l'homme, 2001), 396.

158. Gérards, *Paris souterrain*, 241.

159. Simonin, "Les Carriers et les carrières," 1601.

160. "An Underground Election Meeting in Paris," *Illustrated London News* 55, vol. 1568 (November 27, 1869): 537 and 541.

161. Gérards, *Paris souterrain*, 384, 368.

162. Laurent Olivier, "The Past of the Present: Archaeological Memory and Time," *Archaeological Dialogues* 10, no. 2 (December 2003): 210.

163. François-Marie Arouet (Voltaire), "Enterrement," *Oeuvres complètes de Voltaire* (Paris: Garnier Frères, 1878), 18:551–52.

164. For cemetery projects during the Enlightenment, see Richard A. Etlin, *The Architecture of Death: The Transformation of the Cemetery in Eighteenth-Century Paris* (Cambridge, MA: MIT Press, 1987).

165. See Thomas W. Laqueur, *The Work of the Dead: A Cultural History of Mortal Remains* (Princeton, NJ: Princeton University Press, 2015), esp. chapter 3, "The Cemetery and the New Regime."

166. The idea of transferring ossuaries to the quarries has been variously attributed. Michelet claims it came from Lavoisier: Jules Michelet, *Histoire de la revolution française*, ed. Gérard Walter (Paris: Gallimard, Pléiade, 1952), 1:530. Héricart de Thury, inspector general of the quarries and director of police under the First Empire, credits Jean-Charles-Pierre Lenoir, lieutenant general of the police under Louis XVI. Louis-Étienne François Héricart de Thury, *Description des Catacombes de Paris, précédée d'un précis historique sur les catacombes de tous les peuples de l'ancien et du nouveau continent* (Paris: Bossange et Masson, 1815), 158.

167. Gérards, *Paris souterrain*, 447.

168. Kunstler, *Paris souterrain*, 87.

169. In 1860 alone, eight hundred cartloads of bones were transferred to the catacombs. Hérald, "Paris," *Le Petit journal*, May 2, 1863, 1.

170. Entry of November 14, 1853, *Journal de Eugène Delacroix* (Paris: Plon-Nourrit, 1893), 2:269.

171. Du Camp, *Paris, ses organes, ses fonctions et sa vie*, 6:122–24.

172. Lefebvre, *Production of Space*, 35.

173. Élie Berthet, *Les catacombes de Paris* (Paris: Le Siècle, 1856), 1:139.

174. Émile Gigault de La Bédollière, *Le Nouveau Paris: Histoire de ses vingt arrondissements* (Paris: Gustave Barba, 1860), 219.

175. Gigault de La Bédollière, *Le Nouveau Paris*, 219.

176. For a critical reading of this trope, see Pike, *Subterranean Cities*, 72.

177. Quoted in Gérards, *Paris souterrain*, 463.

178. Michel-Augustin Thouret, who wrote a report on the skeletons exhumed from the Cemetery of the Innocents, thought that deformities were

a boon to science and began to gather a collection of pathology later completed by Héricart de Thury. Héricart de Thury, *Description des Catacombes de Paris*, 279–83. Gigault de La Bédollière, *Le Nouveau Paris*, 219. Texier criticizes this cabinet in Edmond Texier, "Les cimetières et les catacombes," *Tableau de Paris* (Paris: Paulin et le Chevalier, 1853), 2:147.

179. Élie Berthet's *Les Catacombes de Paris*, 2 vols. (1854; Paris: Le Siècle, 1856); Alexandre Dumas, *Les Mohicans de Paris* (Paris: Hachette, 1854–59); Pierre Zaccone, *Les Drames des catacombes* (Paris: Ballay Ainé, 1854); see also Joseph Méry, *Salons et souterrains de Paris* (Paris: Michel Lévy, 1851); Paul Taillade, *Les Catacombes de Paris: Drame en 5 actes et 6 tableaux* (Paris: Théâtre Beaumarchais, 1860). For these novels, see Pike, *Subterranean Cities*, 120–24.

180. Nadar, "Le Dessus et le dessous de Paris," 1569–91. For Nadar's photographs of the Paris underground, see Shelley Rice, *Parisian Views* (Cambridge, MA: MIT Press, 1997), 156–72; Shao-Chien Tseng, "Nadar's Photography of Subterranean Paris: Mapping the Urban Body," *History of Photography* 38, no. 3 (2014): 233–54.

181. Nadar, *Quand j'étais photographe* (Paris: Seuil, [1900] 1994), 138, emphasis in original.

182. Nadar took a patent on photography lit by electricity in 1861, the year he began to photograph the catacombs.

183. "I thought it useful to enliven some of these scenes with a mannequin, not out of any picturesque concern but to give a sense of scale [. . .]. As it would have been difficult for me to obtain absolute, inorganic immobility from a human being for the eighteen minutes' exposure required, I tried to circumvent the difficulty by means of mannequins." Nadar, *Quand j'étais photographe*, 156.

184. Hérald, "Paris," *Le Petit Journal*, May 2, 1863, 2.

185. Nadar, *Quand j'étais photographe*, 150–51.

186. Radford, "'Cloacal Obsession,'" 73; Claude Malécot, *Le Monde de Victor Hugo vu par les Nadar*, preface by Jacques Seebacher (Paris: Les Éditions du Patrimoine, 2002).

187. The word *cemetery* comes from *koimêtêrion*, the place where one sleeps. Michel Ragon, *L'Espace de la mort: Essai sur l'architecture, la décoration et l'urbanisme funéraires* (Paris: Albin Michel, 1981), 223. For Lenoir, see Alexandra Stara, *The Museum of French Monuments 1795–1816: "Killing Art to Make History"* (Burlington, VT: Ashgate, 2013).

188. For "museums of death," see Victor Fournel, *La Déportation des morts: Le Préfet de la Seine et les cimetières de Paris* (Paris: Armand Le Chevalier, 1870), 63.

189. Suzanne Glover Lindsay, *Funerary Arts and Tomb Cult: Living with the Dead in France, 1750–1870* (Burlington, VT: Ashgate, 2012), 28.

190. Ragon, *L'Espace de la mort*, 261–62.

191. Ragon was alluding to the class difference between the two parts of Paris. *L'Espace de la mort*, 113.

192. G. F., "Nouveau cimetière musulman au Père-Lachaise," *L'Illustration* 28, no. 713 (October 25, 1856): 261. Another mosque was built for the Turkish section of the 1867 World's Fair. See also Patricia Hidiroglou, "Le cimetière juif," in *Le Père-Lachaise*, ed. Catherine Healey, Karen Bowie, and Agnès Bos (Paris: Action Artistique de la Ville de Paris, 1998), 80–89; and Alice Brinton, "Le cimetière musulman," in Healey et al., *Le Père-Lachaise*, 90–92.

193. Alphand was possibly Jewish. Joan M. Chapman and Brian Chapman, *The Life and Times of Baron Haussmann: Paris in the Second Empire* (London: Weidenfeld and Nicolson, 1957), 87. If so, Alphand must have converted, as his funeral service was held at Notre-Dame. See also Saskia Coenen Snyder, "Not as Simple as 'Bonjour': Synagogue Building in Nineteenth-Century Paris," in *The Jews of Modern France: Images and Identities*, ed. Zvi Jonathan Kaplan and Nadia Malinovich (Leiden: Brill, 2016), 291–98.

194. Bernadille (Victor Fournel), *Esquisses et croquis parisiens* (Paris: E. Plon, 1876), 83.

195. Haussmann, *Mémoires*, 3:425.

196. Haussmann, *Mémoires*, 3:442.

197. Edmond and Jules Goncourt, *Germinie Lacerteux* (Paris: Flammarion, 1990), 261. Robinson admired Charles Lyell's contention that "all flesh is grass" (Isaiah 40:6), but he never realized "what a poor, transient, weedy kind of grass is the flesh of the lords of creation till I became acquainted with Parisian cemeteries." William Robinson, *Gleanings from French Gardens* (London: Frederick Warne, 1868), 108.

198. Robinson saw workers building a new road through the cemetery of Montparnasse, "*the bottom being made with broken headstones, many of them bearing the date of 1860 and thereabouts.*" Robinson, *Gleanings from French Gardens*, 108, emphasis in original.

199. Haussmann, *Mémoires*, 3:457.

200. La Chapelle, "Le Jour des Morts—la fosse commune," *L'Illustration* 18, no. 454 (November 8, 1851): 293.

201. Haussmann, *Mémoires*, 3:411.

202. Chadwick, *Health of Nations*, 2:158.

203. Laqueur, *Work of the Dead*, 231.

204. Haussmann, *Mémoires*, 3:437.

205. Henri Siméon, Travaux pour la Commission des embellissements de Paris, vol. 1, MS 1779, 85, BHdV. For the London precedent, see John M. Clarke, *The Brookwood Necropolis Railway* (Great Hinton, Townbridge: Oakwood, 2006). Several contemporaries mentioned the English example. Fournel, *La Déportation des morts*, 66; Léon Pagès, *La Déportation et l'abandon des morts: Cimetière de Méry* (Paris: Olmer, 1875).

206. Haussmann, *Mémoires*, 3:449 and 463.

207. Haussmann, *Mémoires*, 3:442.

208. Chenel-Lacour, *Documents divers, pétitions, lettres, notes, articles de journaux sur la question de la translation des cimetières et sur le chemin de fer mortuaire* (Paris: Renou et Maulde, 1869), 28. Part of the letter had already been published in "Chronique," *Le Temps*, December 19, 1867, 2 (unnumbered).

209. Quoted in Chenel-Lacour, *Documents divers*, 29.

210. Fournel, *La Déportation des morts*, 4.

211. Jules Simon, quoted in Pagès, *La Déportation et l'abandon des morts*, 21.

212. Léon Vafflard, *Plus de fosse commune!!! Le cimetière de l'avenir, Méry-sur Oise* (Paris: A. Lacroix, Verboeckhoven, 1867), 11.

213. Quoted in Chenel-Lacour, *Documents divers*, 29.

214. Simon, quoted in Pagès, *La Déportation et l'abandon des morts*, 22–23.

215. Fournel, *La Déportation des morts*, 62 and 67.

216. Chadwick, who saw morality as one of the mainstays of the social and political order, was concerned with what he considered a rampant lack of propriety, "diminishing the solemnities of sepulture; scattering away the elements of moral and religious improvement." Yet he believed that the necessary end of intramural interment need not entail a weakening of funeral rites. *Health of Nations*, 2:165.

217. Honoré de Balzac, *Histoire des Treize, Ferragus, La Duchesse de Langeais, La Fille aux yeux d'or* (Paris: Livre de Poche, 1999), 160.

218. Lucien-Victor Meunier, *Les clameurs du pavé*, with a preface by Jules Vallès (Paris: L. Baillière et H. Messager, 1884), 147.

219. Meunier, *Les clameurs du pavé*, 148–49.

220. Haussmann, *Mémoires*, 3:466–73. See also Mumford's succinct praise of Haussmann's planned cemetery in Lewis Mumford, *The City in History: Its Origins, Its Transformations, and Its Prospects* (New York: Harcourt, Brace and World, 1961), 478.

221. For this mythical, tenebrous Paris, see Dominique Kalifa, "Crime Scenes: Criminal Topography and Social Imaginary in Nineteenth-Century Paris," *French Historical Studies* 27, no. 1 (Winter 2004): 192.

222. Mains for private water supply also ran along the walls. Feyrnet, "Courrier de Paris," 371. See also "The Paris Sewers," *Illustrated London News* 56, no. 1578 (January 29, 1870): 129.

223. This entire discussion owes much to Nicholas Papayanis, "Urbanisme du Paris souterrain: Premiers projets de chemin de fer urbain et naissance de l'urbanisme des cités modernes," *Histoire, Économie et Société* 17, no. 4 (October–December 1998): 745–70.

224. Hector Horeau, *Examen critique du projet d'agrandissement et de construction des halles centrales d'approvisionnement pour la ville de Paris, soumis à l'enquête publique en août 1845: Description et avantages d'un nouveau projet de Halles centrales d'approvisionnement* (Paris: Imprimerie de madame veuve Bouchard-Huzard, 1845).

225. Horeau, *Examen critique*, 9–12.

226. Papayanis, "Urbanisme du Paris souterrain," 751.

227. Hector Horeau, "Assainissements, embellissements de Paris: Édilité urbaine à la portée de tout le monde," part 1, *GAB*, no. 6 (1868): 41–48, and part 2, *GAB*, no. 7 (1868): 49–57. This important study was published with an introduction by Viollet-le-Duc and Anatole de Baudot, editors of the magazine, who, however, did not agree with everything.

228. "Submarine Railway between England and France," *Illustrated London News* 19, no. 530 (November 22, 1851): 612–13.

229. Édouard Brame and Eugène Flachat, *Chemin de fer de jonction des Halles centrales avec le chemin de ceinture: Rapport à l'appui du projet* (Paris: Au Bureau de la Revue Municipale, 1854).

230. Quoted in Papayanis, "Urbanisme du Paris souterrain," 763. See also David Van Zanten, "Mais Quand Haussmann est-il devenu moderne?," in Bowie, *La Modernité avant Haussmann*, 162–64.

231. Louis Le Hir, *Réseau des voies ferrées sous Paris: Transports généraux dans Paris par un réseau de voies ferrées souterraines desservant les principaux quartiers et les mettant en communication avec les gares des chemins de fer et par un service complémentaire de voitures à chevaux* (Paris: Imprimerie Guiraudet et Jouaust, 1856); See also Louis Jourdan, "Les Chemins de fer souterrains," *Le Siècle*, June 19, 1855, 1–2; Alain Auclair, *Les ingénieurs et l'équipement de la France: Eugène Flachat (1802–1873)* (Le Creusot: Ecomusée de la Communauté urbaine Le Creusot-Montceau-les-Mines, 1999).

232. Henri Siméon, Commission des embellissements de Paris, vol. 4, MS 1782, 120, BHdV.

233. "On March 31st, 1866, I visited the sandpits of the plain of Vincennes with Mr. Prestwich and several other English geologists, notably Mr. Jeffreys and Mr. Warrington, president of the Geological Society of London, and with a Belgian geologist, Mr. Dupont [. . .]. The day of this visit, we found several bones there, in particular a large humerus of an *elephant*, today kept at the Muséum." Eugène Belgrand, *La Seine: Le Bassin parisien aux âges anté-historiques* (Paris: Imprimerie Impériale, 1869), 1:175, italics in original. Belgrand must have been alerted beforehand, else he would not have taken his distinguished colleagues along.

234. This whole section is deeply indebted to my colleague Alan Mann, professor of anthropology at Princeton University, for his help with the facts and implications of the paleontological finds in France

and the rest of Europe during the second half of the nineteenth century.

235. Quoted in Belgrand, *La Seine: Le Bassin parisien aux âges antéhistoriques*, 1:258.

236. Voltaire, "Des singularités de la nature," *Oeuvres completes de Voltaire: Nouvelle édition avec notices, préfaces, variantes, table analytique, les notes de tous les commentateurs et des notes nouvelles, conforme pour le texte à l'édition de Beuchot, enrichie des découvertes les plus récentes et mise au courant des travaux qui ont paru jusqu'à ce jour; Précédée de la vie de Voltaire par Condorcet, et d'autres études biographiques, ornée d'un portrait en pied d'après la statue du foyer de la Comédie-Française* (Paris: Garnier Freres, 1879), 27:145–46.

237. Martin S. Rudwick, *Bursting the Limits of Time: The Reconstruction of Geohistory in the Age of Revolution* (Chicago: University of Chicago Press, 2005), 5–6.

238. In his unpublished manuscripts, however, he gave a different timescale to the age of the earth, ranging from three million to a speculative ten million years. Georges-Louis Leclerc, Comte de Buffon, *Les Époques de la nature par Monsieur Le Comte de Buffon* (Paris: Imprimerie Royale, 1780), 1:117. See also Rudwick, *Bursting the Limits of Time*, 128–29.

239. Jean-Baptiste Lamarck, *Philosophie zoologique, ou Exposition des considérations relatives à l'histoire naturelle des animaux*, 2 vols. (Paris: Dentu, 1809).

240. Georges Cuvier and Alexandre Brongniart, *Essai sur la géographie minéralogique des environs de Paris* (Paris: Baudoin, 1811).

241. Quoted in Mrs. R. Lee, *Memoirs of Baron Cuvier* (New York: J. and J. Harper, 1833), 58.

242. Quoted in Edward Stuart Russell, *Form and Function: A Contribution to the History of Animal Morphology*, with a new intro. by George V. Lauder (Chicago: University of Chicago Press, [1916] 1982), 36.

243. Georges Cuvier, *Recherches sur les ossemens fossiles de quadrupèdes, où l'on rétablit les caractères de plusieurs animaux dont les révolutions du globe paroissent avoir détruites* (Paris: Deterville, 1812), 2:20.

244. Hugo, *Les Misérables*, 1:179.

245. Nadar, *Quand j'etais photographe*, 332.

246. See Toby A. Appel, *The Cuvier-Geoffroy Debate: French Biology in the Decades before Darwin* (New York: Oxford University Press, 1987).

247. For an excellent account of the intersection of French literature and paleontology, see Göran Blix, *From Paris to Pompeii: French Romanticism and the Cultural Politics of Archaeology* (Philadelphia: University of Pennsylvania Press, 2009).

248. Honoré de Balzac, *The Wild Ass's Skin*, trans. Herbert J. Hunt (Harmondsworth: Penguin, 1977), 40–41, translation modified. For the impact of paleontology on Balzac, see Richard Somerset, "The Naturalist in Balzac: The Relative Influence of

Cuvier and Geoffroy Saint-Hilaire," *French Forum* 27, no. 1 (Winter 2002): 81–111.

249. Nerval, "Les nuits d'octobre," part 1, 234. The "primitive revolutions of the globe" refer to the title of Cuvier's famous book.

250. Adolphe Watelet, *Description des plantes fossiles du bassin de Paris* (Paris: J.-B. Baillière, 1866), 3–4.

251. Quoted in Sheldon Wolin, *Tocqueville between Two Worlds: The Making of a Political and Theoretical Life* (Princeton, NJ: Princeton University Press, 2003), 124.

252. For the impact of paleontology on architecture, see David Van Zanten, *Designing Paris: The Architecture of Duban, Labrouste, Duc, and Vaudoyer* (Cambridge, MA: MIT Press, 1987), 57; Paula Young Lee, "The Meaning of Molluscs: Léonce Reynaud and the Cuvier-Geoffroy Debate of 1830, Paris," *Journal of Architecture* 3, no. 3 (Autumn 1998): 211–40. On Viollet-le-Duc and Cuvier, see Bernard Thaon, "Viollet-le-Duc, pensée scientifique et pensée architecturale," in *Actes du Colloque International Viollet-le-Duc* (Paris: Nouvelles Editions Latines, 1980), 131–42; Laurent Baridon, *L'imaginaire scientifique de Viollet-le-Duc* (Paris: L'Harmattan, 1996); Philip Steadman, *The Evolution of Designs: Biological Analogy in Architecture and the Applied Arts* (Cambridge: Cambridge University Press, 1979).

253. Viollet-le-Duc, "Style," in *Dictionnaire de l'architecture française du XI*e *au XVI*e *siècle* (Paris: A. Morel, 1869), 8:486.

254. Viollet-le-Duc, *Learning to Draw or the Story of a Young Designer*, trans. Virginia Champlin (New York: G. P. Putnam and Sons, 1881), 120 and 132.

255. Gottfried Semper, *The Four Elements of Architecture, and Other Writings*, trans. Harry Francis Mallgrave and Wolfgang Herrmann (Cambridge: Cambridge University Press, 1989), 170.

256. Belgrand, *La Seine: Le Bassin parisien aux âges antéhistoriques*. For Belgrand's knowledge of paleontology, see Pierre-Alain Roche, "Belgrand: Hydrologue et géologue," in *Eaux pour la ville, eaux des villes: Eugène Belgrand, XIX*e*–XXI*e *siècle*, ed. Jean-Claude Deutsch and Isabelle Gautheron (Paris: Presses des Ponts, 2013), 69.

257. See, for example, the letter by Baron de Ponsort, *L'Illustration* 23, no. 574 (February 25, 1854): 128; Simonin, "Les Carriers et les Carrières," 1591–95.

258. Verne also mentions the geologist Élie de Beaumont. Jules Verne, *Voyage au centre de la terre* (Paris: Hetzel, 1864), 257–58.

259. Alan Mann, personal communication, September 23, 2020.

260. Édouard Lartet, "Nouvelles recherches sur la coexistence de l'homme et des grands mammifères fossiles réputés charactéristiques de la dernière période géologique," *Annales des sciences naturelles*, 4th ser., 15 (1861): 177–253.

261. Charles Darwin, *On the Origin of Species by Means of Natural Selection, or the Preservation of Favoured Races in the Struggle for Life* (London: John Murray, 1859).

262. The complexity of this issue lies beyond the scope of the present work. For a detailed account of the controversy, see Yvonne Conry, *L'introduction du darwinisme en France au XIX*e *siècle* (Paris: J. Vrin, 1974).

263. "It is in the lower beds, in a white and crumbly limestone marl, that we have often found palm trunks petrified into flint." Cuvier and Brongniart, *Essai sur la géographie minéralogique des environs de Paris*, 35.

264. Each marine cycle varied between two and four million years. *Atlas du Paris souterrain*, 8. See also Robert Soyer, *Géologie de Paris* (Paris: Ministère de l'Industrie et de l'Énergie, 1966).

265. Kunstler, *Paris souterrain*, 17.

266. Thomas Hobbes, *Leviathan; or, The Matter, Forme and Power of a Common Wealth Ecclesiasticall and Civil*, ed. Michael Oakeshott, with an intro. by Richard S. Peters (New York: Collier Books, 1962), 100.

267. Fournier, *Paris-Capitale*, 19.

268. Berthet, *Les catacombes de Paris*, 140.

269. Charles Delon, *Notre Capitale Paris*, preface by Léon Cladel, 2nd ed. (Paris: Georges Maurice, 1888), 8, emphasis in original.

270. "Why does the human spirit seem to lose itself in the extension of time rather than that of space [. . .]? Why are one hundred thousand years more difficult to conceive and to count, than one hundred thousand pounds of currency? Would it be because the tally of time cannot be touched nor embodied in visible species? Or is it because, being accustomed by our too short existence to consider a hundred years as a great stretch of time, we have difficulty conceptualizing a thousand years, and cannot conceive of ten thousand, nor even a hundred thousand years?" Georges-Louis Leclerc, Comte de Buffon, *Oeuvres complètes de Buffon augmentées par M. F. Cuvier* (Paris: F. D. Pillot, 1829), 5:94.

271. Gérards, *Paris souterrain*, 95.

272. André Hurtret, *Le métropolitain et les vestiges souterrains du vieux Paris* (Paris: A. Poidevin, 1950), n.p.

273. Belgrand, *La Seine: Le Bassin parisien aux âges antéhistoriques*, iv.

CHAPTER SIX: DISENCHANTED NATURE

1. Nicholas Green brilliantly analyzes the concept of *natura naturans* in nineteenth-century Paris as "a mode of apprehension" or visualization triggered by the urban condition. Nicholas Green, *The Spectacle of Nature: Landscape and Bourgeois Culture in 19th Century France* (Manchester University Press, 1999), 71.

2. George Sand, "La rêverie à Paris," in *Paris Guide* (Paris: A. Lacroix, Verboeckhoven, 1867), 2:1199, emphasis in original.

3. For the transformation of Fontainebleau, see Green, *Spectacle of Nature*, 154–81; Bernard Kalaora, "Les salons verts: Parcours de la ville à la forêt," *La Théorie du paysage en France (1974–1994)*, ed. Alain Roger (Seyssel: Champ Vallon, 1995), 109–32.

4. Michel Crouzet, "Préface," Edmond and Jules de Goncourt, *Manette Salomon*, ed. Stéphanie Champeau and Adrien Goetz (Paris: Gallimard, 1996), 70.

5. Gustave Claudin, *Paris* (Paris: Achille Faure, 1867), 175.

6. Émile Zola, "Les Squares," *Le Figaro*, June 18, 1867, 2.

7. Victor Fournel, *Paris nouveau et Paris futur* (Paris: Jacques Lecoffre, 1865), 92.

8. It was used for the first time in a review of Alphand's book: H.D.B., "Les Promenades de Paris," *L'Illustration* 58, no. 1479 (December 16, 1871): 391.

9. Charles Baudelaire, "Salon de 1859," in *Écrits sur l'art*, ed. Yves Florenne (Paris: Gallimard, 1971), 2:95.

10. For this topic, see Jean Starobinski, "Les cheminées et les clochers," *Magazine littéraire*, no. 280 (September 1990): 26–27; Françoise Chenet-Faugeras, "L'invention du paysage urbain," *Romantisme: Revue du dix-neuvième siècle*, no. 83 (1994): 27–37.

11. Baudelaire, "Salon de 1859," 98.

12. Daniel Stern (pseudonym of Marie de Flavigny, Comtesse d'Agoult), *Mes souvenirs* (Paris: Calmann Lévy, 1877), 123–24.

13. Alphonse Karr, "Les Fleurs à Paris," in *Paris Guide*, 2:1217–18.

14. Michel Conan, "The Coming of Age of the Bourgeois Garden," in *Tradition and Innovation in French Garden Art*, ed. John Dixon Hunt and Michel Conan (Philadelphia: University of Pennsylvania Press, 2002), 168–69.

15. A. J. du Pays, "Embellissements de Paris," *L'Illustration* 23, no. 586 (May 20, 1854): 315.

16. Du Pays, "Embellissements de Paris," 315.

17. Gérard de Nerval, "Promenades et souvenirs," *L'Illustration* 24, no. 618 (December 30, 1854): 442.

18. Adolphe Alphand, *Les promenades de Paris* (Paris: J. Rothschild, 1867–73), lix. See also Georges-Eugène Haussmann, *Mémoires du Baron Haussmann*, vol. 3, *Grands travaux de Paris* (Paris: Victor-Havard, 1893), 260–61.

19. M. E. Chevreul, "Mémoire sur plusieurs réactions chimiques qui intéressent l'hygiène des cités populeuses," *AHPML* 50 (July 1853): 31–33; Alexandre Jouanet, *Mémoire sur les plantations de Paris* (Paris: Imprimerie horticole de J.-B. Gros, 1855), 4.

20. William Robinson, *The Parks, Promenades and Gardens of Paris, Described and Considered in Relation to the Wants of Our Own Cities and of Public and Private Gardens* (London: John Murray, 1869), 90.

21. Edwin Chadwick, *Report to Her Majesty's Principal Secretary of State for the Home Department from the Poor Law Commissioners on an Inquiry into the Sanitary Condition of the Labouring Population of Great Britain* (London: W. Clowes and Sons, 1842), 277.

22. *Oeuvres de Saint-Simon & d'Enfantin publiées par les Membres du Conseil institué par Enfantin pour l'exécution de ses dernières volontés* (Paris: E. Dentu, 1869), 4:52n.

23. On travel and the growing interest in nature, see Élisée Reclus, "Du sentiment de la nature dans les sociétés modernes," *Revue des Deux Mondes* 63 (1866): 352.

24. Second Empire gardens were often compared to opera. Calonne preferred a nature "less *opéra-comique*." Alphonse de Calonne, "Les transformations de Paris. II—Jardins et jardinets," *Revue contemporaine*, 2nd ser., 51 (May–June 1866): 747; L.D., *Parc des Buttes Saint-Chaumont: Guide du promeneur* (Paris: Lacroix, Verboeckhoven, 1867), 38: "Each leafy element installed its greenery, without trouble or error, precisely in the place that had been assigned to it! And all this with the swiftness of a change in plain sight, as if it were an opera set." For Gautier, the Bois de Vincennes offered an agreeable mélange of architecture, landscape, rocks, and trees "disposed a bit like an opera set." Théophile Gautier, "Le Bois de Boulogne" (1857), now in *Paris et les parisiens* (Paris: La Boîte à Documents, 1996), 66.

25. For colonial *jardins d'essai*, see Christophe Bonneuil and Mina Kleiche, *Du jardin d'essais colonial à la station expérimentale, 1880–1930*, Éléments pour une histoire du CIRAD (Paris: CIRAD, 1993).

26. Kalaora, "Les salons verts," 115.

27. Peter Barberie, "Conventional Pictures: Charles Marville in the Bois de Boulogne" (PhD diss., Princeton University, 2007), 167–68.

28. Philippe Cebron de Lisle, "L'oeuvre édilitaire du préfet Chabrol," in *Les Canaux de Paris*, ed. Béatrice de Andia and Simon Texier (Paris: Délégation artistique de la Ville de Paris, 1994), 86.

29. Claude-Philibert Barthelot Rambuteau, *Mémoires du Comte de Rambuteau* (Paris: Calmann-Lévy, 1905), 377. Rambuteau considered himself a disciple of Jean-Marie Morel, who created two gardens for him (32–33).

30. Rambuteau, *Mémoires*, 368.

31. Vergnaud expressed regret "at seeing the Bois de Boulogne preserve its current, regular outline, for this forest is without doubt the one that would be easiest to restore to its natural beauty, that of a picturesque site, enriched by the slopes of Sèvres, Saint-Cloud, and Calvaire, of numerous villages and châteaux, disposed like an amphitheater along the smiling banks of the Seine." Narcisse Vergnaud, *L'art de créer les jardins* (Paris: La Librairie Encyclopédique de Roret, 1839), 83–84.

32. Hippolyte Meynadier, *Paris sous le point de vue pittoresque et monumental; ou, Éléments d'un plan général d'ensemble de ses travaux d'art et d'utilité publique* (Paris: Dauvin et Fontaine, 1843), 140.

33. Meynadier, *Paris sous le point de vue pittoresque et monumental*, 105 and 107.

34. Louis Lazare gathered material on parks and gardens for the Siméon committee. Pierre Casselle, "Les Travaux de la Commission des embellissements de Paris en 1853: Pouvait-on transformer la capitale sans Haussmann?," *Bibliothèque de l'École des Chartes* 155, no. 2 (July–December 1997): 672.

35. Calonne, "Les transformations de Paris," 736.

36. Lucien Augé de Lassus, *Le Bois de Boulogne* (Paris: Société Générale d'Éditions, 1908), 156.

37. Henry W. Lawrence, "The Neoclassical Origins of Modern Urban Forests," *Forest and Conservation History* 37, no. 1 (January 1993): 34.

38. Thomas W. Evans, *Memoirs of Thomas W. Evans: The Second French Empire*, ed. Edward A. Crane (New York: D. Appleton, 1905), 35.

39. Georges-Eugène Haussmann, *Mémoires du Baron Haussmann*, vol. 1, *Avant l'Hôtel de Ville* (Paris: Victor-Havard, 1890), 14.

40. Haussmann, *Mémoires*, 1:25.

41. Haussmann, *Mémoires*, 3:255.

42. Françoise Hamon, "Les Buttes-Chaumont," in *Les Parcs et jardins dans l'urbanisme parisien, XIXᵉ–XXᵉ siècles* (Paris: Délégation artistique de la Ville de Paris, 2001), 99.

43. Alan Tate, "Birkenhead Park, Merseyside," in *Great City Parks* (London: Spon, 2001), 78.

44. Frederick Law Olmsted, *Walks and Talks of an American Farmer in England* (New York: George P. Putnam, 1852), 1:79 and 81. Alphand illustrated Paxton's parks (Birkenhead, Sydenham, Battersea, and Victoria: Alphand, *Les promenades de Paris*, xlix, lii, lii, lvi.

45. Olmsted, *Walks and Talks of an American Farmer*, 81. On real estate and Parisian parks, see Heath Massey Schenker, "Parks and Politics during the Second Empire in Paris," *Landscape Journal* 14, no. 2 (Fall 1995): 208–10.

46. Albert Fein, "Victoria Park: Its Origins and History," *East London Papers* 5 (October 1962): 83; Françoise Choay, "Haussmann et le système des espaces verts parisiens," *Revue de l'Art* 29 (1975): 84.

47. George F. Chadwick, *The Park and the Town: Public Landscape in the 19th and 20th Centuries* (New York: Frederick A. Praeger, 1966), 111.

48. Chadwick, *Park and the Town*, 184.

49. Guy Surand, "Haussmann, Alphand: Des promenades pour Paris," in *Paris Haussmann* (Paris: Picard, 1992), 237.

50. *Les promenades de Paris* was published in installments over a six-year period, followed by a two-volume folio in 1873. The first part, on the Bois de

Boulogne, was timed to coincide with the opening of the 1867 World's Fair.

51. Alexander Pope, "Epistle to Burlington," in *Epistles to Several Persons (Moral Essays)*, ed. F. W. Bateson (New Haven, CT: Yale University Press, 1951), 142.

52. Christian Cajus Lorenz Hirschfeld, *Théorie de l'art des jardins*, 4 vols. (Leipzig: Weidmann et Reich, 1779–85); René-Louis de Girardin, *De la composition des paysages ou des moyens d'embellir la Nature autour des Habitations, en joignant l'agréable à l'utile* (Geneva: P.-M. Delaguette, 1777); Claude-Henri Watelet, *Essai sur les jardins* (Paris: Prault, 1774); Jean-Marie Morel, *Théorie des jardins* (Paris: Pissot, 1776).

53. For Alphand, see *Eaux pour la ville, eaux des villes: Eugène Belgrand, XIXᵉ–XXᵉ siècle*, ed. Jean-Claude Deutsch and Isabelle Gautheron (Paris: Presses des Ponts, 2013); *Jean-Charles-Adolphe Alphand et le rayonnement des parcs publics de l'école française du XIXᵉ siècle*, actes de colloque (Paris: Petit Palais, March 22, 2017): file:///C:/Users/Chris/AppData/Local/Temp/actesAlphand.pdf; *Le Grand Pari(s) d'Alphand: Création et transmission d'un paysage urbain*, ed. Michel Audouy, Jean-Pierre Le Dantec, Yann Nussaume, and Chiara Santini (Paris: Éditions de la Villette, 2018); Gordon Fink Shapiro, "The Promenades of Paris: Alphand and the Urbanization of Garden Art, 1852–1871" (PhD diss., University of Pennsylvania, 2015).

54. Jules Prat, *Le Livre des Promenades de Paris: Mémoire à M. le Président, et à MM les Juges du Tribunal civil de la Seine. M. Jules Prat contre M. Adolphe Alphand* (Paris: Imprimerie brevetée Charles Blot, 1889).

55. Jean-Pierre Le Dantec, "Adolphe Alphand: Une introduction à l'oeuvre et à l'homme," in Audouy et al., *Le Grand Pari(s) d'Alphand*, 26. Prat lost, not surprisingly, given Alphand's closeness to the emperor.

56. Eugène Belgrand, *Les Travaux souterrains de Paris* (Paris: Veuve Charles Dunod, 1872–87), 5:66, 78, 150, 356.

57. For Alphand's collaborators, see Chiara Santini, "Construire le paysage de Paris: Alphand et ses équipes (1855–1891)," in Audouy et al., *Le Grand Pari(s) d'Alphand*, 33–49.

58. Émile Rafarin, "M. Barillet-Deschamps," *Journal de l'Agriculture* 4 (October–December 1873): 185–86.

59. Alfred d'Aunay, "À la découverte: Un jardinier," *Le Figaro*, September 22, 1873, 1.

60. Alphand, *Les promenades de Paris*, 126.

61. Élie-Abel Carrière, "Pierre Barillet," *Revue Horticole*, March 1, 1876, 96.

62. Jean Darcel, *Étude sur l'architecture des jardins* (Paris: Dunod, 1875).

63. Édouard André, *L'art des jardins: Traité général de la composition des parcs et jardins* (Paris: G. Masson, 1879), cover and 112. According to Joseph Disponzio,

the term had been coined by Morel: Disponzio, "From Garden to Landscape: Jean-Marie Morel and the Transformation of Garden Design," *AA Files*, no. 44 (Autumn 2001): 6. See also *Édouard André (1840–1911), un paysagiste-botaniste sur les chemins du monde*, ed. Florence André et Stéphanie de Courtois (Besançon: Éditions de l'Imprimeur, 2001).

64. "Furthermore, I shall endeavor to specify what the union of art and nature should be and seek models for the gardens as much in the most beautiful paintings by artists as in scenes selected from the outside world. In this respect, the composition of *jardins paysagers* resembles the Beaux-Arts, or rather it is part of the Beaux-Arts, whenever the artist becomes worthy of his subject and considers it from its loftiest perspective." André, *L'art des jardins*, 111.

65. Major treatises of the time include Pierre Boitard, *Traité de la composition et de l'ornement des jardins* (Paris: Audot, 1825); Arthur Mangin, *Les Jardins: Histoire et description* (Tours: A. Mame et fils, 1867); and Alfred-Auguste Ernouf, *L'art des jardins: Histoire, théorie, pratique de la composition des jardins, parcs, squares* (Paris: J. Rothschild [pour] Libraire de la Société botanique de France, 1868).

66. Auguste Erhard, *Le Prince de Pückler-Muskau* (Paris: Plon, 1928), 2:264.

67. Alphand, *Les promenades de Paris*, xlviii and lviii. Pückler-Muskau's work had been translated into French: Hermann von Pückler-Muskau, *Aperçu sur la plantation des parcs en general: Joint à une description détaillée du parc de Muskau* (Stuttgart: Halberger, 1847).

68. Jules Lobet, *Le Nouveau Bois de Boulogne et ses alentours* (Paris: Hachette, 1856), 14.

69. Alphand, *Les promenades de Paris*, 2–3.

70. Stern, *Mes souvenirs*, 240.

71. Maurice Halbwachs, "Les Plans d'extension et d'aménagement de Paris avant le XIXᵉ siècle," *La Vie Urbaine*, no. 5 (1920): 13.

72. Marc-Antoine Laugier, *An Essay on Architecture*, trans. and with an intro. by Wolfgang and Anni Hermann (Los Angeles: Hennessy and Ingalls, 1977), 128.

73. André Chastel, "Du Paris de Haussmann au Paris d'aujourd'hui," in *Paris, présent et avenir d'une capitale* (Paris: Institut Pédagogique National, 1964), 7.

74. Élisée Reclus, *Nouvelle Géographie universelle: La Terre et les hommes*, vol. 2, *La France* (Paris: Hachette, 1881), 731.

75. Charles Merruau, *Souvenirs de l'Hôtel de Ville de Paris, 1848–1852* (Paris: E. Plon, 1875), 489.

76. Édouard Ferdinand de Beaumont-Vassy, *Histoire intime du Second Empire* (Paris: Librairie Sartorius, 1874), 189–90.

77. Meynadier, *Paris sous le point de vue pittoresque et monumental*, 2; John Dixon Hunt, "French Formal Gardening as a Mapping Process," in *Tradition and Innovation in French Garden Art*, 29–34.

78. Lobet, *Le Nouveau Bois de Boulogne*, 41. For Varé work at the Bois de Boulogne, see Shapiro, "Promenades of Paris," 132–43; Florence Collette, "Louis-Sulpice Varé (1803–1883), un paysagiste français du XIXᵉ siècle à redécouvrir," *Polia, la revue de l'art des jardins*, no. 3 (Spring 2005): 5–30.

79. Édouard Gourdon, *Le Bois de Boulogne, Histoire, types, moeurs* (Paris: Librairie Charpentier, 1854), 100.

80. Haussmann, *Mémoires*, 3:122.

81. Girardin, *De la composition des paysages*, 99.

82. Shapiro, "Promenades of Paris," 133–34.

83. A plan of the Bois de Boulogne designed by Varé, colored by Eugénie, includes captions by Napoleon III, dated June 10 and 24, 1854. *Créateurs de jardins et de paysages*, ed. Michel Racine (Versailles: École Nationale Supérieure du Paysage, 2001), 2:22.

84. For positive appraisals of Varé, see Gourdon, *Le Bois de Boulogne*, 98–103; A. de L., "Inauguration de la rivière artificielle du Bois de Boulogne," *L'Illustration* 23, no. 581 (April 13, 1854): 228; Lobet, *Le Nouveau Bois de Boulogne*, 42–43; Gautier, "Le Bois de Boulogne," 61; "Le Nouveau Bois de Boulogne," *Le Magasin pittoresque* 27 (1859): 179 (unsigned). See also Joseph Disponzio, "Landscape Architecture: A Brief Account of Origins," *Studies in the History of Gardens and Designed Landscapes* 34, no. 3 (2014): 192–200.

85. Collette, "Louis-Sulpice Varé," 9.

86. Sand, "La rêverie à Paris," 2:1202.

87. Jules Clavé, "Les Plantations de Paris," *Revue des Deux Mondes* 55 (February 1, 1865): 791.

88. Kevin Coffee, "Hydrology and the Imperial Vision of Bois de Boulogne," *Post-Medieval Archaeology* 51, no. 1 (2017): 75.

89. Jean-Michel Derex, *Histoire du Bois de Boulogne* (Paris: L'Harmattan, 1997), 168.

90. Alphand, *Les promenades de Paris*, 28; Robinson, *Parks, Promenades and Gardens of Paris*, 20.

91. Alphand, *Les promenades de Paris*, 31–32. The Grande Cascade used four thousand square meters of sandstone from Fontainebleau, and two thousand square meters of cement: Robert Joffet, "Paysages du Bois de Boulogne," *La Vie Urbaine: Urbanisme et habitation*, no. 1 (January–March 1953): 9.

92. Haussmann, *Mémoires*, 3:186.

93. "Obviously, I should have asked for half of the net earnings of the enterprise, as in the treaty of the Gas Company." Haussmann, *Mémoires*, 3:194.

94. Morny used influence to get what he wanted. In November 1867, he wrote Alphand haughtily, enclosing a list of trees that he wanted the municipality to send him straight away for one of his properties near Versailles. Papiers Adolphe Alphand, MS 2255, BHdV.

95. A. de L., "Inauguration de la rivière artificielle du Bois de Boulogne," 228.

96. Émile Zola, "Livres d'aujourd'hui et de demain," *Le Gaulois*, March 8, 1869, 2 (unnumbered).

97. Clare A. P. Willsdon, "'Promenades et Plantations': Impressionism, Conservation, and Haussmann's Reinvention of Paris," in *Soil and Stone: Impressionism, Urbanism, Environment*, ed. Frances Fowle and Richard Thomson (Aldershot: Ashgate, 2003), 114.

98. Rafarin, "M. Barillet-Deschamps," 186.

99. D'Aunay, "À la découverte," 1.

100. Robinson, *Parks, Promenades and Gardens of Paris*, 64.

101. Haussmann, *Mémoires*, 3:129.

102. Gabriel Thouin, *Plans raisonnés de toutes les espèces de jardins* (Paris: Imprimerie de Lebègue, 1820); Conan, "Coming of Age of the Bourgeois Garden," 160–83.

103. Alan Tate, "Parc des Buttes Chaumont, Paris," in *Great City Parks* (London: Spon, 2001), 54.

104. Alain Corbin, *The Foul and the Fragrant: Odor and the French Social Imagination* (Cambridge, MA: Harvard University Press, 1986), 195.

105. Quoted in Luisa Limido, *L'art des jardins sous le Second Empire: Jean-Pierre Barillet-Deschamps (1824–1873)* (Seyssel: Champ Vallon, 2002), 81.

106. William Robinson, *Gleanings from French Gardens* (London: Frederick Warne, 1868), 82, 88, 94. For the "jardin anglais," see "Le Nouveau Bois de Boulogne," *Le Magasin pittoresque* 27 (1859): 180; Clavé, "Les Plantations de Paris," 791.

107. Rafarin, "L'art des jardins en France," *Revue Horticole* 42 (1870): 98.

108. John Claudius Loudon, "On Laying Out and Planting the Lawn, Shrubbery, and Flower-Garden," *Gardener's Magazine and Register of Rural and Domestic Improvement* 19 (1843): 166.

109. John Claudius Loudon, "Remarks on Laying Out Public Gardens and Promenades," *Gardener's Magazine and Register of Rural and Domestic Improvement* 11 (1835): 648.

110. Jean-Pierre Barillet-Deschamps, "Des massifs à effet pour l'ornement des jardins pendant la belle saison," *Annales de la Société d'Horticulture de la Gironde* 5, no. 17 (April 1851): 381.

111. Limido, *L'art des jardins sous le Second Empire*, 63.

112. Edouard Grimard, *Le Jardin d'Acclimatation—le Tour du monde d'un naturaliste* (Paris: Hetzel, 1870), 331–32.

113. Jules Michelet, *Histoire de France* (Paris: A. Lacroix, Verboeckhoven, 1872), 2:53.

114. Haussmann, *Mémoires*, 3:181. The *parterres de broderie* at Versailles had been based on Oriental carpets and textile designs. Chandra Mukerji, *Territorial Ambitions and the Gardens of Versailles* (Cambridge: Cambridge University Press, 1997), 124.

115. Alice M. Ivimy, *A Woman's Guide to Paris* (New York: Brentano's, 1910), 92.

116. Gourdon, *Le Bois de Boulogne*, 206.

117. André Michaux, *Histoire des arbres forestiers de l'Amérique Septentrionale*, 3 vols. (Paris: Imprimerie de L. Haussmann and d'Hautel, 1810–13); Elie-Abel Carrière, "Une visite aux Pépinières du Bois de Boulogne, près Paris," *Revue Horticole* 1 (January–December 1852): 412; Roger Williams, "French Connections: Cultivating American Trees in Revolutionary France," *Forest History Today*, Spring 2008, 20–27; Henry Savage Jr. and Elizabeth J. Savage, *André and François André Michaux* (Charlottesville: University Press of Virginia, 1986).

118. Clavé, "Les Plantations de Paris," 792.

119. Alphand, *Les promenades de Paris*, liv. According to Darcel, a *jardin paysager* should not look like a botanical garden. Jean Darcel, "De l'architecture des jardins," *Annales des Ponts et Chaussées* 10, no. 33 (July–December 1875): 257.

120. Marcel Proust, *Du côté de chez Swann* (Paris: Gallimard, 1987), 409–10.

121. Alphand, *Les promenades de Paris*, 6.

122. Richard S. Hopkins, *Planning the Greenspaces of Nineteenth-Century Paris* (Baton Rouge: Louisiana State University Press, 2015), 26–27.

123. Alphand, *Les promenades de Paris*, 111. François Lacour, "La Glacière du Bois de Boulogne," *Le Monde illustré*, no. 46 (February 27, 1858): 135, 138.

124. "Supply of Ice in Paris," *Journal of Horticulture, Cottage Gardener and Home Farmer*, January 21, 1862, 336.

125. For this issue, see Michael A. Osborne, *Nature, the Exotic, and the Science of French Colonialism* (Bloomington: Indiana University Press, 1994).

126. Louis Énault, "Les Jardins," in *Paris et les parisiens au XIXe siècle: Moeurs, arts et monuments* (Paris: Morizot, 1856), 289.

127. "Une promenade au jardin zoologique d'acclimatation," *Le Magasin pittoresque*, April 1861, 123–25.

128. Grimard, *Le Jardin d'Acclimatation*, 380.

129. Osborne, *Nature, the Exotic, and the Science of French Colonialism*, 85.

130. Quoted in Michael A. Osborne, "Acclimatizing the World: A History of the Paradigmatic Colonial Science," *Osiris*, 2nd ser., 15 (2000): 136.

131. Augé de Lassus, *Le Bois de Boulogne*, 188; Élie Frébault, "Les Courses d'autruche au Jardin d'Acclimatation," *L'Illustration*, August 3, 1872, 74–75.

132. Alphand, *Les promenades de Paris*, 146.

133. Lobet, *Le Nouveau Bois de Boulogne*, 37.

134. Gautier, "Le Bois de Boulogne," 61.

135. Adolphe Joanne, *Paris illustré: Nouveau Guide de l'étranger et du parisien* (Paris: L. Hachette, 1867), 220.

136. Amédée Achard, "Le Bois de Boulogne, les Champs-Élysées, le Bois de le Château de Vincennes," in *Paris Guide*, 2:1242.

137. Gourdon, *Le Bois de Boulogne*, 182, emphasis in original.

138. Gourdon, *Le Bois de Boulogne*, 183.

139. Lobet, *Le Nouveau Bois de Boulogne*, 26.

140. Alphand, *Les promenades de Paris*, 6.

141. "Le Nouveau Bois de Boulogne," *Le Magasin pittoresque*, 1859, 182.

142. Barberie, "Conventional Pictures," 254.

143. Olmsted, *Walks and Talks of an American Farmer*, 79.

144. Alphand, *Les promenades de Paris*, lvii–lix. For complaints against excessive surveillance, see Clavé, "Les Plantations de Paris," 793.

145. Nadar, *Quand j'étais photographe* (Paris: Seuil, 1994), 335.

146. Choay, "Haussmann et le système des espaces verts parisiens," 96.

147. Haussmann, *Mémoires*, 3:210.

148. Alfred des Cilleuls, *Histoire de l'administration parisienne au XIXe siècle*, vol. 2, *Période 1830–1870* (Paris: Honoré Champion, 1900), 343–44.

149. Ferdinand de Lasteyrie, *Les Travaux de Paris: Examen critique* (Paris: Michel Lévy Frères, 1861), 146; Calonne, "Les transformations de Paris," 747.

150. Alphand, *Les promenades de Paris*, 155. By decree, the city could never receive compensation to any damage done to trees, harvests, bushes, etc. (158).

151. Jean-Michel Derex, *Histoire du Bois de Vincennes* (Paris: L'Harmattan, 1997), 216–17. See also Pierre Champion, *Le Bois de Vincennes, promenade parisienne* (Paris: Imprimerie municipale, 1931).

152. Achard, "Le Bois de Boulogne," 1251.

153. P. de Brescy, "Travaux du bois de Vincennes," *L'Illustration* 31, no. 791 (April 24, 1858): 261.

154. Jean-Marie Morel, *Théorie des jardins* (Paris: Pissot, 1776), 116.

155. Gautier, "Le Bois de Boulogne," 59.

156. Théophile Gautier, "Le Bois de Vincennes" (1865), now in *Paris et les parisiens*, 66.

157. Alphand, *Les promenades de Paris*, 165.

158. Alphand, *Les promenades de Paris*, 165.

159. César Daly, "Promenades et plantations: Parcs; Jardins publics; Squares et boulevards de Paris," *RGA* 21 (1863): col. 130 and 132.

160. Achard, "Le Bois de Boulogne," 1257.

161. Alfred Delvau, *Les Plaisirs de Paris: Guide pratique et illustré* (Paris: Achille Faure, 1867), 35–36.

162. Haussmann, *Mémoires*, 3:224.

163. Lasteyrie, *Les Travaux de Paris*, 147.

164. Edmond and Jules Goncourt, *Germinie Lacerteux*, ed. Nadine Satiat (Paris: Flammarion, 1990), 203.

165. For the Parc Monceau in the days of Carmontelle, see Émile Gigault de La Bédollière, *Le Nouveau Paris: Histoire de ses vingt arrondissements* (Paris: Gustave Barba, 1860), 262–65.

166. Haussmann, *Mémoires*, 1:27.

167. Paul Léon, *Histoire de la rue* (Paris: La Taille Douce, 1947), 165.

168. David H. Pinkney, *Napoleon III and the Rebuilding of Paris* (Princeton, NJ: Princeton University Press, 1972), 101.

169. Louis Lazare, *Les Quartiers de l'est de Paris et les communes suburbaines* (Paris: Bureau de la Bibliothèque Municipale, 1870), 184.

170. Alan Tate, "Birkenhead Park, Merseyside," 78.

171. Edouard André, "Les Jardins de Paris," in *Paris Guide*, 2:1210.

172. Joris-Karl Huysmans, *L'art moderne* (Paris: Charpentier, 1883), 101.

173. The etymology probably derived from Chauve-Mont (*Calvus Mons*): bald mountain. Alphand, *Les promenades de Paris*, 198.

174. Alphand, *Les promenades de Paris*, 203. See also André, "Les Jardins de Paris," 1213: "The city of Paris knew that material improvements have great influence on habits, and that by cleaning up these areas it would either transform the population or compel it to leave."

175. André, "Les Jardins de Paris," 1213.

176. Robinson, *Parks, Promenades and Gardens of Paris*, 59.

177. For a sociopolitical analysis of the park's concept of nature, see Ulf Strohmeyer, "Urban Design and Civic Spaces: Nature at the Parc des Buttes-Chaumont in Paris," *Cultural Geographies* 13, no. 4 (October 2006): 557–76.

178. Anette Freytag, "When the Railway Conquered the Garden: Velocity in Parisian and Viennese Parks," *Landscape Design and the Experience of Motion*, ed. Michel Conan (Washington, DC: Dumbarton Oaks Research Library and Collection, 2003), 237.

179. Critics have always compared the peak of the Buttes Chaumont to the needle of Étretat, on the Normandy coast, painted by Courbet in 1869 and by Monet in 1882 and 1883, but it looks more like the rock at Bayard.

180. Watelet, *Essai sur les jardins*, 56. For Watelet, see Disponzio, "Introduction," in Claude-Henri Watelet, *Essay on Gardens: A Chapter in the French Picturesque*, ed. and trans. Samuel Danon, with an intro. by Joseph Disponzio (Philadelphia: University of Pennsylvania Press, 2003), 1–15.

181. Alphand, *Les promenades de Paris*, liii. The connection of theater to Second Empire greenery is treated throughout Shapiro's "Promenades of Paris."

182. Alphand, *Les promenades de Paris*, lviii.

183. Michel Racine, *Jardins "au naturel": Rocailles, grotesques et art rustique* (Arles: Acte Sud, 2001), 82–84; Ann Komara, "Concrete and the Engineered Picturesque: The Parc des Buttes Chaumont (Paris, 1867)," *Journal of Architectural Education* 58, no. 1 (September 2004): 5–11.

184. André, *L'art des jardins*, 447.

185. André, *L'art des jardins*, 512 and 486–521 ("Les Rochers"); Racine, *Jardins "au naturel,"* 88.

186. Pierre Wittmer, "Au jardin d'art," *Le XIXᵉ Arrondissement—une cité nouvelle*, ed. Jean-Marie Jenn (Paris: Délégation à l'action artistique de la ville de Paris / Archives de Paris, 1996), 68; Komara, "Concrete and the Engineered Picturesque," 7.

187. William Robinson, *Parks, Promenades and Gardens of Paris*, 63.

188. Darcel, "De l'architecture des jardins," 273. For Morel's training in engineering, see Joseph Disponzio, "The Garden Theory and Landscape Practice of Jean-Marie Morel" (PhD diss., Columbia University, 2000); Disponzio, "From Garden to Landscape," 8.

189. André, *L'art des jardins*, 503.

190. Alphand, *Les promenades de Paris*, 200.

191. Paul de Lavenne, Comte de Choulot, *L'art des jardins, ou Études théoriques sur l'arrangement extérieur des habitations: Suivi d'un essai sur l'architecture rurale, des Cottages et la restauration pittoresque des anciennes constructions* (Nevers: I.-M. Fay, 1846), 6.

192. Alfred-Auguste Ernouf, *L'art des jardins: Parcs—jardins—promenades—étude historique— principes de la composition des jardins—plantations— décoration pittoresque et artistique des parcs et jardins publics; Traité pratique et didactique* (Paris: Rothschild, 1886), 131.

193. Antoine Grumbach, "The Promenades of Paris," *Oppositions* 8 (Spring 1977): 65.

194. *The Papers of Frederick Law Olmsted*, vol. 3, *Creating Central Park, 1857–1861*, ed. Charles E. Beveridge and David Schuyler (Baltimore: Johns Hopkins University Press, 1983), 234–35.

195. Dominique Jarassé, "Les Buttes Chaumont," in *Cent jardins à Paris et en Ile-de-France*, ed. Béatrice de Andia, Gabrielle Joudiou, and Pierre Wittmer, preface by Jean-Pierre Babelon, text by Ernest de Ganay (Paris: Délégation artistique de la Ville de Paris, 1991), 79.

196. Y. Lefresne, "La Reconstruction de la passerelle suspendue des Buttes-Chaumont," *Travaux*, no. 482 (May 1975): 59–61.

197. John Merivale, "Charles-Adolphe Alphand and the Parks of Paris," *Landscape Design* 123 (August 1978): 36.

198. Ernouf, *L'art des jardins*, 171.

199. C.-P. Doullay, "Le Parc des Buttes-Chaumont," *L'Illustration* 49, no. 1264 (May 18, 1867): 314.

200. L.D., *Parc des Buttes Saint-Chaumont* 25, emphasis in original.

201. Germaine Boué, *The Squares and Gardens of Paris: The Buttes-Chaumont* (Paris: At All the Booksellers, 1878), 15.

202. Hamon, "Les Buttes-Chaumont," 102; Darcel mentioned several cases of subsidence underneath the lake and the lawns: Antoine Picon, "Nature et

ingénierie: Le parc des Buttes-Chaumont," *Romantisme* 4, no. 150 (2010): 42.

203. Charles Wanderer, "Promenades horticoles dans les jardins publics de Paris: Le parc des Buttes-Chaumont," *Revue Horticole* 54 (1882): 402.

204. Leclerc, "Promenade au Parc des Buttes-Chaumont," *Revue Horticole* 40 (1868): 358.

205. Robinson, *Parks, Promenades and Gardens of Paris*, 62.

206. Haussmann, *Mémoires*, 3:237.

207. Pierre Casselle, "La Création du parc Montsouris," *Montparnasse et le XIVᵉ arrondissement*, ed. G.-A. Langlois (Paris: Action Artistique de la Ville de Paris, 2000), 154.

208. Gabrielle Heywang, "Le Parc Montsouris, un parc haussmannien," *Histoire de l'Art*, no. 73 (December 2013): 2.

209. Acquiring exotic pavilions from World's Fairs was common practice; in London, Pennethorne had bought a Chinese pagoda for Victoria Park. Chadwick, *Park and the Town*, 125; Fein, "Victoria Park: Its Origins and History," 84.

210. The Bardo was bought for 150,000 francs from Jules de Lesseps, representative of the bey. Alphand, *Les promenades de Paris*, 205; Casselle, "La Création du parc Montsouris," 155. It was destroyed by fire in 1991.

211. Haussmann, *Mémoires*, 3:241–52. The exact number of squares varies. Alphand lists twenty squares. Alphand, *Les promenades de Paris*, 211–38.

212. Haussmann, *Mémoires*, 3:240; Werner Szambien, "Du square anglais au square français," in *Hameaux, villas et cités de Paris* (Paris: Action Artistique de la Ville de Paris, 1998), 44–53; Werner Szambien, "Des squares aux passages et vice-versa," in *Les Parcs et jardins dans l'urbanisme parisien, XIXᵉ–XXᵉ siècles*, 63.

213. Jules Claretie, "Les Places publiques, les Quais et les Squares de Paris," in *Paris Guide*, 2:1409; Gilles-Antoine Langlois, "L'éclipse des jardins-spectacles," in *Les Parcs et jardins dans l'urbanisme parisien, XIXᵉ–XXᵉ siècles*, 55.

214. Alphand, *Les promenades de Paris*, 225; Géraldine Texier-Rideau, "Le square haussmannien," in *Les Parcs et jardins dans l'urbanisme parisien, XIXᵉ–XXᵉ siècles*, 68. Square d'Orléans, originally known as Cité des Trois-Frères, didn't acquire its garden until 1856, after it was bought by an Englishman.

215. Meynadier, *Paris sous le point de vue pittoresque et monumental*, 139.

216. Comte Henri Siméon, Travaux pour la Commission des embellissements de Paris, vol. 1, MS 1779, 143, BHdV.

217. The emperor wanted Haussmann to disseminate squares throughout Paris. Haussmann, *Mémoires*, 3:240.

218. Robinson, *Parks, Promenades and Gardens of Paris*, 83; Patrick Abercrombie, "Paris: Some Influences That Have Shaped Its Growth," part 3, *Town Planning Review* 2, no. 4 (January 1912): 320.

219. Brian Chapman, "Baron Haussmann and the Planning of Paris," *Town Planning Review* 24, no. 3 (October 1953): 181.

220. Robinson, *Parks, Promenades and Gardens of Paris*, 85. The idea of designing this square was first mooted in 1836, when the tower was purchased by the city. "La tour Saint-Jacques-la-Boucherie," *Le Moniteur universel*, no. 222 (August 9, 1836): 1720 (unsigned).

221. Robinson, *Parks, Promenades and Gardens of Paris*, 92.

222. Schenker, "Parks and Politics during the Second Empire in Paris," 216.

223. Lasteyrie, *Les Travaux de Paris*, 150.

224. André, "Les Jardins de Paris," 1206.

225. Alphand, *Les promenades de Paris*, 219 and 227.

226. Albert Dresden Vandam, *An Englishman in Paris: Notes and Recollections* (New York, D. Appleton, 1893), 346.

227. Robinson dismissed corbeilles disdainfully: "We know very well that in nature nothing of the kind ever occurs; that away from the wood strays the clump of low shrubs which do not seem to be gregarious like their pillared fellows of the forest." Robinson, *Parks, Promenades and Gardens of Paris*, 61.

228. Victor Fournel, "Établissements de plaisir," in *Paris dans sa splendeur* (Paris: Henri Charpentier, 1862), 2:30.

229. "This square [Tour Saint-Jacques] is full of *respectability*." Claretie, "Les Places publiques, les Quais et les Squares de Paris," 1410, emphasis and English in original.

230. Claretie, "Les Places publiques, les Quais et les Squares de Paris," 1410.

231. Daly, "Promenades et plantations," col. 129. Daly adds in a footnote that the municipality seems to have changed its mind, since the Arts et Métiers square was open until late at night (col. 129).

232. Hopkins, *Planning the Greenspaces of Nineteenth-Century Paris*, 54–59.

233. Robinson, *Parks, Promenades and Gardens of Paris*, 88.

234. Claretie, "Les Places publiques, les Quais et les Squares de Paris," 1410; see also David Harvey, *Consciousness and the Urban Experience: Studies in the History and Theory of Capitalist Urbanization* (Baltimore: Johns Hopkins University Press, 1985), 205.

235. Limido, *L'art des jardins sous le Second Empire*, 46.

236. Calonne, "Les transformations de Paris," 740.

237. Quoted in H. Parizot and A.-V. Boileau, *Guide-album historique et descriptif du Bois de Vincennes et du chemin de fer de Paris à Vincennes et à La Varenne-Saint-Maur* (Paris: H. Parizot, 1860), 141–42. "The

French," Voltaire once grumbled, "make a parody of English gardens by cramming 30 acres into three." Quoted in Patricia Taylor, *Thomas Blaikie (1751–1838): The "Capability" Brown of France* (East Lothian: Tuckwell, 2001), 73.

238. Alphand, *Les promenades de Paris*, vi.

239. Daly, "Promenades et plantations," part 3, col. 246. Napoleon III may have gotten the idea from John Claudius Loudon, "Hints for Breathing Places for the Metropolis, and for Country Towns and Villages, on Fixed Principles," *Gardener's Magazine* 5 (London, 1829): 686–90.

240. Georges-Eugène Haussmann, *Mémoires du Baron Haussmann*, vol. 2, *Préfecture de la Seine* (Paris: Victor-Havard, 1890), 232–34.

241. Jeanne Hugueney, "Napoléon III et Haussmann, dessinateurs de Jardins," *Monuments historiques*, no. 1 (1974): 25; Thomas von Joest, "Hittorff et les embellissements des Champs-Élysées," in *Hittorff: Un architecte du XIX^e* (Paris: Musée Carnavalet, 1986), 153–56.

242. A long-standing tradition linked the geometries of French formal gardens to security. "Straight allées are not only allowable here [in public gardens] but they have the advantage of simplifying the task of the authorities, whose supervision is often indispensable in such areas." Christian Cajus Lorenz Hirschfeld, *Theory of Garden Art*, ed. and trans. Linda B. Parshall (Philadelphia: University of Pennsylvania Press, 2001), 407. The old quincunx plan, Haussmann acknowledged, channeled crowds more easily than the jardin à l'anglaise. Haussmann, *Mémoires*, 3:495. Vergnaud, however, claims this was a misconception. Vergnaud, *L'art de créer les jardins*, 83.

243. Daly, "Promenades et plantations," col. 129; "a veritable factory," wrote Charles Friès: "Faits divers," *Le Moniteur universel*, no. 331 (November 27, 1863): 1431. For municipal nurseries, see Limido, *L'art des jardins sous le Second Empire*, 91–102.

244. André, "Les Jardins de Paris," 1215.

245. Alphand, *Les promenades de Paris*, 128.

246. Alphand, *Les promenades de Paris*, 127–28.

247. For plant varieties of the Fleuriste, see Alphand, *Les promenades de Paris*, 130–48.

248. Robinson, *Parks, Promenades and Gardens of Paris*, 151; Friès, "Faits divers," 1431.

249. Robinson, *Parks, Promenades and Gardens of Paris*, 154–55.

250. Friès, "Faits divers," 1431.

251. Interestingly, Blaikie's streams at Bagatelle also had concrete beds. Taylor, *Thomas Blaikie*, 104.

252. For this paragraph, see Henry W. Lawrence, "Origins of the Tree-Lined Boulevard," *Geographical Review* 78, no. 4 (October 1988): 355–74; and Henry W. Lawrence, *City Trees: A Historical Geography from the Renaissance through the Nineteenth Century* (Charlottesville: University of Virginia Press, 2006).

253. Laugier, *Essay on Architecture*, 128.

254. Lawrence, "Origins of the Tree-Lined Boulevard," 373.

255. Jean Gadant, "Les arbres du souvenir et de la liberté," *Revue Forestière Française* 41, no. 5 (1989): 439–44; André Corvol, "The Transformation of a Political Symbol: Tree Festivals in France from the Eighteenth to the Twentieth Centuries," *French History* 4, no. 4 (1990): 455–86.

256. Lawrence, "Neoclassical Origins of Modern Urban Forests," 32.

257. "Between 1790 and 1820, French forests were reduced from 9 million to 3 million hectares." R. Williams, "French Connections," 24.

258. Walter Benjamin, *The Arcades Project*, ed. Rolf Tiedemann, trans. Howard Eiland and Kevin McLaughlin (Cambridge, MA: Belknap Press of Harvard University Press, 1999): 797.

259. Picon underscored the pacifying function of urban plantations. Antoine Picon, "Le naturel et l'efficace: Art des jardins et culture technologique," in *Le Jardin, art et lieu de mémoire*, ed. Monique Mosser and Philippe Nys (Besançon: Les Éditions de l'Imprimeur, 1995), 391.

260. Alphand sets the number of trees at 102,154: Alphand, *Les promenades de Paris*, 246. Guy Surand gives the smaller figure of eighty-two thousand trees: Guy Surand, "Haussmann, Alphand: Des promenades pour Paris," in *Paris Haussmann* (Paris: Picard, 1992), 242. Haussmann says he planted 45,111 trees along streets. Georges-Eugène Haussmann, *Mémoires du Baron Haussmann*, vol. 2, *Préfecture de la Seine* (Paris: Victor-Havard, 1890), 513.

261. Haussmann, *Mémoires*, 3:255.

262. Michel Lévy denied any beneficial effect in his *Traité d'hygiène publique et privée* (Paris: J.-B. Baillière, [1844] 1879), 2:423; Chevreul, "Mémoire sur plusieurs réactions chimiques qui intéressent l'hygiène des cités populeuses," 32–36; Alexandre Jouanet, *Mémoire sur les plantations de Paris* (Paris: Imprimerie horticole de J.-B. Gros, 1855).

263. Chevreul, "Mémoire sur plusieurs réactions chimiques," 19–20. See also Alphand, *Les promenades de Paris*, 244.

264. J. A. Barral, "Chronique horticole," *Revue Horticole*, 4th ser., no. 15 (1859): 395–96.

265. Clavé, "Les Plantations de Paris," 786; Alphand, *Les promenades de Paris*, 244. Robinson, *Parks, Promenades and Gardens of Paris*, 127.

266. Clavé, "Les Plantations de Paris," 787.

267. Victor Fournel, "Les monuments du nouveau Paris," *Le Correspondant* 61 (April 1864): 878.

268. For "arbres voyageurs," see L.D., *Parc des Buttes Saint-Chaumont*, 15.

269. Victor Fournel, *Paris nouveau et Paris futur* (Paris: Jacques Lecoffre, 1865), 107.

270. Augé de Lassus, *Le Bois de Boulogne*, 164–65.

271. Animals languished in the Jardin des Plantes: "The tigers are dying of ennui, lions long for the desert, panthers call out in vain for a hotter climate; they suffer, wither, and die." Énault, "Les Jardins," 292.

272. Clavé, "Les Plantations de Paris," 788.

273. Robinson, *Parks, Promenades and Gardens of Paris*, 38.

274. Lasteyrie, *Les Travaux de Paris*, 162. When the imperial family was away, the private garden was open to the public.

275. Lasteyrie, *Les Travaux de Paris*, 163–65.

276. Théodore de Banville, *Mes Souvenirs* (Paris: G. Charpentier, 1882), 99.

277. Charles Yriarte, "Prolongation de la rue Soufflot," *Le Monde illustré*, no. 276 (July 26, 1862): 62; Haussmann, *Mémoires*, 3:83.

278. Arthur Hustin, *Le Luxembourg: Son histoire domaniale, architectural, décorative et anecdotique* (Paris: Imprimerie du Sénat, 1911), 2:144.

279. *Journal de Eugène Delacroix* (Paris: Plon, 1893), 3:418–19.

280. For Napoleon III's decree, ordering the destruction of part of the garden, see Napoléon, "Partie Officielle," *Le Moniteur universel*, no. 332 (November 28, 1865): 1457.

281. According to politician Alcide Dusolier, Achille Fould, minister of finances, "was behind the measure far more than the minister of public works or the prefect of the Seine." Dusolier, *Les Spécula-teurs et la Mutilation du Luxembourg* (Paris: Librairie du Luxembourg, 1866), 11.

282. Adolphe Joanne, *Sauvons le Luxembourg* (Paris: Sausset, 1866), 3.

283. Dusolier, *Les Spéculateurs et la Mutilation du Luxembourg*, 11.

284. Napoléon, "Partie Non Officielle," in *Le Moniteur universel*, no. 52 (February 21, 1866): 189.

285. Alphand glosses over the episode, asserting that the people of Paris demanded the preservation of the artery that led from the Luxembourg to the Observatoire. Alphand, *Les promenades de Paris*, 233–34.

286. On the reproducibility of Second Empire landscape, see Limido, *L'art des jardins sous le Second Empire*, 215.

287. For a traditional, though erudite, view of gardens as a reproduction of nature, see "De la reproduction de la nature par les jardins," in André, *L'art des jardins*, 110–19.

288. Alfred Lord Tennyson, *In Memoriam A.H.H.* (London: Bankside, 1900), 60.

289. Quoted in D'Aunay, "À la découverte," 1.

290. Robinson, *Gleanings from French Gardens*, 3.

291. Zola, "Livres d'aujourd'hui et de demain," 2 (unnumbered).

292. Lasteyrie, *Les Travaux de Paris*, 143.

293. Calonne, "Les transformations de Paris," 746–47.

294. Alphand, *Les promenades de Paris*, lvi and xviii.

295. On parks and marketing, see Limido, *L'art des jardins sous le Second Empire*, 50–61; Ann Komara, "'Art and Industry' at the Parc des Buttes Chaumont" (MA thesis, University of Virginia, 2002).

296. Alphand, *Les promenades de Paris*, i.

297. Ann Komara, "Measure and Map: Alphand's Contours of Construction at the Parc des Buttes Chaumont, Paris 1867," *Landscape Journal* 28, no. 1 (2009): 30–39; Shapiro, "Promenades of Paris," 128.

298. Grumbach, "Promenades of Paris," 51; Shapiro, "Promenades of Paris," 41.

299. André, *L'art des jardins*, 118.

300. Max Nordau, *Parisian Sketches: Part 1* (Chicago: L. Schick), 42.

301. Gourdon, *Le Bois de Boulogne*, 208.

302. Robinson, *Gleanings from French Gardens*, 81. The man was probably a bird charmer, a common type in Parisian parks.

303. For a suggestive reading of social relations in regard to parks, see Henri Lefebvre, *The Production of Space*, trans. Donald Nicholson-Smith (Oxford: Blackwell, 1991), 83.

304. Michel Vernes, "Les jardins contre la ville," *Temps libre*, no. 9 (Printemps 1984): 50.

305. Ann-Louise Shapiro, *Housing the Poor of Paris, 1850–1902* (Madison: University of Wisconsin Press, 1985), xvi.

306. Michel-Eugène Chevreul, *De la loi du contraste simultané des couleurs* (Paris: Pitois-Levrault, 1839).

307. Darcel, "De l'architecture des jardins," 263–64.

308. André, *L'art des jardins*, 113.

309. André, *L'art des jardins*, 111.

310. Ernouf, *L'art des jardins*, 161.

311. In the late 1860s, American advocates of Coignet's techniques opened the Coignet Agglomerate Company of the United States in Brooklyn. It was responsible for important projects including the Cleft Ridge Span in Prospect Park and early structures in the Metropolitan Museum of Art and in the American Museum of Natural History. Laura K. Raskin, "Birth of the Concrete Jungle," *Brooklyn Rail*, March 7, 2007, 3–4.

312. For this issue, see Laurent Baridon, "Béton et utopie avant 1914: Architecture et 'moule sociale,'" *RACAR, Revue d'Art Canadienne / Canadian Art Review* 31, nos. 1–2 (2006): 7–11; Jonathan Beecher, *Victor Considerant and the Rise and Fall of French Romantic Socialism* (Berkeley: University of California Press, 2001), 360–61.

313. François Coignet, *Socialisme appliqué au crédit, au commerce, à la production, à la consommation* (Paris: À la Librairie Phalansthérienne, 1849), 7, emphasis in original.

314. Denis Cosgrove, "Prospect, Perspective and the Evolution of the Landscape Idea," *Transactions of the Institute of British Geographers* 10, no. 1 (1985): 58. Cosgrove was talking about geography and the arts, but the gist of his argument concerns landscape.

315. James C. Scott, *Seeing Like a State* (New Haven, CT: Yale University Press, 1998), 20.

316. Robinson, *Parks, Promenades and Gardens of Paris*, xxii.

317. Robinson, *Parks, Promenades and Gardens of Paris*, 21.

318. André Hallays, "Haussmann et les travaux de Paris sous le Second Empire," *La Revue hebdomadaire*, no. 5 (February 5, 1910): 39; Lucien Dubech and Pierre d'Espezel, *Histoire de Paris* (Paris: Les Éditions Pittoresques, 1931), 2:148–49; Louis Réau, *Histoire du vandalisme*, ed. Michel Fleury and Guy-Michel Leproux (Paris: Robert Laffont, 1994), 738. See also Jeanne Hugueney, "Haussmann et les Jardins publics," *La Vie Urbaine: Urbanisme et Habitation*, nos. 3 and 4 (July–December 1953): 282.

319. Georges Poisson, "Alphand," in *Dictionnaire du Second Empire*, ed. Jean Tulard (Paris: Fayard, 1995), 55.

320. Comte Henri Siméon, Commission des embellissements de Paris, vol. 2, MS 1780, 269, BHdV.

321. Quoted in Jean Renoir, *My Father* (1962), trans. Randolph and Dorothy Weaver, intro. by Robert L. Herbert (New York Book Review Classics, 2001), 56.

322. Joris-Karl Huysmans, *La Bièvre et Saint-Séverin* (Paris: P.-V. Stock, 1898), 51–52.

323. Choay, "Haussmann et le système des espaces verts parisiens," 88.

324. Robert Moses, "What Happened to Haussmann?," *Architectural Forum* 77 (July 1942): 60.

325. Derex, *Histoire du Bois de Boulogne*, 183.

326. Caroline Ford, "Nature, Culture and Conservation in France and Her Colonies 1840–1940," *Past and Present*, no. 183 (May 2004): 174.

327. Hugo, quoted in Georges Valance, *Haussmann le Grand* (Paris: Flammarion, 2000), 270.

CHAPTER SEVEN: THE PERIPHERY

1. Louis Chevalier, *Classes laborieuses et Classes dangereuses* (Paris: Hachette, 1984), 493; Eugene Weber, *Peasants into Frenchmen: The Modernization of Rural France, 1870–1914* (Stanford, CA: Stanford University Press, 1986).

2. Louis Lazare, *Les Quartiers pauvres de Paris: Le 20e Arrondissement* (Paris: Bureau de la Bibliothèque Municipale, 1870), 95.

3. The faubourg Saint-Antoine alone had thirty-five thousand Germans and thirty-five thousand Belgians. Georges Duveau, *La Vie ouvrière en France sous le Second Empire* (Paris: Gallimard, 1946), 208. Slightly lower numbers appear in Fabrice Laroulandie, *Les Ouvriers de Paris au XIXe siècle* (Paris: Éditions Christian, 1997), 33.

4. Jeanne Gaillard, *Paris, la ville (1852–1870)*, ed. Florence Bourillon and Jean-Luc Pinol (Paris: L'Harmattan, 1997), 8.

5. Alain Plessis, *De la fête impériale au mur des fédérés* (Paris: Éditions du Seuil, 1979), 152.

6. See Alain Cottereau, "Étude préalable," in Denis Poulot, *Le Sublime, ou le travailleur comme il est en 1870 et ce qu'il peut être* (Paris: Maspéro, 1980), 7–102.

7. "Once the father has left, the mother takes care of the household, rules the family, plows, sows, harvests as best she can." Louis Bandy de Nalèche, *Les Maçons de la Creuse* (Paris: Dentu, 1859), 21. See also Casey Harison, *The Stonemasons of Creuse in Nineteenth-Century Paris* (Newark: University of Delaware Press, 2008); Alain Corbin, "Les paysans de Paris," *Ethnologie Française* 10, no. 2 (1980): 169–76.

8. "Workmen Waiting to Be Engaged in the Place de l'Hotel de Ville, Paris," *Illustrated London News* 54, no. 1536 (May 1, 1869): 432. The street's name was changed in 1835: during the cholera epidemic (1832), Rue de la Mortellerie (from mortar) was associated to death (*mort*) because of its high mortality rate.

9. Martin Nadaud, *Mémoires de Léonard, ancien garçon maçon* (Bourganeuf: A. Duboueix, 1895), 47. Paul Mazerolle wrote that the Limousin workers *"remain among themselves*, and the houses in which they live only accept masons. In general, treating each other less well than one currently treats soldiers, the masons sleep two in a bed; this inconvenience aside, they live *as if in barracks.*" Pierre Mazerolle, *La Misère de Paris: Les Mauvais gîtes* (Paris: Sartorius, 1875), 28, emphasis in original.

10. Mazerolle, *La Misère de Paris*, 32.

11. Lazare, *Les Quartiers pauvres de Paris*, 22.

12. Perreymond, "Troisième étude sur la Ville de Paris," *RGA* 4 (1843): col. 28.

13. See Francis Donald Klingender, "Daumier and the Reconstruction of Paris," *Architectural review* 90, no. 537 (August 1941): 55–60.

14. Georges-Eugène Haussmann, *Mémoires du Baron Haussmann*, vol. 2, *Préfecture de la Seine* (Paris: Victor-Havard, 1890), 457.

15. Anthony Sutcliffe, *The Autumn of Central Paris: The Defeat of Town Planning, 1850–1970* (Montreal: McGill-Queen's University Press, 1971), 29–30.

16. Gérard-Noël Lameyre, *Haussmann "Préfet de Paris"* (Paris: Flammarion, 1958), 44.

17. Antoine Granveau, *L'Ouvrier devant la société* (Paris: Hélaine, 1868), 62.

18. David H. Pinkney, *Napoleon III and the Rebuilding of Paris* (Princeton, NJ: Princeton University Press, 1972), 166.

19. Jules Simon, *L'Ouvrière* (Paris: Librairie de L. Hachette, 1861), 212.

20. Othenin d'Haussonville, "La Misère à Paris: I. La population indigente et les quartiers pauvres," *Revue des Deux Mondes* 45, no. 4 (June 1881): 829.

21. Michelle Perrot, "Les Ouvriers, l'habitat et la ville au XIXᵉ siècle," in *La Question du logement et le mouvement ouvrier français*, ed. Jean-Paul Flamand (Paris: Éditions de La Villette, 1981), 35.

22. Between 1873 and 1883, the number of garnis in the center increased by 20 percent, and their population by 80 percent. Laroulandie, *Les Ouvriers de Paris*, 131.

23. Emile Zola, "Causerie," *La Tribune*, October 18, 1868, 6.

24. Eugène Belgrand, *Les Travaux souterrains de Paris* (Paris: Veuve Charles Dunod, 1872–87), 5:288; Ferdinand de Lasteyrie, *Les Travaux de Paris: Examen critique* (Paris: Michel Lévy Frères, 1861), 60.

25. Victor Hugo, *Les Misérables* (1862), ed. Yves Gohin (Paris: Gallimard, 1995), 2:267.

26. Perrot, "Les Ouvriers, l'habitat et la ville," 19.

27. Yves Lequin, "Ouvriers dans la ville (XIXᵉ et XXᵉ siècle)," *Movement social*, no. 118 (January–March 1982): 5.

28. Michèle Perrot, "De la nourrice à l'employée: Travaux de femmes dans la France du XIXᵉ siècle," *Le Mouvement social*, no. 105 (October–December 1978): 4. See also Leslie Page Moch and Rachel G. Fuchs, "Getting Along: Poor Women's Networks in Nineteenth-Century Paris," *French Historical Studies* 18, no. 1 (Spring, 1993): 34–49.

29. Henri Lefebvre, "Le Quartier et la ville," *Cahiers de l'Institut d'aménagement et d'urbanisme de la région parisienne (IAURP)* 7 (1967): 9. See also Alain Faure, "Local Life in Working-Class Paris at the End of the Nineteenth Century," *Journal of Urban History* 32, no. 5 (July 2006): 761–72; Alain Cabantous, "Le quartier, l'espace vécu à l'époque moderne," *Histoire, économie et société* 13, no. 3 (1994): 427–39.

30. "A continuous, uniform pressure is exerted on individual life by the physical violence stored behind the scenes of everyday life, a pressure totally familiar and hardly perceived, conduct and drive economy having been adjusted from earliest youth to this social structure." Norbert Elias, *The Civilizing Process: Sociogenetic and Psychogenetic Investigations*, trans. Edmund Jephcott, ed. Eric Dunning, Johan Goudsblom, and Stephen Mennell (Oxford: Blackwell, 2000), 372.

31. "Partie Non Officielle," *Le Moniteur universel*, no. 226 (August 14, 1861): 1222.

32. *Rapports des délégations ouvrières contenant l'origine et l'histoire des diverses professions, l'appréciation des objets exposés, la comparaison des arts et des industries en France et à l'Etranger, l'exposé des voeux de la classe laborieuse, et l'ensemble des considérations sociales intéressant les ouvriers*, ed. Arnould Desvernay (Paris: A. Morel, 1869), 1:19.

33. *Rapports des délégations ouvrières*, 2:64–65.

34. Docteur Akerlis (pseudonym), *Les Démolitions de Paris* (Paris: Chez tous les Libraires, 1861), 8.

35. Granveau, *L'Ouvrier devant la société*, 57.

36. Granveau, *L'Ouvrier devant la société*, 57. Forced to move from lodging to lodging in her downward spiral, Gervaise (the main character in Zola's *The Dram Shop*) finally ends up on the sixth floor of a large building in the outskirts: the family "now *perched* there." Émile Zola, *L'Assommoir* (Paris: Flammarion, [1877] 1969), 324, emphasis mine.

37. Akerlis, *Les Démolitions de Paris*, 7–8.

38. Haussmann, *Mémoires*, 2:458.

39. Claude-Philibert Barthelot Rambuteau, *Mémoires du Comte de Rambuteau* (Paris: Calmann-Lévy, 1905), 97–98.

40. Florence Bourillon, "Rénovation 'haussmannienne' et ségrégation urbaine," *La Ville divisée: Les ségrégations urbaines en question, XVIIIᵉ–XXᵉ siècles*, ed. Annie Fourcaut (Grane: Créaphis, 1996), 91–104.

41. Duveau, *La Vie ouvrière en France sous le Second Empire*, 344.

42. Duveau, *La Vie ouvrière en France sous le Second Empire*, 204.

43. Florence Bourillon, "La Rénovation de Paris sous le Second Empire: Étude d'un quartier," *Revue Historique* 278 (July–September 1987): 154.

44. "Street Characters in Paris," *Illustrated London News* 56, no. 1585 (March 19, 1870): 306; Jacques Rougerie, "Recherche sur le Paris du XIXᵉ siècle: Espace populaire et espace révolutionnaire; Paris 1870–1871," *Bulletin de l'Institut d'Histoire économique et sociale de l'Université de Paris I. Recherches et Travaux*, no. 5 (January 1977): 76.

45. Rougerie, "Recherche sur le Paris du XIXᵉ siècle," 59.

46. Honoré de Balzac, "Histoire et physiologie des boulevards de Paris," in *Le Diable à Paris: Paris et les parisiens* (Paris: Hetzel, 1845), 2:99.

47. Frederick Engels, "The June Revolution," in *The Revolution of 1848–49: Articles from the Neue Rheinische Zeitung* (New York: International, 1972), 52.

48. The population rose 14.4 percent between 1831 and 1836, 12.68 percent between 1841 and 1846, and 11.5 percent between 1851 and 1856. Louis Chevalier, *La formation de la population parisienne au XIXᵉ siècle* (Paris: Presses Universitaires de France, 1950), 41.

49. Haussmann, *Mémoires*, 2:454–55. His final tally from 1853 to 1869: 27,478 houses demolished, and 102,487 new ones built (2:457). Daly also claimed that that the government built more houses than it destroyed, and that the former were situated in the less affluent arrondissements. César Daly, "Étude générale sur les grands travaux de Paris," *RGA* 20 (1862): col. 184; "Mémoires présentés par M. le

Sénateur Préfet de la Seine au Conseil Général et au Conseil Municipal de la Ville de Paris," part 1, *RGA* 24 (1866): 229.

50. Duveau, *La Vie ouvrière en France sous le Second Empire*, 379.

51. Sutcliffe, *Autumn of Central Paris*, 138. When rents rose, shawl makers had to move from the faubourg Saint-Martin and relocate their workshops: Frédéric Le Play, *Les Ouvriers des Deux Mondes* (Paris: Au Siège de la Société Internationale, 1857), 1:300–301.

52. Perrot, "Les Ouvriers, l'habitat et la ville," 21.

53. Gérard Jacquemet, "Belleville au XIXᵉ et XXᵉ siècles: Une méthode d'analyse de la croissance urbaine à Paris," *Annales: Économies, sociétés, civilisations*, 30, no. 4 (July–August 1975): 824.

54. Denis Poulot, *Le Sublime ou le travailleur comme il est en 1870 et ce qu'il peut être* (Paris: A. Lacroix, Verboeckhoven, 1870), 39–40.

55. Alexandre Weill, *Paris inhabitable: Ce que tout le monde pense des loyers de Paris et que personne ne dit* (Paris: Dentu, 1860), 10.

56. Quoted in Annie Fourcaut, Emmanuel Bellanger, and Mathieu Flonneau, *Paris/Banlieues: Conflits et solidarités; Historiographie, anthologie, chronologie, 1788–2006* (Paris: Créaphis, 2007), 76–77.

57. Fourcaut, Bellanger, and Flonneau, *Paris/Banlieues*, 77.

58. "Partie Non Officielle," *Le Moniteur universel*, no. 226 (August 14, 1861): 1222.

59. Quoted in Louis Girard, *Napoleon III* (Paris: Fayard, 1986), 269.

60. César de Paepe, "Situation économique du prolétariat en France," part II, *Rive Gauche*, 2, no. 31 (August 20, 1865): 2 (unnumbered); Duveau, *La Vie ouvrière en France sous le Second Empire*, 216.

61. Jeanne Gaillard, "Assistance et urbanisme sous le Second Empire," *Recherches*, no. 29 (December 1988): 413.

62. In 1860, Paris had one hundred thousand female workers. Duveau, *La Vie ouvrière en France sous le Second Empire*, 327.

63. Duveau, *La Vie ouvrière en France sous le Second Empire*, 323.

64. Rancière, *Staging the People*, 76.

65. Jacques Rancière, *Staging the People: The Proletarian and His Double*, trans. David Fernbach (London: Verso Books, 2011), 76–88.

66. Simon, *L'Ouvrière*, 277.

67. Lazare, *Les Quartiers pauvres de Paris*, 95.

68. Jeanne Gaillard, "Les migrants à Paris au XIXᵉ siècle: Insertion et marginalité," *Ethnologie française* 10, no. 2 (April–June 1980): 134.

69. Henri L. Meding, *Essai sur la topographie médicale de Paris, examen général des conditions de salubrité dans lesquelles cette ville est placée* (Paris: J.-B. Baillière, 1852), 96.

70. D'Haussonville, "La Misère à Paris," 840; Shapiro, *Housing the Poor of Paris*, 139–40.

71. Public Welfare leased the land to a main tenant on condition that by giving notice six weeks in advance it would be able to take possession of the grounds and destroy the buildings. *Département de la Seine: Commission des logements insalubres; Rapport général sur les travaux de la Commission pendant les années 1877 à 1883* (Paris: Imprimeries Réunies, 1884), 169. For the Fosse aux lions, see Alain Faure, "Paris au diable Vauvert, ou la Fosse aux lions," *Histoire urbaine* 2, no. 2 (December 2000): 149–69.

72. Octave Du Mesnil, *L'Hygiène à Paris: L'habitation du pauvre*, with a preface by Jules Simon (Paris: J.-B Baillière, 1890), 138. See also Shapiro, *Housing the Poor of Paris*, 136–45.

73. For ragpickers, see Alain Faure, "Classe malpropre, classe dangereuse? Quelques remarques à propos des chiffonniers parisiens au XIXᵉ siècle et de leurs cités," *Recherches*, no. 29, "L'haleine des faubourgs" (December 1977): 79–102.

74. Alfred Coffignon, *Paris vivant: Le Pavé parisien* (Paris: À la Librairie Illustrée, 1890), 41.

75. Corbin, "Les paysans de Paris," 169.

76. Mazerolle, *La Misère de Paris*, 1.

77. Coffignon, *Paris vivant*, 41–42.

78. Catherine Bruant, *La Cité Napoléon: Une expérience controversée de logements ouvriers à Paris* (Versailles: LéaV, 2011), 16.

79. Charles-Pierre Gourlier, *Études de maisons ouvrières et de bains et lavoirs publics* (Paris: E. Thunot, 1853).

80. Henry Roberts, *Des habitations des classes ouvrières, traduit et publié par ordre du président de la République* (Paris: Gide et J. Baudry, 1850). For Roberts, see James Stevens Curl, *The Life and Work of Henry Roberts, 1803–1876: The Evangelical Conscience and the Campaign for Model Housing and Healthy Nations* (Chichester, Sussex: Phillimore, 1983).

81. Micheál Browne, "L'Oeuvre d'un architecte 'scientifique,'" in Henry Roberts, *Des habitations des classes ouvrières: Leur composition et leur construction avec l'essentiel d'une habitation salubre*, rpt. of the revised 1867 ed., intro. by Micheál Browne (Paris: L'Harmattan, 1998), xxxv.

82. Lameyre, *Haussmann*, 159–60. Part of this sum, the minister of agriculture, commerce, and public works acknowledged, was diverted from working-class housing. Shapiro, *Housing the Poor of Paris*, 52.

83. For this context, see Nicholas Bullock and James Read, *The Movement of Housing Reform in Germany and France* (Cambridge: Cambridge University Press, 1895), 281–97.

84. Marcel Proust, *À l'ombre des jeunes filles en fleur*, ed. Pierre-Louis Rey (Paris: Gallimard, 1988), 254.

85. Rents varied between 60 and 180 francs, depending on size of the unit. For 180 francs,

workers got a two-room apartment with a stove in the corridor. "Histoire de la Semaine," *L'Illustration* 18, no. 456 (November 22, 1851): 321 (unsigned).

86. Bruant, *La Cité Napoléon*, 38. See also Jean-Pierre Babelon, "Les Cités ouvrières de Paris," *Les Monuments Historiques*, no. 3 (1977): 52.

87. Florence Bourillon, "Les expérimentations parisiennes en matière de logement populaire collectif de 1850 à 1894," *Revue du Nord* 374, no. 1 (2008): 80.

88. P.-A. Dufau, "La Cité Napoléon," *Annales de la Charité* 9 (1853): 249; Marie-Jeanne Dumont, *Le Logement social à Paris, 1850–1930: Les Habitations à bon marché* (Liège: Pierre Mardaga, 1991), 9.

89. *Rapports des délégations ouvrières*, 3:24. For the amenities, see Paul Taillefer, *Des Cités ouvrières et de leur nécessité comme hygiène et tranquilité publiques* (Paris: Imprimerie Boisseau et Compagnie, 1852), 11.

90. *Rapports des délégations ouvrières*, 3:24.

91. Louis-Napoléon Bonaparte, *Extinction du paupérisme* (Paris: Pagnerre, 1844), 42, 29, and 52.

92. See also the critique of Auguste Husson, "Des logements ouvriers et du dernier article du *Moniteur*," *Le Siècle*, May 18, 1853, 1.

93. Armand Audiganne, *Les Populations ouvrières et les industries de la France dans le mouvement social du XIXᵉ siècle* (Paris: Capelle, 1854), 2:310.

94. Taillefer, *Des Cités ouvrières et de leur nécessité*, 15.

95. Taillefer, *Des Cités ouvrières et de leur nécessité*, 9–10.

96. *Rapports des délégations ouvrières*, 2:64–65.

97. C. Détain, "Un mot sur la question des habitations ouvrières à Paris," *RGA* 24 (1866): col. 224.

98. Jean-Baptiste André Godin, *Solutions Sociales* (Paris: A. Le Chevallier, 1871), 164.

99. Edwin Chadwick, "Report on Dwellings Characterised by Cheapness Combined with the Conditions Necessary for Health and Comfort—Class 93," *Illustrated London News* 51 (July 6, 1867): 24.

100. For the emperor's contribution to workers' housing, public baths, washhouses, and other social experiments, see Catherine Granger, *L'Empereur et les Arts: La Liste Civile de Napoléon III* (Paris: École des Chartes, 2005), 87–102.

101. "Partie Non Officielle," *Le Moniteur universel*, May 13, 1852, 1; "Concours pour la construction des cités ouvrières," *RGA* 10 (1852): cols. 182–83.

102. "For example, the houses would be divided into groups of five, one of which would have a façade in ashlar, the other a façade in stone and brick, a third in rubble so that nothing would designate it as working-class housing." Quoted in Michelle Perrot, "Comment les ouvriers parisiens voyaient la crise d'après l'enquête parlementaire de 1884," in *Conjoncture économique, structures sociales: Hommage à Ernest Labrousse* (Paris: Mouton, 1974), 190.

103. *Rapports des délégations ouvrières*, 3:19–26.

104. Dumont, *Le Logement social à Paris*, 12.

105. Henry Roberts, *The Model Houses for Families, Built in Connexion with the Great Exhibition of 1851, by Command of His Royal Highness the Prince Albert, K.G.* (London: Society for Improving the Condition of the Labouring Classes, 1851).

106. They were criticized for their banal appearance. Louis-Alexandre Foucher de Careil and Louis Puteaux, *Les Habitations ouvrières et les constructions civiles* (Paris: E. Lacroix, 1873), 313–14. For housing by workers at the exhibition, see Détain, "Un mot sur la question des habitations ouvrières à Paris," col. 221–23; Roger-Henri Guerrand, *Propriétaires et locataires: Les Origines du logement social en France, 1850–1914* (Paris: Quinette, 1987), 108–9.

107. *Rapports des délégations ouvrières*, 1:20; Norbert Billiart, *Le Groupe de l'Empereur à l'Exposition Universelle* (Paris: Henri Plon, 1867).

108. Henry Roberts, "Dwellings for the Working Classes in Connection with the Late International Exhibition in Paris," *The Labourers' Friend: For Disseminating Information on the Dwellings of the Poor, and Other Means of Improving the Condition of the Labouring Classes*, January 1, 1868, 6.

109. For Chadwick's meeting with the emperor, see "An Interview with Napoleon III," *Sanitarian* 5 (1877): 180–82.

110. "Le Discours de l'Empereur," *Journal des chemins de fer, des mines et des travaux publics* 22 (1863): 69.

111. Détain, "Un mot sur la question des habitations ouvrières à Paris," col. 221–28; Bruant, *La Cité Napoléon*, 41–46.

112. Georges Teyssot, "The Disease of the Domicile," *Assemblage*, no. 6 (June 1988): 83. See also Ambroise Tardieu, *Dictionnaire d'hygiène publique et de salubrité ou Répertoire de toutes les questions relatives à la santé publique*, 2nd ed. (Paris: J.-B. Baillière, 1862), 1:533.

113. Manfredo Tafuri, "*Machine et mémoire*: The City in the Work of Le Corbusier," in *Le Corbusier*, ed. H. Allen Brooks (Princeton, NJ: Princeton University Press, 1987), 206.

114. Détain, "Un mot sur la question des habitations ouvrières à Paris," col. 227.

115. Edmond Demolins, "Les Habitations ouvrières: L'ouvrier propriétaire de son foyer," *La Réforme sociale* 3 (1882): 302.

116. Joseph Rykwert, *The Seduction of Place: The City in the Twenty-First Century* (New York: Pantheon, 2000), 89.

117. Ann-Louise Shapiro, "Housing Reform in Paris: Social Space and Social Control," *French Historical Studies* 12, no. 4 (Fall 1982): 498.

118. For Le Play, see Paul Rabinow, *French Modern: Norms and Forms of the Social Environment* (Cambridge, MA: MIT Press, 1989), 86–95.

119. Foucher de Careil and Puteaux, *Les*

Habitations ouvrières et les constructions civiles, 66–67. The architect was Léon Henri Picard. Roberts mentioned it in "Dwellings for the Working Classes in Connection with the Late International Exhibition in Paris," 8–9.

120. D'Haussonville, "La Misère à Paris," 846; see also Audiganne, *Les Populations ouvrières*, 2:309–10.

121. Duveau, *La Vie ouvrière en France sous le Second Empire*, 390.

122. Duveau, *La Vie ouvrière en France sous le Second Empire*, 52–53.

123. Nicolas Chaudun, *Haussmann au crible* (Paris: Éditions de Syrtes, 2000), 153.

124. Guerrand, *Propriétaires et locataires*, 99.

125. Dumont, *Le Logement social à Paris*, 13.

126. Granveau, *L'Ouvrier devant la société*, 65.

127. Lameyre, *Haussmann "Préfet de Paris,"* 159.

128. Haussmann, *Mémoires*, 2:177.

129. "Nomads" was a common trope; see, for example, Meding, *Essai sur la topographie médicale de Paris*, 149–50.

130. Haussmann's political motivations are often ignored. "Haussmann was in fact the first man to view the great city—the capital with millions of inhabitants—as a technical problem." Sigfried Giedion, *Space, Time and Architecture*, 5th ed. (Cambridge, MA: Harvard University Press, [1941] 1967), 773.

131. Georges-Eugène Haussmann, *Mémoires du Baron Haussmann*, vol. 1, *Avant l'Hôtel de Ville* (Paris: Victor-Havard, 1890), 254–55.

132. Helmuth Graf von Moltke, *Moltke in seinen Briefen: Mit einem lebens- und Charakterbilde des Verewigten* (Berlin: Ernst Siegfried Mittler und Sohn, 1900), 2:100.

133. For the École Polytechnique, founded by the Convention in 1794, see Antoine Picon, "Les Modèles de la Métropole: Les polytechniciens et l'aménagement de Paris," in *Le Paris des polytechniciens: Des ingénieurs dans la ville, 1794–1994*, ed. Bruno Belhoste, Francine Masson, and Antoine Picon (Paris: Délégation à l'action artistique de la Ville de Paris, 1994), 137–42.

134. César Daly, "Nouvelle architecture à l'usage des prolétaires anglais," *RGA* 6 (1845–46): col. 151. A friend of Considerant and Fourier, active in the Second Republic, he silenced this part of his career during the Second Empire. For his politics, see Hélène Lipstadt, "César Daly: Revolutionary Architect?," *Architectural Design* 48, no. 11 / 12 (1978): 18–29.

135. Lanquetin, quoted in Perreymond, "Deuxième étude sur la Ville de Paris," *RGA* 3 (1842): col. 577.

136. Napoleon Bonaparte, quoted in. A. Chevallier, "De la nécessité de bâtir," *Annales d'hygiène publique, industrielle et sociale*, 2nd ser., 7 (January 1857): 106.

137. Perreymond, "Sixième étude sur la Ville de Paris," *RGA* 4 (1843): col. 415.

138. Nicholas Papayanis, "L'Émergence de l'urbanisme moderne à Paris," in *La Modernité avant Haussmann: Formes de l'espace urbain à Paris, 1801–1853*, ed. Karen Bowie (Paris: Éditions Recherches, 2001), 82.

139. Quoted in Lazare, *Paris, son administration ancienne et moderne* (Paris: Ledoyen, 1856), 251.

140. Victor Considerant and Perreymond, "De l'unité administrative du département de la Seine," *La Démocratie pacifique* 1, no. 82 (October 21, 1843): 1.

141. Rambuteau, *Mémoires*, 369.

142. For Thiers's fortifications, see Patricia O'Brien, "*L'Embastillement de Paris*: The Fortification of Paris during the July Monarchy," *French Historical Studies* 9, no. 1 (Spring 1975): 63–82; Jean-Louis Cohen and André Lortie, *Des Fortifs au périf: Paris, les seuils de la ville* (Paris: Picard / Éditions du Pavillon de l'Arsenal, 1991); Antoine Picon, "Les Fortifications de Paris," in Belhoste et al., *Le Paris des polytechniciens*, 213–21.

143. Nathalie Montel, "Chronique d'une morte non annoncée: L'annexion par Paris de sa banlieue en 1860," *Recherches contemporaines*, no. 6 (2000–2001): 217–54; and Nathalie Montel, "L'agrandissement de Paris en 1860: Un projet controversé," in *Agrandir Paris, 1860–1970*, ed. Florence Bourillon and Annie Fourcaut (Paris: Publications de la Sorbonne, Comité d'histoire de la Ville de Paris, 2012), 99–111.

144. Henri Siméon, Travaux pour la Commission des embellissements de Paris, vol. 3, MS 1781, 15, BHdV; Louis Lazare, "Le Plan de Paris: Etudes d'ensemble," part 1, *La Revue municipale*, no 132 (October 1, 1853): 1070.

145. Quoted in Paul Léon, *Histoire de la rue* (Paris: La Taille Douce, 1947), 179.

146. Haussmann, quoted in Préfecture de la Seine, *Documents relatifs à l'extension des limites de Paris* (Charles de Mourges Frères, 1859), 50.

147. Haussmann, quoted in *Documents relatifs à l'extension des limites de Paris*, 35.

148. Haussmann, *Mémoires*, 2:452–53.

149. "Partie Officielle," *Le Moniteur universel*, no. 324 (November 19, 1852): 1.

150. According to Alfred Darimon, a republican member of Parliament, annexation went against Haussmann's plans. Alfred Darimon, *Histoire d'un parti: Les Cinq sous l'empire, 1857–1860* (Paris: E. Dentu, 1885), 256.

151. Bernard Rouleau, *Villages et faubourgs de l'ancien Paris: Histoire d'un espace urbain* (Paris: Seuil, 1985), 232.

152. Montel, "L'agrandissement de Paris en 1860," 105.

153. Gaillard, *Paris, la ville*, 95.

154. Montel, "Chronique d'une morte non annoncée," 241.

155. Rouleau, *Villages et faubourgs de l'ancien Paris*, 222.

156. Horeau called them "ce reste de barbarie." Hector Horeau, "Assainissements, embellissements de Paris ou édilité urbaine à la portée de tout le monde," *GAB*, no. 6 (1868): 48.

157. François Arago, *Études sur les fortifications de Paris: considerées politiquement et militairement* (Paris: Pagnerre, 1843), 30.

158. Perrot, "Les Ouvriers, l'habitat et la ville," 33. The walls were finally destroyed between 1920 and 1930.

159. On this issue, see Jacques Rancière, "Le Bon Temps ou la barrière des plaisirs," *Les Révoltes logiques*, no. 7 (Spring–Summer 1978): 25–66.

160. Perrot, "Les Ouvriers, l'habitat et la ville," 33–34.

161. Mary Douglas, *Purity and Danger: An Analysis of Concepts of Pollution and Taboo* (London: Routledge, 1966), 4.

162. Annie Fourcaut in collaboration with Mathieu Flonneau, "Les Relations entre Paris et les banlieues, une histoire en chantier," in Fourcaut et al., *Paris/Banlieues*, 14.

163. Loïc J. D. Wacquant, "The Rise of Advanced Marginality: Notes on Its Nature and Implications," *Acta Sociologica* 39, no. 2 (1996): 121.

164. André Cochut, "Paris Industriel," in *Paris Guide* (Paris: A. Lacroix, Verboeckhoven, 1867), 2:1758. Of the 462,000 officially classed as "ouvriers," 326,000 were men, 110,000 women, 26,000 children (2:1759).

165. Haussmann, *Mémoires*, 2:446. Haussmann's numbers come from the 1856 census.

166. Quoted in Montel, "Chronique d'une morte non annoncée," 246, ellipsis in original.

167. In 1860, 250,000 people lived beyond the fortifications, a number that reached 700,000 by in the census of 1891. Francis Démier, "Paris, capitale populaire," in *Le Peuple de Paris au XIXᵉ siècle*, ed. Miriam Simon (Paris: Paris-Musées, 2011), 38.

168. Haussmann, *Mémoires*, 2:446.

169. James Fenimore Cooper, *Gleanings in Europe*, with an intro. by Thomas Philbrick, ed. Thomas Philbrick and Constance Ayers Denne (Albany: State University of New York Press, 1983), 66.

170. Charles-Alfred Janzé, *La Transformation de Paris et la question du pot-au-feu* (Paris: Sauton, 1869), 15–16.

171. Michel Chevalier, *L'industrie et l'octroi de Paris* (Paris: Guillaumin, 1867), 2:85–86.

172. Lazare, *Les Quartiers pauvres de Paris*, 28, emphasis in original.

173. Gérard Jacquemet, *Belleville au XIXᵉ siècle: Du faubourg à la ville* (Paris: Éditions de l'École des Hautes Études en Sciences Sociales, 1984), 163.

174. Montel, "L'agrandissement de Paris en 1860," 100.

175. Cooper, *Gleanings in Europe*, 198.

176. Montel, "L'agrandissement de Paris en 1860," 101.

177. Geneviève Massa-Gille, *Histoire des emprunts de la Ville de Paris (1814–1875)* (Paris: Commission des travaux historiques: Sous-commission de recherches d'histoire municipale, 1973), 258–59; Christiane Demeulenaere-Douyère, "L' 'annexion' vue de l'Est parisien: Inquiétudes, espérances et insatisfactions...," in Bourillon and Fourcaut, *Agrandir Paris*, 144.

178. Demeulenaere-Douyère, "L' 'annexion' vue de l'Est parisien," 139.

179. Rougerie, "Recherche sur le Paris du XIXᵉ siècle," 76.

180. Demeulenaere-Douyère, "L' 'annexion' vue de l'Est parisien," 144.

181. Rancière, "Le Bon Temps ou la barrière des plaisirs," 37, emphasis in original.

182. For the villages surrounding Paris, see the refreshing book by Eric Hazan, *The Invention of Paris: A History in Footsteps*, trans. David Fernbach (London: Verso, 2010), 174–223.

183. Cooper, *Gleanings in Europe*, 197.

184. Cooper, *Gleanings in Europe*, 197.

185. Victor Considerant and Perreymond, "De l'unité administrative du département de la Seine," part 2, *La Démocratie pacifique* 1, no. 103 (November 11, 1843): 1.

186. Armand Audiganne, *L'industrie française depuis la révolution de février et l'exposition de 1849* (Paris: Guillaumin, 1849), 29.

187. D'Haussonville, "La Misère à Paris," 828.

188. Jacquemet, *Belleville au XIXᵉ siècle*, 25.

189. Rouleau, *Villages et faubourgs de l'ancien Paris*, 42. See also Jacquemet, "Belleville au XIXᵉ et XXᵉ siècles," 819–43.

190. Émile Gigault de La Bédollière, *Le Nouveau Paris: Histoire de ses vingt arrondissements* (Paris: Gustave Barba, 1860), 306.

191. For the persistence of the rural in French cities and peripheries, see John M. Merriman, "City and Country: That Awkward Embrace," in *The Margins of City Life: Explorations on the French Urban Frontier, 1815–1851* (New York: Oxford University Press, 1991), 31–58.

192. Cooper, *Gleanings in Europe*, 199.

193. Amédée Achard, "Le Bois de Boulogne, les Champs-Élysées, le Bois de le Château de Vincennes," in *Paris Guide*, 2:1231.

194. D'Haussonville, "La Misère à Paris," 836.

195. D'Haussonville, "La Misère à Paris," 828.

196. La Bédollière, *Le Nouveau Paris*, 208.

197. On this topic, see Robert Lethbridge, "Les

Représentations de la banlieue chez Zola et les peintres," *Les Cahiers naturalistes* 38, no. 66 (1992): 59–71.

198. Edmond and Jules Goncourt, *Germinie Lacerteux* (1865; Paris: Flammarion, 1990), 115.

199. Hugo, *Les Misérables*, 2:173.

200. See the exhibition catalogue *Van Gogh à Paris* (Paris: Musée d'Orsay, 1988); Richard Thomson, "Representing the Parisian Suburbs," in Richard Thomson, *Camille Pissarro: Impressionism, Landscape and Rural Labour* (New York: New Amsterdam, 1990), 19–26.

201. Merriman, *Margins of City Life*, 19.

202. Miriam Simon, "Des migrants," in Simon, *Le Peuple de Paris au XIXᵉ siècle*, 42.

203. Anthime Corbon, *Le Secret du peuple de Paris* (Paris: Pagnerre, 1863), 209.

204. Rouleau claims this cannot have been by chance but does not explore the reasons, which are clearly political. Rouleau, *Villages et faubourgs de l'ancien Paris*, 224.

205. Jacquemet, *Belleville au XIXᵉ siècle*, 166–67.

206. Edmond and Jules de Goncourt, *Journal: Mémoires de la vie littéraire*, 2nd ser., vol. 1, 1870–71 (Paris: G. Charpentier, 1890), 365, emphasis in original.

207. Pierre-Antoine Leboux de La Mésangère, quoted in Jean-Pierre A. Bernard, *Les Deux Paris: Les Représentations de Paris dans la seconde moitié du XIXᵉ siècle* (Seyssel: Champ Vallon, 2001), 262.

208. For the municipality's treatment of the banlieue, see Christiane Demeulenaere-Douyère, "L'annexion' vue de l'Est parisien: Inquiétudes, espérances et insatisfactions...," 129–45.

209. Lazare, *Les Quartiers pauvres de Paris*, 78.

210. Frederick Engels, *The Housing Question* (1872), ed. C. P. Dutt (New York: International, 1935), 47.

211. Granveau, *L'Ouvrier devant la société*, 56–57.

212. Gaillard, *Paris, la ville*, 112.

213. In the periphery, a British observer saw workers' hovels "built of lumps of plaster from demolitions, with vegetable earth instead of mortar, and roofed with old tin trays, tin cuttings and bits of painted table-covers." "London and Paris," *Building News*, no. 7 (November 8, 1861): 897.

214. Pierre-André Touttain, *Haussmann: Artisan du Second Empire, créateur du Paris moderne* (Paris: Gründ, 1971), 140. The Péreires probably based themselves on the streets surrounding the new Opéra, named after composers Scribe, Auber, Gluck, and Halévy.

215. Léon, *Histoire de la rue*, 185.

216. Lazare, *Les Quartiers pauvres de Paris*, 5–6.

217. Lazare-Maurice Tisserand, "Avant-Propos," in Adolphe Berty, *Topographie historique du vieux Paris*, completed by Lazare-Maurice Tisserand (Paris: Imprimerie Nationale, 1882), 4:v.

218. Hippolyte Meynadier, *Paris sous le point de vue pittoresque et monumental; ou, Éléments d'un plan général d'ensemble de ses travaux d'art et d'utilité publique* (Paris: Dauvin et Fontaine, 1843), 198.

219. Lameyre, *Haussmann*, 153.

220. For the château de Bercy and its magnificent park, see Édouard Fournier, *Chroniques et légendes des rues de Paris* (Paris: E. Dentu, 1864), 197–209.

221. Lazare, *Les Quartiers de l'est de Paris*, 98.

222. Haussmann, *Mémoires*, 2:528–29. Gaillard suggests that the role of teachers in propagating the ideals of 1848 played an important role. Gaillard, *Paris, la ville*, 203.

223. Quoted in Augustin Cochin, *De la condition des ouvriers français d'après les derniers travaux* (Paris: Charles Douniol, 1862), 29.

224. Rougerie, "Recherche sur le Paris du XIXᵉ siècle," 75.

225. Gaillard, *Paris, la ville*, 202–3.

226. Quoted in Alfred Des Cilleuls, *Histoire de l'Administration parisienne au XIXᵉ siècle* (Paris: Honoré Champion, 1900), 2:351–52, ellipses in original.

227. Perreymond, "Neuvième Étude sur la Ville de Paris," *RGA* 4 (1843): col. 524.

228. D'Haussonville, "La Misère à Paris," 827.

229. Marcel Raval, "Haussmann contre Paris," in *Destinée de Paris* (Paris: Les Éditions du Chêne, 1943), 60, emphasis in original.

230. Letter dated June 22, 1857, quoted in Georges Valance, *Haussmann le Grand* (Paris: Flammarion, 2000), 224.

231. Maxime Du Camp, *Paris, ses organes, ses fonctions et sa vie dans la seconde moitié du XIXᵉ siècle* (Paris: Hachette, 1875), 4:114. Animal black was a pigment made with charred animal bones.

232. Meding, *Essai sur la topographie médicale de Paris*, 149.

233. Auguste-Adrien Ollivier, "Salubrité des logements," in *Rapport général sur les travaux du Conseil d'hygiène publique et de salubrité du département de la Seine depuis 1887 jusqu'à 1889 inclusivement* (Paris: Chaix, 1894), 286.

234. Albert Dresden Vandam, *An Englishman in Paris* (New York: D. Appleton, 1893), 238.

235. Michael J. Heffernan, "The Parisian Poor and the Colonization of Algeria during the Second Republic," *French History* 3, no. 4 (1989): 380–87.

236. Jennifer E. Sessions, "Colonizing Revolutionary Politics: Algeria and the French Revolution of 1848," *French Politics, Culture, and Society* 33, no. 1 (2015): 93; Allyson Jaye Delnore, "Empire by Example? Deportees in France and Algeria and the Re-making of a Modern Empire, 1846–1854," *French Politics, Culture and Society* 33, no. 1 (2015): 43.

237. Delnore, "Empire by Example?," 44.

238. Antony Thrall Sullivan, *Thomas-Robert*

Bugeaud: France and Algeria, 1784–1849; Politics, Power, and the Good Society (Hamden, CT: Archon Books, 1983), 140.

239. Étienne Balibar, "The Nation Form: History and Ideology," in Étienne Balibar and Immanuel Wallerstein, *Race, Nation, Class: Ambiguous Identities* (London: Verso, 1991), 89.

240. Gérard Jacquemet, "Urbanisme parisien: La Bataille du tout-à-l'égoût à la fin du XIXᵉ siècle," *Revue d'Histoire Moderne et Contemporaine* 26, no. 4 (October–December 1979): 522.

241. David Harvey, *Consciousness and the Urban Experience: Studies in the History and Theory of Capitalist Urbanization* (Baltimore: Johns Hopkins University Press, 1985), xvii–xviii; David Harvey, "Between Space and Time: Reflections on the Geographical Imagination," *Annals of the Association of American Geographers* 80, no. 3 (September 1990): 418–34.

242. Granveau, *L'Ouvrier devant la société*, 63.

243. Weill, *Paris inhabitable*, 10.

244. Lazare, *Les Quartiers pauvres de Paris*, 58. Haussmann, *Mémoires*, 2:446.

245. Lazare, *Les Quartiers pauvres de Paris*, 59.

246. Lazare, *Les Quartiers de l'est de Paris*, 96. For the price of railway tickets for workers, see also Henri Siméon, Commission des embellissements de Paris, vol. 4, MS 1782, 67, BHdV.

247. Lazare, *Les Quartiers pauvres de Paris*, 58.

248. D'Haussonville, "La Misère à Paris," 827.

249. Zola, *L'Assommoir*, 99–107.

250. Honoré de Balzac, *La Duchesse de Langeais* (Paris: Gallimard, 1976), 72–73.

251. "It is not money that is lacking in Paris, but time!" Weill, *Paris inhabitable*, 11.

252. Eugène Sue, *Les Mystères de Paris* (Paris: Robert Laffont, 1989), 457.

253. Lazare, *Les Quartiers pauvres de Paris*, 86, emphasis in original. Holidays were subtracted from workers' pay. Simon, *L'Ouvrière*, 265.

254. Mona Ozouf, *Festivals and the French Revolution* (Cambridge, MA: Harvard University Press, 1988), 151.

255. Alain Corbin, "Préface," in *Les Usages politiques des fêtes aux XIXᵉ–XXᵉ siècles: Actes du colloque organisé les 22 et 23 novembre 1990 à Paris*, ed. Alain Corbin, Noëlle Gérôme, and Danielle Tartakowsky (Paris: Publications de la Sorbonne, 1994), 11.

256. Rancière, "Le Bon Temps ou la barrière des plaisirs," 46.

257. For Saint-Lundi and the ancien régime, see Louis Sébastien Mercier, "Le lundi," in *Tableau de Paris*, ed. Jean-Claude Bonnet (Paris: Mercure de France, 1994), 2:1017–18; for the nineteenth century, see Duveau, *La Vie ouvrière en France sous le Second Empire*, 243–48; Michelle Perrot, *Les Ouvriers en grève: France 1871–1890* (Paris: Mouton, 1974), 1:225–29; Jeffry Kaplow, "La fin de la Saint-Lundi, étude sur le Paris ouvrier au XIX siècle," *Temps Libre*, no. 2 (Summer 1981): 107–18; Robert Beck, "Apogée et déclin de la Saint Lundi dans la France du XIXᵉ siècle," *Revue d'Histoire du XIXᵉ Siècle*, no. 29 (2004): 153–71. See also the classic study by E. P. Thompson, "Time, Work-Discipline, and Industrial Capitalism," *Past and Present*, no. 38 (December 1967): 56–97.

258. E. Servier, "Le Gaz à Paris," in *Paris Guide*, 2:1636.

259. Cochin, *De la condition des ouvriers français*, 37.

260. Duveau, *La Vie ouvrière en France sous le Second Empire*, 248.

261. Perrot, *Les Ouvriers en grève*, 1:227.

262. Henri Lefebvre, *The Production of Space*, trans. Donald Nicholson-Smith (Oxford: Blackwell, 1991). Lefebvre complicates the notion of space throughout his book with great analytical sophistication.

263. For this issue, see Duveau, *La Vie ouvrière en France sous le Second Empire*, 466–67.

264. Granveau, *L'Ouvrier devant la société*, 63.

265. Quoted in Émile Levasseur, *Questions ouvrières et industrielles en France sous la Troisième République* (Paris: Arthur Rousseau, 1907), 833.

266. Quoted in Perrot, "Comment les ouvriers parisiens voyaient la crise," 190–91.

267. Edmond About, "Dans les ruines," in *Paris Guide*, 2:920–21.

268. For Hugo, the periphery shared the characteristics of both town and country: "To observe the banlieue is to observe amphibia." Hugo, *Les Misérables*, 1:738.

269. For a strong reading of the role of the periphery, see Merriman, *Margins of City Life*; Lequin, "Ouvriers dans la ville (XIXᵉ et XXᵉ siècle)," 3–7.

270. André Vant, "Géographie sociale et marginalité," in *Marginalité sociale, marginalité spatiale*, ed. André Vant (Paris: Éditions du Centre National de Recherche Scientifique, 1986), 20.

271. Lefebvre, *Production of Space*, 87. For Lefebvre an "ambiguous continuity" exists between spaces separated by walls or thresholds.

272. Rancière, "Le Bon Temps ou la barrière des plaisirs," 28.

273. AbdouMaliq Simone, "People as Infrastructure: Intersecting Fragments in Johannesburg," *Public Culture* 16, no. 3 (Fall 2004): 419.

274. On this issue, see *How Users Matter: The Co-construction of Users and Technology*, ed. Nelly Oudshoorn and Trevor Pinch (Cambridge, MA: MIT Press, 2005). See also Peter Soppelsa, "The Fragility of Modernity: Infrastructure and Everyday Life in Paris, 1870–1914" (PhD diss., University of Michigan, 2009), 17–27.

275. For an excellent analysis of "infrastructural appropriation" in another context, see Swati Chattopadhyay, *Unlearning the City: Infrastructure in a New*

Optical Field (Minneapolis: University of Minnesota Press, 2012), 245.

276. But see Jacques Rancière's problematization of writings by workers in *Proletarian Nights: The Workers' Dream in Nineteenth-Century France*, intro. by Donald Reid (London: Verso Books, 2012).

277. Haussmann, *Mémoires*, 2:203. The same speech praises the District of Columbia, "which does not enjoy real autonomy because it is considered the common property of the United States" (2:206).

278. Janzé, *La Transformation de Paris*, 9.

279. "For our important administrators, the State and the City are two enemies vis-à-vis one another," Perreymond noted. Sadly, he adds, "the City always gets the worse." Perreymond, "Neuvième étude sur la Ville de Paris," *RGA* 4 (1843): col. 523.

280. Lucien Davésiès de Pontès, *Paris tuera la France! Nécessité de déplacer le siège du gouvernement* (Paris: Dentu, 1850), 26.

281. Haussmann, *Mémoires*, 2:197.

282. Henri Lefebvre, *Le Droit à la ville* (Paris: Éditions Anthropos, 1972), 193.

283. Lefebvre, *Le Droit à la ville*, 24; Jacques Rougerie, *Paris libre 1871* (Paris: Éditions du Seuil, 1971), 19.

CONCLUSION

1. Jean Cocteau, "Portraits-souvenir" (1920), in *Oeuvres complètes* (Paris: Marguerat, 1951), 11:119. Her son Napoléon, the so-called Prince Imperial, died in 1879, fighting for Britain in the Anglo-Zulu War.

2. André Chastel, "Du Paris de Haussmann au Paris d'aujourd'hui," in *Paris, présent et avenir d'une capitale* (Paris: Institut Pédagogique National, 1964), 12; for Alphand's role in perpetuating outmoded forms of urban planning, see Anthony Sutcliffe, "Environmental Control and Planning in European Capitals 1850–1914: London, Paris and Berlin," in *Growth and Transformation of the Modern City* (Stockholm: Swedish Council for Building Research, 1979), 81.

3. Quoted in Chastel, "Du Paris de Haussmann au Paris d'aujourd'hui," 8. For this issue, see Arno Mayer, *The Persistence of the Old Regime: Europe to the Great War* (New York: Pantheon Books, 1981).

4. Henri Lefebvre, *The Production of Space*, trans. Donald Nicholson-Smith (Oxford: Blackwell, 1991), 321.

5. It was this France that would ultimately crush the Commune. Élie Konigson, "Introduction," in *Images de la ville sur la scène aux XIX^e et XX^e siècles*, ed. Élie Konigson (Paris: Éditions du CNRS, 1991), 13.

6. Yvon Leblicq, "Les villes haussmanniennes," *Cahiers Bruxellois* 19, no. 242 (1984): 61–100; Gwendolyn Wright, *The Politics of Design in French Colonial Urbanism* (Chicago: University of Chicago Press, 1991).

7. Anthony Sutcliffe, "Architecture and Civic Design in Nineteenth Century Paris," *Growth and Transformation of the Modern City* (Stockholm: Swedish Council for Building Research, 1979), 89; Camillo Sitte, *Der Städtebau nach seinen künstlerischen Grundsätzen* (Vienna: Verlag von Carl Graeser, 1889).

8. Pierre Pinon, *Atlas du Paris haussmannien: La Ville en héritage du Second Empire à nos jours* (Paris: Parigramme, 2003), 180–89.

9. Although the author does not deal with Paris, see Haejeong Hazel Hahn, "Abstract Spaces of Asia, Indochina, and Empire in the French Imaginary," in *Architecturalized Asia: Mapping a Continent through History*, ed. Vimalin Rujivacharakul, H. Hazel Hahn, Ken Tadashi Oshima, and Peter Christensen (Honolulu: University of Hawai'i Press, 2013), 85–100; Cole Roskam, *Improvised City: Architecture and Governance in Shanghai, 1843–1937* (Seattle: University of Washington Press, 2019), 87. For Haussmann's influence in modern China, see Daniel Benjamin Abramson, "Haussmann and Le Corbusier in China: Land Control and the Design of Streets in Urban Redevelopment," *Journal of Urban Design* 13, no. 2 (June 2008): 231–56.

10. Margareth da Silva Pereira, "The Time of Capitals: Rio de Janeiro and São Paulo; Words, Actors and Plans," in *Planning Latin America's Capital Cities, 1850–1950*, ed. Arturo Almandoz (London: Routledge, 2002), 75–108.

11. Frank Sewall, "Diagonal Avenues in Cities," *Engineering News and American Railway Journal*, October 10, 1891, 335.

12. Daniel H. Burnham and Edward H. Bennett, *Plan of Chicago* (Chicago: Commercial Club, 1909), 18.

13. Robert Moses, "What Happened to Haussmann?," *Architectural Forum*, no. 77 (July 1942): 57–66.

14. Elbert Peets, "Famous Town Planners I: Haussmann," *Town Planning Review* 12, no. 3 (June 1927): 181.

15. Derek Gregory, *The Colonial Present: Afghanistan, Palestine, and Iraq* (Malden, MA: Blackwell, 2004), 10.

Index

Note: Page numbers in italic type indicate illustrations.

Photography and Copyright Credits